CHICAGO
FLASHBACK

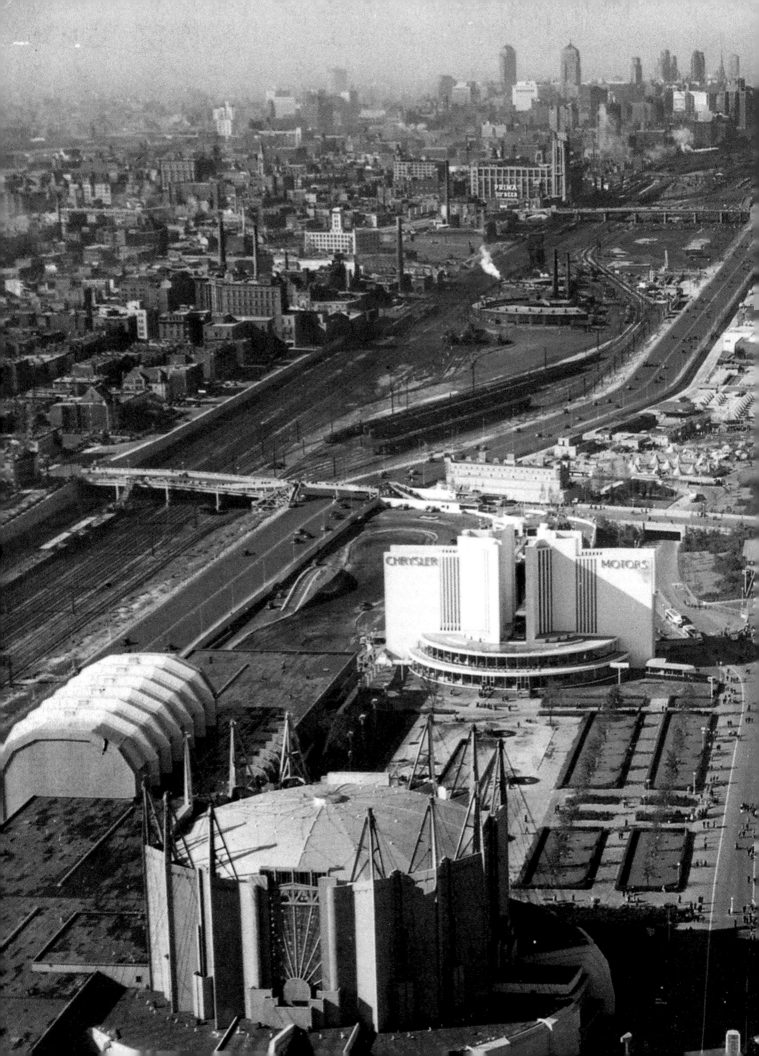

CHICAGO
FLASHBACK

The People and Events That Shaped a City's History

Chicago Tribune

MIDWAY

AN AGATE IMPRINT

CHICAGO

Chicago Tribune: R. Bruce Dold, Publisher & Editor-in-Chief; Peter Kendall, Managing Editor; Colin McMahon, Associate Editor; Amy Carr, Associate Managing Editor/Features; Marianne Mather, Photo Editor; Kathleen O'Malley, Copy Editor.

Printed in the United States

Chicago Flashback
ISBN 13: 978-1-57284-235-9
ISBN 10: 1-57284-235-0
ebook ISBN 13: 978-1-57284-807-8
ebook ISBN 10: 1-57284-807-3
First printing: November 2017

10 9 8 7 6 5 4 3 2 1 17 18 19 20 22

Midway Books is an imprint of Agate Publishing. Agate books are available in bulk at discount prices. For more information, visit agatepublishing.com.

Contents

Photo on title page: Looking north from the bottom left of the midway are the famous Travel and Transport Building, the Chrysler Motors Building and Northerly Island at top right, where the Sky Ride can be faintly seen.

Introduction

WHEN visitors come to Chicago, they gape at the architecture, frolic on the lakefront, marvel in the museums, explore the diverse neighborhoods—and devour the food. They declare Chicago a world-class city and rightly so. Yet to understand what makes this metropolis tick, how it grew into the city it has become, you have to hear its stories.

Here are 100 of those stories. Curated from the Chicago Tribune's Flashback feature—which mined the newspaper's vast story, photo and news page archives—the tales told here breathe new life into well-known historical events by reporting how everyday Chicagoans heard the often-terrible news and how they reacted. In flipping through 170 years of newspapers and tens of thousands of photographs, we also rediscovered events and slices of city life that surely would have been lost to history.

As conceived by then-Editor Gerould Kern, Chicago Flashback was launched in June 2011 to bring context to current events by connecting the news of the day to the city's past. The very first installment, coming in the middle of the Rod Blagojevich scandal, reminded readers about Len Small, the "worst governor ever," who was accused of embezzling millions in the 1920s—and got away with it.

The second added depth to decades-long efforts to clean up the Chicago River and unearthed the remarkable story of a robbery victim in May 1911 who was beaten and thrown unconscious over the side of a bridge. As luck would have it, he landed in Bubbly Creek, a filthy arm of the Chicago River near the stockyards that was so clogged with grease and animal parts that the man didn't sink, but came to hours later to realize he was on the "soft, yielding bosom" of Bubbly Creek.

Compiled here, these stories and others spanning more than two centuries paint a vibrant picture of what city life was like when pedestrians waded through swampy streets, broad-shouldered immigrants stoked steel mills or butchered cattle and the newly wealthy strolled down leafy lakeside paths.

Telling Chicago's story was a labor of love. Tribune reporter Ron Grossman, the newsroom's de facto historian and a natural-born storyteller, not only wrote most of the installments but also provided keen insights and creative energy.

Some of the most entertaining stories arose from the research efforts of Tribune photo editor Marianne Mather. Two prime examples: Hollywood legends stopping in Chicago to change trains and the crazy Depression-era fad of marathon tree-sitting.

Finally, Flashback was made immeasurably better by the thoughtful comments of Tribune readers, who shared personal memories and family stories, suggested insightful installments and were quick to note inaccuracies when they arose.

And they often asked when the book was coming out. So for those readers and anybody else interested in how Chicago got from then to now, this book is for you.

STEPHAN BENZKOFER
Chicago Flashback editor, 2011–2015

A NOTE ON THE PHOTOGRAPHY: Many of the historical photos in this book have deteriorated over time, so you'll see images that are scratched, broken, faded or painted on by long-ago newspaper retouchers.

BUBBLY CREEK VICTIM LIVES

Man Beaten by Robbers Floats Unconscious Five Hours.

NOW HE HAS PNEUMONIA.

Struggles Two Hours Over Surface of Thick Stream.

Robbed! Beaten unconscious! Thrown from a bridge into Bubbly creek! Escapes alive, unaided, after seven hours!

Joseph Mischelot, now a patient at the county hospital, suffering with pneumonia, is the man who had all these experiences. That he was not drowned when three holdup men hurled him over the rail of the Ashland avenue bridge is due solely to the semi-solid nature of the contents coursing through the stockyards channel.

It was 10 o'clock Friday night when Mischelot's unconscious form was thrown over the bridge rail. It was after 8 o'clock yesterday morning when he returned to consciousness and found himself lying on some soft, yielding substance that he soon found to be the bosom of Bubbly creek.

Makes His Way to Shore.

It was almost two hours later that he succeeded in climbing ashore, after having half climbed and half swum across half the width of the creek. For the last few feet of his journey he wriggled his way cautiously through an almost solid bed of grease.

He was suffering great pain from his head, which had been beaten sore by the robbers. He was in constant terror lest he strike some portion of the creek that would not bear his weight. He was too weak to cry for aid and his clothes had become so covered with grease and water that he was not noticed by passers-by from the bridge.

When he reached land he rested a while. Finally he started on his way to his home at 1625 West Forty-third street.

Reaches Home Exhausted.

He attracted considerable attention from men and women on their way to work. None molested him, but neither did any offer to assist him and when he reached home he was exhausted.

Members of his household scraped and washed him clean and put him to bed, but last night he was delirious. The ambulance was called from the Stock Yards station and the surgeon diagnosed his case as one of pneumonia. He was rushed to the county hospital, where it is said he has an even chance of recovery.

Perhaps you do not believe this story. Have you ever seen Bubbly creek?

Happy birthday, Chicago

180 years of memorable, horrible, humorous and remarkable events

The original goal: Gather one headline from each year of the city's existence. Unearthing a meaningful event from the murky past was hard for some periods, but most years overflowed with choices, and the difficulty was in whittling down the candidates to just one, but we made the tough choices. We would not be deterred.

—Stephan Benzkofer and Mark Jacob

P.S. Select years come with a bonus item, included at no extra charge.
P.P.S. The original list celebrated the city's 175th birthday; it was updated for the book.

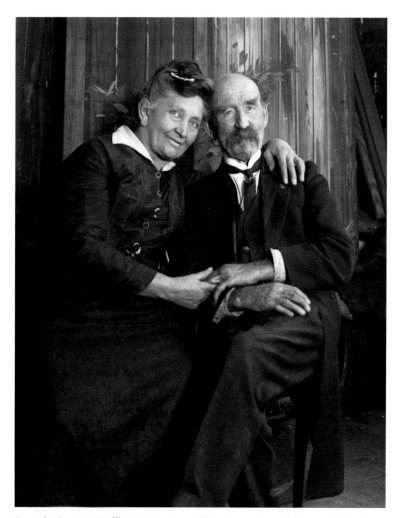

Captain George Wellington Streeter, the namesake of Chicago's Streeterville neighborhood, and Mrs. Streeter in an undated photo.

1837: Chicago becomes a city and elects William Ogden its first mayor.

1838: Hundreds of the mostly Irish workers digging the I&M Canal die of disease.

1839: A night watch is hired to look out for fires and criminals.

1840: Chicago population is 4,470.

1841: City's first permanent Jewish settlers arrive.

1842: Washington Square Park, later known as Bughouse Square and home to orators of all stripes, is established.

1843: Roman Catholic Diocese of Chicago is established.

1844: First Catholic school opened (for boys).

1845: Chicago passes first blue law, closing "tippling houses" on Sundays.

1846: Chicago claims it has one of the "best and safest harbors on the lake."

1847: Chicago Tribune begins publishing.

1848: Chicago welcomes business with opening of the I&M Canal and the Chicago Board of Trade.

1849: Spring storm sweeps away all Chicago River bridges.

1850: City planks 6.7 miles of streets, including 12,000 feet of State Street.

1851: Public Water Board organized to handle recurring cholera epidemics.

1852: First public transportation (a large horse-drawn carriage).

1853: YMCA expands to Chicago.

1854: Lakeview is promoted as a pleasant summer retreat away from city's disease and heat.

1855: Lager Beer Riots in April protest higher saloon taxes and anti-beer laws.

1856: City raises streets out of the swamp.

1857: Allan Pinkerton's men thwart a grave-robbing scheme by a city official.

1858: Police force gets uniforms and fire department switches from volunteer to paid.

1859: First horse-drawn street railway, or horsecars, begins operation.

1860: Republicans meeting in the Wigwam nominate Abraham Lincoln for president.

1861: The Chicago Zouaves, Irish Brigade and Lincoln Rifles are among companies to march off to fight in Civil War.

1862: Camp Douglas converted to prison for rebel soldiers.

1863: Rush Street bridge collapses, killing a girl and scores of cattle.

1864: Free mail delivery begins.

1865: Union Stock Yards open.

1866: City completes two-mile tunnel into lake to draw "pure water."

1867: St. Stanislaus Kostka parish is first of many to serve the Polish community.

1868: Lincoln Park Zoo welcomes its first animals, a pair of swans.

1869: Chicago Water Tower erected.

1870: St. Ignatius University opens (later renamed Loyola).

1871: Great Chicago Fire kills at least 300 people and destroys a huge swath of the city.

1872: First African-American police officer hired.

1873: Tribune reports new city directory shows Chicago has 212 churches, 80 newspapers and 31 railroad companies.

1874: Little Chicago Fire destroys 60 acres on Near South Side.

1875: Tribune reports money available to complete long-awaited "drive along the Lake shore on the North Side."

1876: The team that would eventually be called the Chicago Cubs wins the National League's first title.

1877: Pacific Garden Mission begins offering refuge to the downtrodden.

1878: Fire pole invented in a Chicago firehouse.

1879: Union League Club of Chicago organized.

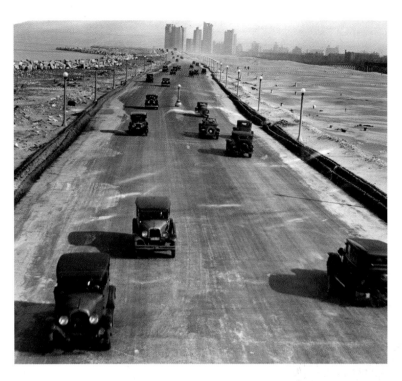

Looking south from 39th Street over Outer Drive (now Lake Shore Drive) in May 1930 after it was opened to traffic.

1880: Rabbi Emil Hirsch takes over Chicago Sinai Congregation and builds it into city's largest.

1881: Town of Pullman opens to house railroad car factory workers and their families.

1882: Cable car system clangs into operation; it would grow into one of the world's largest.

1883: Washington Park Jockey Club established.

1884: Construction begins on the Home Insurance Building, the first skyscraper at 10 floors.

1885: First female police matron hired to watch female prisoners.

1886: Haymarket Square Riot.

1887: Softball is invented on the South Side.

1888: Adler and Sullivan's Auditorium Building is built.

1889: The city triples in size with annexation of the municipalities of Lake View, Hyde Park, Jefferson and Lake.

1889: Jane Addams opens Hull House.

1890: Aaron Montgomery Ward successfully sues the city to keep Grant Park open.

1891: Marie Owens hired as first female police officer.

1892: University of Chicago opens for class.

1893: World's Columbian Exposition.

1893: Mayor Carter Harrison I is assassinated.

1894: Pullman workers go on strike.

1895: The nation's first automobile race is held in Chicago and Evanston.

1896: William Jennings Bryan gives his Cross of Gold speech at the Democratic National Convention.

1897: Elevated train line built in Loop.

1898: First Chicago-to-Mackinac sailboat race.

1899: L. Frank Baum writes "The Wonderful Wizard of Oz" at his Humboldt Park home.

1900: Chicago River's flow is reversed.

1900: Chicago White Sox play their first game.

1901: Walt Disney is born in Chicago.

1902: Marshall Field's opens State Street store.

1903: Iroquois Theater fire kills more than 600 people, the deadliest theater fire in U.S. history.

1904: Riverview amusement park opens.

1905: Advertisement in the Tribune extols the virtues of new home design called a bungalow.

1906: Bosnians establish Chicago's first Muslim benevolence society.

1906: White Sox beat Cubs in World Series.

1907: Cubs win first World Series title.

1908: State and Madison becomes zero point in cleaned-up numbering grid.

1909: Daniel Burnham and Edward Bennett publish "Plan of Chicago."

1910: Stockyard fire kills 22 firefighters, including the chief.

1911: International Air Meet energizes the city with the thrill of flight.

1912: The Rouse Simmons, delivering the annual supply of Christmas trees, sinks.

1913: Art Institute hosts famous Armory Show of modern art.

1914: Weeghman Park opens (later renamed Wrigley Field).

1915: First Chicago mayoral election in which women can vote.

1915: The excursion boat Eastland overturns in Chicago River, killing 844.

1916: Municipal Pier opens (later renamed Navy Pier).

1917: At least seven barbers' homes or barbershops bombed in union dispute.

1918: Morals inspector M.L.C. Funkhouser, who battled prostitution and was official film censor, is ousted.

1919: Race riots kill 38 and injure hundreds.

1920: Michigan Avenue bridge, the first double-decker bascule bridge, opens.

1921: Eight White Sox players acquitted in Black Sox scandal but banned for life from baseball.

1922: Louis Armstrong joins King Oliver's Creole Jazz Band in Chicago.

1922: George Halas renames team Chicago Bears.

1923: Chicago divided into 50 wards.

1924: Richard Loeb and Nathan Leopold Jr. commit "thrill killing."

1925: Tribune Tower completed.

1926: Maurine Dallas Watkins writes the play "Chicago."

1927: Municipal Airport opens (later renamed Midway).

1928: "Amos 'n' Andy" debuts on Chicago's WMAQ radio.

1929: St. Valentine's Day massacre.

1930: Shedd Aquarium and Adler Planetarium open.

1931: Gangster Al Capone convicted of income tax evasion.

Nelson Algren, at the YMCA at Milwaukee Avenue and Division Street, in 1956.

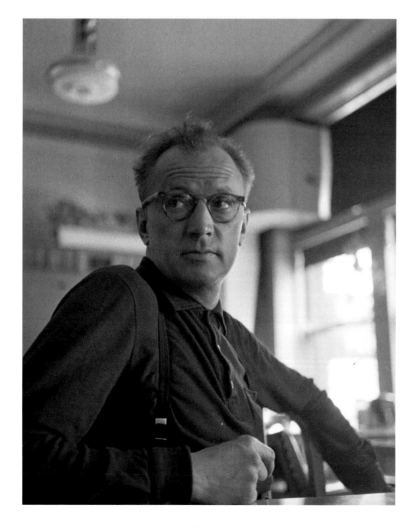

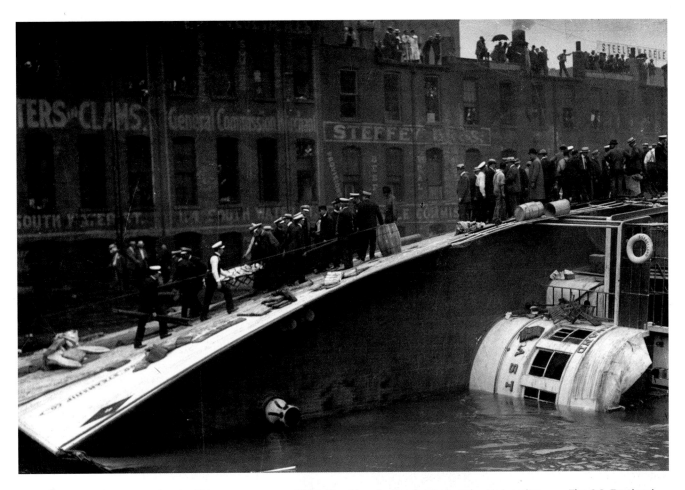

1932: Democratic Convention in Chicago nominates Franklin Delano Roosevelt for president.

1933: Mayor Anton Cermak fatally shot in Miami.

1933-34: Century of Progress Exposition.

1934: Elijah Muhammad moves Nation of Islam headquarters to South Side.

1934: Bank robber John Dillinger shot dead outside Biograph Theater.

1935: Leo Burnett starts Chicago ad agency that will create Jolly Green Giant and Pillsbury Doughboy.

1936: City bans cigarette vending machines.

1937: Robert Johnson records "Sweet Home Chicago."

1937: Pioneering blood bank opens at Cook County Hospital.

1938: Disgraced Chicago utility baron Samuel Insull dies in Paris.

1939: Saul Alinsky creates community-organizing model in Back of the Yards.

1940: Richard Wright's "Native Son" published.

1941: Illinois Legislature creates Chicago's Medical Center District.

1942: The Atomic Age begins at the University of Chicago with first controlled nuclear chain reaction.

1943: Deep-dish pizza mecca Pizzeria Uno opens.

1944: Germany's U-505 submarine captured—later to become major exhibit at Museum of Science and Industry.

1945: John Johnson publishes Ebony magazine.

1946: University of Illinois starts holding classes at Navy Pier.

1947: First parking meters installed in Chicago.

1948: Launch of Chicago Sun-Times and WGN-TV.

1949: Municipal Airport renamed Midway; Orchard Field renamed O'Hare.

1950: Chess Records founded.

1951: Edens Expressway (first in Chicago) opens.

1952: Chicago American Giants, Negro Leagues team, disbands.

1953: First issue of Playboy magazine is produced in Hugh Hefner's Hyde Park apartment.

The S.S. Eastland listed to its side in the Chicago River on July 24, 1915, leaving 844 dead.

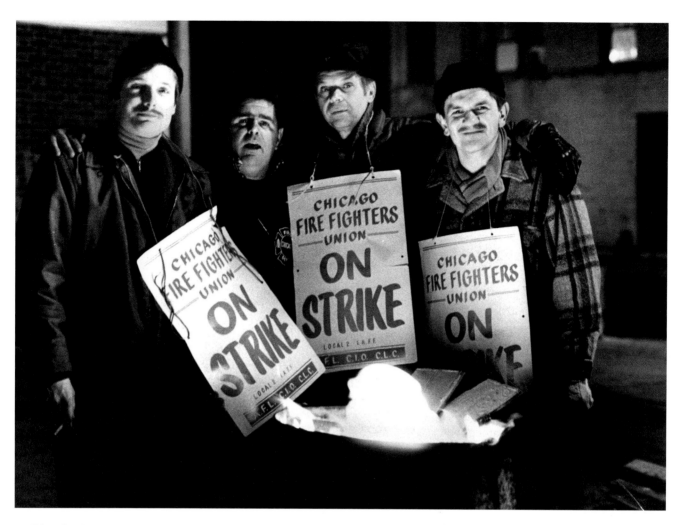

Striking firefighters kept to their picket lines around the city's 120 firehouses, seen here Feb. 14, 1980.

1954: Lyric Opera founded.

1955: Richard J. Daley elected mayor.

1956: First baby chick is hatched at Museum of Science and Industry.

1957: Old Town School of Folk Music founded.

1958: Our Lady of the Angels school fire kills 95.

1959: The Second City improv group opens its Wells Street theater.

1960: Summerdale police scandal—cops linked to burglary ring.

1961: DuSable Museum of African American History founded.

1962: Robert Taylor Homes public housing development opens.

1963: Northwest Expressway renamed for slain President John F. Kennedy.

1964: Completion of Southwest Expressway (soon renamed Stevenson Expressway).

1965: University of Illinois' Chicago Circle Campus opens.

1966: Martin Luther King Jr. and family move temporarily into West Side apartment.

1966: Richard Speck murders eight student nurses on Far South Side.

1967: Chicago's biggest snowstorm in recorded history—23 inches.

1967: Picasso sculpture installed in Daley Plaza.

1968: Riots rock the city after Martin Luther King Jr.'s assassination in April and during the Democratic National Convention in August.

1969: John Hancock Center opens as city's tallest building.

1970: First Chicago gay pride parade.

1971: Jesse Jackson forms Operation PUSH.

1972: United Flight 553 crashes near Midway, killing 43 of 61 aboard, and two on ground.

1973: Construction finished on Sears Tower (now Willis Tower), world's tallest building until 1997.

1974: Federal judge rules police department eligibility tests discriminate against blacks, Latinos and women.

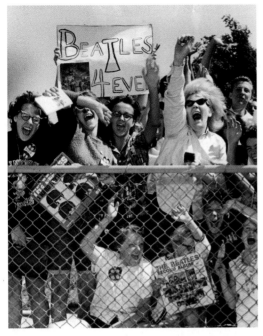

Teen fans of the Beatles await the group's arrival at Midway Airport in 1964.

1975: Deep Tunnel project begun.

1976: Saul Bellow wins Nobel Prize for literature and Steppenwolf Theater opens.

1977: Chicago Marathon debuts.

1978: Demise of Chicago Daily News.

1979: American Airlines Flight 191 crashes, killing 273.

1979: Pope John Paul II holds mass in Grant Park.

1980: The first Taste of Chicago festival is held on North Michigan Avenue.

1980: City allows women to serve as rank-and-file firefighters.

1981: Mayor Jane Byrne moves into Cabrini-Green public housing, temporarily.

1982: Chicago bans handguns (law overturned in 2010).

1983: Harold Washington elected city's first black mayor.

1984: Oprah Winfrey hosts "A.M. Chicago."

1985: Studs Terkel's "The Good War" wins Pulitzer Prize.

1986: Bears win Super Bowl.

1987: Mexican Fine Arts Center Museum opens (renamed National Museum of Mexican Art in 2006).

1988: Lights installed in Wrigley Field.

1989: Richard M. Daley elected mayor.

1990: Sox play last game at old Comiskey Park.

1991: Bulls win first of six championships.

1992: Old freight tunnel punctured, causing river water to flood downtown.

1993: Paxton Hotel fire kills 20.

1994: United Center opens.

1995: Heat wave kills hundreds.

1996: Cardinal Joseph Bernardin dies.

1997: Studs Terkel retires from WFMT radio after 45 years.

1998: First season for Chicago Fire soccer team.

1999: City implements 311 system.

2000: T. rex named Sue on exhibit at Field Museum.

2001: Boeing moves headquarters to Chicago.

2002: Former Chicago gang member Jose Padilla arrested at O'Hare in terrorism case.

2003: Mayor Richard M. Daley shuts down Meigs Field.

2004: Millennium Park opens.

2005: White Sox win first World Series in 88 years.

2006: Immigration reform rally draws up to 100,000 to Loop.

2007: Bears reach Super Bowl but lose to Colts.

2008: First Chicagoan elected president: Barack Obama holds Grant Park victory rally.

2009: Illinois Gov. Rod Blagojevich is impeached and tossed out of office.

2010: Blackhawks win Stanley Cup.

2011: Rahm Emanuel elected mayor.

2012: Chicago teachers strike for first time in 25 years.

2013: Vernita Gray and Patricia Ewert marry in Chicago in state's first same-sex wedding.

2013: Teenager Hadiya Pendleton killed in city park, becoming national symbol of Chicago's gun violence.

2013: Chicago Public Schools votes to close 50 schools.

2014: Jackie Robinson West wins national championship. (In 2015, Little League would strip team of title in fraud scandal.)

2015: City of Chicago releases video of the police shooting of teenager Laquan McDonald, sparking outrage and a federal investigation of the police department

2016: Chicago Cubs win World Series for first time in 108 years.

Pageantry
and
Progress

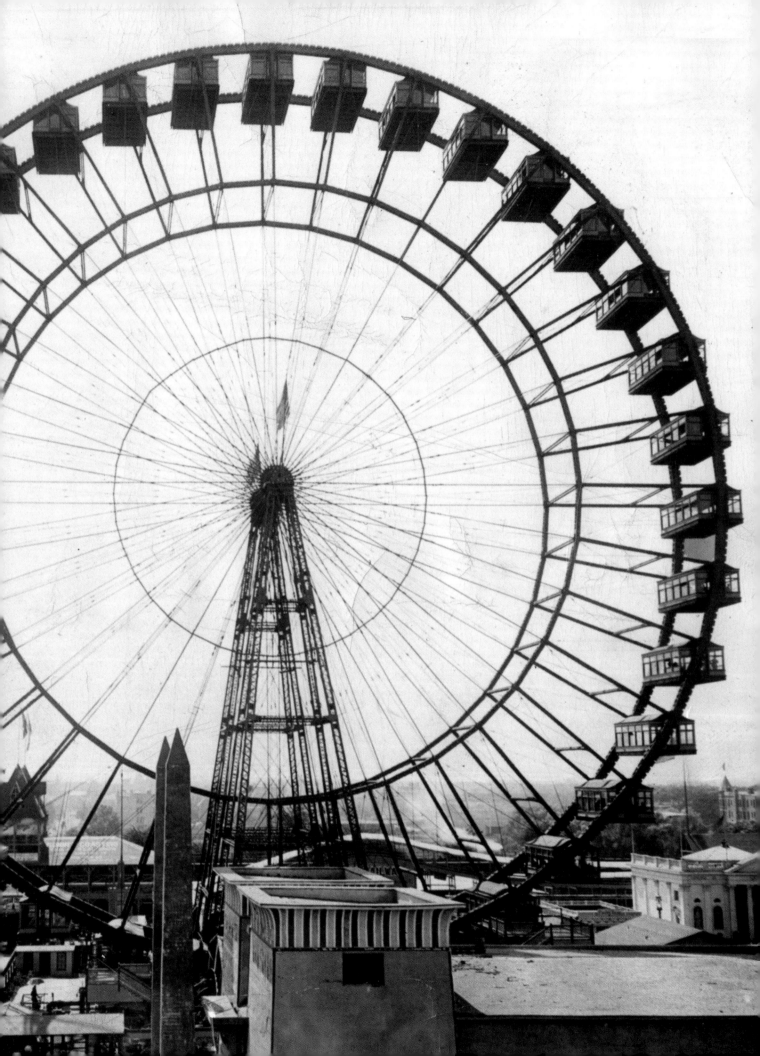

Ferris' wheel deal

How one engineer made his name at the 1893 Columbian Exposition

GEORGE Washington Ferris Jr. was a civil engineer specializing in bridges and other structural-steel designs when Chicago announced a competition for a centerpiece for its 1893 World's Columbian Exposition. Paris had marked its 1889 world's fair with the Eiffel Tower, and Chicago was determined to have something similarly spectacular to boast about.

Ferris proposed building a 264-foot wheel with suspended carriages that could take 2,160 passengers at a time for a bird's-eye view of the fairgrounds. Many thought that was a pipe dream, as the Tribune recalled in Ferris' 1896 obituary: "He consulted the best engineers in the country, but they shook their heads and said the wheel wouldn't revolve."

But Ferris persevered and was declared the contest winner—and his success would attach his name to all subsequent versions of the device, including the attraction at Navy Pier. That wheel, which replaced a Ferris wheel installed in 1995 and was dubbed the Centennial Wheel in honor of Navy Pier's 100-year anniversary in 2016, is just 196 feet tall.

In 1893, Ferris certainly gave Chicago's boosters what they were looking for. It was far shorter than the Eiffel Tower—which had the advantage of having no moving parts, while Ferris' contraption rotated on a 71-ton, 45-foot axle that had, at the time, the world's largest hollow forging. Moreover, Ferris' wheel still answered to architect Daniel Burnham's famed challenge, "Make no small plans." Ferris' wheel was the most lasting memory many visitors took away from the Columbian Exposition—because it gave them a glimpse of the fair before they even got there, as the Tribune noted: "'What on earth is that?' This is the astonished inquiry that every passenger on the Illinois Central, the 'L' and the steamboat lines on the lake makes as soon as he gets his first sight of the Ferris Wheel."

Ferris' remains and his wheel eventually were caught up in litigation. After Ferris' death, a Pittsburgh funeral director put a lien on his ashes pending payment for the funeral services. Chicago friends offered to "Free Ferris' ashes," as one Tribune headline put it. After 15 years, the ashes were released to Ferris' brother; their final disposition is reportedly unknown.

Ferris' wheel was dismantled and moved to a spot at Clark Street and Wrightwood Avenue, where it withstood a lawsuit by William Boyce, founder of the Boy Scouts of America, and other local residents who didn't relish an amusement park in their neighborhood.

From there, Ferris' wheel was moved to St. Louis for that city's 1904 world's fair. Again it was a big hit, going out with a bang and a whimper.

On May 11, 1906, a salvage crew blew it up. "The old wheel, which had become St Louis' white elephant, died hard," the Tribune reported, noting that it took 200 pounds of dynamite to bring it down. "When the mass stopped settling, it bore no resemblance to the wheel which was so familiar to Chicago and St. Louis and to 7,000,000 amusement seekers from all over the world."

—RON GROSSMAN

Opposite: George Washington Ferris Jr.'s wheel was a major attraction at the 1893 World's Columbian Exposition in Chicago.

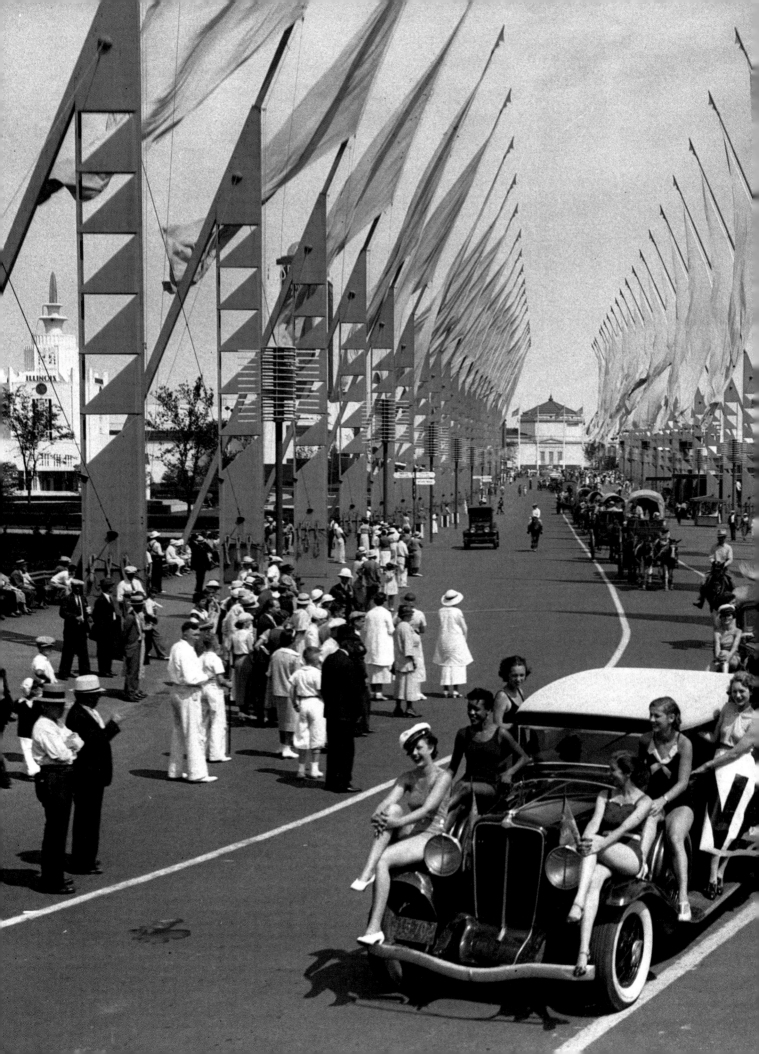

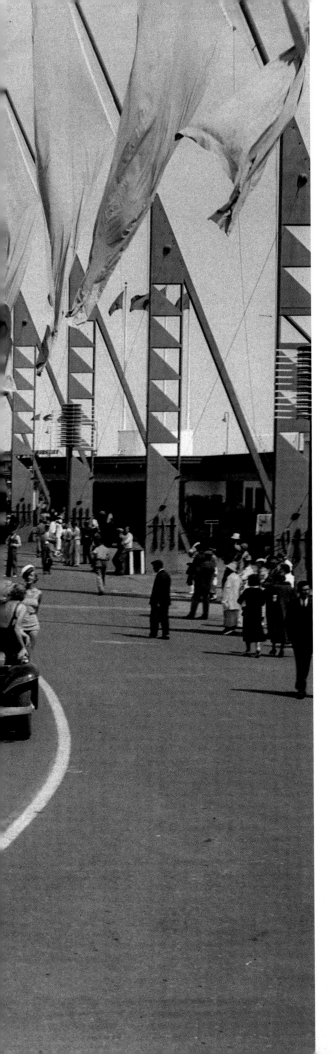

The Second City's second world's fair

Century of Progress was mix of science and sleaze

THE Century of Progress opened on May 27, 1933, with about 12 million Americans—a quarter of the labor force—unemployed and many hungry Chicagoans seeking sustenance and solace at Al Capone's soup kitchen. The city's second world's fair marked Chicago's centennial, the title reflecting the city's spectacular growth from a frontier settlement to an industrial metropolis.

But with the nation enveloped in an economic disaster, the fair also symbolized a conviction that the same can-do spirit that built the city could also overcome the Great Depression, a theme expressed with Chicago's trademark blend of class and crass. In its opening-day issue, the Tribune promised fairgoers "a colossal combination of science and circus."

That evening, the exposition was illuminated by a Rube Goldberg contraption that magnified a faint ray from a star 40 light-years

The Farm Parade kicks off Farm Week as it heads down the Avenue of Flags on Aug. 11, 1934.

away and sent it through a switch that turned a searchlight on the fair's Hall of Science. "Audacity never went farther in the planning of a ceremonial to make mankind gasp," wrote the Tribune, which didn't limit its gushing to astronomical feats.

Reporting on a contest for fair queen, the Trib described the finalists as "winsome, fragile blondes, radiant redheads, dark velvety eyed brunettes" united in a belief "that Cinderella and her glass slipper are no longer a fairyland myth." The crown and $5,000 first prize—a fortune in those hard times—went to Lillian Anderson, who had dropped out of high school to work as a Racine, Wis., tearoom cashier.

The Tribune put up the prize money, and ballyhooed the fair with ebullient news stories, cheerleading editorials and special coverage. Sports editor Arch Ward dreamed up an All-Star baseball game for the occasion. The first one, which featured Lou Gehrig and Babe Ruth, was played July 6, 1933, in Comiskey Park. When the fair did a rerun in 1934, Ward created the College All-Star Game, which pitted the best college football players against the reigning professional champ at Soldier Field.

That Chicago could pull off its fair bordered on the miraculous. Planned during the boom times of the Roaring '20s, it was initially financed by selling $5 memberships redeemable for 10 admission tickets. Additional funding came from $10 million in bonds, issued the day before the stock market crashed. The plan was for corporations to pay their own way because, its trustees explained, "as the interests of industry are served, industry ought to pay for it." Henry Ford balked at that arrangement, but when he saw the success of a General Motors exhibit that featured an assembly line, he built a magnificent pavilion that was a hit of the fair's second year. By the time the fair closed on Oct. 31, 1934, its debts had been cleared, making it the first great American fair to pay for itself.

Over that two-year run, the exposition drew nearly 50 million visitors and a steady stream of bathing beauties, among them the Queen of the Fall Flowers and Lady Anthracite. But the fair's management also reasoned that, if regally clad young women were an attraction, those without clothes would be an even bigger draw. Indeed, the fair was inspired not just by scientific laboratories but the fleshpots of Chicago's red-light district. So many girlie shows lined the midway they were given a separate category for accounting purposes. A Native American exhibit curated by a University of Chicago anthropologist, the Trib reported, broke "paid attendance records for all exposition attractions that are not nudist."

The most famous of the performers was Sally Rand, whose peekaboo fan-dance act made her a national celebrity. But the Tribune thought Julia Taweel's act the most unusual, noting she was "the only solo dancer on the grounds who hasn't dropped her veils nor shaken a single shimmy."

The fair included an Odditorium, a fancy word, the Trib explained, for "snake shows and freaks," and featured a pie-eating contest for 400 monkeys, and bits of pseudoscience, like "a psychograph machine." Looking like a beauty-parlor hair dryer, it supposedly measured the character traits and psychological hang-ups of those who slipped their heads inside. A Tribune headline writer dubbed it "a Robot-Psychoanalyst."

But dozens of the brightly colored buildings—a stark contrast to the White City of the 1893 fair—dedicated to the more traditional sciences and the industries they spawned lined the exposition's campus on Northerly Island and the adjacent lake shore where McCormick Place now stands. Visitors went from one half of the fairground to the other high atop the Sky Ride that became the exposition's symbol much as the Ferris wheel was for the Columbian Exposition in 1893. Running from two

The Tribune regularly chronicled major developments in the Century of Progress Exposition in 1933 and 1934.

625-foot towers (nicknamed Amos and Andy), the cable car thrilled millions of fairgoers.

On the cultural front, the old English village exhibit had a replica of Shakespeare's Globe Theatre. There were concerts of classical and popular music. A 12-year-old Jewish girl played a Stradivarius violin lent by Henry Ford, a noted disciple of anti-Semitic conspiracy theories.

One objective of the fair's planners was to resurrect the public's confidence in science, which had been eroded by the use of chemical weapons during World War I. The unofficial motto of the exposition was: "Science Finds, Industry Applies, Man Conforms."

Despite the Big Brother overtones, the slogan was intended to inspire a conviction that scientists and businessmen were working together to improve the American lifestyle. The House of Tomorrow exhibit confidently predicted that the average family would soon live in air-conditioned comfort and enjoy dishwashers and similar labor-saving devices. When reporters were given an advance tour, the Trib reported: "The previewers, most of whom live in hotels or kitchenette apartments, paused to gape and wonder at the model homes."

Many of the industrial products displayed had clean, crisp lines, giving consumers a taste for streamlining in products ranging from teakettles to automobiles. Bold colors were in. The Trib reported women's garb was influenced by the more casual styles shown at the exposition, noting: "Skirts moved up a bit and became more loose fitting."

President Franklin Roosevelt saw the Century of Progress as a tonic for the country's economic woes. "Who is there of so little faith as to believe that man will not find a remedy for the industrial ills that periodically make the world shiver with doubt and terror?" FDR asked in an opening-day message sent to the fair. He was a prime mover in getting the fair extended a second year.

If imitation is the greatest form of flattery, then Chicago and FDR were on to something. By the end of the 1930s, Dallas, San Diego, Cleveland, San Francisco and New York hosted fairs dedicated to the idea of a better tomorrow.

In 1933, physicist W.A. Gluesing performs tricks at a General Electric display during Chicago's second World's Fair, the Century of Progress Exposition. "Gluesing puts on a show that refills the seats for a new performance every hour," the Tribune reported. The fair thrived with a mix of science, industry and, judging from the array of exotic dance shows, plenty of skin. It was a blend of science and circus.

That was very much the message taken away from Chicago's fair, according to a Tribune chronicler.

She predicted closing-day galas would be haunted by bittersweet feelings, as guests would be all too conscious "that 'the gates will close forever' on the physical manifestation of Chicago's courage and determination in the face of great odds."

—RON GROSSMAN

The dingy city

For much of its history, Chicago was covered by smoke and soot

THE smoke and soot were so thick, they blotted out the sun.

Residents who hung their clean clothing to dry hauled in dingy white shirts and gritty underwear. Opened windows meant soiled curtains and filthy sills.

Brand-new buildings quickly weathered as the caustic pollution ate away the stone.

This isn't a dystopian vision of the future. It isn't a description of rapidly industrializing China or India. It's Chicago's past.

Thanks to government regulation beginning in the 1960s to curtail air pollution, the Wrigley Building now stays blazingly white, and residents can generally breathe deeply as they enjoy the lakefront. Given how far the city has come, it is eye-opening to realize what life was like for Chicagoans for much of the 19th and 20th centuries.

The smoke nuisance, as it was named, was invasive. It ruined belongings, blackened and eroded architecture, spoiled food and caused incalculable health problems for residents. It turned day into night, and sometimes it ate the sun entirely.

As early as 1874, as the city rebuilt after the Great Fire of 1871, the Tribune warned that the huge increase in factories and hotels, and the new skyscrapers with their steam-powered elevators, was a serious problem. "So dense is this volume of smoke that, unless there is a brisk, stirring breeze, the whole of it settles

Darkness hangs over State and Lake streets at 10:15 a.m. Feb. 1, 1957. Severe air pollution was to blame. The Tribune often ran stories about the invasive smoke nuisance.

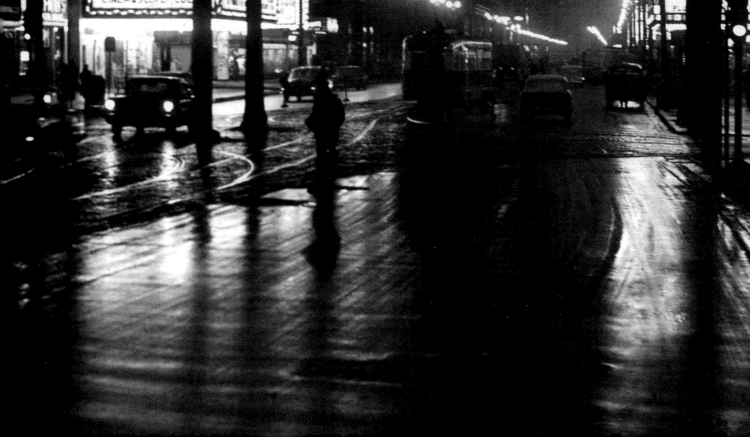

"Its air is dirt."

—RUDYARD KIPLING ON CHICAGO, 1891

down in the central part of the city and leaves its dirty imprint," the editorial said.

Tourists today praise Chicago's glorious architecture and world-class museums, and often marvel at how clean the city is. Visitors then weren't so impressed.

No lesser light than "The Jungle Book" author Rudyard Kipling found much to dislike after a visit, the Tribune reported Feb. 8, 1891. The future Nobel laureate had nothing good to say about the city, including, "Its air is dirt."

This wasn't a literary allusion. He wasn't waxing poetic. His was a statement of fact.

Civic leaders, including the editors of the Tribune, crusaded tirelessly against the "smoke horror."

"The city will shortly be blackened in appearance, new as it is, and grow more unhealthy," the Tribune wrote in 1874. "What is to

This illustration, and those on the facing page, accompanied an article headlined, "Lungs Ruined by the Smoke: Every Chicago Man Has Soot in His Breathing Apparatus," in the Dec. 2, 1900, edition of the Chicago Daily Tribune.

be done should be done quickly, if the beauty and cleanliness of the city are worth preserving.... When the means for securing this result are so cheap and simple, it is the height of folly to go dirty any longer."

But folly was apparently abundant.

"The wisp of smoke that enters your eyes and mouths ... the falling soot that decorates our noses and leaves its trace on our linen becomes more and more disgusting ... and yet nothing is done," the Tribune wrote in 1876. "Marble fronts are blackened, costly goods are spoiled, valuable books and papers are defaced, washing bills are multiplied, and everybody made uncomfortable, in order that a few persons may not be put to the inconvenience of attaching a smoke-consumer to their engines."

On Dec. 19, 1880, the Tribune wrote, "There is not a storekeeper in Chicago whose goods are not seriously injured by it, and to many lines of fine goods it is destructive. It soils and irreparably defaces some things. The deposit of soot finds its way not only into stores, but into public and private offices, where it defaces papers and books. It reaches into every private dwelling, falls upon every bed, curtain, carpet, dining-table, blackens and disfigures all articles of furniture, finds its way into drawers and clothes-presses, is a curse to every laundry, and injures clothing to a costly extent. It is forever falling upon goods and upon persons, it renders the hands and faces of all grimy, sooty and unclean. It is not a special but a universal nuisance, reaching all alike, and by all detested."

Officials recognized early that it wasn't just cosmetics and comfort at issue but residents'

well-being. "Health . . . is directly injured by the nuisance," the Tribune reported in 1880. Twenty years later, at the dawn of the 20th century, the Tribune took nearly half a page to outline the health threat. "How Chicago Men's Lungs Are Blackened By Soot" was the headline over graphics illustrating the problem. An autopsy of a Chicago resident revealed a lung so black that to touch it "would blacken the palm almost as black as to put it wet into a pan of soot," said one doctor.

The issue was clearly visceral for many reporters, who reached far and wide for the proper description. On July 31, 1890, one wrote: "The smoke nuisance in the region west of Wells and south of Pearson streets is of large proportions and of athletic build. It has daily encounters with two fellow-giants–dust and stench–and not being able to settle the question of superiority, they join forces and make war on mankind." Postmen in the area looked like coal heavers, and one claimed he bathed four times a day. "It does no good," he said, "a trip down as far as Kingsbury Street to deliver a snip of a postal card, and I am black-faced and sore-eyed."

The problem was so bad, experts suggested that planting some types of vegetables was a waste of time because of the smoke. In a huge swath from North Avenue to about 50th Street and Western Avenue to the lake, the experts warned that "the following should not be attempted: cucumbers, tomatoes, peppers, parsnips, beans, peas, potatoes, turnips, sweet corn, eggplant, berries and melons."

On Jan. 29, 1892, it got so bad, the smoke ate the sun. Though the suburbs and outer parts of the city enjoyed bright blue skies, "Chicago was dark. . . . There lay on the lake a pall of smoke, making it difficult at noon to see the pier-light on the government breakwater. . . . The westerly wind drove the smoke over the lake, and for a mile from shore all was dark."

Visibility downtown was two blocks. Occasionally, the smoke sunk lower, and "pedestrians had to pass through an atmosphere that was simply choking."

The city ended the year equally gloomy. On Dec. 1, the Tribune reported, "Chicago Enveloped in Smoke Clouds All Day." "Over all the city lay the heavy pall of black, sooty smoke and dimly through it gleamed the gas lamps like stars on a foggy night."

The banks of smoke were "heavy enough to use for paper weights," the Tribune reported. Offices and businesses had to operate with every gas jet and electric light ablaze. But even that didn't shed enough light, and retailers complained that sales were down because customers couldn't see the merchandise. One resident said, "If this thing keeps on, pedestrians will be obliged to carry a lantern."

HOW CHICAGO MEN'S LUNGS ARE BLACKENED BY SOOT

NORMAL LUNGS CHICAGO MAN'S LUNGS

It is hard to know how often the sun lost its battle to shine–though it happened regularly into the 1950s–because the Tribune wrote stories only when it was unusually bad. On Jan. 18, 1925, the newspaper reported the pall that turned day into night was "the densest, thickest and darkest smoke screen which has been thrown over the city this season." The "plague of darkness" on Dec. 7, 1929, was caused by low-hanging clouds, fog and "the customary smoke screen."

And the power needed to light the day meant Commonwealth Edison had to burn even more coal.

—STEPHAN BENZKOFER

Raising Chicago out of the mud

Herculean effort lifted buildings and streets, added sewer system

P EER over the edge of the sidewalk along 24th Street in the Lower West Side community, and you're looking back into Chicago history. A hole the width of a front yard, 8 feet deep in some places, separates the sidewalk from cottages and two-flats. Residents reach their front door—on what once was a building's second floor—via a concrete slab that spans the open space like a drawbridge over a moat. Some of those sunken front yards are adorned with religious statues—the 2100 block has a Virgin Mary, a monk and nun, and an icon—giving them the look of Old World grottoes.

The holes they sit in weren't dug, but are a side effect of Chicago's herculean effort to pull itself out of the mud. "Chicago is deep in mud," the Tribune observed in March 1862. "Mud floats in the atmosphere—we have mud on the sidewalks, on streets, on bridges, in fact, m-u-d is written everywhere in unmistakable characters."

Overcoming the city's sludgy handicap took decades, required raising the grade level upward of 14 feet, and made Chicago the first American city with a comprehensive sewer system. Even more impressive, Chicago's skyline grew, not by leaps and bounds, but one turn of myriad jack screws at a time. Passers-by marveled as

five- and six-story buildings—sometimes several lifted in unison—were raised up to newer street levels, occupants, furnishings and all.

On New Year's Day 1859, the Tribune reported: "Within the past year from fifty to sixty brick stores, in blocks of two to five to seven in number, have been thus raised."

Chicago's endeavors were pooh-poohed by critics in rival cities, who predicted that the magnitude of the engineering feat would bankrupt the city, as a letter to the editor of the Tribune observed in 1858:

"These people never fail to expatiate before their listeners upon the vast expense of filling up the streets of such an immense city," a Chicago business traveler wrote. "I heard a capitalist at Cincinnati, while enlarging upon this subject, offered to bet his whole fortune that Chicago would be so retarded by this measure that she would not double her population in the next fifty years."

That Cincinnatian would have lost his shirt had he put his money where his mouth was: Chicago's population doubled in 10 years.

Previously, the city was infamous for streets that were less thoroughfares than sinkholes.

The problem was that the city had been born on low-lying land along its namesake river. Floods and rainstorms produced quagmires, as Mrs. Joseph Frederick Ward recalled in her memoir, "As I Remember It": "The streets of the young city were frightful, with deep mud and holes and many places marked 'No bottom.' A frequent sight was a cart stuck fast and abandoned."

Chicago's topography also made it virtually impossible to separate drinking water and wastewater. Carried off into Lake Michigan, sewage contaminated Chicago's water supply, recycling deadly germs during an epidemic. In 1854 alone, cholera killed 1,424 Chicagoans, prompting the Tribune to link the outbreak to the city's marshy site: "It comes like a spark to powder. Here is contained that which can swiftly make destructive—soaked into soil, stagnant in water, griming the pavement, tainting the air."

Accordingly, the Chicago Board of Sewerage Commissioners was created with a mandate to fix a problem nature had left the city. Putting storm sewers under the streets

wouldn't work; they'd be too low to drain properly. So it was decided to lay sewers on top of existing streets, cover them with tons of fill and put new streets on top of the resulting embankments. By a series of city ordinances, beginning in 1855, the grade level of streets was raised, about 10 feet along the river, and by varying heights in outlying districts.

Some homeowners brought their residences up to the new level, but others did not, leaving some neighborhoods looking like a random assemblage of children's building blocks.

Blocks where homes weren't raised to the new street level can still be seen in neighborhoods like South Chicago and Back of the Yards.

But in the city's center, it wouldn't do to leave structures below the new ground level. Chicago was a bustling metropolis, and visiting entrepreneurs and local movers and shakers were loath to step down to a hotel or office building's entrance to cook a deal.

"One of the most astonishing results of this alternation of the grade was the raising of large buildings, hotels and whole rows of brick and stone stores," a visitor from Indiana noted in an article reprinted by the Tribune in 1859. "The operation was first looked upon with universal suspicion, and many watched for the buildings thus being raised to come tumbling down."

With new buildings going up at the higher grade level, owners of older buildings had to have theirs raised by a large array of jack screws, lest their businesses, literally and figuratively, go under. "All being ready, the superintendent takes his position at some central point, and by a signal, usually a shrill whistle, directs the movements of the men," the Indiana visitor noted. "He continues his whistle long enough for every man to turn every screw one complete round of the thread. Thus the building is raised at every point precisely at the same moment, and to the same extent."

In 1860, Joseph Ryerson, a steel magnate, saw a whole block of buildings on Lake Street between Clark and LaSalle streets lifted 6 feet by the simultaneous movement of 6,000 screws. In his memoirs, Ryerson pronounced it "a feat of mechanical operation the country had never heard of before."

The following year, the Tremont House, a fashionable, six-story hotel at Lake and Dearborn, was lifted 6 feet. George Pullman, then in the building-raising business, got the contract by promising that he could do the job without disturbing a guest or breaking a pane of glass. Indeed, the huge hotel was occupied right through the project. One guest was surprised to find that windows that had been at eye level when he checked in were over his head when he checked out.

In fact, Pullman and other building raisers did such a thorough job that contemporary Chicagoans walk Clark, Lake and other Loop streets scarcely realizing they were once muddy traces marked with gallows-humor signs, like "The shortest route to China." Yet an old, lower-level Chicago is there for the seeing in outlying neighborhoods, as in the 9000 block of South Houston Avenue. There a wire-sculpture reindeer bedecked with Christmas tree lights stands guard over a sunken garden where flowerpots have lost their blooms.

—RON GROSSMAN

In a rush, the river is reversed

Did Chicago officials jump the gun to avoid court order?

These illustrations of the canal ran in the Jan. 2, 1900, edition of the Chicago Tribune, the day after work began.

A T the dawn of the 20th century, Chicago reversed its river with massive earthmovers—and a bit of Windy City chutzpah that made the razing of Meigs Field look like a bulldozer accident.

The engineering feat was named by the American Society of Civil Engineers in 1955 as one of the seven wonders of engineering in the United States, along with the Empire State Building and San Francisco-Oakland Bay Bridge. More important, it cleaned up the city's drinking water by keeping the polluted river water out of the lake.

Long used as an open sewer, the Chicago River flowed into Lake Michigan carrying contaminants that recycled germs to residents' faucets. Waterborne diseases were endemic in early Chicago. So it was decided to reverse the river's flow—sending its pungent water away from the lake via a 28-mile-long canal to rivers draining into the Mississippi.

That didn't seem like such a hot idea in St. Louis, which sat astride the project's path. "The Chicago River is probably the most foully polluted river in the world," that city's health commissioner said in 1899 during the construction of the "Big Ditch," as it was dubbed. Hearing that St Louis was going to court, Chicago's authorities got a jump on the process servers with a sleight of hand as bold as the canal project itself.

On New Year's Day 1900, a steam shovel began clawing a hole in the earth barrier still separating the river from the drainage canal. When a wooden sluice gate was installed the following day, a canal commissioner assured a Tribune reporter it wouldn't be opened without the governor's approval. But he added a prescient caveat: "If the water ever gets in we could not bail it out."

And so it came to pass, by accident or design. The following day, the Tribune reported that newly flushed with lake water, the river "had taken on a clearer tinge." Another remarkable sight was reported along the lackadaisical river: "slight current was noticeable at the Archer Avenue bridge." On subsequent days, the paper traced the water's steady progress. On Jan. 18, the paper announced the opening of the canal's southern barrier with a verbal drumroll: "Chicago and Lake Michigan water started with a rush and roar for the Mississippi and the Gulf of Mexico at 11:16 yesterday."

Down the drain as well went St. Louis' hopes to legally bar the Sanitary and Ship Canal, as it's now called, though the case dragged on for years. Courts are loath to write unenforceable orders: Like the commissioner said, what could Chicago be required to do? Bail out the water?

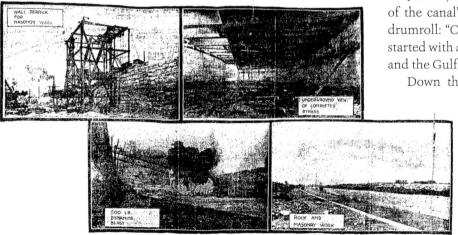

THE DRAINAGE CANAL AND METHODS OF ITS CONSTRUCTION.

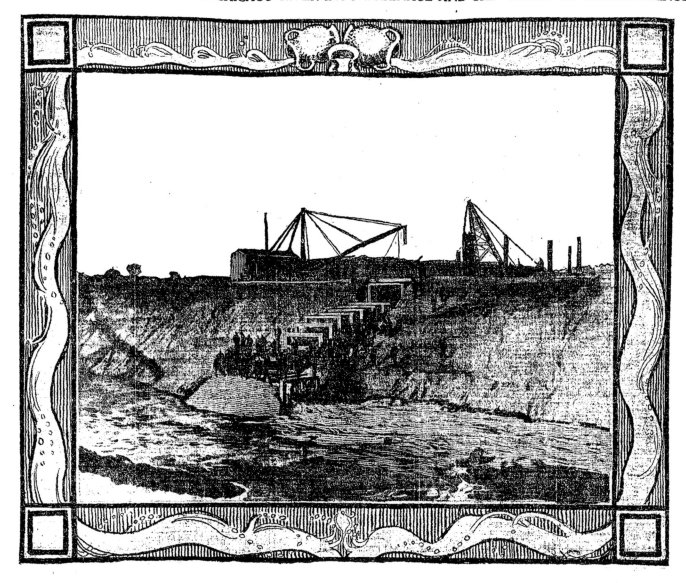

Still, St. Louis cried foul, claiming its famed beers were being harmed by Chicago River water. But that charge was refuted by Dr. Robert Wahl, head of the Scientific Station for Brewing in Chicago, an organization apparently accepted by St Louis' brewers to referee the dispute.

Under the headline, "Says Canal is Innocent," the Tribune reported that Wahl found St. Louis' water so contaminated that a little Chicago sewage wouldn't matter much. Perhaps gloating over the reversed river's prospects for a healthier Chicago, Wahl chided St. Louis for not attending to its sanitary needs.

"It's little short of a miracle," Wahl told the Tribune, "that St. Louis has not had an epidemic of typhoid fever all the time."

Though the U.S. Supreme Court eventually dismissed St. Louis' case in 1906, Justice Oliver Wendell Holmes Jr. threw the plaintiffs a bone and took a poke at Chicago. "It's a question of the first magnitude," Holmes wrote, "whether the destiny of great rivers is to be the sewers of the cities along their banks."

—RON GROSSMAN

This image from the Jan. 3, 1900, Tribune shows the pouring of waters of the West Fork through the sluiceway after the restraining barrier of frozen earth was removed by dynamite and dredging.

The Ward-Field museum fight

Two business titans went head-to-head over putting museum on lakefront

THE fight over the proposed Lucas Museum of Narrative Art eerily mimicked the struggle, more than a century ago, over the site of the Field Museum.

Both fights involved bitter differences of opinion over the city's lakefront: Should it be left pristine or dotted with cultural amenities? Both involved head-butting by the rich and powerful. In the earlier donnybrook, two local moguls squared off: Marshall Field, who made State Street the city's shopping rialto, on the side of a proposed museum, against Montgomery Ward, who made Chicago the hub of the mail-order industry and was a staunch protector of the city's lakefront as a public space.

Lawsuits involving arcane legal principles were accompanied by insults worthy of a guttersnipe. Ward's attorney accused Field of building a monument to himself, facetiously adding: "And being a poor man, he could not afford to pay for a site. Now it is proposed to secure a site from the city of Chicago by violating a trust."

Asked why Ward was bucking Field, one of the early presidents of the museum said: "I do know he once was a clerk in the Field store."

That battle, which would ultimately outlive one of the combatants, began Oct. 27, 1893, when Field pledged to contribute $1 million toward a museum to permanently house exhibits from the World's Columbian Exposition, which was about to close. Originally it was to be known as the Columbian Museum. Field didn't court publicity.

"Really I do not care to discuss the museum question at all," Field told a Tribune reporter. "I would prefer that my name be kept out of it entirely."

Others involved in the project recognized that a famous name attracts others with money. So a year later, the museum was renamed the Field Columbian Museum, subsequently shortened to The Field Museum, changes that lived up to their promise. John G. Shedd, the second president of Marshall Field & Co., would endow the aquarium that sits alongside the Field Museum. Max Adler, vice president of Sears, Roebuck & Co., would do the same for the nearby planetarium.

More immediately, it put Field on a collision course with Ward, the self-described guardian angel of Chicago's lakefront.

The Field Museum was originally sited for the lakeshore at Congress Parkway, and upon its announcement, Ward filed a lawsuit. He claimed that when he bought nearby property, "he relied on plats . . . in which appeared the words: 'Public ground, a common to remain forever open, clear and free from any buildings or other obstruction whatever.'" Still, Ward was open to compromise, tired after years of hectoring and suing the city to clean up what is now Grant Park, which was then little more than a dumping ground. If guaranteed that the museum would be a unique exception, Ward would drop his opposition.

But developers were rushing proposals to the park's commissioners, who turned down Ward's offer. The game was on.

The combatants were very different types. Field had a broad circle of friends, business associates and fellow philanthropists to support

his fight for the museum. Ward was a loner who shunned social gatherings. "Perhaps I may yet see the public appreciate my efforts," he told the Tribune. "But I doubt it."

Ward had one critical ally, however: time. Like a sports team, he could win by running out the clock.

Field, who died in 1906, left an additional bequest of $8 million for the museum, but his donation was contingent upon the city providing a site, free of charge and within six years of his death. Ward knew that if he could keep the project tied up in the courts until midnight Jan. 1, 1912, he would win.

Accordingly, the legal papers flew back and forth, accompanied by a war of words. Field's supporters played on the public's heartstrings. A Field Museum trustee vowed: "We are going to help 2,000,000 people have their way against one obstructionist," the Tribune reported.

There were oddball legal maneuvers. The Illinois legislature passed a bill in 1903 enabling the park board to void Ward's easement on Grant Park, his legal right to have it free of buildings. "You can pass all the state legislation you want to," an aide to Ward responded, "but it will not be constitutional if Mr. Ward complains." Indeed, the Illinois Supreme Court sided with Ward, as it did on several occasions.

Stymied, the museum's partisans offered ways out of the deadlock. Stanley Field, Marshall Field's nephew and successor, lobbied the state legislature in 1910 on behalf of a bill that would grant the museum submerged land in Lake Michigan to fill in and build on the resulting island. The project was dubbed the Atlantis museum, but Ward vetoed it.

The park board offered a site in Garfield Park, and then an alternate one in Jackson Park, the site of the World's Fair that gave birth to the museum project. The clock was ticking down, and the museum trustees were about to settle for the latter offer. But at the last minute, the Illinois Central Railroad offered land at 12th Street upon which it had planned to build a terminal.

That is where the Field Museum finally came to be built, starting in September 1911.

Montgomery Ward, left, saw himself as a protector of Chicago's lakefront and opposed a lakefront location for the Field Museum. Marshall Field, right, made the establishment of the museum possible with a monetary gift in 1893.

"Really I do not care to discuss the museum question at all. I would prefer that my name be kept out of it entirely."

—MARSHALL FIELD

The battle of the Titans had ended in something of a draw. Field got his museum, albeit posthumously. Ward, who died in 1913, lived to see his lakefront still largely unspoiled. Chicagoans got both: a world-class museum and an incomparable shoreline.

Perhaps balancing the exhausting struggle that accompanied its birth, the Field Museum opened without fanfare on May 2, 1921.

"The doors were simply opened at 2 o'clock, and the first of the 8,000 guests entered," the Tribune observed. "Speeches and music would have been superfluous."

—RON GROSSMAN

Of hobos, tramps and bums

For all its bad reputation, Skid Row served a purpose

C HICAGO once was celebrated in hobo camps coast to coast as a good place to hole up for the winter, especially along a strip of West Madison Street called Skid Row, a 12-block stretch of flophouses, gin joints and battered dreams.

That began to change in 1982 when a wrecking ball took a whack at the Starr Hotel, 617 W. Madison St., now the site of Presidential Towers, a complex of luxury apartments and upscale shops. The Starr catered to a down-market clientele that paid $1.50 a night for a room. According to a Tribune reporter who visited the hotel in 1966: "Plywood partitions separate the cubicles, and each cage—as one resident described the rooms—is covered with chicken wire."

Still, the Starr was home to several hundred men and a mutt named Shana, who became a squatter on the hotel's rubble. Other displaced alums of the Starr, the Trib reported, "found a few planks of wood and a strange looking, crudely built doghouse was made for her." But a wave of renovation rolled westward along Madison from Canal Street to Racine Avenue until there was no room for down-and-out men and homeless dogs.

Fast forward to the 21st century and the number of single-room-occupancy hotels had declined so precipitously that housing advocates called for Chicago to protect the few remaining SROs.

Some 50 years earlier, Chicago had lots of

A group of men sit around a stove at Hobo College on Madison Street and discuss world events in 1937.

CHECKER BOARD

PINOCHLE DECK o

CROSS WORD PUZZ

ARE AVAILABLE TO A

HALL O AILY- M

THE
TRUTH
ABOUT
SPAIN

BY RUDOLPH ROCKER

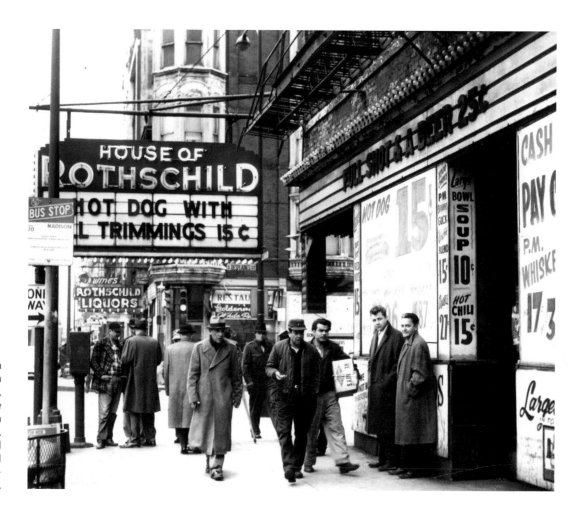

For years, a multiblock stretch of Madison Street, including the corner of Madison and Desplaines, was known as Skid Row and featured many single-room-occupancy hotels.

SROs. Along Madison in addition to the Starr there were the Major Hotel, the Union Hotel, the Workingman's Palace and nameless others with entrances marked only by a sign proclaiming "Men Only." Still more dotted smaller Skid Rows on State Street just south of the Loop, and Wilson Avenue in Uptown. They housed a mixed population of railroad workers between seasons on track crews, dropouts from respectable society and men seeking refuge from their demons in a bottle of cheap wine. After the wars, the SROs welcomed influxes of veterans; in the 1960s they blossomed with younger people dropping out.

For all its lack of amenities, Skid Row provided one creature comfort: anonymity. The Starr's most notorious guest was Richard Speck, a drifter who raped and murdered eight nurses in 1966. When a Tribune reporter asked the desk clerk what he knew of Speck, he replied: "This is Skid Row. If you start asking questions, pretty soon you don't have customers."

"This is Skid Row. If you start asking questions, pretty soon you don't have customers."

—DESK CLERK AT THE STARR, 1966

In 1960, a Tribune reporter encountered a man clutching a book by Henry David Thoreau, a classic of American literature. Intrigued, he asked how the fellow wound up on Skid Row. "He didn't reply," the reporter noted. "He was among the many residents who are there to lose their identity."

Others were less shy, including William

Wood, a former professor at Chicago-Kent College of Law. A self-proclaimed "wino," he showed up in the courtroom of the Monroe Street police station in 1955 to represent a Skid Row neighbor, Sun Smith. "Wood pleaded Smith guilty on an intoxication charge but contended that this sufficed and that a disorderly charge should be dismissed and it was," the Tribune reported. "Wood's two previous appearances in skid row court this week were involuntary as he'd been arrested in police roundups."

Skid Row's origins are in the late 19th century, when railroad lines converged on Union Station, just west of the Loop. That became a convenient jumping-off point for railroad workers, and the strip joints and greasy spoons soon attracted other seasonal workers—agricultural laborers after harvest time, seamen when ore boats on the Great Lakes and Mississippi River barges were iced in, and lumberjacks, who may have brought with them the term "Skid Row." Some think it's a derivative of "Skid Road," the path down which timber was skidded to town, and, by extension, a place where the lumbermen spent their pay on booze and slept off benders.

However it came by its name, Chicagoans were both repelled and attracted by Skid Row, and not just literary types such as Willard Motley, who set his novel "Knock on Any Door" partially on Madison Street. Some solid citizens enjoyed an evening of "slumming" in its honky-tonks. One mayor after another talked about cleaning it up but didn't. Partially the delay was due to fears that sending bulldozers to Skid Row would dispatch its denizens to other neighborhoods. But Skid Row also survived because of Chicago's unabashed link between civic policy and private gain. The Starr Hotel was owned by Charles Swibel, head of the Chicago Housing Authority under mayors Richard J. Daley and Jane Byrne. Other politicians, equally happy to make money out of poverty, were also invested in Skid Row property.

The area's formative years corresponded with the pioneering establishment of sociology as an academic discipline at the University of Chicago, where Nels Anderson was inspired to study Skid Row.

To Chicagoans driving homeward along Madison, its street life seemed a blur of indistinct figures curled up in doorways or sitting on curbs passing a bottle. But Anderson was a scientist, interested in identifying subtypes, much as a biologist assigns specimens to their species.

And in Dr. Ben Reitman, he found a guide. In his 1923 book "The Hobo," Anderson reported Reitman's observations:

"There are three types of the genus vagrant: the hobo, the tramp, and the bum. The hobo works and wanders, the tramp dreams and wanders and the bum drinks and wanders."

Reitman was among a stream of outsiders—evangelists, do-gooders and the curious—drawn to Skid Row. A physician with a Loop office and a home in a middle-class neighborhood, Reitman was fascinated by the anarchy of life on Madison. A lover of Emma Goldman, the famed apostle of anarchy, he led a march of hobos down Michigan Avenue in 1908. Unimpressed, the Trib called it a "Parade of the Idle."

Reitman also served a term as the dean of Hobo College, Skid Row's institution of, more or less, higher education, lecturing on panhandling "from the viewpoint of a scientist."

Skid Row had its resident intellectuals. During his research, Anderson met a would-be novelist carrying a great roll of manuscript written in pencil, and a hobo economist with a surefire best-seller business book, if only he could find a publisher. Dreams don't die just because the dreamer is on the skids.

So it is fitting and ironic that Skid Row is now home to young professionals who may actually be realizing their dreams. Their vanished predecessors weren't so fortunate, though for one evening, at least, some got a taste of how the other half lives.

When Reitman died in 1942, his will provided $250 "for food and drink for hobos and unemployed who will be invited by my son to a funeral dinner. I should like the service to be held in a big hall with food, drink, and fun, and a happy good time for all."

—RON GROSSMAN

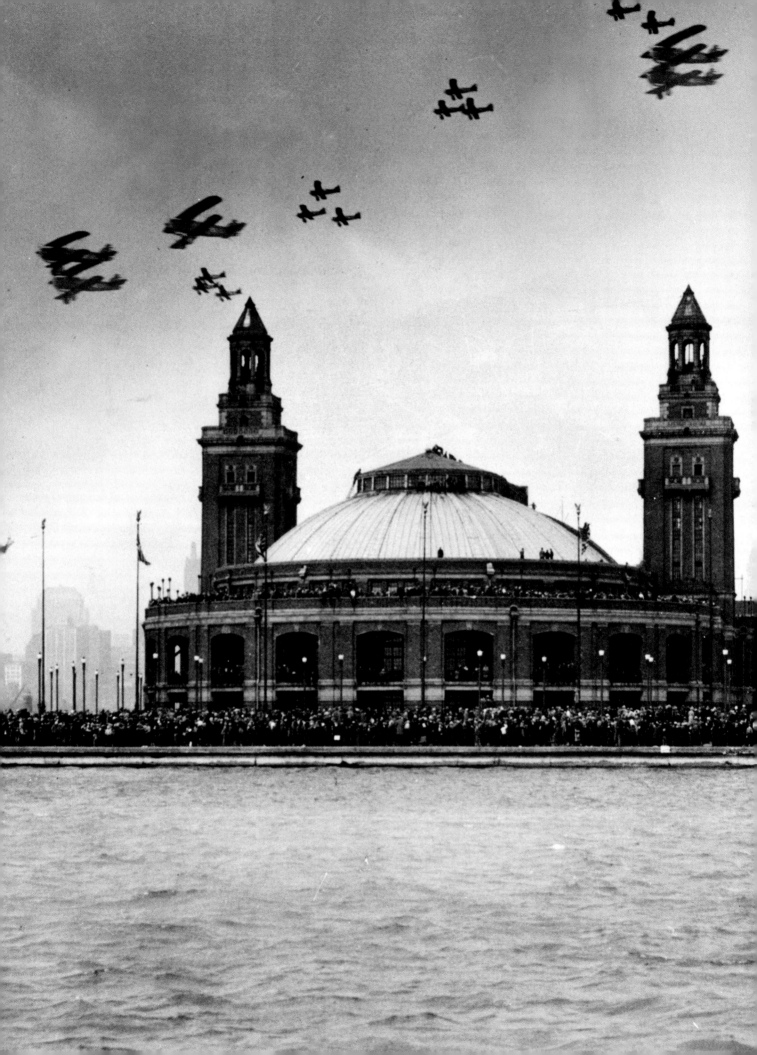

Navy Pier's zany past

Sky divers, pirate attacks, pigeon races, music and, of course, Dental Day

Navy Pier has been an entertainment venue, a university, a naval base, an army base, a convention center, a food storage facility and, well, a pier. It has hosted stars as diverse as the Johnny Hand Band and Kool and the Gang, and festivals as big as the Pageant of Progress and ChicagoFest. It has been the home of sporting events, too, namely boxing, tennis, swimming—and in 1921, a race between airplanes and pigeons. (The pigeons won.)

The municipal pier opened in July 1916 to much fanfare. The Tribune boasted on July 5: "No city in the world has any structure on a water front that compares with the new Municipal pier."

In fact, the pier was so popular that first summer that the crowds overwhelmed the transit system. The streetcars ran to the end of the pier but officials complained that not enough cars were running. Saying "the streetcar problem is the worst we have," the harbor master tried to arrange ferryboats to taxi visitors to and from the pier.

In addition to the city view and the cool lake breezes, the pier in its early years offered dancing and music, and there was much excitement about the regular appearance of famed Chicago conductor Johnny Hand.

Despite its current name, which was adopted in 1927, the Army moved in first. In May 1917, a month after the U.S. declared war on Germany, the pier made its first transformation, this time to a barracks and training facility for the Third Reserve Engineers regiment.

Thousands gather in 1931 to watch Army air maneuvers over Navy Pier. The Army moved to the pier in World War I, adding barracks and a training facility. The Navy followed the Army onto the pier shortly afterward. In 1941, the Navy's presence greatly expanded.

In 1941, about 10,000 people lived, trained and worked at the Pier.

The Navy had to settle for tents in Grant Park.

None of that activity infringed on the public's enjoyment of the pier. The summer schedule in 1917 included dancing, Sunday evening community singalongs and lots of "mechanical devices intended to please the little folk," such as teeter-totters, slides and merry-go-rounds.

In 1921 and 1922, the pier hosted the Pageant of Progress, billed as the "greatest collection of business and industrial exhibits this city has seen" since the 1893 World's Columbian Exposition. The two-week summer pageants drew hundreds of thousands of visitors who were wowed by such disparate entertainment as pirate attacks, sky-diving stunts, speedboat races, the advance of firefighting equipment through time, a typing contest (126 words per minute was good enough to win) and, of course, Dental Day. The pier was a major convention center for decades, hosting the Flower and Garden Show as early as 1932, the National Motor Truck Show in 1939 and the Automotive Services Industry Show in the late 1930s.

With World War II, Navy Pier became the Navy's pier. In 1941, about 10,000 people lived, trained and worked there, requiring a 2,500-seat theater, gymnasium, 12-chair barber shop, tailor and cobbler shops, soda fountain, vast kitchen and hospital. The city turned over the entire upper level for the nation's largest training center for naval aviation mechanics and metalsmiths.

The Navy held live-fire and submarine-hunting exercises, and in possibly the oddest exhibition ever at the pier, they subjected graduating sailors to a real gas attack in a specially constructed chamber. The Navy presence also included two training aircraft carriers, the USS Wolverine and the USS Sable, which docked at the foot of the pier.

Just as the Navy was winding down its mission at the pier in 1946, the University of Illinois opened a Chicago branch at the pier. In October, 4,000 students were enrolled and taking classes. But with a maximum capacity of less than 5,500, the school outgrew the pier. In 1965, the school moved to the Circle Campus.

After the university departed, the pier fell into worse disrepair. It's hard to remember just how bad it was. ChicagoFest, which drew tens of thousands of music fans to the pier for a few weeks each summer from 1978 to 1983, was held between the two original hulking warehouses, the crowd stretching the length of the pier. As the visitors rocked and boogied to Kool and the Gang and Frank Sinatra, pigeons and gulls flew in and out of the buildings through numerous broken windows and holes in the roof. But ChicagoFest's success reminded city planners of Navy Pier's great potential, and with the massive renovation in the early 1990s, the pier was back where it started as a "pleasure pier for public good."

Big Bill's grubby hands

The pier opened with the notoriously corrupt Mayor William Hale "Big Bill" Thompson in office, and such a big public project meant contracts and favors for him and his friends. The pier's opening summer was marred by a lack of restaurants, soda fountains or popcorn stands because the mayor squashed the con-

MAYOR REPLACES HARRISON TABLET ON PIER WITH OWN

Implies He's Its Builder, and Not Predecessor.

If Mayor Thompson's friends can accomplish it, the hundreds of thousands who visit the Municipal pier during the Pageant of Progress exposition will leave with the impression that credit for its construction should go to "Big Bill."

Yesterday laborers working on orders from Commissioner of Public Works Francis took down the bronze tablet bearing the name of former Mayor Harrison, under whose régime all preliminary work and the greater part of actual construction was done, and substituted another tablet bearing the name of William Hale Thompson in large raised letters.

Pet Project of Harrison.

Construction of the huge pier at a ~f $3,400,000, extending 3,000 feet ~ ~rand ~~anue, was

Mayor William Hale Thompson's duplicity at Municipal Pier was the lead story on July 12, 1921.

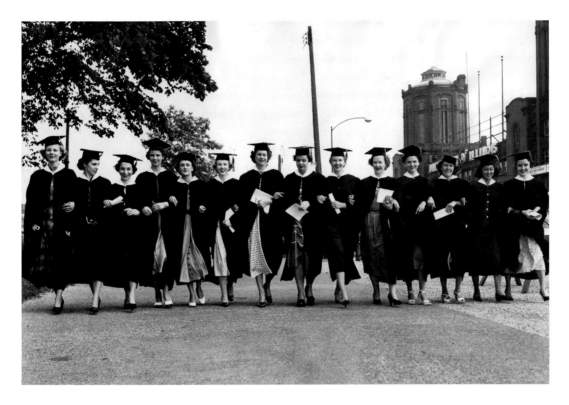

Graduates celebrate their new nursing degrees in 1953 from the University of Illinois' Chicago branch, located at Navy Pier from 1946 to 1965.

tract, then handcuffed the businessman with a temporary permit. To make matters worse, one concessionaire complained, when he finally did get city approval, he had to deal with "friends of the administration" who insisted on being subcontractors.

Thompson also was accused of making a personal profit as president of the Pageant of Progress committee in 1921. He denied everything but was forced to step down as pageant president following an investigation. Further, convention exhibitors repeatedly complained of "extortion" at the pier during Thompson's reign as strict union rules and other city regulations meant they were "being robbed right and left."

To add insult to injury, before the thousands of visitors arrived for the pageant, Thompson replaced a plaque commemorating the pier's opening and honoring former Mayor Carter Harrison, who had worked mightily to get the pier built, with one bearing his own name.

The Pugh Pier?

Chicago's Navy Pier almost was named the Pugh Pier. James A. Pugh was Thompson's friend, as was made clear in the Tribune's Oct. 8, 1915, story about the Harbor Commission's naming decision. But Pugh's claim was actually much stronger. Pugh was a businessman, politician, developer and sportsman known as "Commodore Jim." While the idea for the pier is often credited to Daniel Burnham's Plan of Chicago, which was published in 1909, Pugh was presenting plans and architect's illustrations for a pier to the Chicago City Council in October 1908. His original plan included a vast harbor running from Chicago Avenue to just north of the river, with three massive docks placed where Navy Pier is now. Pugh fought for years in court and the newspapers to get his pier built, but eventually the city's desire to build a publicly owned pier won out, and Pugh relinquished his rights to the land. The Harbor Commission voted to put that animus aside to honor the Commodore in 1915, less than a year before the pier was to open. So what happened? Pugh and Thompson had a falling out in January 1916. Municipal Pier it became. On Dec. 28, 1927, the Municipal Pier became Navy Pier, a counterpart to the army memorial that is Soldier Field.

—STEPHAN BENZKOFER

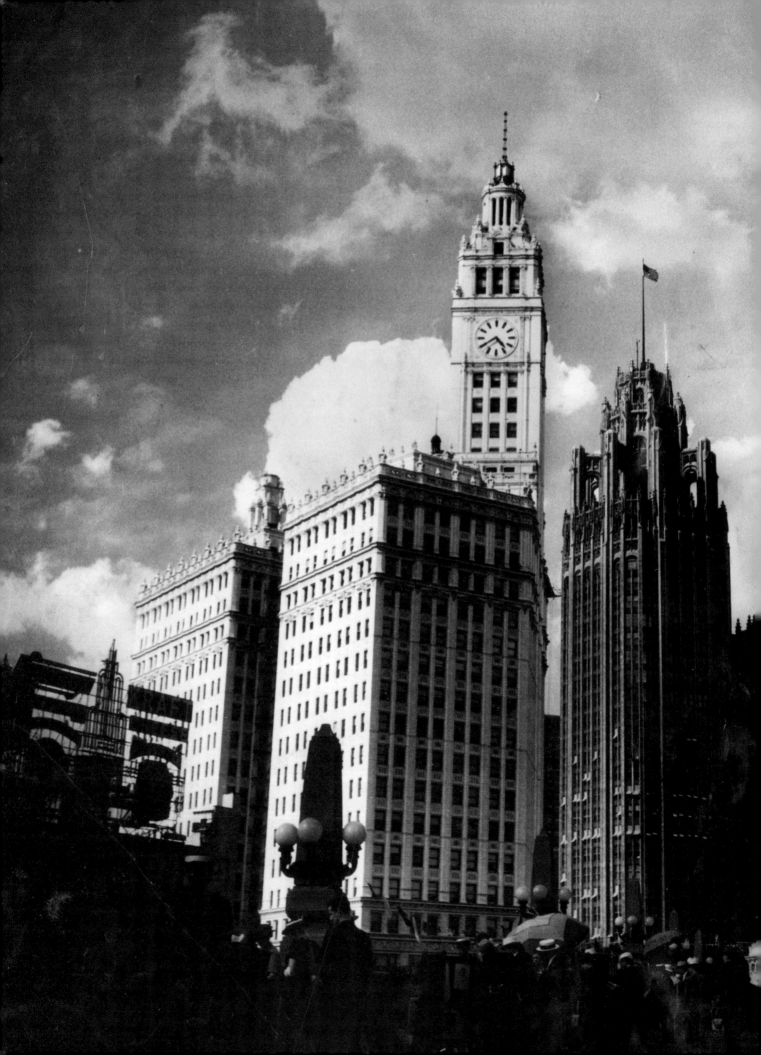

Wrigley: Star of the skyline

The Wrigley Building opened up North Michigan Avenue

WHETHER the Wrigley Building was the catalyst or just an important piece of the puzzle, its completion in the early 1920s came during a remarkable period of change for the city, when business—mostly confined to the iron chains of the Loop—jumped north of the river. In a short period, too, the public space around the Michigan Avenue Bridge, completed in 1920, coalesced into arguably the heart of the city. The London Guarantee Building brought its graceful curve in 1921 to the southwest corner. Before the decade was out, this square would be further defined by the art deco statement at 333 N. Michigan Ave. and the Gothic landmark Tribune Tower.

William Wrigley Jr.'s decision to put his offices on the north side of the river was a bold move—and he wasted no time. He bought the irregularly shaped parcel for the south tower for about $215,000 in 1919, broke ground in March 1920 and declared it 95 percent rented in February 1921, two months before it opened. It was the first major office building north of the river in that area, and demand clearly was strong.

It didn't take long for the rest of Chicago to fall in love with the terra-cotta clad Wrig-

The Wrigley Building, left, seen in 1935 with the Tribune Tower across Michigan Avenue, helped lure businesses north of the Chicago River.

ley Building. Even before the south tower was completed in 1921, "Mme. X" extolled its virtues Jan. 30 on the Tribune's society pages: "Well may the famous leaning tower of Pisa and the two less famous, less leaning towers of Bologna totter and tremble. Their supremacy, in the tower line is menaced, if not destroyed, by the Wrigley tower of Chicago.... It is magnificent, imposing, unforgettable."

No small part of the building's impact was the decision to light the gleaming white tower at night. It looks like the city was built just to provide the Wrigley Building with a backdrop. Seen from the south, it appears to sit astride Michigan Avenue; Situated on the Chicago River, it offers plenty of room to gawk. For years, it was a jewel gleaming unobstructed from as far south as the Field Museum.

Three times, though, those floodlights went dark for extended periods. The first was during World War II for security reasons.

Then from December 1970 to February 1971, the moon had to suffice while the lights were replaced and moved as the double-decker Wacker Drive was extended east of Michigan Avenue. The third and final time was for about 10 months during the energy crisis in 1973-74. (Fittingly, the Wrigley Building participated in a nationwide minute of darkness in October 1931 to mark the passing of Thomas Edison.)

Designed by architects Graham, Anderson, Probst & White, the Wrigley Building isn't just eye candy, of course, but a bustling office building. William Wrigley Jr. Co. moved into the 14th-16th floors. Other early tenants included the Elmer E. Perkins Coal Co., Railway Materials Co. and the Minneapolis Heat Regulator Co. In 1924, Calvin Coolidge's campaign for presidency and the National Republican Committee were run out of second-floor offices.

In 1936, the Wrigley Building Restaurant opened and became a legendary lunch and dinner spot for Chicago advertising's Mad Men. It closed in 1989. From 1926 to 1947, Wrigley was home to the Arts Club of Chicago, and from 1929 to 1956, WBBM-AM broadcast from the building. A big tenant beginning in the 1950s was the National Boulevard Bank of Chicago, which even had a drive-up window on East North Water Street.

In July 1965, the Wrigley Building was damaged by a large bomb set on North Water. The blast destroyed a parked car and shattered scores of windows in the towers. The attack was part of a mysterious series of bombings that

An automobile is destroyed by a bomb that was set between two sections of the Wrigley Building in July 1965.

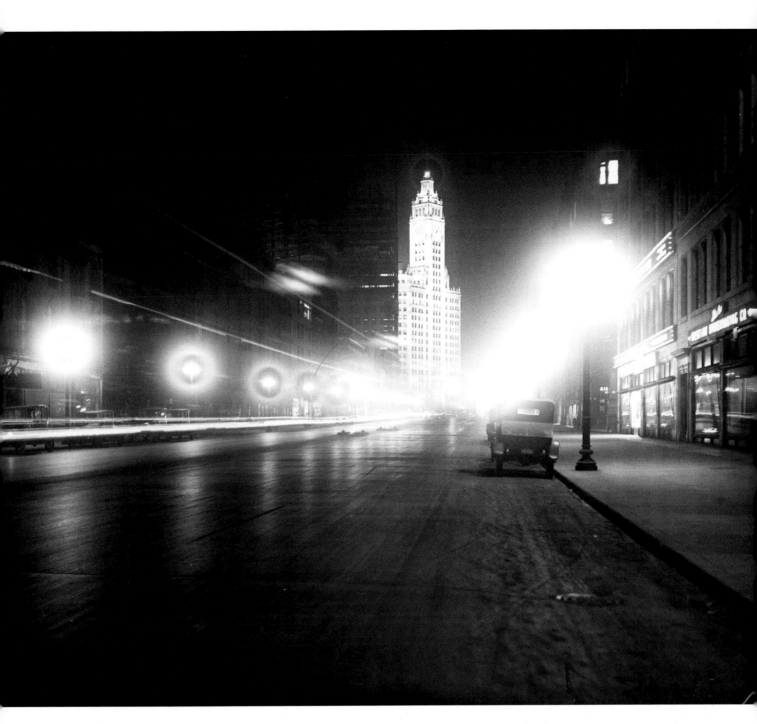

targeted a number of downtown structures that month. Nobody was ever arrested.

In 1997, Wrigley was center stage after the death of Diana, princess of Wales. Thousands came to pay respects at the British Consulate offices there.

It's worth noting that William Wrigley Jr.'s decision to construct an office building was just one of a number of big moves he made at the time. The same year he negotiated to buy the Wrigley Building land, he also bought Catalina Island off the coast of California (the Cubs would practice there). He also announced he was doubling the size of his chewing gum plant at Ashland Avenue and 35th Street. And in 1924, the same year the second tower was completed, Wrigley bought a certain ballfield at Clark and Addison streets—for $295,000.

—STEPHAN BENZKOFER

The Wrigley Building is lit up at night in an undated photo.

Tribune Tower a winner

Landmark building has storied history, inside and out

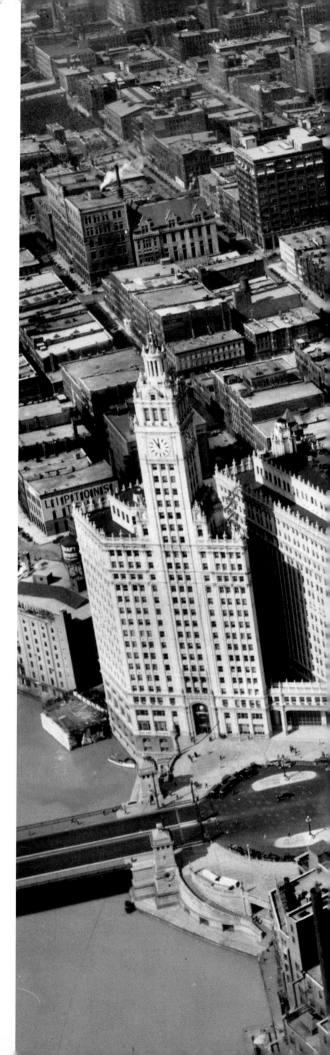

THE Tribune Tower oozes history. It's written on the granite walls of its landmark lobby. It wears it on its facade inlaid with hunks of the Great Pyramid and the Great Wall.

Like the Wrigley Building just across Michigan Avenue, the Tower is a beacon. Illuminated at night, the Wrigley Building marked Chicago's location for ships on Lake Michigan. The 36-story Tower's flying buttresses marked a bastion of traditional—that is to say, Middle American—values.

Upon its opening on July 6, 1925, the Tribune Editorial Board observed that the Tower was intended to be more than a building to house printing presses and want-ad order takers. "It was conceived, designed, and completed in a sense of trusteeship for the higher needs of a civilized community."

If ever a building lived up to its specs, it has been the Gothic Revival Tribune Tower. Inside and out, it has kept historical memory alive. Gathered from the world over, the famed Tribune stones embedded in its walls recall civilizations ancient and modern, Western and non-Western. In its newsrooms, generations of reporters have pounded out stories illustrative of the best and worst sides of human nature. They have chronicled wars and natural disasters, the achievements of great scientists and the passing parade of workaday folks.

For the Tower's first three decades, it was presided over by Col. Robert McCormick, the

The winning design for Tribune Tower, under construction in 1924, was crowned in late 1922, and the Gothic Revival building opened for business on July 6, 1925.

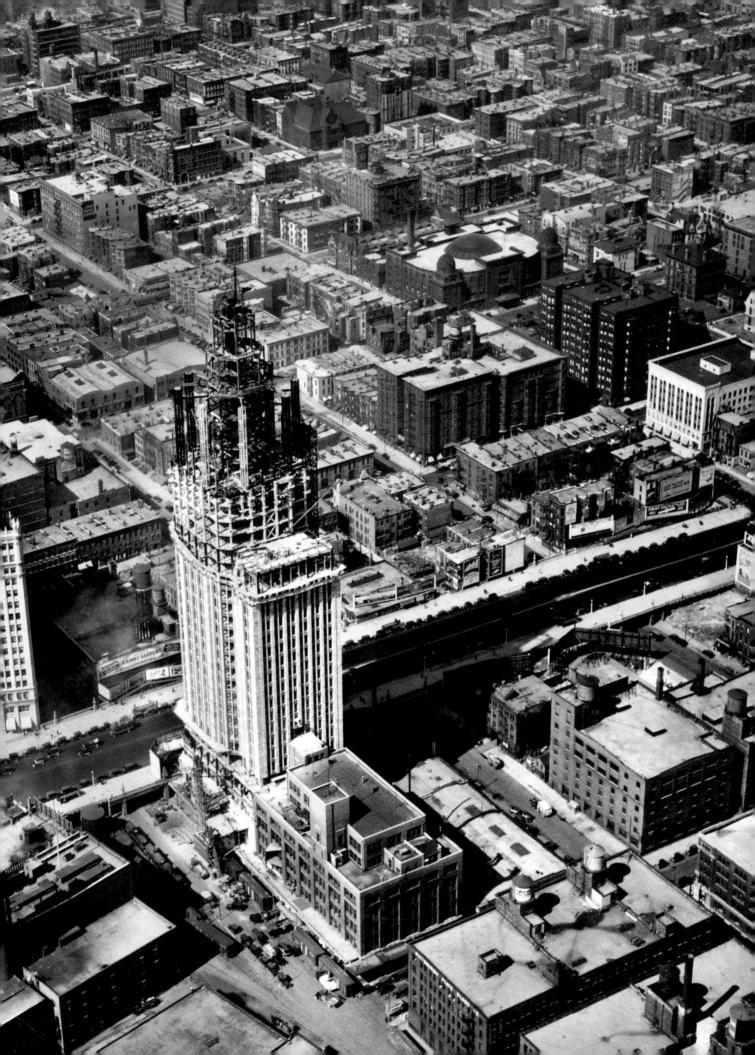

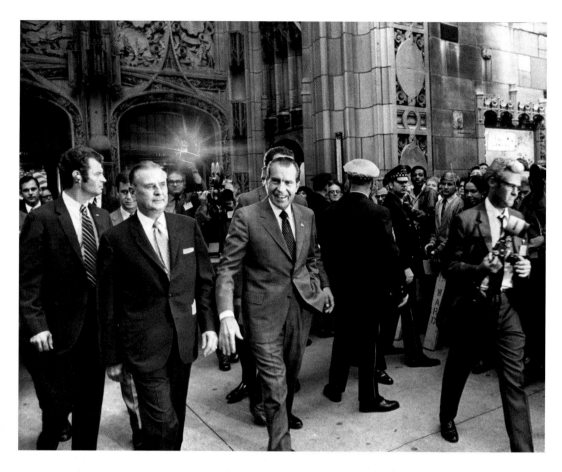

President Richard Nixon is all smiles Sept. 17, 1970, after meeting with the Tribune's editorial board. His relationship with the newspaper would sour considerably during the Watergate scandal.

paper's editor and publisher, from a palatial 24th-floor office. A born-again conservative— he had been a progressive-minded reformer— McCormick railed against President Franklin Roosevelt's New Deal, decried Al Capone's baneful influence on Chicago and opposed America's involvement in World War II, right up to the Japanese attack on Pearl Harbor. During the Cold War, McCormick had the Tower's basement retrofitted as an air-raid shelter.

"To inform the Tribune population and others in the neighborhood that an atomic bomb attack is imminent, a steamboat whistle soon is to be installed on the seventh floor of the light court behind the Tribune Tower," the paper reported Nov. 14, 1949.

The Tower's fourth-floor newsroom witnessed a remarkable scene April 30, 1974, when Tribune editor Clayton Kirkpatrick got on a desk to announce the paper was printing the full text of the Watergate tapes. The paper had supported Richard Nixon for president, but after reading the transcripts noted: "Now in about 300,000 words we have seen the private man, and we are appalled." Shortly afterward, Nixon resigned.

In 2008, the paper backed Barack Obama, observing: "This endorsement makes some history for the Chicago Tribune. This is the first time the newspaper has endorsed the Democratic Party's nominee for president."

On June 10, 1922, the Tribune made a splash with a worldwide design competition for a new headquarters building on the up-and-coming, though still-quite-mundane, Michigan Avenue. The colonel, no stranger to publicity, threw in a gaudy $100,000 prize, nearly $1.5 million in today's money.

Announcing the winner, the Tribune saluted New York architect John Mead Howells. "The embattled crown of his building utters the Tribune ideal," the paper wrote Dec. 8, 1922.

The article went on to compliment the runner-up, Eliel Saarinen. "Of Mr. Saarinen, the Finlander who wins second place, the Tribune knows nothing save that he has done a notable and lovely thing. His Tribune design

arrived during the final days of our competition and it created a sensation."

It would continue to do so. Saarinen was a modernist, an inheritor of an architectural style born in Chicago with Louis Sullivan's famed skyscrapers.

Civic pride would suggest the sleek lines and well-proportioned setbacks of Saarinen's design would have given it a leg up. Sullivan praised it. Yet it was destined to be the missing link of Chicago architecture: an unrealized vision midway between those of Sullivan and Mies van der Rohe.

In giving the nod to Howells, the contest jury noted: "One gratifying result of this world competition has been to establish the superiority of American design." The jurors reported: "Only one foreign design stands out," happily adding that it "did not come from France, Italy or England, the recognized centers of European culture, but from the little northern nation of Finland."

Those judgments meshed with McCormick's worldview, which is not surprising. He was one of the judges.

He had begun as an enthusiastic supporter of President Woodrow Wilson's declaration that World War I was a war to "make the world safe for democracy." McCormick pulled strings to get an officer's commission and recruited his own fighting unit at the Tribune's headquarters prior to the Tower.

But while proud of his military service with the 1st Division—mementos of the "Big Red One" decorated his Tower office—what he witnessed in Europe turned McCormick into an isolationist. Having won the war, America's allies carved up the spoils, notwithstanding Wilson's lofty ideals.

So it was inevitable that the commission to design Tribune Tower would go to an American architect. His design has been criticized as a throwback to premodern architecture, especially compared with Saarinen's forward-thinking vision. The Tower has been satirized as looking like a supersize wedding cake.

Yet its hope when pitting competing architects, the Tribune had said, was to give Chicago "the most beautiful and distinctive office building in the world."

So if beauty is in the eye of the beholder, McCormick got what he was looking for. All day long, sometimes well into the night, pedestrians pause before the Tower. Some crane their heads to look at those buttresses flying high over Michigan Avenue.

Other eyes are captured by the 150 Tribune stones, the first gathered by McCormick's correspondents before the building's construction commenced. More recent additions, fragments of Wrigley Field and Comiskey Park, were set in place in 2015. Some passers-by are inspired to put a hand on the facade, wanting even a moment of physical contact with the history it represents: the Alamo and John Brown's cabin, Abraham Lincoln's tomb and Independence Hall, where the Declaration of Independence was signed.

—RON GROSSMAN

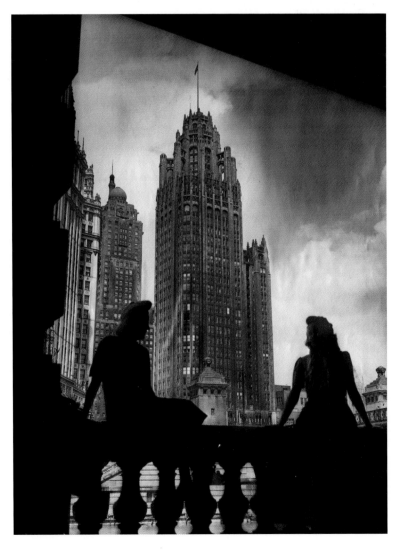

Critics called the Tower a throwback to premodern architecture, especially compared with Saarinen's forward-thinking vision. Also likened to a supersize wedding cake, it is now a Chicago icon.

CHAPTER TWO:

Transportation

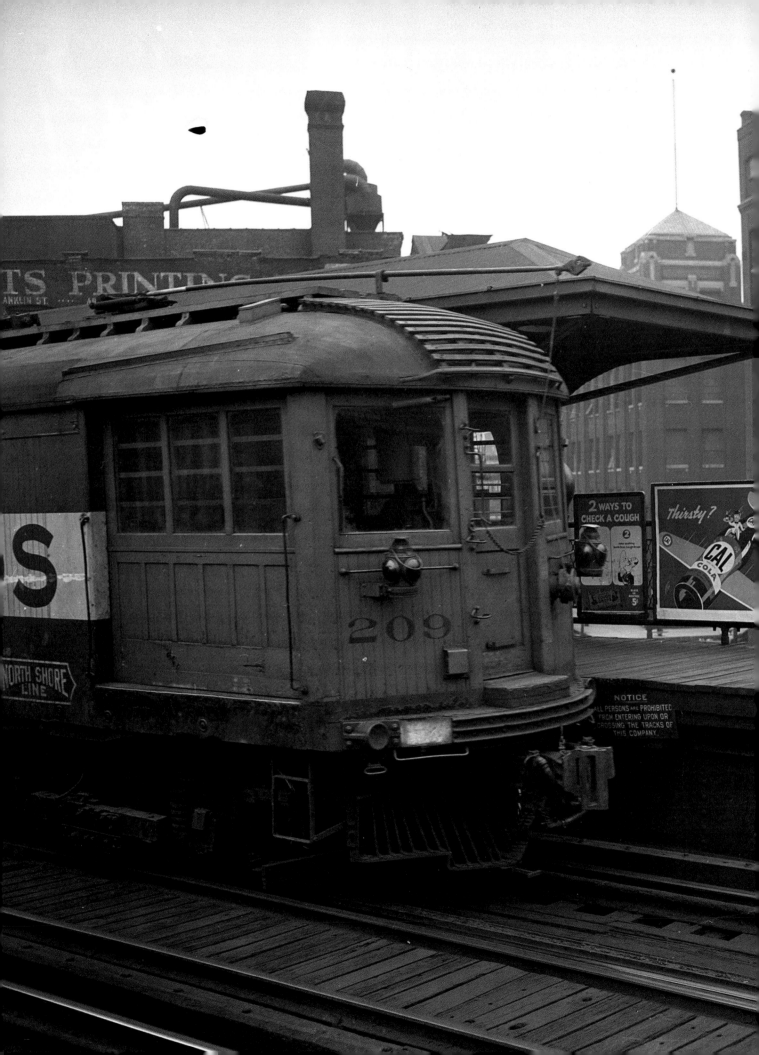

'L' defines the city

Elevated train—with trademark screech—knits Chicago together

As the "L" carried Chicagoans to work and home for more than 125 years, its girders and beams provided a rusty picture frame for the city's skyline and neighborhoods. The screech of binding wheels as a line of cars bends around its tight curves created the unmistakable soundtrack of a big city.

Born of a simple idea—getting commuters above congested street traffic—the elevated rail line not only became emblematic of a no-nonsense industrial powerhouse, but also stitched Chicago together as the system branched into new neighborhoods, offering riders a tempting peek into life in its mansions and tenements.

A Tribune reporter noted of its June 6, 1892, inaugural run: "Those who made observation trips early in the day were well-repaid for the trouble, for the people living on either side of the tracks had seemingly forgotten the warning about the start, and the passengers saw bits of domestic life generally hidden from the gaze of passing crowds. Late risers were confronted with the alternatives of lying in bed until darkness came again, or watching until there would be no train in front, giving them the opportunity of pulling down the all-concealing blind."

As that first leg, running above the alley between State Street and Wabash Avenue, was about to open, the Tribune, judging that it would be big, sent a correspondent to ride New York's elevated train. He said Chicagoans should expect congestion to follow them up the stairs to the ticket window. "While you are picking up your change the crowd behind you

A rider poses in a typical stance next to the final "L" train at Chicago Avenue before a rapid-transit strike in 1945.

"Every day is D-day under the El."

—NELSON AGREN, 1951

will try to walk up your back, but if you remain firm they can't do it," he advised.

He proved prophetic, another Tribune reporter noting a downside to the Alley "L"'s immediate popularity. "In fact, at the present rate of push and shove incident to every train, it is only a question of time as to when every man and woman in Chicago who travels that way will become dyspeptic, and the peace and quiet of many a home will be threatened with destruction," he wrote in 1893.

The sound of the "L" was as memorable as its look. Long after leaving his hometown, novelist Albert Harper recalled it in a short story, "My Aunt Daisy," describing her sitting on a Chicago back porch "while a hundred yards to the south the Lake Street elevated roared and crashed along, hurtling its racket through the summer night like long-range artillery."

Through much of its history, the "L" was called upon to provide real people-moving muscle when needed. One of the first was an extension to the 1893 World's Columbian Exposition in Jackson Park. Another branch ran west from the Alley "L" to loop the stockyards, providing an awe-inspiring view of a sea of cattle and hogs. Another branch line ran east from the Alley "L" to Kenwood, carrying the "beef barons" who owned the packing companies to the lakeshore mansions.

Northwest Siders got a widening perspective on back porches and rear windows as elevated structures snaked through neighborhoods along the Ravenswood line. Branch lines had their own branches, like the Humboldt Park line that came off of the Logan Square line and the diminutive Normal Park branch that ran south for a few blocks from the Englewood branch.

Riders on the West Side's Metropolitan line might see the special funeral car carrying mourners and the departed to Waldheim Cemetery in Forest Park. The North Side "L" overlooked Graceland Cemetery with its mausoleums and memorial columns of Chicago's former movers and shakers.

For others, the new vantage point provided unwanted information.

Harold Blake Walker, the paper's religion columnist, bemoaned "the decaying factories and rubble filled empty lots." "Reading Henry Thoreau's 'Walden Pond' on an elevated train racing toward Chicago is an incongruous experience, like trying to swim in an empty pool," Walker wrote.

Nelson Algren saw that bleak landscape at ground level, where the alternating stripes of light and shadow cast by railroad ties high overhead were reminiscent of a battlefield.

"Every day is D-day under the El," Algren wrote in his 1951 essay "Chicago, City on the Make."

Earlier, the view from the "L" was more inviting. "Just where the track curves at Halsted Street and North Avenue, in a backyard about 10 feet wide and three feet below the sidewalk level, a mother goat and two kids have their happy home, and they are almost on speaking terms with half the patrons of the Northwestern 'L,'" a Tribune writer observed in 1908.

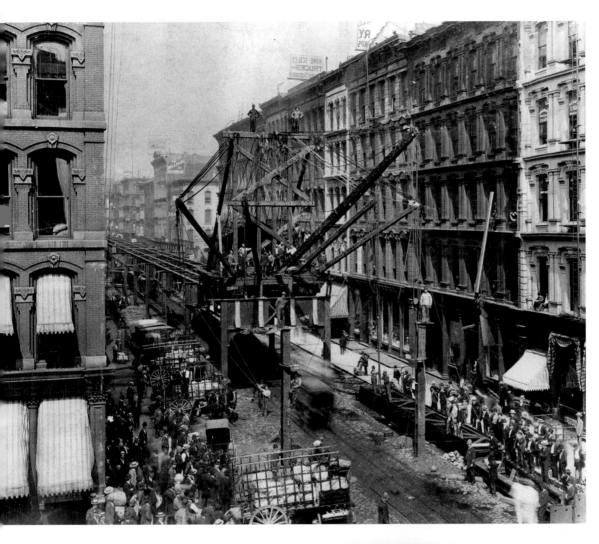

An early construction project to extend the "L" system was quite an undertaking—as this view of Lake Street looking west from Wabash Avenue in 1896 shows.

The North Shore line's Milwaukee Limited makes a stop along its Skokie Valley route in 1931.

Farther out, the scene was positively bucolic, the "L" running through empty vistas and attracting development in its wake. Real estate promoters touted its virtues, as in a 1911 Tribune ad: "Just two years ago, we secured directly on the Ravenswood 'L' ... an entire Quarter Section," a developer boasted. "The very moment we opened it up, there was a rush of the better class of people to obtain home sites in a refined community."

The one-letter nickname proved as enduring as the girders. Despite two lines now rumbling under the Loop—the O'Hare branch of the Blue Line is practically a roller coaster of elevated, ground level and subterranean travel—all the lines were still simply called the "L." Witness a 1984 Tribune headline that saw no reason to get mired in the pedestrian details: "O'Hare's 'L' service gets inaugural cheer."

—RON GROSSMAN

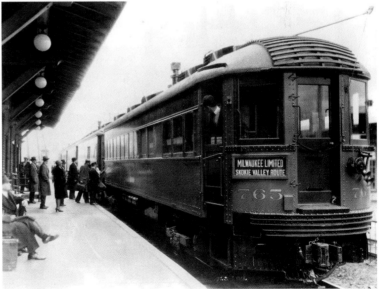

'Ain't no road just like it'

As superhighways go, Lake Shore Drive is as unusual as it is picturesque

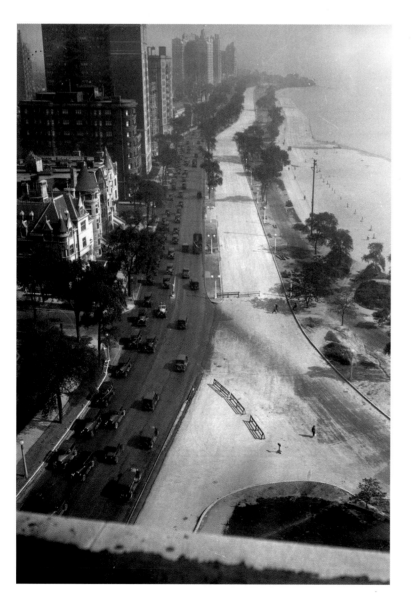

Both a boulevard and one of the nation's first superhighways, Lake Shore Drive arguably showcases Chicago like no other street does for any other city. From Hollywood Avenue to the Chicago Skyway, the drive offers an incomparable view of the beauty of nature and the power of man. With barely a turn of the head, motorists can behold the skyscrapers that put Chicago's stamp on modern architecture and a shoreline virtually unspoiled by industry.

Returning to her native city in 1931, novelist Mary Borden (think dairy family) was enchanted by the drive's panorama. "Palaces rise on your left, the lake shimmers on your right," she wrote in Harper's magazine. "On you go, fast, so fast."

The drive not only provided a speedy way downtown, it's also a route to the city's past, as the Tribune predicted in 1896 when construction of its southern portion was being debated in the City Council: "Every block and every mile is full of places interesting historically, and it is doubtful if another five mile drive could be selected about the outskirts of the city which would be so full of reminiscence for the pioneers of Chicago."

On the South Side, the drive follows an old trail that Fort Dearborn's garrison and settlers took in 1812 in an ill-fated attempt to escape the Native Americans' wrath. On the North Side it runs past Lincoln Park, the site of one of the battles between anti-war protesters and Chicago cops during the 1968 Democratic National Convention.

And the latest of its several extensions, a stretch between 79th and 87th streets, poses a gnawing question about the city's future. It runs through a no-man's land, the largely empty former site of U.S. Steel Corp.'s South Works, once a seemingly eternal job reservoir for the Southeast Side.

If you asked a 19th-century Chicagoan about a lake shore drive, she would have pictured a winding road through what is now Lincoln Park. The land on which the current drive runs didn't even exist. Much of the drive, as well as the parks that parallel it, sits on landfill. Over the years, the names Lake Shore Drive, Inner Drive, Cannon Drive,

Sheridan Road, Outer Drive and South Shore Drive have referred to different stretches of the roadway—and even different roads. For a brief period, a stretch on the Near North Side was Palmer Drive, understandable since the campaign for a waterfront boulevard quickened in 1899, when Potter Palmer asked for a street improvement in front of his mansion at 1350 N. Lake Shore Drive. Other residents of the ritzy neighborhood objected, but Palmer's will prevailed. He was a merchant prince who had made State Street the city's shopping rialto and his wife, Bertha, was the grand dame of Chicago society.

While the project would boost the value of his real estate, Palmer argued for it in democratic terms, even suggesting a method for accomplishing it. "Mr. Palmer had noticed the stream of people that went up the drive seeking the large breathing spot and felt it was his duty to tell the board that he did not object to having a spot where they could stop along the way," the Tribune reported. "Mr. Palmer said he would not object to putting a sea wall farther out into the lake and having a strip of land filled."

Chicago was already doing that—extending itself eastward with landfill—in a counterattack on Lake Michigan's persistent erosion of the shoreline. City fathers considered that newly created acreage ripe for development, but not Montgomery Ward, the merchandising genius who created the mail-order industry. A contemporary of Palmer's, he fought numerous lawsuits to keep the lakefront "forever open, clear and free," as it was described on the original plat map of Chicago.

Strictly that applied only to the city's original boundaries, but as the boulevard Palmer advocated was progressively extended, the principle Ward fought for accompanied it. The result is a Lake Shore Drive flanked by beaches, parks and athletic fields, instead of the warehouses, piers and factories that line the waterfronts of other Great Lakes cities, such as Milwaukee and Cleveland.

Of course, like Palmer's neighbors, not everyone was a fan of Lake Shore Drive. In 1898, when an 11-story apartment building was announced for Goethe Street and the drive, res-idents of the mansions that still dominated the skyline were aghast. "I am sorry to see tall apartment buildings coming in on the drive," one neighbor told the Tribune. In 1934, when the drive was extended past the swanky Saddle and Cycle Club at Foster Avenue, the Trib's society columnist reported that it "gives such an excellent view of club activities that club habitues now call it 'the goldfish bowl.'"

One impediment to making the drive a true boulevard ended in 1936 when the Illinois Commerce Commission ended a 12-year legal battle and ordered the Chicago Surface Lines to remove the streetcar tracks that crossed the drive at Chicago Avenue. The next year, the Link Bridge over the Chicago River finally sewed up the northern and southern sections.

While most of the drive was built in seeming haphazard bits in the late 1920s and early 1930s—the southern portion generally came first—one of the final stretches, from North Avenue to Belmont, didn't open until 1941. The nasty right-angle turns south of the Chicago River weren't straightened until the early 1980s. But the drive was an engineering landmark: Its limited access entrances and long stretches without a traffic light were a prototype for superhighways built after World War II. From the 1940s to the '70s, a section north of North Avenue featured a unique—though problem-plagued—system of curb-high lane barriers that could be raised or lowered to provide six lanes in the direction of rush-hour traffic instead of the standard four lanes.

Lake Shore Drive is now a go-to image for TV and movie directors, and many performers give a musical nod to the drive, including Kanye West, Juice, Fall Out Boy, and most memorably, the rock group Aliotta Haynes Jeremiah in their 1971 ode "Lake Shore Drive."

That song's refrain—"There ain't no road just like it"—echoed the sentiment offered by a Tribune columnist in 1927 who asserted: "Whether you look northward up that meandering shore line by day, or at twilight, or when dark has come, it is beyond compare with anything that New York, or Paris, or London, or Berlin, or Rome, or any other world capital can offer its residents."

—RON GROSSMAN

Opposite: A view of Lake Shore Drive, looking north from the Drake Hotel, in 1927. While most of the drive was built in seeming haphazard bits in the late 1920s and early 1930s—the southern portion generally came first—one of the final stretches, from North Avenue to Belmont, didn't open until 1941.

Those @#$%&! bridge-tenders!

Perhaps unfairly, workers picked up a reputation for being arrogant, lazy

THEY were scorned, hated and reviled. They were called despots and tyrants. They were lazy. On their good days, they needlessly made the public wait; on the bad, they endangered the public safety.

They were bridge-tenders, and it is hard to overstate the contempt Chicagoans in the late 1800s and early 1900s felt toward the men who operated the spans across the Chicago River.

That may be difficult to understand now, when the bridges and the river are a tourist attraction, and the relatively rare sight of a bridge going up is a reason to whip out a camera, not resort to curses.

But it wasn't always that way. The city straddles a river and getting across that river in the late 1800s was a difficult task. There were fewer bridges, so workers and commercial traffic were funneled into congested chokepoints. The bridges weren't reliable; the spans frequently closed to allow river traffic to pass as the landlubbers waited. It wasn't uncommon for traffic jams to back up for blocks. The real poke in the eye, though, came when the bridge stayed open for no good reason or lazily swung closed.

City law in 1872 prohibited the bridges from remaining open longer than 10 minutes during the morning, noon and evening rush hours, but the "rule is shamefully disregarded," the Tribune reported. "It is a notorious fact that the bridge-tenders, with one or two exceptions, are the laziest men in the employ of the city."

Outraged citizens couldn't do much about it. This was Chicago, and the bridge-tender wasn't just any laborer off the street. He knew somebody—the alderman or the mayor or the mayor's supporter. The appointed job became a lucrative way for politicians to reward friends and supporters. In 1878, a bridge-tender could make about $1,200 a year. By 1901, the Tribune reported that four were paid a whopping $3,400 annually (nearly $100,000 in today's money) and 14 others took home $2,700. Many official bridge-tenders farmed out the actual labor and pocketed a profit.

But just as there are two halves to Chicago's famous bascule bridges, there are two sides to the bridge-tenders' story. There were conscientious men—probably more than the one or two exceptions the Tribune mentioned—who did try to balance a difficult, lonely job where pleasing one group meant angering the other. In 1908, the job became covered under the civil service law, lessening the rampant patronage abuse, though not ending it. As the century progressed, so did the professionalism of the bridge-tenders.

An unwritten, grisly part of the job was suicide watch. Veteran bridge-tenders became adept at spotting people at risk. They looked for pedestrians who lingered or stared too long into the river. A 30-year veteran named Frank Ward said in 1945, "It's either love, liquor or finances that cause people to want to jump into the river. Most of our work is talking them out of it, rather than the actual saving of lives."

—STEPHAN BENZKOFER

On New Year's Eve 1953, bridge-tenders Joseph M. Egan, left, and Frank Duckman work the controls of the Michigan Avenue Bridge's southeast tower.

Looking east down the Chicago River in 1955 as a barge inches under the bridges.

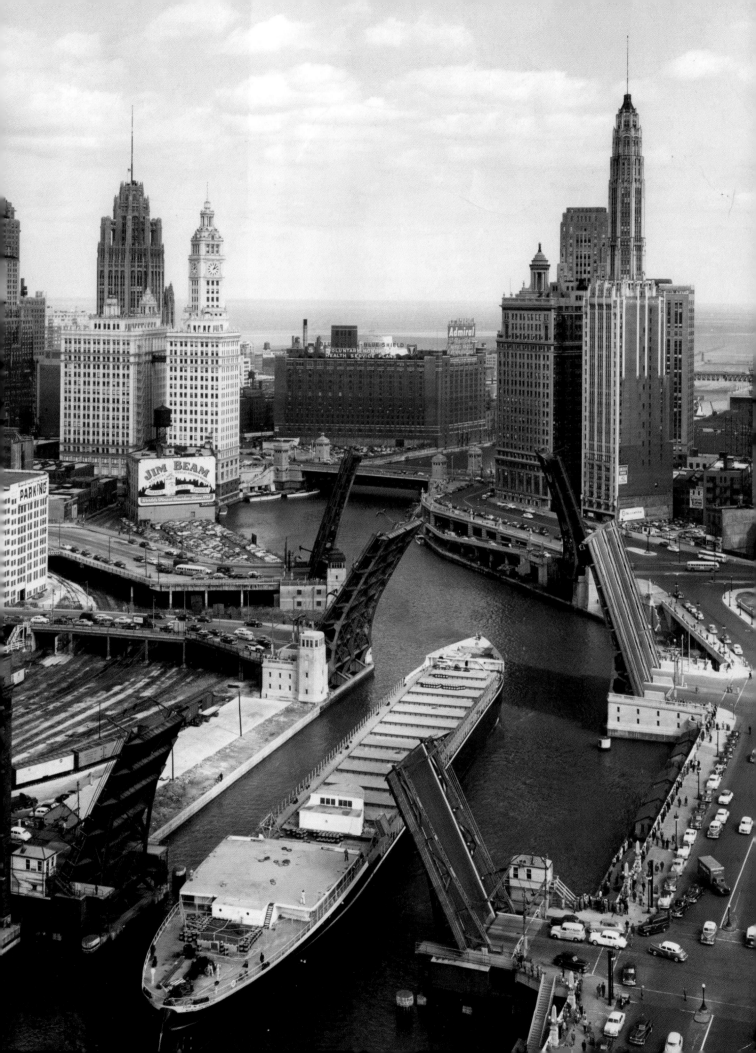

Before Uber, there was jitney

Renegade cabs provided vital service for South Side

THE battle between cabbies who pull a meter and upstarts who book fares via a smartphone app is evocative of an action-packed taxi drama that long ran on Chicago streets.

Decades before Uber and Lyft, taxis that operated outside municipal regulations were called jitneys, named from a slang expression for a nickel, the original fare. While many cities had jitney cabs, in Chicago the phrase for most of the 20th century referred to cars that worked the South Side and operated like buses on a set route.

August Wilson's award-winning play "Jitney" is set in Pittsburgh, where he took his mother by jitney to see the production.

At other times, jitneys would spontaneously appear during transit workers strikes, as car and truck owners tried to capitalize on the opportunity.

Then as now, there was a concern about safety. The jitney drivers were known as daredevils—especially along King Drive, where a Tribune reporter observed them in 1971. "They look like cabs but they behave like buses," he noted. "You can ride as far as you want between 29th and 63rd."

The same year, a CTA official told the Tri-

High school students take a jitney cab to school in 1974. At the time, there was concern about the safety of the cabs because jitney drivers had a reputation for being daredevils.

bune that bus drivers needed special training before being assigned the King Drive route: "The driver has to learn how to dodge the attack like a fighter pilot when the cabs cut in front of him to grab passengers at the stops or stop short to pick up passengers who may wave to them anywhere along the drive."

Chicago's jitney fleet, once estimated to number 400, was the beneficiary of a perfect storm: white cabbies who wouldn't take passengers to or from black neighborhoods; racism that denied African-Americans jobs with established taxi companies; the long, narrow geometry of the South Side ghetto, making its thoroughfares ideal for cabs running back and forth, just like buses.

And above all else, politicians who, with a wink and an outstretched palm, tolerated a business model that played fast and loose with rules and regulations. Not running the meter, "high flagging" in cabby argot, is illegal. So, too, is picking up multiple riders en route and taking them aboard at bus stops.

In the 1940s, the city of Chicago and the Illinois Commerce Commission squabbled over jurisdiction of the jitneys. The state claimed control because jitneys operated like buses over regular routes. City Hall countered that jitneys, like other cabs, came under its authority. The argument wasn't just a matter of semantics—at least to judge by the rise and fall of James Carter, the city's taxi commissioner from 1960 to 1975.

For years, the word on the street was that his office operated on a pay-to-play basis, and in 1978, a federal jury convicted Carter of extortion, racketeering and income tax fraud. A jitney cab operator testified against Carter that, in addition to the prescribed licensing fees, "He said he wanted something for himself."

Three decades earlier, taxi commissioner Edward Gorman resigned after a Tribune series reported his office's benign neglect of the jitney problem. Asked his plans for retirement, Gorman replied: "I think I should go to Bermuda, where there aren't any automobiles or taxicabs."

For as long as Chicago has had jitneys, public officials have been quicker to praise than

"I think I should go to Bermuda, where there aren't any automobiles or taxicabs."

—TAXI COMMISSIONER EDWARD GORMAN, ON HIS RETIREMENT PLANS

decry them. In 1915, Mayor Carter Harrison Jr. invited "private capital to step in and operate 'jitneys' just as soon as it can put the machines on the streets." In 1961, reminded by the press that jitneys were illegal, Mayor Richard J. Daley said, "I also know they are rendering a service." His newly appointed taxi commissioner—and future felon—Carter echoed the Boss' sentiments, saying, "I feel they are doing a darned good service."

Defenders of a live-and-let-live approach to Chicago's jitneys claimed they offered employment opportunities in neighborhoods where jobs were scarce. But a Tribune editorial dissented, noting that drivers rented jitneys from a few fleet operators. The bosses took their share of the proceeds; politicians and cops got a cut. Exorbitant premiums went to insurance agents, including James Veitch, who was close to William Dawson, political boss of the city's black wards. Veitch also touted his ties to Gorman, Mayor Martin Kennelly's vehicle license commissioner. "In at least one case," the Trib reported, "an applicant was told to pay Veitch $2,000 for the 'clearance' to get a city license which costs $5.50, critics asserted."

So what was left for the guy behind the wheel? "The cabdrivers concerned cannot be

regarded as struggling little businessmen," the Trib editorialized in 1949. "Rather they are metropolitan sharecroppers."

Some thought otherwise. "Why do I work for this company?" jitney driver John Watson told a Tribune reporter in 1973. "I can hustle and do better." There were fortunes to be made—at the top of the jitney pecking order.

Bertel Daigre was one of four children born to a Baton Rouge, La., headwaiter. Coming to Chicago, he built a fleet of more than 50 jitneys and served as president of the Cosmopolitan Chamber of Commerce, the premier association of black business leaders. In 1967, he established the Free School of Business Management, so other blacks could learn entrepreneurial skills.

"I believe that once we are self-sustaining, we black people can combat the racism and other diseases in America," Daigre said.

But in 1978, Daigre confessed to one secret of his success. Under a grant of immunity, he testified to having paid $93,000 to taxi commissioner Carter when he was stalling Daigre's license applications. He paid the bribe money, Daigre told the jury, "because Carter could put him out of business."

In subsequent decades, the jitney business declined. Residents along jitney routes complained about traffic congestion. The CTA and city officials claimed the jitneys were responsible for the neighborhood's high accident rates. Additional buses left fewer customers for the cabbies. From time to time, there have been proposals to bring back legal jitneys, but none got off the ground until Mayor Rahm Emanuel opened the door to the rideshare companies, whose arguments to be allowed to operate echoed those made for jitney drivers even as they flout some of the very same regulations. A 1974 U.S. Department of Transportation report lamented: "Public transit is organized as a franchised monopoly. Innovative services such as the jitney are excluded."

At the end of Wilson's play, a character whose business is threatened by urban renewal, proclaims his defiance: "'Cause we gonna run jitneys out of here till the day before the bulldozer come!"

—RON GROSSMAN

Bertel Daigre, president of the First Congressional District Business and Professional Men's Club, addressed a City Council committee in May 1964 at City Hall.

Land grab to Loop flood

Underground tunnels started and ended in scandal

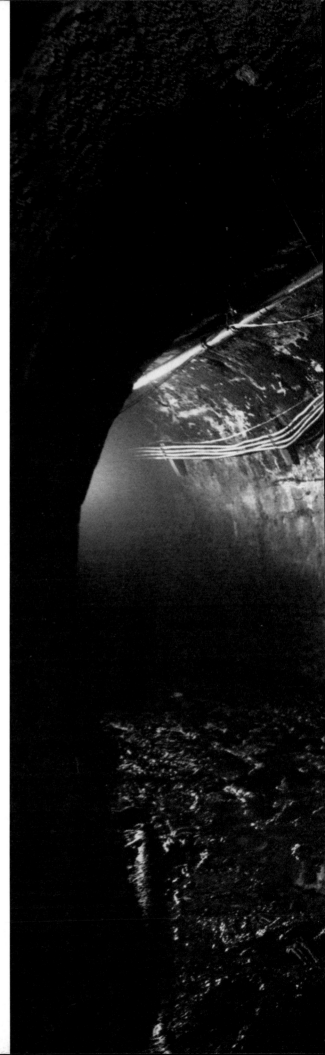

W HEN the Chicago River infamously sprung a leak, it wasn't the first time the city's system of underground tunnels was the source of an unpleasant surprise.

But on that Monday, April 13, 1992, many Chicagoans learned for the first time of the miles of freight tunnels honeycombing downtown. As Loop basements filled with water and emptied of people in a mostly invisible urban disaster, the heads started rolling and the cleanup bills piled up. An embarrassed Mayor Richard M. Daley immediately blamed a bungling city bureaucracy, and indeed it was revealed that city officials had had at least a month to fix the leak but failed to act in time. It took four days to plug the leak and weeks to pump out the waterlogged basements, sub-basements and sub-subbasements, like those at Marshall Field, Carson Pirie Scott, 29 E. Madison St. and DePaul University.

But imagine Daley's shock if he or his staff hadn't known about the tunnels at all. That's what happened to Mayor Carter Harrison II at the turn of the last century.

See, the tunnels themselves were an audacious, legally suspect land grab by a wealthy businessman who received city permission to lay telephone wires under the Loop and par-

The system of tunnels under the Loop began in 1899 as a simple infrastructure for telephone wires. The tunnels were closed in 1959.

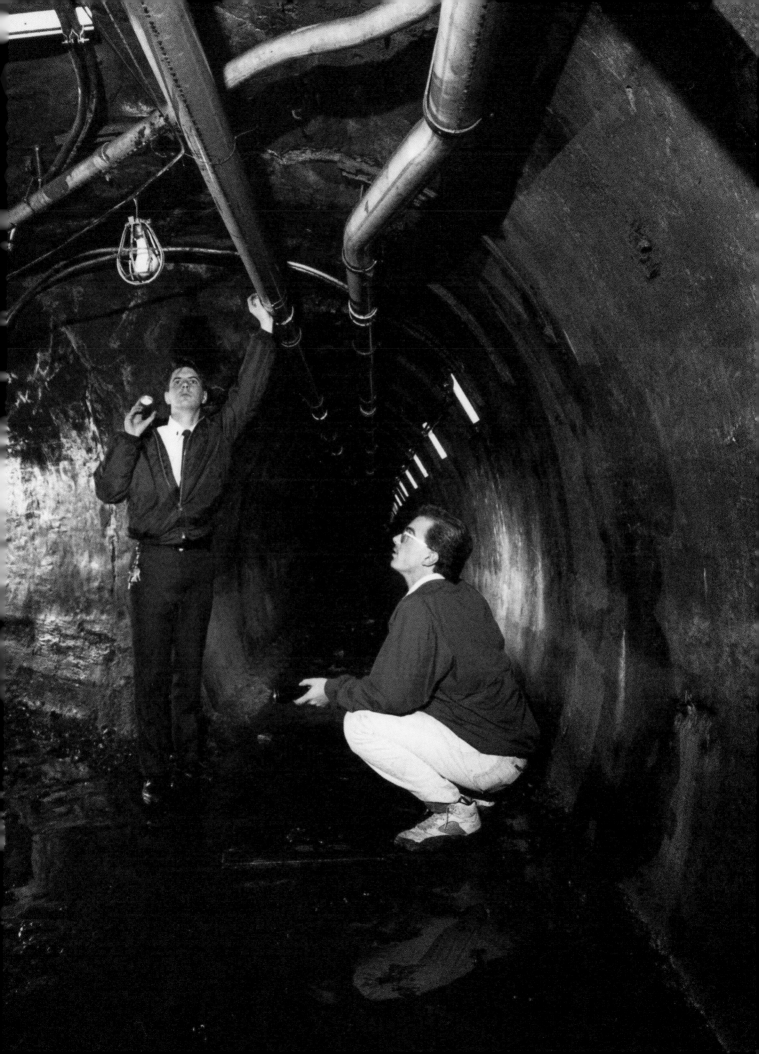

layed that into constructing an extensive underground railroad.

In March 1899 the Illinois Telephone and Telegraph Co. and its president, Albert Wheeler, received a 30-year lease "to construct and operate in all the streets, avenues, alleys, and tunnels and other public places of the city . . . conduits and wires or other electrical conductors . . . for the transmission of sound signals by means of electricity or otherwise."

Less than a year later, the commissioner of public works reported, "The city will be unable to head off the promoters of this scheme. Something should have been done long ago, but it is now too late, I fear. More than two blocks of the concrete tunnel have been completed, beginning in Powers & O'Brien's basement and running in Madison street to La Salle, and then to Monroe and Washington streets."

This illustration accompanied the Tribune's 1909 story on the tunnels, begun 10 years earlier without the knowledge of the mayor or his staff.

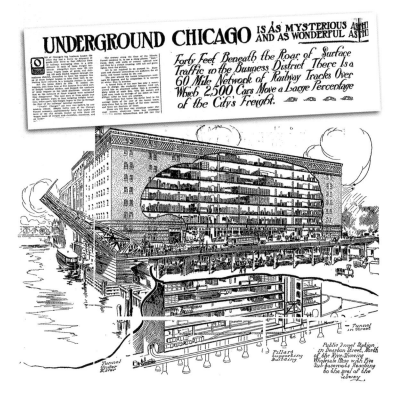

Wheeler refused to explain himself, saying only, "We don't want the question aired before the public."

As city officials blustered, Illinois Telephone kept digging. Harrison was told these big 7-foot-high by 6-foot-wide tunnels were needed to handle the hundreds of thousands of telephone wires intended to service the Loop. But the surprises kept coming. In March 1902, city officials found tunnels big enough to "drive a load of hay," 14 feet high and 12 feet wide. Wheeler said it was storage space.

A month later, Wheeler finally came clean on his scheme. In a blatant example of "ask for forgiveness, not permission," he announced plans to use the tunnels to deliver packages, newspapers, mail and other goods throughout downtown. He admitted he would need the city's permission to operate such a business, and said, "The wires . . . will be strung in the roofs of the tunnels, and we will have left ample space to be devoted to other uses."

Of course, Wheeler got his approval, but not before a Tribune editorial headlined "The illegal tunnels" took the city to task for the whole fiasco. And city lawyers issued a report questioning the existence of the tunnels themselves. "The city has never admitted that the company is entitled to build anything more than conduits for the carrying of telephone wires," the report read.

Five people—Wheeler, a former alderman, the former city clerk, the deputy city clerk and the city printer—were indicted in 1905 for forgery in the scandal. But the charges were tossed by a judge who, while ruling that the company "knowingly intended to defraud the city," found a technicality: The prosecutors failed to show how the defendants benefited.

But over the years, as the outrage faded, the wonder grew. These tunnels were a marvel. A 1909 story, headlined "Underground Chicago is as mysterious as the sewers of Paris and as wonderful as the catacombs of Rome," painted a vivid picture of thousands of tons of merchandise, coal, ash and refuse being transported 40 feet underground on a narrow-gauge electric railroad. A company could drop tons of merchandise at a South Loop tunnel depot and have it reappear as if by magic at four different locations, delivered in some cases directly to a firm's basement warehouse or to any of the city's main railroad depots. At its height, the system of concrete-lined tunnels ran for more than 60 miles, under nearly every Loop street and south to Roosevelt Road, north to

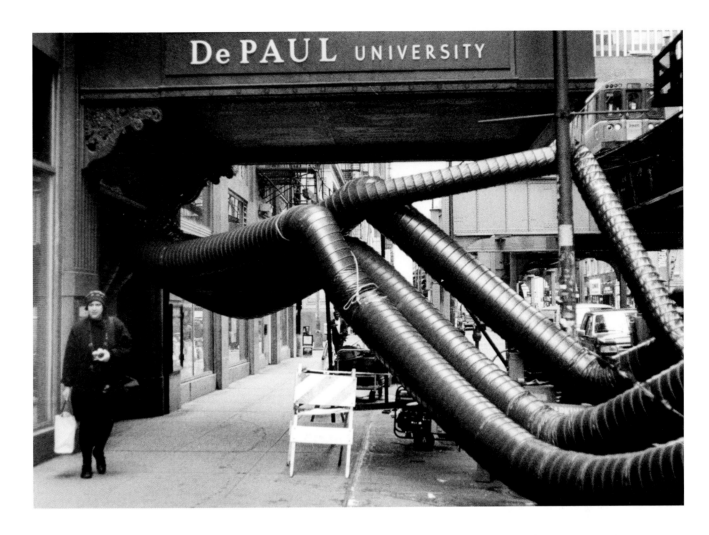

North Avenue and as far west as Halsted Street.

The benefit went beyond the speed and ease of delivery and extended above ground. Loop streets then were an almost impassable tangle, with multiple streetcar lines competing with pedestrians and hundreds of horse-drawn wagons (and later, automobiles). And don't even get a shipping manager started about the vagaries of getting his goods across the Chicago River via one of the fickle lift bridges! As the 1909 story pointed out, that one shipment of goods took 106 wagon loads of freight off the streets. Also sent underground were the hundreds of coal shipments, and banished from the streets were the three-horse drays groaning under 5-ton loads the Tribune called "one of the bugbears of the Loop district."

But the system never made money, at least for the company's shareholders, who never saw a dividend in the life of the venture. In 1929, when the lease expired and the tunnels became city property, the various corporate entities that owned the tunnels owed the city more than $1 million in unpaid franchise fees. A new 30-year franchise was granted in 1932, but by 1949, a city report found that the system was deteriorating and accused the company of diverting revenues to avoid paying a portion to the city. As late as 1954, the system still moved 220 tons a day, but competition from trucks and a changing economy forced the tunnels to close in 1959.

But the tunnels didn't go quietly. In July 1959, in a spot very close to the 1992 leak at Kinzie Street, excavators punctured the tunnel. Water poured in, but a widespread disaster narrowly was averted.

So could it happen again? Not likely. After the 1992 flood, massive concrete bulkheads were installed at the 30 spots where the tunnels intersect the river.

—STEPHAN BENZKOFER

More than a week after the April 1992 Loop flood, dehumidifier tubes snake from a DePaul University building at Jackson Boulevard and Wabash Avenue.

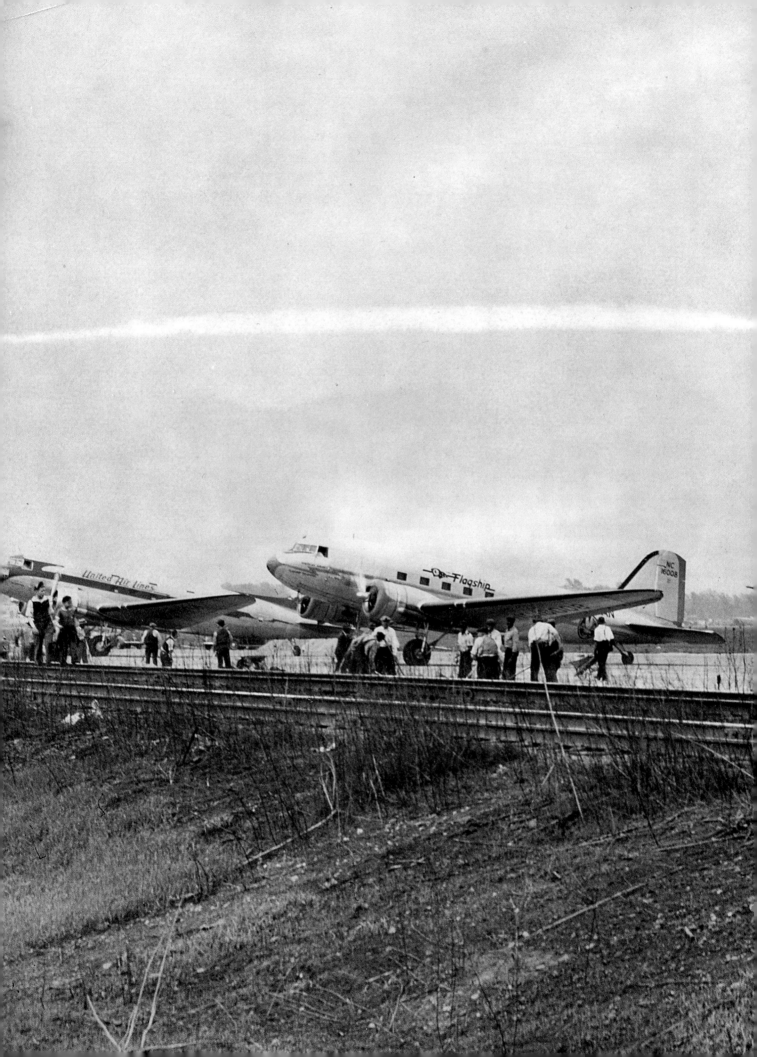

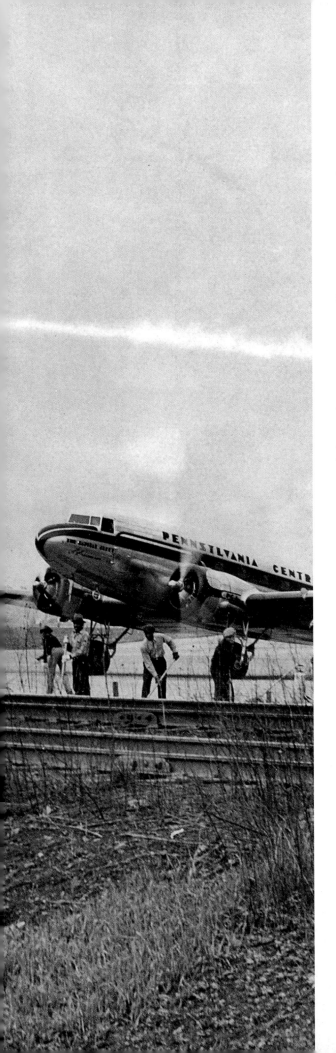

Midway's ups and downs

Chicago's other airport overcame low expectations before becoming nation's busiest

DESPITE numerous hurdles, it managed to become the busiest airport in the world, a title it held for at least 15 years. Don't remember the golden age? The little airfield on the city's Southwest Side understands that. It has battled low expectations and self-esteem issues since its birth in the 1920s.

The early years

In the mid-1920s, flying was still a relatively new idea. Consider that when city officials worked out early leases for the airfield that would become Midway, they insisted on 10-year, early-out clauses because they thought the flying machines might just be a fad.

City planners envisioned more than one "sky port" for Chicago. In June 1924, they outlined two near the lake—south at 18th Street and north at Grace Street—and the third "on the west side on Cicero avenue." But the airport's birth lacked much fanfare. On April 4, 1925, on page 6, the Tribune reported the news: "Chicago this morning has a municipal airport." Leased from the school board, the 75-acre site would expand to 300 acres in short order, officials hoped.

Growth was quick, and with it came growing pains. Already in 1929, aviation officials warned the city the airport was too small, too crowded and bordering on unsafe. "It is a crime to operate in the area with full loads

The first section of railroad track at what is now Midway Airport is ceremonially removed to make room for transport planes in this May 1941 photo.

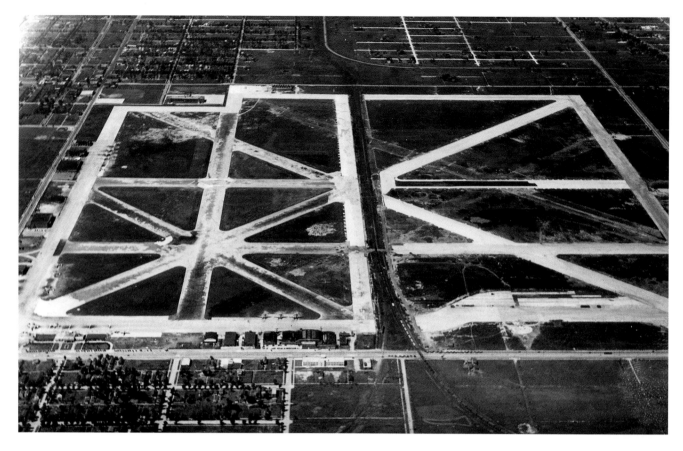

Aerial view of the Chicago Municipal Airport in 1938 shows the old and the new field bisected by railroad tracks.

and it will be nearly impossible to have the new thirty-two passenger planes land there," complained an executive of Universal Aviation Corp. Another big concern was the numerous student pilots buzzing around the same airspace, he said. In 1931, the Tribune reported a quarter of the nation's airmail carried annually by airlines passed through Municipal Airport.

Railroads fight back?

A major sticking point in the airport's growth was the little problem of the railroad tracks running across the property at 59th Street, a ribbon of steel curtailing further expansion as effectively as a bird cage. In 1936, as "great 50 passenger, four motored airliners" were on the horizon, the airport was warned again of its limitations, this time by an infant United Air Lines. The sensible suggestion that the tracks be moved north of 55th Street would prove a herculean task involving the City Council, state legislature, Illinois Supreme Court and the federal government. It took more than five years. Indicative of the process: Even after the new tracks

were laid, the Chicago and Western Indiana Railroad refused to tear up the old tracks until the city paid money into an escrow account to cover a piddling $10,627 it felt it was still owed.

And the school?

If railroad tracks running through an airport weren't odd enough, there was also the matter of an elementary school at the southwest corner—just feet from one of the runways. Maybe that shouldn't be considered an odd pairing given that the land was being leased from the school board, but this wasn't a case where the airport grew up around the school.

Hale Elementary School was built in 1925, the same year the site was declared the official city airport and years after the airstrip had become a busy airmail center and home to many pilot schools. Further, the building was condemned just four years later because of shoddy construction. Students were taught in poorly heated portable classrooms for the 1929-30 winter. Classes continued despite Municipal Airport being described in 1929 as the nation's busiest and the school's construction problems.

In the late 1940s, the issues of noise and safety made headlines. In 1947, the principal said that idling planes warming up before takeoff rendered instruction impossible numerous times an hour. Flashback reader Noreen Johnson Becker recalled that when the planes taxied by the school and revved their engines, students would "scream and holler because the teacher wouldn't know the difference."

A year later, prompted by a runway accident and other "close calls," officials finally talked about relocating the school. Amazingly, that was shelved Jan. 27, 1949, when it was announced that the airport would limit use on the two runways near the building during class hours instead of closing the school.

The school and airport coexisted for about two more years before ground was broken on a new Nathan Hale School nearby, though the old building wasn't demolished until 1955.

The Glory Years (aka life before O'Hare)
On Feb. 24, 1929, the Tribune reported Municipal Airport handled more than 30,000 passengers and was home to 10 airlines. It handled more than 1.6 million pounds of airmail. So would begin a parade of stories boasting of the little airport's productivity. In 1949, there was one landing or takeoff every 2 minutes. But even as the newly renamed Midway was sitting atop the aviation world, Tribune editorial writers were pining for the upstart O'Hare and its "super air terminal." Midway traffic peaked in 1959 when it handled one landing or takeoff every 51 seconds. That equated to more than 10 million passengers.

The fall was sudden. By early 1962, Midway was an "aviation backwater" as the major airlines switched their main service to O'Hare. Predictions that both could thrive proved inaccurate. A 1962 story already referenced the need for a "comeback" and the airport's "ghost terminal." Midway was relegated to freight until it received a much-needed lifeline with the 1964 opening of the Southwest Expressway (later renamed the Stevenson), which cut the drive time to the Loop in half. That same year, commercial air service returned when United started offering two daily flights to New York. The airport's rebirth had begun.

About that name
Municipal Airport was renamed Midway Airport in December 1949 to "emphasize Chicago's position as the center of aviation and also honor heroes of the battle of Midway," the Tribune reported. The famous clash near Midway Island in early June 1942 had turned around the war in the Pacific when a much-smaller U.S. fleet sank four Japanese aircraft carriers and numerous other ships and downed hundreds of airplanes.

A wonder to behold
The airport very much shaped the neighborhoods around it. When retired Chicago police officer Martin Bilecki was growing up near the airport in the late 1930s and early 1940s, there was plenty of room to roam—as in open prairie. Bilecki said he and his friends would hunt snakes and shoot rabbits and other small wildlife. It wasn't until World War II that the airport drew their interest, he said, when military planes—fighter planes and B-24 and B-25 bombers—were using the airstrip regularly.

He wasn't alone in his attraction to the airport. The Tribune reported in February 1952 that millions of people came to watch the action from the terminal promenade, dine at the Cloud Room restaurant or peer through the airport's perimeter fences. No small part of the appeal was the parade of movie stars, entertainers, politicians and the otherwise famous who came through the airport. It was a tradition that started with Charles Lindbergh's visits in 1927 and Amelia Earhart's in 1928.

Flashback reader Marion Kowalski grew up near the airport. He recalled how planes would fly so low near his house that he "could see people in the plane windows."

Kowalski and his friends would hang out in the terminal in the 1950s watching airplanes come and go. He said the flight attendants would invite them aboard and give them postcards, plastic toy planes and other mementos.

"It was very interesting," he said. "We spent most of our childhood at Midway."

—STEPHAN BENZKOFER

Air show daredevils

1911 International Air Meet highlighted danger and wonder of flight

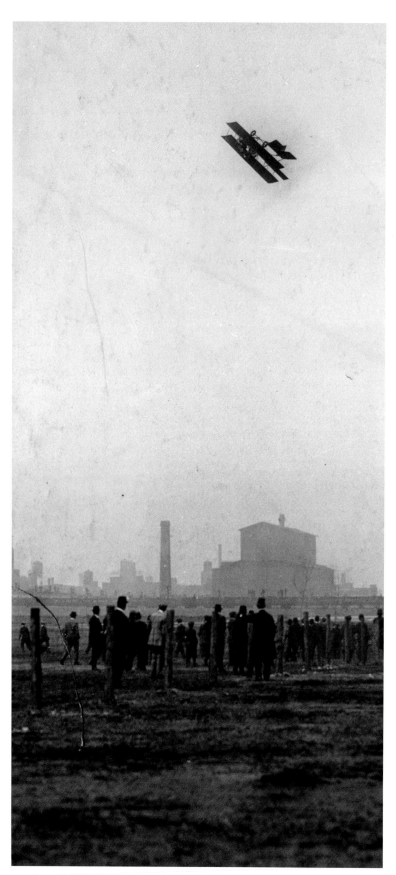

Aviator Lincoln Beachey at an air show in Grant Park in 1911.

CHICAGO was the center of the aviation world when it hosted a 1911 international air meet. The show was considered a great success. Only two pilots died.

Coming just eight years after the Wright brothers first flew, it was a time when the phrase daredevil pilot was redundant. Men regularly died in these very fragile aircraft. In May 1911, a plane crashed into a crowd at a Paris event, killing the French minister of war and injuring the premier.

But the excitement surrounding these new machines couldn't be tempered; the city had a serious case of "aviationitis." The 1911 "air carnival" would amaze the world in its scope, size and number of planes and famous pilots, the organizers said. It had much in common with the city's annual Air & Water Show: big crowds, thrilling aerial expositions, exciting lake exercises. It also had many things the modern events don't include: Races, duration contests, world records and a bombing competition.

Chicagoans flocked to the specially constructed Grant Park airfield, built east and south of the Art Institute, and the imminent threat of danger was no doubt part of the draw.

The nine-day event did not disappoint. Almost immediately, world records—and planes—started falling.

Arthur Stone's Queen Bleriot monoplane "turned turtle" just two minutes into his run, at a height of 10 feet, and crashed. The 30,000 spectators "were silent or screaming with horror," the Tribune reported on Aug. 13, but

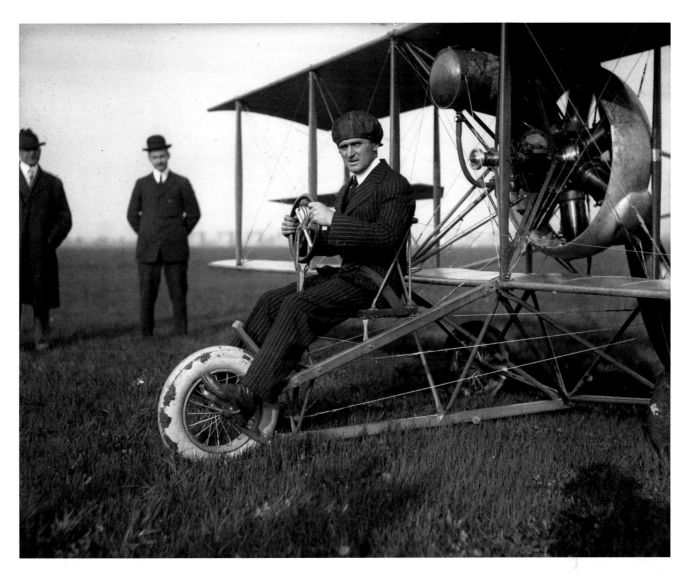

then the wreckage stirred, and "Stone's head popped out from under the fuselage. The machine, raising up some more, both Stone and (mechanic Fritz) Romain crawled out and stood up." The crowd cheered in relief.

The first world record was broken when A.L. Walsh kept his Wright biplane, carrying one passenger, aloft for more than two hours. He won $3,000.

Spirited races and awe-inspiring aerial feats kept the stands packed. The Tribune reported that hotel rooms were hard to come by, especially along South Michigan Avenue. One front-page cartoon wondered who had the rooftop concession, the illustration anticipating the rooftop stands surrounding Wrigley Field.

It wasn't until Day 4 that tragedy struck. On Aug. 15, two aviators were killed, one in the lake, the other while attempting a daredevil dip. But the show went on—and the spills and chills kept coming. The next day a pilot crashed a half mile out in the lake but was rescued.

There was no doubt that these early aircraft were being flown to their limits. Pilots understood, even welcomed, the risks. Such was the lure of flying.

Events of Aug. 17 put that in sharp focus. In the morning, six aviators helped bury their colleague before returning to the meet to excite the crowd with mock bombing runs, with the pilots dropping "bombs of flour" on the chalk outline of a battleship. The Tribune reported the crowd's enthusiasm "reached its maximum."

—STEPHAN BENZKOFER

Aviator Lincoln Beachey at an air show in Grant Park in 1911. Beachey was noted for his low-altitude loops and stunt flying.

Chicago, cycling capital

In the 1890s, bikes were all the rage—as were the 'scorchers'

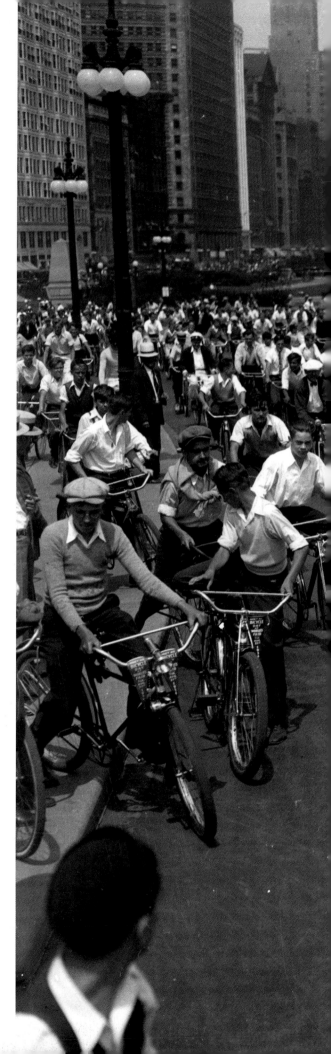

Chicago's fastest, rudest bicyclists were called "scorchers." They hunched over their handlebars as they raced in the streets.

They were "selfish, reckless, impudent transgressors of the law and trespassers upon the rights of others," the Tribune harrumphed. The newspaper described scorchers as cyclists "who delight to whirl around corners without warning and sweep down upon the unwary on a crossing, with a laugh at the alarm they cause and only a very slight fear of the police."

It was 1896, the pinnacle of America's first cycling craze, and Chicago was caught up in the excitement over these new "noiseless steeds." Then as now, bicycles jostled with other modes of transportation, vying for supremacy.

At the turn of the last century, bicycles were such a novelty they required their own vocabulary.

Scorchers weren't the only breed of "wheelmen," as cyclists were known. Upper-class citizens leisurely rode bicycles down the boulevards. Some laborers—those who could afford a bicycle—were using bikes to do their jobs, as a Tribune reporter noticed one morning, observing people carrying carpentry tools, carpet, chickens, cameras and even shotguns as they pedaled around.

Women and girls were riding bikes, too, but it was cumbersome in the ankle-length dresses considered proper female attire. According to a Tribune story, Lucy Porter was the first Chi-

A parade beginning at Congress Parkway and Michigan Avenue kicked off Bicycle Day on Aug. 21, 1934, for the Century of Progress World's Fair.

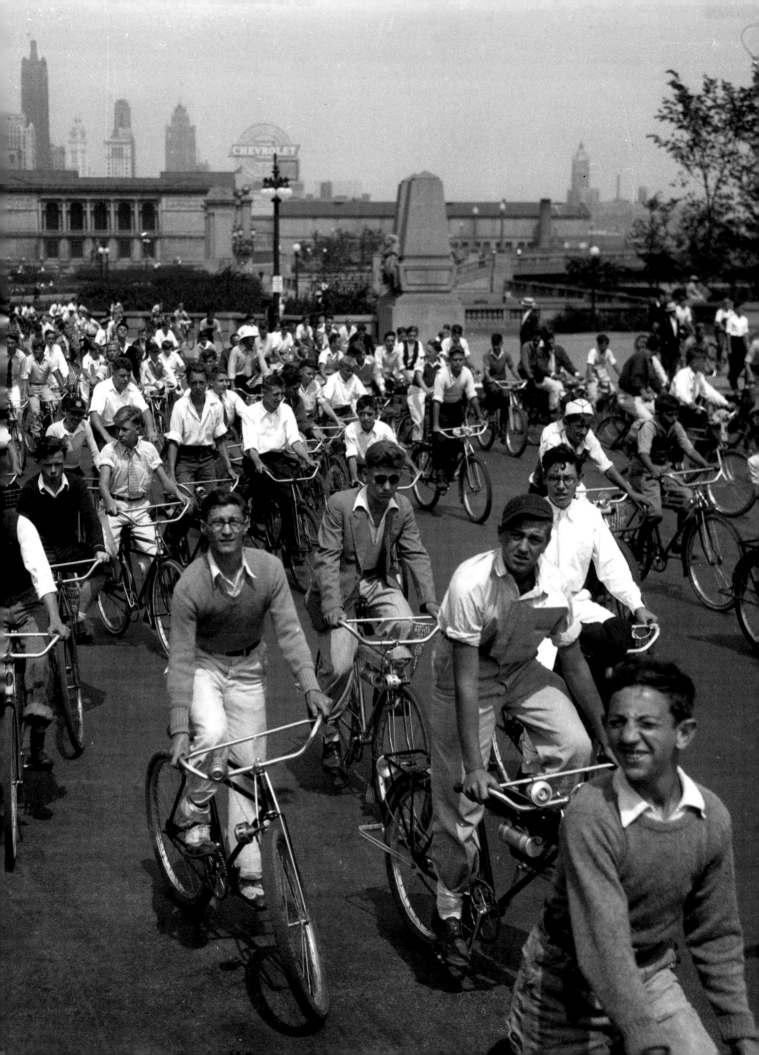

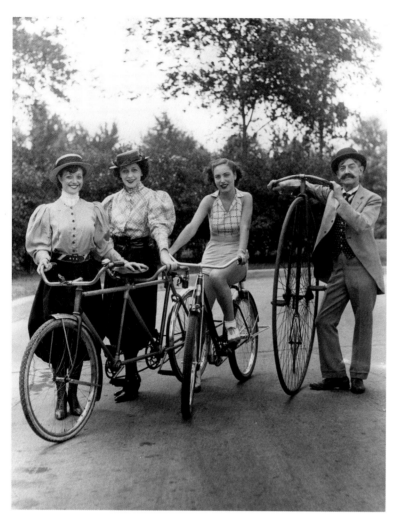

Fannie Ellen, from left, Lillian Dushell, Anita Conier and Guy Hickman with old-fashioned bikes in Lincoln Park in 1936.

1880s, when "safety bicycles" came onto the market. These models, with two wheels of equal size, launched a bicycle boom.

One day in 1893, a Tribune reporter saw "hundreds" of bicycles on the streets and parks within a couple of hours. By 1897, about 300,000 people—1 of every 5 Chicagoans—were riding bikes, a city official estimated.

"Chicago is the bicycle center of the United States," the Tribune proclaimed in 1896. Over the previous six years, the city's bicycle-making industry had grown from four companies to 25. The average cost of a bike was $75 (the equivalent of $2,000 today), and Chicago's factories were turning out 250,000 a year.

By that time the city had about 50 cycling clubs, with some 10,000 members. Cycling enthusiasts included Carter H. Harrison Jr., whose father had been mayor. When the younger Harrison ran for mayor for the first time in 1897, he posed for a campaign photo on a bicycle. Harrison said he knew the picture "would carry weight with the vast army of Chicago wheelmen." He won the race, the first of his five mayoral election victories.

Hundreds of cyclists vied each year in the Pullman Bicycle Race, which drew as many as 100,000 spectators along its 15-mile route. Cycling tracks were built in parks, including Garfield Park, where the African-American cyclist Major Taylor (the Tribune called him "the colored wonder") set a world record in 1899, scorching a mile in just over a minute and 22 seconds.

Other cyclists tested their endurance by racing for six days with only short breaks, at venues including the Chicago Coliseum. Alarmed by this behavior, the Illinois General Assembly in 1897 made it illegal for bicyclists to race for more than 12 hours straight.

Some Chicagoans worried that the female body was too fragile to withstand the physical effects of bicycling. "It is a somewhat violent exercise under some circumstances, and is not a safe kind for a woman who is delicate," said Dr. Henry Byford. But most doctors contacted by the Tribune said female cycling was perfectly safe. "Bicycle riding is an antidote against moping, indolence and enervation," said Dr. Edwin Kuh. "I believe that physicians

cago woman who took the bold step of riding in a style of baggy trousers called bloomers.

"I felt dreadfully nervous," she said in 1894. "I became so weak I could scarcely ride." Some male bicyclists approvingly shook her hand when they saw her wearing pants astride her bike for the first time. But as she rode, "a group of silly, half-grown boys indulged in cat-calls." Porter also was a pioneer bike commuter, the Tribune reported, keeping a slip at work.

Another "bloomer girl," who lived on the West Side, heard the same insults dozens of times as she bicycled in pants: "Shameless creature!" "Just look at her!" "Whose little boy are you?" "What a freak!" But she persisted. Women were turning their bikes into a tool for liberation.

Bicycles had been in Chicago since at least 1868, when local resident Augustus Wheeler went about on a French "velocipede." But they were little more than a novelty until the late

"No greater crime against civilization can be committed than the action of bicycle clubs to hold meets, parades, races and other sports on Sunday."

—REV. DAVID BEATON

should advise their bachelor clients not to marry any girl who doesn't ride a bicycle."

For strict moralists, the real worry was that bicycling made it easy for young men and women to socialize away from watchful eyes. And men were ogling female cyclists. One coachman crashed in 1896 when he was distracted by the sight of "a well-formed woman wearing a suit of red bloomers."

Some local clergy condemned the riding of bicycles on the Sabbath. "No greater crime against civilization can be committed than the action of bicycle clubs to hold meets, parades, races and other sports on Sunday," the Rev. David Beaton said.

Bicycles were blamed for Chicago's declining theater attendance, railroad revenue and horse riding. Temperance advocates hoped people would drink less if they bicycled, but liquor sales held steady. Chewing gum sales went up, however. As the Tribune explained, "The man or woman who rides a wheel and does not chew gum is now placed somewhat in the position of a freak."

Automobiles were a rarity at that time, but cyclists had plenty of other vehicles to worry about as they navigated the city, including carriages and wagons pulled by horses, which sometimes got spooked by bicycles brushing past them. Increasing the risk of accidents, pedestrians weren't accustomed to watching out for bicycles, which made barely any noise compared with all of the other contraptions clattering on the roads.

"Woe Follows the Trail of the Bicycle," a Tribune headline declared in August 1897,

after the police handled 100 accidents involving bicycles in two months. In a few cases, cyclists were blamed for fatal accidents, resulting in headlines like "Death Due to Scorcher."

Seeking a solution to the havoc, some dreamers suggested building elevated bicycle paths. And cycling organizations lobbied Chicago to pave some of its bumpy streets. In 1897, the City Council passed an ordinance requiring cyclists to put an identification tag on their bikes and pay a fee of $1 a year. Cycling clubs supported the tax, hoping the money would be used to pave streets.

The Illinois Supreme Court tossed out the ordinance in 1898, ruling that Chicago had overstepped its limited taxation powers.

Rather quickly, the bicycle boom went bust. Sales plummeted, and many cycling clubs disbanded. The number of bicycles manufactured nationwide plunged 79 percent from 1897 to 1904, according to the U.S. Department of Commerce. Suddenly, bikes were far less common on Chicago streets. The Tribune reported that the social elite had lost interest in the "fad."

Of course, bicycles didn't go away entirely, even when the car became king. As other bicycle companies shut down, one Chicago firm—Arnold, Schwinn & Co.—stayed in business, emerging as one of the 20th century's iconic brands.

Indeed, the words of a Chicago bicycle merchant in 1896 no longer sound quite as farfetched. He told the Tribune that bikes might become "the great necessity of modern times."

—ROBERT LOERZEL

Business, Labor and Industry

Built with steel

Mighty mills forged Southeast Side and a middle class

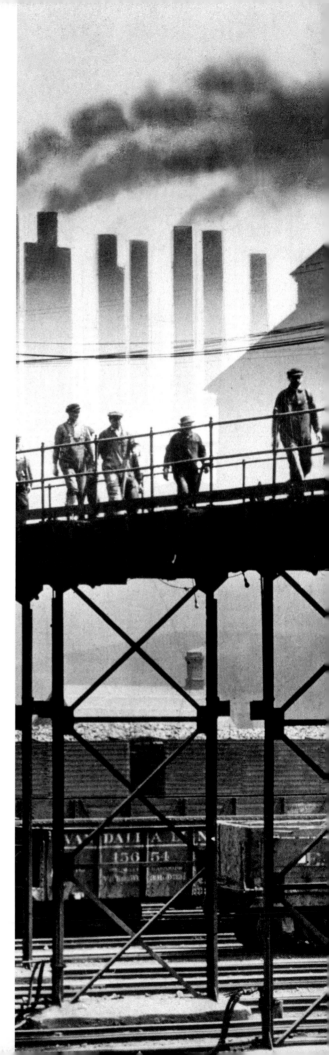

Workers leave U.S. Steel's South Works in an undated photo. (Note: Buildings in back left of photo were painted in by a retoucher)

M ore than a century ago, the steel industry made the fortunes of the Southeast Side. For much of the 20th century, uncountable numbers of the girders that spanned America's rivers, the rails that linked its cities and the I-beams of its skyscrapers were made by steelworkers who lived in neighborhoods with gritty names like Irondale, Millgate, Bessemer Park and Slag Valley.

Forged there as well was a middle class, as immigrants who arrived in Chicago penniless took home paychecks that enabled their children to go to college.

Because Chicago survived the transition to a postindustrial economy better than other Rust Belt cities, it is easy to forget how dominant steel was.

In 1950, the region produced a third of the nation's steel. In 1952, a Tribune headline trumpeted, "Chicago steel output higher than Britain." Headlines through the decades announced new mill openings that promised the latest and most efficient steel production.

In 1968, William Kornblum, a University of Chicago graduate student, and his wife moved from Hyde Park to Irondale for a research project that became a classic of sociology. When he told other students he was going off to interview steelworkers, they thought he must be talking about Gary.

"Chicago's mill neighborhoods begin on 79th Street, just 19 blocks from the university,

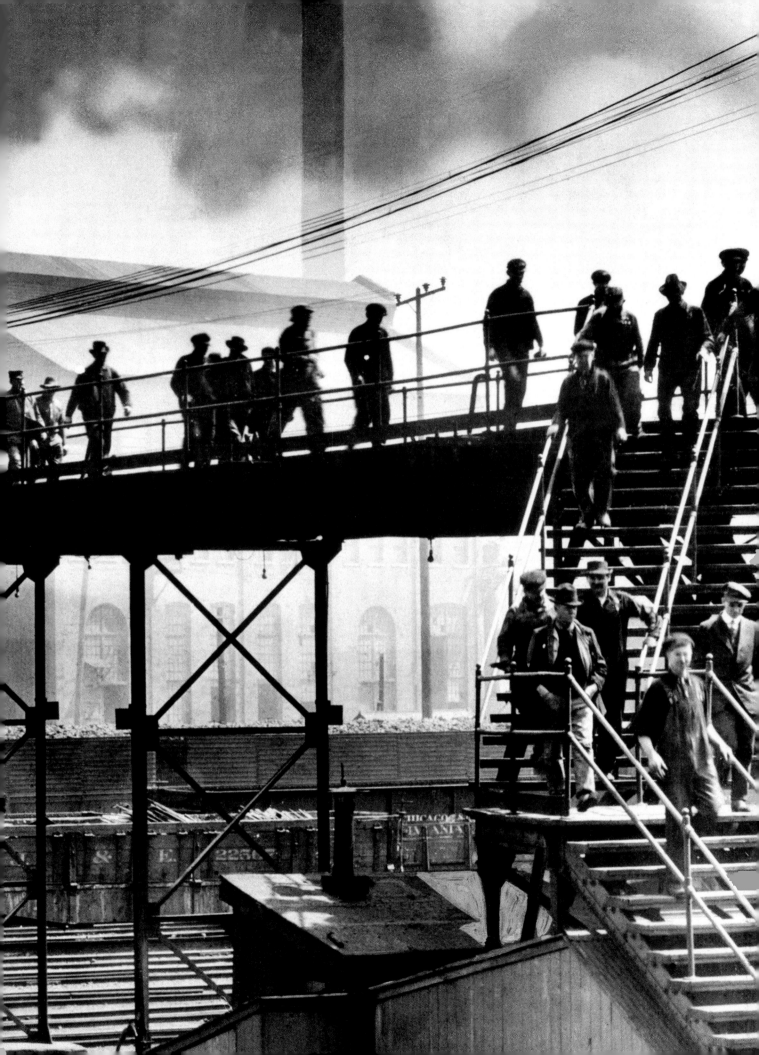

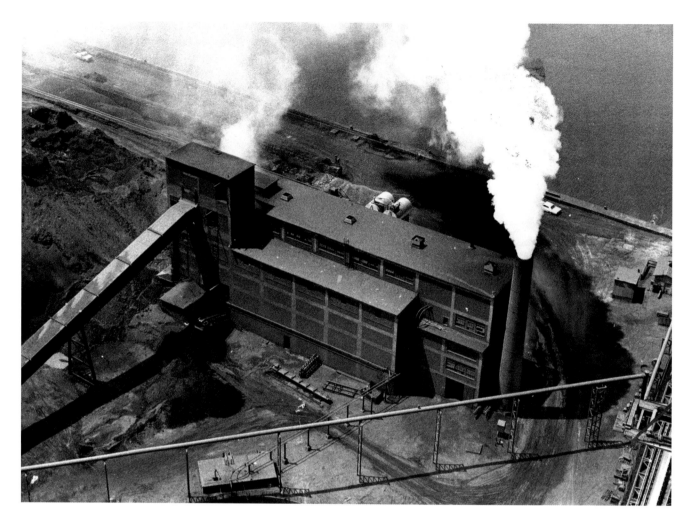

The South Works plant at work, as seen from a helicopter in 1967.

but they are often perceived as being closer to Gary, more than 30 miles to the south," Kornblum wrote in "Blue Collar Community."

Curiously, the story of South Chicago's steel-making career begins on the other side of town. Chicago's first mill opened in 1857 on the North Branch of the Chicago River. Within three years, the North Chicago Rolling Mill had 200 workers, making it one of the city's largest employers.

In 1875, the Tribune applauded its founder, Ebner B. Ward, a Detroit shipping magnate, for "the intuitive business sagacity with which he selected Chicago as the future center of the iron industries of the Northwest."

Ward's acumen was based on geographical logic. Chicago was an ideal place to bring together iron ore carried by ship from Upper Michigan and Minnesota and coal transported by railroad from Ohio and Pennsylvania.

"Alternate layers of fuel and iron are placed

in the cupola," the Tribune wrote of an 1875 visit to Ward's mill. "When it is molten, a gate in the lower part is opened. A stream of fire pours down the trough and flows into a (huge scale) which a Cyclops might have used."

Shortly afterward, Ward built a satellite facility in South Chicago, a remote district being touted as ripe for development as an alternative to the overcrowded industrial areas of the North Side. Real estate speculators noted that the Calumet River offered better harborage than did the Chicago River.

Mayor Edward Dunne waxed eloquently on that theme when leading a tugboat-load of VIPs on a tour in 1905: "Sometime, when my dust is stopping the cracks in the new city hall," Dunne asserted, "South Chicago will be one of the greatest manufacturing and shipping centers in this country."

A Tribune reporter aboard discounted the mayor's prediction: "It may have been the ef-

> ## "Sometime, when my dust is stopping the cracks in the new city hall, South Chicago will be one of the greatest manufacturing and shipping centers in this country."
>
> —MAYOR EDWARD DUNNE, 1905

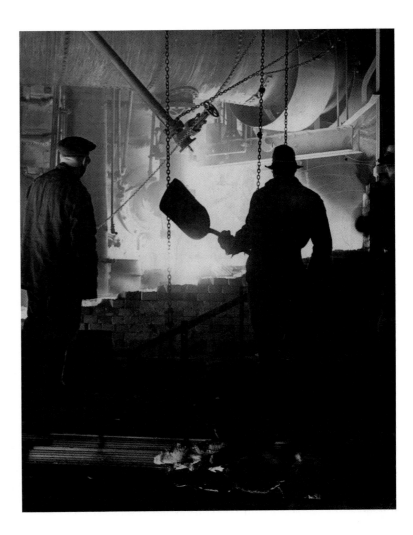

fect of the 5 cent Hegewisch cigar, which he held between his lips, vainly trying to keep lit."

Whether or not the product of nicotine intoxication, Dunne's words were prophetic. Other mills opened on the Far South Side—Wisconsin Steel, Republic Steel, Acme Steel, Youngstown Sheet & Tube—and Ward's South Works was incorporated into U.S. Steel, at one time the world's largest business enterprise.

The neighborhood went from sparsely populated to greatly overcrowded as the mills recruited myriad workers, many from abroad.

A Tribune reporter who visited South Chicago in 1908 observed "the turning of alley woodsheds and barns into lodging houses."

"No matter how little English an immigrant may have at his command he is pretty apt to mention Chicago in the opening stage of his conversation after reaching America," the Tribune reported in 1895. In 1909, it noted that the ethnic map of Central Europe had been redrawn on the Far South Side: "Hungarians, Austrians, and Slavs of various denominations, like Macedonians, Croatians, and Slovaks, do most of the 'plodding labor' in the iron and steel industry of Chicago."

The work was hard and dangerous. Accidents were frequent and many times fatal. Initially, wages were low and strikes frequent, but eventually steelworkers made a decent living—as can be seen in the tidy, brick homes built in the neighborhood after World War II.

Three decades later, the bottom fell out. Mills were abandoned, a harbinger of America's deindustrialization.

Workers were discarded, sometimes without so much as a straight story.

"The day before they shut us down we had a big meeting with the chairman of Envirodyne Industries, the company that owns it," Ralph Gomez told a Tribune reporter when Wisconsin Steel was shuttered in 1980. "He assured us we wouldn't shut down. The next day, kachong!"

The neighborhood's life cycle came full around. Before the steel mills got there, South Chicago had a lakefront amusement pier; when South Works was torn down, the site was converted into a public park.

Long gone are the days when, as the Tribune observed in 1906, the Southeast Side's "mills, factories and shipyards are making of it a Babel of mechanical and spoken words."

—RON GROSSMAN

Workmen watch steel pour out through a torch lined with sand at the Carnegie-Illinois steel plant in 1946.

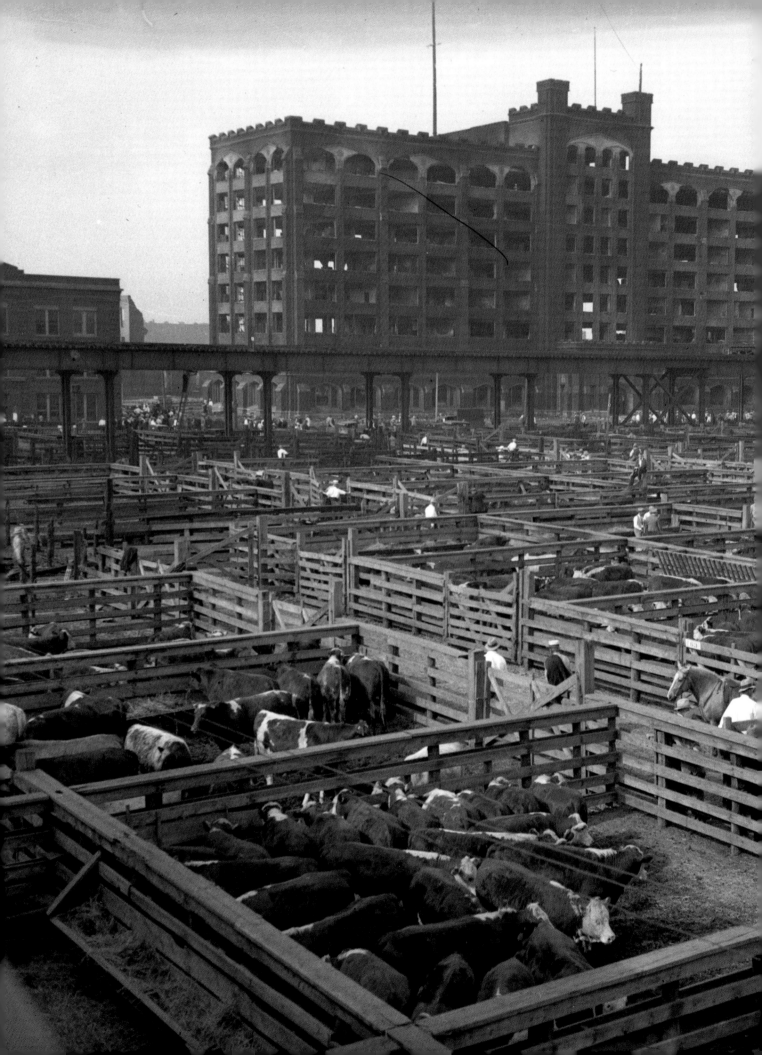

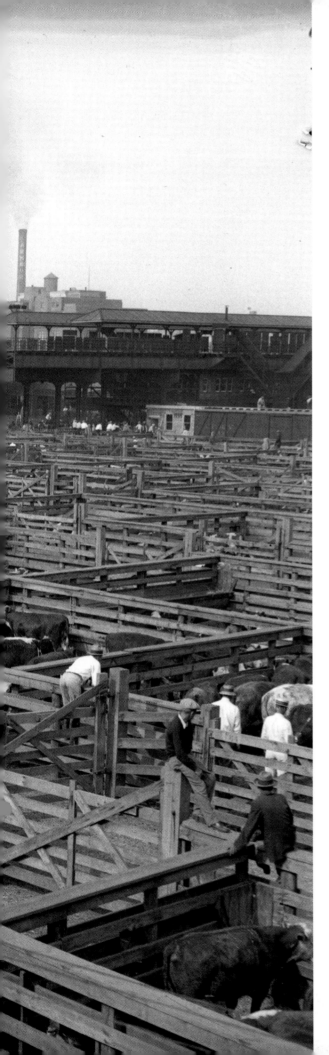

'Hog butcher for the world'

Memories of Chicago's Union Stock Yards as strong as its stench

THE shuttering of the Union Stock Yard and Transit Co. on July 30, 1971, didn't mark the end of Chicago's role as "hog butcher for the world." That came a year earlier, when "hog alley" closed, a victim of the stockyards' long descent from years of glory and gore.

But when bulldozers knocked down pens vacated by the last cattle, a hole was torn in Chicago's identity. A stockyards official acknowledged how emotionally difficult its closing was. "We decided to let it go quietly," he told the Tribune, on the yard's final day. "We didn't want to conduct a wake." Outsiders still identify our city with the long-vanished landmark. Four decades later, a New York Times headline lamented: "Chicago Losing a Chef Who Refined its Stockyards Palate."

The stockyards and allied industries employed 40,000 workers, but it was more than a jobs base for the South Side. Well over a billion head of livestock were sold and shipped out or became steaks and chops in nearby slaughterhouses, but this also was more than America's butcher shop.

It was the heart of a veritable small town—Packingtown, as it was known—in the midst of a metropolis.

It had a baseball league. According to the

Pens in the Union Stock Yard are filled with cattle in 1934.

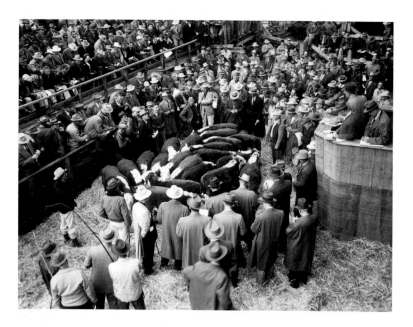

Champion cattle are auctioned off at the Union Stock Yard in 1947.

they bathed in the large swimming tank." A federal investigation sparked by "The Jungle" found that girls as young as 16 worked 10-hour days in refrigerated rooms in standing water.

The yards, which covered a huge area from Halsted Street to Ashland Avenue and Pershing Road to 47th Street, were a kaleidoscope of constant motion and deafening noise. In 1904, the Tribune painted a word picture of "a vast sea of pens, viaducts, buildings, railroad tracks, etc, the whole paved with brick and divided into blocks and streets like a city."

At the yards' peak in 1924, more than 18.6 million cattle, hogs and sheep passed through that labyrinth—leaving an odoriferous trail behind.

In "City of the Century," historian Donald Miller quotes a description by Mary McDowell, who ran a Packingtown settlement house, of what life was like in the shadow—and smell—of the yards. "In the night we would be awakened by a choking sensation. One night it would be the odor of burned flesh, another of feathers, another of sties, etc, etc."

Cather observed that especially where life is harsh "beauty is necessary, and in Packingtown there is no place to get it except at the saloons, where one can buy for a few hours the illusion of comfort, hope—whatever one most longs for."

Packingtown had its natural disasters—like the 1910 fire that took the lives of 24 firefighters including the department's chief, and the 1934 fire that raged across much of the yards and the surrounding area. It had its own unnatural wonder, Bubbly Creek, a stub of the Chicago River where the slaughterhouses dumped offal. On its hardscrabble streets, community organizing was largely invented by Saul Alinsky, who would be resurrected from relative obscurity after he was decried by Newt Gingrich as Barack Obama's spiritual godfather.

But Packingtown also had an upscale restaurant, the Stockyards Inn, where steaks were branded with patrons' initials. And its International Amphitheater hosted an annual livestock exhibition as well as national political conventions, including the notorious 1968 Democratic National Convention. (Both buildings were rebuilt after the '34 fire.)

Trib's score card, on opening day 1918, the Wilsons beat the Soap Works, 14-8. It had its own police chief and "L" loop. A branch of the South Side elevated servicing the yards had stops named Swift and Armour, after major packers. It lent its name to an adjoining neighborhood with its own fight song:

Back o' the yards—back o' the yards
In old Chicago town,
Where each fellow and gal is a regular pal

Packingtown inspired civic pride. When in 1906 Upton Sinclair published "The Jungle," a novelistic expose of the dark side of working-class life, the Tribune's reviewer dismissed it as "an attempt to create a sensation by an attack on the stockyards." The yards also made appearances in novels by Willa Cather and Thomas Pynchon. Its literary fame extended to Europe. In "Saint Joan of the Stockyards," the German playwright Bertolt Brecht reset the French heroine's story on the South Side.

Long before becoming mayor, Richard J. Daley worked as a bookkeeper in Packingtown. But most workers toiled under miserable working conditions. An 1886 strike failed to win a reduction of the workday from 10 to eight hours. A 1904 walkout provided an unaccustomed holiday from back-breaking labor, as a Tribune reporter observed. "Many of the strikers went to the new McKinley Park, where

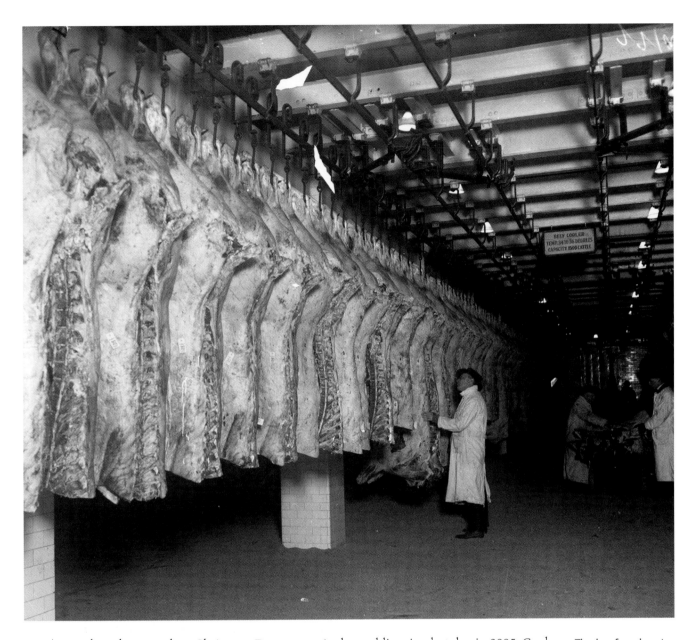

The stockyards opened on Christmas Day 1865 as a consolidation of older stockyards scattered around the city, and during its 106 years curiously so endeared itself to Chicagoans that some couldn't afterward let go. It produced a terrible stench, but for some Chicagoans it was our stench.

"That smell is sweeter than a bunch of American beauty roses to me," Frank Keigher told the Trib's "Inquiring Reporter" in 1920. Even now, some swear that on warm summer evenings a whiff of the yards returns. Along the bar at nearby Schaller's Pump, bits of family lore are dated with phrases like: "That was when my granddad had a job in a packing house."

And on a blistering hot day in 2005, Cook County Commissioner John Daley, a son of one mayor and brother of another, came to Packingtown for a centennial commemoration of "The Jungle," which was serialized in a magazine a year before the book was published. Why was he out there in the burning heat, a Trib reporter asked?

Gesturing toward the Union Stock Yards Gate, a lonely sentinel of its place in history, Daley said: "My father walked through that gate to work in the stockyards."

—RON GROSSMAN

The beef cooler at the Union Stock Yard in August 1942.

Marching off the job

Firefighter, teacher strikes were traumatic

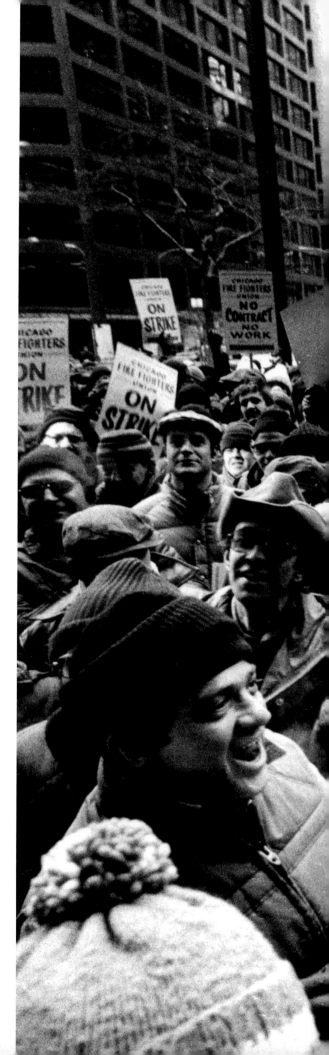

I N 1980, Mayor Jane Byrne and the Chicago Firefighters Union dared each other to blink. Neither did.

The result was the city's first and only firefighters strike, which left the city with minimal fire protection and ambulance service for the 23 days of a walkout whose bitter echoes reverberate through the Tribune's archives.

Attending a 20th reunion of strikers, a Tribune reporter noted: "Even today, fliers for invitations to retirement parties are marked with B.O.B., to make it clear that only strikers are welcome."

The initials stand for "Brotherhood of the Barrel," a reference to the makeshift heaters that picketers used to warm themselves during a Chicago winter.

From Feb. 14 to March 7, Chicago's 4,350 firefighters were like families divided during the Civil War, when brother fought brother. There were angry confrontations through firehouse windows between strikers and scabs.

A reporter witnessed a picketer busting three windows, "two with his own hands." Two striking firemen later were convicted of arson for setting fire to an empty apartment building.

Carol Moseley Braun, then a state representative, watched an improvised crew fight a fire across from her South Side office.

"People were screaming and jumping out windows," she said. "Those firemen didn't know what they were doing."

During the strike, 24 people died in fires in Chicago. How many of them died because of the walkout will never be known.

For residents, it was a horror show of the

Striking firefighters demonstrate at a rally Feb. 17, 1980, in Daley Plaza in downtown Chicago. About 500 turned out.

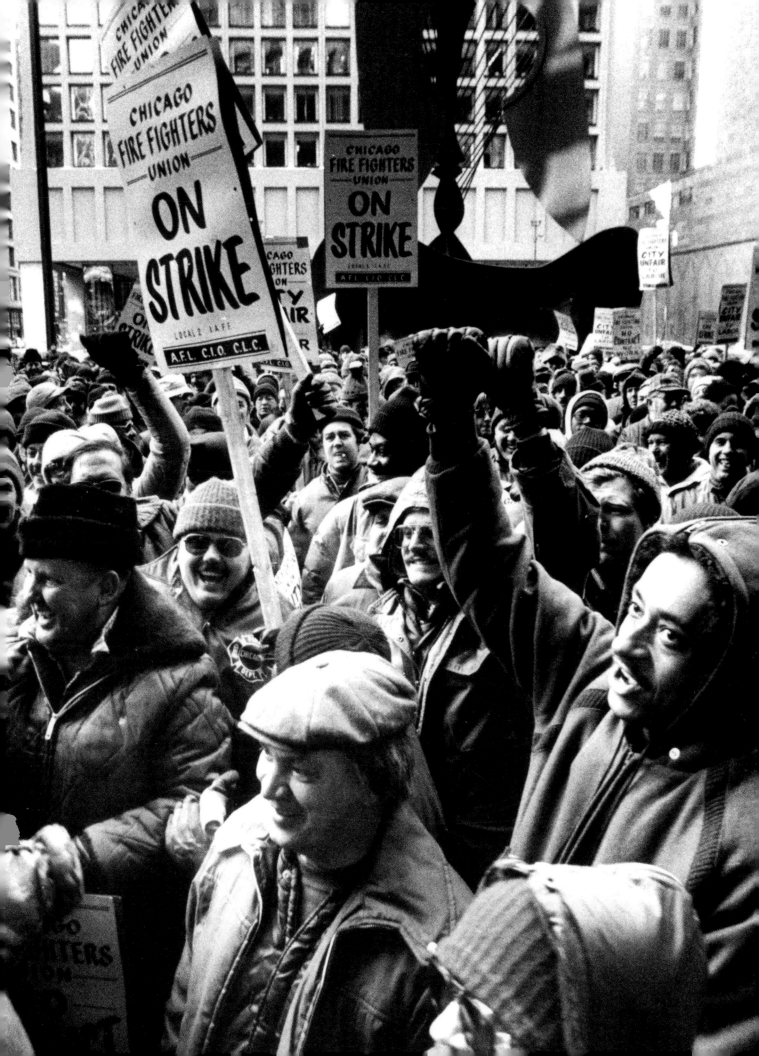

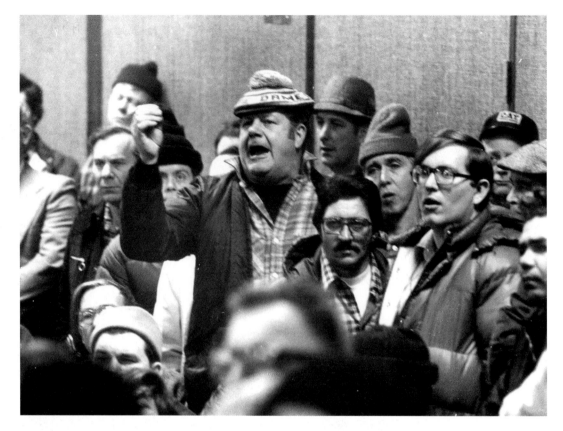

A fireman challenges the firefighters union president, Frank Muscare (not shown), about what was taking so long to get a contract during their strike Feb. 17, 1980. The group was gathered for a firefighters union meeting at McCormick Inn.

mayor's making, as Tribune columnist Bob Wiedrich noted: "Mayor Byrne created her own Frankenstein."

Running for office, she'd promised firefighters an innovation—a written contract—but hadn't fulfilled the promise.

Byrne vowed to fire strikers, marking her resolve Chicago-style: "No fix, no clout, nothing will put them back." The city rushed half-trained recruits and city truck crews onto the rigs.

In the end, Rev. Jesse Jackson nudged the two sides back to the bargaining table. The firefighters got the contract promised. Best of all, they got back to what is for them not a trade, but a calling:

"I've pulled babies out of burning buildings," one striker said. "And I've been in those abandoned warehouses that just happened to catch on fire and your foot sinks through the rotten floor and you just about disappear for good. I love the job."

—RON GROSSMAN

Teachers had era of strikes

Before Chicago teachers went on strike for a week in 2012, it had been a quarter century since they walked off the job, long enough for many residents to forget that teacher strikes at one time were a common threat. The first teachers strike, in 1969, surprised the city—and some teachers. The Chicago Teachers Union, which dates to 1897, had never taken such action. But over the next 18 years, the union would strike eight more times.

Indeed, before Chicago teachers set up picket lines on May 22, 1969, a strike seemed unthinkable in this city.

At some schools, no pickets showed up.

"For some (teachers), it's beneath their dignity to carry a sign," a union official explained.

They learned quickly. When the board of education said teachers would be paid for returning to schools though students had been sent home, a biblical allusion was posted at strike headquarters: "Don't cross the line for 30 pieces of silver."

Within two days, the strike was settled. The union won on its demands—on class size, teacher aides, pay raises—issues, it will be noted, that are with us still.

—STEPHAN BENZKOFER

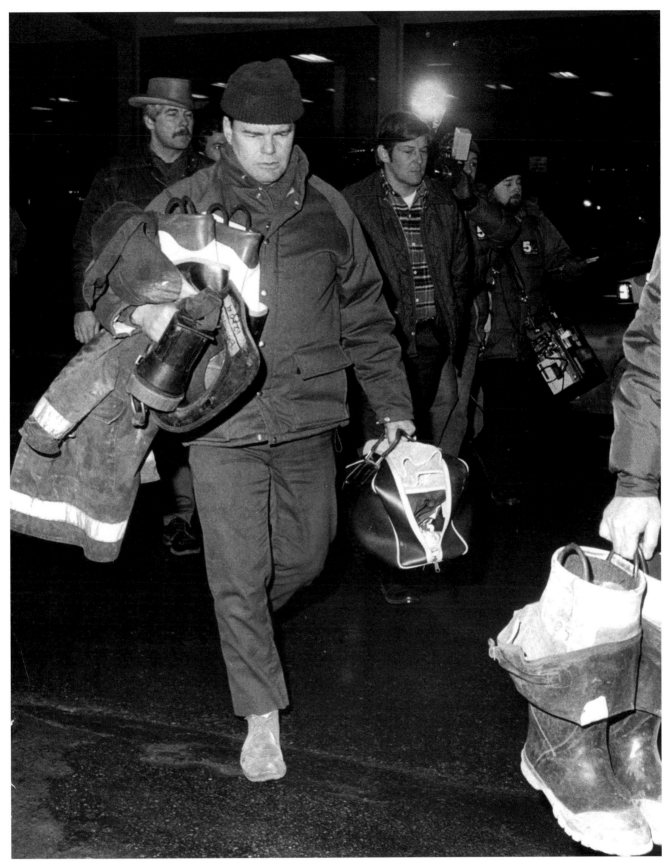

Firefighters take belongings from a station at Dearborn and Illinois in the strike's first moments Feb. 14, 1980.

Raise a glass to barmaids

Called into service during WWII, women were right at home tending bar

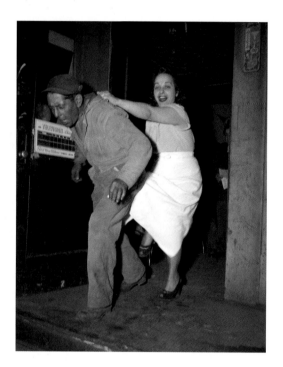

Carmella Sinks bounces a patron from her father's tavern in Chicago in 1949.

CALL it the shattering of the martini glass ceiling–that moment when bar and tavern owners decided that a woman could pour a pint or mix a Manhattan as well as a man.

It took a war to get there.

For much of America's history, laws and local customs prevented women from working as bartenders. But when the U.S. entered World War II and thousands of men shipped off for military service, women went to work.

These "barmaids-for-the-duration," as they were called in a 1945 Tribune story, were hired on the condition that they resign as soon as the men came home. That year, the local bartenders union admitted 123 women who "already have donned the apron and taken to swabbing the mahogany." They worked under union rules and earned the Chicago minimum wage of $45 weekly.

It turned out that the women did just fine. The bosses of the area bartenders unions seemed surprised. "When it comes to mixed drinks they appear to have the touch," Louis Morel of Decatur told a Tribune reporter. "Maybe it's their instinctive food mixing ability. Anyway, they can shake or stir up a whiskey sour or cocktail as if they were at home stirring up a cake."

After the war, most of the female bartenders lost their jobs, but about 30 were still working. The Chicago bartenders' union set April 30, 1946, as the deadline for tavern owners to fire the women, according to the Tribune. "The union's ultimatum makes only one exception. It is all right for a woman to tend bar, it says, if (1) she owns the place, or (2) is the wife of an owner."

Union rules and laws against female bartenders stayed on the books for decades afterward, until the Civil Rights Act of 1964 led to most of the bans being overturned–but in some bars women kept tending bar anyway.

In 1950, the Tribune picked up an Associated Press story from Detroit with the headline "Grandmas fight to keep jobs–as bartenders." The story described the plight of a bar owner who was being pressured by the local bartenders union to oust "his elderly barmaids." One was 50, the other 51. "I don't want to put the girls out of work," the conflicted owner said.

"They are the best help I've ever had and they've been with me since 1942."

"But if I don't sign the contract, the union will keep picketing my place and I won't be able to get any beer. I have to sign it or go out of business. Ah, me! Such a business!"

—LARA WEBER

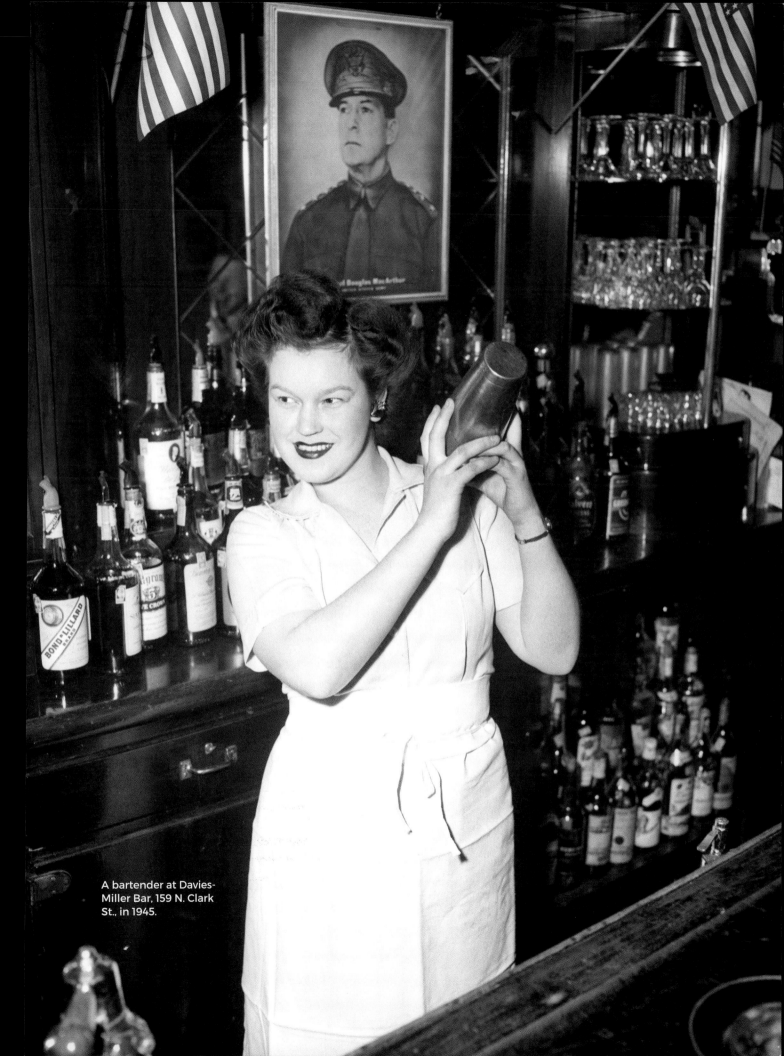

A bartender at Davies-Miller Bar, 159 N. Clark St., in 1945.

Sears, the Amazon of its day

Mail-order firm revolutionized shopping for rural America

M ORE than a century ago, Sears, Roebuck and Co. was its era's version of a hot tech company. Like Facebook, Apple or Amazon, it wasn't just a corporation—it was a revolution.

"The catalog was the Internet of the day," said James Schrager, a University of Chicago business professor. "Sears was Amazon."

The young Chicago mail-order company held its IPO in 1906, selling preferred shares at $97.50. That's more than $2,000 today, so it wasn't for the common man.

But the purchase of even one share would have been lucrative. Counting from 1924, when Sears entered the Dow Jones index, to 1996, and adjusting for stock splits, the Wall Street Journal calculated Sears shares soared 434,552 percent. The skyrocketing value was rivaled only by the story of the company itself—and the young Midwesterner who founded it.

Richard W. Sears was hailed in his Tribune obituary as a man "whose career typified the romance of American business." Mix the youthful risk-taking of Facebook's Mark Zuckerberg and the marketing instincts of Apple's Steve Jobs— that was Sears.

It started in 1886, when Sears was a rail-

People shop at Sears in the Hawthorn Shopping Center in Vernon Hills on July 22, 1983.

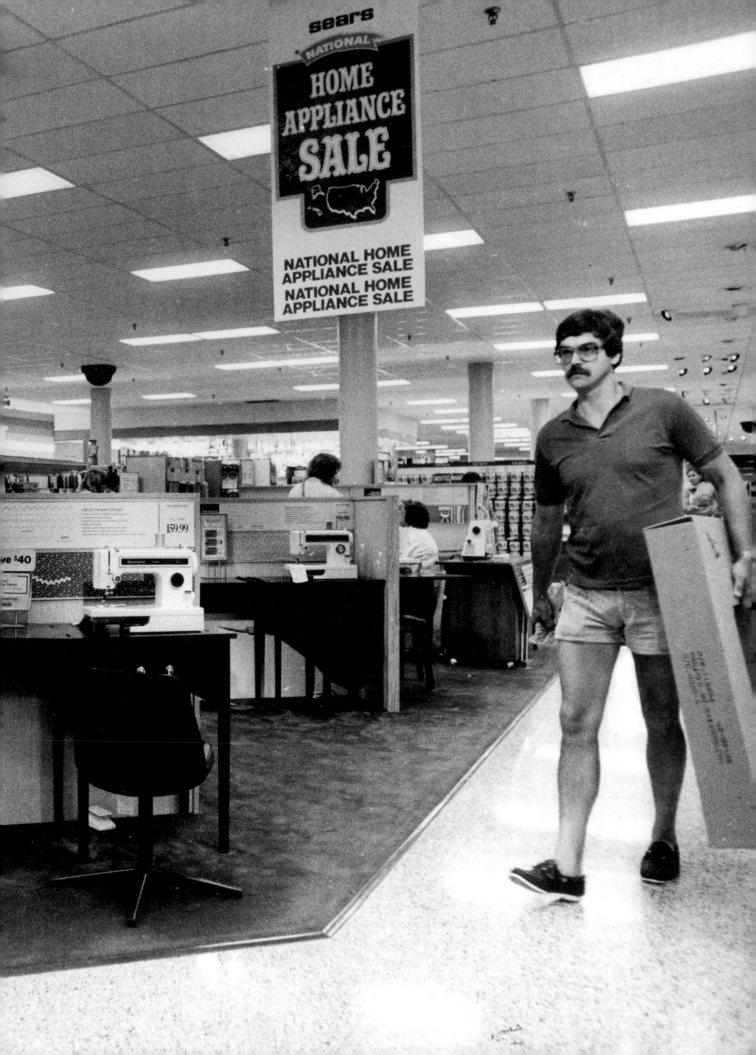

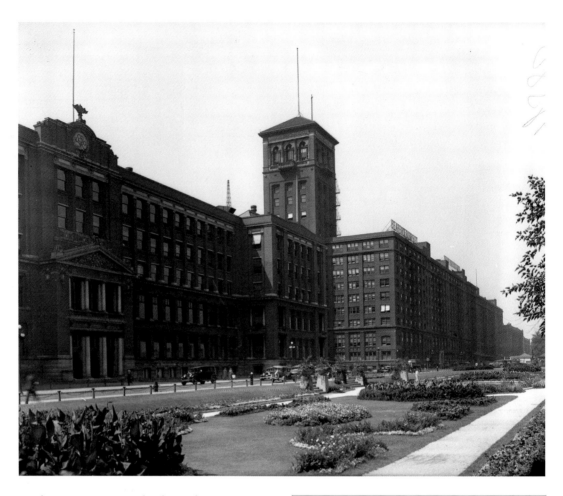

The Sears, Roebuck & Co. complex in Chicago's Homan Square neighborhood in 1930. The main tower, shown here, was at Arthington Street and Homan Avenue.

road station agent in backwoods Minnesota, wrote historians Boris Emmet and John Jeuck in "Catalogues and Counters: A History of Sears, Roebuck & Company." A shipment of gold watches arrived for a local jeweler, who refused them.

The rebuffed wholesaler told 22-year-old Sears he could have the watches for $12 apiece. He said yes, pivoted, and offered them to agents along the line for $14. With that type of watch retailing for $25, there was room for the agents to profit, and Sears pocketed $2 for every one sold.

Within six months he had made $5,000, and his watch business started to outstrip his railroad salary. "The tail had begun to wag the dog," he said in a 1906 Tribune article.

Sears moved to Chicago, set up at Dearborn and Randolph streets, and hired a watchmaker "thin to emaciation," Alvah Roebuck. Their watch company grew rapidly into a general mail-order company that used high volumes to enable low prices.

> **WHAT SEARS WROUGHT**
> Sears, Roebuck created:
> - WLS (World's Largest Store) radio
> - Allstate Insurance
> - the Kenmore and Craftsman brands
> - the Discover Card
> - the Sears Tower (now Willis Tower), at one time the world's tallest building

It was a recipe perfect for the time, when millions of rural Americans were disgruntled with their general stores. A barrel of flour in 1891 was $3.47 wholesale, according to the company, but $7-plus at a country store.

Sears, Roebuck used comforting ads to overcome farmers' fears. "Don't be afraid that you will make a mistake," read one catalog. "We receive hundreds of orders every day from young and old who never before sent away for goods."

The company adopted a money-back guarantee and "send no money" became a famed tag line. Richard Sears delighted in writing his own ad copy and, typical of the time, often pushed the envelope. One offer advertised a sofa and chairs–"with beautiful plush"–for 95 cents. (By comparison, a John M. Smyth ad in a 1906 Tribune offered a single chair for $1.50.) Only when Sears' furniture arrived did the customer discover it was for dolls.

Later, Sears would tone down the ads and was said to have concluded, "Honesty is the best policy. I know because I've tried it both ways."

By 1905, Sears' sales had surged past $38 million, passing Montgomery Ward, the Chicago company that had invented the mass mail-order catalog. Sears needed more capital to grow. Julius Rosenwald, who had joined Sears as a partner, asked old banker friend Henry Goldman for a loan, according to Rosenwald's grandson and biographer, Peter Ascoli.

Goldman suggested an IPO instead, leading to Sears, Roebuck's sale of its stock in 1906. It aimed to raise $40 million, which proved crucial for surviving the Panic of 1907. For Goldman, co-managing the Sears IPO is still touted as a landmark for his bank, Goldman Sachs.

Only the rich could afford to buy stock in 1906, but Americans' disposable incomes were growing, and the company took full advantage. Its catalog, the "consumer's bible," made available everything from sewing machines to Encyclopaedia Britannicas to ready-to-assemble houses. "The story is the coming of the middle class," Schrager said, "and the desire of the middle class to have more things."

Sears retired in 1908 with a fortune estimated at $25 million. He died in 1914 more than a decade before the company he founded opened a single store.

Sears leapt into the retail store business in 1925, as rural customers moved to the cities. A December 1924 Tribune, in announcing Sears' branching out into brick-and-mortar stores, made note that "several mail-order houses have considered" such a move but, "heretofore they have confined themselves to their own method of merchandising." Sears promoted the new store at Homan Avenue and Arthington Street in the Homan Square/Lawndale area as "easy

Richard Warren Sears, left, and Alvah C. Roebuck in undated photos. Sears and Roebuck joined together to form Sears, Roebuck & Co. in the late 1800s.

"Honesty is the best policy. I know because I've tried it both ways."

—RICHARD WARREN SEARS

to shop for men" with a "whole square block of free parking."

The first Sears store on State Street, between Van Buren Street and Congress Parkway, opened to great fanfare in March 1932. By 1950, Sears had 650 stores nationwide, including eight major department stores in Chicago and stores in Joliet, Waukegan and Gary, according to the Tribune. By the mid-1950s, Sears would be international too, with stores in Mexico, Venezuela, Cuba, Colombia, Peru and Brazil.

Sears opened mall stores after World War II, as customers headed for suburbia, teaming with Marshall Field to build the Oakbrook shopping center, which opened in 1962. "Rosenwald and others had an uncanny ability to see which way things were going to go," said Ascoli.

Today, Sears is struggling, but it still will probably have fared better than a company like Amazon when all is said and done, said Schrager, who likes to ask his students why Sears built the Sears Tower, which opened in 1973. "Because they could," he said. "They were unbelievably successful. I don't know if Amazon is ever going to build the tallest building in the world."

—MATTHEW NICKERSON

Arsenal of democracy

Chicago factories, workers mobilized quickly for WWII

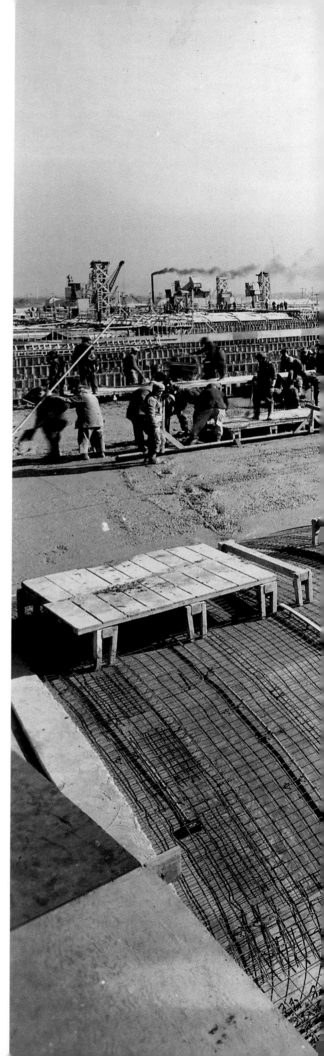

WHEN told about the Japanese attack on Pearl Harbor on Dec. 7, 1941, British Prime Minister Winston Churchill envisioned what would come: "Now at this moment I knew that the United States was in the war, up to the neck and in to the death. So we have won after all!" Britain's wartime leader knew that America's immense manufacturing potential would lead the world to salvation. The sleeping giant had awakened.

So began one of the most remarkable mobilizations in history as thousands of businesses converted to war manufacturing. Huge new factories were built in months; tens of thousands of workers were recruited, hired and trained even as hundreds of homes were built to house them. And that was just in the Chicago area.

Chicago's large labor pool, expansive rail network and central location—insulated from the threat of enemy bombers—made it an ideal location for such war production. The mobilization led to sometimes-jarring changeovers. Radio Flyer ended production of its famous little red wagon at the Grand Avenue factory and switched to blitz cans, or fuel containers. Cracker Jack made powdered coffee and other GI rations. Chicago Roller Skate Co. retooled to make parts for shells and guns. A manufacturing marathon began at more than 1,400 Chicago-area factories, putting muscle and brains behind nearly every aspect of the war effort, and for the first time hiring thousands of women, sometimes more than 50 percent of a plant's workforce.

G.D. Searle & Co., Baxter and Abbott Laboratories collaborated to mass-produce penicil-

A factory building rises on the Southwest Side at the gigantic Dodge-Chicago plant, which turned out more than 18,000 B-29 engines by the end of World War II. Today Ford City Mall is on the site.

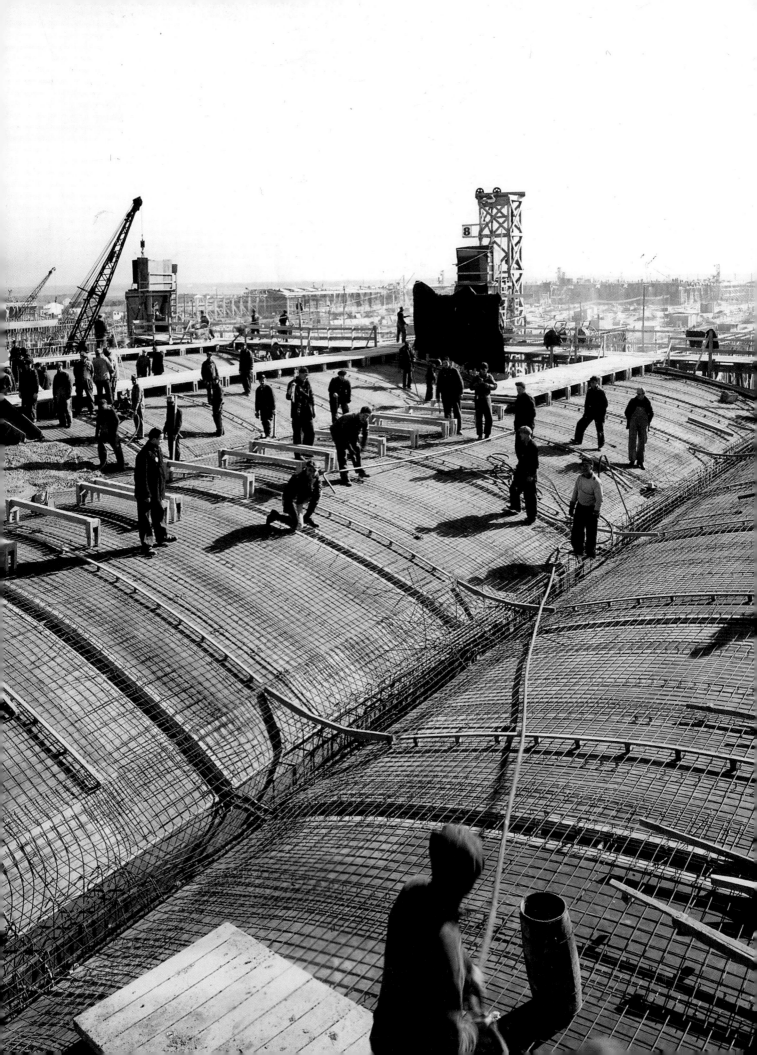

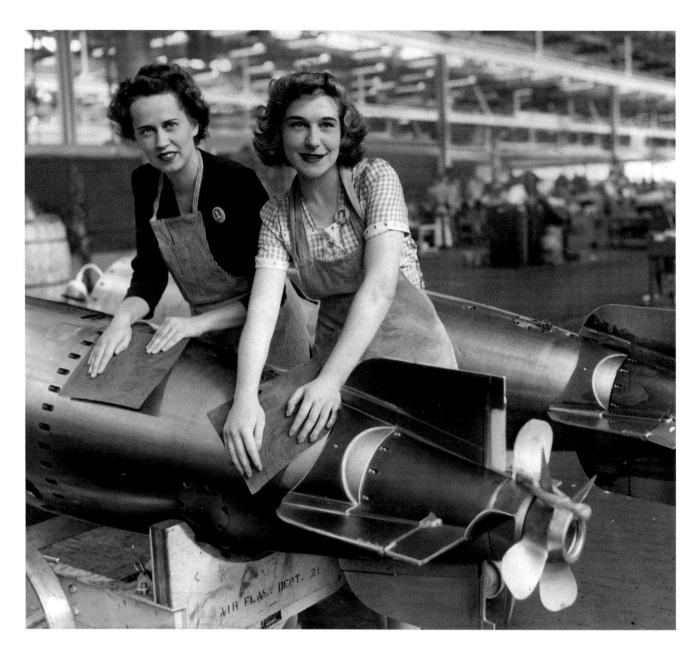

At the Amertorp plant, Lenore Radway, left, and Sherley Becker polish a torpedo flask in 1943.

lin, the war's wonder drug. Scores of companies, including Galvin Manufacturing (the precursor to Motorola) and Hallicrafters Co., made as much as half of the military's electronic equipment. In Forest Park, about 10,000 Amertorp technicians assembled 5,000 complex parts for 19,000 torpedoes. The region's steel mills, including Inland Steel and Republic Steel, churned out armor plating and other products.

But possibly the most impressive feat, after the creation nearly from scratch of an entire industry here, was the production of engines and aircraft at four massive Chicago plants.

From a million-square-foot plant at Archer and Cicero avenues near what was then called Municipal Airport, Studebaker assembled parts for the B-17 Wright Cyclone engine. Buick's 125-acre factory on North Avenue in Melrose Park made nearly 75,000 Pratt & Whitney engines for the B-24 Liberator bomber. In the prairies of unincorporated Cook County at Orchard Place (the source of O'Hare International Airport's ORD designator), Douglas Aircraft assembled more than 650 C-54 transport planes in a 2 million-square-foot plant, reportedly the largest timber building ever made. But it was the 6.3 million-square-foot, multibuilding Dodge-Chicago works—"the largest airplane engine fac-

tory in the world"—and its B-29 engine production that led all Chicago war production.

On Dec. 15, 1944, the Tribune noted the shipment to Boeing of the 5,000th Dodge-Chicago B-29 engine: "The plant was turning out at least 90 per cent of the engines for the Super Fortresses."

Even that record, achieved in only 11 months, was shattered three months later on March 24, 1945, when another 5,000 engines had been completed.

The facility extended from 71st Street to 77th Street and from Cicero Avenue to Pulaski Road. Inside the 82-acre assembly building, base metals from foundries and forges emerged as fully tested 18-cylinder, 2,200-horsepower radial engines with 6,000 precision parts.

Fifteen cafeterias fed 35,000 daily, while seven massive coal-fired boilers produced enough energy for a city of 300,000.

Classroom instruction at the site converted unskilled workers into precision crafters to operate 9,300 metal fabrication machines. Fifteen cafeterias fed 35,000 daily, while seven massive coal-fired boilers produced enough energy for a city of 300,000. By the war's end, the Dodge-Chicago plant had turned out more than 18,000 engines, nearly five engines for every four-engine B-29 that ever flew.

These massive new factories transformed the neighboring areas. Thousands of workers and their families settled near the plants, buying hundreds of hastily built "war homes" that sold for $6,000 or less or rented for $40-$50 per month. Large tracts took shape across a wide area, especially from Des Plaines south to Melrose Park, Bellwood, La Grange, Westchester, Western Springs, Forest Park and Summit. Chrysler Village was built for and named after the Dodge plant, which also spurred growth in the then-sparsely populated area near the future Midway Airport. The neighborhoods would become closely knit as most of the residents, men and women, worked the

same nine-hour days and six-day weeks. In Park Ridge, scores of two-story Georgian-style homes were built to house officers training to fly the C-54 transports being assembled in the Douglas plant.

The war effort also transformed the workplace by bringing thousands of women onto factory floors and assembly lines. Recognizing the magnitude of that change, the Tribune started a regular feature in January 1942 called "Women in War Work," which chronicled the momentous change in the American workplace.

But as quick as the mobilization was, the end may have been even quicker when the war ended and factories closed or turned back to civilian uses. Some sites became dormant, others were quickly put to good use. The Douglas plant is now O'Hare; the Buick site in Melrose Park is a Navistar Inc. plant. Amertorp, at Roosevelt Road near Desplaines Avenue in Forest Park, is a mall.

The Dodge-Chicago works possibly had the most colorful history. In 1947, automobile innovator Preston Tucker leased half of the assembly building to produce his futuristic Tucker 48, but he never got the torpedo-shaped auto out of first gear. The factory closed after making only 51 cars. The site picked up the Ford name when the automaker made engines for the military during the Korean War. Ford City Mall opened in 1965, and it uses the plant's extensive network of tunnels to this day. In 1967, Tootsie Roll Industries began production in another section of the former assembly building. Today, a fully assembled B-29 engine is exhibited alongside confectionery samples.

There was every hope these huge new aircraft enterprises would become permanent industries in Chicago. On Jan. 4, 1943, the Tribune reported: "Well-informed Chicagoans predict that this city at last is well on its way to becoming the nation's aviation manufacturing center." While that prediction proved false, it is hard to argue that Chicago wasn't the heart of America's Arsenal of Democracy.

—JEROME O'CONNOR

When candy was dandy

Of Baby Ruth, Oh Henry! and other Cracker Jack feats

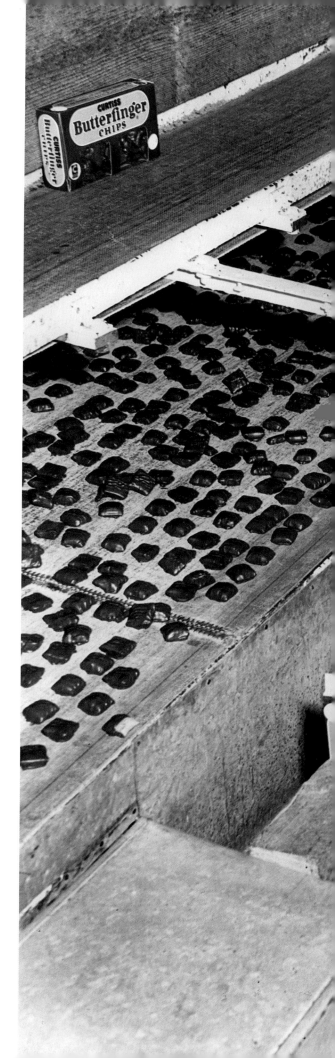

Lottie Solomon and Anna Kosan pack Butterfinger candy bars on an assembly line at the Curtiss Candy Co. plant in Chicago in 1952. Curtiss Candy was famous for making Baby Ruth candy bars.

L ET us tell a tale of sweet success.

Once upon a time, the Chicago candy industry was an economic powerhouse. At its height in the mid-20th century, more than 100 manufacturers employed more than 25,000 people and produced a third of all the candy in the United States.

"Every time you go to a candy counter and purchase a bar with one of the well-known wrappers, you help prove that the mighty brand name is still an American institution," raved Tribune reporter Joseph Egelhof with typical postwar gusto in 1951. "Chicago's confectionery business, the world's largest, has a prize collection of these multimillion dollar labels."

But why Chicago?

"People often mention Chicago's location in the middle of the country, plus its access to rail transport and agricultural goods as the chief reasons why it became a candy giant," said Leslie Goddard, Evanston-based author of "Chicago's Sweet Candy Industry."

"But just as important was Chicago's large immigrant population. There was plenty of cheap labor available."

Not just cheap but experienced. Many of those immigrants hailed from countries with

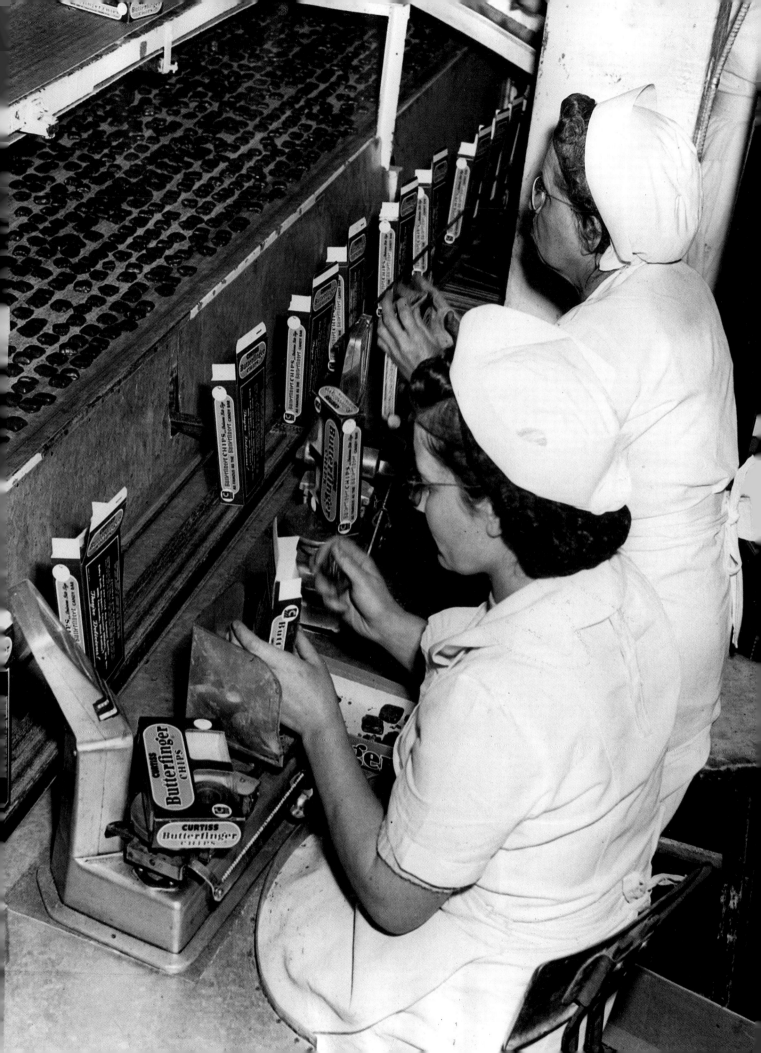

"Everything you want for a nickel."

—THE ORIGINAL BABY RUTH MARKETING SLOGAN

strong candymaking heritages, like Germany and Italy. Many of the top Chicago firms grew out of mom and pop shops.

The delectable candies and the industry titans who made them are the stuff of Chicago legend. F.W. Rueckheim and his brother Louis created a caramel popcorn confection in 1896, christened when one of their salesmen tasted it and said, "That's a crackerjack!"

William Wrigley got into the chewing-gum business when he discovered it was more profitable than selling baking powder and soap. Frank Mars allowed his wife to choose the brand name for his company's soon-to-be-famous malted-milk bar, the Milky Way—and the fact both the Milky Way and the Mars family name referenced astronomical objects was just a "celestial coincidence," the Tribune reported.

Emil Brach was the king of penny candies like lemon drops and caramels. George Williamson of Williamson Candy Co. named the Oh Henry!—the most popular candy bar sold in the region in the late Teens—after an electrician who frequented his store and flirted with the female candymakers.

But mostly forgotten now—and yet famous in his time—was Otto Schnering, owner of the Curtiss Candy Co. and producer of the Baby Ruth and Butterfinger candy bars.

A University of Chicago graduate and former piano salesman, Schnering had a larger-than-life personality and a knack for clever marketing.

When the Baby Ruth bar launched in the early 1920s, it supposedly was named not after the famous baseball player but for President Grover Cleveland's daughter Ruth, who died at age 12. Schnering claimed he named his new chocolate-peanut confection in the girl's honor after her father visited Curtiss' Chicago plant. But that story always raised eyebrows, considering the child had died 17 years earlier and Cleveland had been out of office for decades.

"The Ruth Cleveland story is indeed the one that Schnering and most official Curtiss statements gave" about the Baby Ruth, Goddard said. "But historians today dispute that and believe the Ruth Cleveland story was a way to capitalize on the baseball player's popularity without paying him royalties."

Schnering developed the Baby Ruth to compete with the Oh Henry! bar, which sold for 10 cents. Schnering decided to sell a similar bar for 5 cents, hiring legendary Chicago ad man Eddy S. Brandt to market the Baby Ruth under the slogan "Everything you want for a nickel."

The catchy slogan, cheaper price and other innovative marketing tactics like sponsoring circuses, hot air balloons, and even airplane barnstorming shows with the Baby Ruth moniker rocketed the bar to the top sales spot in Chicago.

Curtiss Candy became a major player in the emerging national candy-brand biz, launching other bars, like the peanut-butter crunch Butterfinger, along with now-vanished confections like the Dip (a chocolate-covered soft nougat bar, similar to today's Three Musketeers), the Buy Jiminy (a peanut bar similar to today's PayDay) and the Jolly Jack (yet another peanut-and-chocolate bar).

Schnering diversified his business into champion cattle breeding and poultry raising on farms he owned in Cary, Marengo, Arlington Heights and elsewhere, using the resulting eggs and milk in his candymaking and selling his famed "Curtiss chickens" to

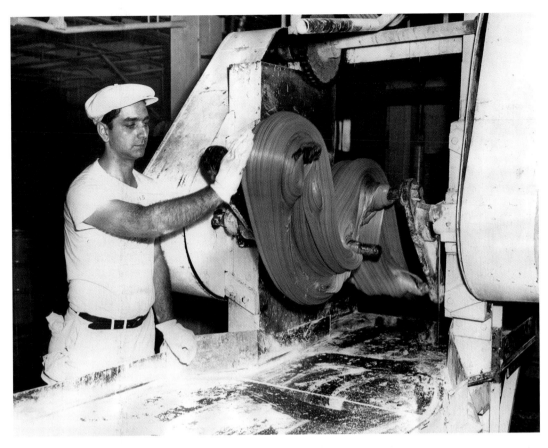

Leonard Tornabene pulls candy at Curtiss Candy Co. at the company's plant in Chicago in 1952.

premier Chicago-area restaurants, according to a 2001 Tribune article on the history of the Cary farm.

And unlike many industrialists of his day, Schnering allowed the thousands of workers in his factories to share in his immense success.

"He went to four six-hour shifts per day at the height of the Great Depression to help keep more people employed," Goddard said. "He brought families out to his Cary, Ill., farm for picnics and parties. The company had employee bowling leagues, softball leagues. It was a family feeling that was real."

Schnering named Curtiss Candy after his mother's side of the family, a decision that may have also recognized the anti-German sentiment during World War I. Schnering's devotion to his mother was legendary. When she died in April 1944, he closed the company offices for a day in her honor and announced the closing with a large, somber ad in the Tribune.

Tribune reports from Curtiss' heyday also reflected Schnering's generosity with his workers. When the federal government mandated national wage increases in 1933 to battle the Depression, about 6,000 of Schnering's workers were affected. But when the U.S. Supreme Court struck down the law in 1935, Schnering kept paying the higher wages.

Otto Schnering died of a heart attack in 1953. Although his widow, Dorothy, and his sons Robert and Philip helped run the company for a while, it was eventually bought out by Standard Brands (later part of Nabisco, and then Nestle) in 1964 during a time of economic upheaval for the candy industry.

But the Chicago Candy King's stamp still can be found today. The offices and outbuildings for Schnering's cattle breeding operations in Cary still stand, though remodeled as the community's Village Hall, senior center and police station. And the rotating Baby Ruth/Butterfinger sign by the still-operational former Curtiss plant in Franklin Park (now owned and operated by Nestle) is familiar to I-294 commuters—showing that while some tastes may change, these two old-time confections remain timeless.

—JILL ELAINE HUGHES

Chicago's original Mad Men

Jolly Green Giant and Marlboro Man agree: 'You deserve a break today'

I N 1904, a Chicago adman gave a junior colleague a lesson in how the advertising business works—or ought to work. Having previously been a reporter, Albert Lasker thought of advertising as news, a means of imparting facts about products. Vigorously dissenting, John E. Kennedy said he could explain advertising in three words: "Salesmanship in print." Lasker profited from that message.

At the age of 32, eight years after starting at Lord & Thomas as an office boy, he bought the firm.

Dubbed the father of modern advertising, Lasker didn't just promote existing industries, he created them. When he acquired Sunkist Growers as a client in 1916, the market for oranges, then considered only something to eat, was in a slump. Lasker's copywriters came up with a slogan, "Drink An Orange," that revolutionized America's breakfast menu. "To speed acceptance, Albert Lasker hired a man to invent a juice extractor," the Tribune afterward recalled. "It sold for 10c and more than 3 million were distributed almost overnight."

Though AMC's hit series "Mad Men" was set in New York, the epicenter of the advertising world today, in earlier decades, the celebrated "Chicago School of Advertising" dominated the industry and taught East Coast firms a trick or two.

Over the decades, Chicago gave birth to not only the Jolly Green Giant, the Marlboro Man and Snap, Crackle and Pop, but also "Hey, Culligan Man" and "You Deserve a Break Today."

"If it doesn't sell, it ain't creative," said Leo Burnett, who had the gumption to open his Chicago firm in the depths of the Great Depression. The bowl of fresh apples that greeted visitors to Burnett's offices was his riposte to gloom-and-doom predictions he'd wind up selling apples on the street.

As early as 1907, a speaker at a meeting of the Chicago Advertising Association defined the Chicago approach, as the Tribune reported: "Adam's interest in the apple industry was aroused by Eve," he said. "When she persuaded him to taste the fruit the fact that it was her personal act that caught his atten-

Heard of Rice Krispies cereal, Sunkist oranges and Lucky Strike cigarettes? You can thank the admen of Chicago.

tion demonstrated a fact that the world was a long time in learning—that it is personality that counts, and that a direct appeal to the customer is necessary to successful advertising."

Five years later, the association laid the cornerstone for its own building at 110 W. Madison St.

Five hundred admen marched behind a newsboys' band to the new headquarters, and the group's president told the Tribune: "Chicago has been the best advertised city in America ever since the great fire. Right now Chicago advertising managers, advertising agencies and solicitors influence more advertising than those of any other city in America."

When the trade paper Advertising Age was founded in 1930, logic dictated that it be published in Chicago. By 1980, advertising was one of Chicago's largest industries. Its 500 agencies had 8,000 employees and enjoyed $6 billion in annual revenues.

The legacy that Lasker passed on to other Chicago admen was the short, snappy characterization of a client's product. He hated jargon and wordiness. "Have you ever read a consumer bulletin from Washington?" he asked, setting forth his philosophy in a 1936 Tribune article. "Do you believe the average person could even understand it?"

Watching Quaker Puffed Rice Cereal explode in containers resembling a cannon, a Lasker copywriter wrote: "Food Shot From Guns." Sales increased dramatically. The successor firm, Foote, Cone & Belding, coined the phrase "When you care enough to send the very best" for Hallmark greeting cards. The Leo Burnett agency dreamed up a pair of slogans—"You Are in Good Hands with Allstate" and "Fly the Friendly Skies of United"—that caught America's attention and still resonate with consumers today.

Some plotlines of "Mad Men" seemed to be thinly fictionalized versions of Chicago admen's experiences. A running theme of the show was the mythical New York firm's adventures keeping the account of Lucky Strike, a company run by a boorish good old boy. Fairfax Cone, protege and successor of Lasker's, recalled for the Tribune similar encounters with the real-life owner of the American Tobacco Co.,

whose Lucky Strike account was highly prized. "George Washington Hill was accused of devouring adverting people, especially savoring the better ones," Cone wrote of Hill, who wore a dented hat decorated with trout flies. "He both looked and sounded like a man playing Nero."

A Lord & Thomas employee sent to a tobacco auction observed that, of discarded cigarette packages on the auction house floor, Lucky Strike held a 3-1 advantage over other brands. Thus was born a sales pitch—"With Men Who Know Tobacco Best, It's Luckies 2 to 1"—after Hill's editing.

He explained to Cone: "Two-to-one has a better ring to it. Two-to-one is one of the great, confident expressions in our language."

Cone recalled Lasker's teaching-by-example method. Once a dejected group returned to the firm's office in the Palmolive Building. They had pitched a prospective client hard, parading dozens of advertising campaign ideas to no avail. Lasker said he'd give a try, and he came back triumphantly waving a signed contact. Asked how he had done it, Lasker said: "I told the gentleman that I would make him rich."

Regardless of whether he fulfilled that promise, Lasker turned the trick for himself, in spades. He lived in a 50-room mansion on a 480-acre estate west of Lake Forest. Among its amenities were an elevator for raising logs to a gigantic fireplace and an 18-hole golf course, which was "rated by Bobby Jones and Gene Sarazen as one of the three best in the country," the Trib noted when Lasker donated the estate to the University of Chicago in 1939.

He also had a pied-a-terre, an 18-room mansion at Burton Place and Dearborn Parkway.

That opulence far outstripped even the most lavish lifestyles of the "Man Men," and in one key respect, Lasker differed from those sardonic characters. They were quick to throw down a drink in the office, accompanied by a cynical remark, but Lasker truly believed that advertising's virtues went far beyond just moving goods and making money.

"Advertising has given wings to our culture, our civilization," Lasker wrote in his 1936 Tribune piece. "Remove it, dilute it, vitiate its effort, and presently you will depress the masses of our people to a lower class mediocrity."

—RON GROSSMAN

Christmas stockings

End of WWII put nylons at the top of women's wish lists

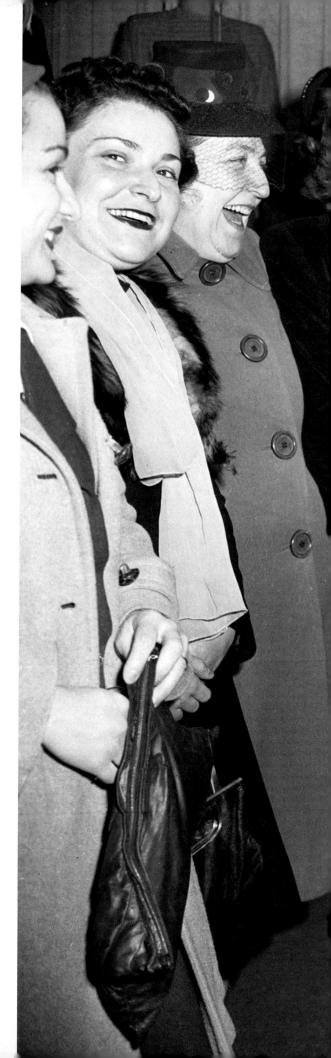

ALL they wanted for Christmas was nylon stockings.

Women cheered the end of World War II in the late summer of 1945, and then they hit the department stores. At last, after years of using nylon to make parachutes and other supplies for the war effort, the hosiery factories would start churning out women's nylons once again. And from the news pages to business, sports and women's columns, the Tribune documented shoppers' frenzy for nylons.

At first, the expectation was "Nylons by New Year's," as one headline from Aug. 12, 1945, promised. The story quoted the president of Gotham Hosiery Shop: "Assuming the government meant what it said when it promised to release nylon immediately after the conclusion of the war, women can expect to be wearing nylon stockings in time to celebrate a victorious new year."

Another story a few days later told of a veritable nylon riot in Northern California as 1,000 women rushed a hosiery mill that had just released 12,000 pairs of prewar nylons the president of the mill had squirreled away back when manufacturing was halted.

Tribune features writer Edith Weigle traveled the country that fall reporting on the manufacturing process of nylons and updating shoppers on expected availability. "Because the well of women's demands apparently is bottomless, due to the complete lack of nylons in the war years, manufacturers are united in trying to get as many stockings to them as quickly as possible. The idea is to produce nylons—just nylons. Not fancy colors, not varied leg lengths."

Lorene Nystrom shows off her new nylons to other women hoping to pick up a pair on West Madison Street in Chicago in 1945.

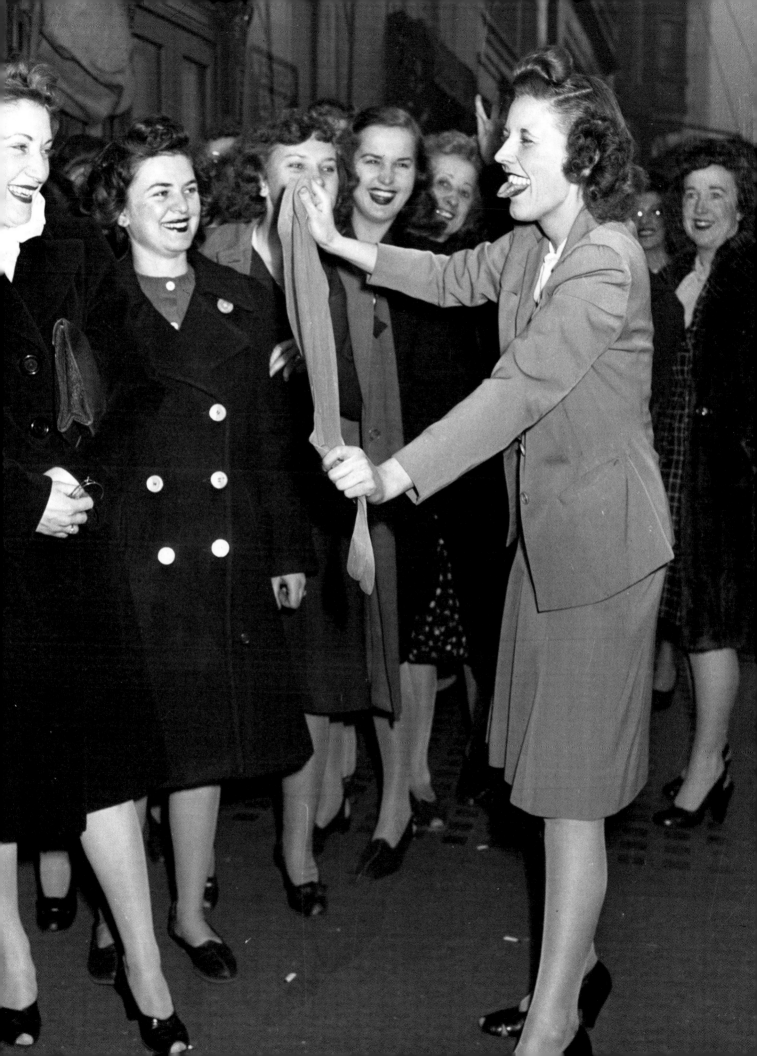

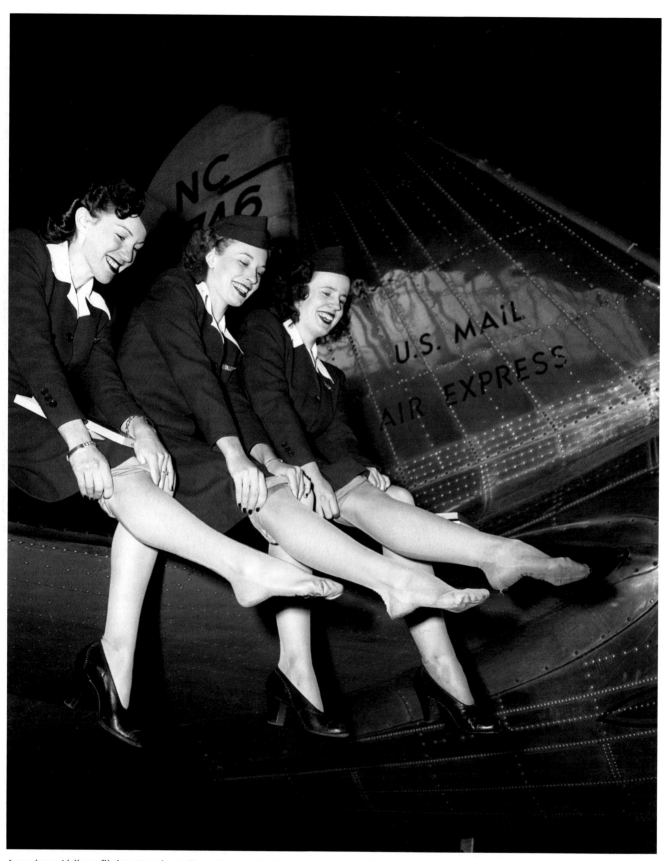

American Airlines flight attendants Terry Feeney, Louise Agnew and Marie Rice display nylons that were provided to flight attendants during the nationwide shortage in 1945.

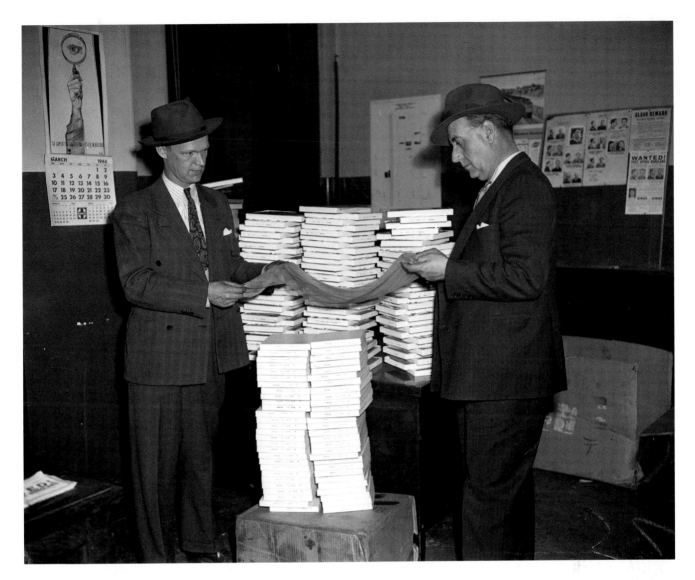

By September, women were setting their sights on a nylon-filled Christmas, but they knew supplies would be limited. The rush to production hit a snag, a headline Sept. 19 warned. "Less than one pair of nylons per woman will be available by Christmas with predicted production of 3,500,000 dozen pairs by that time.... It probably would be late spring or early summer before women could buy nylons whenever they wished."

In November, small batches of nylons began to arrive at stores in Chicago. A Nov. 30 Tribune story said 1,000 women (and a few men) lined up at Robinson's, 233 S. State St., to buy 300 pairs of nylons, $1.35 each. It was hardly enough to meet demand, and a Dec. 11 story prepared women for the worst: "Early predictions that huge quantities of nylon hosiery would be available before Christmas were 'far too optimistic,' the manufacturers said."

Hopes for holiday hosiery were dashed, as "White Collar Girl" columnist Ruth MacKay wrote Dec. 31, but even in the darkest nylon shortage a glimmer of goodwill emerged.

"Nylons? Well, the year ends with that particular white collar girl commodity in critical state as illustrated by a State St. incident. A regular customer kept asking 'How about some nylons for my wife?' to which the salesgirl would reply, 'Haven't been able to get any for myself.' Each time the customer clucked sympathetically. Just before Christmas he was back at the counter with a pair of nylons for the salesgirl— (he) had picked them up at a jobber's."

—LARA WEBER

Police Officers Russ Burton and Warren Hayes show confiscated nylons that were headed to the black market in 1946.

Innovation and Social Change

ATION OVER 600,0

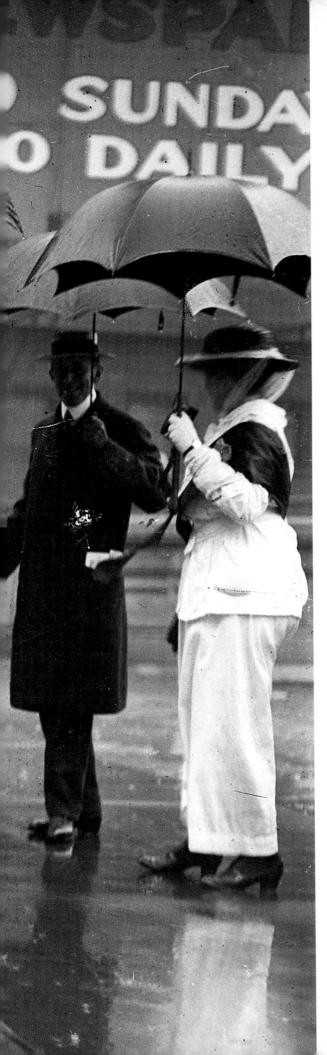

Illinois women win the vote

And they waste no time flexing their political muscles

SHORTLY before Illinois women won the right to vote in June 1913, the state's delegation to a suffragettes march in Washington was bitterly divided over the issue of what to call each other. Belle Squire, herself unmarried, insisted on addressing all delegates, married or not, as "Mrs." According to a Tribune reporter aboard the train carrying them to the nation's capital, another member vigorously protested: "I am a married woman and object to maids taking the title 'Mrs.' They are parading on a married woman's preserve."

That drew the rejoinder: "The first married woman was not 'Mrs. Adam' but Eve." Still another of the 65-member group proposed dropping all gender-specific titles in favor of addressing each other, just as men do, simply as "Mister." When the question of what they wanted to be called was put to the 14 unmarried delegates, Miss got eight votes, Mrs. got four and Mister got two.

The debate spoke to how much enfranchising women pushed society into such uncharted waters with scarcely a vocabulary to discuss it. The same women who organized statewide tours to advance their causes also made sure there were matrons to chaperon the unmarried women. The same legislature

Janet Ayer Fairbank, left, was a 1916 suffragette parade's grand marshal.

The rights parade the Illinois suffragettes joined was set upon by counterdemonstrators, the police refused to intervene, and 100 women ended up in hospitals.

that finally voted yes to women also considered a bill that would have allowed a woman to shield her age in legal proceedings because that "concerns her alone." And the same newspaper that supported women's rights also published a story that asked: "Would you rather have a vote than a husband? Wherein lies woman's greatest chance for happiness and advancement?"

So when Gov. Edward Dunne signed into law on June 26, 1913, a bill making Illinois the first state east of the Mississippi where women could vote, the milestone was hailed—and decried—around the world. When Jane Addams, of Hull House fame, announced the news at an international suffragette conference in Budapest, the delegates wildly applauded and sent their congratulations to Dunne. An opinion writer in the Tribune predicted: "Illinois' victory will push the woman's suffrage movement forward in every country in the world."

Reading a textbook account a century or so later could leave the impression that Illinois took a giant leap forward from a dark age of male chauvinism to a new era of equal rights. Actually, Dunne and the legislature did

quicken the pace toward the 19th Amendment, which extended voting rights to women nationwide and which Illinois would be the first state to ratify.

Yet Illinois' actual leap forward was more a giant baby step.

For one thing, Illinois' legislation didn't give the sexes equal voting rights. They won the right to vote for presidential electors, mayor, aldermen and most other local offices, but not for governor, state representatives or members of Congress. For a while, women were separate and unequal, as the Tribune reported of a Morgan Park election, a month after Illinois women got the vote: "A separate ballot box was used for the women on the advice of the city attorney."

Still, there are always those who know how to mark a victory, no matter how limited. Shortly after the Illinois House of Representatives passed the voting rights bill, Florence Peterson—described by the Tribune as "a comely little woman"—walked into the auditorium of the Hart School and joined a meeting of the West North Edgewater Improvement Association, the first woman to do

Suffragettes Mrs. Francis Shaw, from left, Mrs. Emmons Cracker and Mme. Carola Loos-Zooker.

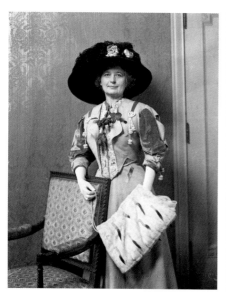

so. "The uproar died down," the Tribune reported of her reception. "Most of the smokers threw away their cigars."

Peterson, Squire and the legion of those who had worked for voting rights had something to celebrate. The suffragettes' battle had been long and bitterly fought. They'd been mocked and belittled by their opponents, whose ranks included women as well as men. An anti-suffragette woman writing in the Tribune decried the prospect of female voting rights as "the grave peril that threatens our fine American womanhood."

When suffragettes took their campaign to Chicago street corners in 1910—for the first time, according to the Tribune—after a day of speeches and handing out literature, "thousands had passed by unheeding or contemptuous."

The insults weren't only spoken, or the disdain expressed only with dirty looks. That train carrying Illinois suffragettes to Washington in 1913 stopped at Harper's Ferry, so they could preach their cause where John Brown had made his fateful stand against slavery. "In the midst of a speech by Mrs. Trout, while the platform was crowded with women, men and boys threw snowballs at the speaker and her brigade," the Tribune correspondent reported.

In Washington, the rights parade they joined was set upon by counterdemonstrators, the police refused to intervene, and 100 women ended up in hospitals. They got no sympathy even from Rep. James Mann of Illinois, who led the fight for the amendment in the House, who said: "They should have been at home."

Many suffragettes took an extra burden on themselves, linking their cause to the campaign for Prohibition. Frances Willard of the Evanston-based Woman's Christian Temperance Union was a prominent advocate for both causes. That bought the enmity of men who felt that giving women the vote would close their favorite saloon's doors, a fear that would not be unfounded, and which was played upon by the alcoholic-beverage industry. "Liquor Interests Defeat Suffrage In Ohio Election," a 1912 Tribune headline announced.

When they finally did get the right to vote, women didn't waste time flexing their polit-

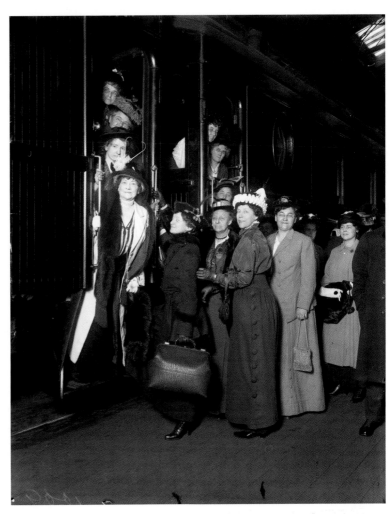

ical muscle. At their first major opportunity, the local elections on April 7, 1914, more than 200,000 women registered to vote in Chicago. In another "innovation," eight women ran for aldermanic seats. While female voters were credited with kicking a number of bums off the council and saving what the Tribune called "good men," they failed to elect one of their own.

Still, across the state, more than 1,000 bars were voted closed, and 16 counties moved to the "dry" column. So on balance, those election returns fulfilled a prophecy made by Mrs. George W. Plummer in the thrilling moment when Illinois women won the vote: "Before we had bricks without straw, now we have the straw and the bricks and we have an opportunity to do the things for the city that we have only desired to do."

—RON GROSSMAN

Members of the Illinois Equal Suffrage Association head to Peoria for the state suffrage convention in the fall of 1913. On June 26, 1913, Gov. Edward F. Dunne signed the Suffrage Bill that gave Illinois women the right to vote in some elections.

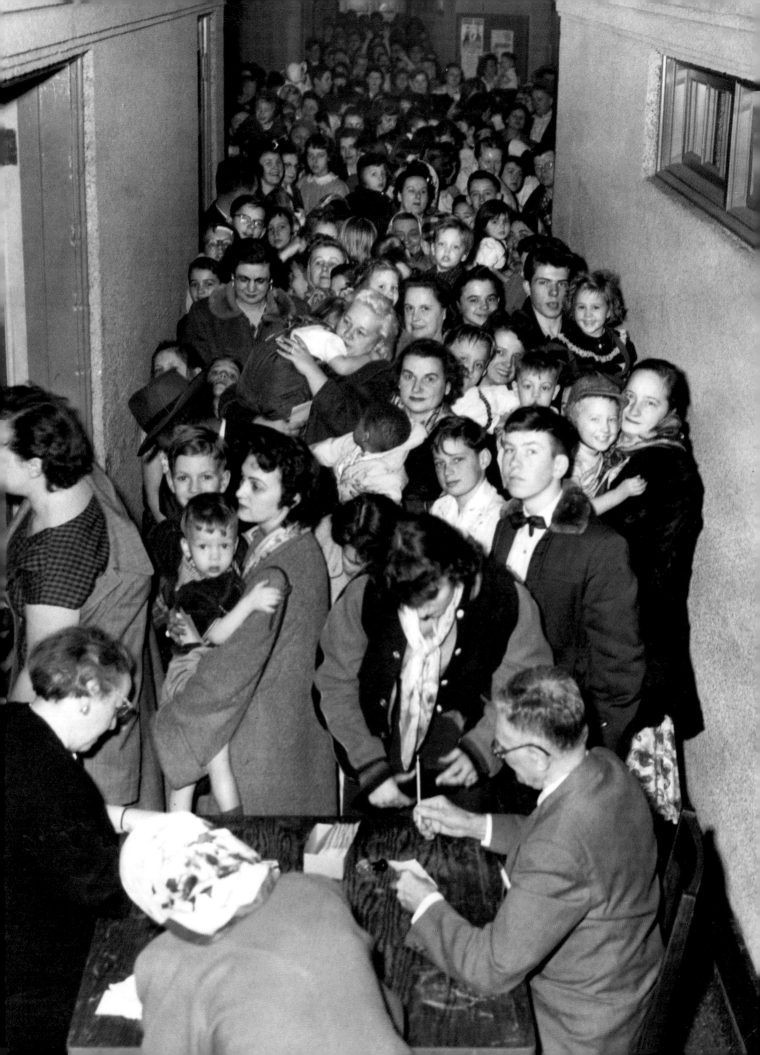

When polio was defeated

Dime by dime, public got behind Salk vaccine

CHICAGO BOARD OF HEALTH
POLIO SPOT MAP

MAP OF
CITY of CHICAGO

Less than a week after a Tribune banner headline proclaimed "Salk Vaccine Called Safe, Effective" on April 13, 1955, Robert Ludford was the first of 300 Antioch schoolchildren to be inoculated against polio.

"It didn't hurt a bit," the 7-year-old said. For youngsters less blase about getting a shot in their left arms, lollipops were on hand. Shortly, first- and second-graders were lining up to get their inoculations at Armstrong, Boone, Ogden and other schools on Chicago's North Side. Citywide, parents of an astonishing 89 percent of those young students—well more than 75,000 kids—had quickly returned school consent forms.

After World War II, polio wasn't just another disease, it was every parent's worst fear. Mysterious and ubiquitous, it crippled victims it didn't kill, seeking out young children—but also striking adults, as if to show there was no place to hide from its morbid powers. It turned summer, a time of family picnics on Chicago's beaches, into a season of fear. Its incident rate multiplied exponentially in warm weather. Yet it also brought scientists and workaday folks together in an unprecedented crusade to defeat it—and then a remarkable campaign to inoculate hundreds of thousands of the most vulnerable in the shortest possible time.

The mass inoculation campaign in the mid-1950s put a strain on the Chicago area's medical providers, prompting dentists to volunteer:

They knew how to give shots. "It's a shame to wait a single day when it may mean that some child may contract polio before his immunity becomes effective," said Dr. Adolph Doe, a Chicago dentist.

Parents feared supplies might run out before their children were inoculated, despite the reassurance given by the medical director of the National Foundation for Infantile Paralysis, which later adopted the name of its fundraising campaign, the March of Dimes.

"The miracle of making substantial supplies of it available within days after it was proven effective was unique in the annals of

A map in the office of Dr. Herman Bundesen, Chicago Board of Health president, in July 1956 tracks polio. Each dot indicates a case.

Opposite: More than 1,200 people waited hours at the Gage Park field house for polio shots in 1957.

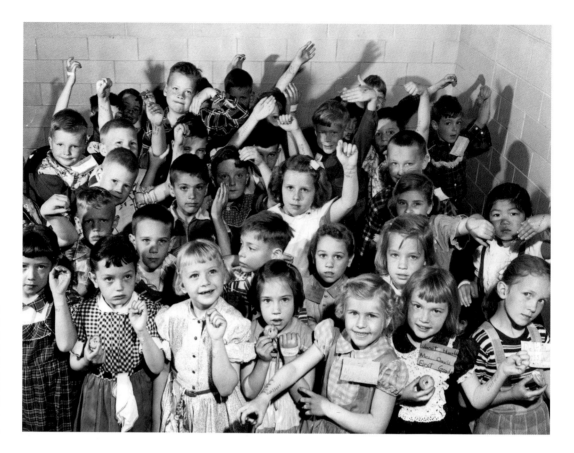

Children from schools in DuPage County, shown eating cookies after getting their polio vaccinations, were part of a field trial in 1954 involving 1.8 million school-children nationwide.

medicine," said Dr. Hart Van Riper, explaining to a Tribune reporter that it was possible through the foundation's planning and its "daring $9 million gamble on the success of the vaccine before it was proven effective."

Indeed, an initial shipment of 532 pounds of Salk vaccine arrived at Midway Airport on April 12, just hours after hundreds of scientists and journalists gathered at the University of Michigan to hear that statistical analysis of a large-scale test of Dr. Jonas Salk's vaccine showed it worked. The 1954 field trial itself was a massive undertaking, involving 1.8 million schoolchildren nationwide, including thousands in DuPage County. The chairman of the American Medical Association called the results "one of the greatest events in the history of medicine." As the word spread, church bells rang, and shop windows were lettered with thanks to Salk. That evening, Salk was interviewed by Edward R. Murrow, the dean of television anchors, who asked who owned the patent.

"There is no patent," Salk said. "Could you patent the sun?"

To parents who lived through annual epi-

demics of "childhood paralysis," as polio was alternately known, Salk's achievement was worth the sun, the moon and the stars.

To understand the sense of relief that Salk's achievement brought, consider this: During a 2014 measles outbreak in the U.S., 644 cases were reported. Cook County officials in early 2015 reported 15 cases of measles and no deaths. By comparison, in 1952 alone, nearly 58,000 cases of polio were reported in the U.S., of which 145 resulted in death and 21,269 in paralysis. While that was an all-time high, epidemics of similar magnitude were a fact of life in the years immediately preceding the introduction of the Salk vaccine.

A grim procession of headlines reporting the disease ran in the Tribune, year after year: "Polio Strikes 2 Nurses in Hospital in Evanston" (Sept. 29, 1948); "Polio Kills 2 In Gary Family Within 3 Days" (Aug. 1, 1949); "Report 3 Polio Deaths, 60 New Cases In Week" (Oct. 3, 1950); "Polio Strikes Six Of Family's Eight Children" (Aug. 9, 1951); "Polio Cases In U.S. Top 38,000 for '54; Third Worst Year" (Dec. 31, 1954).

Those who escaped the disease were not

"There is no patent.
Could you patent the sun?"

—DR. JONAS SALK, ON HIS POLIO VACCINE

spared the epidemics' side effects: families and communities terrified by the thought that polio was lurking outside the front door. Especially in summer—when the outbreaks tended to peak—ordinary activities were interrupted. Beaches were closed, day camps were suspended and hospitals were avoided.

In 1949, Dr. Herman Bundesen, president of the Chicago Board of Health, simply put an embargo on social life, advising residents to "keep out of crowds and avoid contact with other persons as much as possible," the Tribune reported. That same year, Anderson, a small town in Indiana, established a blockade on Muncie, where polio was epidemic, turning back some 400 cars headed its way from Muncie.

Yet for all their suffering and anxiety in the years after World War II, Americans didn't despair of a solution being found. The search for a polio vaccine was a joint effort of scientists and ordinary citizens. Salk's research wasn't supported by a government agency, but by the private charity March of Dimes. As the name suggests, it depended on lots of small contributions by workaday folks.

When President Franklin D. Roosevelt, himself a polio victim, created the polio foundation in 1938, a popular entertainer of the era, Eddie Cantor, asked Americans to send a dime or two in honor of the president's birthday. By the day of that celebration, 2,680,000 dimes had piled up in the White House mail room.

Cantor's idea stuck. Annually, volunteers collected for polio research and treatment of its victims. When the lights came on between features at movie houses, members of women's clubs took up collections. Fraternal organizations held funding drives; children carried the distinctive March of Dimes cans through their neighborhood.

In 1950, the Tribune reported that a group of youngsters put on a variety show for the March of Dimes in the basement of a South Side apartment building: "The audience paid 10 cents for admission and bought popcorn and cookies for another dime," the paper noted. "A 5-year-old sang, her 10-year-old brother played the drums, and the fight against polio was $22.43 richer."

Along the way, some promising leads fizzled, and quacks tried to exploit the public's fears.

Despite that—and maybe because so many Americans had contributed—there was no second-guessing Salk's achievement. Politicians didn't preach parents' rights to not have their kids vaccinated. Instead, they protested if the vaccine was slow in coming to their community. In the first week, more than 45,000 Chicago-area children were vaccinated. Nationwide, 7.7 million kids received shots in a matter of months. The government estimated paralytic polio cases fell as much as 80 percent.

In the heady days after the announcement, there was no conflict between science and religion. Instead, the Tribune reported that Chicago's Protestant churches would host Thanksgiving prayers. "We should all be grateful that God has given Dr. Jonas Salk the wisdom to uncover the new secret of the physical world," said the Rev. John Harms, executive vice president of the Church Federation of Greater Chicago.

Salk's discovery and the resulting public health campaign marked a watershed moment in the history of American childhood. No longer was summer a season of fear. By 1965, the number of paralytic polio cases had fallen to 61. Polio was beaten.

—RON GROSSMAN

Dorothy Eagles with dogs from her North Side Animal Shelter during Be Kind To Animals week in 1932.

From dog pound to humane society

As early as 1896, residents have helped 'friendless' dogs and cats

"THREE hundred dogs whined and shivered and shivered and whined in the freezing temperature of the pens in the city dog pound yesterday," a Tribune reporter wrote in a Nov. 29, 1896, story about Chicago's shelter for stray and unwanted dogs at Fillmore Street and Central Park Avenue.

The account of the pound's pathetic conditions sparked an immediate public response. A story the next day told of efforts by one woman to deliver straw to help warm the dogs' beds. The pound master, Eli Montgomery, rejected the offer. John G. Shortall, president of the Humane Society, called the conditions "a disgrace to the city" and demanded that Chicago officials hand over the pound to more caring hands.

Within a few days, another story reported, "Somebody has stolen 300 half-frozen dogs from the cold-storage pound operated by the city on the West Side." The dogs were reportedly loaded onto a Santa Fe railroad car headed for Texas and sent off to an unknown future.

The fates of other stray, abandoned and—

as the Tribune called them—"friendless" dogs and cats have tugged at the hearts of Chicagoans for nearly all of the city's history. The City Council's approval in 2016 of a nonbinding resolution to implement "no-kill" policies for Chicago's animal shelter is merely the latest of many efforts to treat animals humanely. In 1907, the council took up an ordinance regarding the then-common practice of sending unclaimed dogs from the city pound to medical schools for vivisections.

The council's unanimous vote banned the practice, even as a health department official was quoted: "I understand dogs at the clinics never are cut up until they are placed under an anesthetic. I'd a good deal rather the surgeons would experiment on dogs than on women and children who might be their patients."

A group of prominent women, about the same time, led the charge in Chicago to develop shelters for abandoned animals, including the city's old workhorses. In 1899, the Anti-Cruelty Society was founded and Rose Thomas, the wife of the city's symphony conductor, was elected its first president.

When the vivisection issue came before the council, Thomas issued a public statement that was published by the Tribune and began: "I appeal to every man and woman in Chicago who owns or loves a dog to join with the society to stop the disgraceful ordinance before it

Mildred Fitz-Hugh, of Lake Forest, from left; Dorothy Eagles; Chris Paschen, building commissioner; Mrs. William Swift and Mrs. M.P. Wamboldt, both of Lake Forest; Ted Hines, animal keeper; and Jim Scottie, start work on the North Side Animal Shelter at 6500 N. Clark St. in Chicago on May 27, 1929. Eagles headed the North Side Animal Shelter, which was a subsidiary of Irene Castle McLaughlin's "Orphans of the Storm" animal shelter.

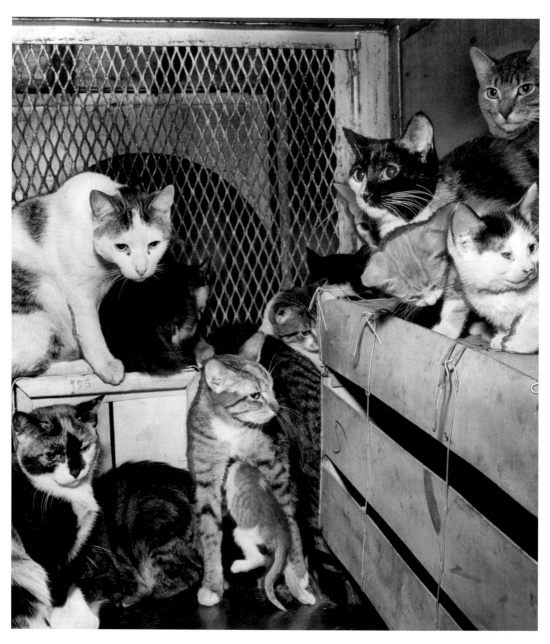

The Anti-Cruelty Society was founded in 1899. In 1963, it picked up 43 cats and 25 kittens from a residence.

is too late. Yes, I mean you—you, who at this moment read these lines with your faithful household guardians sleeping peacefully at your feet, trusting and believing implicitly in your protecting power and love."

The Anti-Cruelty Society raised money quickly and opened a small shelter in 1904 on North Clark Street, with a larger one following in 1910.

A rift was growing, though, over the very definition of humane animal control—especially the treatment of dogs. While the Anti-Cruelty Society, in its first decades, considered it better for the city if unclaimed animals were euthanized after a certain number of days, other shelters followed a different philosophy. A Tribune reporter wrote that during a 1929 board meeting, the superintendent of the society's headquarters reported that more than 29,000 of the 30,169 small animals that had come under the society's care that year had been "humanely destroyed." Board members, some of whom also supported other shelters, erupted and a passionate debate unfolded over the practice of killing unclaimed animals.

Irene Castle McLaughlin, who ran a shelter called Orphans of the Storm out of her Lake Forest home and later at a facility in Deerfield,

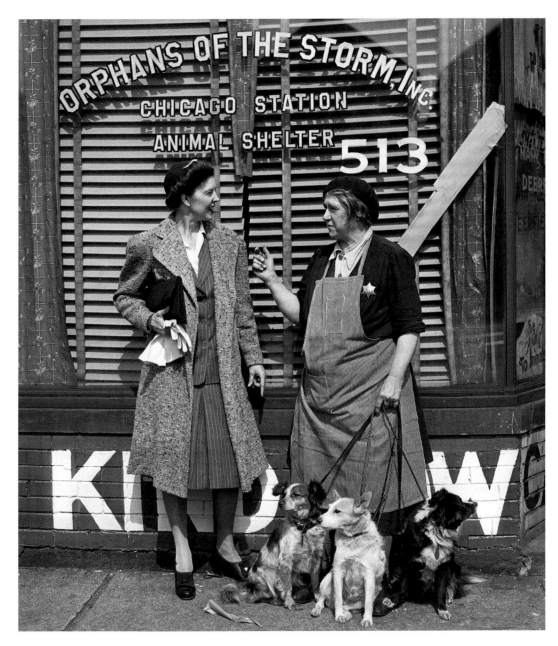

Viola Larson, right, helped operate an animal shelter on Ashland Avenue in Chicago in 1945

was outraged and said she never destroyed animals unless they were "vicious, very old, female puppies or hopelessly injured."

"I have found that some of the plainest looking dogs have the best characteristics," she said.

McLaughlin also supported the efforts of Dorothy Eagles, another shelter founder. "Woman gives home and love to dog waifs," read the headline on a Tribune profile of Eagles in 1928 that highlighted her personal attention to finding homes for the dogs brought to her—and her willingness to reclaim the dogs if she didn't believe they were being cared for properly. "Some people came to me for a watchdog once and I gave them a magnificent dog," she said. "But when I discovered that they kept him chained to a kennel all day long I took him back."

Eagles started taking in strays in her Rogers Park home in the 1920s and then opened the North Side Animal Shelter on North Clark Street, which still left her wanting. "I only wish," she told the Tribune reporter, "I had room for lost horses too. I saw one wandering the streets in Rogers Park yesterday, and if I had had a place for him I should have brought him in."

—LARA WEBER

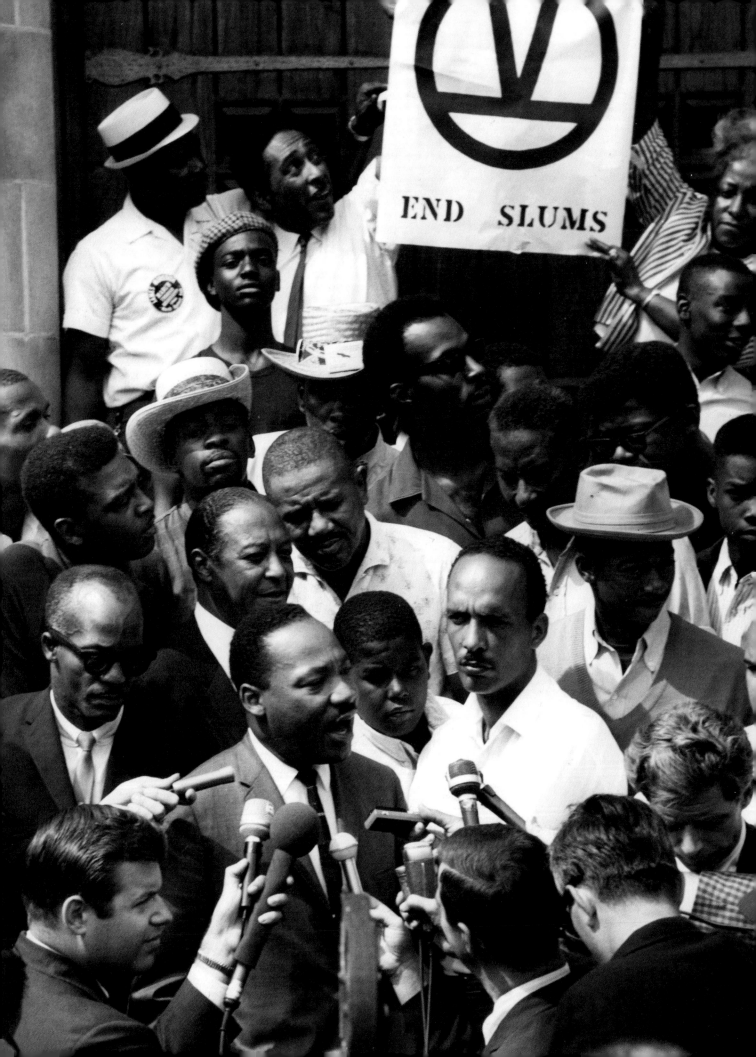

When King came to town

Famed civil rights leader endured scorn and even an attack in 1966

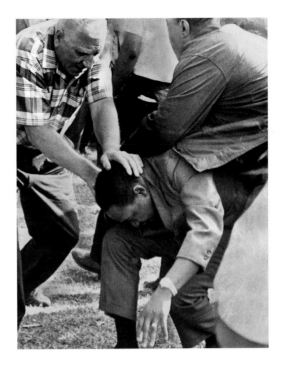

Aides shield the Rev. Martin Luther King Jr. after he was struck by a rock in Marquette Park during an Aug. 5, 1966, march in Chicago.

> "I have seen many demonstrations in the South, but I have never seen anything so hostile and so hateful as I've seen here today."
>
> —DR. MARTIN LUTHER KING, 1966

Two years before his assassination, the Rev. Martin Luther King Jr. rented an apartment in Chicago. At the time, blacks and whites here lived lives as firmly separated as in the Deep South, where his civil rights crusade had begun. African-Americans faced violent mobs if they tried moving into white neighborhoods and were refused service at Loop restaurants. Gerrymandering of school boundaries kept the public schools segregated.

King, who was murdered April 4, 1968, is most remembered for his campaigns against Jim Crow, like the iconic 1965 march from Selma to Montgomery, Ala., interrupted by police with billy clubs and tear gas, and subsequently completed with the protection of federalized Alabama National Guardsmen and FBI agents. Less well known is King's Chicago campaign the following year, inspired by his conviction that blacks would be liberated when they were free not only to vote in the South, but also to live where they chose to in the urban North.

"We don't have wall-to-wall carpeting to worry about," King said shortly after moving into a run-down, third-floor flat at 1550 S. Hamlin Ave. on Jan. 26, 1966. "But we have wall-to-wall rats and roaches."

To underscore the point, he led marches through middle-class, white neighborhoods, where he was confronted by hostile crowds. "Many of the residents waved signs referring to George Lincoln Rockwell, head of the American Nazi party," the Tribune reported about one such standoff on the East Side, at the southeast corner of the city. In Marquette Park on the Southwest Side, signs read, "Join the White Rebellion," and "We Worked Hard For What We Got," and a rock was thrown that knocked King to the ground.

"I have seen many demonstrations in the South, but I have never seen anything so hostile and so hateful as I've seen here today," King said afterward.

Though King came to Chicago with a Nobel Peace Prize, he was greeted with suspicion by the city's establishment—even those who recognized the evil of racism. Some of his most vocal critics were black, such as Ernest Rather, president of Chicago Committee of One Hundred, an interracial alliance of businessmen and professionals. The Tribune reported Rather advising King and his staff that they "should go back to the South where they are needed." Edwin Berry, executive director of the Urban League, had to defend himself over charges that, by inviting King to Chicago, he'd brought in a carpetbagger.

Opposite: The Rev. Martin Luther King Jr. speaks in front of Friendship Baptist Church in Chicago in August 1966.

"We needed help so badly that I would have sent for the Apostle Paul if I had known his address," Berry said.

White Chicagoans, often ministers and rabbis, who marched with King faced the Tribune's editorial scorn: "Those 'rights' leaders and the foggy clergymen who abet them are not heroes." Throughout King's Chicago stay, the Tribune savaged him, sometimes with satire: "The commander in the paper hat has waved the wooden sword. Who will follow him in the charge against Cemetery ridge?" it asked, comparing his open-housing marches to the Battle of Gettysburg.

"This day we must decide to fill up the jails in Chicago, if necessary, in order to end slums."

—DR. MARTIN LUTHER KING, 1966

Alternately, the paper redbaited King, accusing him of fomenting "criminal syndicalism"—a hoary charge leveled at a long line of labor organizers and political dissenters. "If the marchers keep up their sabotage, it will be time to indict the whole lot of them," an Aug. 18, 1966, editorial advised.

The apartment where King chose to highlight his Chicago campaign was in Lawndale, an impoverished neighborhood on the West Side—then as now, virtually 100 percent black. By choosing it as an example of what was wrong in Chicago, King was throwing down a gauntlet to the city's mayor.

"I've lived in Chicago all my life, and I still say we have no ghettos in Chicago," Mayor Richard J. Daley had said three years earlier, a pronouncement that got him booed off the stage at an NAACP meeting.

At a massive rally in July 1966 at Soldier Field, King told the crowd: "This day we must decide to fill up the jails in Chicago, if necessary, in order to end slums." He also posted a list of demands on a City Hall door—much as, four centuries earlier, his namesake had posted a demand for church reform on a cathedral door.

Daley responded by accusing King of playing a dangerous game, saying, "There is a danger of using nonviolence in such a way that it will create violence."

But recall what else happened here that summer—and what it must have felt like for Chicagoans. In June, police clashed with rioters for two nights along Division Street in a largely Puerto Rican neighborhood after an officer shot a young man there. And in July, two people were killed and 300 arrested in disturbances along Roosevelt Road that began after police shut down a fire hydrant where residents sought relief from the summer heat. The National Guard was called in to help quell the violence, which spread across the West Side. But the riots and the 2,200 National Guardsmen patrolling city streets weren't even the lead story that week. Why? Because seven nurses were found slain July 14 in a Southeast Side town house, and their killer, Richard Speck, was arrested July 17. The horrendous crime could only have solidified the sense that the city was on the brink of chaos.

Then came the incident of Aug. 5, when King was assaulted in Marquette Park, which led many on both sides to temper their rhetoric. On Aug. 26, King and Daley met at City Hall, where the mayor pledged to enforce the city's open-housing ordinance. In fact, it was more a fig leaf than an olive branch. The city remained segregated, as King acknowledged when assessing his Chicago campaign, saying, "It was the first step in a 1,000-mile journey."

Yet less than two decades later, Chicago had a black mayor. Could King have imagined that? Hard to say, but one of King's great strengths was his ability to see the potential for progress in the bleakest of scenes—like the overcrowded, threadbare classrooms of Chicago's ghetto.

"It's criminal to have our children have the kind of education they are getting," King said. "There may be another Plato or Einstein in a Chicago school."

—RON GROSSMAN

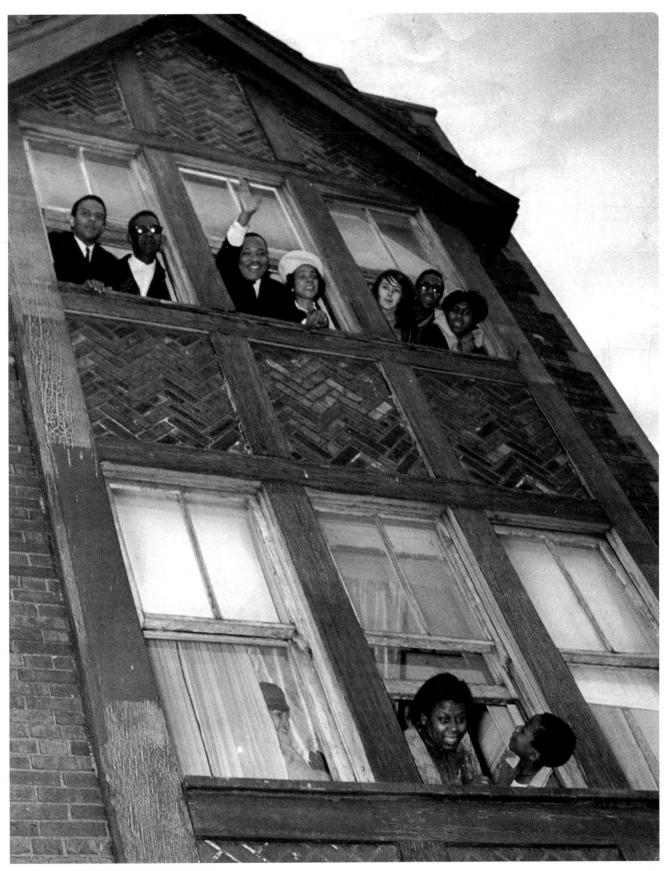

The Rev. Martin Luther King Jr. and his wife, Coretta, wave to a crowd after moving into an apartment at 1550 S. Hamlin Ave. in 1966.

Saluting the Moon Men

Apollo 11 astronauts get joyous parade after lunar landing

CHICAGO went loony for the Moon Men. It was Aug. 13, 1969, and the city threw one monster party for Neil Armstrong, Edwin "Buzz" Aldrin Jr. and Michael Collins, the Apollo 11 astronauts whose journey to the moon and back had captivated the world.

Three weeks before, the Moon Men had splashed down in the Pacific Ocean, and more than 2 million people thronged into downtown Chicago to see their "heroes" in person for, as the Tribune reported, "The astronauts were here, alive and real and with their families."

The scene was joyous bedlam. The Tribune's lead story reported: "It was more than a parade, it was glory. The brilliant blue sky was filled with ticker tape that seemed without source, streets and avenues were no longer thorofares but masses of humanity, and the cheers, the sirens, the ringing bells created so great a din that no other sound could be heard."

The astronauts were in town for a whirlwind three hours. In that time, they managed to attend a ceremony at what is now called Daley Plaza with city leaders, engage schoolchildren at the old band shell north of the Field Museum, and traverse a packed seven-mile parade route along Michigan Avenue and in the Loop—during which the cars reached speeds of 40 mph when they weren't halted by the throngs.

What was the rush? The Moon Men were on a tight schedule that started with similar ceremonies in New York City and were to end

Apollo 11 astronauts Edwin Aldrin Jr., from left, Neil Armstrong and Michael Collins acknowledge the cheers of the Chicago crowd at the Michigan Avenue Bridge on Aug. 13, 1969.

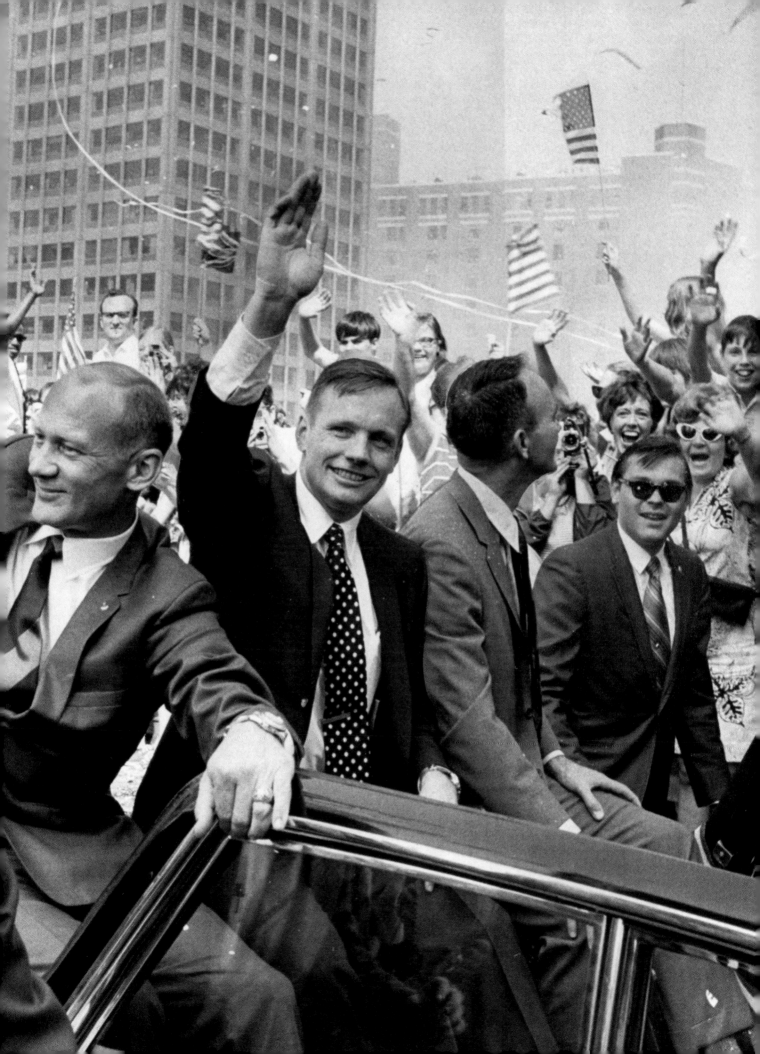

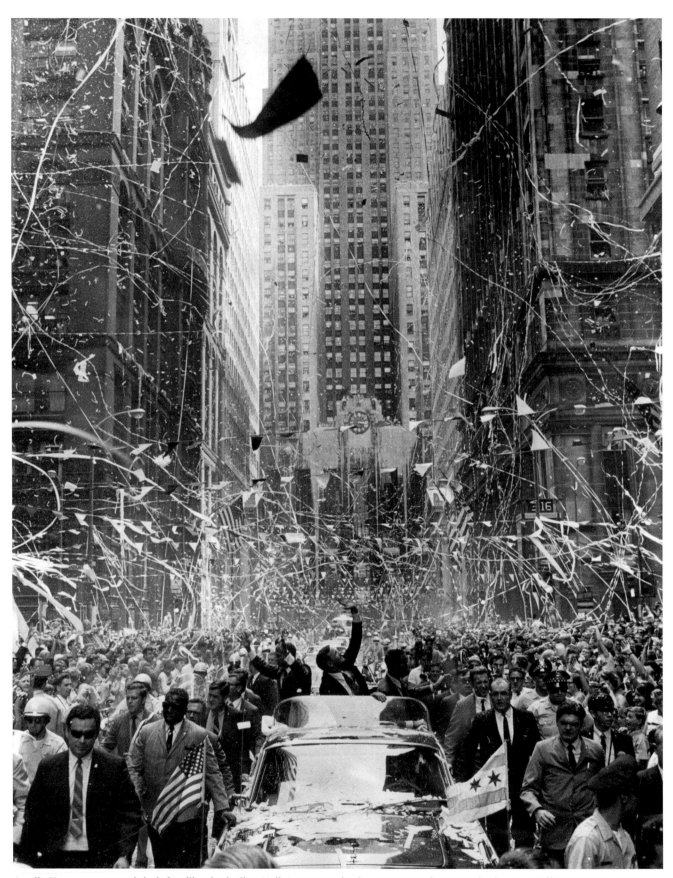

Apollo 11 astronauts and their families, including Neil Armstrong in the center waving, parade down LaSalle Street on Aug. 13, 1969, in Chicago.

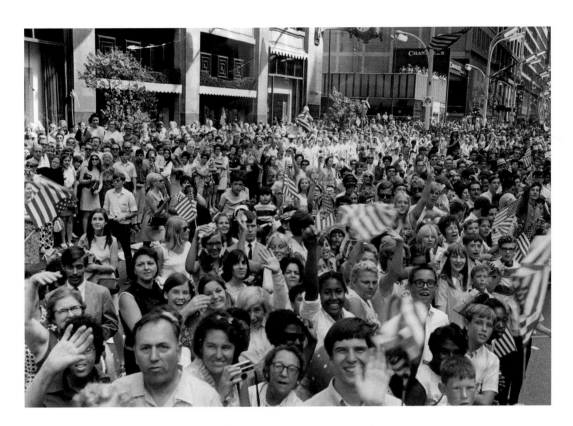

Thousands lines State Street to watch Apollo 11 astronauts and their families parade by on Aug. 13, 1969.

later that day in Los Angeles with a dinner hosted by President Richard Nixon and myriad celebrities.

While it lasted, Chicago was in heaven. Some 150 buses brought Park District day campers to Grant Park to see "their heroes." The children cheered when Aldrin said, "I bring you greetings from the planet Moon!"

Sixteen-year-old camp counselor Jacqueline Zielinski loved it. "Wow! I'd give all three of them a kiss if I could get up on that stage!" she told the Tribune.

"That sounds like me," Zielinski said in 2011 when she was reminded of her quote. "When I go to concerts, I like to get up front. I'm a first-row-seat person."

Zielinski said it was a very exciting time. She remembered watching the moon landing on TV and marveling at that August day's events. "When you stop to think that these guys were actually on the moon, and here they were in Chicago.... Wow."

She said she regrets that she never watched a shuttle launch in person, but she takes an optimistic view of the future of space travel.

"Who knows, we may be buying tickets to go up there soon," she said.

Parade-happy in 1969

The Apollo 11 astronauts weren't the only ones feted that year.

JAN. 14: The Apollo 8 spacemen, Frank Borman, James Lovell Jr. and William Anders, got a tickertape parade through the Loop. The Tribune reported that well over a million people lined the Kennedy Expressway and the parade route, though police said that didn't include the vertical crowds, the thousands who watched from office building windows. The three were the first to orbit the moon. Borman was born in Gary, though he grew up elsewhere, and the Borman Expressway is named after him.

JUNE 29: Bellwood native Eugene Cernan and fellow Apollo 10 crew member Thomas Stafford and their families were welcomed by tens of thousands of people during a parade that ended at Proviso East High School in Maywood. Their mission in May was a crucial dry run for the Apollo 11 moonwalk. Cernan would be the last person to set foot on the moon during the Apollo 17 mission in 1972.

—STEPHAN BENZKOFER

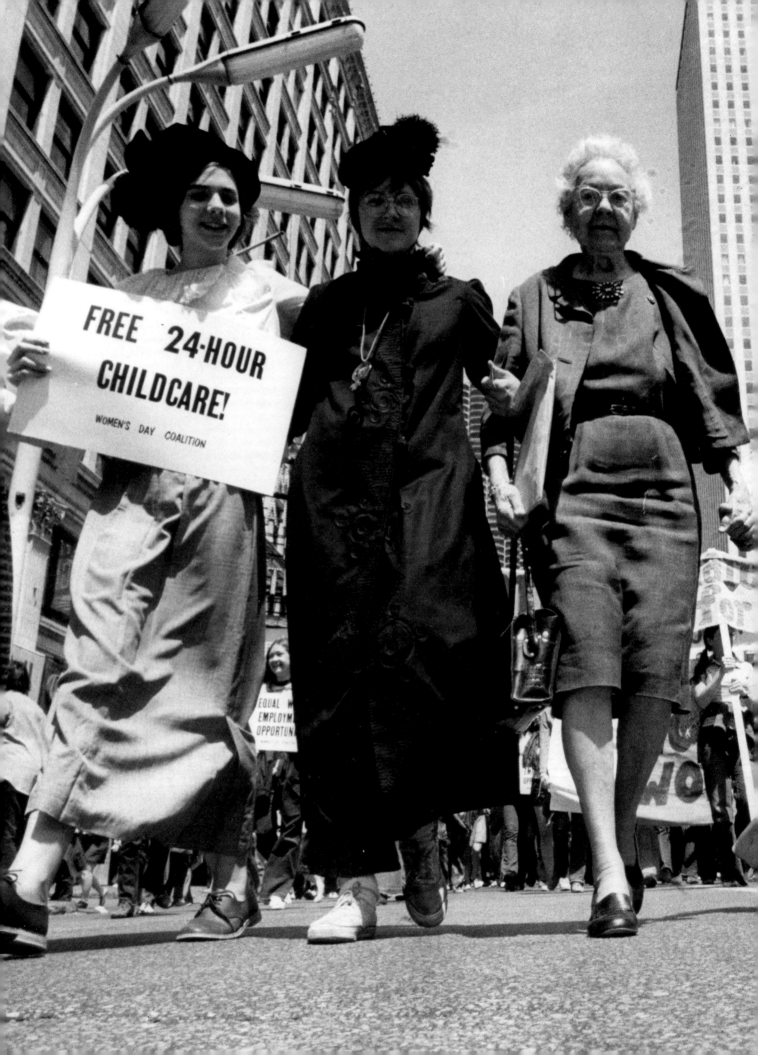

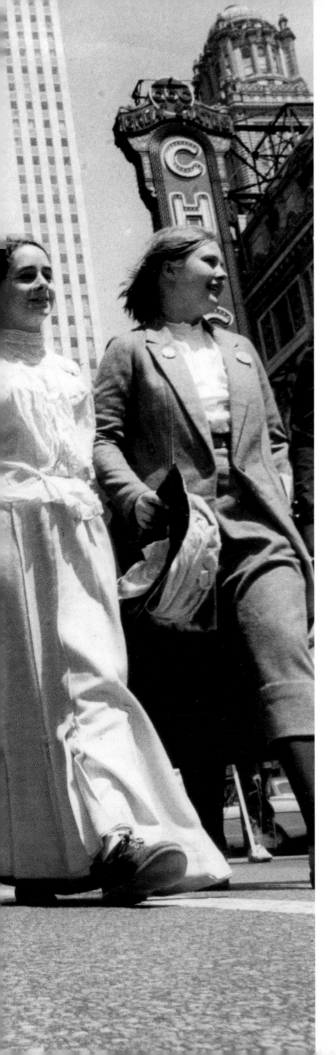

Before Roe v. Wade, the Jane Collective

Band of women persisted in fight for reproductive rights

THE anniversary of the Supreme Court's Roe v. Wade decision that decriminalized abortion sparks heated debate every year.

Before the 1973 decision, terminating pregnancies was a monopoly of back-alley abortionists. Some were medically competent, others were butchers, and a desperate woman couldn't be choosy. In Chicago, as in most parts of the U.S., a woman who wanted to end her pregnancy had few safe options—unless she found her way to the Jane Collective, a medical underground that emerged on the city's South Side.

Officially, it was the Abortion Counseling Service of Women's Liberation, and it enabled thousands of women to safely end an unwanted pregnancy in those final years that abortion was illegal.

One of the group's founders had an abortion during a time when it could be performed only if pregnancy endangered a woman's life. She barely got doctors and hospital officials to sign off on hers, even though she had cancer. But another aspect of the process troubled her too.

Women march on State Street during a rally for equal rights and health and child care considerations in 1971, when the Jane Collective was covertly providing abortions.

"Through that whole experience, there wasn't one woman involved. It was men—the doctors, the hospital board—controlling my reproductive rights and condemning me to death," she told Laura Kaplan, author of "The Story of Jane," a history of the collective.

In Kaplan's book, that woman was given the pseudonym "Jenny." Other members were similarly disguised to protect their subsequent careers. What they had done may have been laudatory to some, but it was illegal. Kaplan, who belonged to the collective, appears in her book as "Kate."

As for Jenny, the group's evolution addressed her concerns about entrusting a woman's health issues almost exclusively to men.

The Jane Collective began as a referral service, putting pregnant women in touch with reliable abortionists. By the time it closed, female members of the collective were trained to perform abortions. The women hadn't been to medical school, but their skills were attested to by a doctor who risked his license by doing postoperative checkups on the clients.

That doctor, a gynecologist, had trained at Cook Country Hospital, where poor women often wound up after being operated on by back-alley abortionists. He contrasted that with women whose abortions were performed by Jane's members.

"From my examinations, these women were not maltreated and had no ill effects," he told Kaplan.

"Their periods had returned; they were in good health; they had no complaints. All that says is that one does not need to be a doctor. You only need good training to do an abortion."

The Jane Collective's abortions weren't the first performed by Chicago women who weren't doctors. A 1918 Tribune headline read: "U. of C. Professor Says Midwife and Abortionist Are Synonymous." The accompanying story attributed that definition to Dr. Rudolph Holmes, who also fought to remove ads for abortionists from Chicago newspapers. It also quoted a Northwestern University doctor who said infant mortality rates wouldn't be reduced "until the general public realizes that child birth today is not a normal function but a pathological one."

The Jane Collective had a different take on pregnancy: The only non-normal thing about it were laws that denied access to birth control and abortion, thus robbing a woman of choice. It wasn't until 1965 that the Supreme Court overturned a Connecticut law that made it a crime for a woman to use birth control devices, or to ask a doctor to prescribe them.

"We are for every woman having exactly as many children as she wants, when she wants, if she wants," Jane's founders proclaimed.

"It's time that the Bill of Rights applied to women."

Jane was founded in 1969, in Hyde Park, home to the University of Chicago, and a neighborhood where progressive ideas were welcome. Some came to the group bearing the conviction from the civil rights movement that securing justice sometimes requires defying unjust laws. Others were feminists who were bored by endless meetings, eager for action.

Kaplan referenced her own path to an African-American spiritual. "All I know is that one day my eyes were opened, like in 'Amazing Grace': Was blind but now can see," she wrote.

She and other members—usually about 20—quickly found that the actual work was less poetic.

Rumor had it that some of the Chicago abortionists were tolerated by the cops, purportedly because unwanted pregnancies occured in police families. But there was no guarantee that wouldn't change.

"You're going to wind up in jail," one member's husband warned.

"You'll be a felon."

It was also commonly assumed that the mob controlled the abortion market. That posed a problem because the Jane Collective aimed at reducing the cost of the medical procedure, and negotiating with gangsters could be dicey. The going price was $600—a fortune to clients from poor nearby neighborhoods.

Plucky women, Jane's members dangled the prospect of volume to abortionists in return for discounts. The bait was taken by a man in Cicero who called himself a doctor. The women quickly learned that many abortionists' medical titles were self-awarded.

After cutting several deals with abortion-

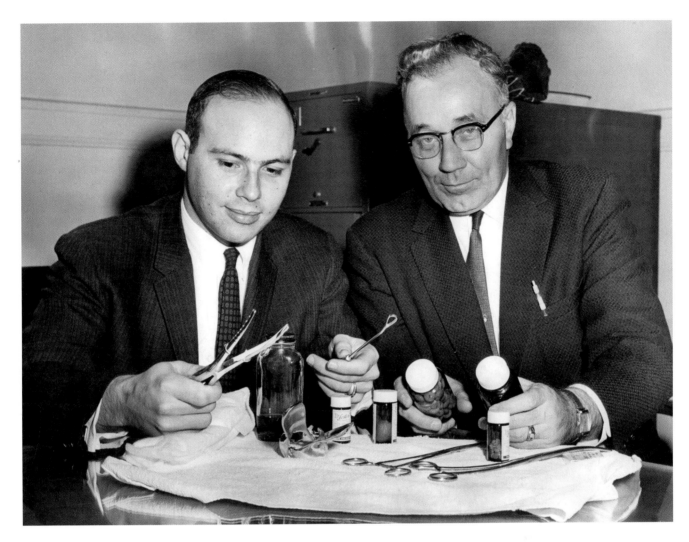

Assistant State's Attorney Allen Engerman, left, and Lt. Edward Barry of the state's attorney's police display confiscated abortion equipment in 1961.

ists—some were guaranteed 10 cases a week to bring the price down to $500—Jane's women realized they were trapped in an unholy alliance: They were do-gooders. The abortionists were rapacious. So a few of the members dreamed of cutting the "doctors" out and doing the procedures themselves.

A West Coast man who had learned to perform abortions befriended the women of Jane. He trained Jenny, who served as his nurse, to do the procedure. She trained other women, and soon the Jane Collective became an abortion provider for as many as 60 women a week.

Then disaster struck: Jane's facilities were raided by police, who kept asking: "Where's the doctor?" They couldn't imagine the women they arrested were performing abortions. The Jane Seven, as they were dubbed, were indicted by a grand jury—but spared a trial only by the Supreme Court's timely legalization of abortion in 1973.

After the court decision, the women of the Jane Collective pondered what to do with their covertly acquired skills.

A female doctor offered them a place in her office. "Could we still do abortions?" they asked. She said yes, but her lawyer said: "Within the law that would be impossible."

So they went their separate ways. One of the members said that had she not been a part of Jane, she might have "gone to my grave sweeping the floor and vacuuming."

She hosted a farewell party, attended by the West Coast man who had trained Jenny. He spoke of his time working with the Jane Collective: "There was a movement, and I was part of it. I liked that."

—RON GROSSMAN

CHAPTER FIVE:

Politics

Barack Obama's historic election

Chicagoans were jubilant in 2008 after historic vote

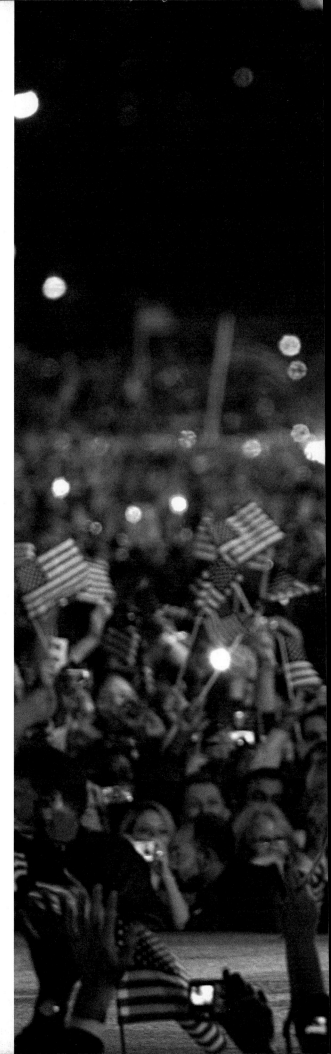

Whesthetic Barack Obama was elected president on Nov. 4, 2008, tens of thousands of people gathered in Grant Park and the nearby streets to celebrate the senator's victory, cry tears of joy and declare it a historic day. It was true: Chicago had never seen a presidential party quite like it.

The optimism was nearly tangible, as Obama's campaign slogan of "Yes, we can!" transformed that night into chants of "Yes, we did!" Residents white and black talked about how important the election of the first African-American president was to them.

Tribune reporters were on the scene.

"I never thought I would live to see a black president," said Marcie Rogers, holding a tissue to her eyes.

The famous were moved too. Civil rights leader the Rev. Jesse Jackson openly wept. TV personality and actress Oprah Winfrey hugged people all around her.

The joy spoke to race relations, to a favorite son's success and to a belief that the future would be better than today. And it stood in the face of the worst economic recession since the Great Depression.

In endorsing Obama—the first time the Tribune ever backed a Democratic candidate for

Over 200,000 celebrated at Grant Park in Chicago after Barack Obama's first election to the presidency on Nov. 4, 2008.

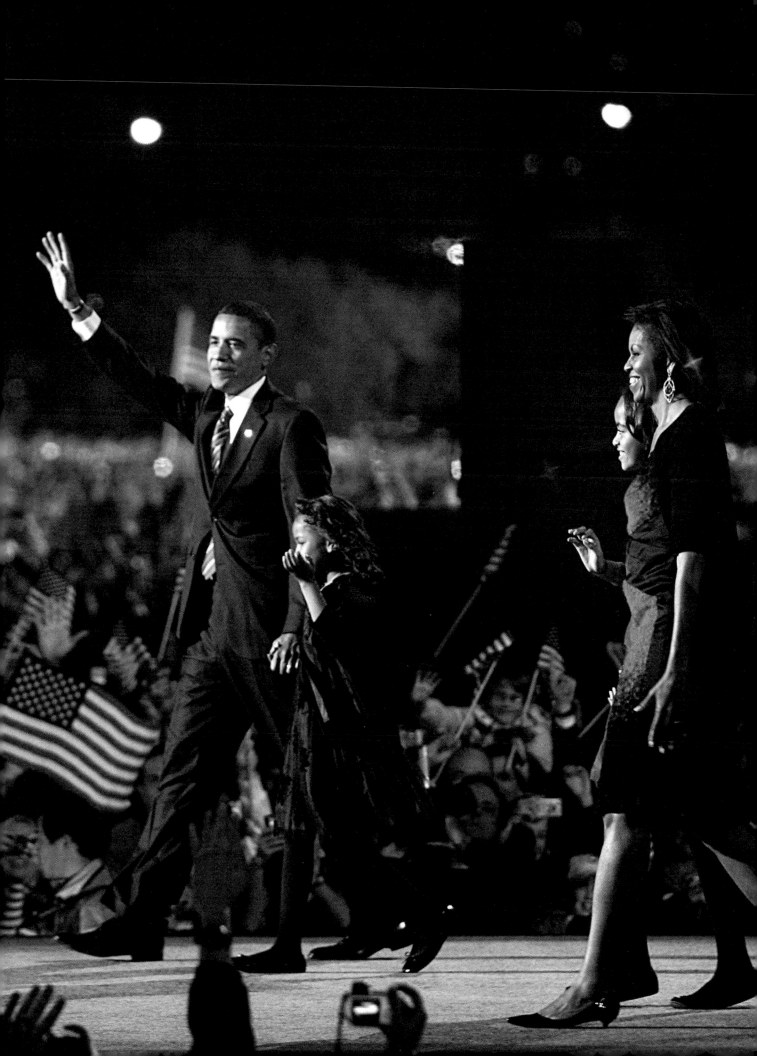

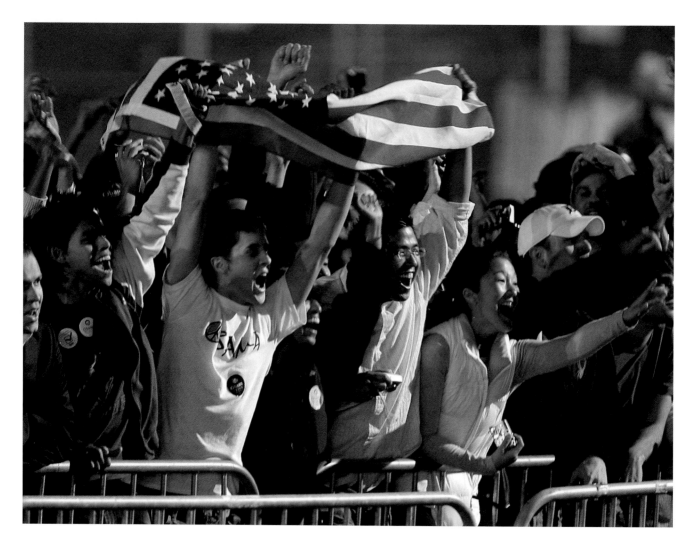

Barack Obama supporters celebrate near the stage of the election-night rally in Grant Park on Nov. 4, 2008.

president—the editorial board acknowledged those difficult, uncertain times as one reason Obama was the right candidate for the job: "On Nov. 4, we're going to elect a president to lead us through a perilous time and restore in us a common sense of national purpose."

Four U.S. presidents have had significant ties to Illinois: Abraham Lincoln, Ulysses S. Grant, Ronald Reagan and Obama. Each man was elected in the midst of political or economic crises. And while Reagan was the only one born in the state, his elevation to the highest office garnered the least enthusiasm in Chicago. In fact, he wasn't even endorsed in the Republican primary by the Chicago Tribune, which opted for local Congressman John Anderson, whose Illinois bona fides were considerably stronger: born and raised in Rockford, graduated from the University of Illinois and represented the 16th Congressional District for 20 years.

"There is hope yet for freedom, for honesty, for purity. Let distrust and apprehension be banished forever. . . . Let the people shout. The battle has been fought and the victory won."

—THE CHICAGO TRIBUNE ON LINCOLN'S VICTORY, 1860

The newspaper's editors liked Anderson's mix of conservatism and conscience as well as his "ability to see the complexity of a problem along with the determination to find the best— as distinguished from the easiest—solution."

But Anderson failed to capture the Republican nomination, and though he continued the fight as an independent, his candidacy never gained momentum.

His problem, of course, was that he was running against Reagan, the former Hollywood actor and California governor. The Great Communicator had all the charisma, and Anderson had no chance. Neither did President Jimmy Carter, for that matter. So with the favored favorite son's chances dwindling, the Tribune held its nose three weeks later and endorsed Reagan for the general election.

"We're not going to pretend that the decision was easy," the editorial stated. "There is good reason to worry about Gov. Reagan—about his age, his glibness, his inconsistencies, and his failure to delve more than skin-deep into important issues."

Yet, the endorsement argued, Anderson wasn't going to win, and a Reagan presidency would be better than four more years of Carter.

"With public support and sound management, a Reagan administration might propel us in the right direction," the endorsement said. "It's not an unrealistic hope."

Reagan won in a landslide, capturing 44 states, including Illinois. (Reagan's re-election four years later marked the last time the state of Lincoln would vote Republican for at least 32 years.)

And while there was a parade in Reagan's hometown of Dixon, about 100 miles west of Chicago, and celebrations in the streets of nearby Tampico, his birthplace, there was no outpouring of support on the streets of Chicago.

The political climate was considerably different in the 19th century, though the threats were no less dire, when Lincoln and Grant were elected.

Grant's victory on Nov. 3, 1868, came less than six months after the bitter impeachment trial of President Andrew Johnson and amid an economy struggling to find its footing after the Civil War. The celebration was boisterous yet marked by a grim relief of disaster averted, the Tribune noted. Grant's supporters were called Tanners because the general had tanned the hides of those Confederate generals and was sure to do the same to his political foes, and they marched through the streets shouting pro-Republican and pro-Union slogans. At Lake and Clark streets, the Tribune reported a "sea of heads."

"Ladies and gentlemen filled each and every window, and when the first torch passed the corner, their enthusiasm was displayed by the ignition of fireworks of every description," the unabashedly pro-Grant Tribune reported.

The stakes in the 1860 election were higher, and the Tribune's editors were more deeply involved in the campaign. Editor Joseph Medill and co-owner Dr. Charles Ray were full-throated supporters of "Honest Abe" Lincoln.

"For no fact stands out more clearly than this—that Abraham Lincoln is indebted to the people—not to the politicians—for his nomination," the newspaper wrote on May 21, 1860.

But while Medill and Ray would take credit for Lincoln's successful candidacy, the grass-roots support Lincoln enjoyed can't be discounted. The Wide Awakes, marching clubs of mostly teens and young men who supported the anti-slavery cause, were popular across the North, and they took up the Lincoln banner. In October, the Tribune reported that more than 75,000 rallied in Chicago for the Republican cause, including more than 10,000 Wide Awakes.

When Lincoln won that November, 200 guns were fired from the Randolph Street bridge and the Wide Awakes paraded 16 abreast for 10 miles through downtown streets. At the intersection of Randolph and Clark streets, rockets and Roman candles lit up the night, witnessed by a big crowd.

The Tribune was jubilant: "There is hope yet for freedom, for honesty, for purity. Let distrust and apprehension be banished forever. . . . Let the people shout. The battle has been fought and the victory won."

Yet the war was just beginning.

—STEPHAN BENZKOFER

The accidental mayor

Medill consolidated power but couldn't stomach the fight

THE man who grabbed real power for the Chicago mayor's office occupied it for scarcely 20 months and, in truth, was an accidental mayor—and a reluctant one at that.

The accident was the Great Chicago Fire, which began Oct. 8, 1871. Less than a month before that year's municipal elections, four-fifths of the city burned and 350,000 were made homeless. Stunned, Chicago's civic leaders realized that the city's survival depended upon setting aside the political squabbling for which it was famed. So they formed an ad hoc "Citizens Fire-Proof" party and asked Joseph Medill to head its nonpartisan ticket.

He was a logical choice. As editor of the Chicago Tribune, he saw its building consumed by the flames. Yet on Oct. 11 he managed to print a paper carrying a front-page editorial, beginning with the stirring words: "In the midst of a calamity without parallel in the world's history, looking upon the ashes of thirty years' accumulations, the people of this once beautiful city have resolved that CHICAGO SHALL RISE AGAIN."

Still, Medill initially declined to run. In a letter to a son-in-law, he explained that "the powers of the mayor were so restricted that he did not amount to much more than a figurehead."

Joseph Medill, 1880

But his suitors kept up the pressure, and Medill relented, while driving a hard bargain. He would run if they would sponsor a bill in the Illinois legislature amending Chicago's charter by putting some teeth in the mayor's prerogatives. Should the bill fail, Medill warned, "I would feel at liberty to resign the office and slip down and out."

Eventually he did "slip down and out," but not before changing the whole game of Chicago politics. Historians credit Medill with creating the mayor's office as we know it. Before him, mayors greeted visiting dignitaries and cut ribbons. The aldermen called the shots. But seizing on the powers handed him by the legislature—a veto over City Council actions, authority to hire and fire city officials—Medill set the stage for the strong-willed, occasionally strong-arming, mayors to come: Anton Cermak and Edward Kelly, co-founders of the Chicago Machine; the two Daleys; Jane Byrne; Harold Washington; and Rahm Emanuel.

It wasn't easy. Although Medill got three times the votes of his Democratic opponent in the November election, Democrats won seven of the 20 aldermanic seats, enough to ensure that the City Council wasn't going to roll over and play dead. For his part, Medill took a thinly veiled swipe at the Democrats in his inaugural address:

"When the municipal rulers of a city are sober, upright and honest men, and discharge their duties with integrity and dignity, they set an irresistible example for good before their fellow citizens which powerfully quickens and promotes common honesty and fair dealing among all classes."

The implication was clear: I and my friends are honest; you and yours are crooks. The city's population was then roughly half immigrants and half patricians like Medill, who told a Senate committee that workers "squander the greater part of their wages in drink and tobacco." Medill denounced the spoils system, by which aldermen considered jobs and con-

tracts as theirs to hand out. With the city's finances nearly exhausted, belt-tightening was in order, the mayor insisted. "The services of hundreds of persons now on the payrolls can be dispensed with."

Those different perspectives set up a prequel to the Council Wars of the Washington era in the 1980s. After the Chicago Fire, aldermen and real estate developers wanted to house the homeless in the same kind of frame buildings that had burned. In his inaugural address, Medill prophesied: "If we rebuild the city with this dangerous material, we have a moral certainty, at no distant day, of a recurrence of the catastrophe."

Medill won that battle, vetoing council ordinances allowing some frame construction, a victory consolidated by a new fire code that prohibited any new wooden structures in Chicago. The city limits of Medill's day are still to be seen along streets where brick-and-stone structures give way to wooden buildings.

Extracting the police and fire departments from the spoils system was tougher going. Aldermen were shocked when the corporation counsel, at Medill's bidding, ruled that they no longer could hire the cops. Wasn't that the way things were always done? For their part, council members challenged Medill's assertion that he had the authority to revoke saloon licenses. The neighborhood saloon was many a ward heeler's headquarters, a place to press the flesh and distribute largesse.

The two issues collided when Medill replaced the get-along-go-along police chief with a reform-minded cop who wasn't even a Chicagoan. Worse, the new chief ordered taverns to close at 11 p.m. The police board, an Old Guard stronghold, fired the police chief for "negligence of duty." In reality, it was for doing his duty, and Medill responded by firing two members of the police board. But when he nominated replacements, the remaining board members boycotted a meeting to confirm them, while the fired members showed up.

Under the headline "When Will It End?" the Tribune reported the resulting circus as if it were a fashion show: "It is true that the ex-commissioners were present, Mr. Reno in a striped overcoat and Mr. Klokko in a silk hat,

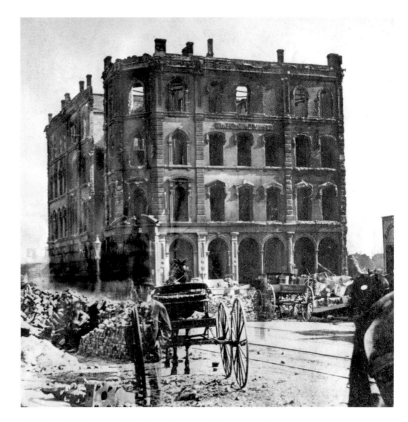

which well became his classic cast of features."

In fact, the end was nigh for Medill's mayoralty. The culture wars were taking a toll on Medill, a teetotaler trying to govern a city of corner taverns. When immigrant groups organized a People's Party to oppose him—a mayor's term then was two years—he decided not to give them the opportunity.

In August 1873, he informed the council that he "would be absent from the city for an unspecified period of time." He went off on an extended European vacation, and the aldermen appointed an "acting mayor," who served the rest of Medill's term.

His reforms largely survived, though, and Medill returned to his earlier loves, journalism and political kibitzing. As editor of the Tribune, he offered advice to President William McKinley, as he previously had to President Abraham Lincoln. But asked to run for the U.S. Senate, Medill declined, indicating he'd learned a lesson during his brief time in Chicago's City Hall. He expressed it in true patrician style:

"Politics and office seeking are pretty good things to let alone for a man who has intellect and individuality."

—RON GROSSMAN

The first Tribune Building at Dearborn and Madison burned in the Great Fire of 1871.

Capone's battle for Cicero

Threat of reform in Chicago pushed gangster into suburb

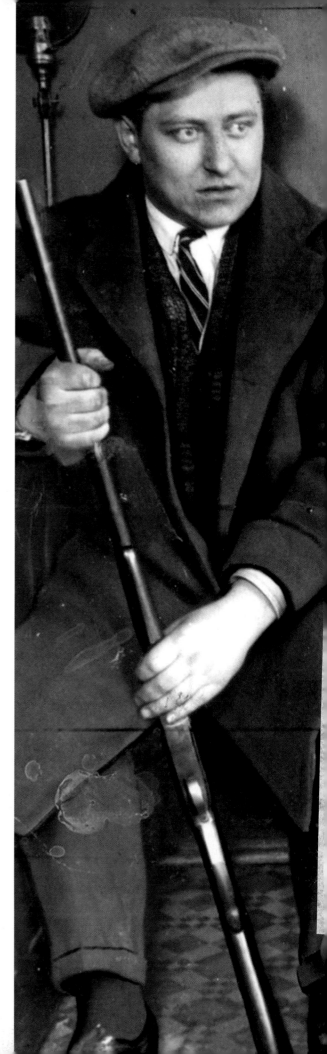

W HEN reporters write today that political candidates took shots at each other and their supporters battled for voters, readers know it is figurative language to spice up humdrum campaign coverage.

On April 1, 1924, such language was literal.

"Bullets Fly in Cicero on Election Eve" was the headline over a story that described "gun play and riotous scenes" in the western suburb ahead of its local vote. The man who had the nerve to run against Mayor Joseph Klenha was roughly handled, to say the least. Gunmen shot up his offices, and he "fled from the headquarters with bullets whistling at his heels and took refuge in a nearby house."

The Democratic challenger for city clerk was pistol-whipped in front of his wife, children and numerous supporters. Men who came to his defense were answered with brass knuckles. Campaigners from both parties were beaten up on town streets by roaming gangs of "sluggers." Election violence was not unheard of in the 19th and early 20th centuries, but this was a whole new level, even for Prohibition. The next day, under the screaming banner headline "GUNMAN SLAIN IN VOTE RIOTS," the Tribune reported that the Cicero election was "marked by shootings, stabbings, kidnappings, and other outlawry unsurpassed in any previous Cook County political contest."

What was happening in Cicero?

Three Cicero residents guard a Democratic candidate's headquarters against mobsters during the 1924 election, when election workers were attacked and kidnapped. The headquarters had been shot up earlier in the day.

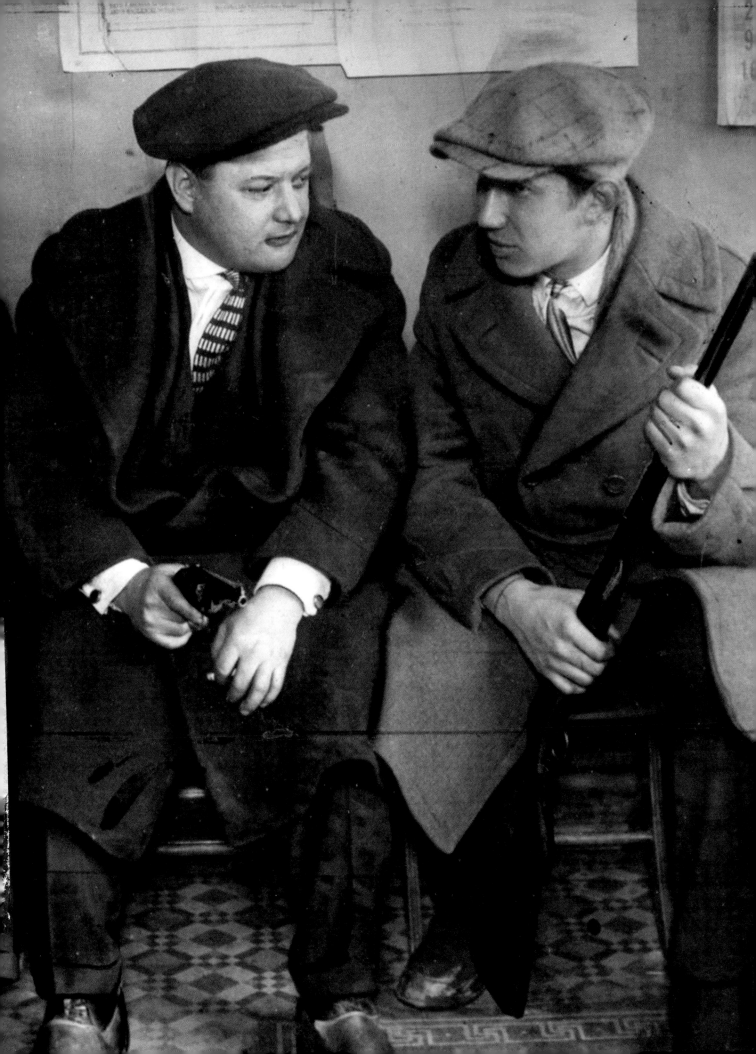

Cicero police Chief Albert W. Valecka, left, with one of the people injured by roving bands of "sluggers," who intimidated, beat up and even kidnapped voters, election workers and campaign workers on Election Day in Cicero in 1924. Valecka was ousted by the Republican election winner, and Capone-backed candidate, Joseph Z. Klenha, one month after the election.

Al Capone. Scarface was taking control of the town, though he would pay dearly. In 1923, Chicago voters elected reformer William Dever after enduring eight years of notoriously corrupt William Hale "Big Bill" Thompson, who was in bed with gangster Johnny Torrio. The reform movement didn't have much of a chance against the powerful bootleggers, but it spooked Torrio anyway and the mobster decided he needed a second base of operations in case Chicago suddenly decided to take the Volstead Act seriously. He picked Cicero, and the man he sent to do the job was Capone, then just a young gunman and brothel bouncer.

According to Chicago municipal Judge John Lyle, who battled bootleggers and corruption throughout his career, when the mob wanted in on the action, small-time gangsters didn't have much of a chance. Capone muscled some, bribed others and threatened still others with retaliation from Cook County Sheriff Peter Hoffman, who was in Torrio's pocket. He also went directly to the voters, paying off mortgages and buying new fur-

naces, Lyle wrote in his 1960 book, "The Dry and Lawless Year," which was excerpted in the Tribune.

Cicero politics was turned on its head, and Klenha suddenly worried for his future. According to Lyle, "He asked Capone's assistance in turning the tide. Scarface was only too happy to oblige."

Unlike the mob's multipronged campaign to infiltrate Cicero vice, Capone's election day game plan was nothing but brute force and terror. Commanded by Al and his brothers Frank and Ralph, gunmen in automobiles "sped up and down the streets, slugging and kidnapping election workers," the Tribune reported. "A Cicero policeman was disarmed, beaten and sent to the hospital."

Stanley Stankievitch, a Democratic worker, was one of the first kidnapped. "He was blindfolded, carried to a basement, and held a prisoner until 8 o'clock last night, when he was tossed out of an automobile at Harrison Street and Laramie Avenue," the Trib reported. He was hospitalized in serious condition. As many as 20 men were kidnapped, carted off to

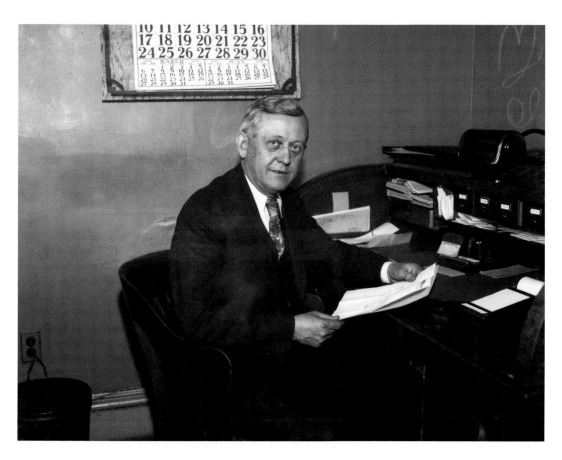

In 1924, Cicero Mayor Joseph Klenha sought help for his re-election campaign from Al Capone, according to a book by John Lyle.

the basement of a plumbing shop in the city, and chained to pipes and posts.

Would-be voters were accosted outside polling places, and if they didn't have the right answer to "Who ya votin' for?" they were sent packing—or worse.

By the afternoon, election officials appealed for help, and a Cook County judge deputized 70 Chicago police officers and five squads from the detective bureau to try to bring law and order back to Cicero.

It was one of these detective squads that rolled up to 22nd Street and Cicero Avenue, in the shadow of the massive Hawthorne Works facility of Western Electric Co., to see three gunmen clearly up to no good. One of the gunman was Frank Capone, who opened fire on the detectives. He missed; they didn't. Frank fell dead. His brother Al "took to his heels." He was never arrested.

The Chicago cavalry's rout of the Capone brothers failed to turn the tide at the polls. Klenha and his GOP cohorts won by comfortable margins. The brazen violence shocked many Chicagoans, but nothing much came

of it. There was a short investigation and four low-level thugs were jailed for assaulting voters, but in short order, "Scarface came out of retreat and swaggered down Cicero Avenue," Lyle wrote.

Capone set up shop in the three-story brick Hawthorne Inn, which no longer exists, and Cicero became "Caponeville." (If Klenha had any illusions of being mayor, it was corrected after Capone once knocked him down outside City Hall.)

Klenha was re-elected handily in 1928, with Chicago police again standing guard, though by then Capone didn't need overt thuggery to stay in power. But in April 1932, Klenha's GOP machine was "smashed to bits," the Tribune reported, "by an outpouring of Democratic votes such as had never been approached in the town before."

What was happening in Cicero?

Al Capone had other things to worry about.

He had been convicted in October 1931 for tax evasion—and was due to start his 11-year prison term the next month.

—STEPHAN BENZKOFER

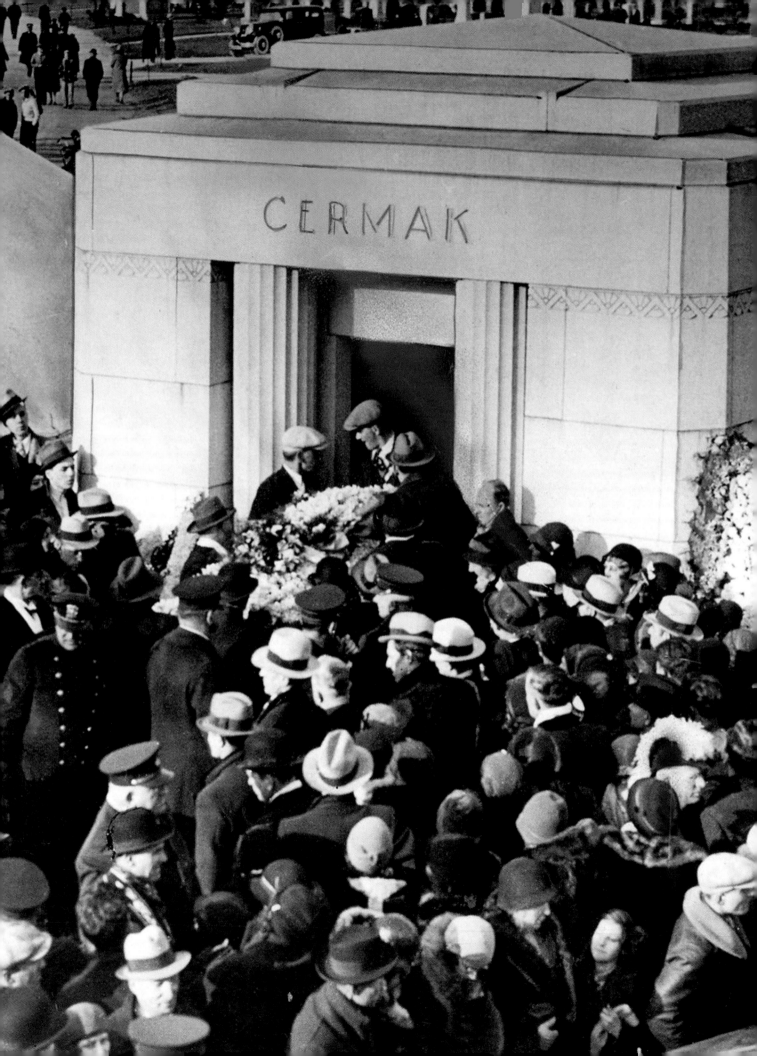

'Tell Chicago I'll pull through'

A bullet meant for FDR hit Chicago Mayor Anton Cermak

I N 1933, Chicago Mayor Anton Cermak was shot in Miami by a "maniac" aiming to kill President-elect Franklin Roosevelt. Cermak was rushed to the hospital in Roosevelt's car.

So began a 19-day ordeal as Chicagoans waited to hear if their mayor would pull through. As Cermak was fighting for his life in that Miami hospital, Tribune readers got a crash course in trauma medicine—and remarkable access as the drama unfolded.

Day 1: 2 a.m. Feb. 16, 1933, just hours after the bullet lodged hear his spine, the 59-year-old first-term mayor was given "more than a 50-50 chance" of survival, doctors announced. They reported his vital signs as normal but his condition was "regarded as dangerous": Pulse, 88; temperature, 98.6; respiration rate 24.

"Normal pulse for an adult of Cermak's age varies from 74 to 88; normal respiration is 18 to 22; normal temperature is 98.6," the Tribune explained.

Roosevelt was returning from a fishing trip on Feb. 15 and stopped at a rally in a Miami park. Enthusiastic supporters cheered and waved at his motorcade as it wound its way from harbor to park. At the park, he found VIPs seated at a band shell and thousands more people crowded around. His open-topped car was driven up to the band shell, where the president-elect noticed Cermak.

Roosevelt smiled broadly and motioned the Chicago mayor to join him, the Tribune reported.

But Cermak shook his head and said, "After the speech, Mr. President."

So Roosevelt took up a microphone, said a few words, then "beckoned again to Mayor Cermak, who came down the steps of the shell to the car. They shook hands warmly" and exchanged a few words.

"Suddenly two shots rang out," the Tribune reported. One witness said Cermak fell. Another said the mayor sagged but didn't fall down, instead turning to his friend and travel companion Ald. James Bowler and saying, "I'm hit, Jim."

Roosevelt's driver and security detail had immediately covered FDR and started driving away, but Bowler yelled, "Mr. Roosevelt, Mayor Cermak is shot. Wait."

Cermak was "half dragged across the few feet" into the waiting car and pushed in next to Roosevelt. Once at the hospital, Cermak reportedly uttered the line that is engraved on his tomb. Speaking to FDR, Cermak allegedly said: "I'm glad it was me instead of you." The Tribune reported the quote without attributing it to a witness, and most scholars doubt it was ever said. The newspaper at the time didn't doubt it—or at least liked the sentiment enough to perpetuate it. The quote was featured two days later in Carey Orr's Page 1 cartoon headlined "The Voice of a Patriot."

Day 3: 2:55 a.m. Feb. 18. Pulse 94, temperature 99.8; respiration 24. Mayor is resting easily but now it is reported that the bullet pierced a lung, and he has been coughing up blood. Further, the mayor already suffered from a pre-existing heart condition; was he strong enough to survive this stress?

"Tell Chicago I'll pull through," Cermak said from his hospital bed. "This is a tough old body of mine and a mere bullet isn't going to pull me down. I was elected to be World's Fair mayor and that's what I'm going to be."

That wasn't the only reason he was elected. Many had invested their hopes and dreams in this foreign-born Czech immigrant. The Great Depression was tearing apart the social fabric

Opposite: A crowd of 50,000 attends the burial services for slain Chicago Mayor Anton Cermak on May 10, 1933.

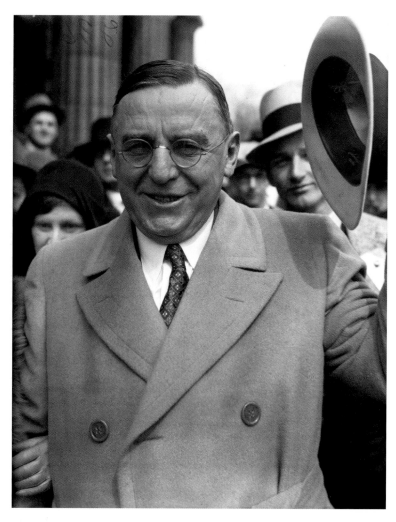

of the city and nation. Chicago's financial situation was dire.

Reform-minded citizens, including the Chicago Tribune, wanted him to continue cleaning up City Hall, which had been a cesspool under a third term with the notorious William Hale "Big Bill" Thompson.

"All right-thinking citizens of Chicago have come to have a high regard for the man," the Tribune editorialized two days after Cermak was shot. "We think he faced his problems courageously and did the best that was in him to put this punch drunk city back on its feet, to restore its reputation in the eyes of the world."

The varied ethnic communities had rallied around a fellow working man who truly seemed to understand them. With very little formal schooling, Cermak proved to be a decisive leader and a natural organizer, the Tribune would later say. By bringing together the

Germans, Czechs, Italians, Jews, Russians, Lithuanians and even the disaffected Irish, he created the Chicago Democratic Party Machine. But he was not a saint.

He was tough, never shying from a fight, be it figurative or literal, and once somebody was a member of the party, that person had better obey. "He demanded loyalty and discipline, and he made sure he got it by whatever means it took," the Tribune said.

But Cermak was the kind of brilliant politician who could make all these disparate groups see what they wanted to see. So the whole city was counting on him to pull through.

Day 7: 4:30 a.m. Feb. 22. Pulse 108, temperature 101.2, respiration 30. Doctors report the mayor is in considerable pain despite opiates as his fever spikes. "If he is not better by morning, the situation will be very grave, indeed," says Dr. Karl Meyer, chief surgeon at Cook County Hospital and one of seven doctors attending Cermak. The Tribune's headline reads, in part, "MAYOR IN CRISIS."

Day 12: 2:30 a.m. Feb. 27. Pulse 128, temperature 101, respiration 36. The medical team's greatest fear is realized. Cermak faces a threat even deadlier than the bullet: pneumonia. "The latest complication stunned the group of physicians at his bedside and reduced them to despair," the Tribune reports.

The would-be presidential assassin was Giuseppe Zangara, a naturalized Italian-American who hated government, the Tribune reported. He was sitting about four or five rows back when he stood up and opened fire on the president. He might have been more successful if Mrs. W.F. Cross hadn't grabbed his arm and pushed it into the air. Zangara managed to get off a few more shots before the crowd descended on him, beating him severely. "A policeman with a blackjack belabored the assassin unmercifully until it seemed he would be killed," the Tribune reported. In court, Zangara didn't put up any defense, and justice was swift. Just six days after the attack, he was sentenced to 80 years of hard labor. When he heard the sentence, he said, "That's fair! That's right! I'm satisfied!"

Day 14: 2:45 a.m. March 1. Pulse 120, temperature 101, respiration 36. Cermak rallies and

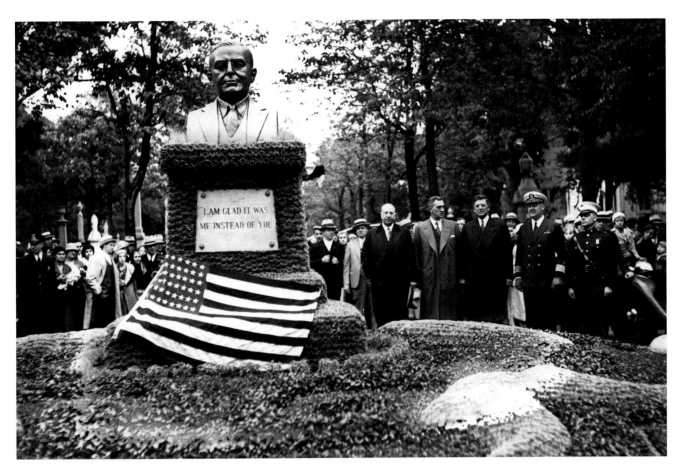

Mayor Anton Cermak's memorial service at the Bohemian National Cemetery in Chicago in June 1933.

is able to eat a little. He's even strong enough that his famous temper flares. "Take that tent thing off me and give me something to drink. Quit shooting that stuff into my arm and leave me alone. I'm going to get well," he says. The doctors are all smiles.

Day 18: 3:30 a.m. March 5. Pulse 126, respiration 32. Cermak is in considerable pain. His groans can be heard 100 feet from the oxygen room. Gangrene has developed in his right lung.

Cermak died at 5:57 a.m. Chicago time on March 6, two days after Roosevelt took the first of his four oaths of office. The end came peacefully, the Tribune reported, with Cermak surrounded by members of his family, three daughters, their husbands and children.

The outpouring of public grief and respect in the following week was immense. Crowds met Cermak's funeral train at stops all the way from Florida to Chicago. Back home, thousands solemnly marched through the Cermak home at 2348 S. Millard Ave. to view the mayor's body. Then tens of thousands waited in

line for hours in the bitter cold to pay their respects while his body lay in state in City Hall. Many had to be turned away then as mourners escorted his coffin to a packed Chicago Stadium for the service. Then the final march began. About 30,000 joined a procession from the stadium to Bohemian National Cemetery at Foster Avenue and Crawford Avenue (now Pulaski Road) on the Northwest Side.

A crowd of 50,000 was estimated at the cemetery. The Tribune summed it up: "Mayor Anton J. Cermak was buried yesterday after the most spectacular funeral demonstration ever seen in Chicago."

On the same day, March 10, Zangara was re-sentenced to die by electrocution for Cermak's murder.

Five days later, the City Council voted to change the name of 22nd Street to Cermak Road.

And less than a week after that, Zangara was executed.

—STEPHAN BENZKOFER

The Lager Beer Riot

Violent protest proved immigrants' political power

L ong before Donald Trump touted his border wall, Chicagoans elected a mayor on the anti-immigrant, anti-Catholic platform of the Know-Nothing Party.

In his March 13, 1855, inaugural address, Levi Boone, a doctor by profession, warned ominously: "I cannot be blind to the existence in our midst of a powerful politico-religious organization, all its members owing, and its chief officers bound under an oath of allegiance to the temporal, as well as the spiritual supremacy of a foreign despot."

That would be the pope. Railing against the head of the Catholic Church and his American followers, many of them immigrants, was a popular political strategy of the day. It made a national force of the Know-Nothing Party, a virulently xenophobic group demanding a 21-year residency for people seeking citizenship. It also wanted public offices restricted to native-born Americans. Also called the American Party, the group got its name because early members reportedly were supposed to disavow any knowledge of the group.

Buoyed by his victory, Boone decided that if he couldn't get rid of the foreigners flocking to Chicago, he could deny them a bit of life's pleasures. In that era, the six-day workweek was standard. On the seventh day, Germans liked to relax in a tavern with a stein of beer, an old-country tradition. The Irish also enjoyed a nip or two.

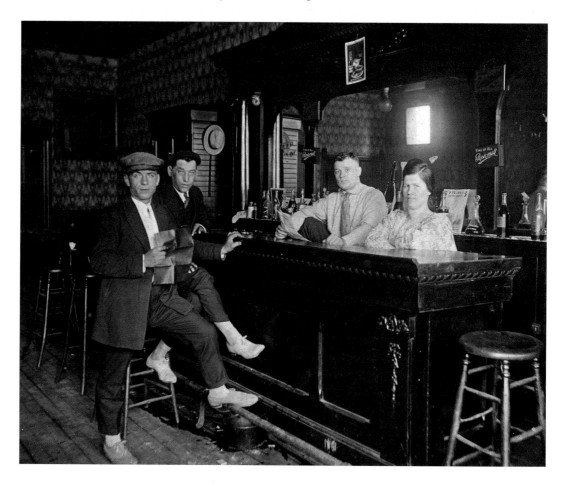

A husband-and-wife team worked as saloonkeepers around 1900 at this Chicago neighborhood tavern. Nearly 50 years earlier, Chicago's mayor, elected on the anti-immigrant platform of the Know-Nothing Party, sharply raised liquor license fees to try to shut down German- and Irish-owned bars. What he got instead was a riot.

The Tribune, which backed Boone for mayor, connected the dots: "Who does not know that the most depraved, worthless and irredeemable drunkards and sots which curse the community are Irish Catholics?"

A temperance advocate himself, Boone ordered the police to enforce an old ordinance requiring taverns to be closed on Sunday—at least, in immigrant neighborhoods. Taverns where American-born patrons drank whiskey were quietly allowed to remain open. Boone also increased the annual liquor license fee to $300 from $50, hoping to drive out of business Irish- and German-owned taverns (625 out of the city's 675).

Soon, about 200 tavern owners were up on charges of violating the Sunday-closing law. In a test case, one tavern owner was brought to trial, stirring an immigrant protest march on City Hall. "They filled the sidewalks and pushed the Americans... into the street," the Tribune reported of the events of April 21, 1855. "In the Lager Beer Saloons other parties were engaged in loading their guns and preparing apparently for a fight."

The mayor hurriedly swore in more peace officers and put the National Guard on alert, but an immediate clash was averted by a quick-thinking bridge tender. As the marchers, coming from the north with fife and drum, approached the Chicago River at Clark Street, he swung the bridge open, preventing most protesters from reaching their goal.

It proved only a brief postponement of a long-festering conflict. Chicago's early settlers were chiefly English-speaking Protestants, a demographic that mirrored the nation as a whole. But then large numbers of Irish came, seeking refuge from a devastating famine. Germans joined them, political refugees after an unsuccessful Revolution of 1848. By 1855, Chicago's foreign-born residents were approaching half of its total population.

Like ethnic groups yet to come, they were accused of every possible human failing. An 1854 Tribune headline proclaimed: "Irish Riot In The Thirteenth Ward." A letter to the editor posed a series of rhetorical questions about immigrants: "How many are occupants of our police courts, jails, penitentiaries and pauper houses?... How many cannot read, write, think for themselves or vote without being led or bought by whiskey and clerical demagogues?"

By the afternoon on April 21, Boone felt he had assembled sufficient force. He had a pair of cannons set up in front of City Hall at Clark and Randolph, ready for the crowd when it finally streamed across the bridge. "The Germans fought savagely and repelled the officers with the obstinacy so peculiar to that race of people," the Tribune reported. "One German was taken off the field of battle with his head pounded to a jelly." Another "had his nose almost entirely knocked off by a blow from the baton of one of the officers."

One protester was killed and dozens wounded in the brief clash, but the resulting backlash destroyed Boone's political career. That summer, a statewide referendum on prohibition was voted down. In the following year's mayoral election, the Irish and Germans got together to defeat the anti-immigrant slate. Boone didn't even stand for re-election. The tavern license fee went back to $50, and pubs again opened on Sundays.

It marked the emergence of ethnic politics that a subsequent election would lock into Chicago's DNA: Mayor Joseph Medill, longtime Chicago Tribune editor, revived Sunday closings, only to have his efforts frustrated by the Irish and Germans in 1874. Anti-immigrant sentiment long remained a national political force—only in 1960 did John Kennedy become the first Catholic president—but the Know-Nothing Party declined precipitously soon after the Lager Beer Riot. In the years leading up to the Civil War, the slavery issue eclipsed preoccupation with immigrants.

The Know-Nothings were accused of being sympathetic to Southern slaveholders. Boone held that slavery was endorsed by the Bible, and during the Civil War he was charged with helping a Confederate prisoner escape from a Chicago POW camp.

Boone eventually made his peace, if not with immigrants, then with their favorite drink. According to an 1877 report: "Venerable Dr. Boone, who is now in mellow old age enjoys a glass of beer... as well as the next man."

—RON GROSSMAN

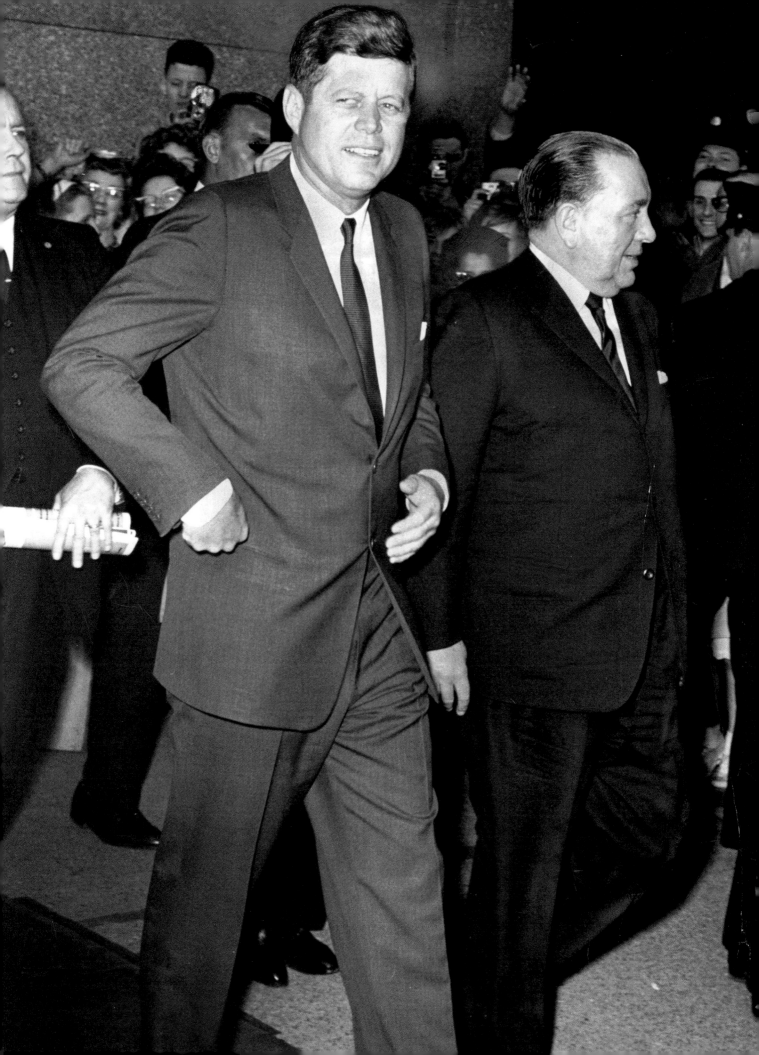

Why JFK came to town

Visit knits Kennedy, Daley, O'Hare storylines together in city fabric

IN early 1963, President John F. Kennedy came to Chicago to officially dedicate O'Hare International Airport. The visit offers a window into two Chicago families: the Daleys and the O'Hares.

The trip is also of interest in light of Kennedy's assassination, which staggered the nation eight months later. The Tribune report on the balmy March Saturday here carried eerie echoes of the Dallas trip. The Trib reported that Kennedy's motorcade route downtown was lined with cheering supporters, that he ordered his plastic bubble-topped limo stopped at the Cumberland Avenue exit so he could shake hands with residents, that highway traffic ground to a halt as motorists left their cars and crossed the median to get a closer look at the president. That highway still was called the Northwest Expressway. It would be renamed in his honor a week after his death.

The O'Hare dedication was blatant political theater. As the Tribune noted, the need for such a ceremony was suspect: The airport had been renamed in memory of a heroic aviator in 1949 and again feted in 1955, when it was opened to commercial traffic.

But Daley was in the midst of a re-election campaign against former Cook County State's Attorney Benjamin Adamowski, who hammered away at what he called Daley's shady construction contract deals involving the airport's expansion and made inroads with the city's white ethnic community.

It wasn't lost on anybody that the event would bring the popular president to town just two weeks before the April 2 election. It also was no accident that Kennedy flew here with U.S. Reps. Roman Pucinski and John Kluczynski, the state's high-profile Polish-American politicians backing Daley in his fight with Adamowski. Kennedy played his part, too, praising the airport and the mayor who fought to build and expand it. Daley would beat Adamowski with 56 percent of the vote.

But the political considerations didn't diminish Navy pilot Edward "Butch" O'Hare's heroism. As Kennedy said, O'Hare's "courageous acts" in the early weeks of World War II inspired him and other Americans in those "dark days."

Then-Lt. O'Hare was flying solo support for the aircraft carrier Lexington, four cruisers and 10 destroyers on Feb. 20, 1942, in the South Pacific. The Lexington's other fighters had just repelled an attack by Japanese bombers and were refueling and rearming when a second Japanese squadron of nine bombers appeared.

The 28-year-old O'Hare, seeing his first action, threw his plane into the fray, knowing that if the bombers got through, the Lexington and its 1,700-man crew would almost certainly be lost. O'Hare had speed and maneuverability on his side, but he was heavily outgunned. The nine bombers had three guns each to direct at the single American fighter. But in less than five minutes, O'Hare shot down five of the massive planes and damaged a sixth before approaching reinforcements from the Lexington sent the Japanese bombers fleeing. Only one escaped.

Coming less than three months after Pearl Harbor, O'Hare's heroism was the jolt of good news the United States needed. President Franklin Roosevelt presented now-Lt. Cmdr. O'Hare the Medal of Honor on April 21. The citation called his feat "one of the most daring, if not the most daring, single action in the history of combat aviation."

Opposite: President John F. Kennedy joins Mayor Richard J. Daley in Chicago on March 23, 1963, the day of the O'Hare dedication. The airport had been renamed in 1949 and again celebrated in 1955, when it was opened to commercial traffic.

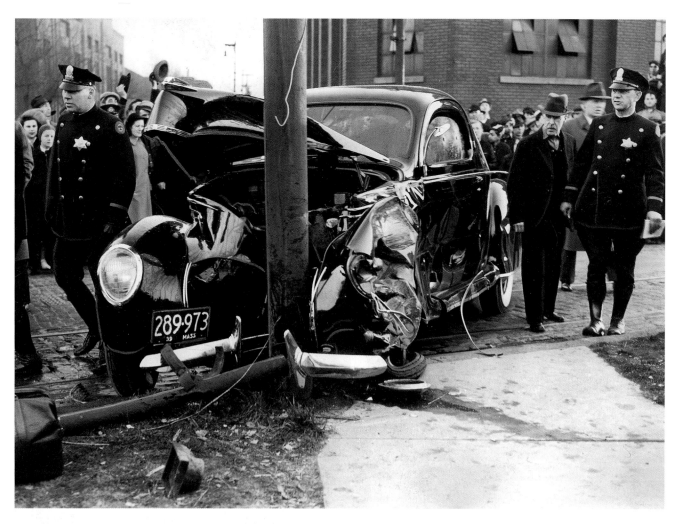

Edward O'Hare's car crashed after he was killed by two shotgun blasts during a high-speed chase along Ogden Avenue in 1939. He was said to be killed on orders of Al Capone.

But O'Hare wouldn't survive the war. America's first World War II naval ace was shot down in November 1943 in a nighttime dogfight defending his ships from a torpedo plane attack in the Pacific. His death was front-page news.

The O'Hare name wasn't new to Tribune readers. On Nov. 8, 1939, Butch's father, Edward O'Hare, who was president of Sportsman's Park racetrack in Stickney and the frontman for Al Capone's gang syndicate, was gunned down in a gangland execution. His crime? Double-crossing Capone. When the mob boss went to prison in 1932, he appointed O'Hare to run the racetrack. But five years later, as he sat in federal prison, Capone learned it was O'Hare who had cooperated with the government to send him to Alcatraz, according to a Tribune scoop published just days after O'Hare's murder. O'Hare lived in fear the last two years of his life, rarely driving his cars or even sleeping in his own house, the Tribune reported. The precautions

were for naught. About a week before Capone was released from prison, O'Hare was killed by two shotgun blasts during a high-speed chase along Ogden Avenue. His car crashed into a pole just west of Rockwell Street.

The Tribune surmised that O'Hare risked Capone's wrath not only because he faced his own tax problems but also because he wanted to preserve the gang's lucrative businesses. He recognized the feds wouldn't give up until Capone was "out of the picture."

Eight years later, Frank Wilson, one of the main federal investigators who got Capone and who would later become chief of the Secret Service, wrote about O'Hare's importance and role in putting Public Enemy No. 1 in prison: "On the inside of the gang, I had one of the best undercover men I have ever known: Eddie O'Hare."

As it turned out, bravery ran in the family.

—STEPHAN BENZKOFER

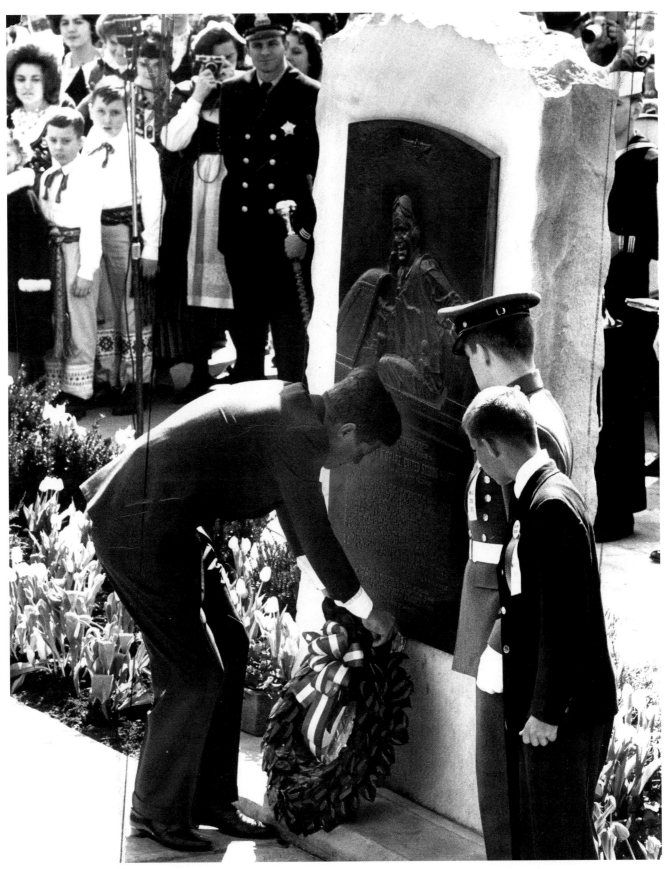

President John F. Kennedy lays a wreath on the monument to Lt. Cmdr. Edward "Butch" O'Hare in March 1963.

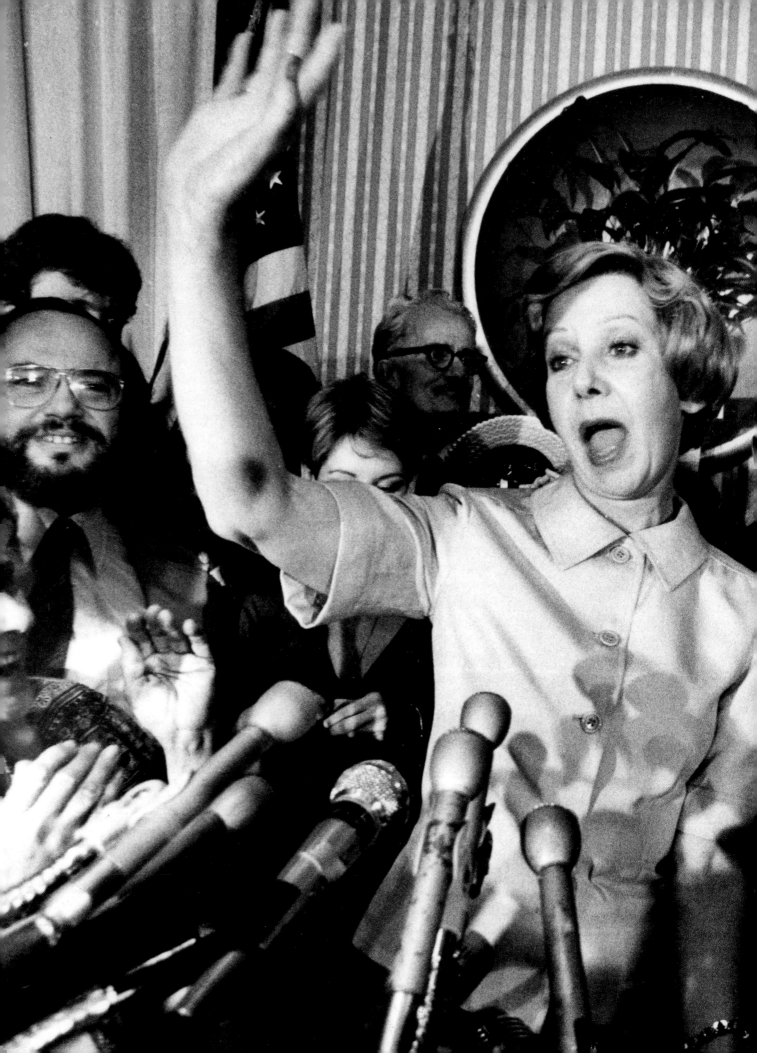

Byrne vs. the Machine

First female mayor humbles powerful party pols in 1979

UNTIL Jane Byrne managed the feat, nobody—reformers or liberals, dissidents or Democratic Party dropouts—had been able to loosen the famed Chicago Machine's iron grip on City Hall.

So going into the 1979 mayoral election, Byrne and her campaign manager, Don Rose, seemed an unlikely pair to succeed where so many had failed. She was a recently canned city official who didn't know when to shut up. He was left-wing political operative with ties to yippie troublemakers. She was a pragmatist; he was an ideologue.

Byrne announced her bid to unseat Mayor Michael Bilandic about four months after he fired her as head of Chicago's Consumer Affairs Department, a post to which she had been appointed by Mayor Richard J. Daley.

She lost her job for not only publicly opposing a taxi-fare increase that Bilandic supported, but for saying it was the product of a backroom deal. Asked by the Tribune if she was pointing a finger at Bilandic, she replied: "I feel he greased it."

In fact, greased palms and patronage—requiring city workers to double as political foot soldiers who would deliver tens of thousands of votes—were key ingredients of a string of mayoral victories dating to the Machine's birth in the 1930s. Such was its power that it could beat a mayor it put into office. In 1946, when scandals surrounding Edward Kelly,

An exuberant Jane Byrne celebrates her upset Democratic primary victory over Mayor Michael Bilandic on Feb. 27, 1979, which assured she would be the next mayor.

"The people of Chicago freed themselves tonight."

—MAYOR JANE BYRNE, ON HER ELECTION NIGHT, 1979

mayor since 1933, put the Machine's survival in doubt, he was persuaded to retire in favor of Martin Kennelly, a businessman touted as a reformer. Elected in 1947, Kennelly took the label too seriously for the ward bosses' comfort. So in the 1955 election, Daley, the party chairman, ran against Kennelly, soundly defeating the incumbent in the Democratic primary, and going on to serve as mayor until his death in 1976.

For his part, Rose cut his political teeth in Hyde Park, an enclave of independent—meaning anti-Daley—politics, and had been nipping at the Machine's heels, knocking off a party candidate here and there. But Rose's role as an organizer of the anti-war protests at the 1968 Democratic National Convention left him vulnerable to criticism in a city where Daley's popularity, though damaged nationally, had never really waned. In 1979, Rose had to downplay his anti-Daley resume, telling the Tribune that "he had never made any secret of his work in helping to organize the 1968 demonstrations, but he denied any connection with the violence that ensued."

When Byrne's campaign went on offense, it initially concentrated on little things. Byrne's hair was famously scraggly, seeming impervious to a comb. One day she showed up neatly

coiffed; she was wearing a wig. "Keep it!" Rose ordered. Getting down to business, the famously outspoken Byrne fired broadside after broadside on her "Cannonball" campaign, portraying Bilandic as a corrupt, out-of-touch, backroom dealer who didn't care about the average Chicagoan.

But it seemed she was just spinning her wheels. Campaign coverage in the Tribune was light. Bilandic rarely if ever bothered to respond to criticism or even acknowledge the primary election was approaching.

On Dec. 27, Bilandic won the top spot on the Democratic primary ballot, and the Democratic Machine seemed to be comfortably in control.

But there was the small problem of Mother Nature. She began her work in November, surprised Chicagoans with a heavy, wet storm Dec. 1 and by early January had dumped nearly a season's-worth of snow. Yet she was just getting started.

The now-famous 1979 blizzard paralyzed the city, burying cars, closing airports and bringing mass transit to a crawl. Byrne was right about at least one criticism: Bilandic proved to be out of touch. He told residents to park in public lots and didn't believe them when they said they weren't plowed. He told the elderly and ill to talk to the judge if they

had a problem with their cars being towed. Chicagoans seethed.

The Byrne campaign didn't let the opportunity go to waste. Byrne called on him to quit. She said he should fire the Chicago Transit Authority chief. Most telling, the Byrne campaign advertised its candidate as more Daleyesque than Bilandic, Daley's political heir. Its theme: "No one could have stopped the snow. But good planning could have prevented the collapse of public transport." One of Byrne's ads crowed: "If you want to know what kind of mayor Jane Byrne would make, hear the words of the late Mayor Daley."

A picture of Daley in a hard hat appeared, as he praised Byrne as "one of the most competent women I have ever met."

A Bilandic ad, the Tribune observed, showed the summertime "ChicagoFest, with the mayor at the event in a T-shirt and (his wife) Heather greeting crowds."

The difference wasn't lost on primary voters, who came out by the droves on a warm and sunny Feb. 27 to give Byrne "the most stunning political upset in Chicago history," the Tribune reported, adding that the Democratic Machine hadn't suffered a defeat since it was created half a century earlier.

That left just two more hurdles, the general election and Rose's uncontrollable candor.

Byrne started reaching out to ward committeemen, the party's nabobs, just as Rose was proclaiming that politics as usual had to go. Byrne's brother bailed out Rose, explaining the gaffe much as an indulgent parent might defend a wayward son: "Don has been fighting the organization for so long that I think he just got carried away in the heat of victory and said some dumb things." The general election usually wasn't a problem for Chicago Democrats. Republicans hadn't elected a mayor in half a century.

Yet in 1979, Byrne was aiming to break the glass ceiling, and the Republican candidate, Wallace Johnson, didn't shy from playing the gender card.

Not worrying about how many people he might offend, he explained to a Trib reporter that voters were opposed to Byrne. "No babe for mayor," Johnson said. "That's what they

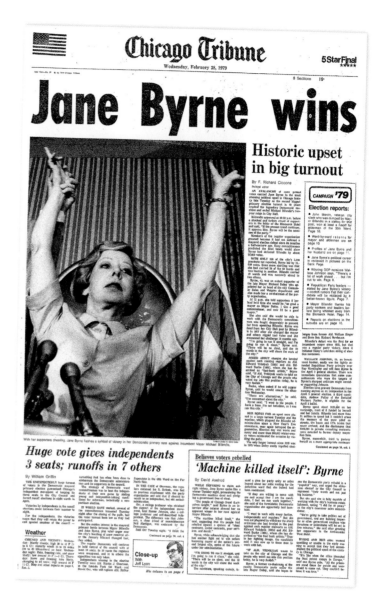

told me last night. 'She gets her period every month. No babe for mayor.'"

Shortly afterward, Byrne was elected Chicago's first female mayor, receiving a record-setting 72 percent of the vote.

Byrne and Rose—with an assist from Mother Nature—beat the Machine, an astounding political feat. In the afterglow of her primary victory, Byrne promised a bright future for the city.

"The people of Chicago freed themselves tonight," she said.

—RON GROSSMAN

The Tribune's Feb. 28, 1979, front page gave readers all the details of Jane Byrne's historic upset.

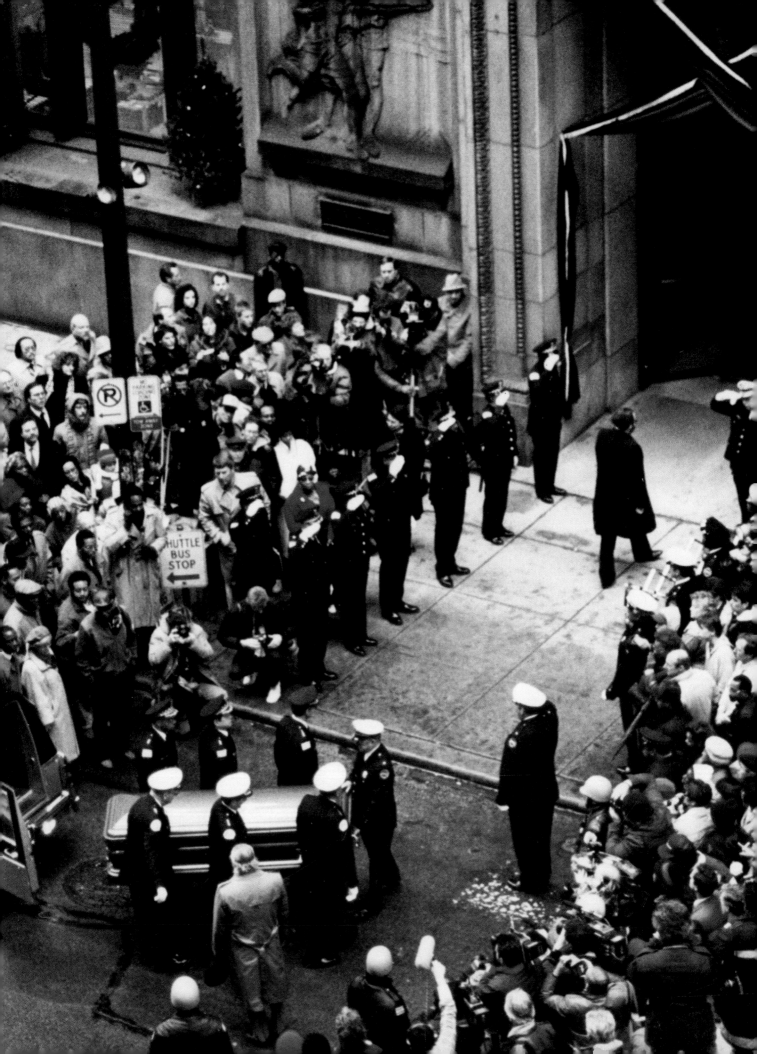

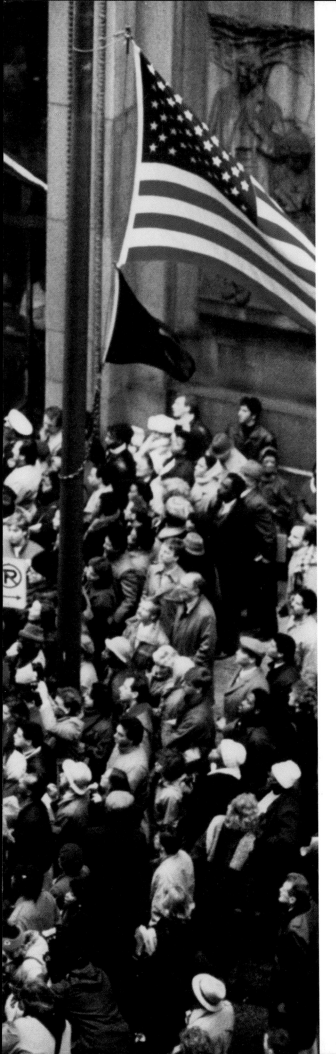

Mourning Harold Washington

**Death of first black mayor
cut dreams short**

T HE death of Chicago's first black mayor was marked by tears of sorrow, words of praise—and down-and-dirty politicking.

A few days after Harold Washington had a fatal heart attack in his City Hall office on Nov. 25, 1987, a Tribune reporter came upon a 9-year-old girl at his grave. Catreece Bozeman clutched a poem she said she'd written:

> "Farewell to our mayor, our first black mayor, who relieved our troubles and saved our sins, who left our sidewalks clean and our houses
> together.
> Farewell, farewell, the one and only our mayor.
> Sleep tight."

It is hard to underestimate the impact of Washington's unexpected death on the black community. Many compared it to a death in the family. He embodied the hopes and dreams of those who had twice elected him to office. When the news broke that the mayor had fallen ill, the day before Thanksgiving, residents of the South and West sides spontaneously gathered in Daley Center Plaza. At the announcement he had died, many people wept.

Tens of thousands viewed Washington's body when it lay in state at City Hall. They waited for hours in a line that extended five blocks. More than 4,000 people an hour walked by the coffin.

An honor guard of firefighters and police officers carries Mayor Harold Washington's casket into City Hall on Nov. 27, 1987. The building's U.S. flag was at half-staff.

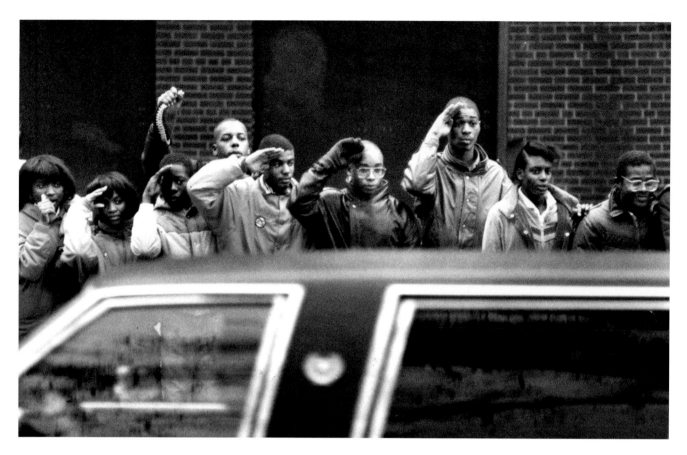

Students salute the hearse bearing Mayor Harold Washington's casket as it passed Simeon Vocational High School on Nov. 30, 1987. South Side residents flooded out of their homes to stand in the drizzle and pay final respects to the late mayor as the hearse passed by.

His funeral the following Monday at Christ Universal Temple, 11901 S. Ashland Ave., was televised, but more than 10,000 tried to attend, and the vast majority were left outside in the rain, singing and mourning.

Hundreds lined the nine-mile route from the church to Oak Woods Cemetery, streaming out of their houses after watching the rites on television. Signs along the route read, "We'll miss you, Harold. Love, Chicago" and simply, "Goodbye, Harold."

The day after the funeral, the City Council met to choose a successor, a session that lasted well into the next morning. At one point, the Tribune reported, Ald. Richard Mell jumped up on a conference-room table and implored a reluctant Ald. Eugene Sawyer to stay in the race, saying: "You've gotta, or we will be surrendering to mob rule." Sawyer, the senior black alderman, feared being labeled the "white man's mayor." A crowd in the council chambers was noisily demanding the election of Ald. Timothy Evans, arguing that he was more likely to advance Washington's agenda.

But Sawyer was finally persuaded and

> "These people are walking around saying what a great man Harold Washington was. The same people who never let up on him for five years and tried to knock him down every chance they got now love the man. That's bull."
>
> —JACKY GRIMSHAW, WASHINGTON'S CAMPAIGN MANAGER

sworn in at 4:04 a.m. Four minutes later, letters went out firing Washington's top aides.

It came as no surprise to Jacky Grimshaw, director of the Office of Intergovernmental

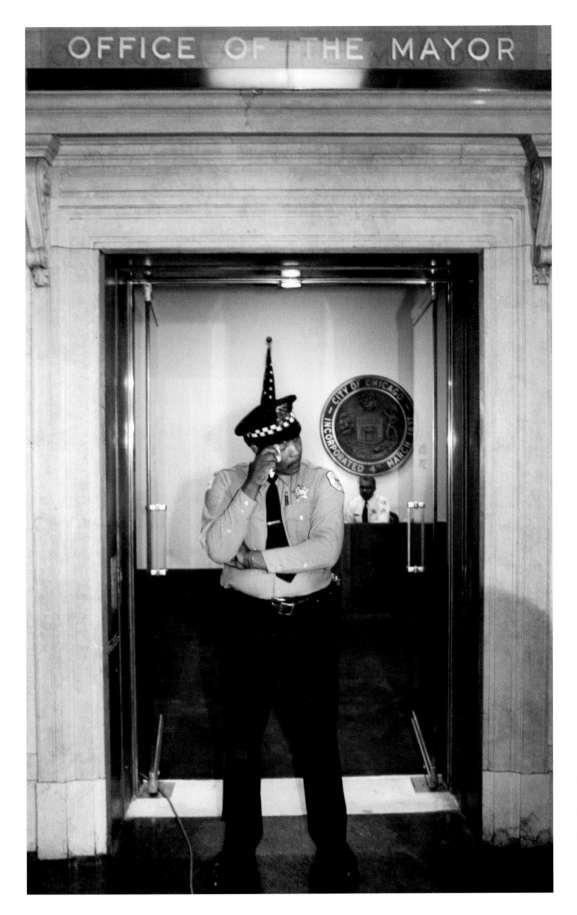

OFFICE OF THE MAYOR

Police Officer Curtis Jones stands as the lone guard outside the City Hall office of the late Mayor Harold Washington on the day he died at his desk in his office, Nov. 25, 1987.

Affairs, who managed the late mayor's final campaign.

The day Washington died, an alderman–using Chicago slang for "political sponsor"–told Grimshaw her "Chinaman was dead."

For Grimshaw, the tributes to her boss were as tough to take as the personal insult she suffered.

"These people are walking around saying what a great man Harold Washington was," she told a Tribune reporter. "The same people who never let up on him for five years and tried to knock him down every chance they got now love the man. That's bull."

Yet in a sense, all the backbiting, insults and racial slurs marked the magnitude of Washington's accomplishment. Shoving history forward by the sheer force of a charismatic personality isn't a guaranteed crowd pleaser, especially in a polarized city like Chicago. Washington became mayor in 1983 by narrowly defeating Bernard Epton, a former state legislator who ran as a Republican–which should have been enough to sink him in heavily Democratic Chicago, except that he was white.

His campaign slogan got right to the point: "Epton–Before It's Too Late."

Campaigning for his first term on the Northwest Side, Washington faced the hostility long provoked by the sight of a black face in a white neighborhood; an angry crowd told black police officers accompanying him to "go back to the South Side where you belong."

Even after Washington won the election, some aldermen refused to address him with the traditional honorific title "Mr. Mayor." Washington took those slights philosophically, saying: "Every time a black person gets closer to the Holy Grail, they move it back."

He hoped his election would put an end to "plantation politics," the entrenched system in which black politicians were expected to toe the mark dictated by white party leaders.

That didn't happen without a fight. A bloc of white aldermen was committed to stopping Washington's agenda–and the "Council Wars" began.

Washington dismissed the phrase with

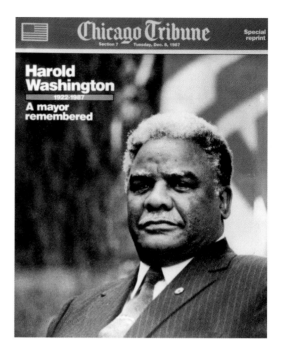

Chicago Tribune Special reprint
Section 7 Tuesday, Dec. 8, 1987

Harold Washington
1922-1987
A mayor remembered

"In many ways, Washington's legacy is not what he did, but what he was on the verge of doing."

—TRIBUNE, 1987

one of his trademark literary references: "Now, I object to glamorizing this kind of behavior by calling it 'Council Wars,' implying some kind of struggle between equals on a darkening plain where enemies clash by night."

The Tribune thought the bitter battles were an "embarrassment" that damaged the city's bottom line.

"Last week's clownish performance by Ald. Edward Burke reinforced to investors and financial analysts around the country the image of a die hard white council majority hellbent on humiliating a black mayor," an editorial said, following a kerfuffle in which Burke declared Washington was no longer mayor be-

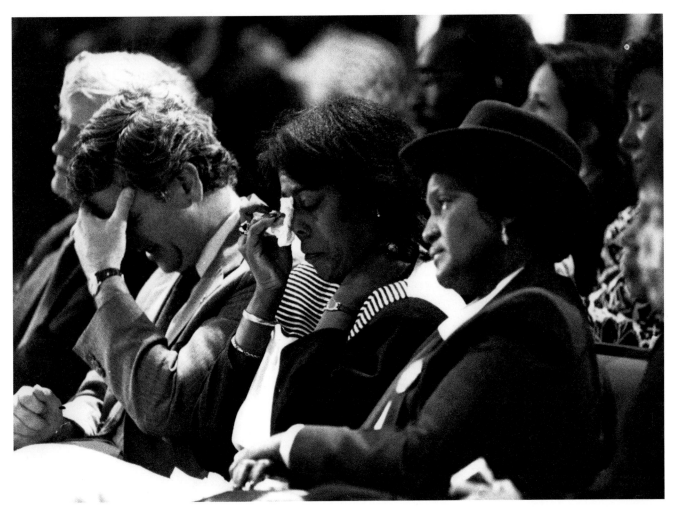

cause he missed a financial disclosure filing deadline.

Not one to turn the other cheek, Washington also could wield his famed oratorical gifts on the attack. His nickname for one council nemesis was Edward "Darth Vrdolyak," whom he also called a "scurrilous lowlife." He said Burke was "a pimple on an elephant's butt."

When Cook County State's Attorney Richard M. Daley was mentioned as a possible opponent in the 1987 election, Washington dismissed him as "some young buster who if he were black, couldn't get a job shining shoes."

It was only after Washington was re-elected that he had solidified control of not only the council but also the Democratic organization. That made his death even more painful for many, who felt that Washington finally would be able to advance his agenda. On hearing of his death, one mourner in Daley Plaza cried, "He wasn't finished." As the Tribune reported

that first day, "In many ways, Washington's legacy is not what he did, but what he was on the verge of doing."

Less than a week after his death, Loop College was renamed Harold Washington College. Now the city's main library also bears his name. But less material legacies are harder to define, especially when the change comes in people's hearts and minds—and their dreams.

After the 1983 Democratic primary, a jubilant crowd was celebrating Washington's surprising victory when an African-American woman told a Trib reporter: "Now we can go for president."

—RON GROSSMAN

Alton Miller, from left, Judson Miner, Brenda Gaines and Jackie Grimshaw, all members of Mayor Harold Washington's staff, attend his funeral Nov. 30, 1987, at Christ Universal Temple in Chicago.

Crime and Vice

Chicago, the sin city

Crusaders love declaring war on vice. Vice is handling it just fine.

N OT since the days of Sodom and Gomorrah has a city seemed so ripe for exorcism as Chicago repeatedly has to preachers and do-gooders with a flair for theatrics.

En route to his 1918 anti-vice crusade in Chicago, Billy Sunday, a baseball player turned evangelist, arranged for a passenger train to make an unscheduled stop in Winona Lake, Ind. The Tribune proclaimed Sunday to be "the 20th-century Joshua who commanded the Manhattan Limited to stand still at an Indiana crossroads that he may clamber aboard with his ram's horn to blow down the walls of our iniquity."

Sunday—who had played for the predecessors of the Cubs—hyped the difficulties he expected. "I'm going to Chicago realizing that I have a big job on my hands, as the devil's interests have already shown their ugly fangs in anticipation of my campaign there," he told a Trib reporter.

Evidently Sunday wasn't so good with a ram's horn as with a bat, and his lifetime batting average was an unimpressive .248. The efficacy of his crusade is measured by the lyrics of "Chicago," Frank Sinatra's ode to the Windy City:

"Chicago, the town that Billy Sunday couldn't shut down."

Indeed, the story of Chicago can be traced through the perennial dire warnings that the city was sinking beneath a morass of sin. From the beginning, some prominent citizens have

Baseball player and influential evangelist Billy Sunday, in the 1920s. Sunday played baseball for eight years, including for the Chicago White Stockings, before leaving baseball and devoting his life to God in 1891.

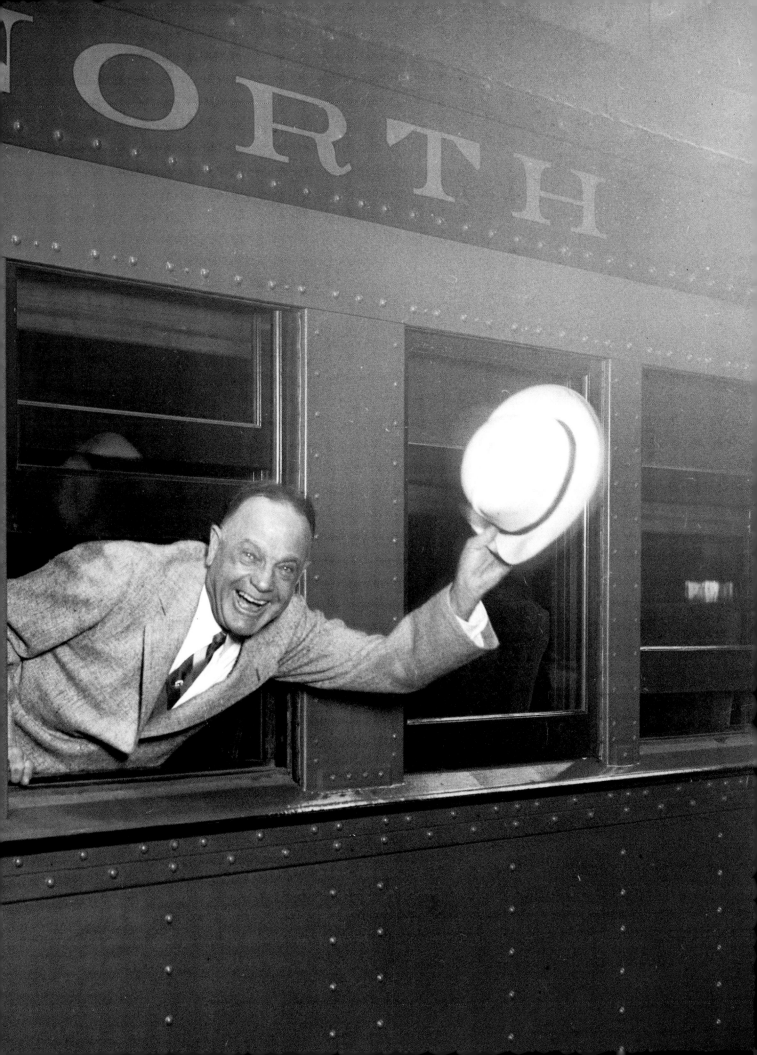

"I'm going to Chicago realizing that I have a big job on my hands, as the devil's interests have already shown their ugly fangs in anticipation of my campaign there."

—BILLY SUNDAY, 1918

always decried the vices favored by other prominent citizens, be they gambling, drinking, or especially whoring. Every few years, an outraged minister, a mayor or a police chief would proclaim a crusade—maybe because they were honest officials, more likely in hopes of increasing their share of the boodle. Mostly, nothing happened. When crusaders did shut down a red-light district, flesh merchants would generally move their operations elsewhere. Today prostitution is considered less a criminal issue than a social problem. Will new efforts be successful? History suggests that, as with earlier approaches, it won't be easy.

In 1857, worrisome lowlife inhabited the Sands, a motley collection of houses of ill repute and whoop-and-holler taverns on the lakeshore, then at about Michigan Avenue and the Chicago River. Convinced the Sands had to go, lest Chicago's reputation (and property values) be sullied, then-Mayor Long John Wentworth invited the pimps and booze merchants to a day at the races. In their absence, their establishments were demolished.

The next day's Tribune reported the coup, adding an upbeat forecast: "Hereafter, we hope the Sands will be the abode of the honest and industrious, and that efficient measures will be taken to prevent any other portion of the city from becoming the abode of another such gathering of vile and vicious persons."

Instead, purveyors of sin relocated to the Custom House district along State Street, just south of Jackson Boulevard, near what's now the Printers Row neighborhood. One bordello, Carrie Watson's opulently furnished Clark Street mansion, offered a more refined approach to the pleasures of the flesh than had been available at the Sands. A parrot welcomed guests, saying: "Carrie Watson. Come in gentlemen."

In 1883, a Trib reporter saw a less attractive street scene. "Women stood in the dark doorways and on the stairways retailing filthy alleged jokes," he noted. "Clusters of colorful prostitutes in varying shades, pitch-black, mahogany, and yellow-chromatic were gathered about the entrances to the lowest class of brothels."

William T. Stead, an English journalist and social reformer, studied the Custom House district much as an anthropologist might. "Women who are desperate go to Carrie Watson and her class, as men go to the gambling hall in the hope of recouping their fortunes," Stead wrote in "If Christ Came to Chicago" in 1894. Sadly, a woman could make more money as a prostitute "than the ablest woman in America can make at the same age in any profession."

The 1883 Tribune story's headline—"The Portion of Chicago from Which Carter Harrison Expects to Draw Most of His Votes"—pointed to a problem confronting anti-vice

crusaders. For every Mayor Wentworth determined to clean up Chicago, there was a Mayor Carter Harrison Sr. alert to the potential profits, political and financial, of a live-and-let-live approach.

His son, Mayor Carter Harrison Jr., held similar views. "I have never been afflicted with Puritan leanings," he recalled in his 1935 autobiography, "Stormy Years." "I have also recognized the apparent necessity of prostitution in such organizations as have been so far perfected in this world of ours."

Harrison Jr. favored "segregation," confining prostitution to well-defined districts, which made a certain amount of sense—and lots of dollars. And that came to pass, as the sex-for-sale scene moved farther south to the Levee, bounded by Clark, Wabash Avenue and 18th and 22nd streets. A 1911 study by the blue-ribbon Chicago Vice Commission found that prostitution was a $60 million industry. The Levee had offerings at all price levels: Furtive encounters in crummy hotels for those on a budget. Beds inlaid with marble and gold spittoons at the top-of-the-line Everleigh Club, a tourist attraction that widely advertised Chicago's vices as virtues.

European royalty, American millionaires and Chicago ward heelers were equally welcome at the Everleigh Club, 2131-2133 S. Dearborn St., now the site of the circular towers of architect Bertrand Goldberg's Hilliard Homes. When Prince Henry of Prussia visited Chicago in 1902, the city planned various high-society events, but he insisted on visiting the Everleigh Club. Sisters and co-proprietors Ada and Minna Everleigh led the grand march at the First Ward Ball, the highlight of the demi-monde social scene.

The Levee's notoriety made it a high-value target for crusaders, such as the Rev. Ernest Bell, who led a 1907 protest march past its "resorts." The Tribune reported of Bell's pep talk at a pre-march rally: "Many of the women in the 22nd Street resorts," he said, "attract young boys by the scantiness of their wearing apparel." Two years later, Gipsy Smith, a British evangelist, led a march through the Levee, proclaiming: "We are going to win the lost, the forsaken, the degraded, and the destitute." Not many got a

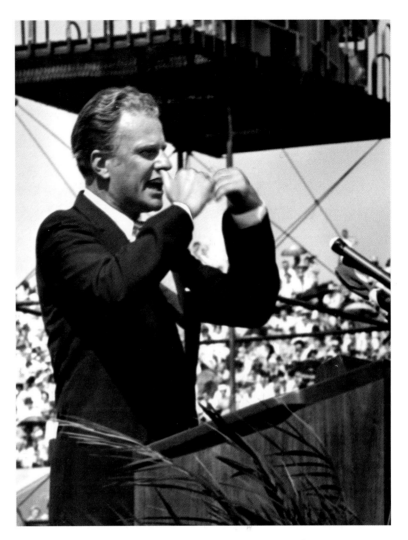

chance to be saved: The police chief ordered the hookers and madams to lie low.

But pressure to crack down permanently on vice built, and in 1911 Mayor Harrison Jr., feeling the heat, ordered the Everleigh Club shut and announced a similar fate for others—notwithstanding his I-am-no-Puritan position. Of course, prostitution didn't end. It just shifted venues over the decades, to strip clubs offering a little extra in backrooms in Uptown, Cicero and Calumet City. Crusaders didn't give up either. In 1962, evangelist Billy Graham came to town seeing doomsday at hand. "It may be that your reaction tonight will determine whether Chicago will have another chance to become right with God," he told a McCormick Place audience.

—RON GROSSMAN

Billy Graham joined the crusaders against vice in Chicago when he spoke to a crowd at Soldier Field in 1962, a time when he was telling Chicagoans that doomsday was at hand.

The great grain gamble

Wealthy upstart tries to corner the wheat market

FINANCIAL scandals resonate deeply in Chicago, where the futures industry matured into a global juggernaut.

The early years of the Chicago Board of Trade are littered with stories of the corpses of high-flying traders who didn't know when to get out.

But one scheme in 1897-98 rises above in its example of unblinking, ice-water-in-the-veins derring-do. It featured a Harvard-educated, charismatic young scion of a wealthy merchant family going toe-to-toe with one of the biggest names in Chicago social and financial circles, the "Old Man" of the Board of Trade. It involved the purchase and stockpiling of vast amounts of wheat and the movement in the dead of winter of millions of bushels of grain in an operation lesser men would not—could not—even have conceived.

It would be one of the most audacious attempts to corner the wheat market the city had ever seen.

Joseph Leiter was the only son of Levi Leiter, an early partner of Marshall Field.

In April 1897, at just 29 with $1 million of his father's money to spend—seed money, if you will—he began surreptitiously buying up wheat contracts. Into June and July, he was still buying when other traders "scented a corner."

The game was on.

On Aug. 22, 1897, the Tribune published a story headlined "Klondike in the Chicago wheat market." Secondary headlines read, "Joseph Leiter the most conspicuous figure of all" and "Old Operators Dazed by a Newcomer, Whose First Experience Promises to Net Him a Fortune."

In just four months, Leiter made $500,000. That just whetted his appetite.

On the other side of the ledger was Philip D. Armour, the financier and meatpacker, who was known as "the Old Man of the Wheat Pit." He was so famous that his obituary didn't even bother describing who he was.

By all accounts, Armour had no qualms selling. Selling wheat had been a moneymaker for Armour for years. But this Leiter kid's scheme was no run-of-the-mill effort. Unlike most such attempts, Leiter wasn't speculating on the price of wheat, buying paper contracts low, artificially driving up prices and hoping to sell them high. Leiter actually wanted the wheat.

"I have bought your wheat," Leiter said, "and I am ready to pay for it. I don't want your money, but I do want your grain."

Leiter got his grain and shipped much of it east to go overseas.

This illustration ran with a June 19, 1898, Tribune story on Joseph Leiter and other big speculators who "stuck to the game too long."

Leiter's buying and Armour's selling continued. By the time the December contracts were coming due, it became clear there simply wasn't enough actual wheat to satisfy all of the paper wheat contracts.

Even Armour, who owned most of the grain elevators and was plugged into the supply chain like few other traders, looked around and saw he was short 9 million bushels. Leiter was poised to make a killing–and to humble "the Old Man" himself.

Armour wasn't afraid of risk. He made his fortune betting on Confederate defeat (another great futures deal), outsmarting the millions who dashed to California during the Gold Rush and building one of the biggest meatpacking houses in Chicago.

But he could see that he was over a barrel. He made overtures, sending one of his men to talk to one of Leiter's agents. But in the 1897 version of Groupon turning down Google, Leiter refused. Had Leiter called it a day, he would have cleared $4 million. He wanted more.

That would prove to be a mistake.

If Leiter wanted his grain, Armour would give it to him. He launched what the Tribune on Dec. 19 called "the most stupendous generalship in connection with the handling of a food product that the eyes of man have ever seen."

He leased, bought and rented every available freighter and steamship on the Great Lakes and sent them to Duluth, Minn. With the shipping lanes already icing over, he ordered a fleet of tugboats to break up the ice. And he shipped grain by train, running hundreds of cars laden with the amber grain from the northwest.

"Does anybody realize what it means to move six or seven million bushels of wheat by boat and rail to Chicago?" the Tribune asked.

But Armour didn't move 6 million. He moved 18 million.

Instead of a $4 million profit, Leiter cleared $330,000 and owned more than 10 million bushels of wheat. As he paid Armour tens of thousands of dollars in storage fees, he was forced to jump into May wheat futures to keep his scheme afloat until the shipping lanes thawed in the spring.

It was about this time that Leiter's father returned from Washington, D.C., and a funny

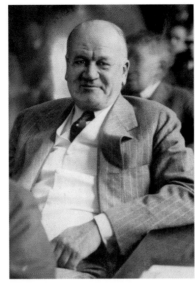

Joseph Leiter, left, and Philip D. Armour.

thing happened. Armour pulled out. While neither man talked publicly, the Tribune clearly assumed that Levi Leiter paid a visit to Philip Armour and the two came to an agreement.

"It was said that he figured in the truce that was made with Armour," the Tribune reported. "There was a settlement of some kind, and the big packer retired from the pit."

But the patriarch's intervention was too late. The price of wheat plummeted.

Suddenly, Joseph Leiter went from being a "new star of the first magnitude" in the financial firmament to a person who "overstayed the market" and was "figuring his losses, not his profits."

Those losses were staggering. Leiter said later that the final tally after numerous legal battles was close to $20 million.

Interestingly, it all turned out fine for Leiter, whose father covered nearly all of his losses and didn't appear to hold it against his son. (Though he was forced to sell quite a bit of Loop real estate.) Leiter never lost his confidence, either, according to the Tribune, or his oversize "booming laugh," and was a regular at the horse track.

Ironically, it fell to Armour to clean up Leiter's mess. Who else could move that much grain? The bold headline on June 15, 1898, said it all, "ARMOUR TAKES THE WHEAT."

—STEPHAN BENZKOFER

White City's serial killer

Authorities first thought H.H. Holmes was just a swindler

THE man who became infamous as H.H. Holmes, one of the first serial killers in the United States, preyed mainly on naive and gullible women—young women who wouldn't be missed amid the thousands of World's Fair tourists streaming into Chicago's fashionable Englewood neighborhood.

As Chicago basked in the bright light of the White City, the 1893 Columbian Exposition that was making headlines around the world, Holmes was remorselessly collecting people, using them and efficiently discarding them. After arriving in Chicago in the late 1880s, he built what became known as his Murder Castle at 63rd and Wallace streets and proceeded to murder, swindle, lie, steal and cheat, all under the facade of upper-class respectability as the friendly neighborhood druggist and businessman.

Holmes gave Americans one of their first well-publicized cases of serial killings. The specter of anonymous victims murdered in the big city runs through our popular culture, kept alive by rare but notorious cases. Readers today likely know Holmes, whose real name was Herman Mudgett, from Erik Larson's 2003 best-seller, "The Devil in the White City." Tribune readers near the turn of the last century

H.H. Holmes' "Murder Castle" at 63rd and Wallace streets, shown in March 1937. Holmes built in features to facilitate his murder spree, including a third-floor room padded to muffle sound and fitted with a gas pipe to asphyxiate his victims.

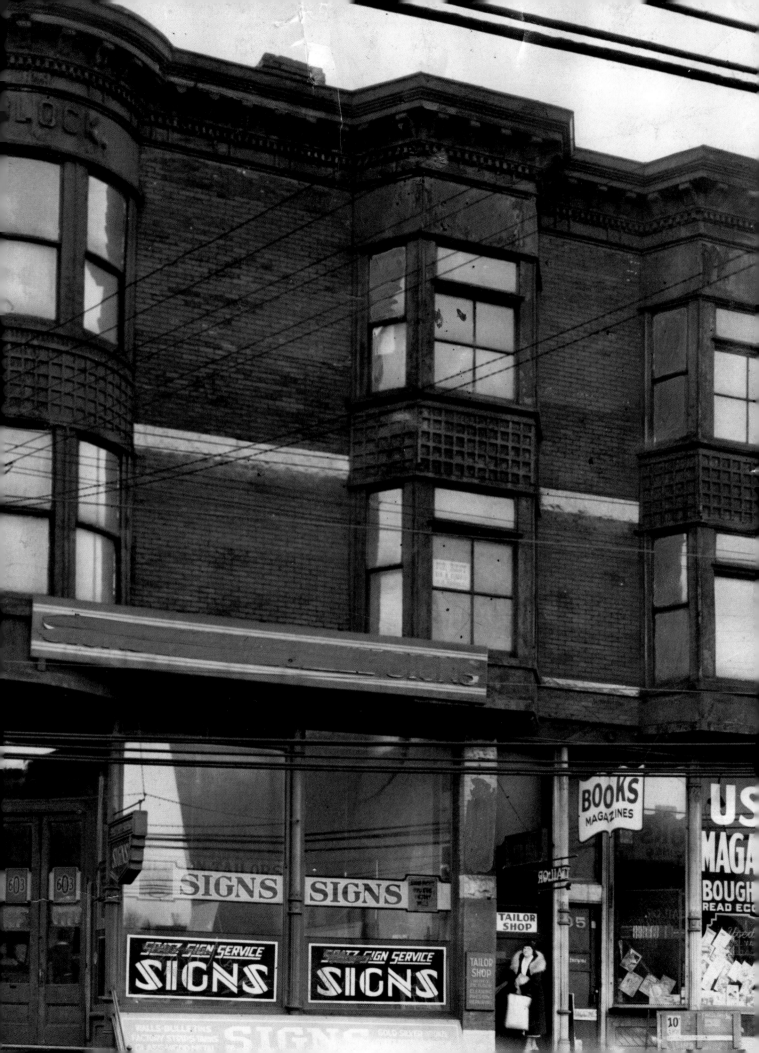

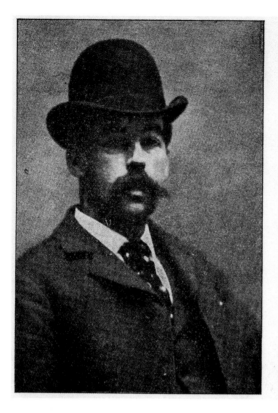
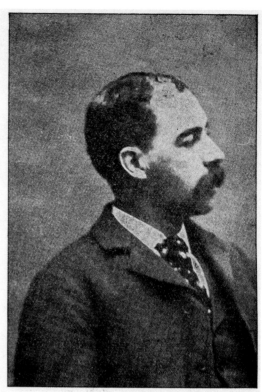

American pharmacist and convicted serial killer Herman Webster Mudgett, better known by his alias H.H. Holmes, in the mid- to late-1890s.

met Holmes as the subject of a disturbing story published March 31, 1893, just over a month before the World's Fair was to open.

The article detailed how Holmes had failed to pay for hundreds of dollars in furnishings for a hotel he planned to run at the castle to cash in on fair tourists. When angry merchants showed up to demand that he return the goods, they found nothing but empty rooms. Later a hidden room containing much of the furniture was discovered. Other concealed areas held a number of mattresses and box springs. The furnishings were removed; Holmes was left behind.

And Holmes might well have gotten away with it all had his last nefarious scheme not unraveled faster than he could cut away the loose ends.

On Nov. 17, 1894, he was arrested and accused of attempting in Philadelphia his favorite ploy: a life insurance fraud wherein a badly disfigured corpse plays the role of the insured. Though his methods were unsavory,

at this point authorities still thought he was a prolific and gifted swindler. But in the following days, the Tribune's headlines revealed the growing, horrifying reality that Holmes wasn't just a con man: "Murder in the case," "Hint of dark deeds" and "Spins his own web." Officials suspected Holmes didn't bother to bring in a corpse this time, and just killed his partner, Benjamin Pitzel.

About a week later, the Tribune's big Sunday paper unspooled a 2 1/2-page tale of Holmes' long history of chicanery, much of it in Chicago. Headlined "H.H. HOLMES, CROOK," with secondary headlines such as "Bad From His Boyhood" and "Began to Tread Devious Paths When a College Student," it told how Holmes, while attending the University of Michigan, teamed up with a med student there to pull off the corpse-life insurance scheme multiple times.

"As an all around fraud Holmes had a wonderful success with men, but he preferred women and insurance companies. He said they came easier. Swindler of men, betrayer of women, he has left behind him a wake of ruin and tears that not all the courts of America can wash away," the Tribune reported.

The story detailed his goofy swindles, such as his patented water-to-gas invention and his "discovery" of an artesian well in his basement that produced water with curative powers. It also revealed his multiple wives, who were sometimes pretty but always wealthy. Case in point: Minnie Williams, "a singular beauty" whose estate was worth at least $75,000. Both she and her sister were missing.

The story also asked: Whatever happened to Pitzel's three children? The horrifying truth would have to wait about eight months. On July 15, 1895, the bodies of Pitzel's two daughters, Alice and Nellie, were discovered buried in a cellar in Toronto. Little Howard was believed dead, but his body was still missing.

The swindler was revealed to be a serial killer. It was front-page news across the country. And the search for other bodies began.

In Chicago, authorities looking for clues turned to Holmes' house. The Tribune described it in a 1937 article: "O, what a queer house it was! In all America there was none other like it. Its chimneys stuck out where chimneys should never stick out. Its stairways ended nowhere in particular. Winding passages brought the uninitiated with a frightful jerk back to where they had started from. There were rooms that had no doors. There were doors that had no rooms. A mysterious house it was indeed—a crooked house, a reflex of the builder's own distorted mind. In that house occurred dark and eerie deeds."

Police found a house of horrors. Holmes had created a "murder factory." Rooms could be locked from the outside. A third-floor room was a veritable bank vault, padded to muffle sound and fitted with a gas pipe to asphyxiate victims. A hidden shaft to the cellar made for easy disposal of bodies. And it was the cellar of the "murder factory" where Holmes undoubtedly worked, the Tribune reported. Behind a fake wall, police found a butcher's table, quicklime vats, bones, bloody clothing—and a crematory. In the oven, "They found a woman's watch chain. They found the buckle of a woman's garter," the Tribune reported.

The watch chain was Minnie's. The garter buckle was her sister's.

Through the summer, Tribune readers learned of Holmes' other victims, including the Conner family. Ned and Julia Conner and their 12-year-old daughter, Pearl, had moved to Chicago from Davenport, Iowa. Holmes hired Ned Conner to handle the jewelry counter in his corner store, installed Julia as a bookkeeper and leased the family rooms in his hotel. He then seduced Julia, breaking up her marriage and sending the "mild, inoffensive" Ned packing. Julia and Pearl went missing in 1893.

A former secretary named Emeline Cigrand and her fiance also went missing. Her remains were reported found in a story headlined "Bones in a trunk."

As the bodies piled up, Holmes, still jailed in Philadelphia, remained cool, admitting only to insurance fraud and denying killing anyone. But when a jury convicted him of Benjamin Pitzel's death, his facade began to crack. The Tribune reported, "Once in a reckless, or more likely cynical moment, Holmes announced, 'O, sure, I've killed twenty-seven people!'" Authorities doubted that, having identified just 12 victims, but some now suggest he killed many more. Jeff Mudgett, who says he is Holmes' great-great-grandson, claims in a book that his ancestor was Jack the Ripper, who supposedly killed five prostitutes in London in 1888.

Holmes was sentenced on March 9, 1896, to be executed. A month later, the North American newspaper in Philadelphia printed what it said was Holmes' confession, running three whole newspaper pages, in which Holmes wrote of his "blood-curdling atrocities with an abandon that simply appalls one," the Tribune said.

Claiming again that he killed 27 people and was preparing to kill six more, he wrote, "I was born with the very devil in me. I could not help the fact that I was a murderer, no more than the poet can help the inspiration to song, nor the ambition of an intellectual man to be great. The inclination to murder came to me as naturally as the inspiration to do right comes to the majority of persons."

On May 7, H.H. Holmes was hanged by his neck until he died. His name lives on.

—STEPHAN BENZKOFER

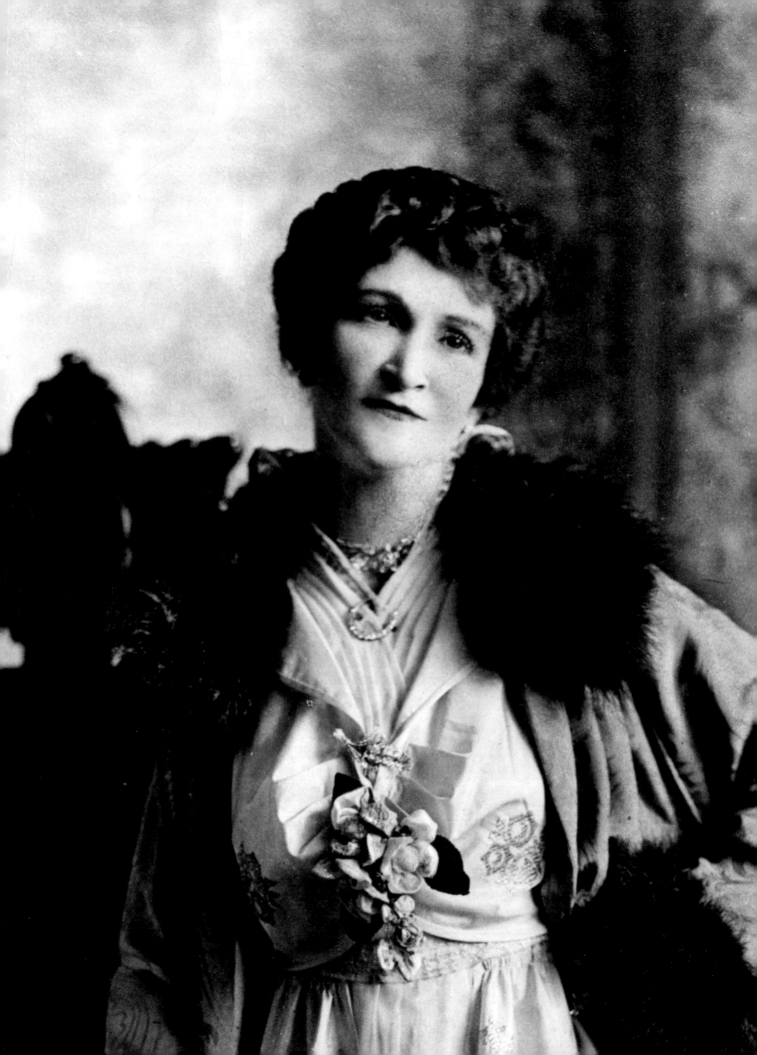

No ordinary whore-house

Everleigh Club was legendary house of ill repute

Minna Everleigh took the news philosophically when told the city was shuttering her "resort," as establishments of the kind she and her sister Ada ran were called in Chicago a century ago.

"If the ship sinks, we're going down with a cheer and a good drink under our belts, anyway," Minna told a Tribune reporter on Oct. 24, 1911.

Brothels generally are shut down by police swinging an ax through the door and loading scantily clad ladies into a patrol wagon. But the Everleigh Club wasn't just any whorehouse, and the last night at Minna and Ada's place had more the feel of a theatrical closing than a vice raid. The sisters sold flesh—by all reports young, beautiful and nubile—but they packaged their product with trappings worthy of royalty. The sisters screened their clientele no less than their employees, barring the unwashed masses in favor of the rich and famous.

The Everleigh Club was the centerpiece of a vice district known as the Levee, roughly Clark Street to Wabash Avenue and 18th to 22nd streets. Just after Mayor Carter Harrison II took office, a municipal commission appointed by his predecessor reported that the Near South Side neighborhood was home to 1,000 brothels and 4,000 prostitutes, producing annual revenues of $60 million. Targeted by anti-vice crusaders, it was a ghost town when visited by a Trib reporter five years later. Yet reform in Chicago is a sometime thing. Harrison, who ordered the houses of prostitution closed, was succeeded by William Hale "Big Bill" Thompson, whose idea of a cleanup was to give reformers a hard time.

The Levee's demise also was quickened by a guidebook Minna published, "The Everleigh Club, Illustrated," showing a three-story brownstone at 2131-33 S. Dearborn, furnished with brass beds inlaid with marble, gold cuspidors, Oriental rugs and a library of leather-bound books. Pressured by outraged ministers, Harrison told his police chief to get rid of the Everleigh Club, an order that slowly worked its way down a chain of command.

The delay allowed for a grand finale, the Tribune reporting: "Lights blazed in every room, music rang through the richly tapestried corridors, wine popped in all the parlors."

Though it lasted for only a little more than a decade, the Everleigh Club became known around the world for its blend of upmarket sex and gilded glamour. Even Chicago's Vice Commission gushingly proclaimed it "probably the most famous and luxurious house of prostitution in the country." European tourists put it on their must-see lists, among them Prince Heinrich of Prussia. During a Bacchana-

Opposite: Minna Everleigh of the Everleigh Club. The original caption from the Tribune archive reads: "These photos made in 1908 were presented to their legal advisor—and in solid gold frames. He still has the original frames in which these photos have remained through the years."

The grand ballroom of the Everleigh Club, at 2131 and 2133 South Dearborn Street. This is reproduced from a brochure published by Minna and Ada Everleigh, who operated the club.

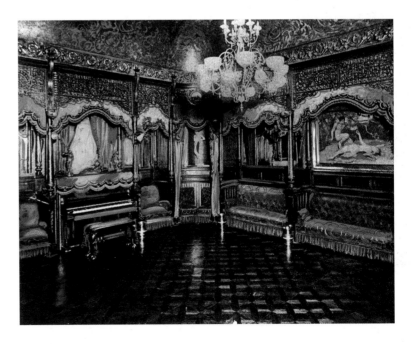

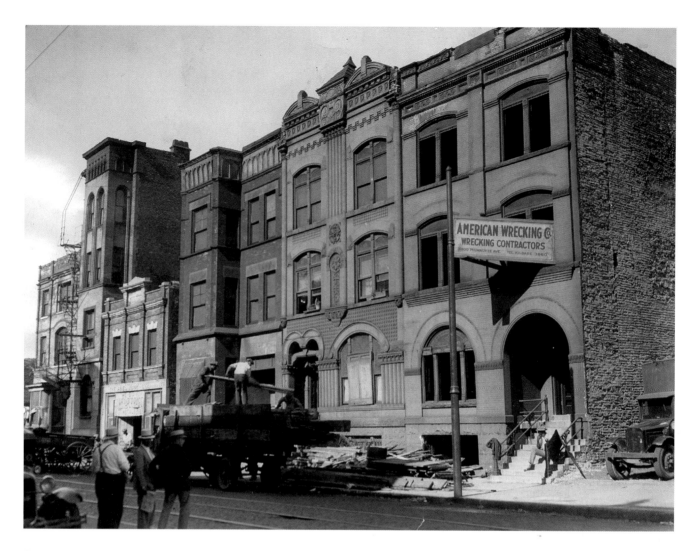

Above: The Everleigh Club, the two side-by-side buildings on the right, before it was demolished in 1933. The club was open from 1900 to 1911.

Right: Ada Everleigh.

lia staged in his honor, a prostitute's shoe came off and someone filled it with Champagne, which one of the prince's attendants quaffed. The incident is often credited with starting the cafe-society fad of drinking Champagne from a woman's slipper.

The Everleigh sisters were young when they came to Chicago from Omaha, and young when they left for New York—with millions earned honestly, as they saw it. On her death-bed in 1948, Minna told a visitor, a former Trib reporter: "We never robbed widows and we made no false representations."

After their club was closed, the sisters, who also took the last name Lester, lived comfortably and quietly in Manhattan. Perhaps too quietly for Ada, who died in 1960. Her farewell address at the club ended with a prediction: "From bawd to worse—retirement."

—RON GROSSMAN

Darrow's courtroom eloquence

Famous lawyer at top of his game saving Leopold and Loeb

On a sizzling August day in 1924, a riot took place outside a Chicago courtroom as spectators fought for a chance to see attorney Clarence Darrow, the famed "defender of lost causes," try to save the least sympathetic of clients from a hangman's noose.

Bailiffs lost control of the mob and the cops had to be called. "Once during the height of the rush, two women were knocked down and trampled," a Tribune reporter noted. "Capt. Westbrook succeeded in dragging them to their feet only after he leaped into the mad crush and knocked men around like tenpins with his fists."

Some who shoved and pushed and ducked punches had come a considerable distance. "Down in New Orleans they write as much in the paper about these boys as they do in Chicago," one visitor said, referring to Nathan Leopold and Richard Loeb, on trial for an unspeakable crime.

They had kidnapped and murdered 14-year-old Robert Franks, a neighbor in the posh South Side enclave of Kenwood and a relative of Loeb's. They didn't do it for money; they did it because they were convinced that their towering IQs equipped them to commit the perfect crime. They so missed the mark that they were arrested shortly after Franks' body was found in a remote area far southeast of the city. That's where Leopold had dropped his glasses, an uncommon model.

Darrow was a well-known opponent of the death penalty. Yet this was hardly an ideal case with which to win others to his philosophy. Leopold and Loeb were wealthy men's sons—and looked down their noses at those who weren't. They put on a show of being bored in court, smirking and grinning. After one session, Leopold forecast: "With our looks and Darrow's brains, I think we'll get along pretty well."

Given his clients' demeanor, and the public's outrage at the senseless crime, Darrow didn't dare put their fate in the hands of a jury. So he pleaded them guilty, leaving it up to a judge to determine their sentences. For a month, the prosecution and defense called witnesses—Franks' family members and squads of psychiatrists. Those called by the prosecutor said Loeb and Leopold were in full possession of their faculties when they lured the Franks boy into a car as he was walking home from school. The defense's psychiatrists said a mental defect inspired the crime.

The prosecutor insisted the heinous nature of the crime required the death penalty. Then it was the moment for Darrow to make his closing argument.

After a phalanx of cops restored a modicum of order outside his courtroom, Judge John Caverly said: "Keep that door closed! If they persist in coming, bring somebody up here and I will send them to jail."

Darrow began speaking on Aug. 22, and when he finished two days later, the judge was in tears. So too were others in the courtroom. They had heard perhaps the most eloquent argument ever made against the death penalty.

According to the Tribune's account, Darrow began by suggesting that as incomprehensible as his clients' deed seemed, there had to be a reason for it. "On the 21st day of May, poor Bobby Franks, stripped naked, was left in a culvert down near the Indiana line," he told the judge. "I know it came through the mad act of mad boys."

A Tribune photograph shows Jacob Franks, the murdered boy's father, sitting one row in front of Loeb and Leopold during one court session.

Darrow distributed blame for their crime widely. Wealthy and indulgent parents had given the defendants too much too soon—but not enough love and guidance. They had com-

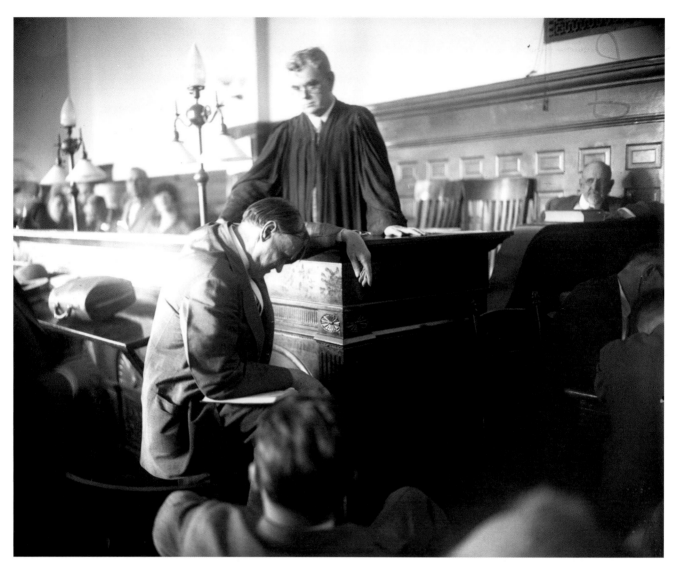

In 1924, chief defense attorney and famed Chicago lawyer Clarence Darrow makes his case before Cook County Circuit Judge John Caverly against sentencing Richard Loeb and Nathan Leopold to death.

pleted college as teenagers—Leopold at the University of Chicago, Loeb at the University of Michigan.

According to the Tribune's report, Darrow "indicted the age in which we live for cruelty. He indicted war for callousing the hearts and sympathies of men. He indicted the educational system under which 'young and plastic minds' are given the pagan philosophers of all times."

Loeb and Leopold had read Friedrich Nietzsche's philosophy of morals, which they took to mean that their accomplishments freed them from the restraints society imposes on ordinary men.

Had Darrow left it there, he might not have served his clients well. Historically, the-devil-made-me-do-it defense, as lawyers term an

insanity plea, is seldom successful. But then Darrow turned to the heart of his plea.

Killing is just wrong, whether the state or a criminal commits it.

"The easy thing and the popular thing to do is to hang my clients," Darrow told the judge. "Men and women who do not think will applaud. The cruel and the thoughtless will approve."

In olden times, hangings were a popular entertainment. They were performed in public, even on children as young as 6, and for a variety of crimes now considered worthy of lesser punishment. It's now reserved for adults, who have reached the age of judgment. Yet the public and the prosecutor had demanded it for Loeb and Leopold, both minors.

"Your honor stands between the past and

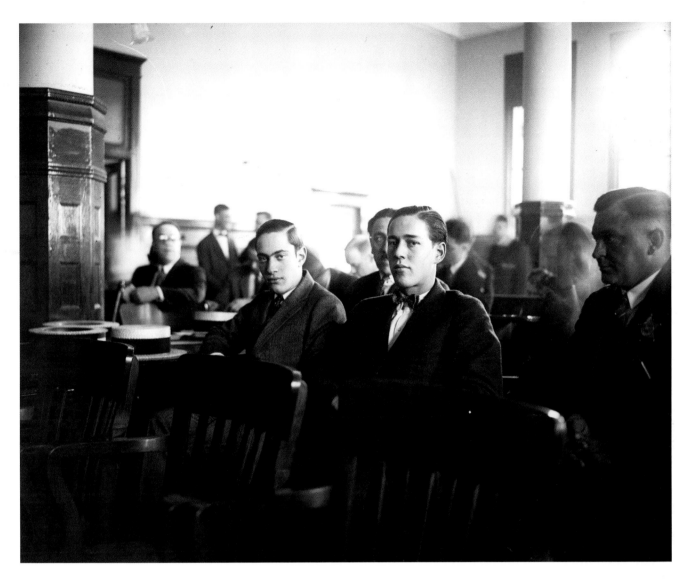

the future," Darrow said. "I am pleading for a time when hatred and cruelty will not control the hearts of men. . . . When we can learn by reason and judgment and understanding and faith that all life is worth saving, and that mercy is the highest attribute of man."

Darrow finished with some lines from the poet Omar Khayyam. His voice fading, spectators leaned forward to hear him.

> So I be written in the Book of Love,
> I do not care about that Book above.
> Erase my name or write it as you will,
> So I be written in the Book of Love.

One spectator said you could hardly tell where Darrow's final words left off and the silence began.

The following month, Judge Caverly sentenced Loeb and Leopold to life plus 99 years in prison. Neither served the full term. Loeb was killed by a fellow prisoner in 1936. Leopold was paroled in 1958.

In the immediate aftermath of the verdict, Darrow visited Loeb's father. Seeing the lavish furnishings, he said: "Look at these things then try to tell me that Dick Loeb is sane. Try to make me believe that any boy would leave this."

His clients, who had behaved appropriately during his speech, reverted to type after their sentencing, the Tribune reported.

On being led back to their cells, Loeb told a jailer: "Get us two steaks, thick and juicy." Leopold added: "Yes, and make sure they are smothered in onions. And bring every side dish."

—RON GROSSMAN

Attorney Clarence Darrow surprised the world by having Nathan Leopold Jr., left, and Richard Loeb, right, plead guilty in their trial for the murder of Robert "Bobby" Franks in 1924. Darrow hoped he could save the two youths from being hanged.

When gangsters were celebrities

Salacious news coverage glorified Jazz Age killers

S ome Tribune headlines of the 1920s and 1930s–like "6 Wounded in 4 Gun Affrays; Gangs Fight Running Battle"–could be recycled today, drive-by shootings being a common denominator of Chicago then and now.

Yet while today's coverage of gang violence is appropriately sober, crime reporters of the Jazz Age felt no need to emotionally distance themselves from their subject matter. They would parse the style of a murder like drama critics analyzing a theatrical production: "Two killings of the traditional 'ride' variety occurred yesterday in Chicago," the Trib observed on Oct. 20, 1932. Poetic allusion prevailed over straight reporting, as in a 1930 account of a mobster who "came to the end of gunman's trail last night."

Some of the dialogue from Prohibition-era crime stories reads like a script of a gangster movie, as when a cop tried to get a stricken racketeer to finger his assailant. "'I'm going for good. Let me die in peace,' he whispered," the Trib reported of the 1930 bedside plea of James McManus, a beer runner. And above all else, the Tribune felt an obligation to keep the reading public fully informed of the bad guys' nicknames. Tribune clips are dotted with col-

"Diamond Joe" Esposito had a hand in bootlegging, prostitution, racketeering and other enterprises in Prohibition-era Chicago. He also was the Republican boss for the 19th Ward.

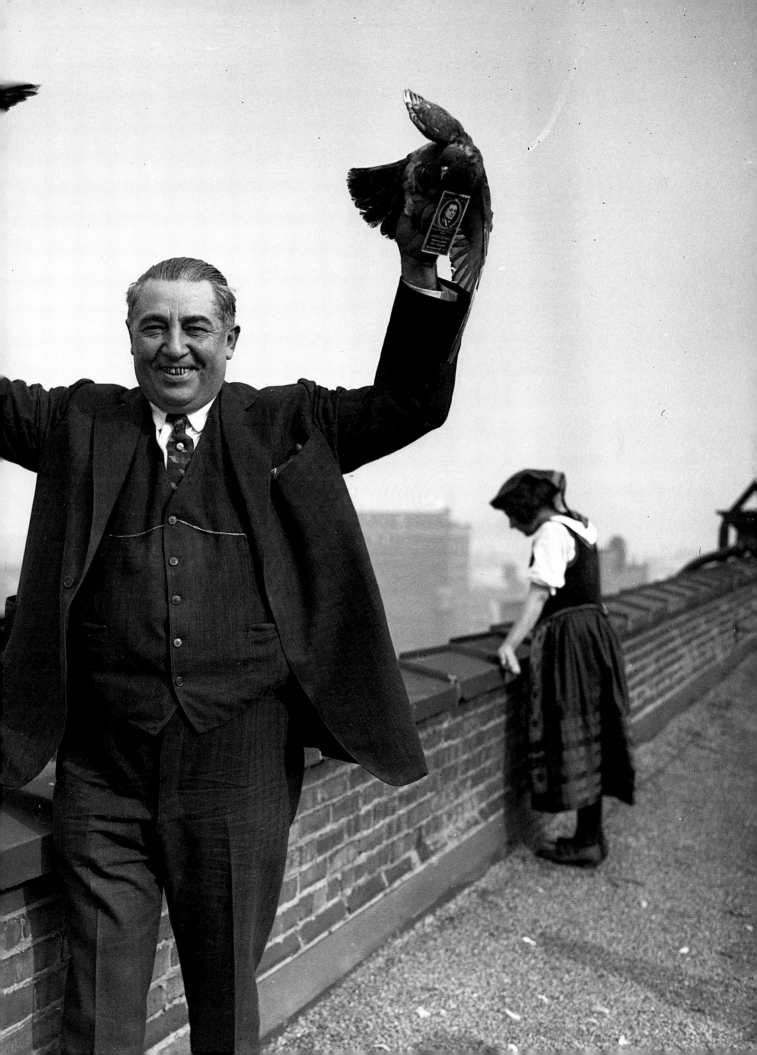

orful monikers like "Mossy," "Big Steve," "Little Hymie," "Dutch," "Spike" and "The Scourge."

Once again, Chicago is confronted by a seemingly intractable problem of gang violence, just as it faced in the 1920s. But back then, the forces of law and order were handicapped by a popular-culture romanticization of the gangster. Hollywood and the media made household names of mobsters who held huge swaths of the city in their deadly grasp, and reduced elected officials to being their lackeys. For the Tribune, it was an era of journalistic civil war between its Editorial page and its news columns—the former decrying lawlessness, the latter feeding the public's seemingly inexhaustible hunger for tales of tough guys with blazing guns.

In a 1925 editorial, the paper noted: "Why should the criminal worry? If he's caught, there's the grand jury. If he's indicted, there's the trial. If he's convicted, there's the Supreme Court. If his sentence is upheld, there's still the board of pardons and parole and a governor widely heralded for his benevolence. And through all these vicissitudes the constant aid of shrewd and unscrupulous lawyers, lax bail laws, and the sort of help that can be bought with crooked money."

Almost as if to make the Tribune's point, when South Side mobster "Diamond Joe" Esposito celebrated his son's christening that year, the guests included two sitting judges, a former judge, the clerk of probate court and a U.S. senator. "My fren's are de beegest an' highest men in the ceety," Esposito bragged, according to the Trib's report. Three years later, Esposito was killed in a drive-by shooting while sitting on his front steps. The day he died, U.S. Sen. Charles Deneen publicly praised Esposito as a loyal and generous friend. The day of the funeral, the senator's house was bombed, the most high-profile event from the infamous Pineapple Primary that pitted Deneen's camp against corrupt Mayor William "Big Bill" Hale Thompson.

Of course many Chicagoans, unlike Esposito's A-list guests, declined to make their peace with the mobsters' hold over the life of the city. In July 1925, the Trib reported a meeting at Senn High School of neighbors angered by the reign of lawlessness on the city's streets. As the meeting let out, a motorist was shot and his car

was stolen just a few blocks away. In Chicago Heights, residents formed an anti-mobster vigilante group. And when gangs shot it out on the Boul Mich, a police captain complained: "It used to be a shot in the dark upon some remote prairie, with a dead man or two found the next morning. But Michigan Avenue at noon, and sixteen shootings at once—that's going a little strong."

Still, editorial writers, concerned citizens and indignant cops were fighting an uphill battle in trying raise the public's ire against mobsters, as Page One stories and movies were making them celebrities. A gangland funeral, especially if the guest of honor hadn't died of natural causes, got the kind of gushing coverage usually reserved for a society wedding. "Sammy (Samoots) Amatuna will be laid away, barring police interference, in a festival of death probably as elaborate as that funeral of funerals, that of the late Dean O'Banion," the Trib predicted on the eve of a 1925 funeral.

O'Banion, a mobster who doubled as a florist, was the victim of an assassin who cased his shop pretending to order flowers for another mobster's funeral. Of Amatuna's passing, the Trib noted that he was mortally wounded by two gunmen in a Roosevelt Road barber shop "where he had just been manicured and shaved preparatory, as he then supposed, to an evening at the opera." Winding its way through the Little Italy neighborhood, the paper noted, the funeral cortege passed "Death Corner," the Near North Side site of many gangland slayings.

When the Cabrini-Green housing development subsequently was built nearby, the neighborhood experienced another wave of gangland killings. In both generations, the economic engine driving the violence was the money to be made dealing in an illicit product—drugs in recent times, booze during Prohibition. The profit margin encouraged mobsters to try to grab as much market share as possible via "men with quick revolvers," as the Tribune put it in 1925.

Of the Jazz Age gangsters, one of the most ruthless was Al Capone, who methodically eliminated rival bootleggers. When seven of his gang were machine-gunned in a North Side garage on St. Valentine's Day 1929, George

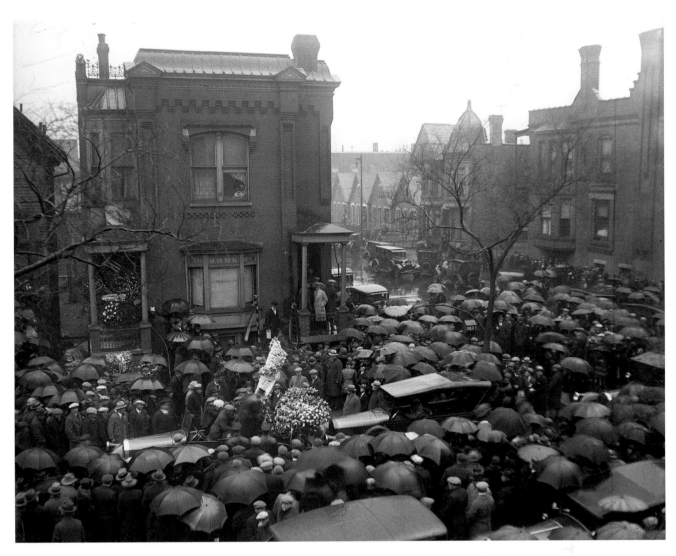

"Bugs" Moran promptly retired, reportedly observing, "Only Capone kills like that."

These bootleggers met the public's thirst for alcohol during the widely unpopular Prohibition years, enabling the press to make quasi-heroes of mobsters or simply fascinating fodder with which to sell newspapers.

In late December 1922, Edward Gorman, a minor league hoodlum, ran off with Lillian Ginsberg, the 17-year-old daughter of a prominent Chicago bondsman, which led to a race between her father's clients and the police to find the couple. When they surfaced, Eddie tried to square things by claiming they'd gotten married. The alleged bride said she could neither affirm or deny his excuse. "I must have been drunk," she said, "because I don't remember marrying Eddie."

Gangsters' family lives were steady fodder for slow news days, as in the story of Florence Murphy Oberta. A "Gun Widow," as the Tribune dubbed her, she married and buried two ill-fated mobsters in rapid succession: "Love, in the span of twenty short months, made her a connoisseur of coffins," the paper noted.

Gangsters' mothers were another standby subject, especially if they stood by their offspring. When one took the witness stand pleading for her son to be spared a hangman's rope, a Tribune reporter pulled out all the stops. His description of Angelina Vinci could have gone straight to the working script for Hollywood movie, without the slightest editing: "In black dress, black crepe shawl over her smooth hair, she looked the classic mother of the poor, the figure that kneels before comforting saints in dim cathedrals the world over."

—RON GROSSMAN

A crowd gathers at the home of South Side mobster "Diamond Joe" Esposito for his funeral after he was gunned down in March 1928. Esposito was well-connected, counting judges and U.S. Sen. Charles Deneen among his friends.

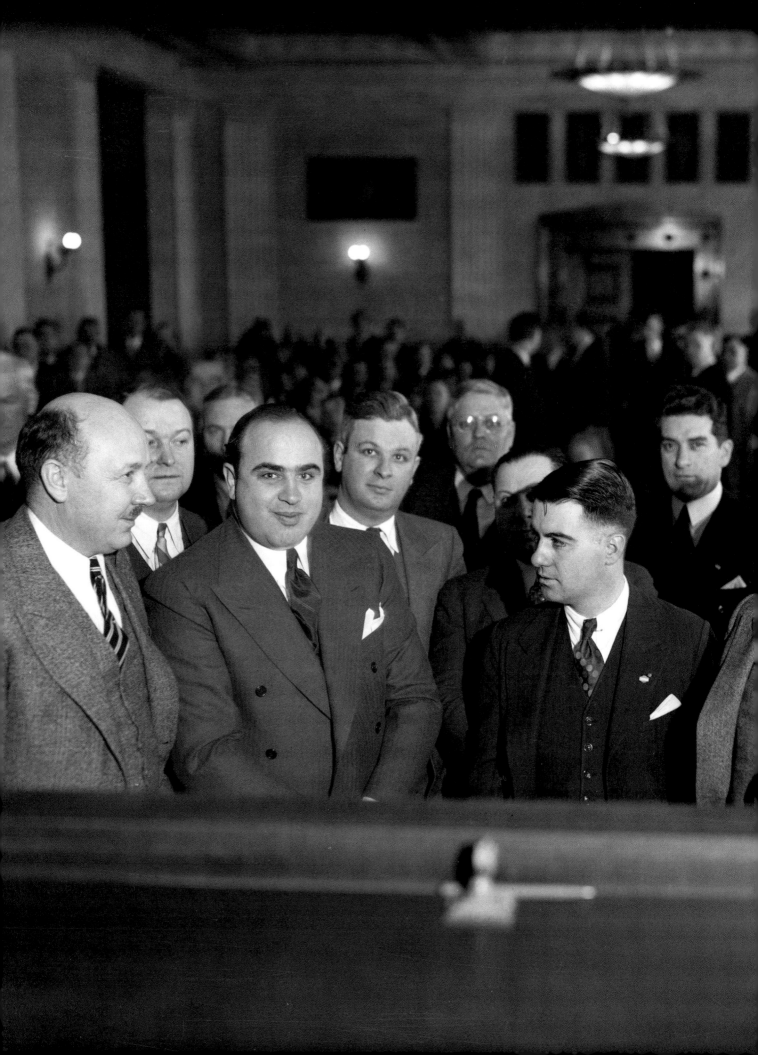

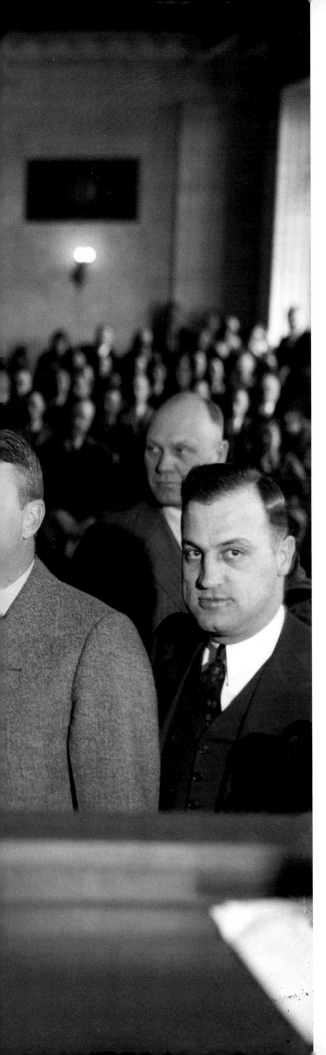

Four who got Capone

U.S. attorney, IRS man, federal agent and judge do the job

AL Capone was a scourge of the city of Chicago. The brutal gangster controlled not only many illegal enterprises, namely beer and booze, but also influenced the legal ones through bribes and threats. It took the full weight and power of the federal government, working on multiple fronts, to bring him to justice.

No one man took down Al Capone. Chicago Crime Commission chief Frank Loesch tried to turn the public sentiment against Public Enemy No. 1. That was a vital weapon in the fight, one that was also wielded by U.S. Attorney George E.Q. Johnson, who railed against the evils of gangsterdom from almost the day he was appointed in 1927. Johnson vigorously took the fight to Capone and his henchmen, successfully prosecuting Capone's brother Ralph, Frank Nitti, the Guzik brothers Harry and Sam, and the beer barons Terry Druggan and Frankie Lake.

Internal Revenue agent Frank J. Wilson gets credit for doing most of the investigative work that led to the tax evasion conviction.

Eliot Ness, on the other hand, was the bulldog. Starting in 1927, he raided Capone breweries, seized thousands of gallons of booze and arrested dozens of gangsters. His work was instrumental in the big indictment reported in the Tribune on June 13, 1931, that named the gang chief and 68 of his top men in a $200 million illegal beer business.

Al Capone, second from left, in Chicago's criminal courthouse in 1931.

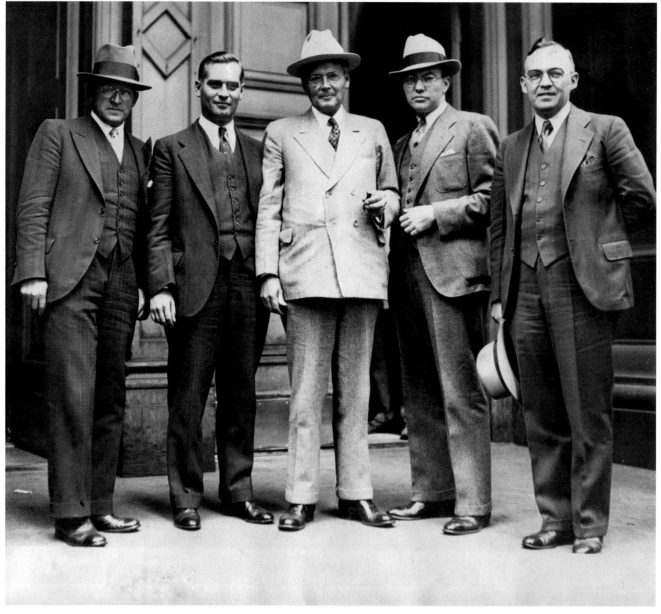

Five federal prosecutors presented their case against Al Capone in 1931. Jacob I. Grossman, from left, Dwight Green, U.S. District Attorney George E.Q. Johnson, William J. Froelich and Samuel Clawson return to court for the afternoon session in 1931.

"Did this Robin Hood buy $8,000 worth of belt buckles for the unemployed? Was his $6,000 meat bill in a few weeks for the hungry? Did he buy $27 shirts for the shivering men who sleep under Wacker Drive?"

—U.S. ATTORNEY JOHNSON

But it was U.S. Judge James Wilkerson who defied not only the power of Capone but also the wishes of the federal government in handing down the unprecedented sentence. Wilkerson famously lectured Capone that "it is utterly impossible to bargain with a federal court" and refused a plea bargain agreement that forced the tax evasion trial.

Each played an important role in ending the gangster's iron grip on Chicago, often in the face of death threats, bodily injury or attempts to smear their good names.

United States attorney

Johnson, who was born and raised in Iowa, started practicing law in Chicago in 1900. The first big salvo in the gang wars came in November 1929 when the U.S. indicted Ralph Capone, Druggan and Lake on tax fraud charges. The Tribune noted it was the first use of the new weapon—income tax evasion charges—which would prove so very effective. Over the next two years, Johnson worked his way through Capone's organization, winning convictions or guilty pleas and sending gangsters to prison for one, three or even five years.

Al Capone was indicted twice, on two consecutive Fridays in June 1931. The first was the tax fraud case, the second was the massive, 5,000-count Prohibition case. And then Capone pleaded guilty. Yes, just four days later, he admitted he did everything the government accused him of doing. The Tribune story speculated that the gangster calculated that he would go to prison for a short time—he hoped for as little as 11 months—get released just as the Depression was ending and take back the reins of his criminal enterprise.

Johnson would be publicly embarrassed by the plea deal and leniency showed Capone, though approval of the deal reportedly went up to the U.S. attorney general and possibly the president. But Johnson felt he had good reasons: His case wasn't great, and he said later he was worried that key evidence wouldn't be admissible.

Wilkerson wouldn't go along, allowing Capone to withdraw his guilty plea. The case went to trial.

While Johnson's assistant, Dwight H. Green,

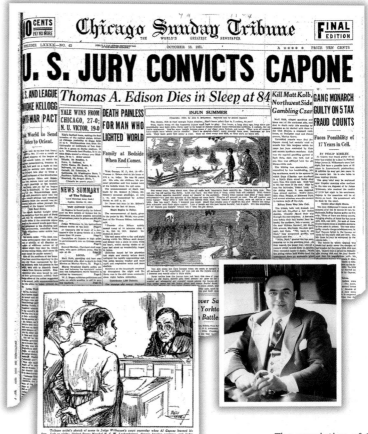

The conviction of Al Capone, above, was the big story in the Tribune on Oct. 18, 1931. A week later, a sketch, left, shows Capone at sentencing before Judge James Wilkerson.

who would later be elected Illinois governor, was the lead lawyer during the trial, Johnson handled the closing arguments. The Tribune reported, "Mr. Johnson was earnest, so much so that he was almost evangelical at times, clenching his fist, shaking his gray head, clamping his lean jaws together as he bit into the evidence and tore into the defense theories." Johnson eviscerated defense arguments comparing Capone to Robin Hood.

"Did this Robin Hood buy $8,000 worth of belt buckles for the unemployed?" he said. "Was his $6,000 meat bill in a few weeks for the hungry? Did he buy $27 shirts for the shivering men who sleep under Wacker Drive?"

Prohibition agent

There has been much debate over how much Ness contributed to bringing down Capone. He is one of the most famous crime fighters of the 20th century. But Ken Burns' "Prohibition" documentary shed doubt on his importance. While it is true Ness played a smaller

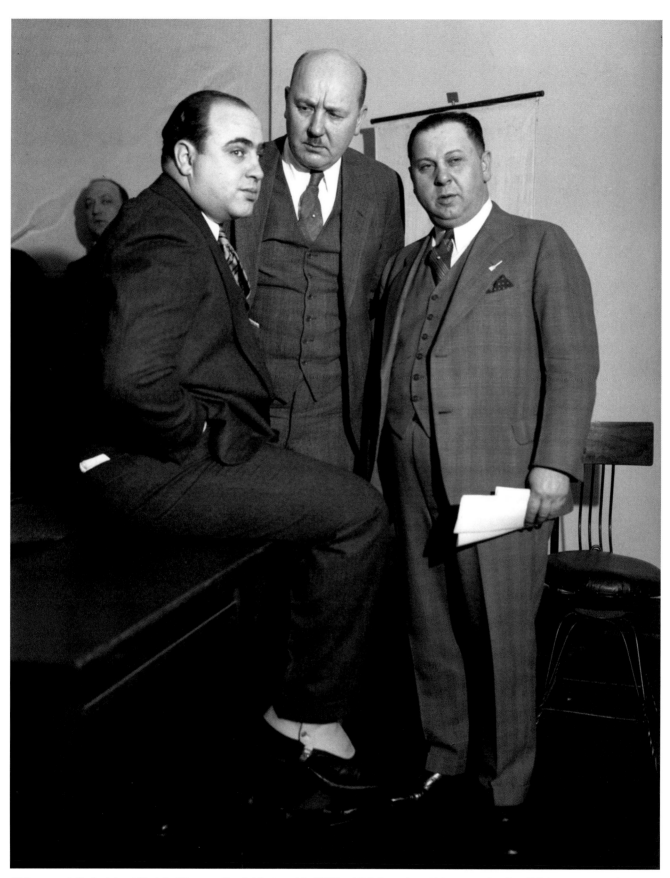

Al Capone, left, Assistant State's Attorney Frank Mast and bailiff Joe Weinberg in a Chicago Federal Building courtroom in 1931.

role in developing the tax evasion case that finally put Capone behind bars, the Chicago native's work was still crucial. As Johnson himself explained, each brewery raid netted more evidence, more papers and a better understanding of how Capone's gang operated. Each conviction led to the next indictment. "This squad from the district attorney's office was led by a very capable young man by the name of Ness, who is a graduate of the University of Chicago, and he selected the squad," Johnson said. "The plan was to cause the Capone gang to lose money, and this squad took brewery after brewery."

Finally, although Ness' work technically may not have put Capone in prison, it very well may have kept him there. In March 1932, Johnson announced a reindictment of the gang chief on Prohibition violations based on evidence found in post-trial raids. The point? With another indictment pending, Capone would not be eligible for parole.

Internal Revenue agent

Wilson is credited with breaking the code of Capone's impounded ledgers, then tracking down the low-level gangsters who could testify to how those ledgers proved Capone made money, which was the trick. Officially, Scarface didn't have a bank account, own anything or make a dime. One of Wilson's biggest assets in that work was Edward O'Hare, a wealthy racetrack owner who was inside Capone's gang. (O'Hare's son, Butch, was the World War II pilot whose name would end up on the airport.) The senior O'Hare fed Wilson a stream of information, including the tip that the gangster had bribed members of the jury pool.

On Dec. 31, 1936, Wilson was named chief of the U.S. Secret Service. The headline labeled him, "Capone nemesis." He retired in 1947. He wrote or co-wrote a number of articles in the Tribune about the effort to get Capone.

Federal judge

In the end, it all came down to the judge. The U.S. attorney and the officials in Washington were willing to settle for a plea deal of 2 1/2 years. Capone was counting on that. And gloating about it. And Wilkerson couldn't stand it.

Judge James H. Wilkerson, Al Capone's trial judge, in 1931.

He ignored the plea deal, embarrassing Johnson and his D.C. superiors, and forced the trial.

Wilkerson also deftly handled a crisis just as the proceedings were starting: Wilson's tip about the bribed jury. Wilkerson's solution was Solomonic but unlikely the dramatic gesture portrayed in nearly every book or movie about the trial. In those accounts, Wilkerson told the bailiff from the bench to swap his jury with that of another federal judge. But if that happened in open court, it was missed by the reporters from not only the Chicago Tribune, but also the now-defunct Chicago Daily News and Chicago Herald-Examiner. More likely, the maneuver was ordered more quietly. Significantly, the swap involved the entire jury pool, not an already impaneled jury. The news reports from that day exhaustively detail the voir dire process that must have occurred after the swap.

A week after his conviction, the gangster stood before Wilkerson for his sentencing, still hoping for the leniency many of his fellow hoodlums had received. It was not to be.

"Let the defendant step to the bar," Wilkerson said. After detailing each count and sentence, Wilkerson summed it up for the man who was once far above the law: "The result is that the aggregate sentence is 11 years and fines aggregating $50,000."

—STEPHAN BENZKOFER

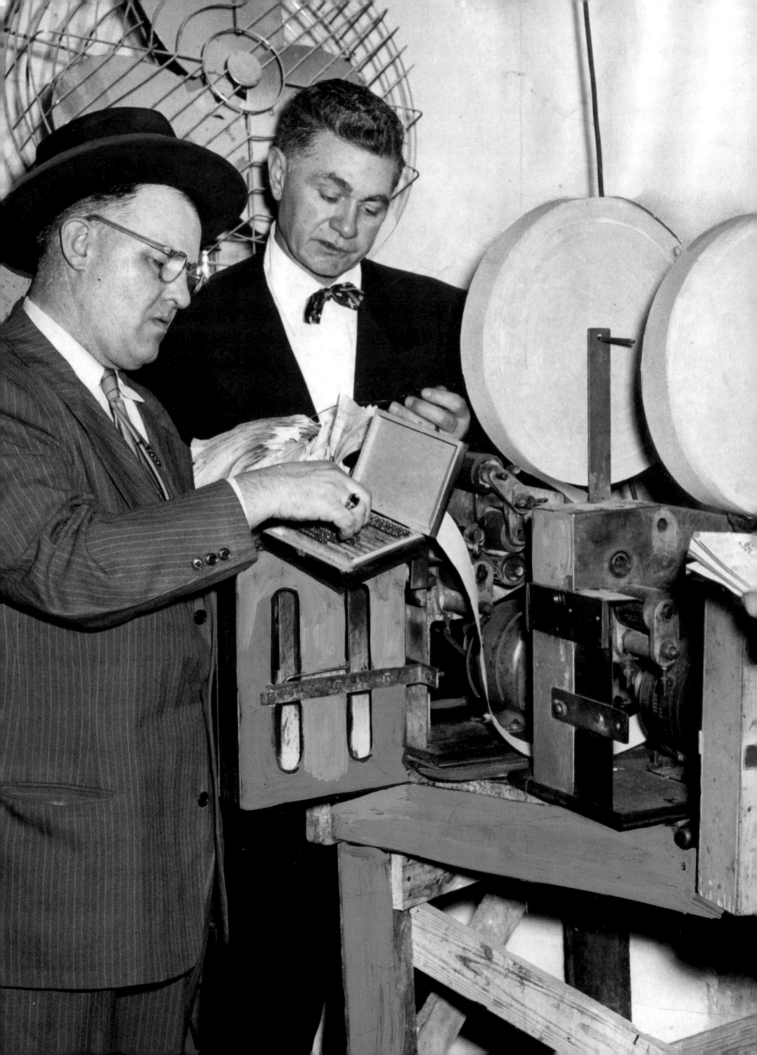

When policy kings ruled

Nickel-and-dime gambling made fortunes for underworld bosses

Long before the state of Illinois figured out how to make big money from gambling, mobsters devised "a 50 million dollar a year business in nickels and dimes," as the Tribune reported in 1950.

Called "policy"—the game took bets for as little as a penny—it was the Monte Carlo of the working class, the Las Vegas of the down and out. Especially popular in the African-American community, the game was decried by preachers and beloved of politicians, who could depend on hefty campaign contributions from the policy kings. The men who ran the policy wheels were some of the wealthiest in the black community when the corporate suites were off-limits to people of color.

Runners, as the game's street-level vendors were known, often doubled as precinct captains, and the game helped shape the fabled Chicago Machine. Because of the obscene amounts of money involved, policy corrupted officeholders and police alike, while making fortunes for underworld types and providing crime reporters with a steady stream of colorful tales.

Despite the name, they weren't like a casino's roulette wheel, but a cylinder from which numbered balls were drawn, similar to what Illinois adopted when it created its lottery in 1974.

Detectives John Hastings, from left, James Flynn and Timothy Allman, from the police commissioner's office, inspect printing presses and other policy wheel equipment in the Rosedale Poultry Shop at 3850 South Park Way in January 1953.

The old-time policy bosses attacked questions like market share and division of profits with a simple set of tools: guns and dynamite.

They had little patience for the argument that gambling is, at best, a vice, and at worst, an addiction.

In 1903, a black pastor, the Rev. R.C. Ransom, sermonized on the evils of policy, whereupon his church was bombed. Ransom said he wouldn't be intimidated, the Tribune reported: "Nevertheless he announced he would carry the revolver which lay beneath his bible when he was preaching on Sunday night."

Yet for all their muscle, the gangsters who ran betting operations with intriguing names like the Spaulding-Silver-Dunlap wheel confronted business expenses that the operators of today's licensed casinos don't face, as Theodore Roe explained to a federal investigating committee in 1950. Roe testified that the wheel he operated with a partner grossed $1 million a year, but that it all wasn't gravy.

"Every time you turn around you have to spend something," said Roe, a big shot in the policy rackets. "And then for courts, lawyers, fines, all kinds of raids."

Raids there certainly were. "Policy Men See Writing On Wall" read the headline for a 1903 Tribune story of the cops shutting down 150 policy wheels. "Police Raid Swank Policy Depot" was the headline for a 1949 story of a rare, up-scale betting parlor. There were grand jury investigations galore. "Indict 3 Policy Kingpins!" a 1951 Tribune headline proclaimed. Under virtually the same headline 11 years before, the Tribune had reported a previous indictment of the same three racketeers.

Indeed, there were so many raids and grand jury probes, you might think the cops and prosecutors weren't really trying that hard. When police Capt. John Golen was asked by a City Council committee in 1945 to assess the war on policy, the Tribune reported: "'We are trying to get the first conviction,' Golden replied. He said he did not recall anyone being convicted on a policy arrest."

No sooner would a policy boss be taken into custody than a lawyer would show up to bail him out. One mob mouthpiece even brought with him an obliging jurist, Judge George Lancelot Quilici, to demand the release of his client, Tony Accardo, who was moving in on the policy rackets in 1951 while making himself "capo di tutti capi," boss of all the bosses, of Chicago's mafia.

That same year, the Tribune editorialized on the slim chances of stamping out numbers betting: "It isn't likely to happen while it is a reasonable supposition that police officers work as body guards for policy kings, and other officers in the areas concerned have incomes many times their salaries."

Policy's corrupting influence was greatest on the South and West sides, the numbers being especially popular in black neighborhoods where residents bore the double burden of poverty and discrimination. The odds against winning were considerable—even if the wheel was honest—but buying a policy ticket from a runner who made the rounds of newsstands and barbershops offered a modicum of hope where it was a rare commodity. Case in point: Getting caught was no deterrent. Arrested bettors would jot down the cop's badge number for future wagers.

Policy also provided thousands of jobs where employment opportunities were scarce, and inspired at least one spinoff industry—the publication of "dream books" that were touted for providing clues to a winning number.

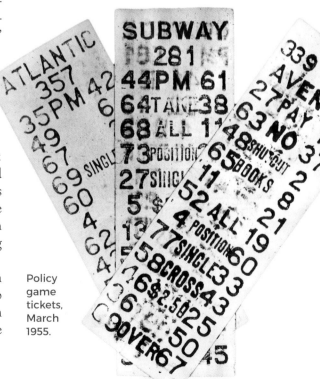

Policy game tickets, March 1955.

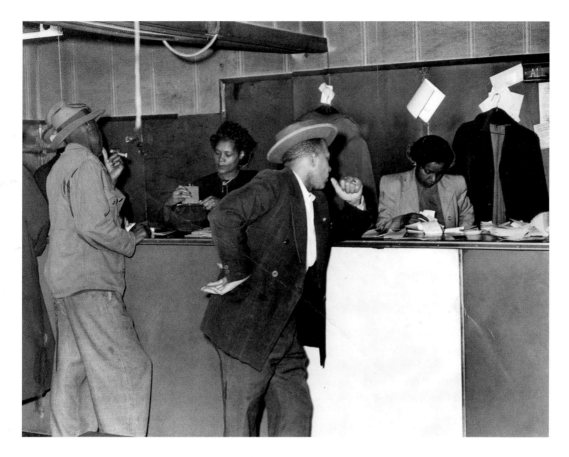

In 1949, female clerks, who were eventually arrested, sell numbers for the policy game to customers just before a police raid at 610 E. 50th St.

The real winners were the policy kings, for decades mostly African-Americans like their clientele. Policy even affected the course of Chicago politics. Blacks were the last urban voting bloc loyal to the Republicans—the party of Abraham Lincoln—until Bill Dawson, a South Side political powerhouse, went over to the Chicago Democratic Machine in the 1930s.

Reportedly, a quid pro quo was assurance that policy would remain in black hands.

In truth, the Machine couldn't, or wouldn't, deliver on the promise. Remnants of the Capone mob belatedly discovered the massive amount of money in numbers—its thinking jogged by the Internal Revenue Service dunning the Jones brothers, three men who went from Pullman porters to policy kings, for more than $2 million in back taxes in 1940.

Six years later, Edward Jones was kidnapped, reportedly by white gangsters. Securing his freedom with a $100,000 ransom, Jones and brother George moved to Mexico. A third brother, McKissack Jones, was killed in a car accident. "Few other policy bosses died so prosaically during the years that the syndicate moved in," the Tri-bune observed of an era of mob warfare the city hadn't seen since Prohibition.

Louis "Buddy" Hutchinson, boss of the Gary rackets, was gunned down in the street. Robert Wilcox was killed in the Chicago shop where he made policy wheels. Big Jim Martin retired from the game after shotgun pellets hit his Cadillac and wounded him. The homes of Caesar and Leo Benvenuti, holdouts against mob control of policy, were dynamited.

Roe, formerly the Jones brothers' lieutenant, was defiant. "I never have and never will hide from the hoods," he told a Trib reporter in 1951, shortly before a shootout in which he killed "Fat Lenny" Caifano, an Accardo underling. Graciously, Roe said his cop bodyguard had nothing to do with it.

The following year, Roe's number came up. He was killed outside his South Michigan Avenue home. The epitaph the Tribune crafted for Roe could serve as well for the other policy bosses killed in those bloody years: "Like the 10 cent bettors on his Idaho-Maine wheel, he wound up losing."

—RON GROSSMAN

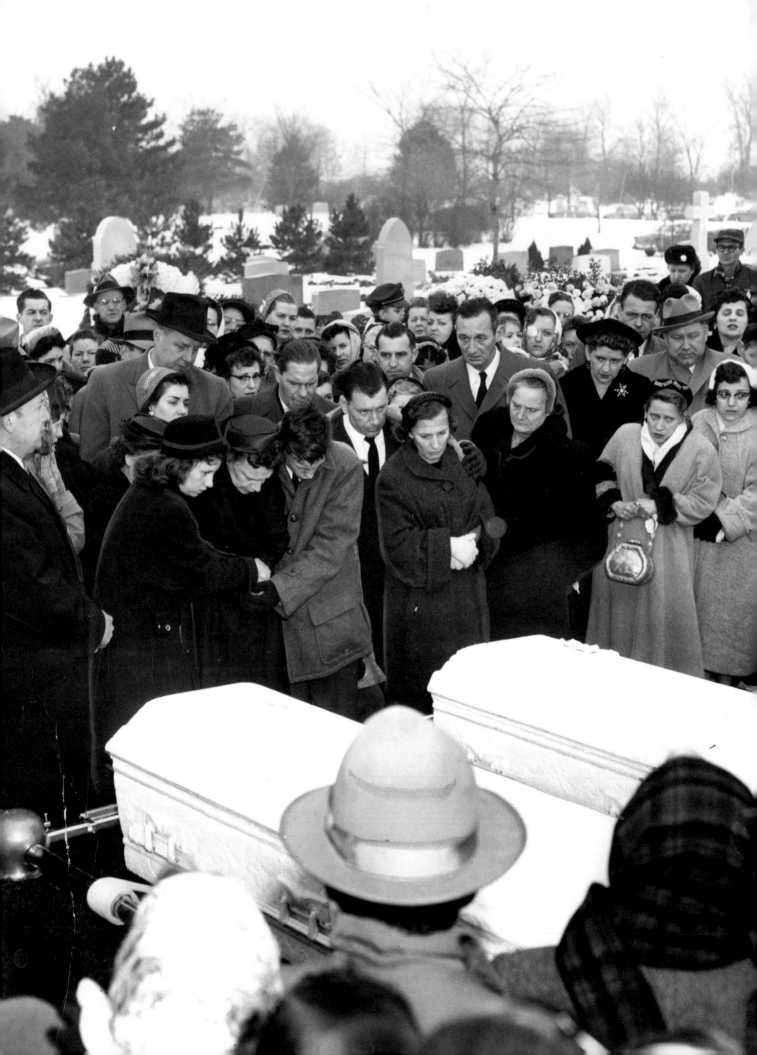

Sisters' deaths changed city

Unsolved Grimes case shattered innocence

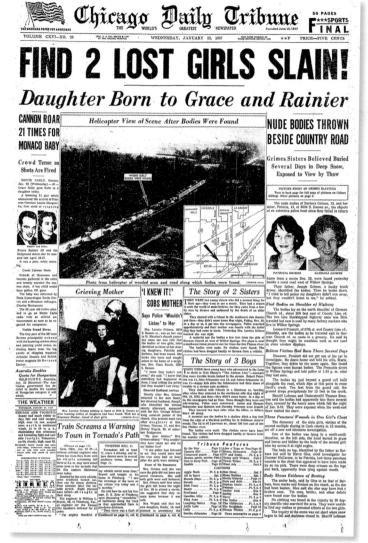

Tribune front page, Jan. 23, 1957.

A GRISLY scene in 1957 was destined not only to be engraved on Chicagoans' memories, but to alter the city's image.

The Tribune's headline screamed "FIND 2 LOST GIRLS SLAIN!" Actually, that was never proved. The saga of the Grimes sisters, Patricia, 13, and Barbara, 15—whose nude bodies were found along a rural road in southwest Cook County on Jan. 22, 1957—is the ultimate mystery story. There wasn't a Sherlock Holmes-like breakthrough. Even as other cold cases are solved by DNA evidence or other breaks, to this day it remains unsolved. Even the question of foul play was never confirmed.

Defending the autopsies performed on the Grimes sisters, a member of the coroner's staff noted that "the pathologists found no evidence of sexual molestation or violence on the bodies." The Tribune reported that twist in the story under the headline "Doctors Stick To Findings in Grimes Probe," reflecting widespread disbelief that the McKinley Park teenagers could come to such a tragic end except at the hands of some monster. Officially, the cause of death was attributed to exposure to winter cold.

The Grimes sisters' case broke between two gruesome murders of young Chicagoans: On Oct. 18, 1955, the nude bodies of three boys,

John Schuessler, 13; his brother, Anton Jr., 11; and Robert Peterson, 14, were found in a north suburban forest preserve, and the dismembered body of Judith Mae Andersen, 15, was recovered from Montrose Harbor in August 1957.

Those killings were widely covered on national television, giving Chicago bitter respite from being identified with Al Capone. "Chicago, gangsterdom of the '20s, was a place now where someone went about killing teenagers, apparently with no motive," the Tribune observed.

Coming while parents still worried about youngsters getting polio—Jonas Salk's vaccine was announced in 1955—the three cases shaped the childhoods of a generation of Chicagoans.

Opposite: Surrounded by family and friends, the bodies of sisters Patricia and Barbara Grimes are buried at Holy Sepulchre Cemetery in January 1957. Grouped near the caskets are Theresa, 17, from left, Mrs. Loretta Grimes, Joseph, 14, Joseph Grimes, father, and Mrs. Shirley Wojcik, sister. James, a brother, is behind his father.

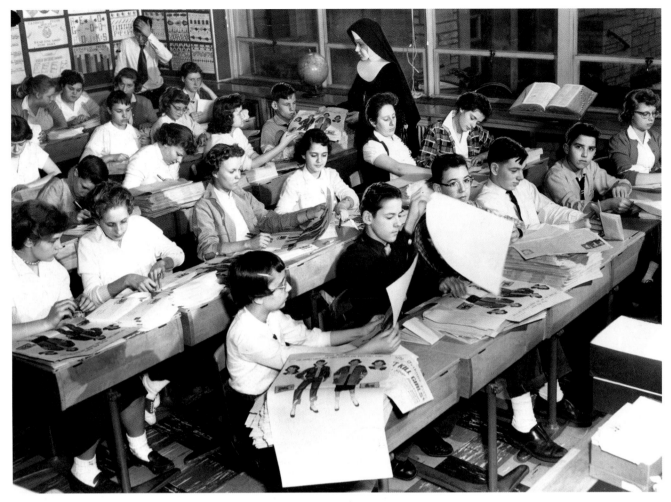

Students in St. Maurice's school fold flyers with color sketches of then-missing sisters Barbara and Patricia Grimes for mailing to 15,000 area homes on Feb. 1, 1957. Sister Mary Ritella is the teacher in the class.

"It isn't safe for children to be on the streets anymore."

—DOROTHY PETERSON, ROBERTA'S MOTHER

"It isn't safe for children to be on the streets anymore," wrote Dorothy Peterson, Robert's mother, in a sympathy card to Loretta Grimes, Barbara and Patricia's mother. A lot of fathers and mothers had a similar foreboding sense that the age of innocence was over.

The Grimes sisters' story began as a missing persons case. On Dec. 28, 1956, they set out to see the Elvis Presley movie "Love Me Tender" at a neighborhood theater. The girls' Presley fan club membership cards arrived at the family home as the search continued. Their

mother pleaded. "If someone is holding them, please let the girls call me." Her ex-husband enlisted fellow truck drivers in the search for the girls.

There were numerous supposed sightings. "A North Shore motorman reported seeing the girls on a train near the Great Lakes Naval Training center," the Tribune wrote. "No, the girls were south of Chicago, in a Blue Island restaurant eating chili and ice cream."

Equally wild speculation followed the discovery of their bodies. From the pulpit of their

parish church, the pastor chastised neighbors spreading vicious rumors about the girls. Reportedly, they were seen on West Madison Street, the city's skid row, in the company of "Bennie" Bedwell, a lowlife drifter. That theory was stubbornly supported by Harry Glos, the coroner's chief investigator, until he was fired. "The scientists took the girls off Madison Street and put them into respectability," a bitter Glos told the Tribune, charging his ex-boss with a cover-up.

Bedwell actually confessed, but that undid the case against him because his account didn't jibe with the facts.

Coroner Walter McCarron threw up his hands in frustration, saying: "I'm going to take a vacation." He went to Florida, and the Grimes sisters' deaths became a cold case—never solved, but never forgotten. Periodically revisiting a case that emotionally shaped a generation, the Tribune once noted: "The story goes on."

—RON GROSSMAN

Technician Emmett Flynn, left, and Sgt. Claude Hazen, of the crime laboratory, inspect the spot where the bodies of Patricia and Barbara Grimes were found in January 1957.

Casino? What casino?

Law enforcement turns blind eye to infamous gambling house

"THIS vice is hard to remedy. It grows out of the restlessness and excitement of man, and prevails most where such restlessness and excitement are strongest. Every one understands its horrid effects; none better than the victims to it. Yet, when it takes possession of the mind, it makes man a mad man—cursing him with an agony which no language can describe. The law seems powerless against it. Now and then, impulsive movements are made by officials in cities, and the hells are broken up, and their inmates scattered. But a lull comes, and in that these hells are re-opened and quickly filled."

This Tribune editorial about gambling was published April 19, 1856, but it could have run in 1956 or any decade in between. The editorial writer described the scourge in almost biblical terms even as he wrote what amounted to a prophecy of how anti-gambling efforts would roll out over the next 125 years.

The pattern became very familiar. A new mayor or sheriff or governor was elected. He announced that he wouldn't tolerate gambling of any sort. Raids followed, along with the big, bold, banner headlines. Maybe there was a photo of a cop taking a sledgehammer to a slot machine. Time passed. The raids stopped or the prosecution faltered. And the gambling continued. A trip through the Tribune archives shows the pattern repeated at least once a decade, sometimes two or three times in 10 years.

The Dev-Lin was run by a "gambling king" with political clout, the Tribune said back then.

Much of that changed when the state introduced the lottery in 1974 and legalized riverboat casino gambling in 1990, but a search of the Tribune's archives revealed one illegal casino in particular that illustrated how such operations thrived in Illinois.

It was May 1935, and Chicago was in the midst of another crackdown. For two months, city and county police had been making life difficult for gamblers, particularly handbook operators betting on the horses, everywhere in Cook County. Everywhere, that is, except Tessville. (It would be renamed Lincolnwood later that year.) The Hide Away sat just outside the Chicago city limits at Lincoln and Devon avenues, and as a Tribune story on May 19, 1935, reported, business was so brisk at the multibuilding casino that three guards were out on Lincoln directing traffic.

The big draw, attracting some 500 bettors, was the horse-race action in the backroom, but others enjoyed roulette, stud poker and slots. County police, however, "reported at the end of a hard afternoon of anti-gambling enforcement that they could find no violations," the Tribune pointedly remarked.

That poke in the eye was enough to get The Hide Away shut down (permanently, vowed police) the very day the Tribune reported business was flourishing.

It didn't stay closed. On Aug. 25, the Tribune ran a story that the joint was running "wide open" again under the new name Dev-Lin. But what got everybody's attention were the three candid blockbuster photos—shot surreptitiously by a Tribune photographer—of men and women eagerly playing dice and roulette and betting on the horses. The story reported more than 600 people were jammed into the gaming emporium, and a fourth photo showed a packed parking lot outside.

The story pulled no punches, written in a tone that was nearly gleeful: "The highway police have reported that there are no gambling violations in their territory. Strangely enough, they don't seem to be able to get to the Dev-Lin while the gambling is in progress. The resort is operating day and night."

The result again was immediate, though this time, the Tribune said, it was the "Chicago gambling syndicate" that shut it down and "sat

back to await developments."

So began a game where Tribune reporters would ask various officials why gambling joints operated unmolested in Tessville, and officials would make various excuses, ranging from ignorance of the problem to being too busy handling traffic accidents. The gambling continued.

So what was going on here? The Tribune connected the dots. Dev-Lin, reported as tiny Tessville's biggest industry, was one of a number of casinos run by Bill Johnson, a well-known figure in "the field of politics and a close friend of (Cook County) Sherif John Toman."

Another story described Johnson as "an honest gambler" and a "gambling king," who worked for years in Chicago before being forced to the city's border. The Tribune said "he was associated politically with the late Mayor Anton Cermak and the late Moe Rosenberg, a Democratic ward committeeman."

Simply put, the Dev-Lin was "immune from interference." It would appear to remain so until at least 1939. That's when the illegal gambling issue was finally brought before a Cook County grand jury that took it seriously. The grand jury raked the sheriff and other officials over the coals and released a withering report of its investigation that blasted the sham raids and the "practice of passing the buck between policing bodies" that allowed gambling to flourish.

The next year, the U.S. attorney went after Johnson, charging him with income tax evasion. During the trial, he was closely linked with not only Toman, but also Cook County State's Attorney Thomas Courtney, Mayor Edward Kelly, Democratic Party boss Patrick Nash and multiple aldermen.

Johnson was convicted on all counts in October 1940, failing to report nearly $2.8 million in income. (That's nearly $49 million in 2017.) He served just half of a five-year prison sentence.

But how does this story end? Very appropriately. On Christmas Eve 1952, President Harry Truman granted Johnson, the former overlord of Chicago gambling and convicted tax cheat, a full pardon. Johnson lived out his days on a large estate on Butterfield Road near Glen Ellyn.

—STEPHAN BENZKOFER

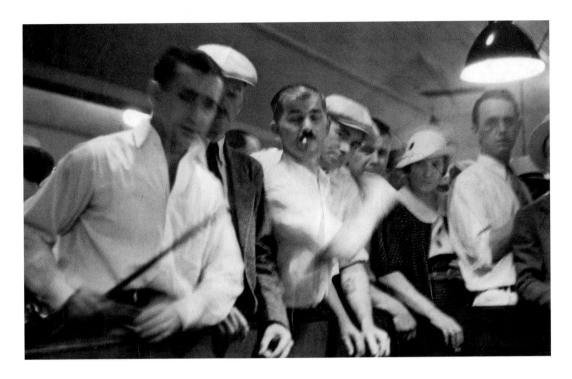

In this 1935 photo shot surreptitiously by a Tribune photographer, gamblers fill the illegal Dev-Lin casino, at Devon and Lincoln avenues in Tessville, now Lincolnwood.

"The highway police have reported that there are no gambling violations in their territory. Strangely enough, they don't seem to be able to get to the Dev-Lin while the gambling is in progress. The resort is operating day and night."

—TRIBUNE, 1935

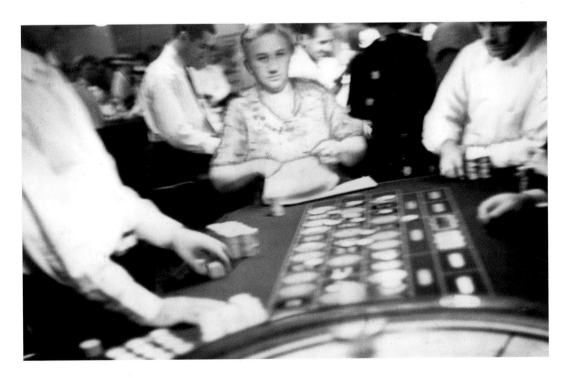

A woman plays roulette at the Dev-Lin casino, as seen in another 1935 photo that was surreptitiously shot. "The resort is operating day and night," the Tribune reported.

CHAPTER SEVEN:

Passion and Protest

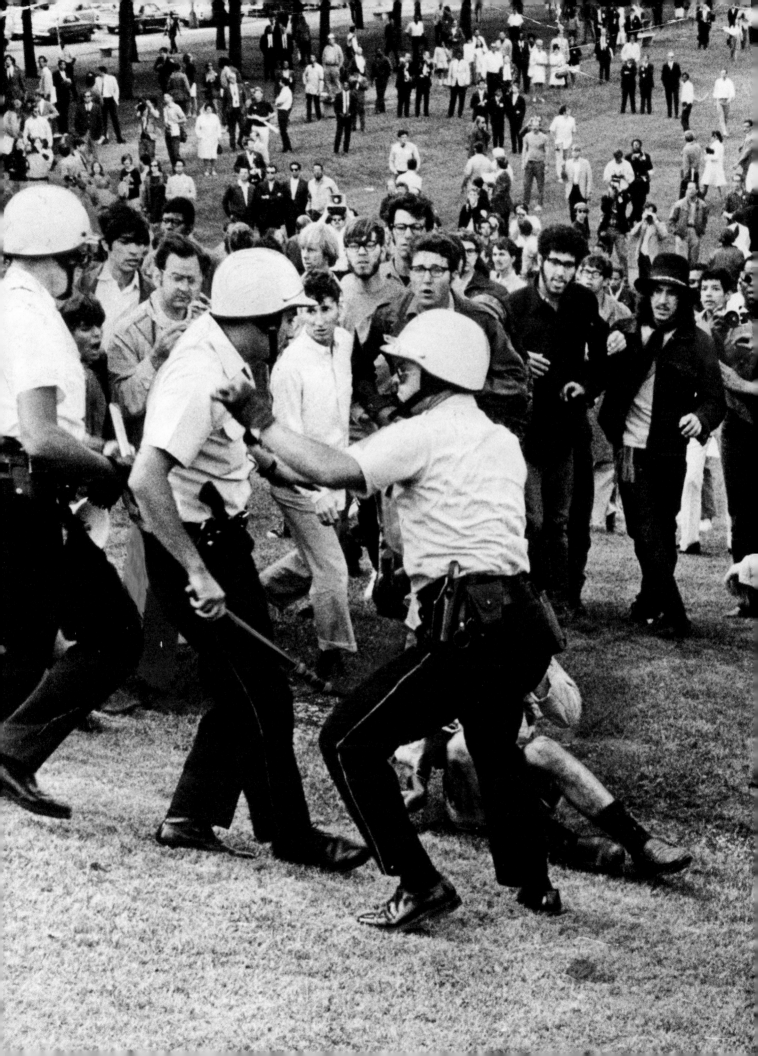

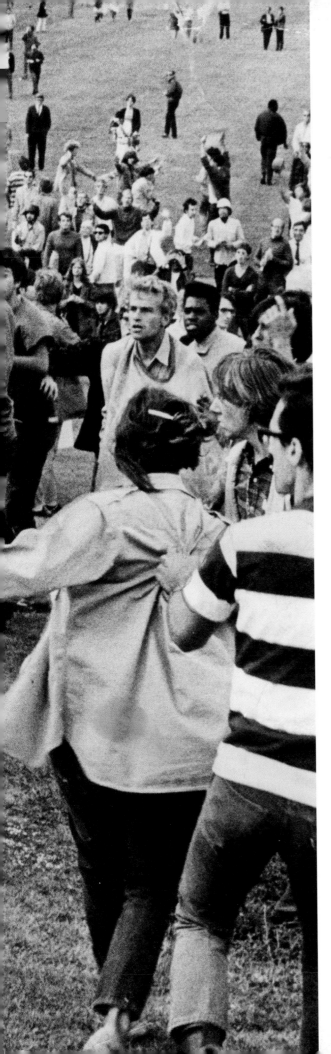

1968's 'police riot'

Democratic National Convention was five-day battle

FOR five days and nights in August 1968, demonstrators fought street battles with Chicago police and National Guard troops, a badly split Democratic Party struggled to pick a presidential nominee and a horrified nation watched it all on the nightly news.

The U.S. was mired in a seemingly endless war in Asia. By March 1968, voter anger over the Vietnam War almost cost President Lyndon Johnson the New Hampshire primary, and he abruptly ended his bid for re-election. His opponent, Minnesota Sen. Eugene McCarthy, had mobilized the discontent of younger Americans turned off by politics as usual and by Victorian social and sexual mores.

Chicago wasn't the only city that would see disaffected young people take to the streets in 1968. In May, university students clashed with police in Paris, triggering a general strike that almost toppled the French government. A week before the Chicago convention, Soviet troops occupied Prague. "Waving Czech flags, youths ran into the street to set Soviet tanks afire with flaming rags," the Tribune reported. "'Russians, Go Home!,' they yelled."

So Chicago tried to prepare for the Democratic National Convention. Protesters and city officials argued over demonstration routes. The National Guard was mobilized. Mayor Richard J. Daley denied rumors that the Democrats were considering moving the convention for fear protests would be too violent.

Chicago police converge on an anti-war protester in Lincoln Park during the 1968 Democratic National Convention.

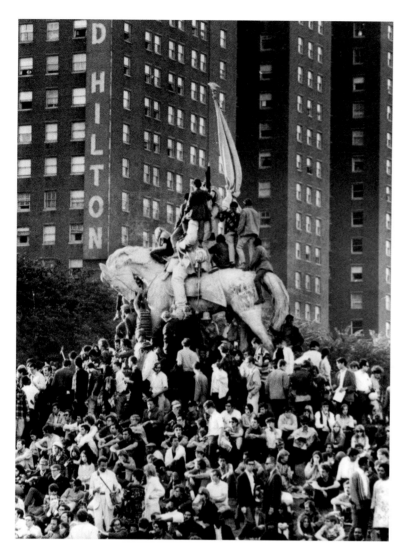

The calm before the storm in Grant Park, across from the Conrad Hilton on Aug. 29, 1968. Demonstrators climb the statue of General Logan while thousands gather on the ground during the Democratic National Convention. Many of the convention delegates were staying at the Hilton.

It didn't take long for police and protesters to collide. On the eve of the convention, Sunday, Aug. 25, they clashed. When police cleared protesters from Lincoln Park, their intended encampment during the convention: "One witness said the scene in Old Town resembled a war, with lines of frightened tourists trying to get away and police moving in against the radicals."

A canopy of tear gas floated over Lincoln and Grant parks and adjoining thoroughfares, and not just hippies but well-dressed suburbanites found themselves on the receiving end of nightsticks. Hugh Hefner took a baton to the back near the Playboy Mansion on the Gold Coast. Newspaper and television reporters, photographers and camera crews also felt the business end of billy clubs as they tried to cover the rioting.

Even inside the South Side convention hall, the scene seemed more like a bar fight than a political gathering. "The Democratic national convention in the International Amphitheater took an undemocratic turn last night when Dan Rather, a Columbia Broadcasting System reporter, was slugged in the stomach and knocked down in full view of the television audience as he tried to interview a member of the Georgia delegation who was being ejected from the convention floor," the Tribune reported of the second day's session.

And it was here, in mid-convention, that Daley famously told reporters: "Gentlemen, let's get the thing straight, once and for all. The policeman isn't there to create disorder, the policeman is there to preserve disorder!"

Ground zero of the protests was the Conrad Hilton Hotel on South Michigan Avenue, which was under siege, the Tribune reported. Each night, protesters would set up camp across the street in Grant Park, and police and National Guard troops would form up opposite them. Protesters hurled rocks, bottles, human feces, noxious chemicals and obscenities. They turned over cars and set fires in trash cans. The cops beat people bloody, arrested them by the hundreds, tried to disperse the mob with several Jeeps jerry-rigged with barbed-wire-wrapped front grills and, of course, threw tear gas.

The federal investigation that followed, led by Daniel Walker, director of the Chicago Crime Commission and future governor, acknowledged that law enforcement officers were under extreme provocation but famously labeled the disorders a "police riot." It called the police response "unrestrained and indiscriminate" and said it was often inflicted "upon persons who had broken no law, disobeyed no order, made no threat."

And while city and Democratic Party officials said the national media overplayed the rioting, the Walker report said that its interviews of nearly 3,500 witnesses and participants painted "a scene of police ferocity exceeding that shown on television."

Walker also singled out the mayor, saying that he was responsible for the attitude of the police because of his inflammatory public

statements about shooting rioters after the race riots earlier in 1968.

Accused of fomenting the disorders, Yippie leaders Jerry Rubin and Abbie Hoffman and others—dubbed the Chicago Seven—were tried in federal court, but their convictions were reversed on appeal. Rubin experienced a conversion to capitalism and went into marketing, with himself as essentially the product. Hoffman kept the faith, in his own way: He died of a drug overdose. Eight police officers indicted for civil right violations also were acquitted.

Chicago was left with a long-lasting black eye. Its trade-show business took a hit, and the Democratic Party didn't hold another convention here for three decades.

"Surely this is not the last time that a violent dissenting group will clash head-on with those whose duty it is to enforce the law," observed the National Commission on the Causes and Prevention of Violence. "And the next time the whole world will still be watching."

—RON GROSSMAN

The Tribune's sorry coverage

The demonstrations and unrest surrounding the 1968 convention were captured in some of the most iconic and important photographs in Chicago's history. None appeared on Page 1 of the Chicago Tribune.

The decision to quarantine the dramatic photographs inside meant readers encountered some jarring pairings on Page 1. Vice President Hubert Humphrey's beaming face ran next to a headline reading, "Scores Hurt in Battle on Michigan av." Vice presidential candidate Edmund Muskie's dour visage looms above, "2,000 Flee to Park in Tear Gas Attacks."

Stories of the unrest did start on the front page—Monday, Aug. 26's edition had a one-column headline above the fold proclaiming, "Police Repel Jeering Mob of Peaceniks"—but the newspaper's editors defiantly gave bigger and more prominent play to political convention news through the week, refusing to legitimize the demonstrators or incite the rioters further by giving them valuable Page 1 space. So more important than "Cops, Hippies War in the Street" was the banner headline "One Ballot; It's Hubert."

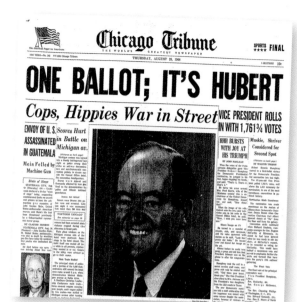

None of the iconic and important photographs from the protests and violence that plagued the 1968 Democratic National Convention appeared on the cover of the Chicago Tribune.

In Sunday's paper, the Tribune led with two photographs from protests in Prague; the Soviets had invaded the week before. The first photo shows thousands of Czechs marching down the street. The second shows two young Czech men carrying a wounded comrade on a stretcher. But just two days later, a strikingly similar photo—an injured demonstrator being carried away on a stretcher in Chicago—was relegated to the back page. The lead photograph on the front page that day? A three-column portrait of a smiling Muriel Humphrey, Hubert's wife.

—STEPHAN BENZKOFER

If that weren't enough

If nightly street battles weren't bad enough, the city also had to deal with multiple striking unions. The biggest blow landed when a wildcat bus driver strike crippled the CTA. "New CTA strike begins" was the headline on Sunday that greeted early delegates. The strike hit hardest the South and West sides and forced some hotels to curtail some services because maids and other employees couldn't get to work. On strike since May were electrical workers for Illinois Bell Telephone. Finally, Yellow Cab and Checker Taxi drivers were idle, meaning there were just 1,000 taxis running during the convention. Those drivers struck a deal—but not until Friday, as the delegates fled town.

—RON GROSSMAN

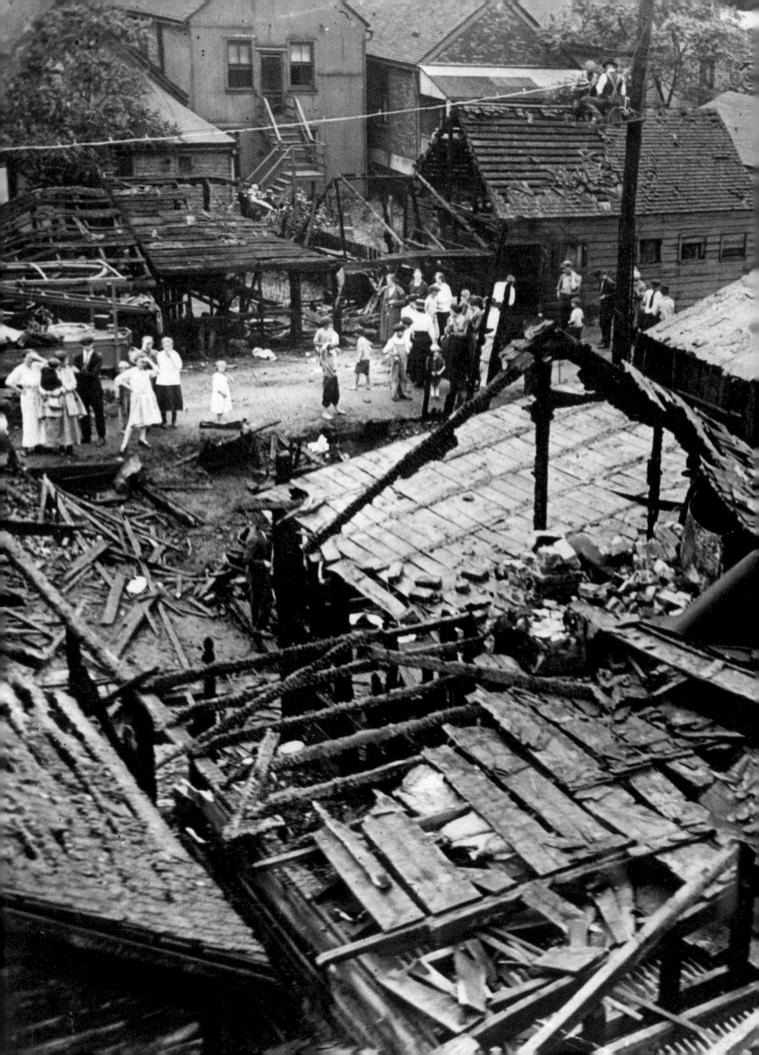

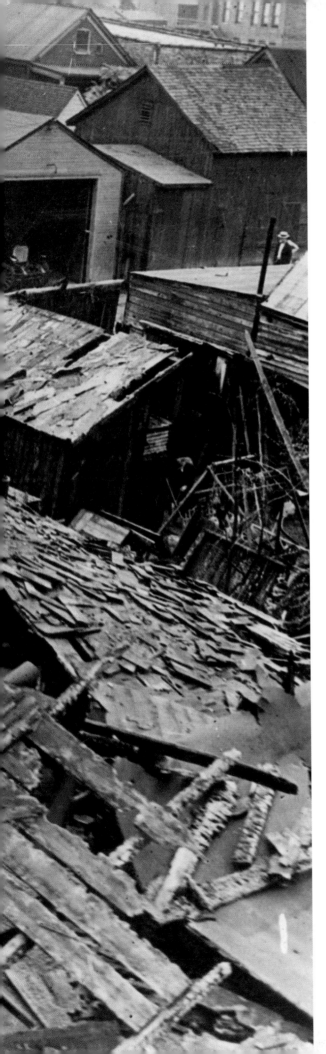

A racial tinderbox

In 1919, divided city turns against itself

ALMOST a century ago, the poet Carl Sandburg, who doubled as a Chicago newsman, searched for the underlying cause of a bloody race riot. Given the level of violence today, his essential conclusion is worth reconsidering: The slums take their revenge.

In 1919, the killing and burning began when 17-year-old Eugene Williams crossed over an unmarked—but deadly real—line dividing a Chicago beach into white and black sections.

"One Negro was knocked off a raft at the 29th Street beach after he had been stoned by whites. He drowned because whites are said to have frustrated attempts of colored bathers to rescue him," the Tribune reported of Williams' July 27 death. The situation worsened after a white police officer, Dan Callahan, refused to intervene or arrest the rock throwers, the Tribune reported. Indignant black residents then started fighting back. "The rioting spread through the black belt and by midnight had thrown the entire South Side into a state of turmoil."

As the violence escalated, the Tribune published maps showing where incidents took place and buildings were torched. On July 29, the paper reported a scene at Provident Hospital in the heart of the black community: "In the emergency treatment room 10 physicians, three interns and 15 nurses, some of whom had been on duty for 24 hours, worked unceasingly bandaging wounds." The paper provided updates on the killed and wounded that must have seemed to Chicagoans more like battlefield dispatches from the recently concluded

Many houses in the predominantly white stockyards district were set ablaze during the 1919 race riots.

World War I than stories of their hometown.

Shortly, the rioting spread to the Cook County Jail, where black prisoners fought with white prisoners and guards. "Last night a machine gun stood in the jail trained upon the Negro quarters," the Trib said on July 30. That same edition reported: "'Uncle Tom's Cabin' in a modern setting—that was the central police station yesterday. Like fugitive slaves of the antebellum South, colored citizens huddled in the squad room and awaited their turn to be taken home under escort."

Gangs of whites, some with fanciful names—and some "undoubtedly drunk," according to the Tribune—descended on the black community. In an affidavit taken by the NAACP, Harriet White recalled her experience at the hands of the Ragen's Colts from the adjoining Bridgeport neighborhood: "Bricks and stones entered my home forcing me to leave." They left her with a warning: "If you open your mouth against 'Ragen's' we will not only burn your house, we will 'do you,'" according to an account in historian William Tuttle's book "Race Riot."

Hoping to dampen the flames, the Catholic Archdiocese sent a representative to white ethnic parishes to preach the gospel of love. A Trib reporter noted that the message had to be translated into Polish, Lithuanian and other Old World tongues.

Residents were likely already on edge because of a wave of horrible news. About a week earlier, Goodyear's Wingfoot Express dirigible plunged into a Loop bank building, killing 13 people. At the same time, residents were worrying about a missing 6-year-old girl. But that anxiety turned to horror with the discovery of Janet Wilkinson's slain body on July 27 and the gruesome confession from a hotel watchman. To make matters worse, 15,000 streetcar and elevated train motormen, who had been threatening a strike, walked off the job as the riots erupted.

Authorities were divided over how to separate troublemakers from protesters with legitimate grievances. The police chief suspended the officer at the beach who failed to arrest the rock thrower, the Trib reported, and said he "believes Policeman Callahan guilty of being

the cause of the disastrous rioting." But the sheriff preferred a show of force and recruited more than 1,000 ex-soldiers and sailors to patrol the South Side.

Black leaders, claiming aggressive police tactics were inflaming the situation, wanted the state militia sent in, and by August, 6,500 troops were deployed on Chicago streets. Taking a bow, Gov. Frank Lowden said: "They went into a district where murder, arson, and anarchy existed for four days and brought peace and quiet."

In the rioting, 23 African-Americans and 15 whites were killed. More than 525 were injured, two-thirds of them black. About a thousand Chicagoans, mostly African-Americans, were left homeless. Many sued the city for damages, including Mr. and Mrs. Thomas Samuels whose list of personal possessions lost to rioters included "piano, $500" and "Pullman uniform, $32."

Just as now, there were strong feelings that blacks were picked on by the police. Even a white judge thought so, telling the cops: "I want to explain to you officers that these colored people could not have been rioting among themselves. Bring me some white prisoners."

On the eve of the 1919 riots, Chicago was a racial tinderbox, noted Carl Sandburg in "The Chicago Race Riots, July 1919," a collection of his newspaper articles. The city's black population had increased from 44,000 to 109,000 during World War I when a labor shortage in the North, and a wave of lynchings in the South, induced blacks to move to Chicago. The Black Belt, the overcrowded area into which blacks were segregated, began to spill over into white neighborhoods, where homes occupied—or thought to be occupied—by African-Americans were dynamited. Sandburg reported eight such bombings in the six months before the riots.

Four days before the first riot, the Tribune editorially warned of the dire consequences of not learning from another city's misfortunes: "Disturbances in Washington between the white and colored residents must remind us here in Chicago, where the need for adjustments of relations is so great that we are

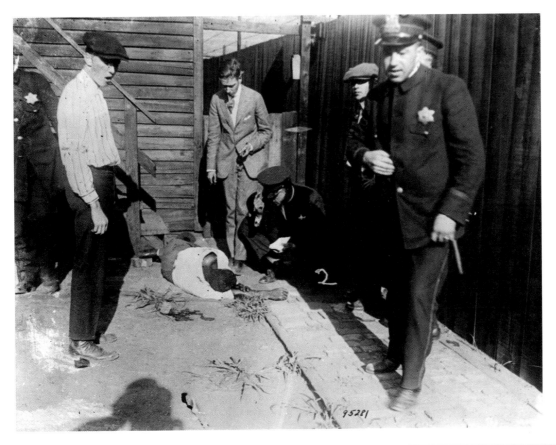

Chicago police hover over the body of a black man killed by white residents in Chicago during the 1919 race riots.

Tensions festered on the streets of Chicago's South Side in 1919 as the race riot continued. The state militia was called in to quell the violence.

headed for trouble on a large scale if some conciliatory process is not undertaken."

Some public officials saw the situation much as today's conservative talk-show hosts do: an indulgent attitude toward lawbreakers. The Cook County state's attorney told the Trib: "These riots and the crimes which attended them may be directly traced to the 'Black Belt' politics of the city hall organization leaders, black and white, who not only permitted but encouraged and participated in the profits of gambling, disorderly saloons and hotels, and other violations of law."

Lowden appointed a blue-ribbon commission to make a more dispassionate study of the riot. Its conclusion still reads hauntingly relevant, all these years and so many similar tragedies later:

"No one, white or Negro, is wholly free from an inheritance of prejudice in feeling and thinking as to these questions. Mutual understanding and sympathy between the races will be followed by harmony and co-operation. But these can come completely only after the disappearance of prejudice. Thus the remedy

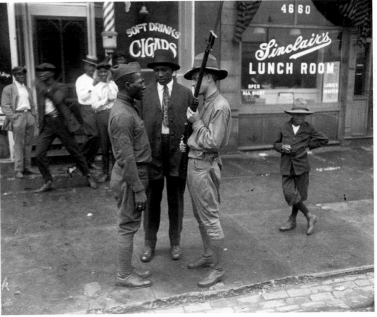

is necessarily slow; and it is all the more important that the civic conscience of the community should be aroused, and that progress should begin in a direction steadily away from the disgrace of 1919."

—RON GROSSMAN

Chicago and the KKK

In 1920s, the Klan found fertile ground in the North

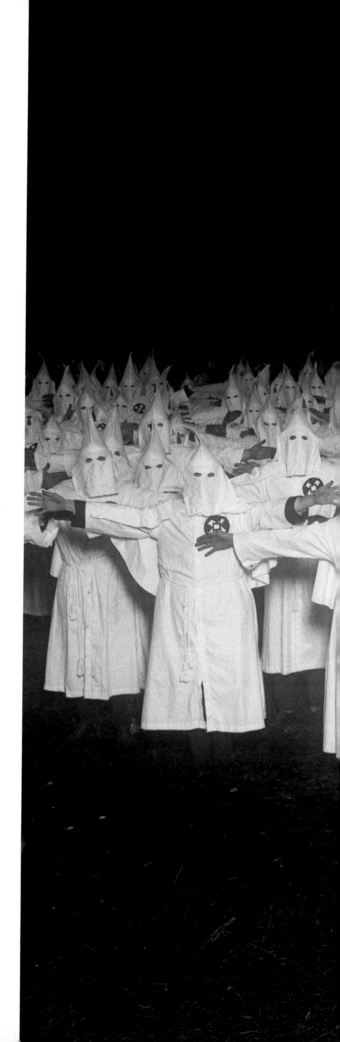

Thousands of Klansmen gather in August 1921 for an initiation rite on a farm near Lake Zurich. The procession there began in Chicago's Albany Park neighborhood.

T HE scene that drew residents of Central Park Avenue just south of Foster Avenue to their front porches on Aug. 16, 1921, was eerily reminiscent of "The Birth of a Nation," the film that celebrated the night-riding vigilantes who restored white supremacy to the post-Civil War South: Thousands of men in white gowns and hoods exchanged ritual handshakes and piled into a long line of cars headed for a secret destination in the northern suburbs.

But while director D.W. Griffith's 1915 movie commemorated a Ku Klux Klan moribund for half a century, the procession that formed on an Albany Park neighborhood street marked its rebirth—and its expansion north. The original Klan had targeted African-Americans newly freed from bondage and became obsolete once Jim Crow laws established a segregated South. The new Klan enlarged the compass of its hatreds, preaching that immigrants, Catholics and Jews were undermining the American way of life. Chicago, the pre-eminent city of immigrants, was a natural recruiting ground for older-stock Protestant Americans fearful of losing their place at the top of the pecking order to Catholics and Jews.

"Our membership is limited to native born American gentiles," William Simmons, the Klan's imperial wizard, told the Tribune.

For the Klan, Chicago was the key to transforming the Southern organization into a national movement, so Simmons came from his

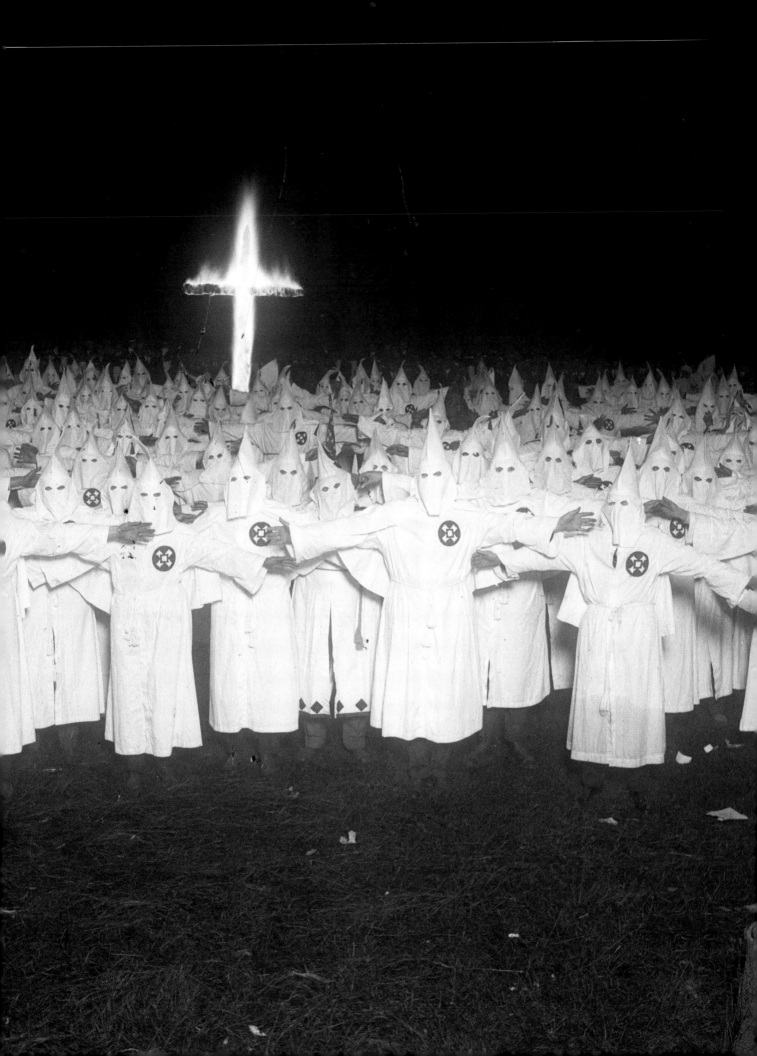

> "Upon the weird assemblage the searchlights of the automobiles drawn about in a great assembly shone with white intensity. Pickets patrolled beyond the pale, terrifying the curious citizens of the countryside by their grotesque appearances."

—TRIBUNE, 1921

Atlanta headquarters to personally lead the procession that assembled on Central Park Avenue. When the caravan had reached its destination, near U.S. 12 and Old Rand Road, new members of the Chicago Klan were put through a ritual called "naturalization," the next day's Tribune reported. "A huge bonfire had been lighted. Thousands of members of the order, each bearing aloft a torch, took position in the form of a blazing cross. The blindfolded initiates were herded inside," the paper reported. "Upon the weird assemblage the searchlights of the automobiles drawn about in a great assembly shone with white intensity. Pickets patrolled beyond the pale, terrifying the curious citizens of the countryside by their grotesque appearances."

The restored KKK's membership wasn't limited to the lower middle class, the traditional breeding ground of xenophobic political movements. That mass initiation ceremony was held on a farm near Lake Zurich owned by Charles Weeghman, whose string of cheap Loop restaurants had made him a millionaire. Weeghman built the North Side ballpark subsequently known as Wrigley Field and owned the Cubs from 1916 to 1918. Perhaps he was among the business leaders attracted to the KKK by its hostility to the union movement, which the Klan equated with the Bolsheviks who recently seized power in Russia, a powerful argument during a wave of bitter strikes in America.

A century ago, membership in the newly revived KKK was a steppingstone to political office. Politicians who cuddled up to the Klan

didn't need to make excuses. In the 1920s, not only many Southern politicians but also Indiana Gov. Edward Jackson, a governor and U.S. senator from Colorado and Los Angeles Mayor John Porter were Klansmen. So was Hugo Black, a future U.S. Supreme Court justice. President Woodrow Wilson gave "Birth of a Nation," used as a recruiting tool by the KKK, the honor of being the first movie screened in the White House.

African-Americans were horrified at the revival of the KKK, which had conducted a reign of terror marked by lynchings and burnings of black churches and homes in the 1860s. The Chicago Defender, the city's black newspaper, editorialized: "The Ku Klux Klan has reached Chicago: Full page ads in the papers, followed by the announcement that 12,000 of them had met at Charlie Weeghman's farm thirty miles out of town, and in the pouring rain initiated nearly 3,000 more, ought to jar us off our do-nothing stools."

The Tribune also editorially decried the revived KKK's presence in Chicago—in a twisted way. By the Tribune's logic, the new KKK besmirched the legacy of the original one: "The first Ku Klux Klan grew out of intolerable conditions in the south and passed away when the danger of Negro domination and the plague of the carpet bagger were lifted," the Tribune wrote. "It was born of an emergency and, while evils were committed in its name, it served an important end, while contributing one of the romantic episodes of our history."

Local clergy decried the arrival of the KKK,

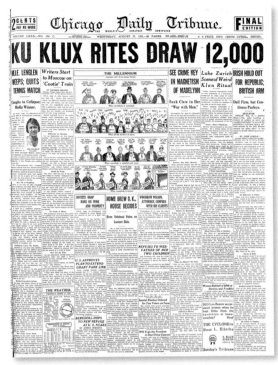

Tribune front page, Aug. 17, 1921.

and the City Council passed a resolution saying that the group wasn't welcome in Chicago. The resolution said: "That it is not necessary to supplement the police force of the city of Chicago with a secret organization."

But the protests of aldermen and ministers hardly impeded the growth of the KKK's Chicago chapters. In 1922, the Klan initiated 4,650 new members in another ceremony in a field at 91st Street and Harlem Avenue. More than 25,000 supporters welcomed the initiates. For the first time, according to the Tribune, a Chicago reporter was allowed to witness the ritual: "Searching eyes inspected them (the candidates) to make certain at the last minute that none should enter 'not fit' for the ritual of the Klan. When the circular march was completed a torch was applied to the cotton covering of the cross, and as it burned the grand representative intoned the oath binding the new members to the Klan."

Two years later, the black community's fears appeared to be confirmed. A fire destroyed the Greater Bethel AME Church at 42nd and Grand Boulevard (now Martin Luther King Drive), which the Tribune noted was considered "the largest colored church in America." A church official told the Tribune: "For the last two months the Ku Klux Klan

has been sending threatening letters to the church." The Klan's involvement was never proved.

Yet the Klan was approaching its peak and would shortly begin to decline. Reborn in 1915, it grew to an estimated 2.5 million members in 1923. Northwestern University history professor Nancy MacLean in her study "Behind the Mask of Chivalry" attributes the rise and fall of the second Klan—it would rise a third time in the 1950s—to a common cause: a morbid fear that "Such things as the rise of divorce, feminism, black radicalism, white racial liberalism and the postwar strike wave were not isolated, random occurrences." When the apocalyptic future of the Klan's forecast didn't materialize, its justification vanished.

The decline of the KKK—by the 1930s it was reduced to a small, insignificant fringe group—was also due to its dual nature: The reborn Klan was both a political movement and a business venture. Its true organizers were Edward Young Clarke and Elizabeth Tyler, public relations consultants, called in to pump up the organization in its struggling early years. Merchandising geniuses, they pushed aside Imperial Wizard Simmons, its founder, and made the KKK a cash cow. Everything was for sale: memberships, official hoods and gowns, and literature, according to a Tribune story in 1937. But as its coffers grew, so, too, did bitter money squabbles between the central office and local branches. Many of those struggles ended up in embarrassing lawsuits—including one episode that provided a coda to this sorry chapter of Chicago history.

Having lost control of the Klan, Clarke attempted a comeback with an offshoot during the Great Depression. He founded a Chicago-based movement, Esskaye Inc., which promised to solve the nation's problems. Again there were membership fees, followed by questions about where the money went. Clarke was convicted of mail fraud, and his own organization disowned him via the tactic of having Clarke confined to a Chicago mental hospital. A judge agreed, noting that the examining psychiatrist, according to the Tribune, "pronounced him a paranoiac."

—RON GROSSMAN

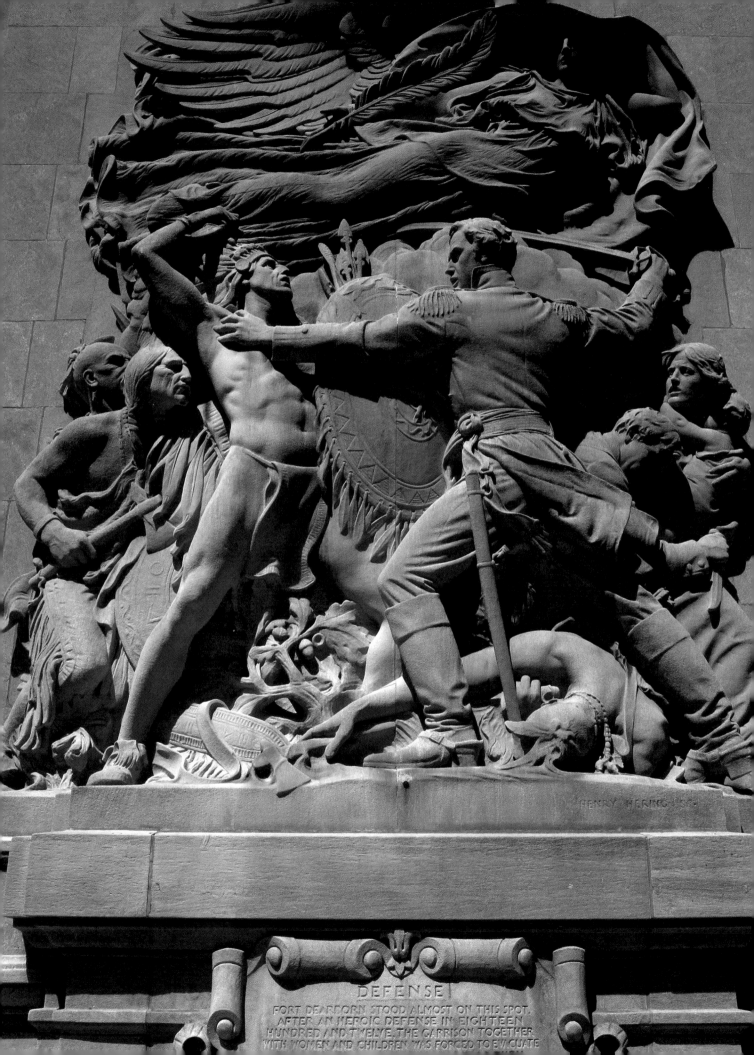

DEFENSE

FORT DEARBORN STOOD ALMOST ON THIS SPOT.
AFTER AN HEROIC DEFENSE IN EIGHTEEN
HUNDRED AND TWELVE, THE GARRISON TOGETHER
WITH WOMEN AND CHILDREN WAS FORCED TO EVACUATE

The Battle of Fort Dearborn

Though a clear victory for the Native Americans, the bloody fight failed to slow the inexorable flood of settlers to the region

THE soldiers and civilians holed up in Fort Dearborn already were jittery before the orders to evacuate arrived. A recent Indian attack to the west had sent settlers fleeing to the safety of the wooden stockade on the south bank of the Chicago River.

Outside those walls, an increasing number of Indians were assembling. The younger warriors were eager to prove themselves in battle, though more senior chiefs had offered the Americans safe conduct in return for the fort's supplies. But the Potawatomi escorts they had been promised were nowhere to be seen when 55 soldiers and about three dozen civilians abandoned the fort. Some had to have feared they were marching into a deadly trap.

John Kinzie, who operated a trading post near the fort on the Chicago River and what is now Michigan Avenue, sensed something was up and sent family members ahead by boat.

The column marched just a couple of miles south along the Lake Michigan shoreline before hundreds of Potawatomis emerged from behind a dune.

The encounter that followed was brutal and brief. Though it was a minor skirmish in a war that stretched from the heart of Europe to America's western frontier, Chicago's history was profoundly shaped on Aug. 15, 1812, by those 15 minutes of intense fighting. For the Indians, it was a Pyrrhic victory that only delayed their eventual exile farther west. For the whites, it convinced them that nomads and settlers can't live side by side.

Yet participants could scarcely guess the consequences of a clash that began when Captain Nathan Heald ordered his forces to charge the Potawatomis. That decision separated the soldiers from the wagon train bearing women and children and a militia composed of settlers who lived near the fort. Indians armed with muskets poured into the gap between the two halves of the American party, surrounding both. In hand-to-hand combat, soldiers fell under tomahawk blows, and Indians were skewered by Army bayonets.

Shortly, with only a handful of troops capable of further fighting, their commander surrendered.

The captured soldiers were shocked when they were led past the wagons. Lt. Linai Helm wrote a firsthand account, noting: "When we arrived at the bank and looked down on the sand beach I was struck by the horror of men, women, and children lying naked with principally all their heads off."

Helm feared his wife was among the dead, but Margaret Helm had been rescued by Black Partridge, a chief who had opposed the attack. He dragged her to the lake and pretended to drown her. Margaret Helm's stepfather, John Kinzie, who had Indian friends, also survived and was reunited with his family.

Militarily, the battle marked a considerable victory for the Potawatomis. Of the 55 soldiers who left the fort, 26 were killed; seven of those who surrendered were murdered; the remainder were enslaved, as were civilian survivors. Some died in captivity; the lucky ones were subsequently ransomed. The Potawatomi losses are unknown but were certainly far fewer than the Americans. The next day, the Indians burned Fort Dearborn.

Though the bloody clash took place somewhere between what's now Roosevelt Road and 18th Street, it was traditionally known

Opposite: The Battle of Fort Dearborn, depicted on a Michigan Avenue bridge house, was a costly victory for American Indians that only delayed their exile. It convinced the whites that nomads and settlers can't live side by side.

MICHIGAN AVE.

N

Looking down from the London Guarantee Building at Michigan Avenue and Wacker Drive at the south end of the bridge shows the outline of Fort Dearborn imposed on a picture, taken in 1939. This is believed to have been the exact site of the fort.

as the Fort Dearborn Massacre. Recently it was renamed the Battle of Fort Dearborn, acknowledging that both sides committed atrocities in the centuries-long struggle between Native Americans and European colonizers for control of what became the United States. Already in 1899, Simon Pokagon, a Potawatomi writer, observed, "When whites are killed, it is a massacre; when Indians are killed, it is a fight."

By either name, it was a classic case of winning a battle but losing the war. The Americans' loss convinced the settlers who continued to pour into the region that their Indian neighbors had to go. Fort Dearborn was rebuilt in 1816, and the Potawatomis were forced to move west of the Mississippi River, setting the stage for the rapid growth of a modern metropolis. In witness to the importance of that early white settlement, one

"When whites are killed, it is a massacre; when Indians are killed, it is a fight."

—SIMON POKAGON, POTAWATOMI WRITER, 1899

of the four stars on the city's flag represents Fort Dearborn—built, burned and built again.

Yet that outcome could scarcely be foreseen at the time. The clash of Potawatomis and U.S. soldiers was one small episode in a global conflict that stretched from a European continent dominated by Napoleon Bonaparte to America's western frontier. Sand dunes and woods covered what would become the Loop.

The future Magnificent Mile had but one emporium, Kinzie's trading post. The site of Millennium Park was under water, the shoreline being then farther west. Heald, who commanded Fort Dearborn in 1812, described the place as a tranquil Eden, "so remote from the civilized part of the world."

Half a world away, Britain and France were locked in a long struggle, like two boxers, each lacking a knockout punch. Napoleon's armies had conquered mainland Europe; the British navy ruled the seas. Frustrated militarily, both sides resorted to economic warfare, each imposing a blockade on the other. As a neutral party, the United States claimed a right to continue trading with France, which the British forbade. They also stopped American ships, seizing any British-born sailors aboard.

Frustrated by those insults to its sovereignty, the U.S. declared war and invaded Canada, which had remained loyal to Britain when the Americans declared their independence, 36 years earlier. The British mounted a counterattack, burning Washington. But lacking the resources to open a second front in the American interior with their forces alone, they recruited Indian tribes by appealing to their sense of having suffered grievously at the Americans' hands. It resonated with many, hard-pressed by the inexorable movement of settlers into their hunting grounds and the corrosive effect of contact with the whites' culture.

In the spring of 1812, the famous chief Black Hawk articulated a question many Indians asked themselves: "Why did the Great Spirit ever send the whites to this island, to drive us from our homes, and introduce among us poisonous liquors, disease and death?"

That message echoed the preaching of a messianic Indian leader, the Prophet, who was traveling widely among the tribes. "The Great Spirit told me to tell the Indians that he had made them and made the world—that he had placed them in it to do good," he said. As for the Americans: "They grew from the scum of the great water."

When the War of 1812 came, the U.S. Army was determined to shorten its defensive perimeter, and orders to that effect were sent to Fort Dearborn by Gen. William Hull, commander at Detroit. Afterward, Hull claimed the order was to evacuate, if it was safe to do so; while Heald claimed he was simply told to proceed to Detroit. Either way, the orders arrived at the fort simultaneously with 500 Indian warriors, who had learned about the evacuation.

Some senior chiefs opposed attacking the garrison, but one brave, Nuscotnumeg, argued: "Now's the time—we have them within our grasp; we must kill them all." Then news arrived that the British had captured Fort Mackinac, which carried the day for the young warriors' argument to attack—and sealed the fate of the Fort Dearborn community when it set out for Fort Wayne, the first leg of its trip, on Aug. 15.

The site of that tragedy is now covered by a man-made forest of postmodern high-rises along Lake Shore Drive just west of Soldier Field. In the middle is a bit of green, the Battle of Fort Dearborn Park, a bucolic oasis reminiscent of Captain Heald's description of Fort Dearborn before the war. It's a fitting place to sit and contemplate the bewildering mixture of human experiences—suffering and heroism, one people's good fortune, another's exile—that underlies Chicago's history and skyline.

And perhaps, also, an apt place to ponder the epilogue to the story of the Fort Dearborn party. In 1835, the Potawatomis assembled in Chicago to receive the final payment due them from the U.S. government for agreeing to move westward. Before leaving, 500 warriors in full regalia and brandishing tomahawks lined up in a procession that snaked through what had already become an urban landscape of hotels and warehouses—and, of course, the rebuilt Fort Dearborn.

One eyewitness, Judge John D. Caton, described it in a lecture to Chicagoans years later:

"It was the last war dance ever performed by the natives on the ground where now stands this great city, though how many thousands had preceded it no one can tell. They appreciated that it was the last on their native soil—that it was a sort of funeral ceremony of old associations and memories."

—RON GROSSMAN

When cab wars were wars

Bullets and bombs flew during turf battles

A crowd in the Loop surrounds a Checker taxicab after it was overturned March 17, 1937, in a bitter taxi strike. Violence continued to trouble the taxi business long after the 1920s, often triggered by labor disputes.

For early cab companies, competition was a matter of life and death, and it often escalated to exchanges of bullets and bombs.

"It has only been comic opera warfare until tonight, but from now on it is going to be a fight to the finish," John Hertz, president of the Yellow Cab Co., told the Tribune on June 8, 1921. "We feel we might just as well end the whole business right now."

His no-more-Mr.-Nice-Guy announcement was occasioned by the killing of one of his drivers as the man was shooting the breeze with fellow cabbies at Roosevelt Road and Kedzie Avenue. Witnesses said a large automobile sped by, and three men fired 25 shots, the fatal one striking P.A. Skirven just above the heart. That same night, another Yellow driver was shot in the foot at Logan Square and Milwaukee Avenue, and a Checker taxi driver was arrested during a brawl at a taxi stand in front of the Hotel Sherman.

Cab wars were turf battles, struggles over who had the right to pick up fares at choice locations. But at the height of the conflict, during the Jazz Age, they also involved political clout, labor unions, corrupt cops and gangsters. Reams of purple prose were gener-

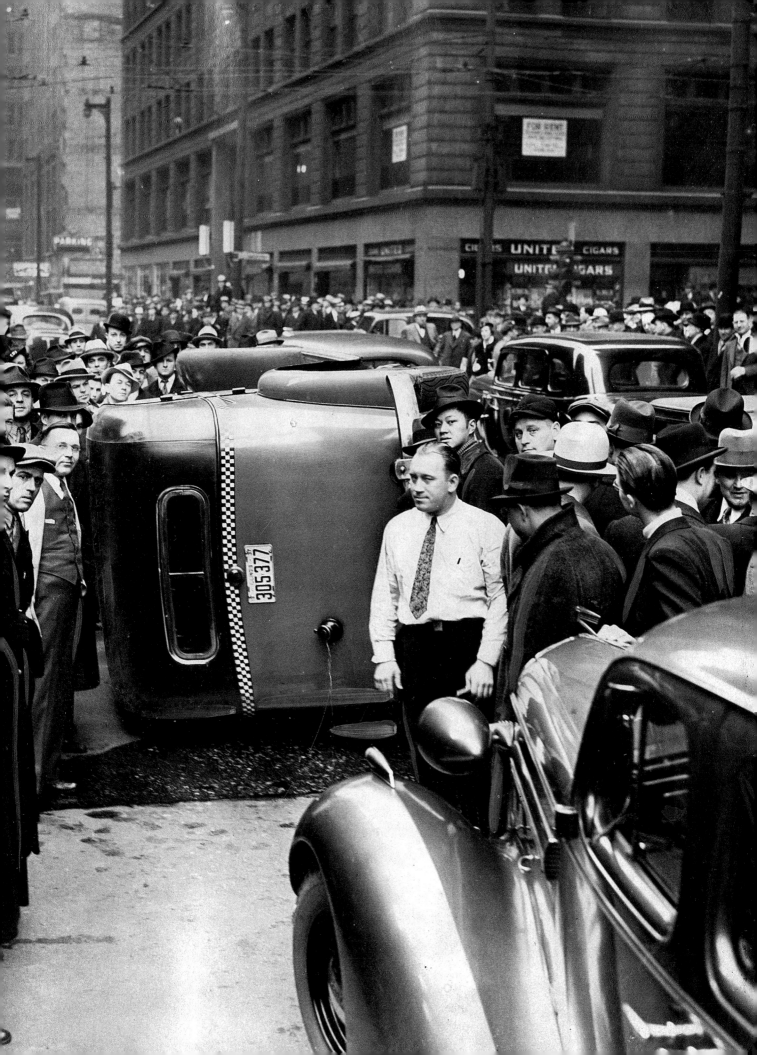

ated, both sides claiming to have the public's best interest at heart. Officeholders disputed such assertions, saying that honor belonged to them. In 1923 Cook County State's Attorney Robert Crowe declared "war against the taxi war." Two years later, Chicago Mayor William Dever threw down the gauntlet, declaring: "We will see whether the taximen control and own the streets or the people."

In a typical report from the taxi-war years, the Tribune reported, on Feb. 10, 1924: "Nearly a dozen of Chicago's leading gun fighters were in custody last night after a day of raiding consequent upon the latest killing in the Checker taxicab warfare."

Checker was the Uber of the 1920s, an upstart trying to break into a market dominated by Yellow Cab. During a 1921 grand jury investigation, each of the combatants declared the strength of its forces. Yellow's president testified to having 1,100 cabs on Chicago's streets. Officials of Checker told the jurors their company operated 674, with an additional 250 on order.

Both companies dated their struggle to 1920, when Checker cabs began using Loop taxi stands, to that point a Yellow monopoly. When aldermen decided to investigate, Checker's president accused Yellow of "trying to drive other companies out of business through the hiring of sluggers." Yellow's attorney countered: "I can prove by court records that the Checker companies employees are an irresponsible bunch of hoodlums."

Each company claimed that cops were showing favoritism to the other, and the evidence suggests they were right. The Tribune reported, in 1928, that when a Checker driver was killed outside the Granada Cafe at 68th Street and Cottage Grove Avenue, a detective posted to that hot spot was conveniently AWOL. Returning to the scene, the detective stopped a patrolman from arresting a Yellow driver, saying "the shooting was done in self-defense."

Beginning as a two-way struggle, the 1920s cab wars soon were complicated by a concurrent civil war inside the Checker company. Yellow was a nonunion shop, but Checker touted the fact that its drivers were union members—at least until union officials were ousted in a

coup by company officials. Checker drivers of one faction shot it out with Checker drivers loyal to the other side.

On Feb. 8, 1924, the nonunion faction, then in control of Checker headquarters, got a threatening phone call shortly after police detailed there were withdrawn. "A few hours later, four gunmen drove up and lined all available chauffeurs and mechanics against the wall," the Trib reported. "Fondling their revolvers, the four read the chauffeurs a forceful lecture."

The following day, the hoodlums returned as promised. One employee was killed and another gravely wounded, and in the dense smoke of the fierce gunbattle the assailants escaped. "The first four–known as 'The Four Horsemen' to the taxi drivers whom they were wont to terrorize–have been named as the men who made the Friday visitation at the Checker garage."

Chicagoans must have been hard-pressed to keep the players straight without the kind of score card included in a 1925 story about the Hotel La Salle. Originally the hotel operated its own cabs, but tiring of defending its cabstand against Yellow cabbies, it sold its taxis and the stand to Diamond Cab, which also inherited the struggle with Yellow. Presumably weakened by the battle, Diamond went out of business, as did the De Luxe Cab Co. that succeeded it. That left Yellow to dispute the stand with the Premier Cab Co., formed by the union faction defeated in Checker's civil war.

The wonder is that enough Chicagoans risked hailing a cab to make the taxi war worth fighting. Sometimes Loop hotel guests witnessed the struggle firsthand. In 1918, a stink bomb was thrown into the bar of the Hotel Sherman, forcing its evacuation. "The theory of the police is that the bombing is directly due to a taxi war," the Trib reported. When a stink bomb went off at the Brevoort Hotel, the same year, the manager theorized: "The hotel has no controversy with any one, but there is a Yellow taxi stand in front of the hotel."

Violence continued to trouble the taxi business long after the 1920s, often triggered by labor disputes. Of a bitter 1937 strike, the Tribune reported: "Organized mobs of striking taxicab drivers, led by professional slug-

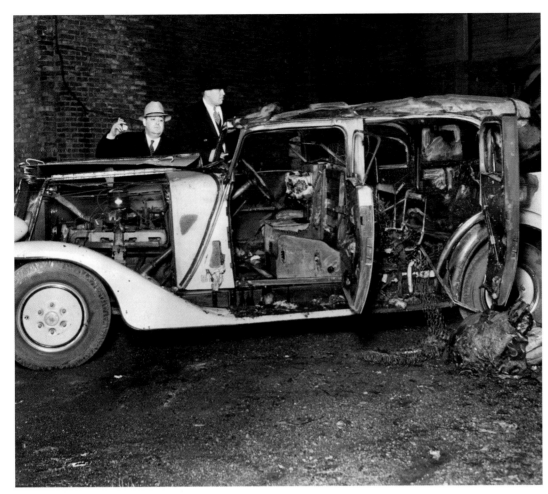

A Yellow Cab was abandoned by the driver when he was approached by strikers, who burned it in the alley behind 2103 Ogden Avenue on March 17, 1937. Following the rioting strikers in the Loop, they turned their attention to cabs in the outlying districts.

Four Yellow Cab employees were near the back door of the Yellow Cab Co. garage when a bomb went off on Sept. 30, 1928.

gers, attacked cabs at a core of points in the Loop yesterday afternoon. They over turned 15 machines, smashed the windows of many more, and fought the police hand to hand."

Still, the taxi wars, properly speaking, reached apogee in 1928, after a summit between Yellow and Checker failed to bring peace to the city's streets. Two Yellow garages were bombed, and a mysterious fire broke out in a barn on the estate of Yellow's board chairman, Hertz, near Cary. Eleven racehorses, valued at $225,000, were destroyed, but that year's Kentucky Derby winner Reigh Count was saved by an alert stableboy.

Hertz told authorities he didn't suspect arson, as they did. Yet if the fire was intended as a message, he got it. The following year, he sold his stock in Yellow Cab. At least for Hertz, who went into the car-rental business, the taxi wars were over.

—RON GROSSMAN

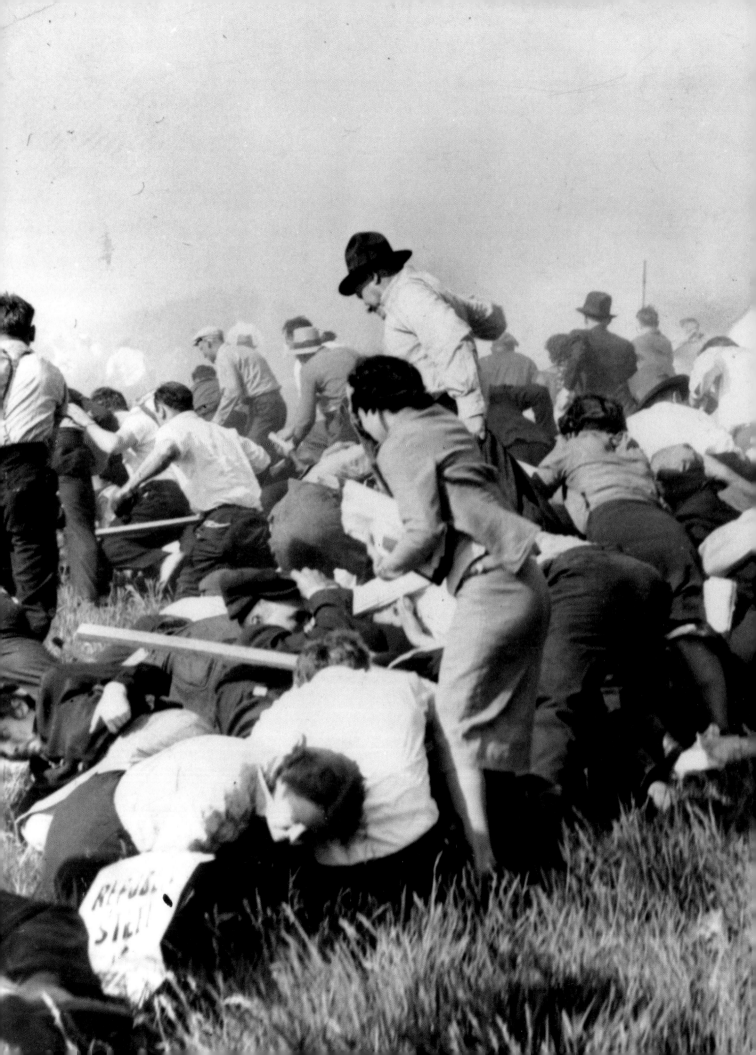

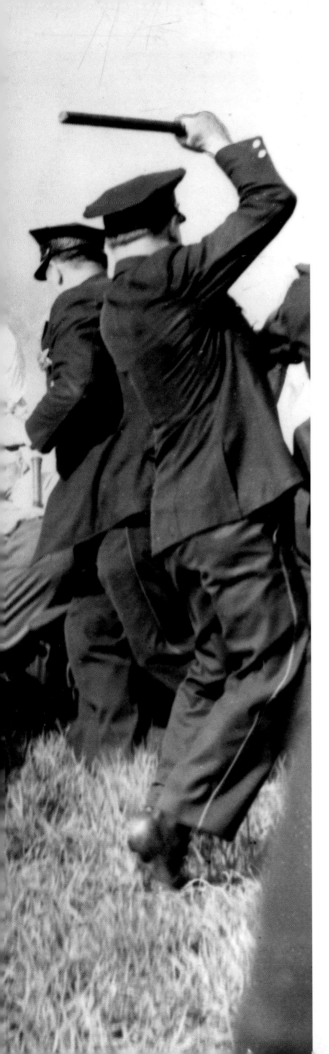

Republic Steel: Riot or massacre?

Plenty of finger pointing after violent Memorial Day in 1937

INITIALLY there was nothing remarkable about a Memorial Day gathering of striking steelworkers at Sam's Place, a Southeast Side tavern, in 1937. A day without picket lines and walkouts would have been something to talk about during the Great Depression. The demonstrators had no idea they were walking into history when they marched south from the barroom serving as their union's headquarters through a gritty labyrinth of massive factories, modest homes, railroad yards and barge docks.

But at 118th Street and Burley Avenue, they confronted a phalanx of Chicago police drawn up in front of a Republic Steel plant, where cops and workers had previously clashed since the walkout began a few days earlier.

An AP photographer witnessed what happened next: "There was so much shouting I couldn't make out what was being said, but it looked like the police were trying to persuade the strikers to go home.

"Suddenly I heard a shot which, I think, came from the strikers. The strikers immediately began throwing clubs—big ones, bricks and pieces of machinery. My picture shows the police ducking and trying to get behind a patrol wagon that was on the field."

In the melee that followed, 10 demonstrators were killed and 60 injured; 40 police offi-

A confrontation between strikers and police turns violent outside a Chicago steel mill as strikers flee or fall down to escape blows from police clubs in 1937.

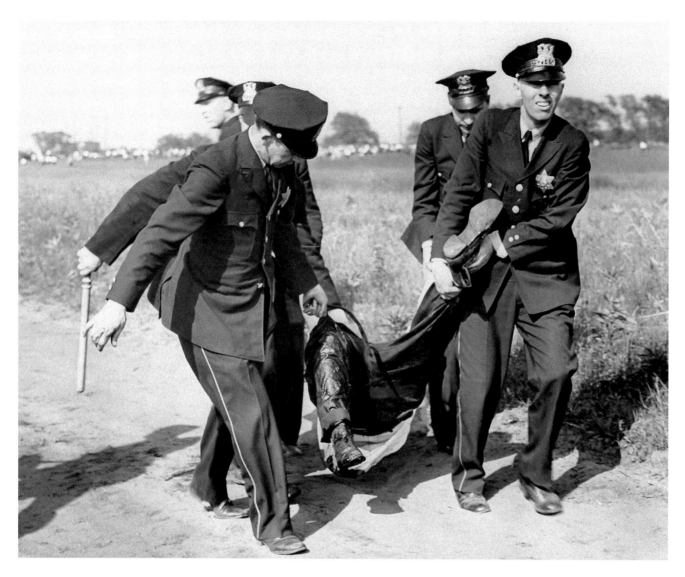

A victim of the strike battle at the Republic Steel plant is carried away after suffering a severe leg wound during rioting in 1937.

cers were hurt. Violence was endemic to labor disputes of the time, but on this occasion a film crew from Paramount News was on the scene, transforming this tragic encounter into the Depression Era's equivalent of earlier labor struggles in Chicago, like the Haymarket Riot and Pullman strike.

"Some of the police are shown swinging their clubs," noted a Tribune reporter after a screening of the footage. "Billows of gas are being wafted over the heads of the rioters. The motion picture is accompanied by sound effects, in which words are indistinguishable. Gun shots can be heard momentarily, perhaps a second or two. No shooting can be seen, and it is impossible to determine where the shots came from."

Despite that film, what happened—indeed, what to call it—remained in dispute. Was it a Memorial Day Massacre, as trade unionists saw it? Or, a Republic Steel Riot, as the company and city officials dubbed it?

Molly West, a young Polish immigrant involved in union organizing, told the Tribune: "Once I got close to the mill, we heard shots. I was lucky, because I was knocked down, and there were other people who fell down on top of me."

Patrolman Walter B. Oakes said: "Suddenly there was a shower of bricks and clubs. The mob pushed forward. I was struck across the back with a club and knocked to the ground."

Under a headline, "Murder in South Chicago," a Tribune editorial blamed the violence on "a murderous mob . . . inflamed by the speeches of CIO organizers." The initials then

> "Billows of gas are being wafted over the heads of the rioters. The motion picture is accompanied by sound effects, in which words are indistinguishable. Gun shots can be heard momentarily, perhaps a second or two. No shooting can be seen, and it is impossible to determine where the shots came from."

—TRIBUNE, REPORTING ON FOOTAGE OF THE STRIKE, 1937

stood for Committee for Industrial Organization, an upstart wing of the union movement led by John L. Lewis. The miners union head, Lewis had decided to organize the less-skilled workers whom craft-union leaders traditionally disdained. A slap in the face of the union movement's establishment, it set off a fury of organizing.

On May 26, 1937, 85,000 steelworkers in five states walked out, idling 37 plants. Five Chicago-area mills were shut with 22,000 workers walking out. Four days later came the deadly clash at Republic Steel.

Two governmental investigations came to opposite conclusions. A Cook County coroner's jury "absolved the police of blame, holding the killings were justifiable," the Tribune reported. A U.S. Senate committee, chaired by Sen. Robert La Follette of Wisconsin, a notable liberal, said the police used "excessive force."

Muddying the waters more, the cameraman who took the newsreel footage claimed it didn't tell the whole story. He said "he was changing lenses in his camera at the time of the strikers' attack and that his film shows an incomplete picture of what happened," according to the Tribune's report of the coroner's inquiry.

In the lean years of the 1930s, some workers saw their salvation in banding together.

Others, thinking themselves lucky to have a job, wanted no part of the union movement.

When the Republic Steel workers walked out, about 1,000 remained on the job, the company feeding and housing them on-site. "We got a good place to eat and sleep and play," one told a Trib reporter. "Think I'm gonna quit, with four kids? G'wan—."

Angered by the nonstrikers' obstinacy, union members and their supporters set out on that fateful march from Sam's Place. What did they aim to do? According to the police, the demonstration was designed to be violent. A police captain said he had heard a leader at the meeting that preceded the march say, "We'll get those cops, knock them over, take their guns away from them, and go right into the plant." According to the Tribune, that was part of a larger conspiracy, "a plan to seize control of the country in the manner of the Russian October Revolution."

But William Waltmire, pastor of the Humboldt Park Community Methodist Church, told the story differently at some of the slain strikers' funerals. "The men lying here had a dream of brotherhood," he said. "They sought to bring a new world, a good world in which men could live and be happy."

—RON GROSSMAN

Chaos after King slaying

Days of rioting and looting ravaged swaths of city

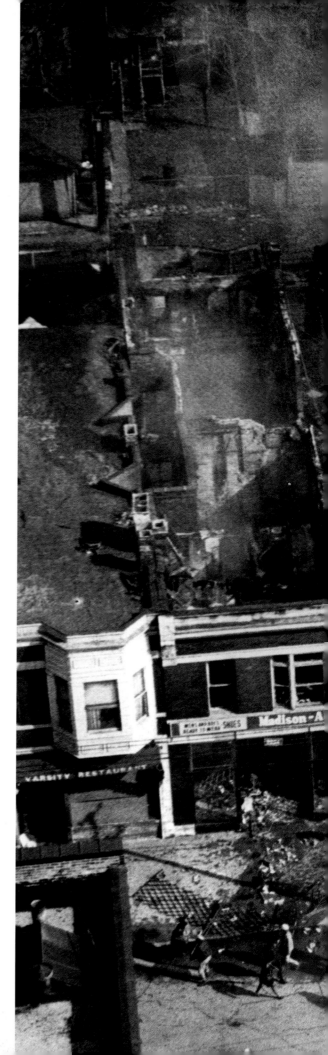

A DAY after the Rev. Martin Luther King Jr. was assassinated in 1968, a 4-year-old girl, abandoned and crying, stood in front of a burning building a few blocks from the West Side apartment where the civil rights leader had lived during his open-housing crusade. She was soaked from one of the hose lines firefighters were directing at blazes up and down Roosevelt Road. Even as they burned, stores were being looted of groceries, clothing, liquor and television sets.

"All the people were just running past her," Theophilas Love, 20, told a Tribune reporter on April 5, 1968. "They either didn't see her or they just simply ignored her," added Jesse LeSure, 19, who with Love brought the child to the Fillmore police station. When officers couldn't coax a name out of her, Love and LeSure volunteered to take the girl home for the night and return her to the station the next morning. The cops agreed, hoping a family member would come by to report her missing.

Despite the city descending into chaos around them, Love and LeSure stopped to help. Their act is a poignant reminder that human kindness doesn't vanish even amid overwhelming violence and lawless greed.

Though the Tribune's clips were silent

The aftermath of rioting over the King assassination can be seen in the 3000 block of West Madison Street on April 6, 1968.

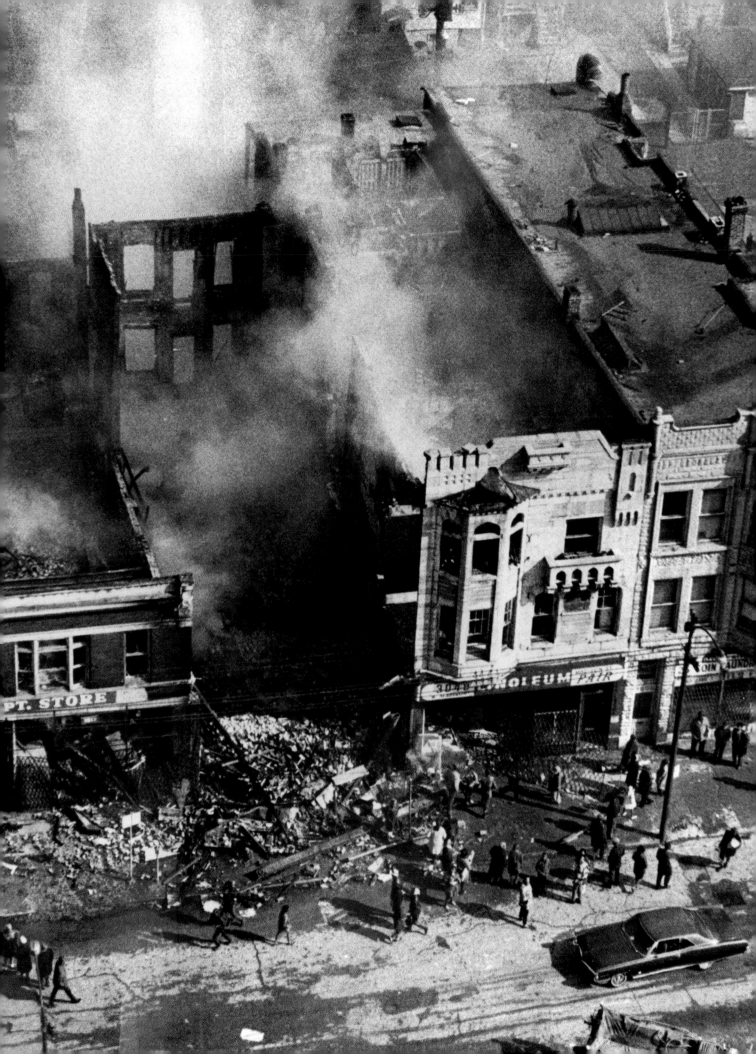

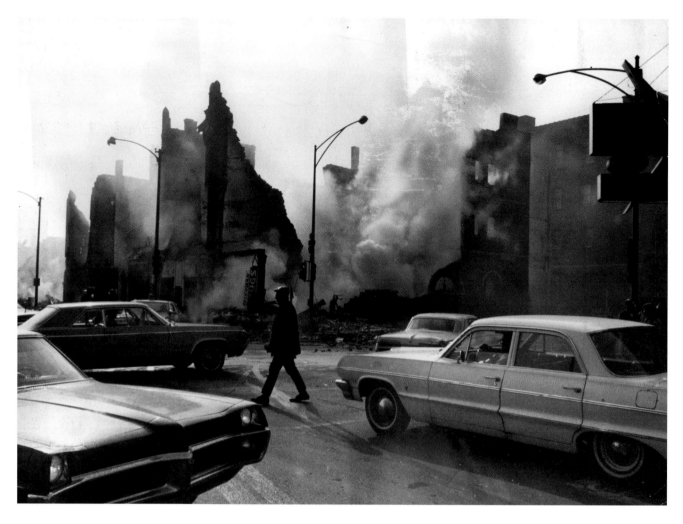

The crumbling shell of a building destroyed in the West Side rioting is silhouetted against the sky as some semblance of order returns to the area for a short period April 6, 1968. The scene is toward the southeast corner of Spaulding Avenue and Madison Street.

on the child's fate, Flashback was able to fill in some blanks in 2013. LeSure, then 64 and living in Potomac, about 30 miles northeast of Champaign, said that they took the girl to Love's house because he had a daughter about the same age. The little girl, whose name eluded LeSure after so many years, was reunited with her mother the next day with the help of WVON radio.

"It was really touching," LeSure said of the reunion at the radio station. "The mother ran to her and got on her knees to hug her."

For LeSure, it was a bright spot in a dark period: His neighborhood was in ruins. "Most of the stores we used were destroyed for blocks. It was devastating for all of us."

After King, a Nobel Peace Prize laureate, was shot down on the balcony of a Memphis hotel on April, 4, 1968, America's cities were shaken to the core by "a spontaneous overflow of pent-up aggression," according to the

"It was the crucifixion of a city, with Madison street the blackened, still smoldering nail that had been driven into its heart."

—TRIBUNE, 1968

Chicago Riot Study Committee, appointed by Mayor Richard J. Daley. In Washington, federal troops took up guard positions at the White House and the U.S. Capitol. Other Army units were dispatched to Baltimore, where riot-

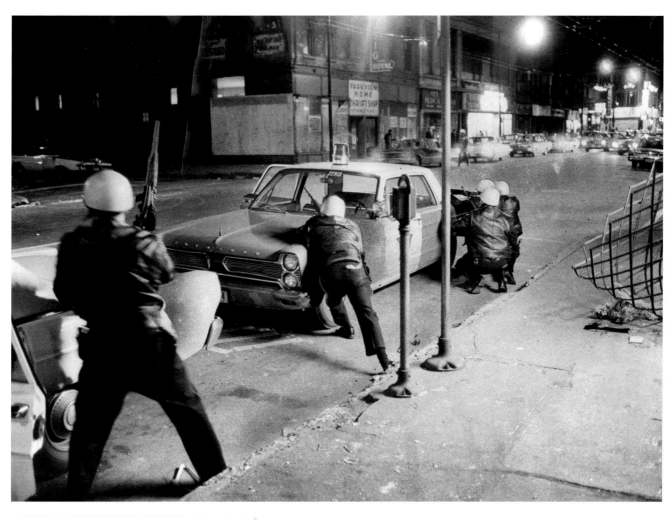

ers tossed Molotov cocktails. New York Mayor John Lindsay walked the streets of Harlem, expressing his sorrow at King's slaying, but had to retreat under a barrage of bricks and bottles. The National Guard also was called out in Baltimore, Pittsburgh, Nashville, and Greensboro and Raleigh, N.C.

Chicago was no stranger to inner-city disorders. During King's housing campaign in 1966, there were riots in Puerto Rican and African-American neighborhoods. Yet it hadn't experienced the mass destruction other cities suffered. In 1968, however, Chicago's riots were among the most costly of those in 100 American cities.

"It was the crucifixion of a city, with Madison street the blackened, still smoldering nail that had been driven into its heart," wrote a Tribune reporter who witnessed the carnage along another West Side street where buildings were torched during three days of rioting.

Chicago police, guns ready, crouch behind a squad car and another parked car as they scan the windows in a housing project at 454 W. Division St. for signs of a sniper. Gunfire also was frequent along the entire 3300 block of West Madison Street, where firemen faced both flames and bullets April 5, 1968.

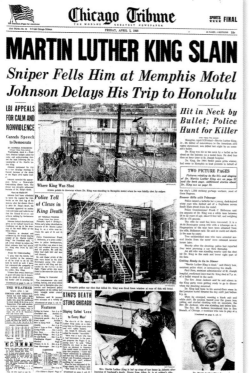

Tribune front page, April 5, 1968.

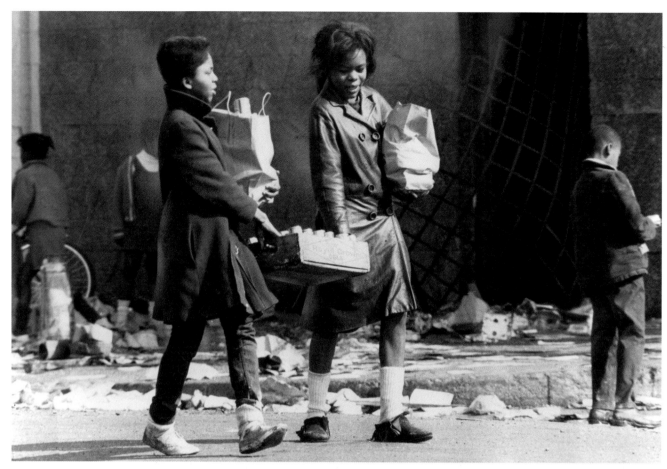

Above: Between them, two girls carry a carton of soft drinks and other merchandise from Del Farm Store at Hobbie and Larrabee streets on April 6, 1968, in Chicago.

Right: Youth on Albany Avenue, south of Madison Street, point fingers at members of the Illinois National Guard on duty in the area April 6, 1968.

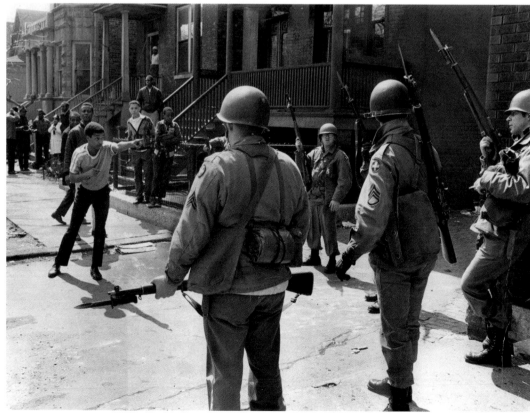

At the May Sons store, 4114 W. Madison, a policeman advised a Tribune photographer: "If you want pictures, look in back of the store." The accompanying reporter wrote: "The body of a looter was found in the store. At least 700 people–young and old were there. Many were pushing and shoving, trying to get into the store. Others were pushing their way out, their arms loaded with merchandise."

Nearby on Homan Avenue, another Tribune reporter saw "one boy, no more than 7 years old, staggering under his load of cartons of beer." A couple posed for a snapshot in front of a burning building, ignoring police orders to move on.

The entire Chicago Fire Department was engaged in a losing struggle to put out arson fires while ducking snipers' bullets. Reporting a completed assignment, fire companies were told to "take your pick" of another blaze.

After 10,500 police officers couldn't stem the violence, more than 6,000 Illinois National Guardsmen and 5,000 Army troops were sent in, most to the South and West sides.

Among the soldiers was Jeffrey Bates, 21, who'd grown up on the West Side and been wounded three times during the Vietnam War. "I hate to see this happening to Chicago," said Bates, a member of the 1st Armored Division from Fort Hood, Texas.

As troops marched down 63rd Street, a Tribune reporter observed "little children enthralled as ever by the sight of soldiers skipped and danced at their sides." But peaceful scenes were more than matched by violent encounters.

On Thursday evening, when news of King's murder arrived, Chicago remained quiet. "Behind thousands of slum doors, however, emotions were bubbling," the Tribune noted.

The next day, students poured out of schools in protest marches that escalated into stone throwing and window breaking. Soon their ranks were joined by looters of all ages, who "swarmed like locusts over the stores," as police Superintendent James Conlisk said. Nine died, though the number of those shot by police and those killed by snipers and rioters is unclear. Thousands were arrested and dozens of police officers and civilians were injured.

It wasn't until after the uprising was suppressed that Daley made his infamous shoot-to-kill declaration. At a news conference April 15, Daley rebuked Conlisk, saying he thought he had given the police superintendent orders "to shoot to kill any arsonists" and "shoot to maim or cripple" looters. The mayor was outraged that his directives–plus another suggesting that chemical Mace be used on children caught looting–had been ignored.

By that point, 210 buildings had been destroyed, 1,000 people were homeless, and food was scarce in the riot zone. "We don't have nothin' left," a resident said. "Now we will have to walk all the way to the white neighborhoods to go shopping."

And all of this in response to the death of King, an apostle of nonviolence, as the Tribune noted in an April 7 special section devoted to his life and work. Sociological explanations of the unrest were already on the table, a federal commission headed by Illinois Gov. Otto Kerner having recently filed an investigation of previous urban riots. But the Tribune didn't buy its conclusion that "white racism is essentially responsible." If poverty was the cause, the Trib asked, "Why, then, were 1,000 persons arrested in the disorders beginning last Friday found to be carrying $85,000 in cash on their persons?"

The Tribune had its own simplistic explanation: "We have spawned a generation raised on the maxims of Baby Doctor (Benjamin) Spock that permissiveness is beautiful." Yet whatever the cause, the consequences of the rioting were clear. Even today, whole blocks on the West Side are empty–a terrible memorial to King, who asked for a different obituary in a sermon shortly before his death:

"Yes, if you want to say that I was a drum major, say that I was a drum major for justice. Say that I was a drum major for peace. I was a drum major for righteousness. And all of the other shallow things will not matter."

–RON GROSSMAN

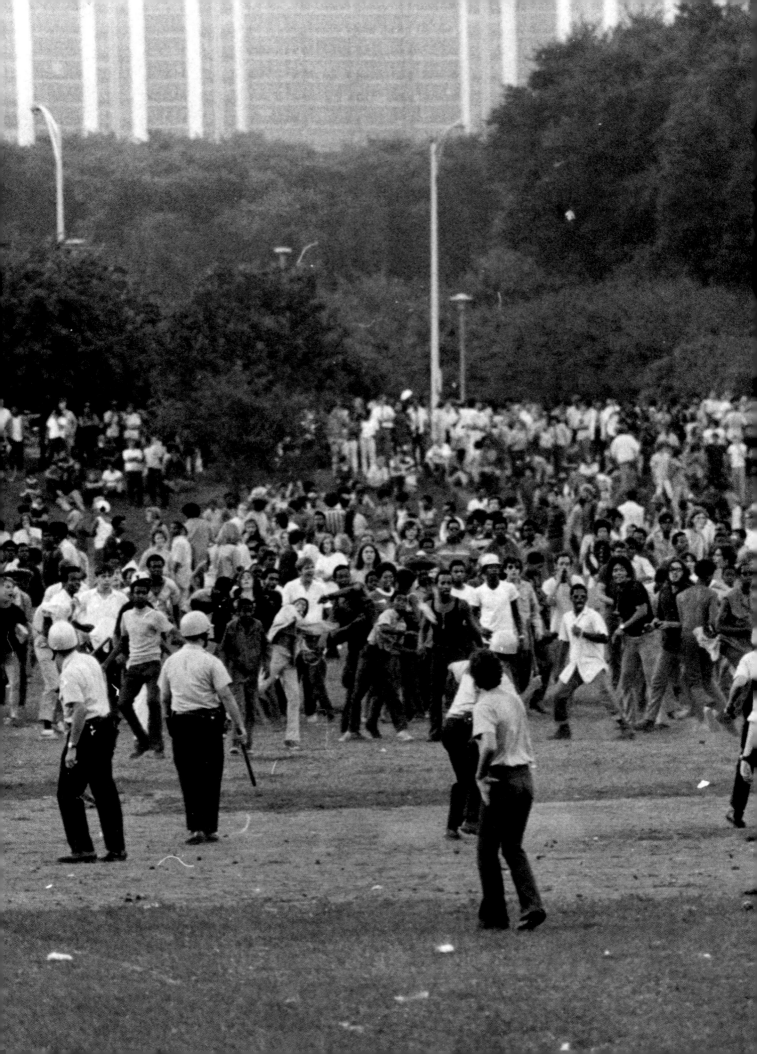

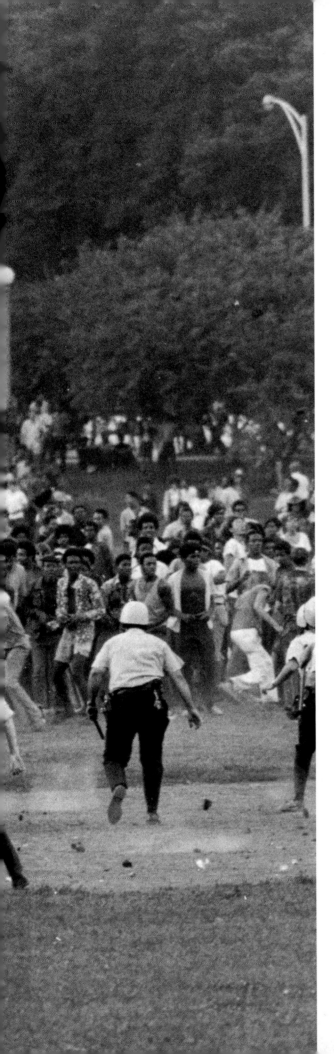

1970 concert was true riot fest

Grant Park became canvas for civil unrest and 162 injuries

Less than two years after police and Democratic National Convention demonstrators rioted in 1968 over the Vietnam War, police and young people battled anew in Grant Park—possibly more violently—over musical artists Sly and the Family Stone.

The Monday concert on July 27, 1970, was supposed to be a goodwill offering, not only from city officials to the area's youths, but also from the band to the city to make up for more than one last-minute no-show.

Instead, the music festival disintegrated into a riot that injured 162 people, including 126 police officers. Thirty of those officers were hospitalized. Three young people were shot, though it wasn't clear by whom. Cars were overturned and set ablaze. Before its fury was exhausted, the mob rampaged through the Loop, breaking hundreds of windows and looting jewelry and department stores. Police arrested 160 people.

In a city that has suffered plenty of civil unrest, from beer riots to race riots, and labor strife to campus protests, this five-hour spasm of violence over poor scheduling was clearly the most pointless.

The Tribune's extensive first-day coverage reported, "The riot was apparently touched

Youths taunt police and hurl rocks and bottles in Grant Park at a rock concert on July 27, 1970. Moments later, police charge the crowd.

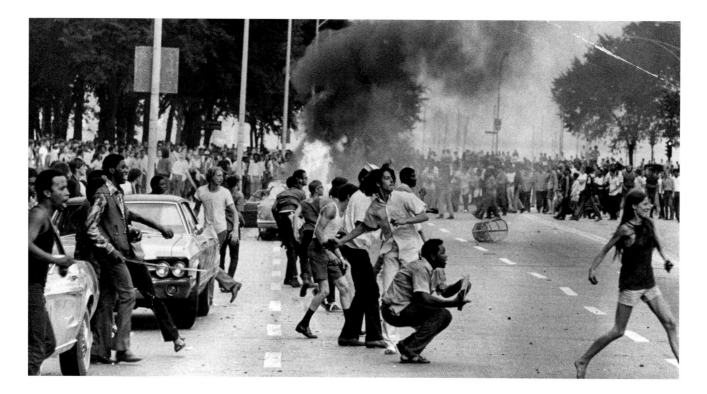

Youths throw stones at Chicago police as a car burns on Balbo Drive after violence erupted during a Grant Park concert on July 27, 1970.

off when the main attraction of the concert refused to perform because of the large crowd." But a report headlined "Anatomy of a Riot" the following Sunday provided a more nuanced description of what went down that afternoon and evening.

Despite the fact that the concert was slated to start at 4 p.m., people started arriving at 7 a.m. at the Grant Park band shell—not to be confused with the Petrillo Music Shell erected in 1978—on the southern edge of the park near the Field Museum, where the mammoth Lollapalooza music festival is staged.

According to the Tribune, many in the growing crowd spent the intervening hours, as temperatures soared into the 90s, drinking beer and cheap Ripple wine and smoking plenty of marijuana, activities to which the Chicago Police Department generally turned a blind eye. Remember, this was a cross-generational peace offering.

When rumors circulated through the crowd that Sly was canceling again, and then a band called Fat Water took the stage about 4:15 p.m., the confused audience members—now numbering 35,000 to 50,000—assumed their fears were coming true.

A chant started: "We want Sly."

Fat Water played just three songs and split. Instruments marked "Sly and the Family Stone" remained onstage, but The Flying Burrito Brothers, a well-known group, began to set up. "They never got to play," the Tribune reported. "Whether it was a rock or a heavy Ripple wine bottle that first crashed into the stage is unimportant. That first object, the object that touched off a war, was quickly followed by others—rocks, bottles, pieces of benches that had been destroyed during the long wait for music."

The riot was on. It was 5:14 p.m.

Riots don't have narratives, they have explosions of images. The Tribune's impressive five pages of coverage the first day and follow-up reports through the week were rife with them.

• Tribune newsman David Thompson took to an elm tree at Balbo and Columbus and watched the riot for more than an hour. He saw police officers dodging glass bottles and rocks. He saw them crush the glass bottles but throw the rocks back. When the cops retreated, Thompson found himself behind the rioters' lines. Four youths spotted him. "'Get the pig,' they screamed as I was pulled from the tree. As my shirt ripped, I shouted

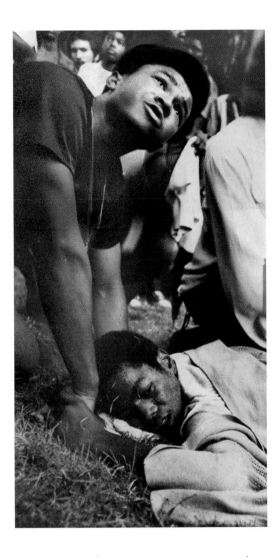

A young man yells for an ambulance for a man who was shot. A police vehicle soon arrives to take the wounded man to the hospital. The rioting that day injured 162 people, including 126 police officers; three young people were shot.

several policemen picked up paving stones and hurled (them) back at the rioting crowd. The mob shrieked with glee, tore up a barricade and heaved it at a squadrol driving in Balbo," the Tribune reported. On more than one occasion, officers fired their weapons into the air to warn off advancing youths.

- The police massed on the baseball fields north of the band shell, a sunken area bordered by grassy berms. It was an untenable position. "Surrounded, with their squad cars parked on the grass, vulnerable, the police had no place to go. The rock and bottle throwing astounded even those who had seen other battles between youths and police," the Tribune reported. Compared with the 1968 convention, "the rain of debris was much more intense this time. And the number of throwers was much greater."
- "It was not a race riot," the Tribune said. "Both whites and blacks, men and women, were in it. There was little mention of race during the trouble or after it. . . . Some of the rioters were as young as 13 and 14."
- As more police officers flooded into Grant Park, they tried to contain the mob, to no avail. Groups of as many as 400 people rampaged into the Loop. Goldblatt's department store was the worst hit, its windows shattered and its mannequins molested. Marshall Field's famous displays were saved when police ringed the downtown landmark.
- Order wasn't restored until after 10 p.m.

The next day, Mayor Richard J. Daley decried the mob, hailed the police officers and immediately canceled all five of the remaining park district rock concerts. Cross-generational peace was tabled.

Reports emerged that Sly Stone twice had asked police to let the band take the stage to help calm the crowd, but the request was denied because the mob had disabled the sound system and the violence had escalated too quickly.

In November 1971, Sly and the Family Stone released their first studio album since the disastrous nonconcert appearance in Grant Park. It was titled "There's a Riot Goin' On."

—STEPHAN BENZKOFER

at the top of my lungs, 'Reporter!' 'Turn him loose,' barked a hippie-garbed youth with a peace symbol around his neck, as he broke the antenna on my walkie talkie and tossed it to the ground."
- "Police seized a teen-ager who had just hurled a bottle," one reporter witnessed. "Down into the curb he went in the midst of six policemen with nightsticks swinging and heels stomping."
- "A jeering mob of shabbily dressed youth surrounded a phalanx of policemen yesterday afternoon, showered quart-sized wine bottles on them and peppered them with mud clots and shards of windshield glass. . . . An hour later, I was standing near a blond-haired patrolman when a large concrete slab crashed into his face. The police officer fell to the grass, screaming in pain."
- "Enraged with the abuse they were taking,

Disastrous Black Panther raid

Early morning violence made a martyr and ruined careers

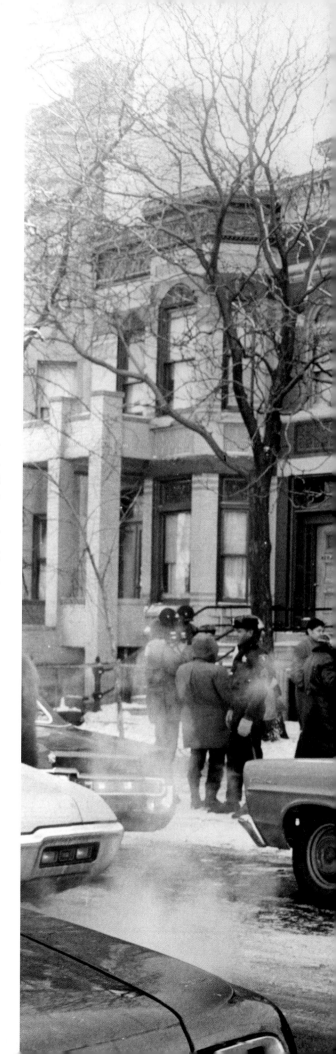

FRED Hampton, the rising star of a declining Black Panther Party, was killed in a 1969 police raid at a West Side apartment that brought him immortality as an improbable hero of the civil rights movement.

The cacophony of gunshots on West Monroe Street in the early morning of Dec. 4, 1969, reverberated politically to the Loop office of Cook County State's Attorney Edward Hanrahan. Aftershocks traveled all the way to the Washington headquarters of the FBI.

The incident also led to one of the biggest embarrassments in the history of the Chicago Tribune.

Hampton was an unlikely candidate for that notoriety. At 21, he was just a little more than two years removed from his role as a teen activist in Maywood demanding a community swimming pool.

Over the next year, he was associated with a school disturbance, the beating of an ice cream truck driver and a demonstration at Maywood Village Hall that ended with the mayor and other officials fleeing the building, tear gas being fired and plenty of glass broken.

By December 1969, he was the Illinois chief of the Black Panther Party, which preached violence as the means to African-Americans' liberation. Yet black leaders and white liberals who were wary of the Panthers appeared at his

A crowd forms in front of the Black Panthers headquarters at 2337 W. Monroe St. as the grand jury heads into the apartment Jan. 8, 1970. Fred Hampton and Mark Clark were killed in a shootout at the apartment Dec. 4, 1969.

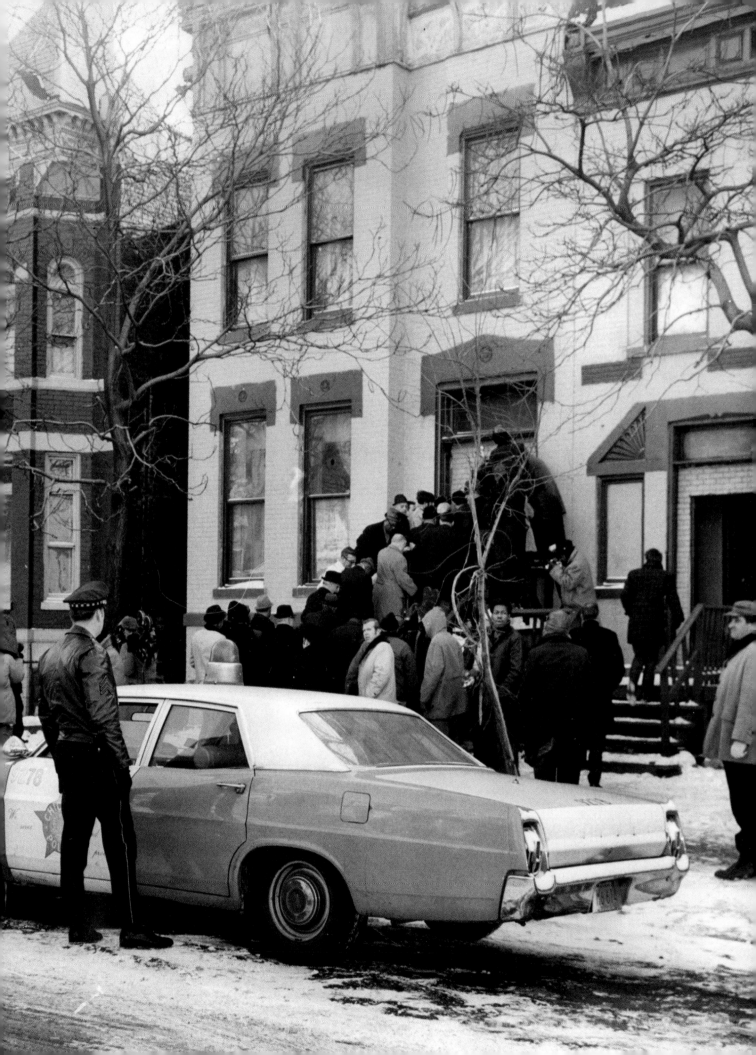

funeral, outraged at the way Hampton died. The Rev. Ralph Abernathy, heir to the Rev. Martin Luther King Jr.'s nonviolent crusade, said during his eulogy, "The nation that conquered Nazi Germany is following the same course as brutal Nazi Germany."

The Tribune noted that Dr. Benjamin Spock, the famous baby doctor and anti-war advocate, was among the 5,000 who filed past Hampton's coffin.

Founded in Oakland, Calif., in 1966, the Panthers had just opened a Chicago office on West Madison Street. Theirs was a short but stormy history marked by infighting–some of it covertly orchestrated by an FBI whose chief, J. Edgar Hoover, had become obsessed with the group. One founder, Bobby Seale, a defendant in the Chicago Seven conspiracy trial, was about to go to prison. Other leaders were facing criminal charges, leaving room for rapid advancement. Hampton was in line for a top post nationally, even as he was appealing a conviction for that ice cream truck incident.

In the months leading up to the raid, Black Panther members were involved in two fiery gun battles with Chicago police. The causes of the incidents were disputed, but in a July shootout, five police officers and three Black Panther members were wounded at the party's headquarters a block north of Hampton's apartment. In November, two police officers were killed and six were wounded in a South Side fight with Black Panther members, who themselves suffered one death and one injury. It was war, and a spy had infiltrated the Panthers' ranks. William O'Neal, a petty thief from the West Side, had driven a stolen car across state lines, a federal offense, and was offered a deal: Become an FBI informant and the case would go away.

"I was beginning to feel clean again, just by helping the FBI," he afterward told the Tribune. Ordered to infiltrate the Panthers, he quickly rose from handyman to security chief, and in November, he was given an assignment by his FBI handler: a sketch of Hampton's apartment.

"He wanted to know the locations of weapons caches, he wanted to know if we had explosives… who spent the night where," O'Neal

said in a videotaped interview at Washington University.

The FBI passed that information on to Hanrahan, and a few minutes before 5 a.m. on Dec. 4, police detailed to his office raided the apartment at 2337 W. Monroe St. According to police, they were met by a barrage of gunfire in what the Tribune described as a "wild gun battle" that lasted 20 minutes. The surviving Panthers said that the cops, guns blazing, stormed into an apartment filled mostly with sleeping people.

Hampton was dead. Mark Clark, on guard duty that night, was killed. Among the wounded were two men, a woman and a 17-year-old girl. One police officer was injured.

Hanrahan was forced to defend the raiders against charges of "murder" and "modern-day lynchings," and activists called for a federal investigation.

On Dec. 10, the Chicago Daily News described what had happened from the Panthers' point of view. Not to be outdone, the Tribune rallied with its own big story, a graphic and a firsthand account from an officer on the raid.

The Tribune account–which the newspaper ballyhooed with the one-word banner headline "EXCLUSIVE"–was supplied by Hanrahan and included photos supposedly showing bullet holes that supported cops' claims they came under fire. The Tribune didn't check that assertion before running with the official explanation of the photos. The next day, Sun-Times reporters went to the apartment and found that the alleged bullet holes were in fact nail heads. The Tribune's take on the photos, a Sun-Times headline crowed, "is nailed as mistake."

When a federal grand jury issued its report May 15, 1970, it blasted all parties–including the press–in harsh terms. The grand jury found the raid "ill-conceived," the post-raid investigation and reconstruction of events riddled with errors, and the news media responsible for "grossly exaggerated" accounts. The grand jury also took to task the surviving Black Panthers, whose refusal to cooperate, it said, hampered the probe.

Instead of chronicling a gunfight, the grand jury "found evidence that 76 expended

shells were recovered at the scene, and that only one could be traced to a Panther." Despite its severe criticism, the grand jury returned no indictments.

FBI agents had supplied the intelligence upon which the police raiders depended, and their boss didn't go unscathed. Also revealed by the various investigations and lawsuits was a hush-hush FBI operation, COINTELPRO, that not only kept track of the Panthers and other radicals but also worked to undermine them with dirty tricks. News of the scheming tarnished Hoover's reputation.

Faced with mounting criticism, including damning testimony in the federal grand jury report about the botched police investigation, the chief judge of Cook County criminal court, Joseph Power, appointed a Chicago lawyer, Barnabas Sears, as a special state's attorney. Sears got a grand jury to indict Hanrahan and the police raiders.

Presented with the indictment, Power refused to open it until the Illinois Supreme Court ordered him to. In the end, the defendants were acquitted in the trial that followed. Hampton's and Clark's families filed a civil suit that resulted in a $1.8 million settlement.

For Hanrahan, who had ordered the raid, his promising political career was buried in an avalanche of protest votes at the next election.

After losing re-election, Hanrahan made quixotic runs for mayor and alderman and practiced law until his death in 2009. His funeral almost witnessed another clash between cops, there to mourn him, and black protesters, there to decry him.

Hampton's son, Fred Hampton Jr., born two weeks after the raid, followed in his father's footsteps. A militant activist, he went to prison for firebombing a grocery store during the protests of the acquittal of the Los Angeles cops who beat Rodney King.

Bobby Rush, Hampton's Black Panther associate who took over as the group's Illinois president, was the subject of a police manhunt after the original raid and went on to lead the protest over it. In 1972, he spent six months in prison for having an unregistered weapon, a charge that predated the raid on the Panthers' headquarters. He then embarked on a conven-

tional political career, serving in the Chicago City Council and the U.S. House—at one point beating back an up-and-comer named Barack Obama who was angling for his seat.

After the raid, O'Neal moved around the country under assumed names, fearing reprisals for his role in Hampton's death, though he denied having guilty feelings.

In 1990, having returned to the Chicago area, O'Neal ran onto the Eisenhower Expressway and was fatally stuck by a car. The medical examiner ruled it a suicide.

—RON GROSSMAN

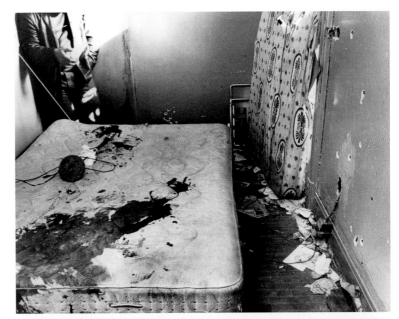

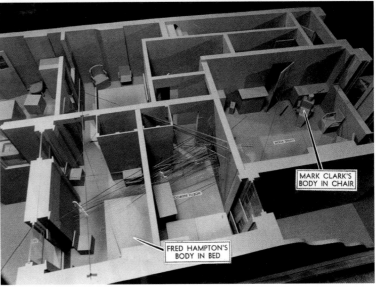

MARK CLARK'S BODY IN CHAIR

FRED HAMPTON'S BODY IN BED

From top: The rear bedroom where Fred Hampton was killed. Police officers raided his apartment on Monroe Street in Chicago early on Dec. 4, 1969.

An FBI model from May 15, 1970, shows the floorplan of the apartment where the police and Black Panther shootout occurred in 1969. The photo includes notations where Fred Hampton and Mark Clark were killed.

The neo-Nazis vs. Skokie

Anti-Semitic group waged First Amendment fight to march in suburb

A NEO-NAZI group announced plans in 1977 to march in Skokie, home to thousands of Holocaust survivors, and set off a rhetorical firestorm that the Chicago Tribune dubbed the "Skokie swastika war."

The swastika became the centerpiece of a constitutional question posed by a small group of neo-Nazis who called themselves "National Socialists"—a callback to the formal name of Adolf Hitler's political party. When the group encountered pushback over its plans to march through Skokie that spring while carrying flags bearing the swastika, its leader, Frank Collin, invoked the First Amendment as his defense.

In a January 1978 letter to the Tribune, months into a court battle over the group's right to march, Collin explained: "By forcing the 'free speech for National Socialism' issue in Skokie we are fighting for our basic rights everywhere."

The leader of Skokie's Holocaust survivor community had asserted that the sight of a swastika would have a devastating effect on those who saw loved ones marched off to Nazi gas chambers. Sol Goldstein invoked a famed maxim of the late Supreme Court Justice Oliver Wendell Holmes Jr. about the limits of free speech.

"I also defend the (First) Amendment," Goldstein told the Tribune. "But this is like calling, 'Fire!' in a crowded theater."

Frank Collin, leader of the National Socialist Party of America, holds a rally in Marquette Park at 71st Street and Sacramento Avenue on Aug. 27, 1972, in Chicago.

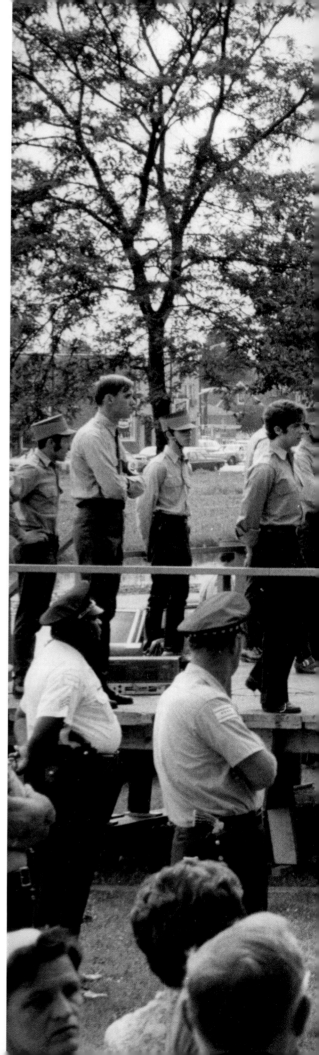

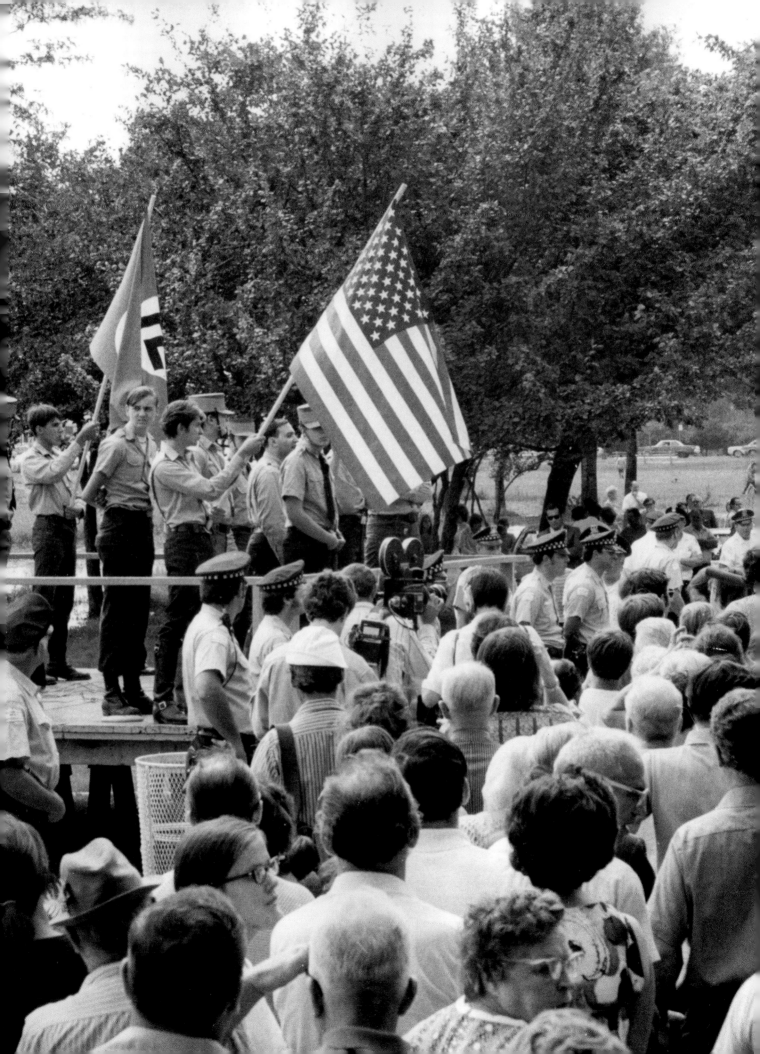

Those positions were hotly argued and rear-gued in state and federal courtrooms until the U.S. Supreme Court resolved the issue. There were screaming matches between Collin's handful of followers and protesters carrying signs that read "Smash the Nazis" and "Never Again Treblinka," a reference to a World War II extermination camp in Poland. Collin's op-ponents founded a counter-organization, the Run The Nazis Out Coalition.

The bitter debate opened crevices in Chi-cago's Jewish community. "My interest in the Nazis' march is quite personal," George Baum wrote in the Tribune in August 1977, recall-ing his liberation from the Theresienstadt con-centration camp in the Czech Republic. "That day of rejoicing and sad-ness haunts the grave-yard of my memories."

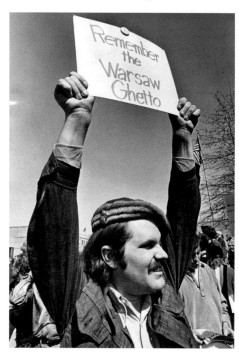

Opposition mounted in Skokie over the neo-Nazi group's campaign in 1977.

About 15,000 chil-dren had passed through the camp. Baum was one of a hundred who sur-vived. He explained his take on the proposed neo-Nazi march by quot-ing Alexander Hamilton: "Liberty may be endan-gered by the abuses of liberty as well as by the abuses of power."

Jews are traditionally champions of free speech. They contribute generously to the American Civil Liberties Union, an organiza-tion that defends First Amendment rights on a nonpartisan basis. But when the Chicago chapter took on Frank Collin as a client, Jewish members were outraged. "I feel strongly that the principle of free speech must be defended," a woman wrote in a letter to the ACLU that was quoted in a Tribune column. "But in this case, please let a non-Jew do the defending."

A Jewish lawyer who served as a volunteer attorney for the ACLU resigned, the Tribune column reported. He wanted no part of an "or-ganization that represents individuals whose ultimate goal is the destruction of us all." Less

than halfway through the 14-month contro-versy, the ACLU's executive director told the Tribune the organization had lost between 700 and 1,000 members. "And the number is prob-ably higher by now," David Hamlin said.

But ACLU members weren't the only ones whose Jewishness and politics were in conflict. "It is a mystery," Collin's grandmother said of his rabid anti-Semitism. Her son-in-law, Col-lin's father, was Jewish.

Collin's parents steadfastly refused to be interviewed. But by his grandmother's ac-count, her daughter, Virginia, and Max Collin lived "quietly in a Chicago suburb," and Frank was the eldest of their four children. Virginia was Catholic, and Max was a German Jew who had survived the Dachau concentration camp in Germany. Coming to America, he changed his name from Cohen to Collin.

Frank Collin went to Catholic elementary and high schools and attended Southern Illi-nois University before dropping out.

Somewhere along the way, Frank Collin be-came infatuated with George Lincoln Rockwell, a white supremacist and self-proclaimed "com-mandant" of the American Nazi Party. Collin became the party's Midwest director, a grandi-ose title considering that its membership na-tionally was estimated at a few hundred or less.

When Rockwell was assassinated in 1967 by a disaffected follower, Collin expected to be named his successor. But he was passed over.

Taking with him a few of Rockwell's fol-lowers, Collin founded his own group, the National Socialist Party of America. He set up headquarters at 2519 W. 71st St., thinking he'd find a receptive audience on Chicago's South-west Side. The Rev. Martin Luther King Jr. had been assaulted there while campaigning in 1966 for open housing in what was then a pre-dominantly white neighborhood.

Many residents were of Eastern European ancestry. They, too, had relatives who had suf-fered under Nazi occupation. So the sight of Nazi regalia was anathema, as was noted by Ju-lian Kulas, a Ukrainian community leader. "To dismiss the appearance of swastikas, brown shirts and jackboots on American soil a scant generation after (the Holocaust) betrays willful inattention to one of the most tragic episodes

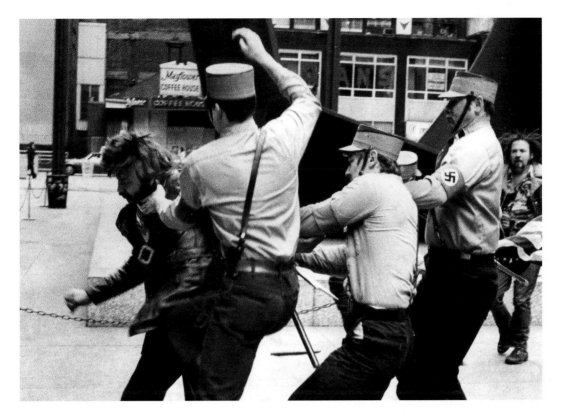

Members of the National Socialist Party of America attack a heckler March 18, 1977, after a melee broke out while local neo-Nazi group leader Frank Collin was giving a speech at Daley Plaza.

of human history," Kulas wrote in a statement of solidarity with the Jewish community that was reported in the Tribune in June 1978.

While the court battles with Skokie waged on, and thinking a dramatic move would get the media's attention, Collin planned a rally in Chicago's Marquette Park, where King had been attacked. The symbolism was patent: Collin's group promised to be a bulwark against the black residents of nearby neighborhoods.

A new confrontation between blacks and whites was the last thing Chicago's leaders wanted. So the Chicago Park District put obstacles in Collin's way. His group would have to post a $350,000 insurance bond. When the ACLU objected, saying that the amount was unreasonable, a federal judge reduced it to $60,000. At a second hearing, the judge found that, because Collin's views were unpopular, brokers weren't willing to write him an insurance policy, so he was given the right to march without posting a bond.

Collin won his courtroom battles almost in spite of himself. "He told me, in effect, to go to h-e-l-l," a judge said after an especially testy session early in the fight. "He said, in effect, he doesn't care what I do—that he's got other plans."

But Collin did float his idea of a compromise. He wouldn't march in Skokie if his group was allowed to hold a rally in Marquette Park. Once the bond requirement was lifted, the neo-Nazis marched twice in the park. Each time, the police cut the demonstration short, in the face of counter-demonstrations. Rallies at Daley and Kluczynski Federal Building plazas were marked by similar clashes.

So in the end it was something of an anticlimax when the U.S. Supreme Court ruled that Collin's right of free speech extended to Skokie. "After bitter controversy, the courts cleared the Skokie march, but Collin called it off," the Tribune noted on July 8, 1978.

Collin disappeared from the political scene but not from the news. In 1980 he was convicted of sexually molesting boys and sent to prison. After being released, he dabbled in paganism and new-age anthropology. He abandoned National Socialism for reasons as mysterious as those that brought him into the cult of Hitler.

As his grandmother had said: "We don't know how or when it started."

—RON GROSSMAN

CHAPTER EIGHT:

Disasters

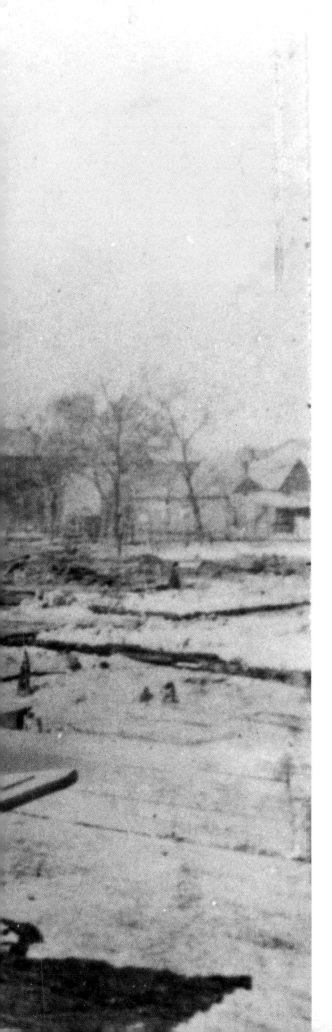

Mrs. O'Leary's legend

How survivors of the Chicago Fire sought scapegoats 140 years ago

E VEN as the embers of the Chicago Fire cooled, the saga of Mrs. O'Leary began. For the scores of decades since, she has been alternately accused and exonerated of setting off the inferno that consumed almost everything in its path from the Near South Side to Fullerton Avenue.

Along with Michael Jordan, Al Capone and her cow, O'Leary is one of our city's most widely known flesh-and-blood icons, though it's hard to get a clear fix on her. To contemporaries, Catherine O'Leary was a mystery, and she remains so to scholars.

There's an irresistible instinct to assign human culpability to tragedies like the fire, which destroyed 18,000 structures, left 100,000 people homeless and killed at least 300, and O'Leary was a natural target. The blaze began about 9 p.m. on Oct. 8, 1871, in her barn. Prevailing winds took the flames north and east, sparing the house where she and her husband, Patrick, lived at 137 De-Koven St, now the home of the Fire Department's training academy.

Testifying before an investigating commission in 1871, O'Leary said she never milked after dark and pointed a finger at others. According to the Tribune's coverage, she said the tenants of a second house on the O'Leary property were partying that evening. Neighbors told O'Leary one reveler went to the barn and milked the cows. Why? she was asked.

In this photo taken shortly after the Great Chicago Fire of 1871, the O'Leary house, center, still stands, but only rubble is left of its barn, right.

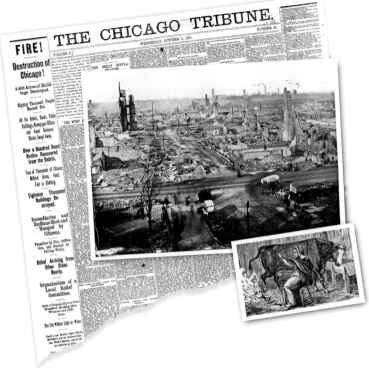

An engraving depicts the legend of Mrs. O'Leary and her cow. The Tribune didn't publish for two days after the fire, the first and only interruption in the newspaper's history. The Oct. 11, 1871, edition was just two pages.

"Some said it was for oysters," she replied.

Earlier, a newspaper reporter said O'Leary blamed the usual suspect of so many mysteries—"a strange man" neighbors spotted. "It wasn't five minutes till they saw the barn on fire," O'Leary reportedly said.

The commission reported it couldn't conclude how the fire started, and O'Leary was determined to return to obscurity. She kept reporters and photographers at arm's length. No photo of her is known, allowing artists to depict her with a happy face or guilty look. Until her death in 1895, journalists vainly pounded on her door every October. She turned down an offer to tour with P.T. Barnum's circus, swinging a broom at his emissary.

In 1997, a City Council resolution proclaimed Mrs. O'Leary and her cow innocent, but very little changed. Legends trump resolutions every time, and the tale is retold thousands of times every summer tourist season.

Whatever her role in the disaster, Mrs. O'Leary certainly knew how to name-drop in quintessentially Chicago style.

Mrs. O'Leary's son James grew up to be gambling boss Big Jim O'Leary. Shortly before her death, she showed the door to the last reporter to try to interview her, saying, "I know bad people."

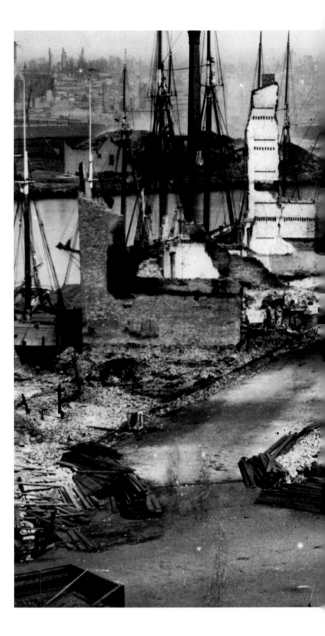

The fire destroyed 18,000 structures, left 100,000 people homeless and killed at least 300 people.

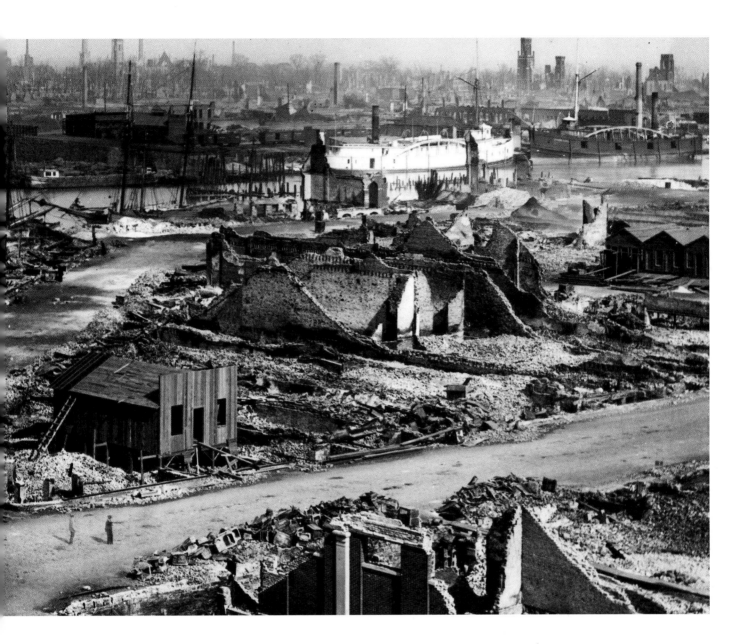

Round up the (un)usual suspects

Mrs. O'Leary wasn't the only one accused of burning down Chicago.

Daniel "Peg Leg" Sullivan: He was a neighbor who brought suspicion on himself by claiming to be first on the scene. More than one would-be Sherlock Homes noted that a wooden leg would have prevented Sullivan from sprinting the distance from where he said he first saw the conflagration to the O'Leary property.

French sympathizer: The Chicago Times newspaper on Oct. 23, 1871, printed an alleged confession by a self-proclaimed revolutionary who said the fire was his revenge for the suppression of the Paris Commune, a popular uprising earlier that year.

Boys shooting dice: In 1944, Northwestern University claimed a wealthy benefactor, Louis Cohn, asserted the fire was started by an accidentally overturned lantern as he, O'Leary's son and "other boys were shooting dice in the (barn's) hayloft."

The cow: On Dec. 17, 1871, the Tribune offered a tongue-in-cheek theory. The cow was being milked by someone from the party at the tenants' house and, resenting being an accomplice in that crime, kicked the lantern over on purpose.

—RON GROSSMAN

The aftermath of the Great Chicago Fire in 1871. The Chicago River can be seen in the background.

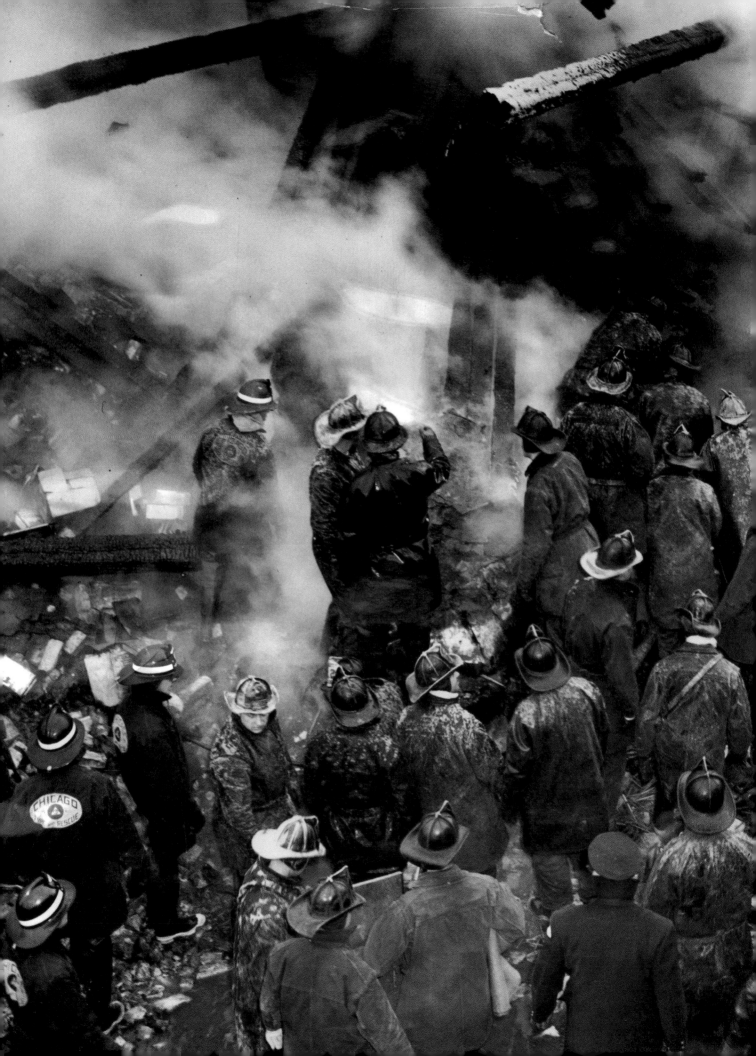

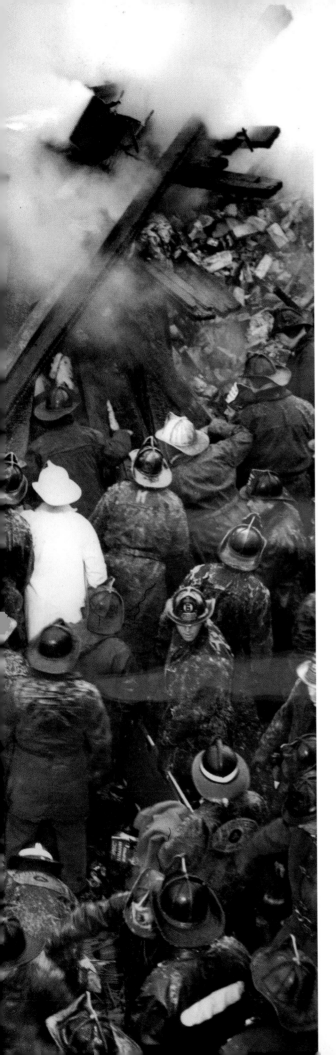

Three deadly infernos

Industrial blazes remind residents of city's fateful rebirth after 1871 fire.

CHICAGO is identified with fire, whether the apocalyptic blaze of 1871, the horrifying loss of life in the Iroquois Theater in 1903 or the unspeakable tragedy of the Our Lady of the Angels School blaze in 1958. For many longtime Chicago residents, fires become markers on the city's timeline.

Flashback was reminded—with the help of its readers—of three warehouse and industrial blazes in particular. They were the 1910 Union Stockyards fire, the 1961 Hubbard Street fire and the 1968 Mickelberry plant fire and explosion.

In all three cases, the bravery, heroism and sacrifice of Chicago firefighters was on display as they faced the unknown dangers presented by the huge warehouses, where the contents often were as lethal as the flames. Another common element: In all three cases, firefighters had to battle bitter cold as well. As Arthur Murray, survivor of the Mickelberry fire, said: "They were just incredible."

1910 Union Stockyards

On Dec. 22, a fire that started in the basement of a Morris & Co. meat storehouse would end with the worst loss of life by a big-city fire department until the Sept. 11, 2001, terror attacks. Twenty-four men were killed: 21 firefighters, including the fire chief, and three civilians. The first alarm rang out at 4 a.m. and the response was heavy because of the nature

Firemen dig for bodies of victims of a fire at 614 Hubbard St. on Jan. 28, 1961. Nine firemen were killed when a wall of the building collapsed, burying them under a mound of rubble.

of the stockyards. As the Tribune reported the next day, "Every fireman knows what a stockyard fire means. The men knew of the treachery of the ancient shells of grease soaked wood and shaky brick walls. . . . Chicago firemen cherish no illusions when they go in to strangle a big fire at the yards with their hands."

The firefighters were forced to battle the blaze from a narrow railroad platform, boxed in behind by train cars, with a "rotten ancient wooden canopy" above them. Access to the building was limited by adjacent structures and fire walls that forced the flames, heat and smoke in one direction. Into this inferno rushed the firemen. They had no chance.

"There was no warning to the men pent up in the narrow gallery," the Tribune reported Dec. 23. "There was a dull roar and simultaneously the great front wall, six stories of solid brick, moved outward about ten feet, and dropped."

The Tribune's front page was remarkable, a visual presentation that was at least 50 years ahead of its time. Page 1 carried no stories but was dominated by a photograph and a list of the deceased. Inside, the coverage filled most

of seven pages, carrying numerous striking photos from the scene, illustrative graphics and mug shots of the deceased.

1961 Hubbard Street

Temperatures were near zero the morning of Jan. 28 when a warehouse building shared by Hilker and Bletsch Co., a bakery supply firm, and P and P Blueberry Packing Co. went up in flames. Disaster struck when a team of firefighters trying to rescue two comrades trapped in the building were themselves imperiled by a collapsing wall. Nine firemen perished, including two battalion chiefs. The emotional toll was heavy because one of them, George Rees, could be heard crying for help for more than 30 minutes as firefighters struggled feverishly but in vain to reach him.

It required more than 300 men, 67 pieces of equipment and two fireboats pumping water from the Chicago River to knock down the blaze at 614 W. Hubbard St. Even then, the rubble smoldered for days.

The Tribune reported the sewers clogged with ice so that the area became an ice rink

Fireman carry the body of a fallen comrade from the blaze at 614 Hubbard St., which claimed the lives of nine firefighters in January 1961.

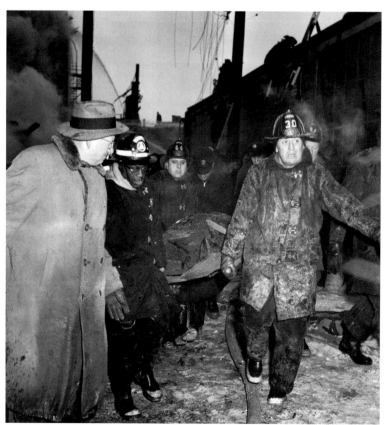

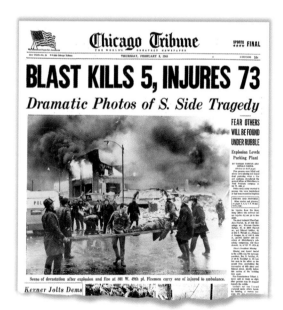

Coverage of the 1968 Mickelberry plant fire was dominated by Tribune photographer Don Casper's pictures. Casper, who lived nearby, was the first journalist on the scene. In a story the day after, he said the devastation rivaled what he had seen after the Oak Lawn tornado the previous year. "It was a battle scene. . . . There were bodies everywhere—dead and injured—you couldn't tell the difference."

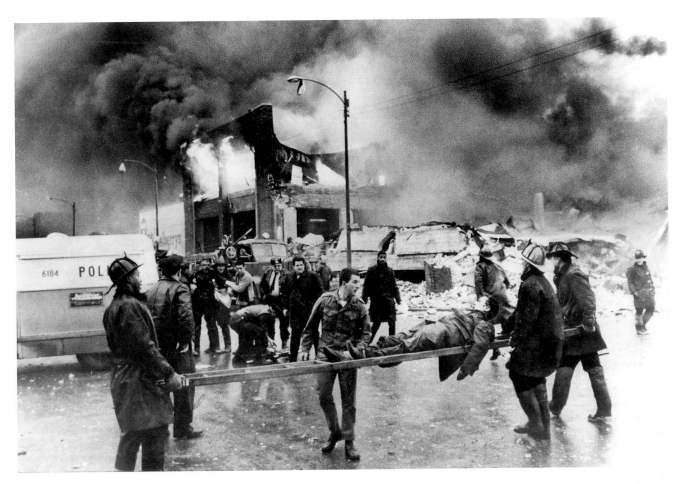

with water up to 18 inches thick surrounding the building.

1968 Mickelberry plant

Nine people, including four firefighters, were killed Feb. 7 when a series of late-afternoon explosions ripped through the general offices of Mickelberry Food Products Co. on the South Side. The fire started when a gasoline tanker truck making a delivery in the alley behind the plant started leaking. The gas flowed through a doorway and into the basement, where the building's boiler was located.

Black billowing smoke had driven Arthur Murray and a number of his co-workers in the corporate headquarters to the roof of the plant. Murray, describing the scene decades later for Flashback, said they weren't panicked on the roof because the fire seemed to be at the other end of the block-long packinghouse. He said he was waiting his turn to descend a ladder, looking out over Halsted Street, when the final, thunderous explosion hit.

"I remember it vividly," he said. "When the explosion came it was horrific. I remember flying through the air with a tremendous amount of heat."

The detonation demolished the building, and the force of the blast knocked some firefighters and bystanders unconscious. Bricks and other debris rained down on rescue workers and passers-by, causing many injuries. Windows were shattered three blocks away, and nearby houses were evacuated for fear they would collapse. More than 70 people were injured.

Murray landed on the other side of Halsted in a used-car lot. He said he suffered three broken vertebrae and a number of scrapes and cuts, and his hair was singed and blackened, but he was relatively—miraculously—OK. The man closest to him on the roof, George Davidson, also survived, but many of the others on the roof did not. "The other poor souls fell straight down" into the building, Murray said.

—STEPHAN BENZKOFER

A ladder becomes a stretcher for an explosion victim as flames engulf what remains of the Mickelberry Food Products building at 801 W. 49th Place on Feb. 7, 1968.

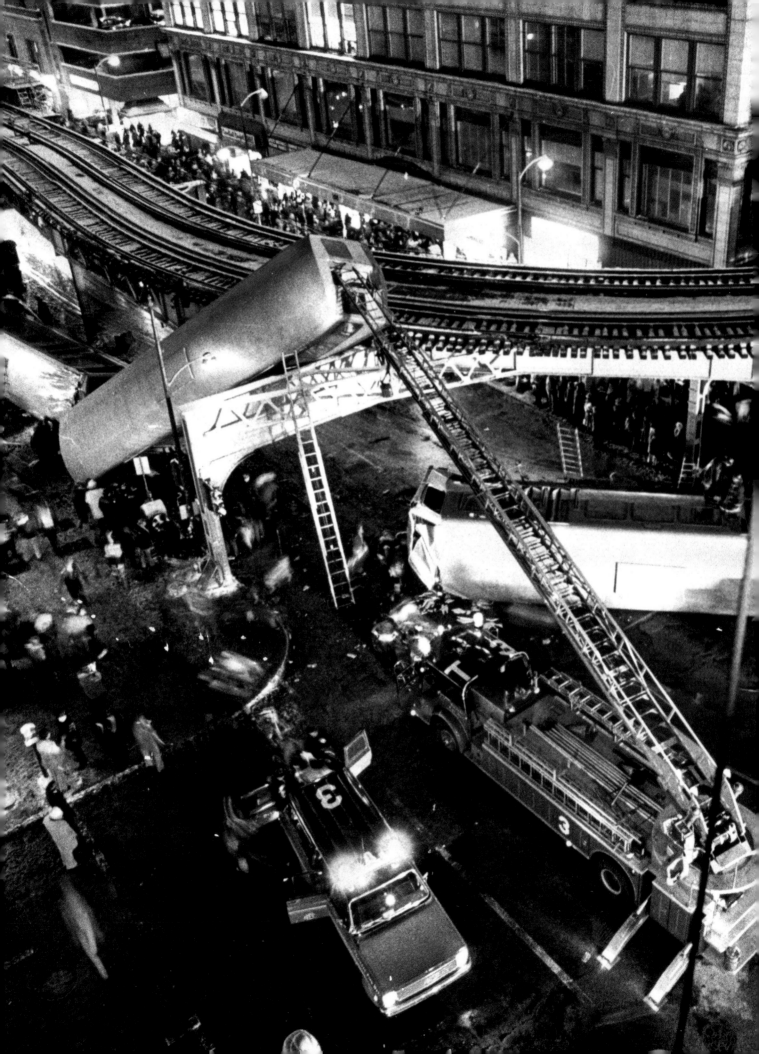

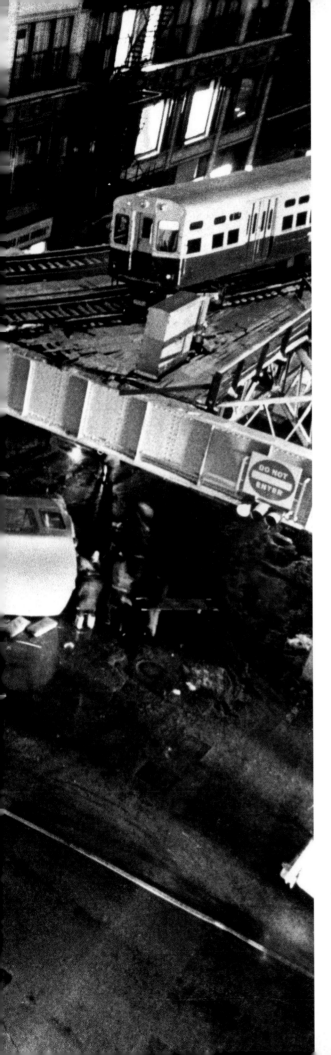

'L' leaps off Loop rails

1977 train crash to street below kills 11, injures 160

Every day, Robert and Kathleen Ferbrache would ride the "L" home together after work. He was a collector for a finance company on Adams Street, she was a receptionist for an accounting firm in the Prudential Plaza building. They lived in Oak Park, a few blocks from an "L" station.

On Feb. 4, 1977, a Friday, they were on their usual train, the Lake-Dan Ryan Line (now parts of the Green and Red lines), on their way to a birthday party for a friend's son. It was just a little after 5:20 p.m.

They must have been surprised—or, perhaps, frustrated—when the train seemed to hit something after coming around the curve at the corner of Lake Street and Wabash Avenue.

After a "quiet thump," the first two train cars started to wobble. Slowly, the back of the first car lifted into the air and then crashed into the street 20 feet below, dragging three other cars with it.

More than 160 people were injured, and 11 were killed, including the Ferbraches—Robert, 29, and Kathleen, 25.

A bystander called it "a slow-motion horror." The Tribune called it the worst CTA crash in history.

It wasn't clear at first what caused the crash. The Lake-Dan Ryan train had turned the corner to pull into the station at State and Lake streets and hit the rear car of a Ravenswood (now the Brown Line) train, which

Emergency workers at Wabash Avenue and Lake Street on Feb. 4, 1977. Eleven people were killed and more than 160 were injured in the CTA derailment.

Badly shaken, but almost able to walk, a man is assisted from the crash scene on Feb. 4, 1977. Others had to be rushed off on stretchers. More than 160 injured people were taken to nine hospitals. Many received aid in stores and buildings near the crash.

were crowded into the restaurant, covering tables, booths, chairs and the floor.

Agnes McCormick, a 59-year-old secretary with the Chicago Public Library, was eating an early dinner at the Lakeview when the train crashed. "The victims were lying in rows in the streets, and some were pinned in the cars," she told the Tribune. "Some of them were obviously dead. I saw one blond girl, about 20, lying in a pool of blood and there was nothing we could do for her."

Cardinal John Cody appeared at the street corner to administer last rites, joined by Michael Bilandic, who was the acting mayor after Richard J. Daley died in 1976; then-Rep. Abner Mikva; and heavyweight champion Muhammad Ali.

When rescue workers arrived on the scene, they moved quickly to get the injured to one of nine hospitals in the city. They worked with an orderly flow for two hours straight, shuffling, sorting and shipping off those they could help. The hospitals had learned a valuable lesson in disaster planning a year earlier when 310 passengers were injured after another Chicago rapid-transit crash.

Train service resumed at 6:02 the following morning. And four days after the crash, the Ferbraches were buried in Brookfield.

It took months for the CTA and the National Transportation Safety Board to nail down the ultimate cause of the crash.

The train's driver, Stephen A. Martin, was badly injured and spent weeks recovering at Northwestern Memorial Hospital. An investigation by the NTSB found that during his eight years as a CTA employee, Martin had a long record of rule violations, including another derailment three years earlier.

Investigators originally thought Martin might have been high while he was operating the train—two police officers had found four hand-rolled cigarettes, supposedly containing marijuana in his bag at the crash site—but toxicology reports showed that Martin wasn't under the influence of alcohol, narcotics or marijuana.

What happened was much more mundane: human error. During NTSB hearings about the crash, Martin admitted he saw a red flashing

was waiting for an Evanston Express (now the Purple Line) train to leave the station. The Evanston train wasn't supposed to be there, but an earlier switching problem meant that a few of the express trains were still running on the wrong tracks.

According to the CTA chairman, a cab signaling device should have stopped the Lake-Dan Ryan train from getting too close to the Ravenswood train.

"Why that didn't work, I don't know," a CTA representative told the Tribune.

Passersby helped pull passengers from the cars before police and firefighters arrived. Businesses along Lake and Wabash were turned into temporary "blood-spattered" hospitals. Lakeview Restaurant, 179 N. Wabash Ave., handed out water, coffee and towels for first aid. At one point, more than 50 victims

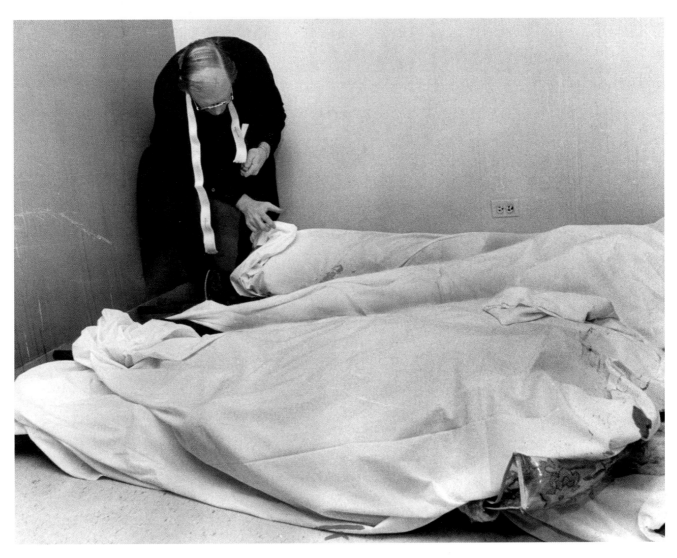

The Rev. Sebastian Lewis administers last rites to several victims of the CTA crash who were pronounced dead on arrival at Henrotin Hospital in Chicago in 1977. Human error was blamed for the crash.

"The victims were lying in rows in the streets, and some were pinned in the cars."

—AGNES MCCORMICK, 1977

light in his cab right before he came around the curve and hit the end of another train. That red light should have prompted Martin to stop and wait for the light to change to yellow or green before continuing.

Instead, Martin testified that he thought the red light meant to slow down to 15 mph, so he continued along the tracks at 10 mph and wasn't able to apply the brakes in time to prevent the crash.

Martin was fired six months later. Three months after that, the NTSB officially blamed him for the accident.

In the wake of the crash, there were calls for reforms to the aging "L" system, but they went nowhere. The CTA did manage to implement a few lasting changes to its safety procedures. Barriers were built along the "L" tracks' sharpest curves to prevent trains from falling off the tracks in a derailment. Train operators with moving violations were required to be retested and retrained. The CTA updated its rule book and conducted a large safety study on distracted driving and train accidents.

And finally, the CTA clarified its rules on red lights on the tracks: Red always means wait.

—BY ELIZABETH GRIEWE

Eastland: Joy turns to horror

1915 outing on excursion ship ended in city's deadliest tragedy

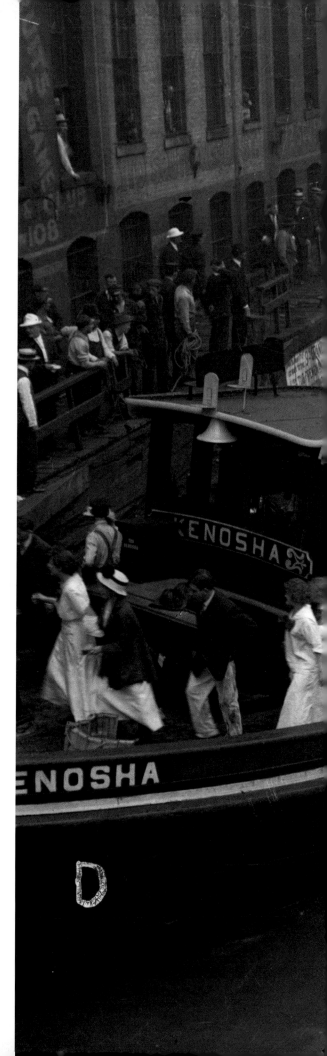

The tugboat Kenosha serves as a floating bridge to let survivors reach safety after the Eastland excursion ship disaster July 24, 1915. Chartered for a Western Electric Co. employee outing, the Eastland rolled over and sank in the Chicago River between LaSalle and Clark streets. The ship was in only 20 feet of water, but that was deep enough to drown hundreds.

ONLY hours after the Eastland disaster, a Tribune reporter witnessed numerous somber processions in Cicero, where many of the estimated 844 victims lived.

"All night long crowds had thronged the streets, going sorrowfully from house to house to learn of the death of a son, a daughter, a mother, a cousin," he wrote.

A Lake Michigan excursion ship, the S.S. Eastland, had been chartered for an employees' outing by the Western Electric Co., whose factory at 22nd Street and Cicero Avenue was the western suburb's job base. Neighbors worked there. Many died together on the ill-fated trip to Michigan City, Ind.

"In one block," the Tribune reporter noted, "there are nineteen dead."

Western Electric, the manufacturing arm of the Bell Telephone Co., had sponsored similar outings for the previous four years, and this one was to be particularly festive, marking the factory's role in the inauguration of coast-to-coast long-distance service. Seven thousand employees, family members and friends were expected to sail on five ships, including the Eastland, which was to depart first.

"The street cars were laden with laughing parties of men and girls, everybody with picnic lunch in hand," the Trib reported.

Known as the "speed queen of the Great Lakes," the Eastland never got a chance to demonstrate that trait on July 24, 1915. It

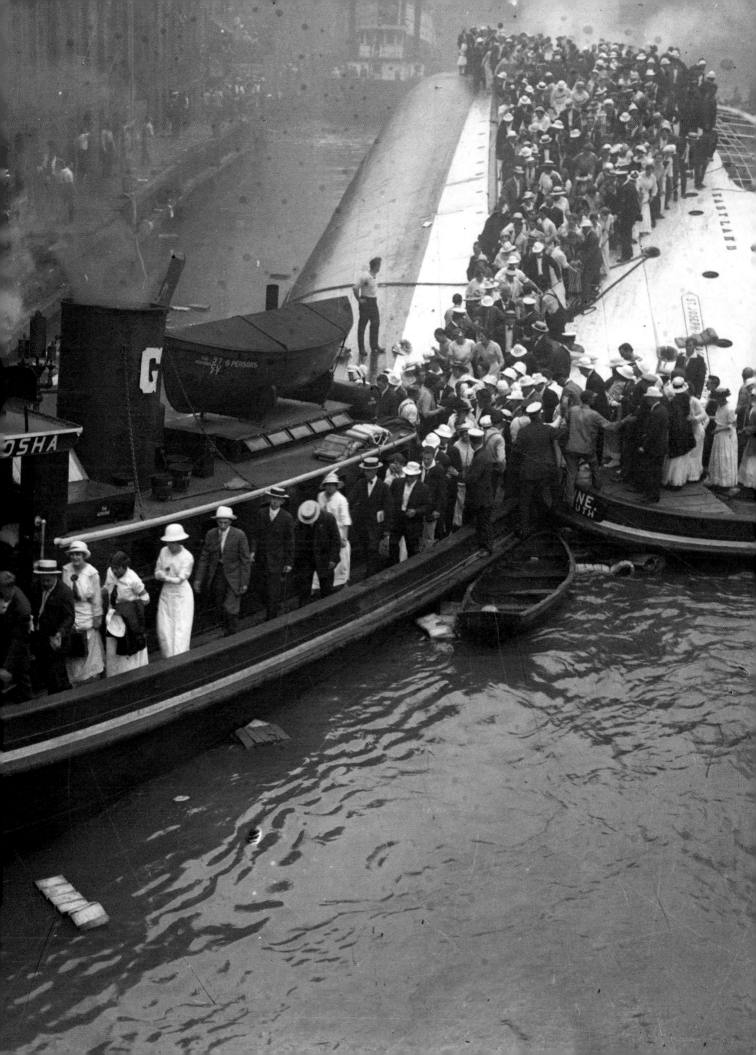

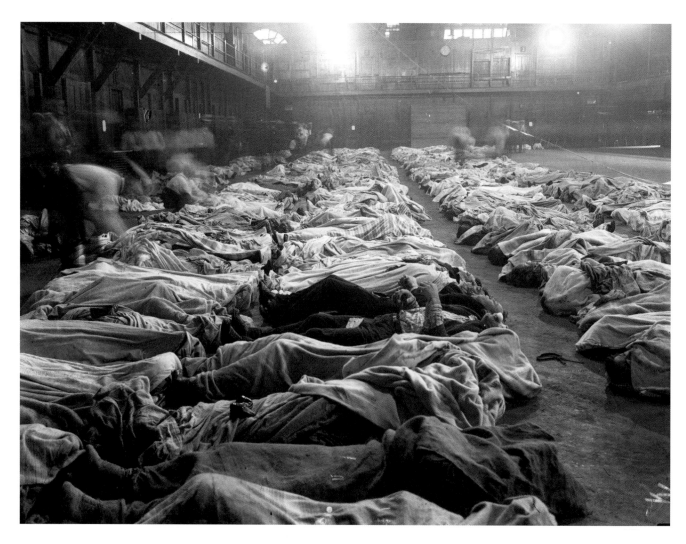

Above: Eastland victims are laid out at the 2nd Regiment armory, a temporary morgue, where enormous crowds waited, "sick at heart," a Tribune reporter wrote, to identify bodies.

Right: Two women in mourning are escorted by a police officer after the S.S. Eastland Disaster in Chicago in 1915.

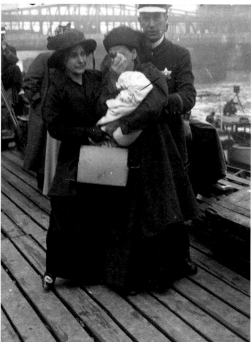

rolled over and sank in the Chicago River between LaSalle and Clark streets, at about 7:30 on a Saturday morning. Even as its 2,500 passengers boarded, there were foreboding signs something was wrong. The ship listed, first toward the wharf, then to the other side, before finally capsizing.

The deadliest tragedy in Chicago history, the Eastland rollover seemed to unfold almost in slow motion. Testimony heard by a coroner's jury convened the day of the disaster showed the ship rocked back and forth for about 15 minutes. "During that time the boat should have been unloaded," jury foreman Dr. W.A. Evans wrote in a Tribune article. Instead, the festivities continued. An orchestra, having attracted dancers to the promenade deck, shifted to ragtime, the musicians digging their heels in as the vessel listed 25 degrees to port. A crew member asked passengers to move star-

board, but a light rain and the angle made that virtually impossible

"We were inside, sitting on a bench," Mrs. E.L. Swangren told the Tribune. "I saw my mother go down. My brother Frank reached for his sweetheart, Miss Louise Smith, who was with him. Both went down together. Perhaps it is best they did."

One crew member, John Elbert, was quick to realize what was happening. He went to alert passengers below deck. "They were hanging to molding, to chairs, and life preservers, and I guess there were several who were drowned in the water which filled the under half of the cabin," said Elbert, who managed to get three dozen to safety.

For Joe Yost and Avina Stubenrauch, it was a first date. "'Come on,' Joe shouted, and with his arm encircling her waist they dashed for the side," the Tribune reported. "Into the water they plunged—together. Up they came—together. Someone threw a rope from the dock, and with this help both were hauled to safety."

Four days later, they were married in Waukegan, having found Chicago's license bureau shuttered. City offices were closed in mourning for the less lucky.

Some passengers were saved thanks to merchants in the city's produce market, then located along that stretch of the river. "I saw the boat begin to turn," police Officer Nicholas Sweig told the Tribune. "Fisher (his partner) and I and a number of commission men and their employees began throwing barrels and coops and other things in the water to help the victims."

Some rescue workers were stymied by the enveloping chaos onshore. A crew from the Acme Welding company was called to the scene to cut a hole in the overturned ship through which trapped passengers might escape. It took an hour of pleading to get through the police lines. "Who knows how many lives we might have saved in that time?" said the company manager. "The captain of the boat told us not to burn the holes. What we answered is not fit to print and he did not take our dare to come near and try to stop us."

Those for whom help came too late were taken to the 2nd Regiment armory on Wash-

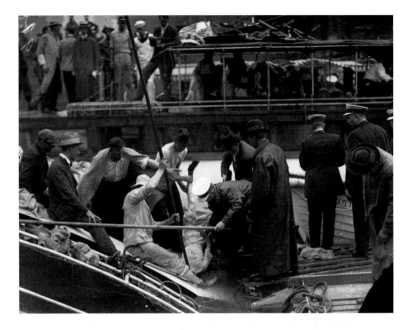

ington Boulevard, where enormous crowds gathered. "They waited in line through the hours of darkness; they made their way through the entrance into the hall of death;" a Tribune reporter wrote, "they passed between the silent lines; and then, sick at heart; they sat down along the wall and waited, waited for some newly recovered body to be brought in disfigured and dripping with water."

One long unidentified victim, tagged No. 396 and dubbed "the little feller" by police, especially pulled at the public's heartstrings. Flowers piled up along his unclaimed body. Later authorities realized his father, mother and sister had also perished. When playmates finally identified Willie Novotny, enormous numbers of Chicagoans marched in his funeral procession.

The Marshall Field Co. sent delivery trucks to carry other victims and their mourners to cemeteries from Cicero's Czech- and Polish-Catholic churches. Many who perished were immigrants, who had come to America full of hope they'd find a better life. A priest alluded to that bitter irony in funeral services at the Church of Mary Queen of Heaven with a reference to a biblical story of inconsolable grief from the Book of Jeremiah:

"There is a cry in Ramah and Rachel will not be comforted because her children are no more."

—RON GROSSMAN

Rescue workers handle a victim after the disaster. Chicken crates were thrown into the river in the hopes that survivors could grab them and save themselves.

Flu hit hard and fast in 1918

Officials downplayed threat and thousands died

THE photos showed a nurse, a hospital worker and a street sweeper wearing face masks. The story reported how a rapidly spreading disease was overtaxing the city's and nation's hospitals, doctors and nurses.

Published in the Tribune in 1918, the story and photos eerily foreshadowed what readers saw nearly a century later in coverage of an Ebola epidemic.

There were similarities between the influenza pandemic and the Ebola outbreak. Officials downplayed the threat, early warnings were missed or ignored, much-needed medical supplies ran short, victims' heart-rending stories came one after another and health care workers were some of the earliest victims.

The Oct. 2, 1918, story accompanying the face mask photo noted that disease was taking its toll on medical personnel tending to Chicago's influenza patients: "A great many of the hospitals are hard hit. At the West Side hospital there have been twenty-five cases among the nurses, and three of them have died. At Michael Reese hospital, there are twelve cases." The city was running out of beds for the afflicted. "Wesley Hospital promised Saturday to take noncontagious cases off my hands," said Lt. Col. J.O. Cobb of the Marine hospital, "but today they turned me down."

The Spanish influenza, as it was dubbed because of its supposed country of origin, was one of the worst plagues in history. It killed quickly, sometimes in less than a day, and attacked not only the weak and the elderly but also otherwise healthy young adults. Historians estimate that it killed 30 million to 50 million worldwide in just a few months from 1918 to 1919. Half of the Earth's population was affected, seemingly in every nook and cranny of the globe. When Tahiti reported that its population was threatened with extinction, the American Red Cross was stretched so thin it couldn't get medical supplies to the remote Pacific island. A Chicago furrier with business connections in Alaska told the Tribune he received a telegram from the postmaster of Nome saying: "65 percent Eskimos here died within two weeks. Epidemic now abating."

By mid-November 1918, Chicago had experienced 38,000 cases of influenza, and 13,000 of its deadly companion, pneumonia. According to a University of Michigan study, some 10,000 Chicagoans died in the epidemic that began locally on Sept. 8, 1918, when several sailors reported sick at Great Lakes Naval Training Station. Military bases had been jammed ever since the U.S. entered World War I the previous year, making them breeding grounds for a highly contagious disease. Yet perhaps fearing to panic the public, authorities were slow to acknowledge the looming disaster. On Sept. 21, the commanding officer of Great Lakes issued a statement reassuring worried relatives that "we have only 800 cases" among the base's 45,000 sailors. A few days later, the Tribune editorially discounted "the so-called influenza epidemic."

On Sept. 24, 1918, the Tribune reported that Fort Sheridan, the Army's nearby counterpart to Great Lakes, logged 120 new cases that day alone, making 300 cases total and prompting officials of neighboring suburbs to act. Every theater and public hall in Waukegan and North Chicago was closed, as were the latter town's public schools. Chicago officials, however, were reluctant to make similar decisions. An assistant chief of police announced that Chicago's anti-spitting ordinance would be enforced.

120 NEW CASES OF INFLUENZA AT SHERIDAN IN DAY

North Shore Towns Close Schools and Theaters as Precaution.

TURN GOLF CLUB INTO A HOSPITAL FOR INFLUENZA

Exmoor Meets Emergency in North Shore Epidemic; 54 Patients.

INFLUENZA CASES HERE ESTIMATED 40,000 TO 60,000

Majority Declared Light Attacks; No Cause for Alarm.

PUBLIC DANCING BARRED IN FIGHT ON INFLUENZA

Emergency Commission Also Limits Attendance at Funerals.

YOU CAN'T SMOKE ON STREET CARS TILL 'FLU' ENDS

Rule Also Applies to "L" Lines; Death Rate Is Highest for City.

Tribune headlines from September to December 1918 point out the epidemic's impact on the city.

But on Oct. 10, the Trib reported that the city's schools would remain open because a state commission appointed to monitor the situation inexplicably "declared the disease is at a standstill in Chicago."

Far from it.

In just the few weeks since it cropped up at Great Lakes, the incidence of the flu had exploded. On Oct. 8, the city reported 135 deaths and 1,342 new cases. The next week, Chicago experienced more than 2,000 new cases each day, according to the Trib.

The situation at the base was desperate, as Josie Mabel Brown found when she was posted to Great Lakes right out of nursing school. "As the boys were brought in we would put winding sheets on them even if they weren't dead," Brown told an oral history interviewer in 1986, the year she turned 100, according to the Navy History and Heritage Command. "The ambulance carried four litters. It would bring us four live ones and take out four dead ones."

Numerous two- and three-paragraph stories in the Tribune put a human face on the tragedy. "With her husband, William Baum, desperately ill of influenza and their five children, four of them girls, so far gone that some were delirious, Mrs. Baum yesterday took all their clothes into the back yard and, poured oil on them and set them on fire." Baum was taken to a psychiatric hospital and the naked children were given shelter in a settlement house (Oct. 24). Some days, all it took was a headline: "Man and Family Sick With Flu, Turns on Gas" (Oct. 27). "Pair And Their Caesarean Baby Die Of Influenza" (Oct. 8).

Alice Proctor asked nurses at St. Luke's Hospital to call the Tribune and ask that a reporter and lawyer be sent to her bedside. "I am dying," she said when the pair arrived at the influenza ward. "My only worry is for my boy, Sanford. His father is dead. He has no relatives near enough to care for him. I want the Tribune to find a good home for him." A few weeks later, the paper reported that the boy, who also had been in the hospital with influenza, had been adopted by a surgeon who treated him.

The Trib reported on Saturday, Oct. 12, 1918, what one Red Cross volunteer found in a West Side home: "Mother, bedridden, helpless, fever 105. Baby, 10 months old, starving, nothing to eat since Monday. Daughter, 3 years old, fever 104. Son, 4 years old, fever 103."

Officialdom continued to shilly-shally. Public dancing was banned and attendance at funerals limited to immediate family and close friends. But as late as Dec. 12, during a convention of the American Public Health Association, "masks were called 'poppycock' and the closing of theaters and churches entirely unnecessary." Badly divided on the issue, delegates adjourned without taking a position on how to fight the disease.

Fortunately, the issue was becoming moot by then. Influenza cases declined, as quickly as the outbreak had struck. The disease returned in 1919, but not in such force.

No other nurse new to the profession would witness the grim scene that greeted Josie Mabel Brown when she reported to Great Lakes Naval Training Station: "You could never turn around without seeing a big red truck loaded with caskets for the train station so bodies could be sent home."

—RON GROSSMAN

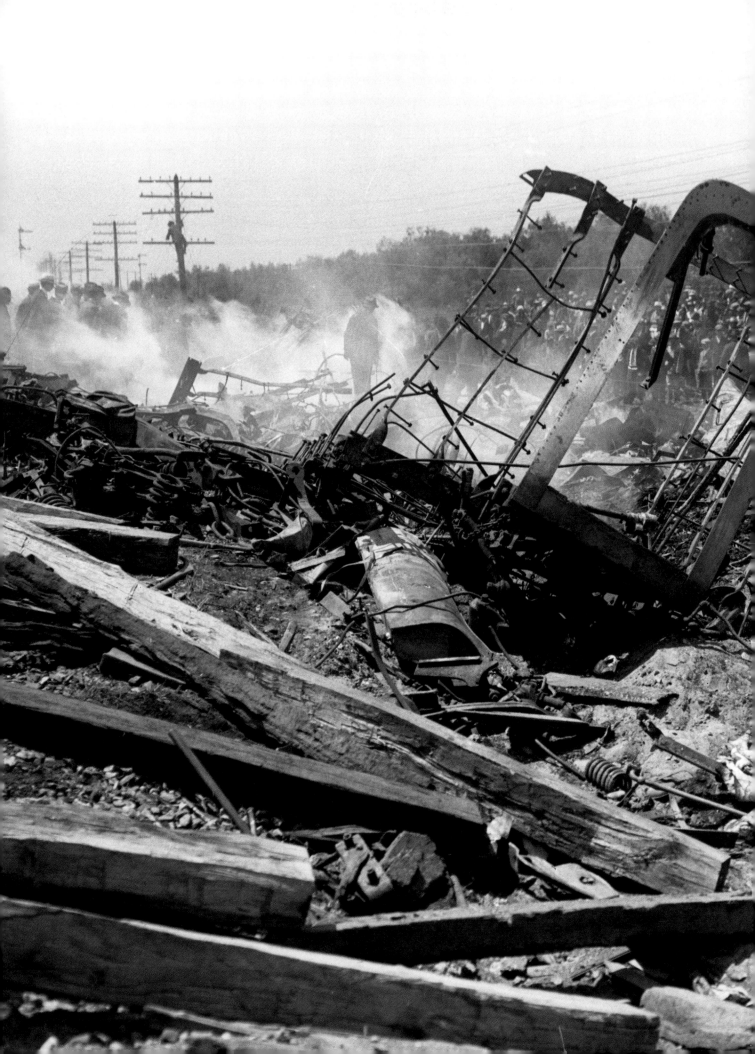

1918 circus train wreck

Victims of horrible collision buried at Showmen's Rest at west suburban cemetery

Sometimes the living have to guess where the departed wanted to be buried. Under a 1943 headline, "Final curtain finds Curly in the big time," the Tribune reported the death of sword swallower Curly Brown in a skid-row hotel on South State Street.

When no one claimed his body, Brown seemed destined for a potter's field grave.

But the Showmen's League of America voted to give Brown a small measure of recognition, even though he wasn't a member. His remains were brought to a cemetery in Forest Park where hundreds of circus performers are buried. That section of Woodlawn Cemetery was what the Tribune once called "a sort of Valhalla for distinguished members of the outdoor showman's profession."

Of Brown's funeral, the Tribune noted: "Pallbearers will be clowns, performers, press agents and bill posters who remember Curly as one of the best sword swallowers of them all."

In that west suburban cemetery, five granite elephants keep watch over Showmen's Rest, the name given to the large plot maintained by the Showmen's League of America. The first to be interred there were victims of one of the worst disasters in circus history, the 1918 train wreck

The Hagenbeck-Wallace Circus train wreck killed at least 86 and injured 127 on June 22, 1918, near Hammond.

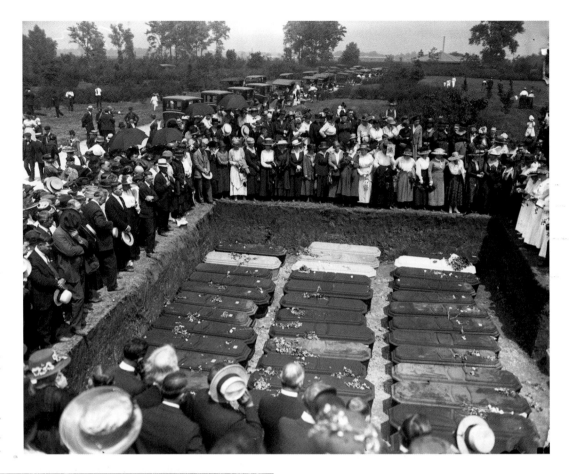

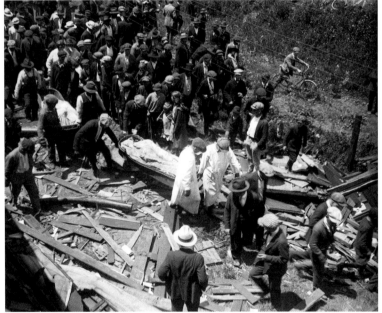

of the Hagenbeck-Wallace Circus. The more recent graves are of those who once traveled with circuses and carnivals and wanted to lie alongside their fallen comrades. The tragedy that marked the beginning of Showman's Rest took place the night of June 22, 1918. The Hagenbeck-Wallace Circus, the nation's third-largest, was traveling on a pair of trains to an engagement in Hammond. The first train carried the show's animal acts and arrived without incident. But at 4 a.m., the second train—in which roustabouts, performers and their families were sleeping—was being moved to a spot near Gary so a mechanical problem could be addressed. The last cars were still on the mainline track when a passenger train plowed into them.

There were no passengers aboard that train, and the engineer and conductor survived to give varying accounts of the accident. One version was that steam from their engine obscured the track signals. According to the Tribune's account of the coroner's inquest that followed, the conductor testified that the engineer told him: "I must have been dozing."

A flagman on the circus train, seeing that the passenger train wasn't stopping, ran down the track waving a flare. In a last desperate attempt to get the engineer's attention, he tried to throw the flare through the locomotive's

Upward of 1,500 mourners, most of them circus people, paid their last respects at the Woodlawn Cemetery.

window. The coroner's inquest heard testimony that the engineer paid no heed to the flare that bounced off his cab.

Upon impact, the circus train's kerosene lamps ignited its wooden passenger cars, and a massive fireball consumed anything in its path. Families and acts were divided into those who managed to escape and those who perished.

Noting that one member of the Flying Wards was killed and three others were seriously injured, the Tribune observed that they "had fought their way up from poverty-stricken childhood to the position of the best-known trapeze artists in the profession."

Joe Coyle Jr., 2½, billed as "the youngest clown in the United States," and his brother, Howard, 11, were members of a celebrated clowning family. "Joe Coyle, their father, saw them and their mother burned to death before his eyes," the Tribune reported.

Accounts varied, but as many as 86 were killed, including: Verna Connor, a Wild West rider; her husband, James, who was in charge of the horses; the McDhu Sisters, another equestrian act; Zeb Cattanach, the circus's lighting rigger, and his wife, Bessie; and Leroy Jessup, an usher.

Despite those tragic losses, the circus missed only two performances: the one in Hammond and another at its next stop, Monroe, Wis. Rival circuses lent some of their performers, enabling the Hagenbeck-Wallace Circus to keep its date at Beloit, Wis. "They bravely went about their work and did their accustomed stunts," the Tribune reported.

The troupe went on to fulfill the rest of its schedule, including a September appearance in Chicago's Grant Park. A benefit for a World War I charity, it was an emotional occasion. When their colleagues lay wounded and dying

on those Indiana train tracks, the Trib noted, "scores of members of the Stage Women's War Relief hurried from Chicago to give comfort and aid."

Some whom aid couldn't save were buried in Woodlawn Cemetery five days after the wreck. The Showmen's League, a fraternal organization, had recently bought a sizable plot there, scarcely imagining how soon it would be needed.

The coffins arrived on three trucks. Upward of 1,500 mourners, most of them circus people, were there to pay their last respects. Five identifiable victims got individual graves. The remains of 48 other victims, who were so badly burned they couldn't be identified, were buried in a common grave measuring just 25 by 35 feet. Their headstones were laconically labeled "Unknown Male," "Unknown Female," "Four Horse driver." One is identified as "Baldy." Another as "Smiley."

Those last two could have been roustabouts. Nomads by nature, roustabouts might join the show at one stop and leave it at another. Perhaps Baldy and Smiley were so recently hired that other members of the troupe knew only their nicknames.

Subsequently, Showmen's Rest was marked by five sculpted elephants, depicted with their trunks lowered. According to circus lore, if an elephant's trunk is up, it's a sign of joy or triumph. A lowered trunk is a sign the animal is mourning.

In nearby towns, a persistent schoolyard legend, passed from bigger kids to littler kids, has it that if you listen carefully you can hear the cries of animals at the nearby Brookfield Zoo mourning their kin.

—RON GROSSMAN

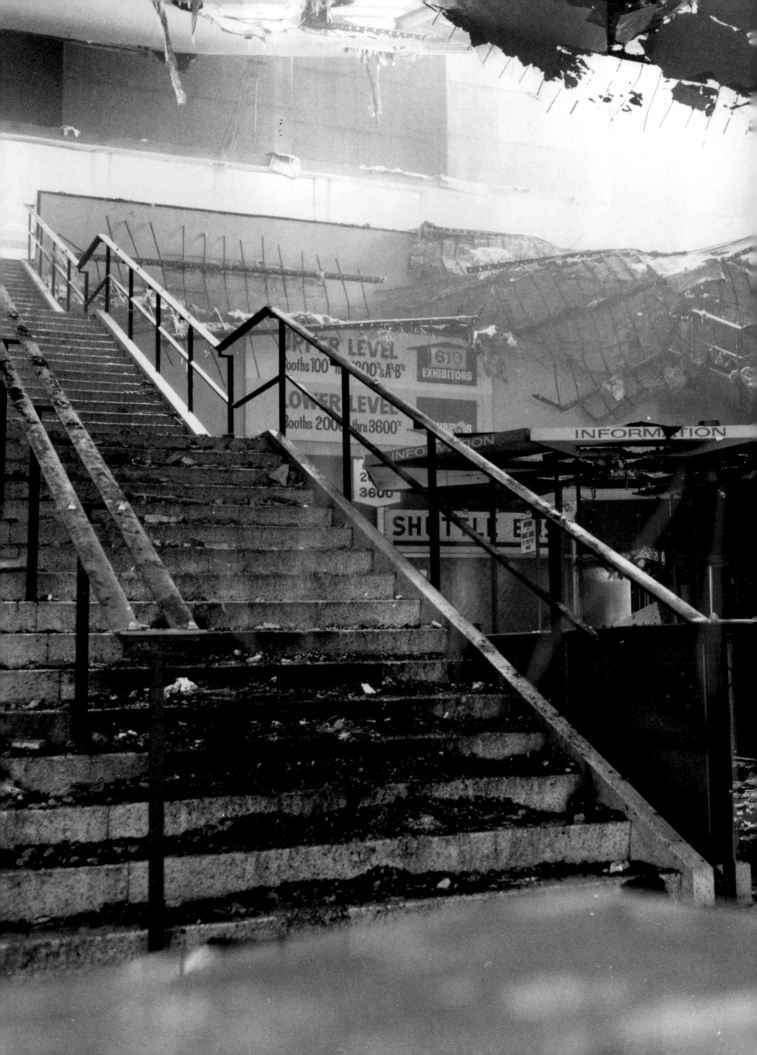

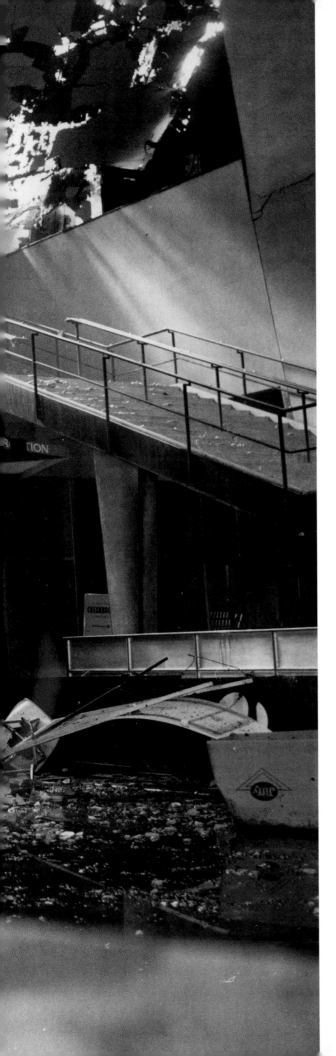

McCormick Place in ruins

In 1967, unthinkable happened: city's 'fireproof' hall burned

THE scope of the disaster was hard to fathom. Tribune reporters and photographers who raced to the scene that bitterly cold January night in 1967 sent word that McCormick Place was ablaze, engulfed in flames, raging–destroyed. Back at Tribune Tower, the night editor said, "It can't be."

But it was. The gleaming white convention center, which had opened in November 1960 and was the centerpiece of the city's dominant trade show business, was gone.

The building that was supposed to be fireproof and "outlast Rome's glories" was consumed frighteningly fast. Smoke was reported by janitors at 2:05 a.m. on Jan. 16. By 2:30 a.m., when Fire Commissioner Robert Quinn arrived, he upgraded it to a five-alarm fire. Eighteen minutes later, he ordered the first special alarm.

Firefighters wasted time trying to thaw four of seven hydrants before discovering they actually weren't frozen, they just weren't hooked up. Contractors building the interchange of the Stevenson Expressway and Lake Shore Drive had disconnected them. Firefighters drew water from the lake; the city's three fireboats also pumped water onto the blaze. Later, Quinn said working hydrants wouldn't have made a difference: "That fire was out of control when the first units arrived."

It took just 45 minutes for two-thirds of the building to be engulfed. Before the fire

Had there been no fire, these stairs would have been used by crowds of spectators flocking to McCormick Place for the National Housewares Manufacturers Association show scheduled to open on Jan. 16, 1967, the day of the fire.

"This is a tragic loss to the people of Chicago. But remember the Chicago fire of 1871. The people recovered from that one."

—MAYOR RICHARD J. DALEY, 1967

Mayor Richard J. Daley, second from right, and Fire Commissioner Robert Quinn, second from left, walk through a destroyed McCormick Place on Jan. 17, 1967, a day after the building was gutted by an "out of control" fire.

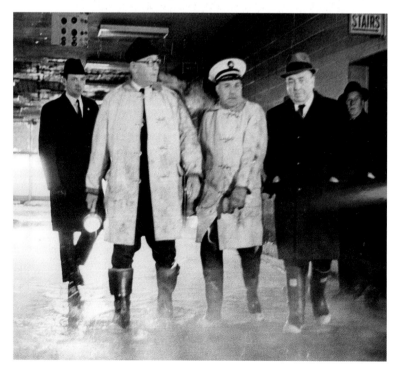

was struck at 9:48 a.m., the roof had collapsed, though the Arie Crown Theater was damaged but not destroyed. About 2,000 firefighters using 65 percent of the city's fire equipment battled the blaze, the Tribune reported.

One person died in the fire, a 31-year-old security guard named Kenneth Goodman, whose burned body was found in the rubble.

For Chicago, this was not only a civic disaster but potentially an even worse economic one. McCormick Place had quickly become a moneymaker. Convention business was worth as much as $300 million a year, the Tribune reported; McCormick Place accounted for a third of that and employed more than 10,000 people.

Mayor Richard J. Daley immediately vowed to rebuild: "This is a tragic loss to the people of Chicago. But remember the Chicago fire of 1871. The people recovered from that one."

Daley wasn't alone in evoking the big one. A front-page editorial reminded readers what our city accomplished after that inferno. It closed, "In that faith, with courage equally high, let us unite and do what now must be done."

There was much to do. The huge housewares show, which was supposed to open that day, lay in ashes. Millions of dollars in booths, not to mention one-of-a-kind samples, were lost. The Tribune reported that would-be conventioneers milled about hotel lobbies, trying to understand what it all meant. Most booked early flights home, but some stayed for a hastily reconstructed show at the Palmer House.

Dozens of other shows scrambled to find new homes. The National Sporting Goods Show, which was just over two weeks away, moved to Navy Pier. The Chicago Auto Show, three weeks out, landed at the International Amphitheater.

An investigation report was released July 31, 1967, and assigned plenty of blame: poorly trained convention personnel and security guards, building construction unable to withstand the severity of the fire, serious deficien-

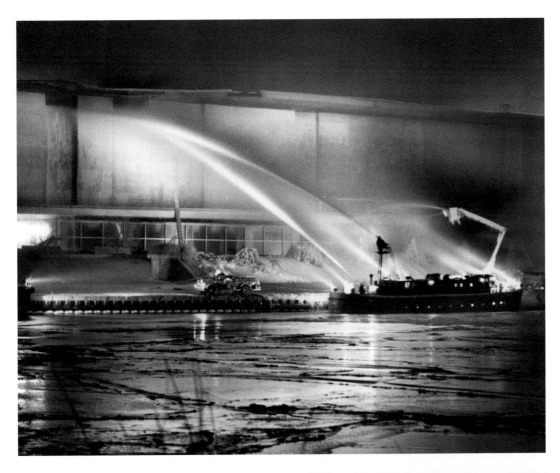

Fireboats battle the blaze on Jan. 16, 1967. Firefighters tried in vain to unfreeze several hydrants, only to discover they had been disconnected by road contractors.

Firemen try to bring under control an extra-alarm fire that completely engulfed McCormick Place on Jan. 16, 1967.

cies in temporary wiring, lack of automatic sprinklers, the disabled hydrants, and no limits to the amount of combustible material allowed in the hall. What fire probers couldn't determine was the cause. Though janitors said the initial smoke came from the vicinity of a booth's electrical wiring, the report said a search for the origin was inconclusive.

The same day, Gov. Otto Kerner gave final approval to a financing deal that guaranteed enough money for the convention hall to be replaced. By January 1971, a new McCormick Place had arisen. It was built on the old foundation and with a renovated Arie Crown Theater, but its dramatic roof marked it for a new, modern, muscular structure.

The new hall wasted no time welcoming back two big convention stalwarts. The housewares show attracted more than 58,000 industry buyers and conventioneers. They got to see lots of avocado-colored appliances and a new household necessity: the rug rake to care for the wildly popular shag carpets.

—STEPHAN BENZKOFER

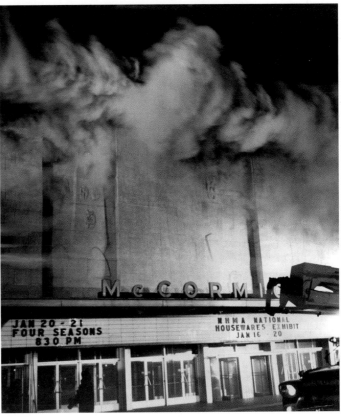

CHAPTER NINE:

Sports

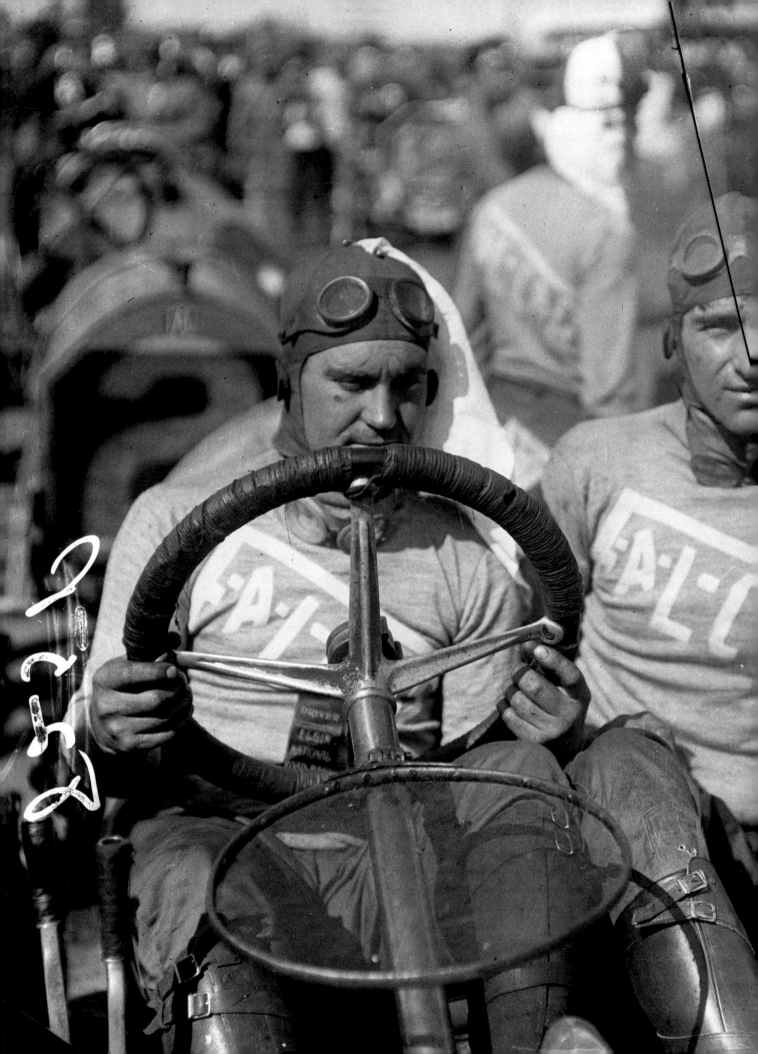

Auto racing's birthplace

Home of the nation's first car race, Chicago was longtime hub

At one time, a motor-sport-loving Chicagoan could catch a race at tracks on Addison Street, Mannheim Road, Fullerton Avenue and Peterson Avenue or in suburbs like Waukegan, Maywood, Cicero, Melrose Park, Blue Island, Hammond and Hinsdale. Not to mention regular events at Soldier Field and the International Amphitheatre.

While auto racing's appeal here has waned since its peak, and most tracks have closed or stopped hosting races, Chicago was the hub of the auto racing world for many years. Big-time racing returned to the area with the opening in 2001 of the Chicagoland Speedway in Joliet, which hosts the NASCAR Chase for the Championship.

No American city has a longer history with auto racing than Chicago. The nation's first automobile race occurred here in 1895, when the machines were called "motocycles." On a cold Thanksgiving Day, six cars started on a 54-mile course from Jackson Park to Evanston and back. Those early cars barreled through city streets and county lanes—clogged by a recent snow and slush—at speeds averaging just over 5 mph.

The winner, finishing in 10 hours, 17 minutes, was Frank Duryea, who with his brother, Charles, owned the Duryea Motor Wagon Co. Their gas-powered "horseless carriage" crossed the finish line first despite Duryea having to make two stops at smithies to forge replacement parts.

Only one other car finished, the Benz-Mueller machine driven by Oscar Mueller, and

Driver J. F. Gilman sits next to his mechanic at the Elgin National Road Races. Gilman and his mechanic were most likely driving a Fal-Car, according to their sweaters. Fal-Cars were manufactured from 1909 to 1914 and were known as A Car Without A Name—the manufacturers wanted buyers to name the cars.

In Chicago's first auto race, early cars barreled through city streets and county lanes—clogged by a recent snow and slush— at speeds averaging just over 5 mph.

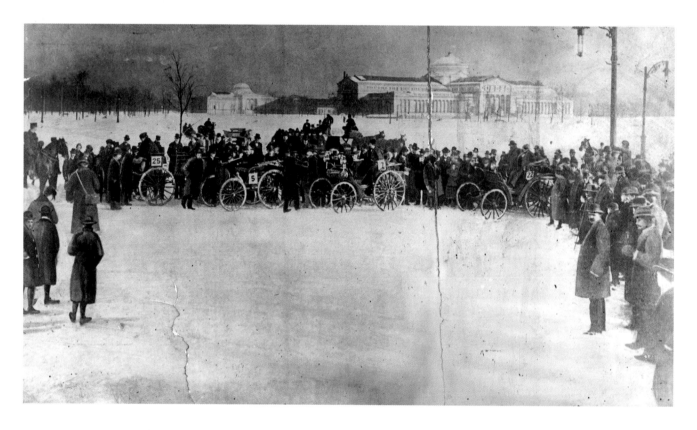

Chicago's first auto race about to start in Jackson Park on Thanksgiving 1895.

he, of course, claimed victory. Mueller said the Duryea vehicle was pushed up the hill to the finish. Mueller's "victory" wasn't without taint, though; he had to let a judge drive his car to the finish after he got too drunk to drive after fortifying himself against the cold.

The Duryea machine was awarded the $2,000 prize money; Mueller received $1,500.

But was it the first race ever? The event had been postponed from Nov. 2. On that date, only two competitors—Duryea and Mueller—were ready to race, which is what prompted the delay.

But an upset Mueller demanded satisfaction that day, and they ran a "scrub race" from Jack- son Park to Grant Park via Waukegan. In that competition, run under the careful eye of judges and reporters, Mueller won and pocketed $500. Duryea didn't even see the finish line.

So in the end, Mueller wound up with the same amount of money, but the Duryeas got the publicity of winning the "official" first-ever auto race in the United States, even if it was the second that month.

The races were on.

The Indianapolis Motor Speedway opened in 1909 and held the first of its famous 500s in 1911. Chicago's answer to Indy was Speedway Park, which the Tribune called "the fastest, saf- est automobile racetrack in the world."

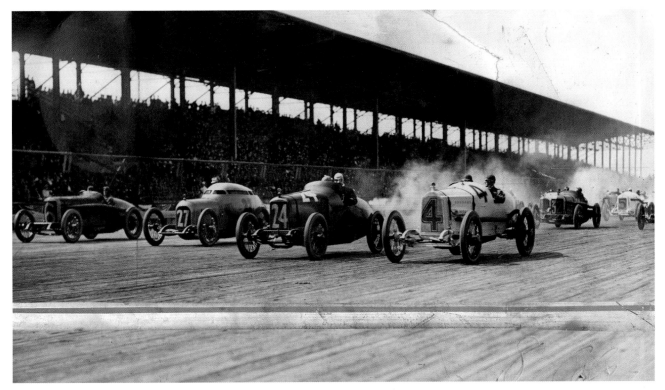

The Windy City's answer to Indy was Speedway Park, seen in 1917, where drivers competed on a two-mile, banked, wood-plank oval. A VA hospital now stands on the site near Maywood.

At the inaugural run June 26, 1915, on the two-mile, banked, wood-plank oval, Dario Resta shattered the speed record for a 500-mile race, averaging 97.6 mph. Speedway Park, near Maywood on Roosevelt Road where the Hines veterans hospital now stands, drew 80,000 people that first race.

The park's opening and Resta's record win merited a banner headline in the Tribune, six photos on Page One and more than three pages of coverage inside. It was a short-lived glory. Doomed by financial troubles, Speedway closed just three years later.

Throughout the 20th century, as one track closed, others opened. By the 1930s, numerous venues were hosting auto races, including Soldier Field and the Amphitheatre.

Stock cars and midgets dominated the events. A time when midget-car racing was very popular, it wasn't uncommon to see the most recent Indianapolis 500 champion competing in one of the powerful minis.

Auto racing took a break during World War II but came back strong. In 1947, if you were willing to drive a bit, a gearhead could see a race nearly every night of the week: Grand Rapids, Mich., on Wednesday, Streator, Ill., on Thursday, Hanson Park on Friday, Raceway on Saturday and Soldier Field on Sunday.

While Chicago's place on the auto racing circuit hasn't kept up with the vision promised by Speedway Park, the region certainly has a long and rich history.

For past and present fans, headlines from that historic 1915 race sum up the experience nicely.

"Riot of color, beauty, noise, joy, thrills," read the main headline.

"Speed Mad Throng on Perfect Day Cheers Death Taunting Drivers," read the deck headline.

And the lead? "It was a thrilling spectacle."

—STEPHAN BENZKOFER

RIOT OF COLOR, BEAUTY, NOISE, JOY, THRILLS

Speed Mad Throng on Perfect Day Cheers Death Taunting Drivers.

BY CHARLES N. WHEELER.

Speedway Park, June 26.—It was a thrilling spectacle.

Not only on the great boardway, where the dare-devil drivers taunted death with smiles on their faces in a smashing grind of five solid hours as they shot around the inverted saucer-like inclines termamabe an hour, but out over the great inclosure and in the parkways and through the mammoth grand stand there was a heart throb in every foot of the splendid panorama.

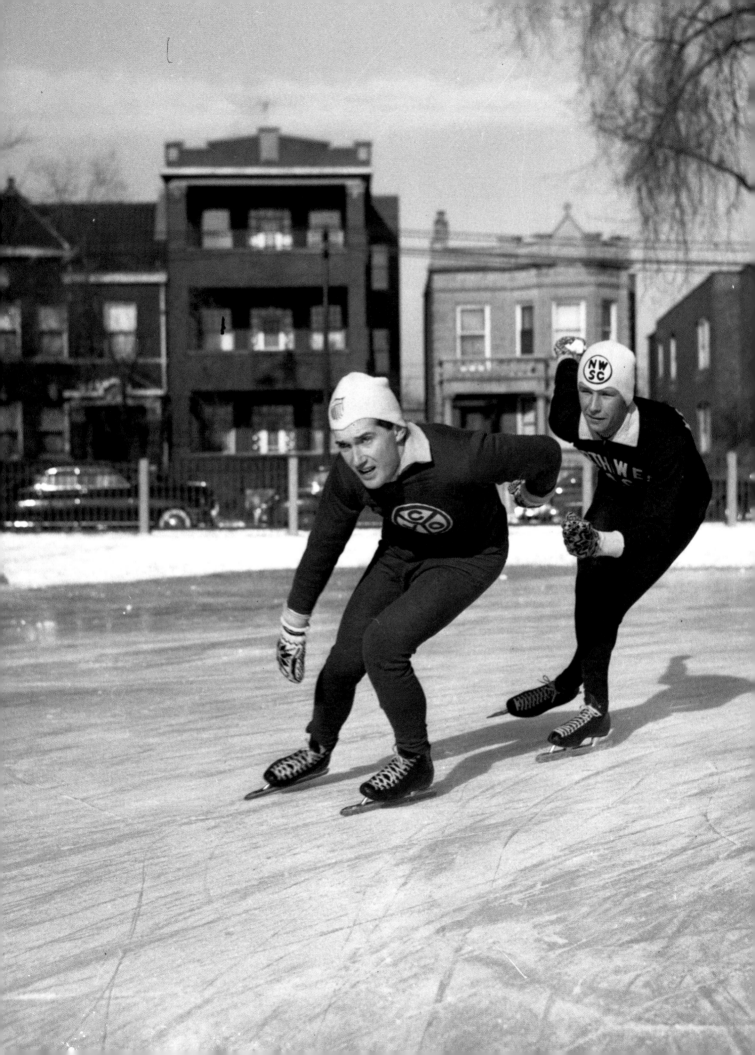

When speedskating was king

Chicago's homegrown talent out-classes world superstar in 1918 race

IN January 1918, Oscar Mathisen, the Norwegian speedskating superstar who was the reigning European and world champ, came to Chicago to put to rest once and for all the ridiculous talk of his not being the fastest man on two skates.

He got his butt kicked.

Delivering the drubbing in the two-day, six-race competition before thousands of skating enthusiasts was Bobby McLean, a Chicagoan "who learned to skate on the parks of the west side," as the Tribune was eager to note at every opportunity. McLean and Mathisen both had just turned pro, and the smart money said the American might be able to compete at the shorter distances. But the first day, McLean swept Mathisen in not only the 220-yard sprint but also the mile and two-mile races. In fact, he beat the world champion by more than a lap at the longer distance. On the second day, McLean easily won the 440-yard sprint but fell during the half-mile for his only loss. But after a short recovery, he "won the three-mile race with ridiculous ease."

It was the first international skating competition held in Chicago, the Tribune reported, and it came as skating was booming in popularity. Speedskating was a relatively young sport—the first world championship was organized in 1893—but was drawing large crowds in Chicago for local races as early as 1904. More than 15,000 people enjoyed an

Buddy Solem of the Catholic Youth Organization, left, and Ken Henry of the Northwest Skating Club, ice skate in 1950.

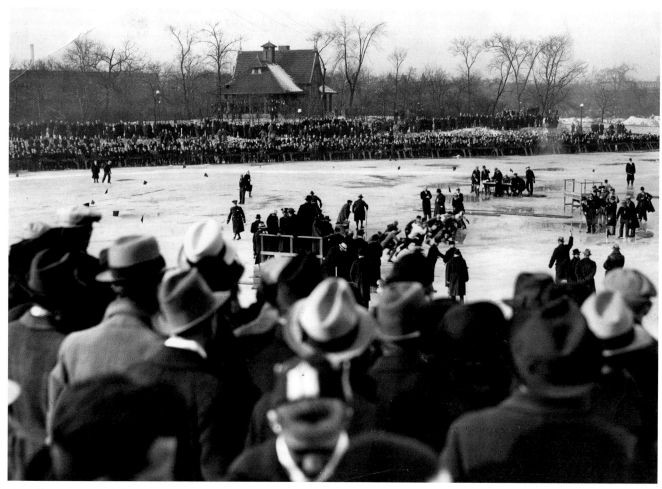

The Tribune reported the 19th Silver Skates Derbies in January 1936 at Garfield Park "was the most successful in the event's history," with a crowd estimated at 30,000.

outdoor race in January 1915 on the Garfield Park lagoon. About 30,000 saw Arthur Staff win the inaugural Tribune-sponsored Silver Skates Derbies at Humboldt Park lagoon in January 1917, according to the Tribune. Silver Skates grew rapidly. A boys division was added in 1919. Women first raced in 1921, and a girls division followed in 1922.

Many private clubs and Chicago parks fielded teams for the contest, which the Tribune—never shy about promoting its events—called the premier speedskating event in the country. Qualifying meets were held at park districts throughout the city and in the suburbs. Thousands com-

peted. The contest launched many a national and Olympic career. Northbrook's Dianne Holum and Anne Henning, both Silver Skates champs, became known as the "Golden Girls" after their great success at the 1972 Winter Games. The Tribune's sponsorship ended after the 1974 event, but the city of Chicago has kept it running.

Of course, recreational ice skating has been around much longer and enjoyed by many more thousands. Area park districts recognized that fact, building indoor rinks, constructing temporary outdoor rinks during the winter and even flooding vacant lots to make ice skating one of the most accessible sports throughout the region. In January 1937, the Tribune reported more than 200 skating venues were open, including the lagoons at the bigger parks. In 1969, that number had grown

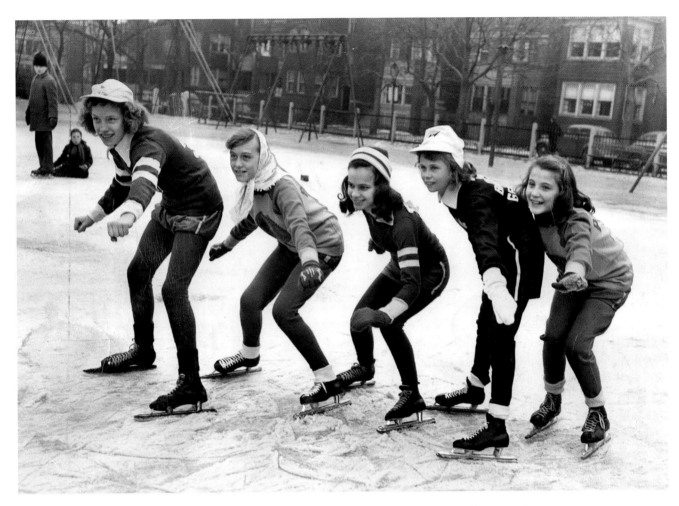

to more than 300. That meant there were skating areas of some kind in more than half of the city's parks, according to Julia Bachrach, the Chicago Park District's historian.

Still, the fervor of those early years was hard to top. And residents' relationship to "King Winter" was different also. It's hard to believe that the city today could muster 5,000 people willing to endure temperatures hovering around 10 degrees to watch a speedskating race as they did in February 1905, or even match the 15,000 who weathered 20-degree temperatures for a race in 1915.

Clearly Chicagoans loved the sport, and many took it very seriously. For some, McLean's victory over the Norwegian champ was too much, ethnic allegiance trumping hometown loyalty such that on the second day of their battle, the Tribune reported that many in the crowd were cheering for Mathisen to at least make a battle of it. They weren't alone in frowning on Mathisen's poor showing. The

king of Norway was none too happy either. The Tribune reported he didn't appreciate Mathisen turning pro to race McLean. And his mood was no doubt not improved a month later when McLean beat Mathisen again in a series of races in Minneapolis, though that competition wasn't quite so lopsided. Mathisen seemed to redeem himself on home ice in 1920 when McLean went to Norway, getting the better of the Chicagoan in a series of races that netted both skaters a hefty $25,000 payday. But McLean left Norway, according to the Tribune, without paying the proper taxes on his winnings.

The king's disfavor was so deep that fellow Chicagoan Staff, following in McLean's footsteps in 1923, cooled his heels for months in Norway waiting for permission to race Mathisen. He never did get to race. Fed up, the king banned professional speedskating events.

—STEPHAN BENZKOFER

Juvenile girls in the annual Silver Skates competition are Betty Kanaby, 13, from left, Lorraine DuPont, 13, Rosemary Fahrenbach, 13, Barbara Geiger, 12, and Sue Crawford, on Jan. 15, 1948.

Civil war: Cubs vs. Sox

North Side vs. South Side on the baseball diamond

LONG before meaningless exhibition matches and "just another series" interleague play, the Cubs-Sox rivalry was a spikes-high contest of players' wills and fans' convictions about which nine represented the real Chicago.

When the American League was founded in 1900, the dominant National League Cubs were determined to remain the Chicago team. The White Stockings had to forgo using the city's name, and the newcomers accepted minor-league status. But in 1903, the World Series was established in response to fans aching to see a showdown. Not only were the league champions pitted, but also intracity matches were born. One of the fiercest was Cubs vs. Sox.

Each league had something to prove: The American, that it really was the major league it proclaimed itself; the National, that its rivals were bush leaguers. In their first meeting, the Sox and Cubs each won seven victories, a rubber game going unplayed when players' contracts expired. A delighted Sox owner Charles Comiskey gave his players a $2,500 bonus.

Stung by the draw, the Cubs declined to play in '04. But after that, the teams usually met in the postseason when one wasn't in a World Series. Sportswriters dubbed the City Series a "civil war." Games were hard-fought celebrity draws. The Tribune ran stories telling readers how to land the must-have tickets.

For the athletes, the City Series meant a share of gate receipts. In 1909, the victorious Cubs got $717.32 each; the Sox took home $455.44 apiece. (The 1934 series was scratched because Cubs owner P.K. Wrigley thought his players were coasting through the pennant race, saving themselves for a City Series payoff.)

The tradition ended in 1942 and was replaced after the war by midseason charity games. Interleague play began in 1997. And while these games mean more to the standings, still they lack something of the original series, where victory could redeem a horrible season, outshine the World Series and earn loyal fans a year's worth of bragging rights: Your side of the river was the true Chicago.

—RON GROSSMAN

Opposite: When a ballclub wins three straight, as these White Sox did over the Cubs in October 1939 to retain their city championship title after all seemed lost, it has reason to show such clubhouse hilarity.

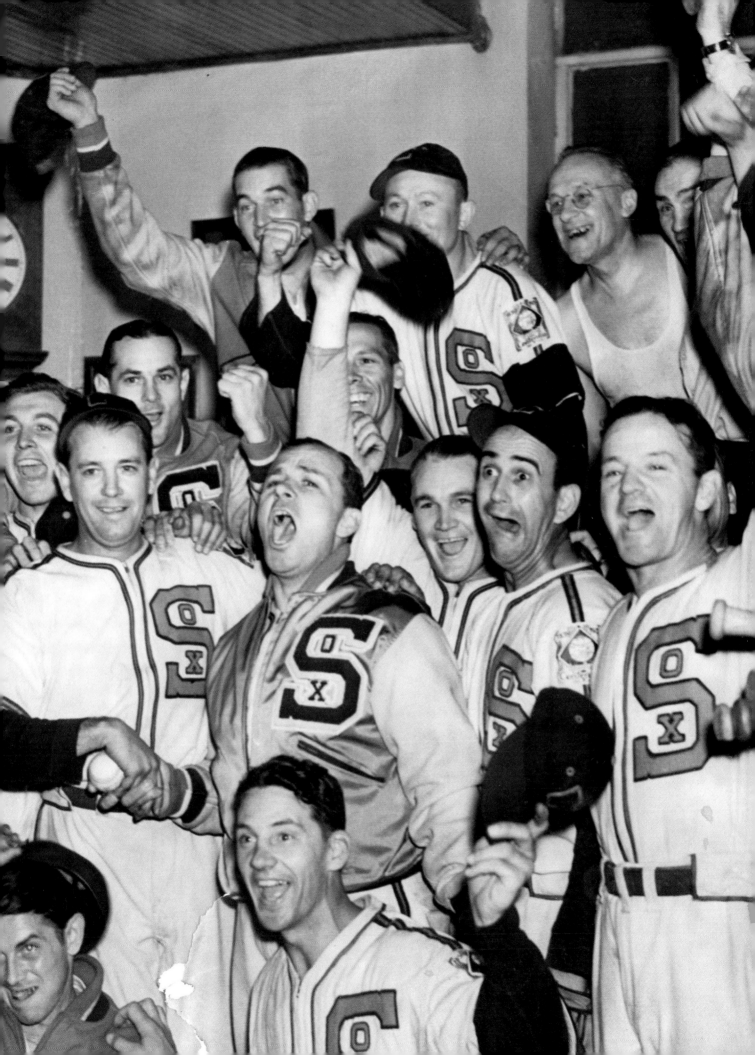

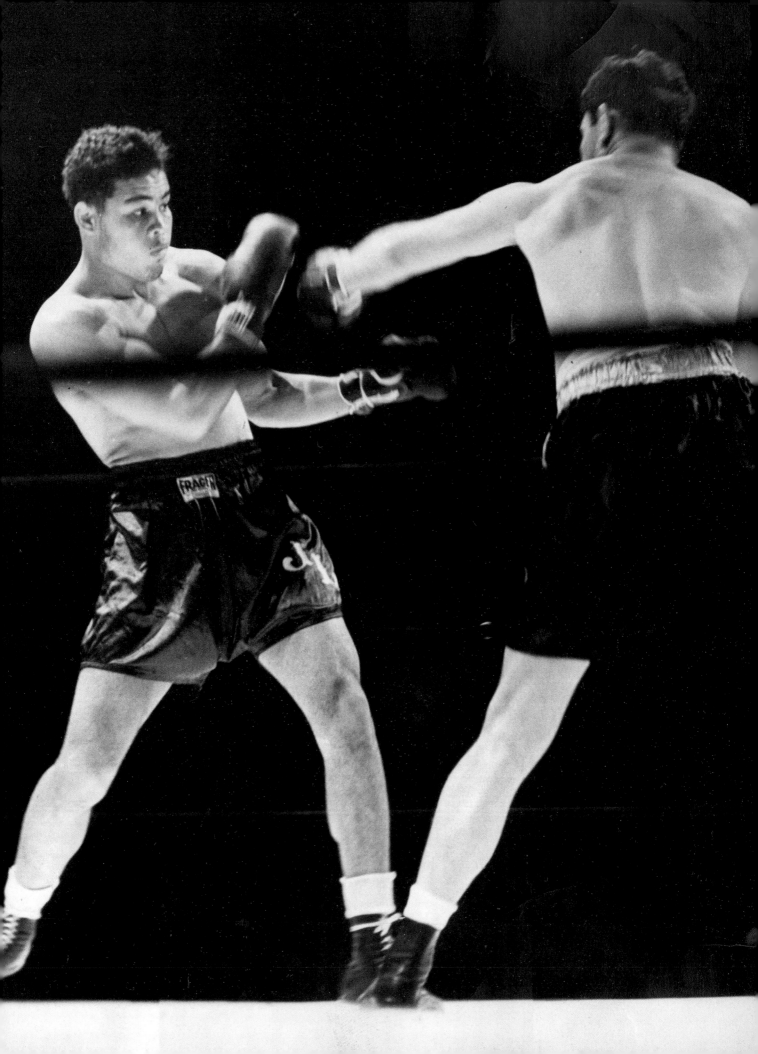

Chicago pulls no punches

Boxing once reigned in the City of Big Shoulders

C HICAGO and boxing are a match made in heaven, both taking perverse pride in rumors that the fix is in, that the mob has a piece of the action.

Where else would a fighter's wife testify in divorce court that her husband "lay down," purposely losing a fight? Sylvia Day wanted her alimony to reflect whatever came Davey Day's way for not trying too hard that night; a Chicago boxer of the 1930s and '40s, he fought championship bouts in the lightweight and welterweight divisions.

And where else would a judge reply, according to a Tribune reporter: "I saw that fight. He didn't lay down. He dove down."

Chicago has hosted some memorable matches, including one of the most celebrated of all sporting events: the "Long Count" fight. Hearing those two little words, any fan worthy of his cigar stub is transported down memory lane to Sept. 22, 1927, when Jack Dempsey, the former heavyweight champion, and Gene Tunney, the titleholder, met at Soldier Field. Tunney survived a seventh-round knockdown when the referee delayed the count because Dempsey didn't go to a neutral corner.

"Probably no event in the history of the world aroused as great a universal interest or was awaited by such vast crowds," the Tribune reported of the fight's broadcast, an early radio milestone. "Trappers in the ice bound north, ranchers in Australia, farmers in South Africa,

Joe Louis, left, and Jim Braddock during their historic fight June 22, 1937, at Comiskey Park, where Louis took the heavyweight championship title away from Braddock.

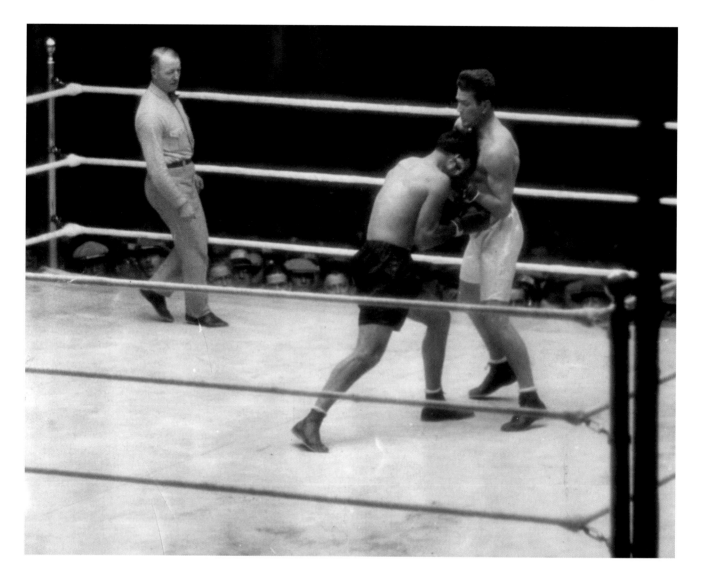

marines stationed in China, members of the American Legion in Paris, and staid Britishers awaited the decision, 'Tunney wins.'"

Another famed match pitted heavyweight champion Floyd Patterson and challenger Sonny Liston. It had been ballyhooed as a morality play between the nice guy Patterson and Liston, who had learned to box in prison while serving a sentence for robbery. The Sept. 25, 1962, fight at Comiskey Park was a dud: Liston KO'd Patterson in 2 minutes and 6 seconds. But the morning-after news conference in the Sheraton Hotel was a doozy.

House detectives had to forcibly remove novelist Norman Mailer, who had covered the fight for Esquire, from the seat reserved for the new champion. It was noted that the match had come to Chicago because Liston couldn't get a boxing license in New York, thanks to his reputed gangster associates. (Floyd Patterson's manager Cus D'Amato also lacked a New York license because of underworld links.) That prompted Liston to plead: "Give me a little time to prove myself to the public that I've been re—" At that point, according to the Tribune's reporter: "Sonny paused and turning to (his manager Jack) Nilon, smiled: 'You finish the word.' It was 'rehabilitated.'"

As the promoters had tax liens slapped on them, Liston's purse was in limbo, leading a reporter to ask if the manager and his fighter had the money to get out of Chicago. "I've got an airplane travel card and Sonny has six bits," Nilon replied.

Which is a nice metaphor for a boxer's life—years of coffee-and-doughnuts purses

hopefully en route to a big-bucks fight. It's a game of young men's dreams and old men's memories, as a Tribune reporter found on visiting a boxing gym in 1986 in the company of Jack Cowen, a longtime matchmaker. When cruiserweight champion Lee Roy Murphy and a sparring partner stepped into the ring, young fighters and the veterans who'd been training them gathered around. Notice the older men's eyes, Cowen said; taking that advice, the Tribune reported:

"They're all re-fighting some long-ago match when—had they only managed to slip a last left hook, or had one judge seen the fight only a little differently—they, too, might have gone on to taste the adrenaline-pumping thrill of hearing the roar of a crowd rise up to greet the announcement: 'And in this corner, wearing white trunks, and fighting out of Chicago, the CHAM-PI-ON OF THE WORLD.'"

A legion of hopefuls passed through the neighborhood gyms and boxing arenas that once dotted Chicago. Some went on to fame, like Barney Ross, the first fighter to hold three world titles, and Joe Louis, who in 1934 won the Chicago Golden Gloves, an amateur tournament created by the Tribune. Turning pro, Louis fought preliminary bouts at venues like the Arcadia Theater, where he once was taking a beating but found no quarter even from his own corner. As fight promoter Irv Schoenwald told the Tribune, Louis' cornerman "took the bottle of water and held it in front of Joe and told him he'd break the bottle over his head if he quit."

So inspired, Louis won the fight and, in 1937 at Comiskey Park, knocked out James Braddock to become heavyweight champion of the world.

With its patchwork of immigrant communities, Chicago was a dream town for boxing—a blood sport that thrives on ethnic loyalties and antipathies. Oscar "Battling" Nelson, a product of the Hegewisch neighborhood, was billed as the Durable Dane; Stockyards Harold Smith was the ring moniker of an Irish boxer from Back of the Yards. When Kingfish Levinsky, so named for his family's Maxwell Street fish market, fought Art Lasky in 1934, the Tribune described the other fighter as "another husky

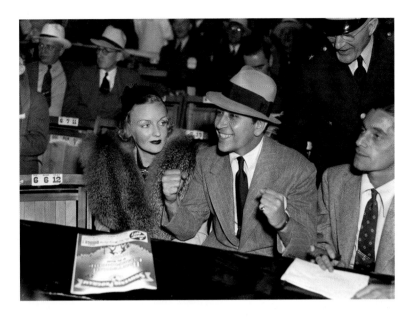

Virginia Pine and actor George Raft at the Joe Louis vs. Jim Braddock fight June 22, 1937, at Comiskey Park in Chicago.

Hebrew heavyweight, who hails from Minneapolis."

Of Levinsky's loss to an out-of-town Irish boxer at the Chicago Stadium, the Tribune reported: "But when the Kingfish jumped over the ropes throwing out kisses to all parts of the packed arena, and as he made his way to his dressing room, he got most of the cheers."

Over them all, the greats and the obscure, hung the tantalizing suspicion that in boxing, things aren't always what they seem to be. In 1926, a losing fighter's manager threatened that if the Illinois boxing commission didn't reverse the decision, he'd blow the whistle on lots of fixed matches he knew about.

Five decades later, when boxing's sun was setting in Chicago—a victim of TV and prosperity, prizefighting being a poor kid's game—Schoenwald and fellow promoter Ben Bentley took a sentimental journey to what had been Marigold Arena at Grace Street and Broadway. Every Monday, they'd put on a fight card for sellout crowds at the North Side venue. Sometimes it was easier to get a ticket to a Bears game. Jake "the Barber" Factor, a notable gangster of the day, was a ringside regular.

But by 1977, the venue had been transformed into Faith Tabernacle, a house of worship, prompting Bentley to wax philosophical.

"This was a dingy place, a smoke-filled arena," Bentley said, with a shrug. "And now it's a pretty church."

—RON GROSSMAN

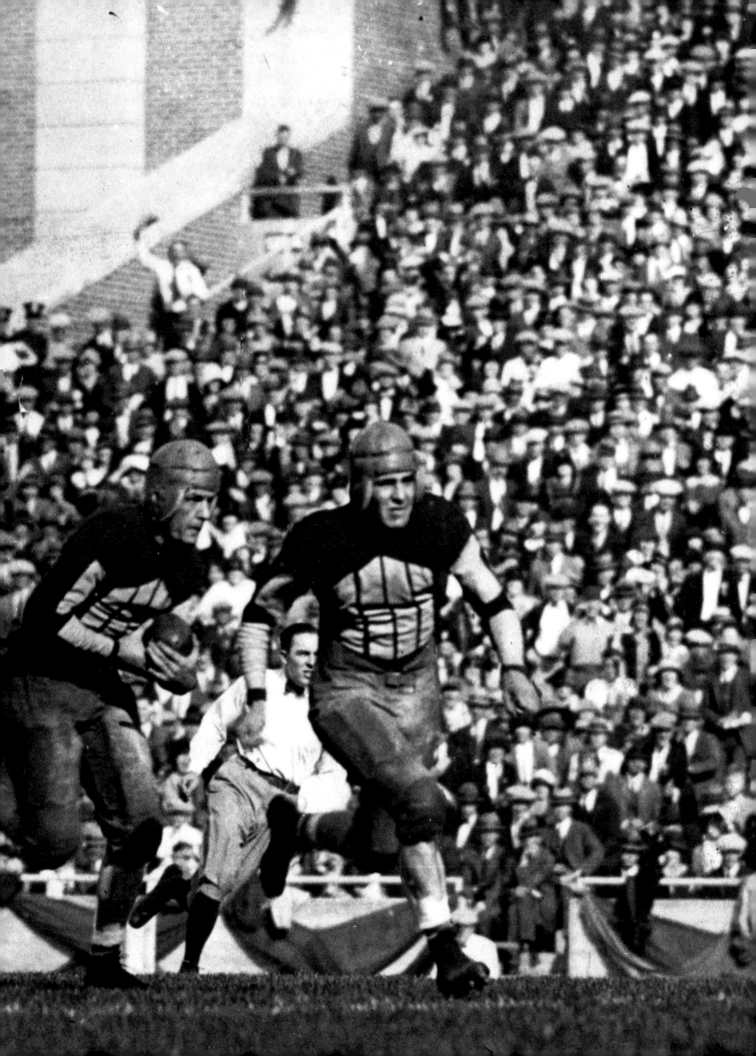

Red Grange's amazing run

In a landmark game, the Illini star was unstoppable

O N a beautiful fall Saturday in 1924, Red Grange took the opening kickoff of the Illinois-Michigan football game on the Fighting Illini's 5-yard line and zigzagged through 11 frustrated defenders to score a touchdown, giving 65,000 fans a down payment on the thrill show they were expecting when they headed to Champaign from all directions.

"There were as many special trains run into this small city as could be parked on all the sidings," the Tribune reported. Though the two universities had tied for the Big Ten championship the previous year, Grange was the real draw. Already a star at high school in Wheaton, his play during the Illini's undefeated season in 1923 had electrified fans. Then on Oct. 18, 1924, on the big stage in the big game, he turned in one of the most dominating performances in sports history. What he did a year later was even more shocking: The three-time All-American dropped out during his senior year to turn pro.

Professional football was still in diapers. What became the NFL had formed in 1920, and, as the author of the Tribune's "In the Wake of the News" column observed when Grange signed with the Chicago Bears, "pro football as

Red Grange grabs the ball from the kickoff of the Illinois-Michigan game on Oct. 18, 1924, beginning a 95-yard sprint for a touchdown for the Illini at Memorial Stadium in Champaign.

Grange signs a contract in 1925 to play with the Chicago Bears, as he is watched by the Bears' Dutch Sternaman, from left, and George Halas and Grange's agent Charlie Pyle.

a sport has not yet entirely warmed the cockles of our heart." He was speaking on behalf of many: Attendance was small, teams came and went, players got chump change. Grange changed all that. By the time he hung up his cleats in 1934, he had transferred his charisma to the NFL, heading it in the direction of its present domination of professional sports.

Harold Edward "Red" Grange was, along with Babe Ruth and Jack Dempsey, one of the most heralded athletes of the 1920s, the storied "Golden Age of Sport." In 2008, ESPN named Grange the greatest college football player ever, a title he all but sewed up on that warm Saturday afternoon in 1924. It was the Illini's homecoming game, and those who witnessed it felt transported to a football fan's Valhalla.

It was played in the university's new Memorial Stadium, dedicated just before game time. As the Trib reported: "The two opposing bleachers rose without a sound, hats off and heads bowed as taps were played for the heroic collegiate dead to whom this stadium is dedicated."

The bugler's mournful tones were a prelude to the disaster the Michigan team shortly suffered. Grange followed up on his first touchdown with three more in the first quarter alone, shredding a Michigan defense that had given up just three touchdowns in its last two seasons, with scoring runs of 67, 56 and 44 yards. His fifth and final TD run was an 11-yard jaunt in the third quarter. If that weren't enough, he also passed for a touchdown in the fourth quarter.

In total, he ran for 409 yards, threw most of Illinois' forward passes, and held the ball for a point-after-touchdown kick. He also played defense, as footballers then did, putting on an unforgettable performance in a game Illinois won 39-14. "There may be a few clear voices in Urbana tomorrow," a Tribune reporter predicted. "They will belong to those who could not get into the game."

Sportswriter Grantland Rice, a celebrity in his own right, gave Grange lyrical immortality with verses such as:

> A streak of fire, a breath of flame
> Eluding all who reach and clutch;
> A gray ghost thrown into the game
> That rival hands may never touch;
> A rubber bounding, blasting soul
> Whose destination is the goal.

Accolades like that made Grange a promoter's dream, as did his all-American-boy personality. He had been photographed delivering ice in his hometown during summer recess. Shortly after his big day, a Tribune profile ran under a headline: "Red Grange, Off Grid, Is A Big Bashful Boy." When the reporter asked about a professional sports career—in high school he won letters in baseball, basketball, track and football—he demurred: "I hardly think so. At least, I feel now that I would prefer a business life."

A year later he changed his mind, perhaps after realizing sports could be big business. Grange was the first pro football player to have an agent—Charlie Pyle, the manager of a Champaign movie theater. He got Grange an unprecedented contract with the Bears that guaranteed him thousands of dollars a game while his teammates were lucky to make $100 per contest. He also got a cut of the gate receipts—which earned Grange $20,000 when the Bears played Philadelphia in 1925 and a cool $20,000 for a game against the New York Giants that same year—that's more than $550,000 in today's dollars.

Pyle also lined up endorsements, wholesale, as Grange recalled for a Trib reporter in 1929: "Charlie Pyle sat in the drawing room of his hotel suite in New York. Agents stood in a changing group outside his door, and now and again his voice could be heard, calling through the transom with smooth urbanity, 'Don't be impatient gentlemen, everybody will be heard in due course.'"

"I gave my approval to a candy bar for a cash royalty of $10,000 and a percentage of all sales," Grange recalled, "signed the trademark for a sporting goods line for $3,500 down, plus a percentage on the gross, and posed for my picture admiring an outboard motor for $500."

On Dec. 8, 1925, the Tribune reported that Pyle had pulled off a big-bucks movie deal: "And today it was discovered that Harold Grange had developed $300,000 worth of dramatic artistry quite unknown to himself while presiding over a pair of spirited ice wagon geldings and delivering strictly fresh country ice in that unsuspecting cradle of thespian genius, Wheaton, Ill." Grange played in two silent movies, "One Minute to Play" (1926) and "A Racing Romeo" (1927).

He also continued to play what he played best, football, as the Bears defeated the Giants for the world championship in 1925. Grange's exploits during that season led popular sportswriters, including Rice and Damon Runyon, to travel with the team, giving professional football a credibility it had lacked.

The following year, Pyle asked for a share in the Bears, and when owner-coach-player George Halas said no, Pyle and Grange formed their own team and a rival league. It folded the following season, and Grange returned to the Bears. An injury that forced him to sit out the 1928 season slowed him down. Yet enough talent remained for him to catch a forward pass for the touchdown that won the Bears the 1932 championship game—played in the Chicago Stadium because of a blizzard and subzero temperatures.

Grange, who died in 1991, downplayed his storybook career, saying a lot of doctors, teachers and engineers had accomplished more. His own success he attributed to a simple philosophy: "If you have the football and 11 guys are after you, if you're smart, you'll run."

—RON GROSSMAN

Public Enemy No. 1 was baseball fan

Cubs star in a bind: How do you refuse Scarface?

T HE Cubs and Sox played an extra game in 1931 after the Tribune campaigned for a charity match to benefit the unemployed in the midst of the Great Depression. Just two weeks before they were scheduled to face off in the heated City Series, the two teams met at Comiskey.

But what made the Sept. 9 event memorable happened before the first pitch. Cubs star Gabby Hartnett chatted it up with Al Capone, who was under indictment for tax evasion. The gangster was seated in the first row with his young son. Bodyguard "Machine Gun" Jack McGurn sat behind him.

When legendary baseball Commissioner Kenesaw Mountain Landis later saw a photograph of the star with Public Enemy No. 1, he wasn't pleased. According to a biography of Hartnett by William McNeil, Landis telegraphed Hartnett, "You are no longer allowed to have your picture taken with Al Capone." Hartnett's response? "OK, but if you don't want me to have my picture taken with Al Capone, you tell him."

Capone was convicted of tax evasion the next month.

—STEPHAN BENZKOFER

Chicago Cubs star Gabby Hartnett gabs with gangster Al Capone at a charity game with the Sox at Comiskey Park that benefited families and the unemployed. Seated with Capone are his son and state Rep. Roland Libonati.

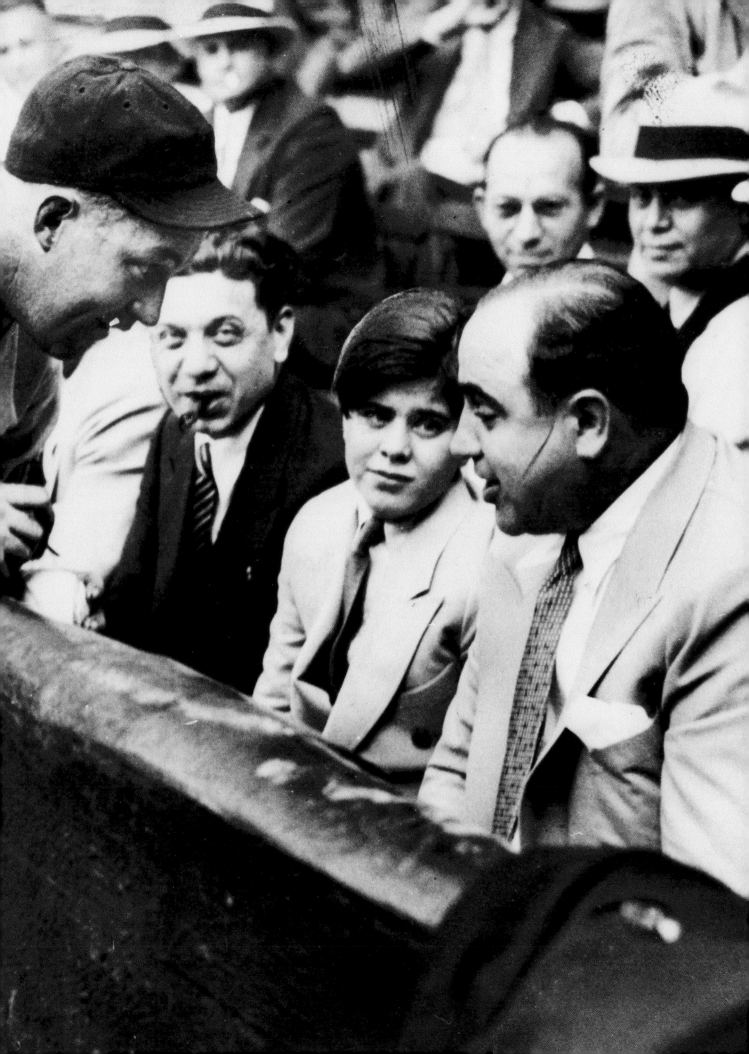

Tidye Pickett's legacy

Chicago track star was first African-American woman to compete in Olympics

THE first black woman to run in an Olympic event was Chicagoan Tidye Pickett. When Pickett made the 1936 U.S. Olympic team, the Chicago track-and-field star leapt from the frying pan into the fire. She traveled from a segregated America to an Olympics in Berlin where Adolf Hitler intended to showcase his racist ideology. The Nazi dictator confidently expected German athletes to vanquish untermenschen—lesser breed—competitors, including Jews and blacks.

"Systematically these Negroid parasites in our national body corrupt our innocent fair-haired girls," Hitler wrote in "Mein Kampf," his autobiography.

That would not have been the first time Pickett was confronted with such hatred. Interracial romantic relationships were equally taboo in the U.S.

Pickett grew up on Chicago's South Side, where it was perilous for blacks to venture across the borders separating black and white neighborhoods. Sports facilities open to blacks were sparse.

Fortunately, her family lived just across from Washington Park, where the Chicago Daily News held picnics for its newspaper delivery boys that featured foot races with prizes. "So I got into the races and started coming home with baseball hats and cameras," Pickett recalled two years before her death in 1984 for the alumni magazine of Northern Illinois University, her alma mater.

Her athletic ability caught the attention of John Brooks, a University of Chicago long jumper, himself headed to an Olympic berth, and he became her mentor and coach.

"He made sure I had my first pair of good running shoes," Pickett said. "And that was it—I'm gone."

Soon the Tribune was taking notice of "a Negress From Englewood High School," as it dubbed her. In 1932, the Tribune reported that "17-year-old Tidye Pickett, colored sprinter from the Board of Education playground, tied the national indoor record of :07.4 for the 60-yard dash yesterday at the Olympic preparatory track meet in the Naval armory."

That achievement earned Pickett an invitation to the 1932 Olympics in Los Angeles. Under the headline "Chicago Girl in Olympics," the Chicago Defender, a black newspaper, called her the "ace dash star on the board of education playgrounds track team."

But her joy was tempered by the realization that some athletes resented having Pickett and Louise Stokes, another black sprinter, as teammates. Among them was Mildred "Babe" Didrikson, the most celebrated female athlete of the day.

"That big girl from Texas, who won so many medals, just plain didn't like me," Pickett recalled much later. "I suppose I shouldn't say anything because she's at peace now, I hope. But it was prejudice pure and simple."

On the team's train ride west, Didrikson poured water on Pickett and Stokes as they were sleeping in their bunks.

When the team paused in Denver, other members were treated royally in a posh hotel. They did media appearances and were honored with a banquet in the hotel ballroom. Pickett and Stokes were not invited.

"All the other girls had private rooms, went to the banquet, were interviewed by reporters," Pickett told the alumni magazine's reporter. "Louise and I shared a room in the attic and ate our dinners upstairs on trays."

In Los Angeles, Pickett and Stokes were expected to be members of a 4 x 100 relay team. But at the last minute, two white runners took

their places. When word of the decision leaked out, the Chicago Defender cried foul under the headline "Tidye Pickett May Lose Olympic Spot."

"Lily-whiteism, a thing more pronounced than anything else around here on the eve of the games, threatened to oust Tidye Pickett and Louise Stokes from participating and put in their places two girls who did not qualify," the Defender's correspondent reported. "The injustice of the move is being placarded by track followers out here but to no avail, for unless Avery Brundage rules otherwise, Misses Pickett and Stokes will not run on the team."

Brundage, longtime head of the U.S. Olympic Committee, didn't intervene. The NAACP sent a telegram urging that the black runners be given fair treatment, but the group got no response.

So Pickett went home with nothing to show for having been on an Olympic team. Half a century afterward, she was still convinced that she and Stokes should have been in that race, even though their replacements helped the team win a gold medal.

"But times were different then," she said in the alumni interview. "Some people didn't want to admit we were better runners."

Back in Chicago, Pickett started preparing for the next Olympics, scheduled to take place in Berlin four years later. She added new events to her repertoire. In her 1934 debut as a hurdler, she missed winning by inches. The Defender noted: "Miss Pickett's performance was very impressive not only because the winner is the holder of the American record but also because Miss Picket had run a heat, semifinal and final in the 50-meter dash, and a heat in the hurdles all within a half-hour."

The following year, Pickett was part of a Chicago team that set a Canadian record for the 400-yard relay. The Defender proudly noted that she was "the only colored girl on the entire Chicago Park District team."

Given her newfound versatility, Pickett was scheduled to compete at the Berlin Olympics in the hurdles, a relay and the 100-meter dash. She worried most about the hurdles, having acquired a bad habit of letting her trailing foot catch the top of the hurdle. That was less of a problem in the U.S., where the hurdles were set to fall over when hit—so a runner could keep on going. But in Berlin, the hurdles were set to remain upright on impact.

Fellow Olympians Jesse Owens and Ralph Metcalfe, a Chicagoan, tried to coach her out of her trailing-foot habit. But in the semifinals, Pickett's foot caught the hurdle and was broken. She couldn't compete in the other events.

Owens and Metcalfe won medals and, being black, famously disproved Hitler's racial theories in his own capital. But Pickett's role in breaking a racial barrier was largely forgotten. She was relegated to a line in record books noting that she had been on two Olympic teams and appeared in one event.

With her athletic career over, she went to college and became a teacher in East Chicago Heights, then served as a principal there for many years. Upon her retirement in 1980, an elementary school was named for her. It's now gone.

When the Olympics returned to Los Angeles in 1984, Mayor Tom Bradley invited Pickett to be his guest of honor. But, in poor health, Pickett couldn't make the trip and instead she watched the Games on television.

What did she think, seeing black women athletes capitalizing on her breakthrough? What did she experience when Valerie Ann Brisco-Hooks, a black woman, won three gold medals? One was for the relay event Pickett had expected to take part in 48 years earlier.

Was it a feeling of pride, maybe with a tincture of regret? When a Tribune reporter asked, all Pickett would say was, "They've come a long way."

—RON GROSSMAN

Pickett was profiled in the Tribune in 1984, 48 years after she competed in the 1936 Olympic Games.

Girls of summer played in skirts

Fans showed up for pretty legs, stayed for quality baseball

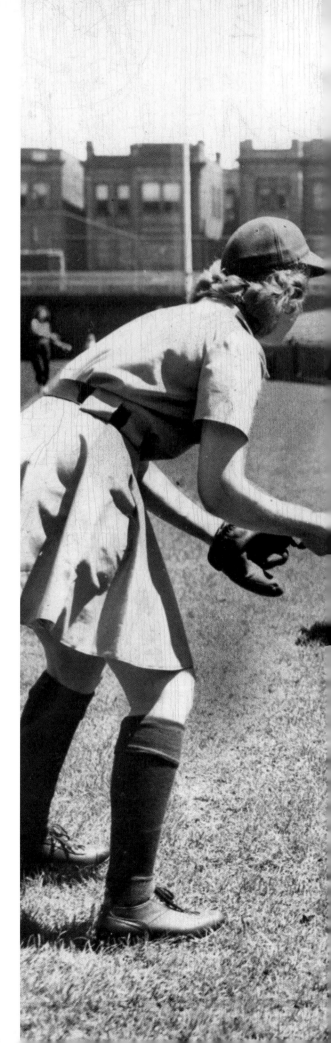

Four players try out for the All-American Girls Professional Baseball League at Wrigley Field for the league's first season, 1943. The league was founded by then-Cubs owner Philip K. Wrigley. Players' uniforms consisted of one-piece skirts over shorts.

Most people think the first night baseball game at Wrigley Field was in 1988. But there was another professional night ballgame played at Wrigley—not in 1988, and not by our highly paid boys of summer, but in 1943, and by women.

Or in the lingo of the day, by girls.

The All-American Girls Professional Baseball League, nearly forgotten until Penny Marshall's popular 1992 film "A League of Their Own" made them famous for a new generation of fans, held its first All-Star Game at Wrigley Field under portable lights on July 1, 1943. One of the only records of that event is a faded photograph now posted on cubs.com. But love for the Girls of Summer's short-lived "show"—not to mention its aging players—lives on.

Former Cubs owner Philip K. Wrigley dreamed up the idea for organized girls' professional baseball—or rather, softball, since the game played in the league's first few seasons more closely resembled the latter—in late 1942 as a way to keep his stadium profitable if World War II shut down the majors. But the league wasn't the first organization to hire female ballplayers.

Jackie Mitchell, a female pitcher, played for a Class AA men's team, the Chattanooga

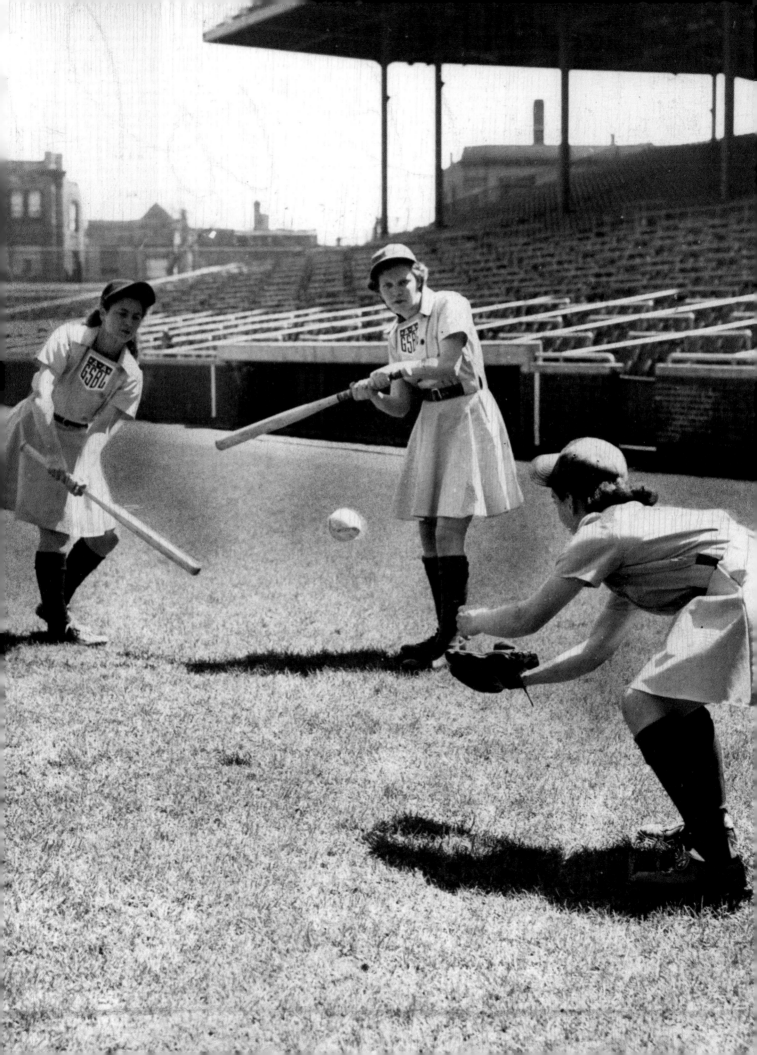

Lookouts, in the early 1930s and gained fame for striking out Babe Ruth and Lou Gehrig in succession at an exhibition game in 1931. (A horrified Kenesaw Mountain Landis, then commissioner of the major leagues, soon canceled Mitchell's contract, saying baseball was "too strenuous" for women.)

But Wrigley's new league, which the Tribune called "a child of the war" upon its launch in 1943, wasn't aiming to turn girls into major-leaguers.

"The idea behind the league . . . is to combine feminine attractiveness and athletic skill," the Tribune reported on May 16, 1944, early in the league's second season. "The muscular, boyish type is out, no matter if she's a potential Babe Ruth or Bob Feller."

That fact wasn't lost on the league's ballplayers. "Mr. Wrigley was trying to make the game feminine," said Joyce Hill Westerman in a 2014 interview when she was 88 and living in Kenosha. "The uniform was a dress, with a skirt that ended 3 to 4 inches above the knee and tights underneath that went only partway down the thigh," said Westerman, who played for the league's Kenosha Comets, South Bend Blue Sox and other teams between 1944 and 1954. She said she first joined the league at age 19 as a late-season utility player with the Comets, adding that the uniform made routine plays like sliding into bases excruciating.

"You were basically sliding on bare skin," said Westerman, who played first as catcher and later as first baseman. Players were also expected to wear makeup and keep their hair long, and spring training included charm school.

Westerman at first scoffed at the idea of wearing a dress. "When I heard about the league's uniform, I thought that was a joke. No way was I gonna play ball in a dress. But then when I saw what kind of ball these ladies played, I was so in awe of them that I changed my mind."

The Tribune reported the league's total attendance in the first season reached 200,000. By 1946, that number had increased to "an anticipated 1 million spectators, a figure topped only by the major leagues and the AAA minors," the Tribune reported in April of that year. It wasn't until two years later that Chicago got its own team, the Colleens, which played at Shewbridge Field on the South Side.

"The Chicago Colleens, new entry in the All-American Girls Baseball League, will open their 126-game schedule tonight when they invade Rockford, Ill., to meet the Peaches in the first of a three game series," reported a Tribune story on May 9, 1948.

The piece included commentary from the team's new manager, former major-leaguer Dave Bancroft, who said, "We've got a well-balanced club, one that can give the other eight league members plenty of trouble. Once our girls start hitting the ball, other teams will certainly know we're on the circuit."

The Colleens didn't last long, however. Unlike the league's other clubs, which operated in small cities such as South Bend, Ind., and Racine, Wis., with little live entertainment competition, the big-city Colleens struggled and folded after only a few seasons.

While "A League of Their Own" takes place in 1943, the brand of overhand-pitched hardball depicted in the movie more closely resembles the style of play the league adopted in the late 1940s and early 1950s, according to Westerman.

"The ball kept getting smaller and smaller every year," she said. "In 1947 they started pitching sidearm, then in '48 they were pitching overhand, and the baselines kept getting longer. By 1954, the last season, it was regulation baseball."

Helen Wyatt, who was known in her playing days as second baseman Helen "Sis" Waddell, was a substitute utility player late in 1949, then a regular contract player in 1950 and 1951—mostly with Rockford.

"The Peaches won four league championships—1945, 1948, 1949 and 1950—which is why Penny Marshall chose them (as the main team) for the movie," said Waddell, who was 84 and living in Loves Park, Ill., when Flashback caught up with her in 2014. She attributed the Peaches' success in part to the fact that unlike most teams, their longtime coach Bill Allington wasn't a major-leaguer, but a former semipro ballplayer "who knew how to coach women."

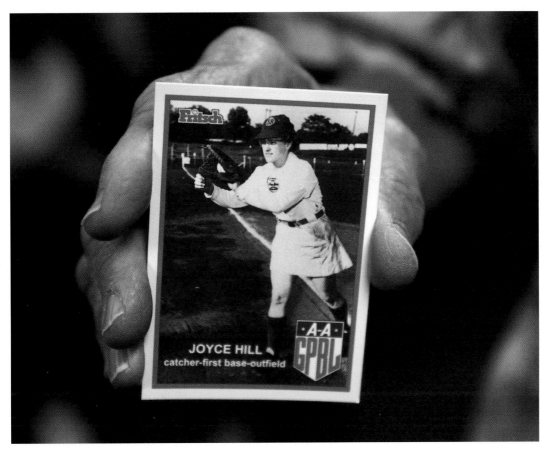

Joyce Hill Westerman, who played for Kenosha and South Bend teams, holds her player card before throwing out the first pitch at Wrigley Field in June 2014.

Wyatt said one of the many areas the 1992 film got right was the coaches' attitudes. "You know how Tom Hanks' (character) was at first—a lot of the coaches who were former major league ballplayers would just sit there in the dugout and not do anything," Wyatt said. "But Bill (Allington) was a great coach. He believed in women playing baseball." He taught Wyatt how to hook-slide in a long-jumping pit because it was the only facility they had available at the time, she said.

Wyatt also developed a lifelong friendship with the league's star player, Dorothy "Dottie" Kamenshek, described in the Tribune as "a sparkling fielder, three-time batting champion and scourge of the All-American Girls Baseball League for nine years of its 12-year history." Wyatt agreed, saying Kamenshek "could outplay any man at first base I ever saw. She was the best."

A men's minor league team in Florida offered to buy Kamenshek's contract in 1947, but she turned it down because she thought it was nothing but a publicity stunt. Kamenshek died in 2010.

The league folded after the 1954 season because of a combination of factors: the rise of television, poor management and the lack of a farm system to develop new talent, which became especially difficult after the switch to regulation baseball rules.

Some former players, including Westerman, still make public appearances. She and some of her fellow players helped throw out the first pitch at Wrigley Field in 2014. Wyatt still gets autograph requests from people who say they saw her play back in the '50s.

"A lot of our most loyal fans were men, guys who first thought they'd just come for a few laughs and to look at some pretty legs," Wyatt said, chuckling. "But then they saw we could really play baseball, and that's what made them stay. We sure changed their minds."

—JILL ELAINE HUGHES

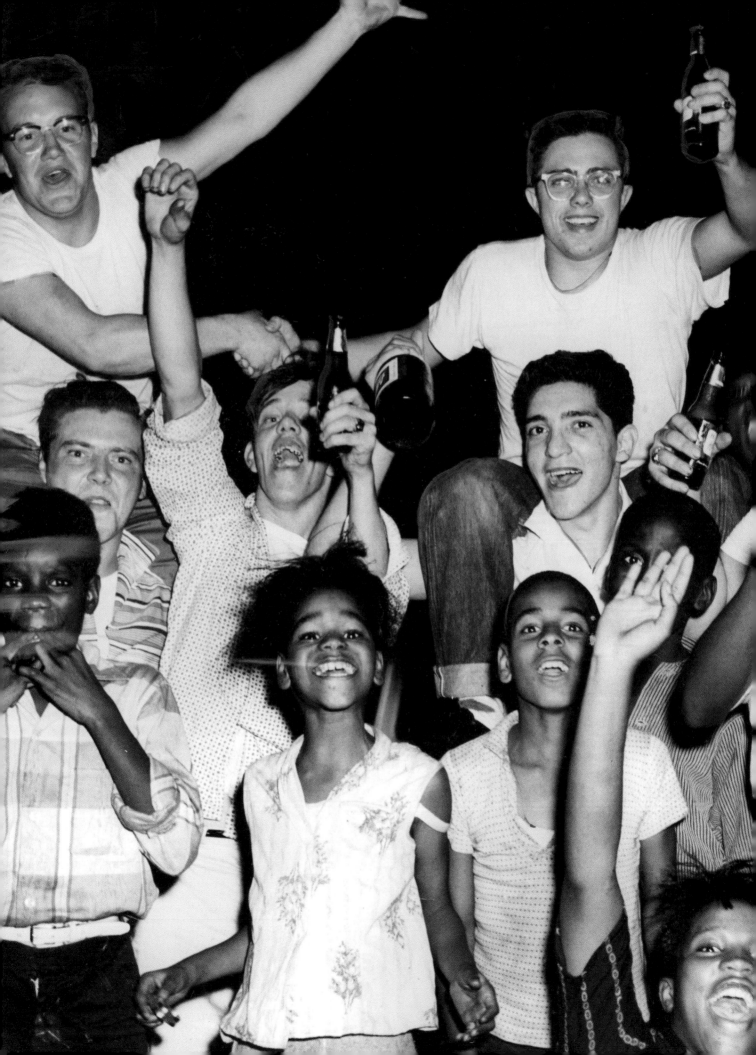

Go-Go Sox win pennant

Celebratory air raid sirens terrify—and infuriate—half the city

W ITH its scrappy, likable team, the players' edge-of-your-seat style and the whole crazy fiasco with the air raid sirens, the Go-Go Sox of 1959 were truly a Chicago baseball original.

The White Sox of the mid- to late 1950s were a hardworking team that put together a series of solid years outhustling the competition. Despite winning 94 games in 1954, they finished third in the American League behind the Cleveland Indians' torrid 111 wins (in a 154-game season!) and the New York Yankees' 103. From 1955-58, despite two more seasons with 90-plus wins, the Indians or Yankees always stood in the way of the Sox's first pennant since 1919.

So on April 5, 1959, when Tribune sportswriter Richard Dozer predicted Chicago "really has a chance to separate the New York Yankees from the American League pennant they have won nine times in the last decade," many might have reasonably questioned his judgment. Nevertheless, Dozer cited the Sox youth and the fact that the aging Yankees appeared "to be running out of supermen."

It turned out the real threat was Cleveland, which won its first six games. The race was on. The Sox season opener in Detroit on April 10 would prove to be indicative of a season that saw few easy wins. It took Nellie Fox's first home run in more than a year for the Sox to finally win in the 14th inning. They started the

Chicago White Sox fans hail their American League champions in a neighborhood celebration near Comiskey Park on Sept. 22, 1959.

season 4-0 and battled the Indians through the first half of the season for first place.

On July 28, when the Sox took possession of first once again (but this time for good), it was another telling game. After Al Smith's two-run homer in the eighth, the Sox overcame a rare Luis Aparicio error at short in the ninth, and Billy Pierce threw a strike to give him a complete-game 4-3 win over the Yankees. It was the 24th one-run victory for the South Siders, who were affectionately, if exasperatedly, called the Runless Wonders. Of their 94 wins that year, 35 were won by the minimum, and they lost 15 games by the same margin.

As is often the case with winning teams, myriad heroes emerge. Behind solid pitching by Pierce and great stuff from ace Early Wynn, and just enough power and timely hitting from Aparicio, Fox, catcher Sherm Lollar, and outfielders Smith and Jim Landis, the Sox pulled away from the Indians in August, and new owner Bill Veeck and manager Al Lopez traded for slugger Ted "Big Klu" Kluszewski for the final pennant push.

Fittingly, the Go-Go Sox clinched the pennant in Cleveland against the Indians—a team they owned all season, beating them 15 times—and with plenty of dramatics. The first White Sox pennant since 1919 (yes, that team) came "with the bases filled with Cleveland Indians, only one out, and the White Sox in danger of losing a two-run lead," the Tribune reported Sept. 23. Lopez brought in Gerry Staley to stem the bleeding. The Tribune's Edward Prell provided the historic play-by-play in the next morning's edition: "Staley pitched one ball—a sinker low and outside. Vic Power swung and Luis Aparicio glided to his left, spearing the ball. For a split second, it seemed he thought of making the toss to Nellie Fox. But he flashed three or four steps, hit the base with his spikes, and rifled the ball to Ted Kluszewski at first base."

Double play! Sox are American League champions!

The drama wasn't over.

Back in Chicago, at 10:30 p.m., the air raid sirens jumped to life. For five minutes, they screamed, blaring the terrifying warning of incoming Soviet bombers. In the middle of the Cold War, that's what many residents thought.

Just a few months earlier, the Tribune reported how a mock 10-megaton hydrogen bomb had "killed" 229,625 and "injured" 622,284 and "spread a vast cloud of deadly radiation fall-out." Such annihilation was a very real fear.

Thousands of residents poured into the streets, looking to the sky and asking neighbors if it was real. One woman woke up her three children and hurried them to the basement, the Tribune reported. A man said he locked himself in a closet with a bottle of beer. Another man jumped in his car and raced to Wisconsin.

Of course, many residents—especially Sox fans watching the game on WGN-TV—immediately understood that the sirens were part of the celebration, an official recognition of the Sox ending a four-decade drought.

But exuberant, altruistic reasons didn't mollify many angry residents. Bell Telephone switchboards and the Tribune newsroom were flooded with calls from confused and scared residents who turned angry when told yes, the Sox had won, and no, the end of the world wasn't nigh.

The anger didn't abate the next day. The Tribune reported City Hall received calls at a rate of 1,100 an hour to protest the sirens. Mayor Richard J. Daley showed off his Sox allegiance when he explained the sirens were sounded "in the hilarity and exuberance of the evening. I regret if anyone was inconvenienced, but after 40 years of waiting for a pennant in the American League, I assume that everyone who was watching the telecast was happy about the White Sox victory."

Fire Commissioner Robert Quinn, who was also acting defense corps director, took full responsibility. "This was intended as just a tribute to a great little team," he said.

Robert M. Woodward, the state's civil defense director, said the siren's misuse was "shocking" and called for an official investigation.

That sentiment was echoed by angry letter writers to the Tribune who asked which "nincompoop" was responsible and demanded "anyone so stupid as to sound the air raid alarm simply to celebrate a baseball victory should immediately be removed from his post."

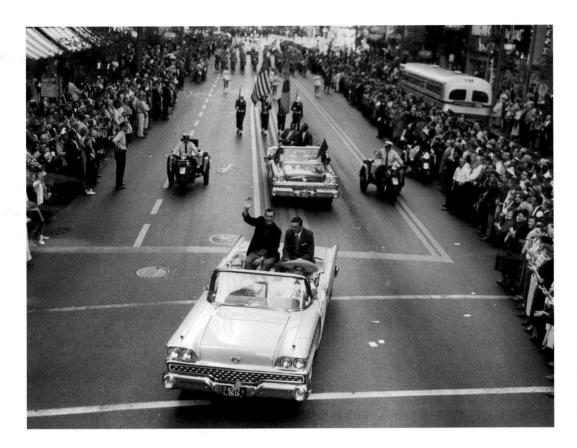

Catcher Sherm Lollar waves to fans as he rides alongside outfielder Jim Landis in the Sept. 24 State Street parade.

"The din lasted into the break of dawn and appeared to have enough steam to last until the opening of the World Series."

—TRIBUNE, 1959

Woodward got his investigation, but in November the U.S. attorney said no federal statute had been violated.

Back to the Sox. They flew into Midway Airport about 2 a.m. Wednesday to find a huge, raucous crowd, not knowing they were wading into an odd mix of joy and anger. The roar of the crowd reportedly drowned out the sound of landing airplanes. "The din lasted into the break of dawn and appeared to have enough steam to last until the opening of the World Series," the Tribune reported.

On Thursday, the team paraded down State Street, which was "packed from curbs to store fronts with fans, wildly cheering." Thousands more jammed windows and showered the parade route with ticker tape and confetti. The festivities were led, of course, by Daley, "self-styled No. 1 Sox fan," along with Chuck Comiskey and Veeck.

In retrospect, it's good that Chicago celebrated the pennant with such unabashed joy and vigor. The Sox finished the season, taking two of three from Detroit. Of the World Series against the Dodgers, just in their second year in Los Angeles, the less said the better. Let's just say the Go-Go Sox ran out of gas, losing in six games.

The 1959 Sox would send three players to the Hall of Fame (Wynn, Fox and Aparicio; four if you count Larry Doby, who saw limited playing time), plus manager Lopez and owner Veeck.

More important, possibly, the Go-Go Sox live on in Chicago baseball fans' hearts and memories, and as an integral part in one of the loudest scandals in city history.

—STEPHAN BENZKOFER

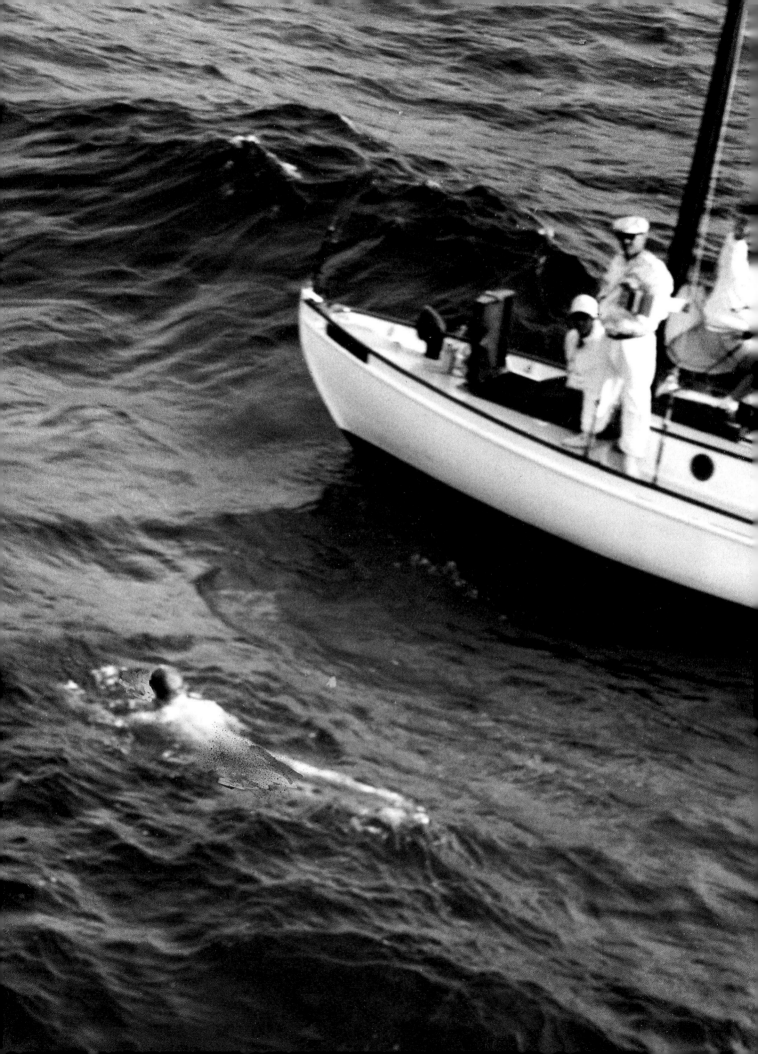

Marathoners vs. the mighty lake

Long-distance swimmers discovered they were mere minnows

J OE Griffith thought he could get the better of Lake Michigan. In the late 1950s, the lifeguard tried four times to swim the 38 miles from Chicago to Michigan City, Ind. Through the years, he faced stomach cramps, indigestion, 15-foot waves, navigation errors, heavy fog, a seiche, multiple rainstorms and relentless currents before the lake spit him out for good. From his hospital bed after that fourth attempt, he said, "I'll never talk about crossing the lake again."

What Lake Michigan lacks in deadly critters, it more than makes up for with shifting currents, cold water and choppy waves. More than one experienced marathon swimmer has emerged from the lake to declare it an ordeal like none other.

In August 1960, after an Alaskan teacher named Harry Briggs gave up on his third attempt to swim the same route as Griffith, a Tribune editorial wrote about "our invincible lake" and pointed out swimmers made the more famous 21-mile English Channel swim nearly once a week while the lake was unconquered. If anyone did manage to cross, the editorial concluded, it would require "a rare degree of cooperation from nature."

The idea of swimming across the lake is a relatively new one. When the long-distance swim craze seems to have started at the turn of the last century, athletes rarely attempted any-

The view from a helicopter as Joe Griffith swims in Lake Michigan toward Michigan City, Ind., on July 14, 1959, in a marathon record attempt. The picture was taken at 6:15 p.m., when Griffith was estimated to have swum 15 miles toward his goal and was northeast of Gary. His wife, Phyllis, is aboard one of the escort vessels.

"Death is the limit, as near as I can tell. I've been close to that a couple of times."

—MARATHON SWIMMER TED ERIKSON, 1977

thing more than five miles. In August 1906, a five-mile race from the Lakeview water intake crib to shore was won by H.J. Handy, who finished in just over an hour. Many of the other participants didn't fare so well. The "roughest seas of the year, white caps, large waves and heavy swells" left even those who finished with bloodshot eyes, lips and noses black from congealed blood and mumbling unintelligibly. Handy emerged from the water appearing "fresh almost as a sea nymph," the Tribune reported.

A year later, not one of 18 swimmers finished a 10-mile swim in calm water. "Three of the men who went the farthest were delirious when they were taken from the water," the Trib said after the Chicago Athletic Association event. One was "entirely out of his mind . . . and attempting to swim under water" when reached by rescue swimmers.

It wasn't until the late 1950s and early 1960s that the idea of swimming across the lake really captured the public's imagination, and much of the credit for that can be laid at the feet of a car salesman. Jim "The Courtesy Man" Moran was a household name at the time because of his numerous TV ads. A natural showman, he sponsored Griffith's attempts and in 1960 offered a cash prize of $3,675 to the first person to swim from Chicago to Michigan City.

One man who took up that challenge would become arguably the city's most successful marathon swimmer. Ted Erikson, a 33-year-old research chemist at the Illinois Institute of Technology, set a world open water distance record in August 1961 when he swam 43 miles–the actual distance was longer because he was pushed off course by wind and currents–from Chicago to Michigan City in 36.5 hours. More than 10,000 people greeted him in a heavy rain when he emerged from the lake.

He didn't get the lake's cooperation, as the Tribune suggested was necessary. He battled waves as high as 16 feet. It was so bad his support team lost him for about 15 minutes in the middle of the night.

An exhausted Ted Erikson, 33, is congratulated by Jim Moran after Erikson's 36.5-hour swim from Chicago to Michigan City, Ind., in August 1961.

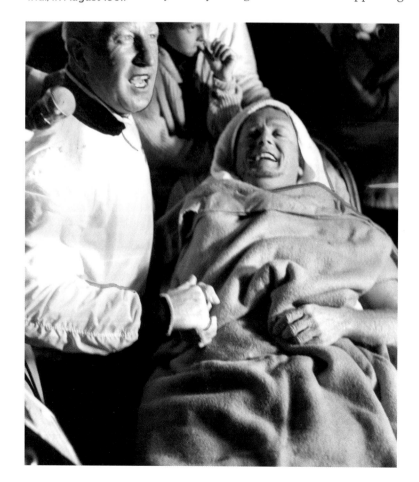

Car salesman and showman Jim "The Courtesy Man" Moran exhorts some of the 41 swimmers training in 1960 at the Illinois Athletic Club for a Lake Michigan race.

Two years later, Moran posted a new challenge: Swim 60 miles from Chicago's Burnham Park Harbor to Silver Beach in St. Joseph, Mich., for $15,000. Most believed it couldn't be done. Erikson and 16 other swimmers disagreed, making the attempt in August 1963. Only two finished. The winner, finishing in a speedy 35 hours, was a 34-year-old Egyptian army officer named Abdel-Latif Abou-Heif. Coming in second, three hours later, was Erikson. He received $1,000.

In trying to understand the drive that pushes a person to swim that long, consider Erikson's reaction after completing that amazing feat—but finishing second. So upset about losing, he turned right around and tried to swim back to Chicago. "He swam a mile back into the lake before friends convinced him to halt," the Tribune reported.

Erikson went on to cross the English Channel multiple times, including a successful round-tripper, and swam a number of other high-profile routes. The only Chicagoan who could make a claim on Erikson's title of being Chicago's best would be his son, Jon, who beat his father's times crossing the English Channel.

In 1981, he became the first person to swim the channel three times nonstop.

Despite the Eriksons' amazing accomplishments, interest in long-distance swimming in Chicago didn't last long. By 1971, the father-son duo were bemoaning the lack of sponsorships and public interest. Moran had stopped funding his "Lake Michigan Challenges," saying the cost of running the events was too high.

More recently, two women have crossed the lake successfully. Vicki Keith, a Canadian, swam from Union Pier, Mich., to Chicago's Oak Street Beach in 1988, a year when she traversed all five Great Lakes. In 2009, Paula Stephanson, another Canadian, made the 32-mile swim from Rainbow Beach on the South Side to Michigan City in just 25.5 hours.

Years later, Ted Erikson tried to explain to the Tribune how he managed the mental ordeal. He said the depression usually hit him in three waves. "That third one seems to have no limit," he said. "I mean, death is the limit, as near as I can tell. I've been close to that a couple of times."

—STEPHAN BENZKOFER

Our kind of sport— right off the bat

How softball, born in Chicago, became quintessential city game

O N summer evenings, players in ragtag uniforms—a few baseball caps, perhaps jerseys bearing a corner tavern's name—converge on parks all across the Windy City, honoring with ball and bat Chicago's contribution to the world of sport: the invention of softball on Thanksgiving Day 1887.

In its golden years, a Chicago softball diamond hosted one game after another, the last of them called by darkness except on an occasional lighted field. It was the quintessential after-work recreation. Some parks had multiple diamonds on opposite corners of a playing field. Outfielders of one contest stood back to back with those of another, sometimes retrieving home-run balls hit by batters in the other game.

In a game justly called "slow-pitch softball," the ball seems to take forever to get from the pitcher's mound to home plate. In the reverse direction, it travels virtually with the speed of light—from the perspective of a barehanded infielder trying to snare a line drive without losing a finger. A Chicago surgeon once published an article in a medical journal titled "Hand Injury Patterns in Softball Players Using a 16-inch Ball."

It can be played for laughs by teams mix-

An informal game of softball is played near Franklin Performing and Creative Arts Magnet School on the Near North Side on a warm day Nov. 26, 1986.

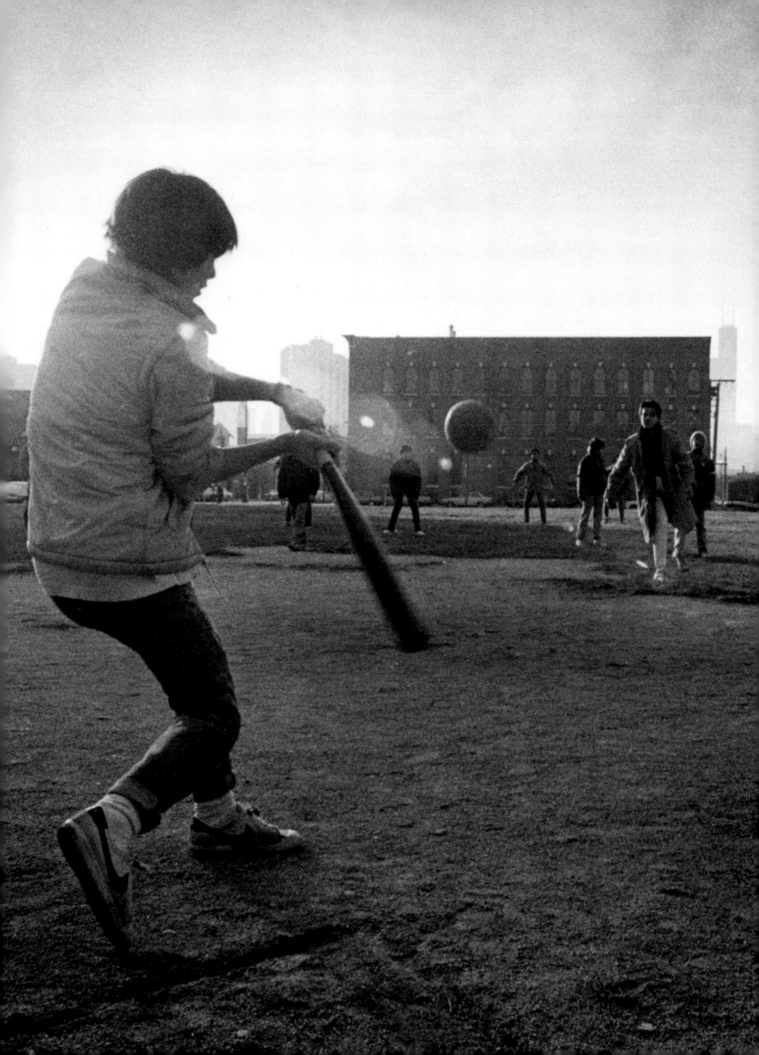

ing youth and age, men and women, but also in deadly seriousness by players who put their money where their ego is, betting big bucks that the other team sucks. Many a game has ended in a brawl, or at least some colorful trash talking.

Yet the players are fewer now, as Don Kirch told a Tribune reporter while umpiring a game in Jefferson Park in 2009. "The way I see kids today, a lot of them are more interested in going to school than playing sports," said Kirch, then 62. "They want to be doctors and lawyers. We wanted to be ballplayers."

A shirt-sleeve patch identified Kirch as a member of the Umpires Protective Association. The name speaks volumes about softball's one-time hold over the local imagination. Competition was so furious that an umpire had to keep one eye on the game and another on angry fans.

But in its formative years, softball was more a "social fad," as the Tribune noted about an 1892 game played not in a park but in a concert hall.

"There will be a merry time at the Auditorium next Saturday evening when athletics and society will be blended in an indoor baseball game," the Tribune predicted of the event, a gala benefit for the Humane Society. "The admirers of both teams will be present to cheer for their respective favorites, having already engaged half the seats in the dress circle. All the members will appear in evening dress."

And what were the origins of the mania? As with many things human, it began with a bit of horseplay. A group of Harvard and Yale alums had gathered on Thanksgiving 1887 at Chicago's Farragut Yacht Club to follow by telegraph ticker tape a football game between the two universities. "They were throwing an ordinary boxing-glove about the room, while one of the boys was striking at it with a broom," the Tribune noted in an 1896 account of the game's origins.

One member, George W. Hancock, struck by some muse of invention, called out: "Boys, let's play baseball." He chalked out a diamond on the club's floor, and others split into two teams to play a game that reportedly ended 41-40. Afterward, Hancock had a ball made on the scale of a grapefruit and a baseball bat modified for use in subsequent games. "A big soft ball and a small bat—that was the central idea," the Tribune wrote of Hancock's breakthrough, which was an immediate hit.

In 1887, basketball and volleyball had not yet been born, so indoor baseball filled a winter void in the sports calendar. Games were soon being played all over Chicago, in social clubs, YMCAs and armories. It didn't take long for enthusiasts to realize there was no need to let go of their passion when the weather turned warm.

That posed the question of what to call the alfresco version of the game. For a while, it bore an awkward moniker: "outdoor indoor baseball." The Kittens, a popular team in Minneapolis, an early outpost of Chicago's game, lent the game a nickname, "Kitten Ball" (an endearing term still in use in this reporter's youth). In Minneapolis as well, the high-scoring game was shortened to seven innings. In 1926, a Denver YMCA official coined the sport's enduring name, "softball."

Seven years later, softball became a truly national sport when championships were played as part of Chicago's Century of Progress Exposition. There were competitions for men's and women's teams in, as the Tribune noted, "12, 13, 14, and 16 inch ball" divisions. It is said that more than 350,000 spectators watched those 1933 games, the success of which led to the founding of the Amateur

The winners of a 1939 softball game that went 105 innings at Rainbow Beach. The winning team is the Windsors.

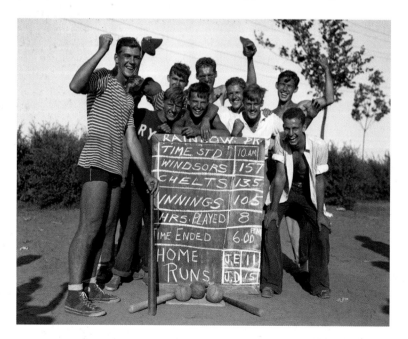

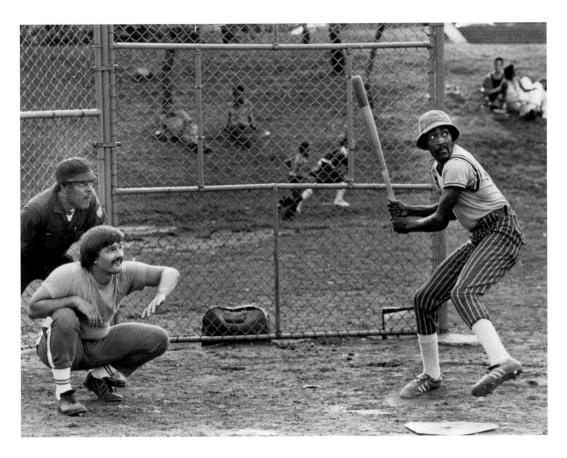

Chicago-style softball, shown in 1973, captivated the city's imagination during its golden years.

Softball Association—which eventually made a 12-inch ball fielded by players wearing gloves the national standard.

Chicago, though, remained faithful to the mush ball of Hancock's design. On July 28, 1935, the Tribune announced the formation of a new Windy City Softball League, noting: "The league will use the 16-inch ball, with slow pitching." And so it remains on local sandlots, in a game without a batter's box and a pitcher's rubber that's sort of advisory.

"Untethered, pitcher and catcher wander about, even as the pitcher sends the ball plateward—in a trajectory statisticians call the normal distribution curve," the Tribune described Chicago-style play. "The ball goes sharply up as it's released, then sharply downward approaching the plate. Batters have to either swing up at the ball, like a boxer throwing an uppercut, or bat it down with a stroke like a tennis serve."

Strange as it might seem to those bereft of a Chicago childhood, that crazy action packed them in at local fields of dreams, like Hilburn Stadium in the Bowmanville neighborhood, Rock-Ola Stadium on the Northwest Side,

Rheingold Stadium on East 75th Street and Parichy Stadium in Forest Park. They were true stadiums with substantial grandstands, not just wooden bleachers. Parichy Stadium was a miniature version of Wrigley Field.

But all things change, including sports fashions. Having gone away to college, recent generations of Chicagoans picked up on their classmates' taste for gloves and 12-inch balls. Still, until the last out of the last inning of Chicago-style softball, it'll be played as newspaper columnist Mike Royko got a court to say it should be played. An avid softball player, Royko was outraged when the Chicago Park District announced that for the 1977 season of its Grant Park league, players would be allowed to use gloves.

So he successfully sued to stop that transgression of tradition, his suit alleging that using gloves "runs contrary to the spirit of 16-inch softball and unfairly penalizes those with talent and calloused hands and gives an unfair advantage to those with tender and well-manicured hands."

—RON GROSSMAN

CHAPTER TEN:
Arts and Culture

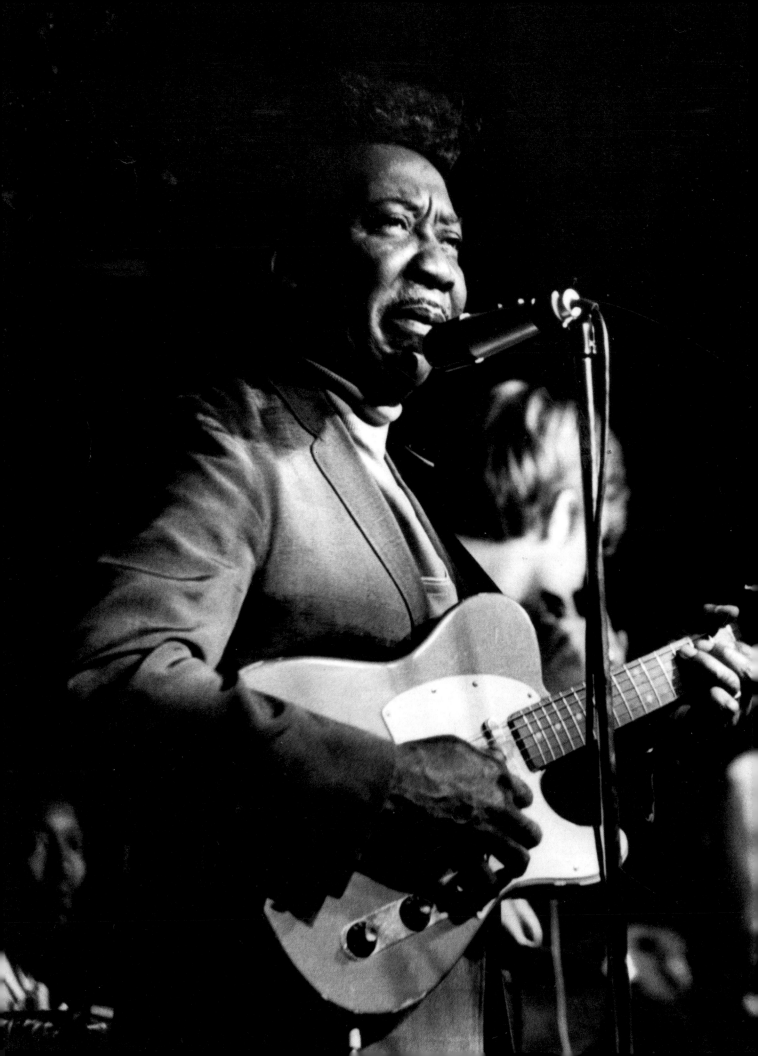

When the Stones played Bronzeville

Jagger and his friends 'passed a quarter' to great musicians, artists

O N Nov. 22, 1981, the Rolling Stones paid tribute to black history at the Checkerboard Lounge on East 43rd Street. In town for concerts at the then-Rosemont Horizon, the famed rock group made a pilgrimage to the South Side, where their musical style and name were born. They shared the now-closed blues joint's tiny stage with Muddy Waters, whose song "Mannish Boy" had the refrain: "I'm a rollin' stone."

One of the many African-Americans seeking refuge from Jim Crow, the legendary bluesman settled in Chicago in 1943, the year Mick Jagger was born.

When Jagger sang a line from a Waters song, "I was born with good luck," Waters replied: "I can see that!"

Racism had greeted blacks in Chicago, shunting them into a long, narrow neighborhood south of the Loop. "There was Bronzeville . . . and there was the rest of Chicago for whites," a Tribune reporter, himself African-American, once noted.

Still, confined quarters make for a rich cultural stew. The blues were born in a small area of the South, the Mississippi Delta. In a similarly restricted strip of his adopted city, Muddy Waters helped shape Chicago's musi-

Muddy Waters and his band at the Plugged Nickel, 1321 N. Wells St., on Aug. 22, 1969.

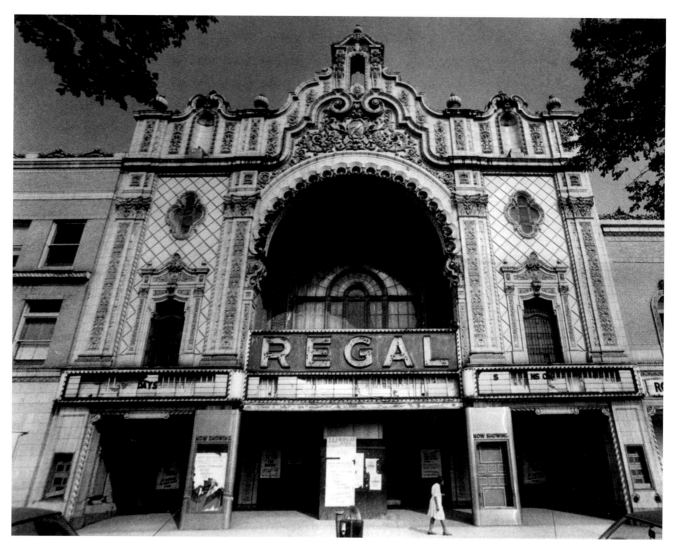

The Regal Theater, built in 1928 on 47th Street and Martin Luther King Drive as part of the legendary Savoy Ballroom, in 1973 before it was demolished.

cal gift to the world: Mississippi blues played on amplified guitars and harmonicas held tight against a microphone.

In the U.S., blues were marketed as "race records," on the assumption only blacks would buy them. But in Europe, they were discovered by young whites looking for an alternative to the hit-parade songs of the day. Among those youths were Jagger and Keith Richards, who met at an English grade school and rode Chicago blues to fame and fortune.

"It didn't bother me at all when bands like the Rolling Stones make it big," Waters told the Tribune in 1981. "The boys were real nice. (The Stones) didn't leave me standing in the rain. They passed a quarter to me—gave me credit, you know."

A foot-stomping lyric could be made of phrases like "standing in the rain" and "passed

"The boys were real nice."

—MUDDY WATERS ON THE
ROLLING STONES, 1981

a quarter to me," and it would have the logic of history. Blues were the musical accompaniment to the Great Migration, mimicking its lofty dream and heartbreaking reality. The blues are not just a musical form but an experience, as those who played them—Howlin' Wolf, Willie Dixon, Little Walter, Junior Wells—have noted. "It's like getting up in the morning and finding your car has been stolen," guitarist Lefty Dizz explained to the Tribune. "That's the blues."

Patrons jam the Checkerboard Lounge to hear a musical tribute to Blues great Muddy Waters after his death in 1983.

An estimated 500,000 African-Americans came to Chicago between 1916 and 1970, hoping for better jobs than they could have in the plantation South. "Used to make up blues while I was drivin' my tractor," Waters told a Tribune reporter of his Mississippi youth.

Whole train loads of migrants came, some with signs chalked on the sides of the cars proclaiming, "Bound for the Promised Land." Some newcomers brought homegrown institutions with them, like the Hattiesburg Barber Shop, whose owner and clients pooled their money to buy discounted tickets on the Illinois Central. Reopened at 35th Street and Rhodes Avenue, the barbershop served as an informal settlement house for others who followed the same path.

Yet in Chicago, opportunity could be as limited as in the South. As a Bronzeville minister said in 1905, at the start of the Great Migration, "The more desirable places are closed against negroes, either because the employers will not hire them or the men will not work with them."

Even with the deck stacked against them, African-Americans created on the South Side a vibrant community. There were tenements and mansions, leftovers from the neighborhood's previous inhabitants. Poverty-stricken families lived side-by-side with successful entrepreneurs. When Jesse Binga, who founded Chicago's first black bank, moved to a white neighborhood, his home was bombed. He stuck it out, but other businessmen and -women chose to remain in the neighborhood where their fortunes were made.

Bronzeville was home to bitter disappointments, but notable accomplishments as well. In Provident Hospital, Daniel Hale Williams, a black doctor, performed perhaps the first successful open-heart surgery. Its streets inspired novelist Richard Wright's transfixing word-portrait, "Native Son." And there was its bright-lights district—clubs, restaurants and the famed Savoy Ballroom.

It was in that spirit that Mick Jagger and his band mates recognized their debt to Chicago blues, at what proved to be one of their hero's last public performances; he died two years later in 1983. But on that magic night, as so many times before, Waters hit a twangy guitar note, threw back his head and sang:

I'm a man
I'm a natural born lovers man
I'm a man
I'm a rollin' stone

— RON GROSSMAN

Dance-hall romance

Grand ballrooms dotted cityscape like splendid constellation

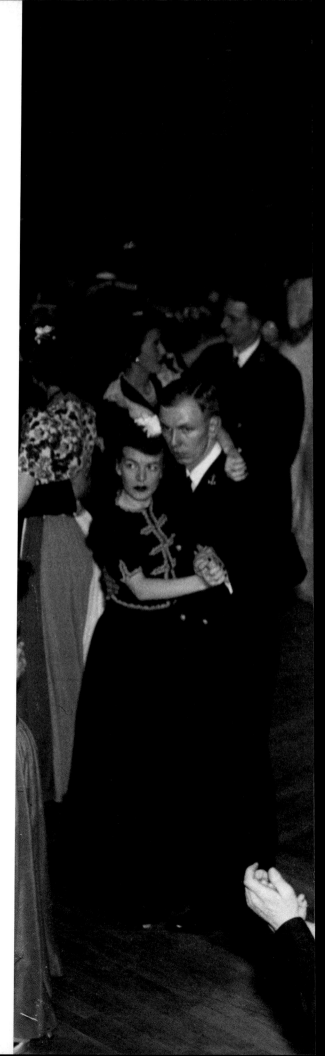

IN an age of information overload, when cellphones double as video cameras, it's refreshing to recall the excitement a radio once produced with simple announcements on the order of: "We're coming to you live, from the lovely Aragon Ballroom in beautiful Uptown! It's the danceable tunes of Wayne King—the Waltz King!"

Then across the stillness of a Chicago evening, the throaty sounds of saxophones and the brassy notes of trombones floated into homes of listeners perhaps too old or too young for a night on the town. From the 1920s to the 1960s, romance ruled the local airwaves and ballrooms.

In living rooms and on dance floors, couples held each other close. Their eyes met, and they moved as one to the accompaniment of lyrics like:

> If you were the only girl in the world
> And I was the only boy

Crowds dancing at the Edgewater Beach Hotel on Jan. 17, 1944. The hotel was known for hosting the famous bands of Benny Goodman, Tommy Dorsey, Artie Shaw, Xavier Cugat, Glenn Miller and Wayne King.

Virtually every neighborhood had a dance hall, and white-tablecloth restaurants had dance floors. Collectively, they constituted a network of big-band music invisibly stitched together by the magic of radio, which was coming into its own. A popular "remote," a live broadcast from a ballroom, could make the career of bandleaders like King, Jan Garber, Kay Kyser and Eddie Howard, regulars at Chicago's upscale venues.

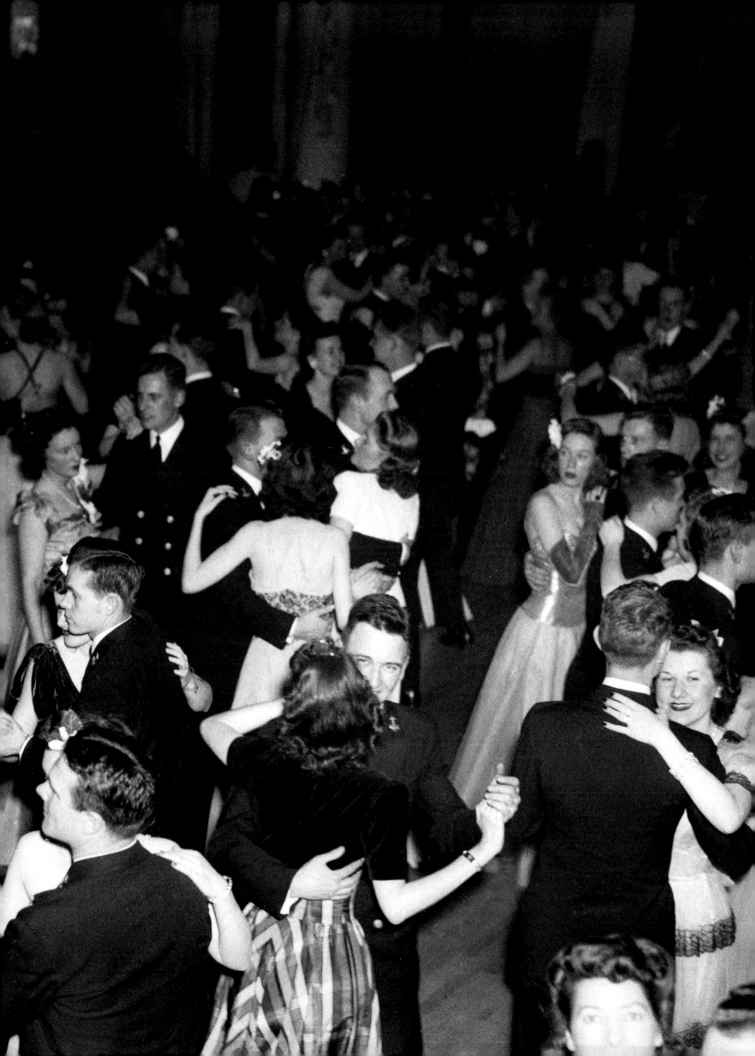

The crowd at the Trianon Ballroom on Feb. 5, 1939, in Chicago.

"We wanted to take dancing out of the speak-easies and put it into good surroundings."

—TRIANON OWNER WILLIAM KARZAS, 1954

Perhaps the most elegant of Chicago's ballrooms, the Trianon, even had its own station, WMBB, reportedly for World's Most Beautiful Ballroom.

Indeed, a truly glamorous ballroom like the Trianon was an occasion for civic celebration. The Aragon's crosstown twin opened with a charity ball on Dec. 5, 1922. The grand march was led by Mrs. Potter Palmer, the grande dame of Chicago society, and Gen. John Pershing, who had commanded American troops in World War I.

"We wanted to take dancing out of the speak-easies and put it into good surroundings," William Karzas recalled for the Tribune in 1954. Karzas and his brother Andrew were Greek immigrants who started with a billiard parlor and became barons of the ballrooms.

Their Trianon was modeled after Louis XIV's Versailles; their Aragon was a wondrous architectural pastiche, Moorish on the outside with innards looking like a Spanish village.

The fantasy must have worked. For its 32nd anniversary in 1954, the Trianon invited married couples who had met on the dance floor to a reunion. "Some sent their wedding pictures, and one even enclosed a photostatic copy of their marriage license," William Karzas said. "So far, no complaints."

For all the magnificence of their ballrooms, the Karzas brothers hardly had a lock on the local market. Not far from the Trianon was the White City Ballroom, with room for 1,000 dancers. An adjoining restaurant seated 2,500. Nothing was ever done halfway, as the Tribune noted of a 1932 St. Patrick's Day bash at White

City: "Fifty thousand shamrocks had been obtained from Ireland to be distributed as favors."

Also on the South Side was Midway Gardens, designed by Frank Lloyd Wright. A Tribune critic pronounced it: "the product of an eccentric builder in his most interesting mood–a gaunt, jagged and yet graceful outline of brick and stone, within which are spacious terraces, balconies, and halls and small nooks and eeries (sic) brilliantly lighted and dim, and all comfortable if haunting to the eye."

Midway Gardens featured dancing under the stars, as did the Edgewater Beach Hotel's Beachwalk, on the North Side. Before Lake Shore Drive was extended north of Foster Avenue in the 1950s, the hotel sat on lakefront property. Patrons could kick off their shoes and dance into the surf.

By current standards, dance steps of the period–the foxtrot, the waltz–were slow moving and stately, even staid. And every generation seems fated to criticism that youth's fads are the devil's handiwork.

In 1913, the Tribune reported: "Ald. George Pretzel, who has become much interested in the tango situation after making a tour of investigation in several of the dance halls, declares the dance is highly immoral and should be stopped."

Pretzel's was a losing crusade. On Feb. 18, 1923, the Trianon presented an appearance by Rudolph Valentino, the great romantic idol of silent movies. A legion of Valentino wannabes showed up. "Many wore their hair glued to their heads," the Tribune reported. "There were sideburns and patent leather dancing shoes."

But when Valentino and his wife danced the tango, women in the audience had eyes only for him. "They hurled bouquets and posies at him," Karzas recalled. "Then came a shower of bracelets, hair combs, gloves, vanity cases, and even wedding rings."

There were notable ballrooms in Bronzeville, where jazz was in fashion. But as in so much of Chicago's life, a color line ran down the middle of the city's dance scene. Blacks who tried getting into the Trianon and White City were harassed, sometimes arrested.

The ballroom craze peaked in the years around World War II–especially when GIs

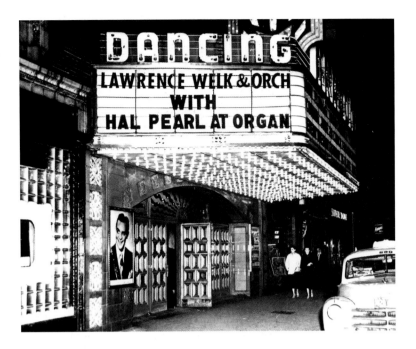

came home looking for romance postponed–but declined quickly thereafter. Couples who met on dance floors moved to suburbia, and while the music didn't stop, it dramatically changed its beat.

By 1966, the Tribune posed the existential question: "Can ballroom dancing survive the era of the frug, Watusi and monkey?"

For his answer, John Dames, manager of the Willowbrook ballroom in Willow Springs, pointed to the Grim Reaper: "The persons like me who appreciate ballroom dancing are getting old, and many are dying off with no one to continue the tradition." Still, the Willowbrook and a few other ballrooms, like Milford on the Northwest Side, hung in by marketing themselves as senior-citizen friendly.

The Aragon went with the flow. It became a roller-skating rink in 1964, hosted boxing matches in the 1970s and now presents rock concerts. The Trianon, which was at 62nd Street and Cottage Grove Avenue, was demolished in 1967, an act of euthanasia for an aging sentinel housing only memories of the big-band era, as a Trib reporter observed of its passing:

"Like a once beautiful woman to whom the passing years have not been kind, the Trianon faded too."

—RON GROSSMAN

Lawrence Welk played the Aragon, which became a roller-skating rink in 1964, as ballrooms fell on hard times, and later a concert venue.

Theaters become movie palaces

Balaban & Katz built auditoriums famous for glamour, fantasy

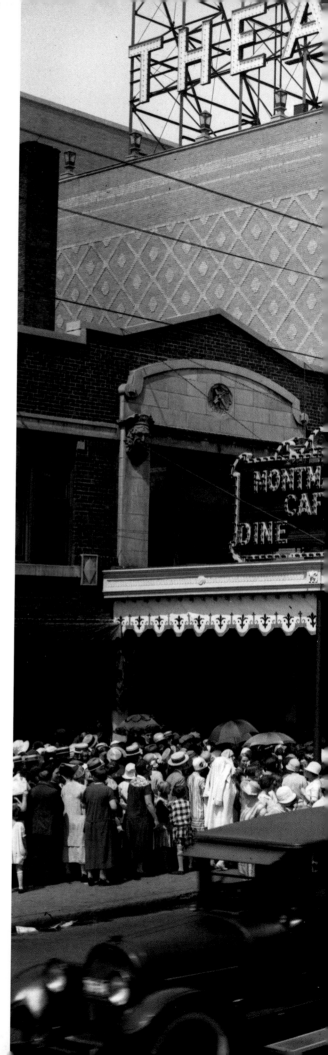

IN October 1917, a theater opened at 3535 W. Roosevelt Road that changed the moviegoing experience, in Chicago and the nation.

In the era of the nickelodeon, a term reflecting not just the price of admission, but the surroundings, motion pictures were shown in cramped, unadorned venues, often converted storefronts. But A.J. Balaban, his brother Barney, and Sam Katz had bigger dreams—and, sharing them with audiences, gave birth to an architectural genre, the "movie palace."

Though it seated 1,780 and was the first air-conditioned movie house, Balaban & Katz's pioneering effort was prosaically named for a cross street, the Central Park Theater. But their subsequent ventures, and those of show-biz moguls they inspired, bore names worthy of royalty: the Palace, the Granada, the Paradise, the Tivoli, the Pantheon and the Regal.

Each was a steppingstone toward the silver-screen glamour of red carpets, paparazzi and Oscar season hoopla. At the same time, the theaters created a social and cultural phenomenon that brought together residents from diverse backgrounds, all eager to experience a bit of that elegance—and Americana—themselves. In a city of immigrants like Chicago, speech patterns brought over from Poland and Italy,

People line up to see the Uptown Theatre at Broadway and Lawrence Avenue during opening week in August 1925. The theater was built by Balaban and Katz. The Montmartre Cafe is on the left.

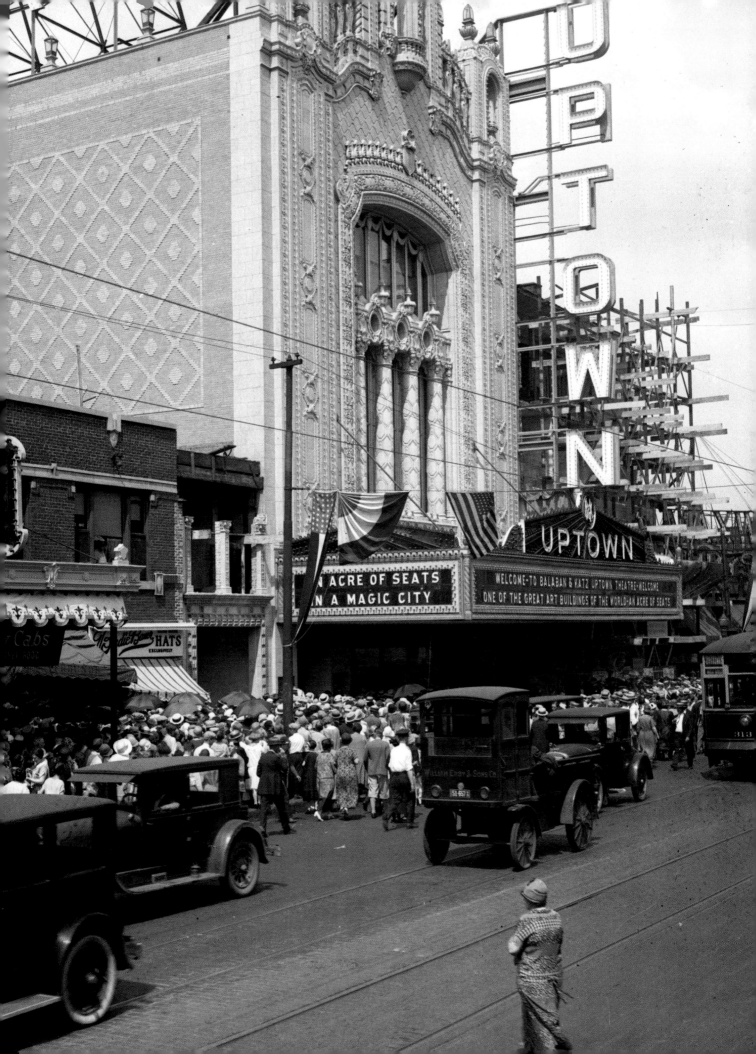

"For sheer splendor, expensiveness, and display, the Chicago Theater sets a world's record."

—TRIBUNE ON THE THEATER'S OPENING, 1921

An ad in the movies section of the June 23, 1919, edition of the Chicago Tribune touted "the only air refrigerating systems in theatrical use" at the Balaban & Katz Central Park and Riviera theatres. The Central Park, built in 1917, was the first air-conditioned theater in the world. The Riviera was opened one year later by Balaban & Katz. Both theaters still exist in Chicago today—the Central Park is a church, while the Riviera is a live music venue.

Greece and Germany, were blended by hearing the posh accents of Hollywood stars like Ronald Colman and Greer Garson.

A night at the movies was a dress-up occasion—and a teenager's rite of passage. A first date might be a matinee at one of the movie palaces that dotted the neighborhoods. Then a boy and a girl would get up the courage to take the "L" downtown and feel on the threshold of adulthood for having passed beneath a six-story-high theater marquee with light bulbs proclaiming: C-H-I-C-A-G-O.

Seeing silver-screen romance emboldened adolescents to take their first, tentative steps toward transforming friendship into love. Especially because a darkened auditorium was forgiving of an awkward opening move. James T. Farrell captured such a scene in his short story, "The Hyland Family": "In the Tivoli Theater, Helen and Jimmy had held hands. When she came out of the theater, she scarcely remembered the picture she'd seen."

A new movie palace was cause for a civic celebration. In 1925, a parade of 200 floats and an army band saluted the Uptown Theatre's opening, and 12,000 people lined up for its 4,381 seats.

B&K's formula escalated from mere opulence to Roman decadence, as the Tribune reported in 1930: "A trained seal room and a small museum of wild animal and bird life will be two innovations to be incorporated in the huge new moving picture theater which the

Publix-Balaban and Katz corporation will erect in Englewood shortly." And huge the movie palaces certainly were: The Chicago Theatre seated 3,800 and boasted an interior modeled on Louis XIV's Versailles. Its opening was reviewed like a high-society coming-out bash. "Yesterday at 5:30, Miss 'The Chicago Theater,' beloved child of Messrs. Balaban and Katz, made her debut," gushed the Tribune's Mae Tinee in October 1921. "...For sheer splendor, expensiveness, and display, the Chicago Theater sets a world's record."

When a B&K theater opened on Randolph Street in 1926, the Trib observed: "The designers... wished the Oriental to live up to its name. The doorman wears a turban and long silken costume, and a pretty girl in like dress presides over the foyer."

In the golden age of movie palaces, a ticket often bought a stage show as well as a movie. In the 1930s, Red Skelton played the Palace, the Three Stooges appeared at the State Lake Theater and John Philip Sousa appeared at the Chicago.

Local talent was showcased at amateur nights in neighborhood movie theaters. Nightlife publicist Benny Dunn, the self-proclaimed King of Rush Street, recalled for the Tribune the night Al Jolson competed in one. In town for a movie opening, he asked Dunn to take him for a drive. Coming upon the marquee announcing amateur night, Jolson decided to enter and billed himself as "Sam Bass," a shoe salesman who did vocal impressions. He finished on one knee, belting out the line for which he was famous, "I'd walk a million miles for one of your smiles!"

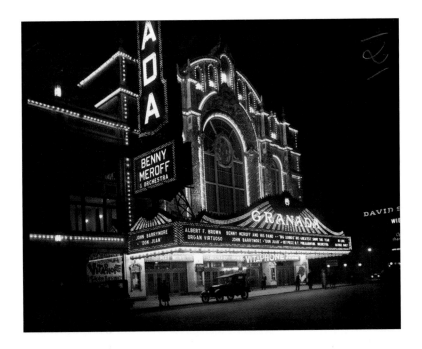

Left: The Granada Theater in 1927.

Below: Mrs. Rose Freeman, from left, Mrs. A. J. Balaban, Mr. A. J. Balaban and Mrs. and Mr. I. Balaban (A. J.'s parents) in 1929.

"When the audience voted, 'Bass' lost to a 9-year-old girl who danced an Irish jig," Dunn recalled. "They never even suspected it was Jolson, and half of the seats were occupied by the kid's relatives."

From that first fantasy movie-house on Roosevelt Road, B&K's theaters were designed by brother architects, George and Cornelius Rapp. Taking their over-the-top style national, they designed hundreds of theaters, including the Paramount Theater in New York City, the Palace Theater in Cleveland and the Paramount Theater in Seattle. Just as the Abbey of St. Denis made Paris the mother city of Gothic architecture, the Rapp brothers' blueprints endowed Chicago with a small measure of similar glory.

Yet, as the poet said, glory is fleeting, and by the 1960s, television and suburbanization were taking their toll on Chicago's movie palaces. The Oriental closed in 1981; the Chicago closed in 1985. Both have since reopened, thanks to the rejuvenated Loop Theater District, but the Uptown Theatre still stands empty. After the Granada Theater in Rogers Park stopped showing movies, its architect waxed philosophical.

"The movie theaters had to submit to progress," said Edward Eichenbaum in 1976. "... The age of cinema that had produced them was gone."

—RON GROSSMAN

Where Hollywood legends changed trains

Glittering stars alighted—if for no other reason than to change trains

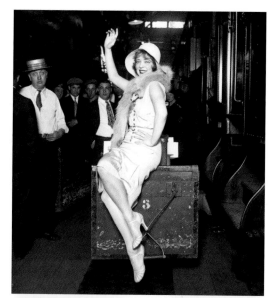

W HILE Chicago occasionally serves as the scenery for a major motion picture, the city used to be a must-stop for Hollywood's top talent and New York's glittering stars. If for no other reason than to change trains.

Whether they were going east on their way to Europe or heading back to Los Angeles for the big movie opening, the stars were forced to spend a few hours in Chicago, the nation's rail hub.

Beginning in the 1920s and continuing for decades, their comings and goings were noted in the Tribune and by die-hard fans who prowled the Dearborn, Grand Central, Union and North Western stations. After the Super Chief or the Capitol Limited rolled in, those waiting would be rewarded with a glimpse of Lillian Gish, Rudolph Valentino, Charlie Chaplin, Marlene Dietrich, Gary Cooper, Fred Astaire, Clark Gable, Judy Garland, John Wayne and Elizabeth Taylor (with varied husbands).

The practice continued even after train lines introduced sleeping cars with through-service in the mid-1940s, and even into the age of air travel. Freelance photographers staked out Midway Airport in the 1950s and early '60s to

From top, Clara Bow, John Wayne and Mary Pickford.

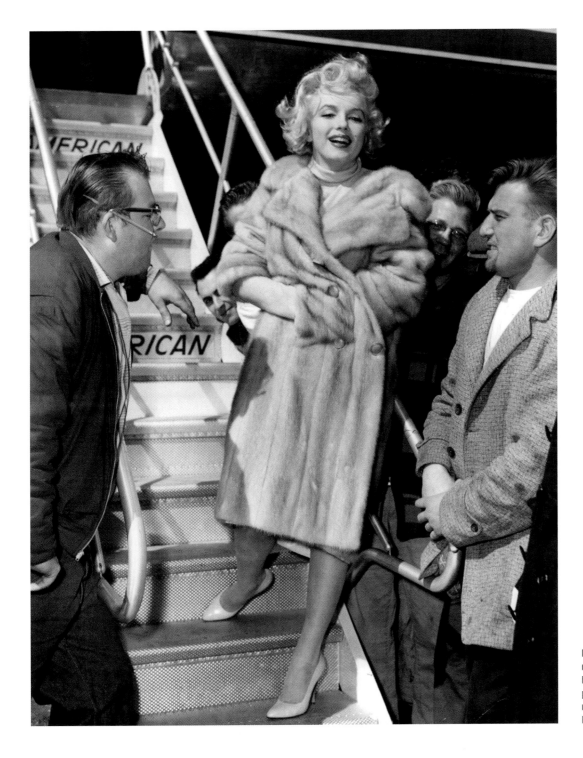

Marilyn Monroe arrives in Chicago at Midway Airport to promote her new movie "Some Like it Hot" in March 1959.

catch such stars as Marilyn Monroe and Elvis Presley.

All that publicity was no accident. The traveling starlet surprised by her fans at the train station was already a tired script by 1927, according to a delightful feature story by famed Tribune reporter Genevieve Forbes Herrick. In it, she describes how a press agent's telegram alerts newspapers of the star's imminent arrival, how the pack of reporters and photographers draws a crowd at the station, how the star—dressed to the nines—feigns wonder at the big to-do being made over her, and how she always manages a throaty, "Chicago, there is really nothing like it."

—STEPHAN BENZKOFER

Buffalo Bill: Urban cowboy

'Buffalo Bill' Cody wowed Chicago with his Wild West shows

When Buffalo Bill died in 1917, the United States lost a legendary link to the Old West. As a young man, William F. Cody won renown, and an indelible nickname, for his exploits—real, embellished and imagined—on the Great Plains. But it was in Chicago that Buffalo Bill embarked on his celebrated career as a showman extraordinaire.

Chicago knew the intrepid frontiersman early on. The first installment of "Buffalo Bill: The King of Border Men"—the sensational tale by dime-novel fabulist Ned Buntline that brought 23-year-old Cody national fame—appeared on the front page of the Chicago Tribune on Dec. 15, 1869. Cody first visited the city in February 1872, exchanging his fringed buckskin for a store-bought monkey suit before attending an elegant ball. "Here I met a bevy of the most beautiful women I had ever seen," he remembered. "Fearing every minute that I would burst my new and tight evening clothes, I bowed to them all around—but very stiffly."

Cody returned to the city before year's end, summoned by Buntline to star in his new play. "Scouts of the Prairie" opened on Dec. 16, 1872, at Nixon's Amphitheatre, a foul-smelling, canvas-topped venue on Clinton Street (not far from today's Ogilvie Transportation Center). Without exception, the city's newspapers panned the lively but ludicrous melodrama.

Theatergoers didn't care. Despite his limited acting skills—the Tribune critic claimed Cody delivered his lines "after the manner of a diffident school-boy in his maiden effort"—Chicagoans loved Buffalo Bill. Full of sound and fury, the play, with its tall, ridiculously handsome leading man, "attracts more people than the house can hold," noted the Tribune. "Crowds are turned away nightly."

For the next few years Cody divided his time between the Plains, where he served as an Army scout, and the theatrical circuit, where he led his own acting troupe, Buffalo Bill Combination. From 1874 to 1886, "Bison William" (as one Tribune wit dubbed him) performed dozens of times at the Olympic, Criterion, Adelphi and other long-vanished Chicago theaters. He headlined in such fare as "Knight of the Plains," "The Prairie Waif," "Buffalo Bill's Pledge" and "May Cody," a contrived Western romance involving Cody's sister.

Cody assumed his most famous role beginning in October 1883 when he brought "Buffalo Bill's Wild West" to the Chicago Driving Park, a horse track on the West Side (immediately west of today's Garfield Park). An outdoor extravaganza, the "Wild West" featured scores of cowboys, scouts, buffalo hunters and Cheyenne, Pawnee and Lakota men and women.

Open to the public, the Native American encampments attracted throngs of curious onlookers throughout the decadeslong run of Cody's traveling show.

Confident they were seeing, as advertisements promised, "genuine illustrations of life on the plains," Chicagoans thrilled to spine-tingling re-enactments of buffalo hunts, Pony Express rides, stagecoach attacks and, in later years, Custer's Last Stand. Staples of the show were rodeo acts and "marvelous shooting" exhibitions, at which Cody excelled. But at the May 1885 Chicago appearance of the "Wild West," a diminutive young woman named Annie Oakley outshone even Cody with her marksmanship. She'd remain a star attraction of the show for 17 seasons.

The pinnacle of Buffalo Bill's Chicago ca-

reer coincided with the World's Columbian Exposition of 1893. On a city block adjacent to the fair, Cody staged the latest incarnation of his show, billed by that point as "Buffalo Bill's Wild West and Congress of Rough Riders of the World." There were "450 horses of all countries," trumpeted the ads.

It was "the greatest equestrian exhibition of the century," said the Tribune. "In addition to Indians, cowboys, Mexicans, Cossacks, Arabs, and Tartars are detachments from the Sixth United States Cavalry, French chasseurs, German Pottsdammer reds, and English lancers. These representatives of trained mounted soldiery are fully as hardy as the barbarous riders, and many of the feats they performed were quite as wonderful."

From April 26 to Oct. 31—a longer run than the Columbian Exposition itself—Cody and his company performed before packed grandstands. Despite the marvels of the White City, visitors couldn't claim to have seen the fair if they didn't also attend the "Wild West." And Cody personally made sure everyone had the opportunity to attend: On July 27, he treated 6,000 poor children to a downtown parade, a picnic and a visit to the Western spectacle at Stony Island Avenue and 63rd Street.

The "Playday of Waifs," as a Tribune headline called it, was an annual picnic for poor children that in 1893 Cody turned into an extravaganza. "For weeks the boys who sell papers and the boys who black boots and the boys who haven't the capital to do either have gazed in speechless wonder at the gaudy billboards on which are depicted thrilling incidents in frontier life."

Buffalo Bill left town a hero, and so he remained on subsequent visits to Chicago: more than 100 performance dates over the next 23 years. Touring the world, the hard-drinking Cody continued to make lots of money, which he steadily lost to bad investments and extravagant living. In July 1913, two weeks after an 11-day engagement in Chicago, creditors foreclosed on his show.

Now the man who once bedazzled European royalty toured with a second-rate circus. His last appearance here came over nine days in August 1916 when he served as little more

than a mounted prop at the Chicago Shan-Kive and Round-Up ("shan-kive" was a Ute word meaning "celebration"). The venue for this sad farewell? The old West Side Park (at Polk Street and Wolcott Avenue), where the Cubs won the World Series in 1907 and 1908.

Cody died at the Denver home of his sister May on Jan. 10, 1917. In an editorial the next day, the Tribune celebrated the "illusion" created by Buffalo Bill. "Fact, after all, is not all of truth," it contended. "Truth is fact perfected by our own dreams, fact plus our emotional reactions from fact. This will live with us while mere facts sink into the shadows of the forgotten past. They are dead. It is what we give facts that makes them immortal."

—RON GROSSMAN

William F. Cody, aka Buffalo Bill, who first visited Chicago in 1872, made his last appearance here in 1916 at West Side Park, where the Cubs won two World Series.

Sinatra and the Chicago mob

When the Outfit called, the Chairman of the Board showed up

I N 1962, at the height of his fame, Frank Sinatra gave a benefit performance at the behest of a British princess. He gave another for the head of the Chicago mob.

In February, he sang at a ritzy London fundraiser for a children's charity favored by Princess Margaret. Later that year, he did a week's gig at the Villa Venice, a gaudy but financially ailing nightclub near Northbrook in which mafioso Sam Giancana had a piece of the action.

Will Leonard, the Tribune's nightlife critic, reported that Sinatra and his pals Dean Martin and Sammy Davis Jr. "croon, carol, caper and clown to the biggest cabaret audiences this town has seen in years." And no wonder.

Gossip columnists had bestowed the honorific "Chairman of the Board" on Sinatra. Giancana was the flamboyant face of the Chicago Outfit. The linking of the two luminaries turned those seven days in November and December into a requiem for an older show-biz era.

Chicago's entertainment scene was changing. Comedian Lenny Bruce had brought his obscenity-leavened act to the Gate of Horn, a hip club where the Chad Mitchell Trio also appeared. Their kind of folk music was already

Singers Sammy Davis Jr., center, and Frank Sinatra, right, howl at Dean Martin's antics on the opening night of their weeklong gig at the Villa Venice nightclub near Northbrook in 1962.

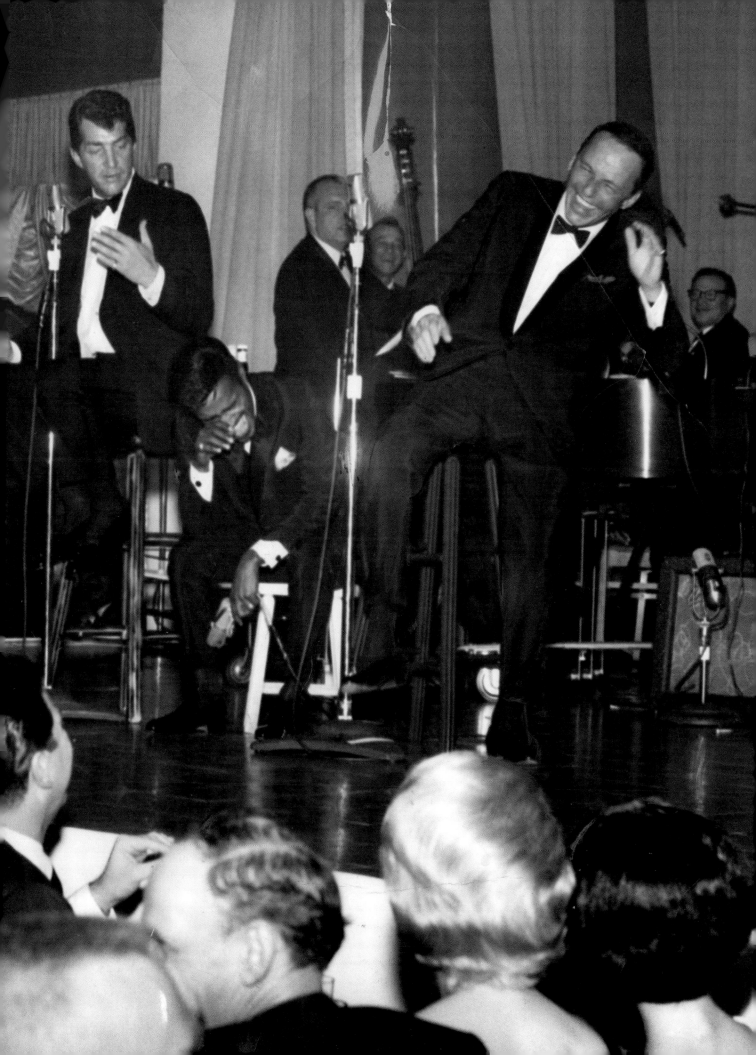

sufficiently popular for the Smothers Brothers to satirize it at the State-Lake Theater. The Rat Pack, Sinatra and his friends, were strictly old-school but still a magnetic draw to nightlife veterans of a time when Rush Street was home to celebrated nightclubs, not dating bars.

"The old Chez Paree crowd has yanked itself loose from the TV sets just once more," Leonard observed in another account of the goings-on at the Villa Venice. "The old waiters and doormen are back, showing the same old palms of the same old hands. There's a great big band on the stand, playing great big music. The chairs are pushed so closely together you can't shove your way between them. Flash bulbs pop in the audience during the show. All that's missing is the girl selling the Kewpie dolls and giant sized postcards."

Herb Lyon, the Trib's gossip columnist, proclaimed the hordes of screaming fans "Madness at the Villa." He quoted Sinatra and his buddies (or perhaps their publicist) as saying: "We've never seen anything like it anywhere—Vegas, New York, Paris, you name it."

Indeed, the Villa Venice had been tricked out in a style imported from Las Vegas. Giancana reportedly spent upward of $250,000 to restore it and its canals plied by gondolas. The showroom seated 800, was furnished with satin ceilings, tapestries, and statuesque, lightly clothed showgirls. Nearby was the ultimate accouterment of a Vegas-like operation: a gambling casino in a Quonset hut a

The Villa Venice, a gaudy nightclub near Northbrook where Frank Sinatra and other members of the Rat Pack performed a weeklong gig in 1962 for Chicago mobster Sam Giancana.

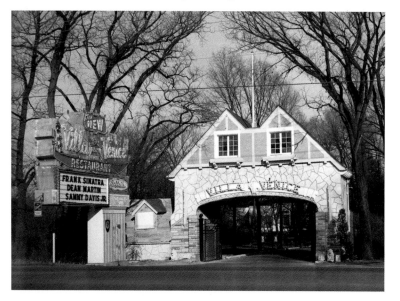

few blocks from the Villa. High rollers were whisked between the supper club and the dice and roulette tables in a shuttle supervised by Sam "Slick" Rosa, identified by the Trib as "the syndicate's chief of limousine service," and his assistant, Joseph "Joe Yak" Yacullo.

The Tribune reported that among the mobsters on hand for Sinatra's opening night were Willie "Potatoes" Daddano, Marshall Caifano, Jimmy "The Monk" Allegretti and Felix "Milwaukee Phil" Alderisio. It was noted that "Sinatra's gangland fans from other cities appeared too." For a week, the Rat Pack's presence turned Milwaukee Avenue at the Des Plaines River into the hottest address in show biz.

Shortly before the Sinatra show closed, the casino shut down under belated pressure from law enforcement authorities who told the Tribune that the gambling operation had grossed $200,000 in two weeks. That threw a monkey wrench into Giancana's business plan, which depended on recouping his investment by attracting gamblers with a parade of big-name acts. But how could he hope to book stars like Sinatra and his buddies into a scarcely known venue in the hinterlands of Chicago? What kind of money did he dangle in front of them? Wondering if there might have been a non-monetary enticement, the FBI interviewed the Rat Pack during their engagement. Perhaps the feds took a clue from Dean Martin's rewording of the old standard "The Lady Is a Tramp."

I love Chicago, it's carefree and gay
I'd even work here without any pay.

According to James Kaplan, author of the "Sinatra: The Chairman," the question was put to Davis. "I got one eye, and that one eye sees a lot of things that my brain tells me I shouldn't talk about," Davis told the agents. "Because my brain says that, if I do, my one eye might not be seeing anything after a while."

Kaplan's verdict was that it was unclear whether the Rat Pack got paid. As a favor to Giancana, Sinatra had previously persuaded Eddie Fisher to play the Villa Venice, reportedly for chicken feed. Sinatra owed Giancana for lending his muscle in the critical state of West Virginia when John F. Kennedy ran for presi-

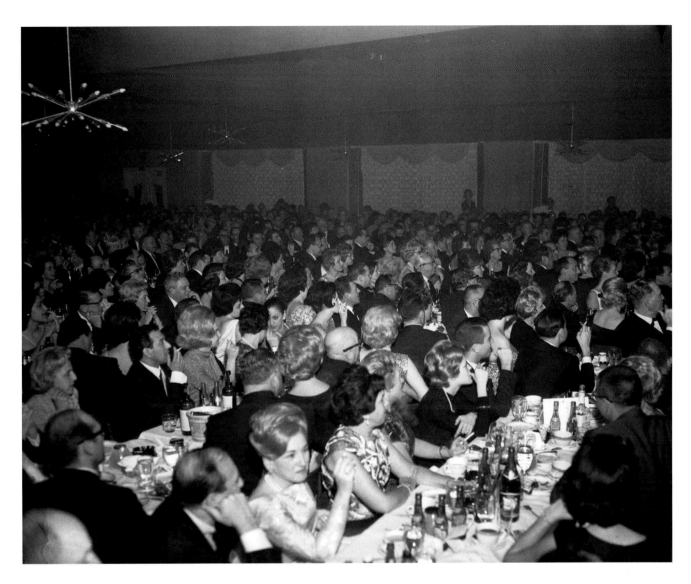

dent in 1960, according to Giancana's daughter Antoinette's memoir "Mafia Princess."

Still, the Rat Pack's Villa Venice appearances were wildly successful, as the Tribune's Lyon reported: "It is now estimated that the total Villa loot for the seven-day Sinatra-Martin-Davis run will hit $275,000 to $300,000, a new night club record." But Dinah Shore, the next scheduled performer, canceled at the last minute, and Sheilah Graham, a nationally syndicated columnist, wrote: "I've been told that Sinatra picked up the hotel tab for his group, to the tune of $5,000. The whole business sounds somewhat odd."

In fact, the Villa Venice never again hosted big-name stars, operating thereafter as a catering hall, with a new management taking over in 1965. Two years later, it was destroyed by a spectacular, if mysterious, fire. The spot is now a Hilton hotel.

Giancana was gunned down in his Oak Park home in 1975.

To the end of Sinatra's days, he sang the Windy City's praises. But Rat Packer Peter Lawford reportedly said the song was a compliment not to the city but to Giancana, calling it "his tribute to Sam, an awful guy with a gargoyle face and weasel nose."

Either way, "Chicago" was Sinatra's theme song:

I saw a man and he danced with his
 wife in Chicago
Chicago, Chicago that's my hometown.

—RON GROSSMAN

The crowd at Villa Venice for the Frank Sinatra, Dean Martin and Sammy Davis Jr. show on Nov. 26, 1962.

The Beatles invade Chicago

The Fab Four were feared— by the press and the parents

Teens Plot and Plan to Meet Beatles
Dauntless in Their Pursuit

When you dive into the Tribune's coverage of the Beatles in 1964, you find fear.

Fear about the hair, the strange music and the screaming.

The hair was an affront; the mop-topped four sported a sheepdog look that was ridiculed mercilessly. Bob Hope joked: "The Beatles are a kind of barbershop quartet that couldn't get waited on." A desperate mother of a 15-year-old son sought help from a Tribune advice columnist, writing: "We've tried everything: ordering him to get a normal haircut, teasing him about looking like a girl, threatening to cut his allowance. Nothing works."

The music was despised too. An early Associated Press story described it as a "violent form of rock 'n' roll." It was also equated with "Calliope" music or dismissed as not music at all.

And the screaming, the screaming was really frightening. On Aug. 26, the Tribune ran a story about the firsthand experience of a Washington state child guidance expert who attended a concert in Seattle. It wouldn't have calmed parental fears. He wrote, "Many of those present became frantic, hostile, uncontrolled, screaming unrecognizable beings." He blamed adults for "allowing the children a mad, erotic world of their own." He described it as "an unholy bedlam" that should not be allowed. "It was an orgy for teenagers," he said.

It is important to note how quickly Beatlemania spread. In January 1964, a Tribune editorial warned readers about an unknown band from Liverpool that was all the rage over there. Just a few days later, "I Want to Hold Your Hand" hit No. 45 on the charts. In February, they appeared on "The Ed Sullivan Show." By April, the Beatles had the top five songs in the country. In August, "A Hard Day's Night" appeared in theaters. In just months, they had become a worldwide sensation. Their concert tour was marked by reports of riots and injuries.

So it was no wonder that Chicago was on edge in the days before the performance at the International Amphitheater. Grim-faced city officials huddled about the impending invasion. The police commander in charge of a special task force told the mayor, "Don't worry, Mr. Mayor. We've been in tight spots before. We'll handle the Beatles just like every other big emergency."

About 5,000 fans greeted the Beatles at Midway Airport on Saturday, Sept. 5. Some tried to scale the fence around the field. The concert that night was a "screaming smash," according to a Page 1 headline over a story that took cracks at the music and John Lennon's long hair but mostly focused on the hysteria, and yes, the screaming.

—STEPHAN BENZKOFER

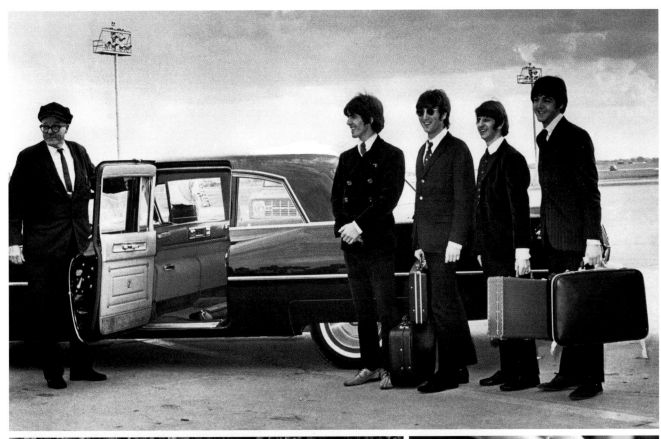

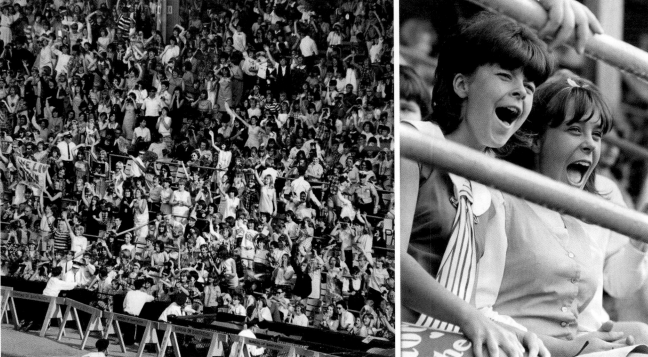

Top: During the Beatles' 1966 Chicago visit, George Harrison, from left, John Lennon, Ringo Starr and Paul McCartney prepare to take a limousine into the city from an outlying hangar at O'Hare.

Bottom row, from left: The Beatles arrive to play before a crowd of teenagers at Comiskey Park on Aug. 20, 1965; fans scream during the performance.

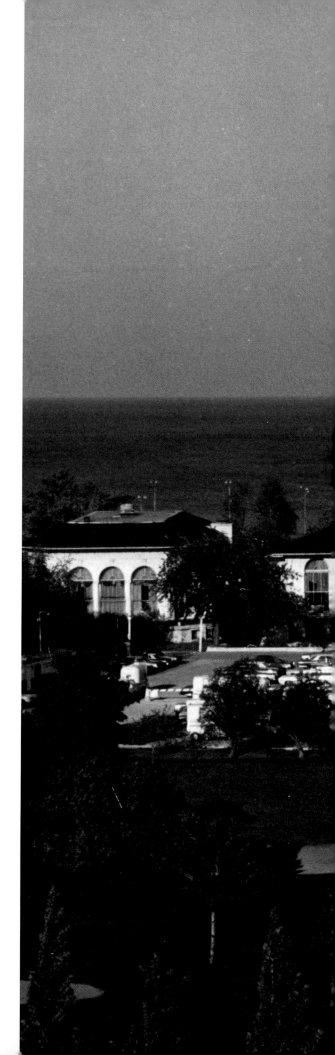

Two faces of South Shore

From exclusive country club to inclusive cultural center

THE view from the South Shore Country Club was like that of Janus, the Roman god with two faces. It depended upon which way members looked.

Hugging the shoreline at 71st Street, the 58-acre club offered stunning views of Lake Michigan, unchanged since the days when Native Americans hunted and trapped there. On the land side, it faced a residential neighborhood that borrowed the club's name, two decades after the club's 1906 founding.

The South Shore neighborhood was, like much of Chicago, a place where ethnic groups came and went. Yet above the club's porte-cochere, its arched entranceway, was a sign proclaiming that the South Shore Country Club was "For Members Only."

Until it closed in 1974, the club was, in the coded language of the time, "restricted."

"Remember that this was a private club in its time and if you were black or Jewish, forget about it," a Chicago Park District official told the Tribune in 1984, when the club was renovated before reopening as the South Shore Cultural Center. "People who have never been here before will walk in and realize they are in the Taj Mahal."

The club was worthy of such hyperbole.

The South Shore Country Club, founded in 1906, was sold to the Chicago Park District in 1975. The former private club is now the South Shore Cultural Center.

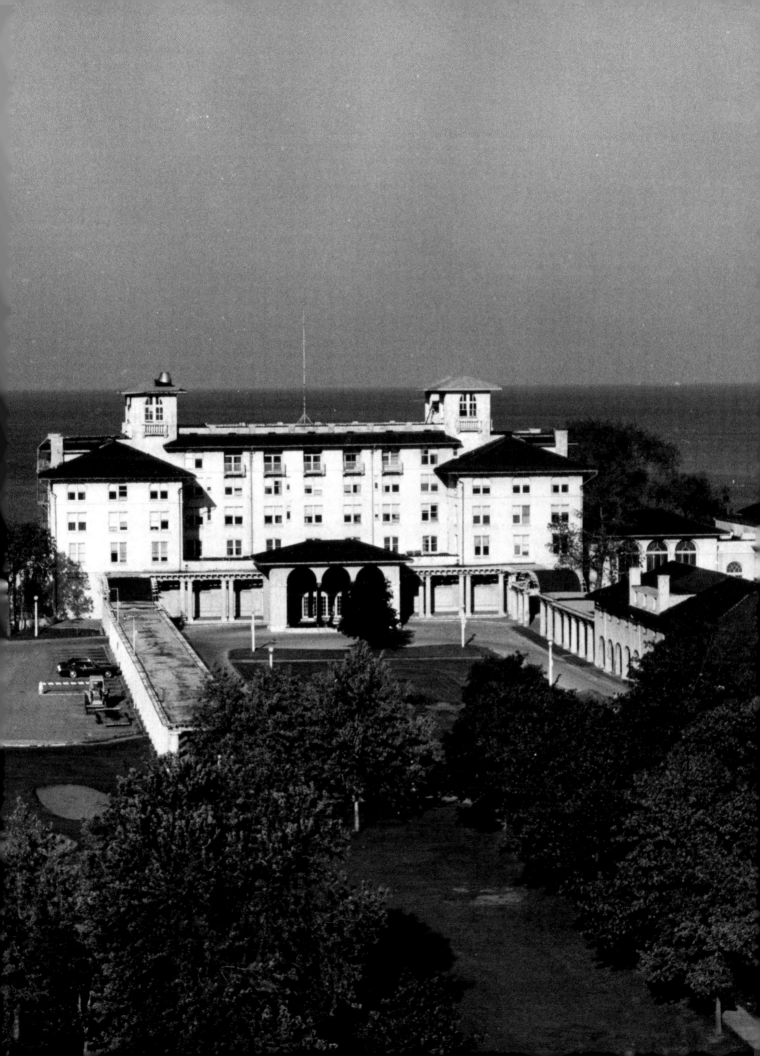

The main clubhouse, built in the then-tony Mediterranean Revival style, featured a cavernous main dining room and grand ballroom joined by a passaggio, a broad and towering corridor. It was so long that three orchestras could play in different parts of the clubhouse without interfering with each other.

At its closing, the Tribune recalled Everett Brown, the club's president in 1916, describing a New Year's Eve gala: "Filled with nearly 3,000 of the most exquisitely gowned women and their escorts all in evening dress, each one wearing an attractive carnival headdress in celebration of the occasion." Brown estimated that partygoers wore finery and jewelry collectively worth $2 million ($49 million in today's dollars).

The South Shore Country Club was the brainchild of Lawrence Heyworth, a banker and president of the Chicago Athletic Club. Recalling his inspiration, Heyworth said he envisioned the country club as a place where members could "enjoy dining and wining in a beautiful place out in the country instead of having to resort to dives and saloons, which at that time were about the only suburban places."

At first, Heyworth had trouble convincing others of his logic. Chicago's movers and shakers were confirmed urbanites. The upper levels of the upper crust lived on Prairie Avenue, a mansion-lined street 8 miles from Heyworth's club. But he got the presidents of 17 Loop banks to back his purchase of the club's site, which he knew from having taken his children fishing there.

Then he convened a meeting of well-heeled South Shore residents who wanted to cash in on the real estate development the club would spark. If they didn't join his project, he warned them, they wouldn't get loans for their building projects from the banker-members of his club.

Lawrence Heyworth in 1905.

That worked: Membership grew so steadily that the club's original clubhouse had to be replaced by a larger one in 1916. Its facilities came to include a nine-hole golf course, tennis courts, a trap-shooting range, lawn-bowling courts and stables, bridle paths and a dressage ring for equestrian members. The club's horse show was the high point of Chicago's social season.

Its social register members were held to rules governing decorum and courtesy. In a 1918 issue of the club's magazine, women were reminded to adjust their fur wraps before their chauffeur stopped at the clubhouse entrance. Otherwise, the resulting backup of cars would consign other members to unconscionable waiting times.

Yet good taste, as we now know it, didn't impede the cast and director of the members' annual Minstrel Follies. In 1945, the Tribune noted that the show would include, presumably by popular demand, a revival of "Skull Orchard, a blackface skit."

In 1920, the club added a band shell to its music venues. On summer evenings, members would gather on the great lawn to hear celebrated bands of the day. Also listening would be residents of tall apartment buildings that had been erected just across South Shore Drive from the club.

Among the orchestras that played for cotillions and dress balls was one led by Paul Whiteman, who blended jazz and symphonic music, bridging black and white musical forms.

Other name performers stayed in the club's luxurious guest rooms while playing Chicago-area theaters and ballrooms. Bing Crosby brought his family there during an appearance at the Drury Lane theater. Hollywood's Dick Powell and Joan Blondell honeymooned at the South Shore Country Club. Jean Harlow, a superstar of the silent film era, was a guest, as were cowboy philosopher Will Rogers and pioneering aviator Amelia Earhart.

A fading age of European royalty was represented by King Peter of Yugoslavia and Queen Marie of Romania. Homegrown notables included former President (and future U.S. Chief Justice) William Howard Taft.

The club reached its high point of a little more than 2,000 members in 1953. By then its

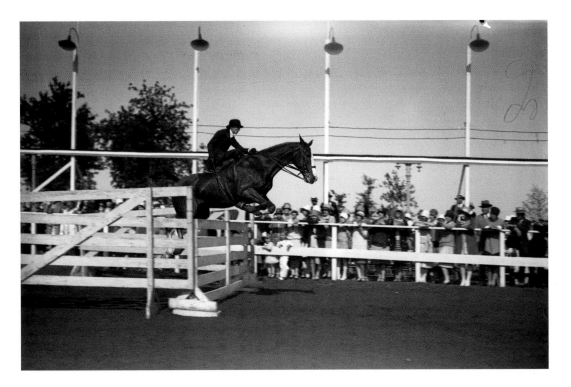

Mrs. O.L. Prime rides Red Ember at an equestrian event at South Shore in 1927. The club's horse show was the high point of the social season on the South Side.

composition had changed: The Yankee-stock founders had died off and were being replaced by Irish-Americans, forcing remaining old-timers to forgo their qualms about socializing with Roman Catholics.

"South Shore Country Club was where it was at," Tribune columnist Pat Condon observed in the club's 1974 obituary. "Particularly after weddings, after funerals. There you shared your happiness and your sadness."

By then, the neighborhood's demographics had changed again. Blacks moved in and whites moved on. Crime increased, and grates appeared on shop windows. Residents who could afford a club membership were the quickest to go. Membership had declined to 800 when Condon wrote.

"More of the regulars wintered in Florida," Condon observed. "Some evenings you couldn't find a monsignor in the house."

Yet the club declined its potential salvation: opening the club to Jews and blacks. In 1969, its president informed the board that there were no plans "to lower the bars and relax the qualifications for membership."

In 1975, the club sold its property to the Chicago Park District. Years of squabbling followed over what to do with the site. Park District officials weren't eager to spend money on the clubhouse and athletic facilities. Maintenance had been neglected as the club's revenue shrank.

"Ironically, blacks—many of whom are now fighting to preserve the structures—were barred from the grounds except to work," the Tribune Editorial Board observed.

In the end, the neighborhood won. The buildings and grounds were renovated and now house the South Shore Cultural Center, which hosts jazz festivals, art exhibitions and lectures. Michelle and Barack Obama held their 1992 wedding reception there.

More recently, a couple was married on the property's great lawn under a chuppah, a Jewish wedding canopy. Black families picnicking nearby were transfixed. Offering congratulations, they said they'd never seen such a ceremony.

All in all, victory in the fight over the country club's remains went to a neighborhood resident who confronted a park official at a community meeting. According to the Tribune's report, the bureaucrat was pushing for downsizing the fairways.

"This community doesn't want a par-3 golf course," the man said. "What was good enough for the millionaires is good enough for us."

—RON GROSSMAN

CHAPTER ELEVEN:

Amusement

19th century Tinder? Personal ads.

Desperate and lovelorn turned to the newspaper's classifieds

In the summer of 1880, when a young woman of "good appearance" and "some money" went on the hunt for a husband, there was no online dating. No Match.com. No OkCupid. No eHarmony. No ChristianMingle.

The poor girl couldn't even swipe right on Tinder—today's social media solution for finding a date in a hurry.

So if fortune or family couldn't find her a husband, what was she to do? Advertise.

For mere pennies, one unnamed woman took out an ad in the Tribune and publicized her hope for a "widower with dark eyes, good height, and some means."

And if she were eager enough to tie the knot, she could have reached out to the two young gentlemen whose ads appeared just below hers, both with a similar goal: matrimony.

Exhibit A: "A young gentleman of high social standing wishes to form the acquaintance of a refined young lady. Object matrimony."

Not precise enough? Here's the other one: "A refined young gentleman of 25 (blonde)

wishes to cultivate the acquaintance of an intelligent, good-looking brunette not over 21. No coquettes need answer."

At the end of the 19th century, Chicago was booming. It was the second-most-populated city in the U.S. in 1890, a big step up from only 20 years before; the city had nearly quadrupled in size. Immigrants flocked to the burgeoning metropolis to work in the steel, meatpacking and railroad industries. While the West was being tamed, Chicago stood as the last beacon of civilized society before the wide-open wilderness.

And, boy, it could get lonely at the edge. Newcomers had few connections. For many, the ties that strung society together—families, friends, churches—were broken, frayed or left behind in the old country. Rather than wait for love or luck, some newly arrived Chicagoans took to the classified pages to attract a mate.

But there was a hitch in this plan to get hitched. While the practice of advertising for matrimony was nothing new (as long as there have been newspapers, there have been lonely souls searching for love in their pages), it was hardly the norm.

As Laura J. Schaefer, author of the book "Man with Farm Seeks Woman with Tractor: The Best and Worst Personal Ads of All Time," explained in a New York Times article, "meeting through the newspapers at that time was not considered respectable. The advertisers knew they were taking a step off the beaten path."

Still, it was a new era, a new place. For the first time, women began throwing their lot in with men on the personal pages. Matrimony ads acted as a great equalizer; they could break down traditional barriers and offer an escape route for young women trapped at home with few other options.

The ads really were the Tinder of their day— along with opportunity came fear. There is no solid number on how many successful marriages were sparked by matrimony ads, but a quick look through the archives reveals bold-faced headlines about practiced con artists cheating young lovers out of their fortunes: "Chicago woman arrested in matrimony swindle." And the ongoing saga of wealthy French-

men murdering their brides: "Latest French bluebeard used matrimony for bait."

In 1884, one Tribune journalist put it bluntly: "No man who has the ability or means to support a wife in comfort needs to advertise for one." In the writer's eyes, all ads were frauds. He claimed that "the woman who inserts a matrimonial advertisement is generally an adventuress—the man who does so is a wolf."

Wolf, indeed. The following year, another journalist decided to "hunt for a wife" in the personal pages. He had no shortage of options and found an added perk: "In reply to the question of whether a presentable man can, from the matrimonial journals, be sure of meeting with a wife who will pay his debts and enable him to soar to a better monetary position in life, I would answer yes, so long as he conceals his purpose from the ladies with whom he corresponds."

It could often be difficult to read into what the advertisers wanted, which added to the ads' less-than-savory reputation; in 1876, two daring "young gentlemen fond of amusement" expressed their wish "to make the acquaintance of two lively young ladies similarly inclined."

Or there was the "prepossessing, refined, educated, and respectable" woman searching for the friendship of a "gentleman of honor, who is engaged in business." No marriage needed, apparently.

Yet, just like today, there were happy stories of love hard-won. For those who chose this "method of securing a choice specimen," there was always the chance, however small, of finding a partner who offered affection, stability and financial security.

Occasionally one such story would find its way back into the paper, as it did in 1887, when the Tribune reported the roundabout tale of an Ohio man who answered a Galesburg merchant's ad for a wife. The Ohio man pretended to be a woman he knew, Nettie Ridgeway, and after several years, managed to get the merchant and Ridgeway together: "In three days, he was acquainted with 'N.R.' who was then a handsome young widow. Well, they are now living in Galesburg."

While those stories were few and far between, each ad gave readers a little hope when they read: "Object, of course, matrimony."

—ELIZABETH GREIWE

Personal ads that ran in the Tribune in 1872, 1876 and 1884, respectively.

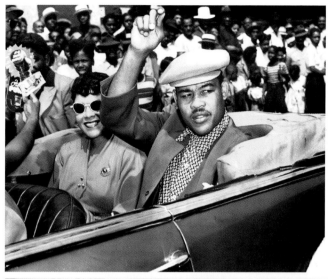

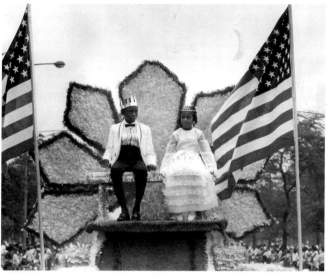

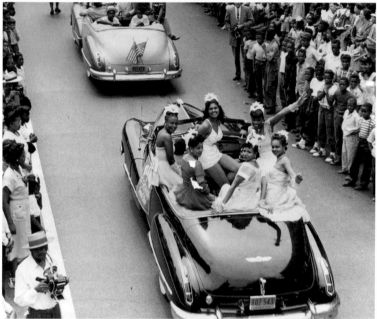

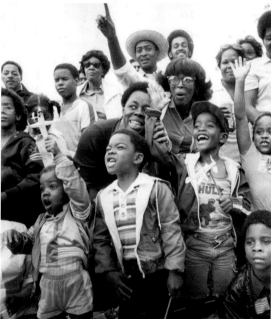

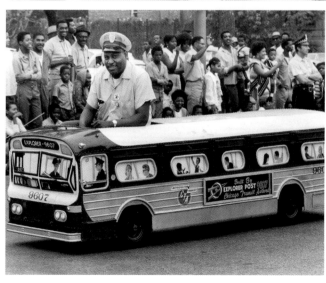

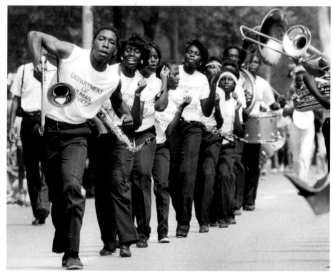

Bud Billiken marches on

Summer parade draws big-league celebrities

IT is hard to underplay the importance of the annual Bud Billiken Parade for Chicago's African-American community—and the whole city.

But at its roots, it's a parade, and kids love a parade.

In 1929, Chicago Defender founder Robert Abbott wanted to do something for the youngsters who sold his newspaper, so he arranged an outing at a South Side park. According to a Tribune story in 1975, the name was the brainchild of the Defender's executive editor, Lucius Harper, who was inspired by a Chinese figurine that Abbott kept on his desk. It was the mythical figure Billiken, who protects children everywhere. Harper added "Bud." The outing grew quickly to become a community-wide event that drew thousands of people to the Washington Park picnic and parade.

Even as it was becoming a can't-miss part of the summer for families, it developed into a can't-miss appointment for politicians who wanted to join the fun—and court the black vote. In 1940, Chicago "Mayor (Edward) Kelly and other civic leaders" gave speeches. In 1956, former President Harry Truman joined Mayor Richard J. Daley and Chicago Defender Publisher John Sengstacke at the head of the parade.

But despite seeing a president, plenty of U.S. senators and a flock of governors over the years, parade-goers in 1983 were truly star-struck. That year, the parade was led by Harold Washington, the city's first black mayor.

"I touched him," 12-year-old Paula Johnson was quoted as saying in the Tribune. Longtime parade director Marjorie Joyner, quoted in the 1980s, said that year's parade "was the best yet" because Washington was there.

Bud Billiken also has boasted a number of heavy-hitting celebrities and civic leaders, including boxing champions Floyd Patterson, Muhammad Ali and Joe Louis. Others included former Olympian Jesse Owens, the Rev. Jesse Jackson, then-U.S. Sen. Barack Obama, Oprah Winfrey, Michael Jordan and many other singers, athletes and entertainers.

But each year, two youngsters got to rule over them all. They were the parade's king and queen. In 1983, that honor went to Alvin Jefferson, then 11, who sold the most Defender subscriptions to earn the crown—and a free trip to Disneyland for him and his family. Jefferson, who said his family attended the parade "pretty much every year," remembers that time vividly. "It was really an eye-opening event," he told Flashback some 30 years later. "It wasn't just being a king for a day. It was almost a monthlong series of activities."

Jefferson said the whole experience changed the way he thought about himself and what he could do with his life. "It was definitely one of those experiences that you remember," he said.

—STEPHAN BENZKOFER

Opposite, clockwise from top left: Boxer Joe Louis and his wife ride along Michigan Avenue in the Bud Billiken Parade in 1948; the 41st annual parade in 1970; the crowd at the 1981 parade; marchers in 1982; another scene from the 1970 parade; South Side Beauties in 1948.

Summer fun: Go sit in a tree

Depression-era craze prompted untold number of kids to climb and roost

D URING the summer of 1930, America's kids took to the trees.

Long before social media linked the nation's youths, the tree-sitting craze raced across the country, infecting kids in Chicago, Wisconsin, New Jersey, Texas and numerous other states in just days.

The first Tribune story about this elevated endurance contest was published July 10 and reported that one Jimmy Clemons, a 10-year-old lad from Racine, Wis., had roosted in his tree for a record 36 hours, 15 minutes, forced down when his mother ruled that his piano lesson wasn't optional. Nevertheless, the "tree sitting stunt" netted him $12, a considerable sum for Depression-era America. Adjusted for inflation, that's $170.

Game on.

On July 13, the Tribune reported that numerous kids across the Chicago area were challenging Jimmy for the title, and that a 14-year-old Kansas City boy already claimed to have stayed "up" 40 hours. One report said 50 boys and girls across the Midwest were up a tree.

Three 12-year-old buds "occupied portions of a comfortably spreading tree on a vacant lot on the southeast corner of 61st Street and

Tree sitters Ray Shukis and Fred King in 1930.

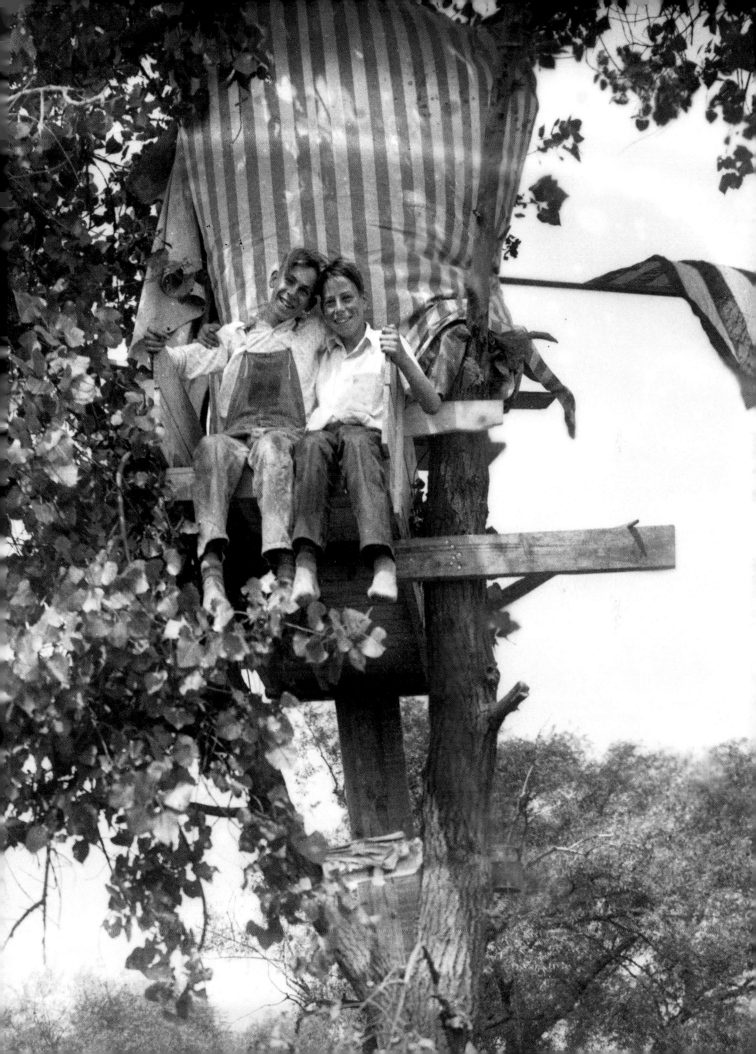

"As long as he doesn't fall out, the tree's a good place for him."

—MOTHER OF TEDDY ARVIDSON, A TREE-SITTER

Crawford (now Pulaski) Avenue." They sat in chairs strapped to branches; at night, one of the dads strapped them in the chairs.

On July 15, two Oak Park boys, Truman Kirkpatrick and Jack Harris, ended their verdant vigil after 115 hours, which meant they must have climbed into their oak tree just hours after reading about Jimmy Clemons. They each pocketed $4.50 for their trouble.

Endurance contests were common crazes in the era. Dance marathons had started in the 1920s. Various endurance bicycle events were even older. Flagpole sitting was a thing. Charles Lindbergh flew across the Atlantic in 1927. More immediately, the Hunter brothers, John and Kenneth, on July 4, 1930, ended a 23-day airplane flight in Chicago. Thousands flocked to Sky Harbor Airport to watch them end their impressive but mind-numbing circling. Many of the tree-sitting stories referenced the Hunter brothers' heroics.

Still, parents and authorities then didn't know what to make of the craze, something parents of Minecraft-obsessed children wasting away summer vacations can sympathize with today. One Chicago mother looked on the bright side. "I do think it's healthful," said Mrs. Harry Simpson, of 6235 W. Wabansia Ave., of her son Harold's new pastime. "Lots of fresh air and sunshine. And he and his pal … are having a lot of fun they'll never forget. They get their meals regularly, too. They don't go off and forget to come home."

For Teddy Arvidson, 12, of Chicago, the time wasn't wasted. "All the rest of the guys are doing it," he said. "I like it up here. Why, I've had time to read 'Fifteen Days in the Air' (the first in a popular aviation adventure series), and I don't even mind missing a swimming party Friday."

His mother added: "Teddy built his treehouse himself. We thought that since we aren't going on a vacation this year that he could do what he wanted to do. As long as he doesn't fall out, the tree's a good place for him."

But that was the rub. Lots of kids did fall, and while most were simply bruised or suffered broken bones, a few were seriously injured or even killed. By early August, unable to curtail the boys—and the vast majority were boys—Chicago police started targeting the parents for letting the kids endanger themselves.

And then, in mid-August, the stories stopped. Whether because of a conscious decision by editors to cut off the publicity and discourage the activity or because the kids climbed down, it isn't clear.

That silence lasted until 1952, when a Tribune columnist wrote about Leslie R. "Rhubarb" Davis, of Gibson City, Ill. Davis said he lived in an elm tree for 107 days, from July 31, 1930, to Nov. 14, and came down because he had broken all the records and it was "pretty cold."

When asked what it was all about, Davis offered as good an answer as any:

"I was just a kid," he said. "I hardly knew what I was doing."

—STEPHAN BENZKOFER

Opposite: Raymond Teivers and Charles Conover send up a basket to Jack Harris and Truman "Pat" Kirkpatrick, who ended their tree-sitting vigil after 115 hours, at the request of their parents. Many parents didn't know what to make of the tree-sitting craze.

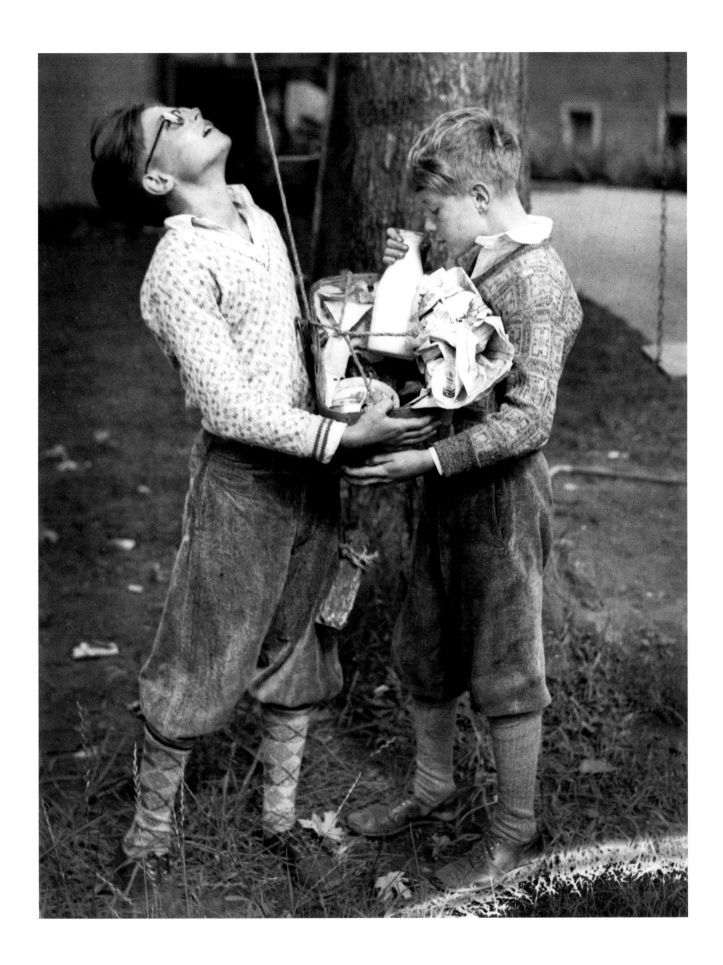

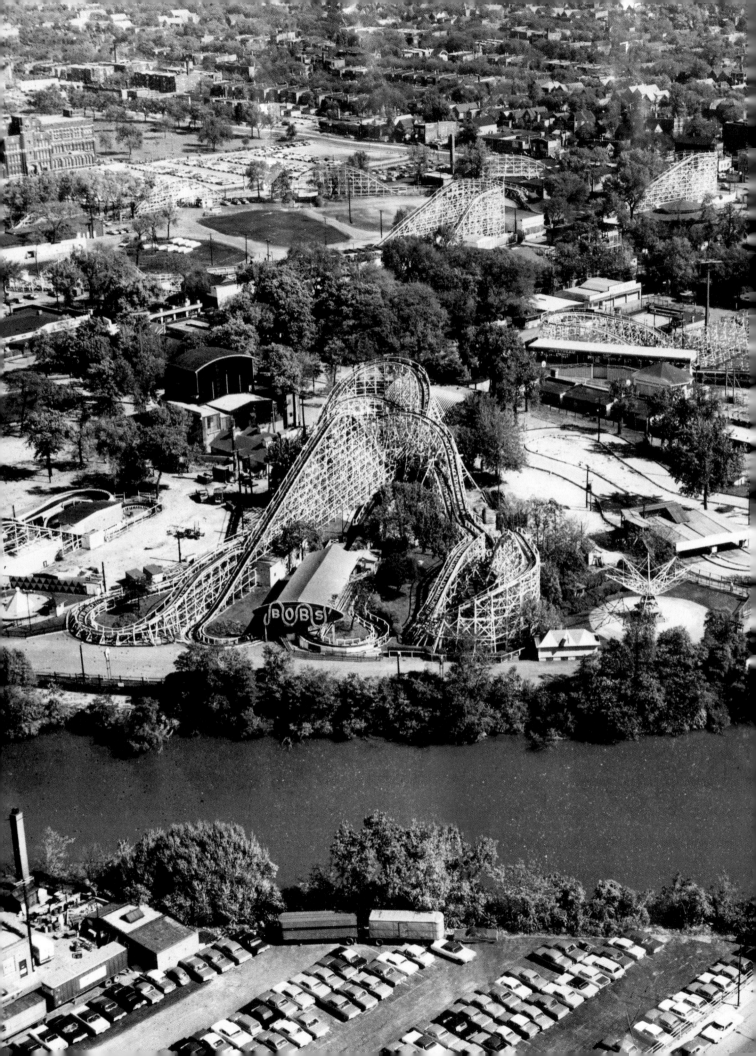

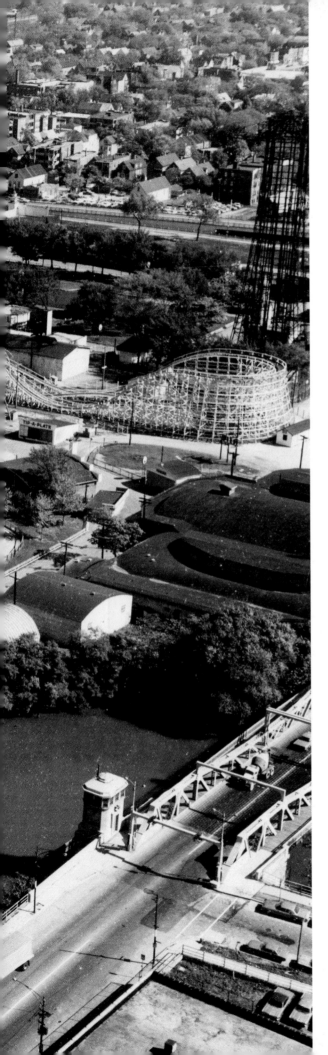

Remember Riverview?

Famous Western Avenue amusement park thrilled generations

F OR certain generations of Chicagoans, the stretch of Western Avenue between Belmont Avenue and Addison Street still conjures memories of just one thing: Riverview Park.

From 1904 to 1967, Riverview's roller coasters—the Bobs, the Comet and the Fireball—and its Aladdin's Castle fun house provided endless amusement for Chicago families.

In 1960, the surrounding streets were redesigned to accommodate the traffic and a Western Avenue overpass was installed. That flyover bridge—and a shopping center on the former park site—have become local landmarks for current residents, but now even that is changing. The deteriorating overpass was torn down in March 2016, and the streets were reconfigured—but the memories remain.

An aerial view shows a closed Riverview Park on Oct. 4, 1967. Belmont Avenue is on the lower right. See photos from the park's heyday on the following pages.

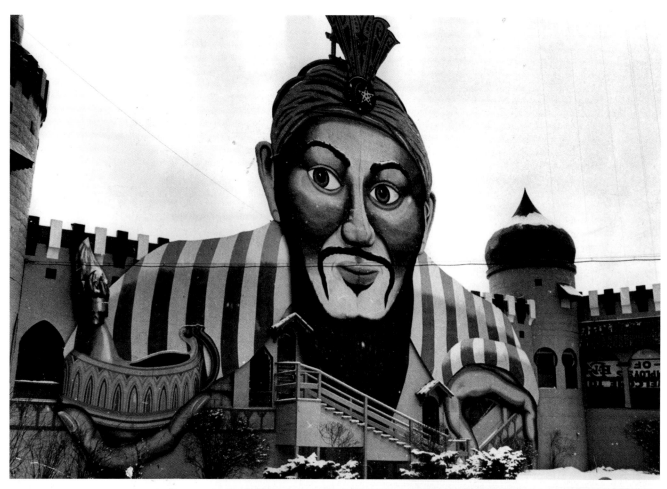

Above: Aladdin's Castle at Riverview Park in January 1968, the year the amusement park was torn down.

Right: Chicago American news carrier boys enjoy a ride on the Wild Mouse at Riverview Park in Chicago on July 17, 1962.

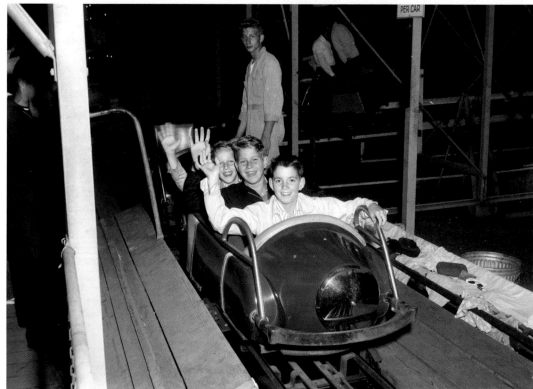

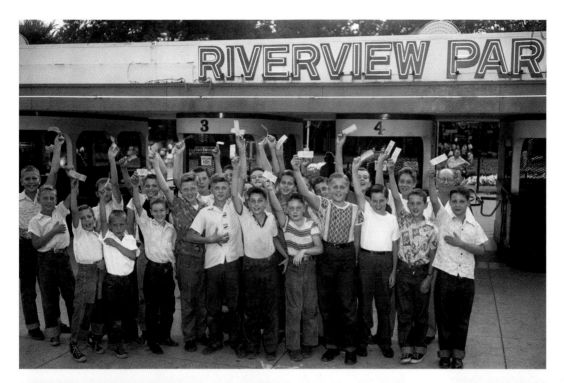

Left: Young Chicago American newspaper carriers standing at the entrance to Riverview Park wave their tickets for free rides on Aug. 15, 1955.

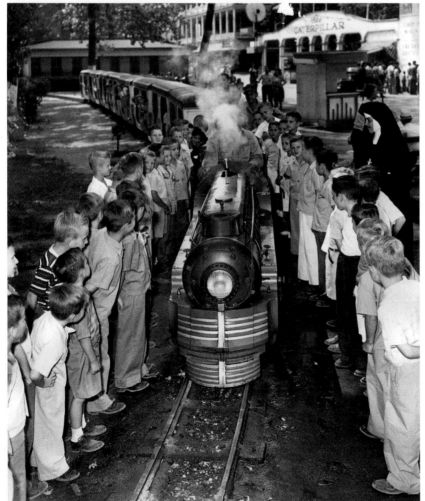

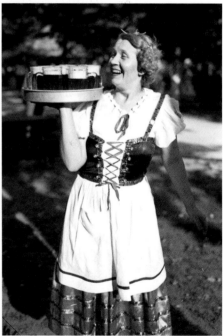

Above: Herta Hadeler carries beer at the German picnic at Riverview Park in 1939.

Left: Children from St. Hedwig Orphanage watch a train at Riverview Park on July 30, 1946. Sister Mary Oswalda, right, was in charge of the group of boys.

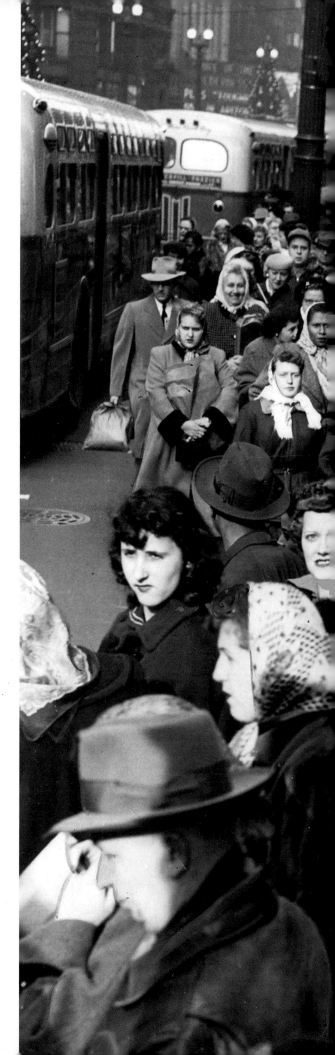

State Street magic

Holiday spirit had extra sparkle on Department Store Row

THE children in front press their noses against the windows, staring slack-jawed and wide-eyed at the magic of the department store window at Christmastime. Behind, kids are hoisted—careful with that hot chocolate!—on the shoulders of a dad, who enjoyed a similar perch when he was young.

Christmas hereabouts has long meant a trip or two to State Street, which for many years was a veritable Department Store Row. Yes, there were parades with elves and marching bands, carolers and holiday luncheons in Marshall Field's Walnut Room with its signature 50-foot tree. But maybe the biggest thrill was discovering what fresh enchantment those window designers would create each year.

Store windows often told a story in multiple chapters, as parents and children moved from one to another. "Starting at Randolph street and continuing south on State to Washington streets, Marshall Field & Company tells, in 13 scenes, the story of a Christmas eve dream-tour taken by two girls thru 'The Christmas Eve Dream House,'" the Tribune noted in 1960, also reporting: "Herald angels are posed to sound their trumpets in front of stained glass windows over the entrances to The Fair store."

Every major department store offered up a display, and many years the Tribune reviewed them like the productions they were. Besides Field's and The Fair, Carson Pirie Scott & Co.; Sears, Roebuck and Co.; Mandel Bros.; and

Stores like Mandel Bros., background, at State and Madison drew hordes of shoppers in 1952.

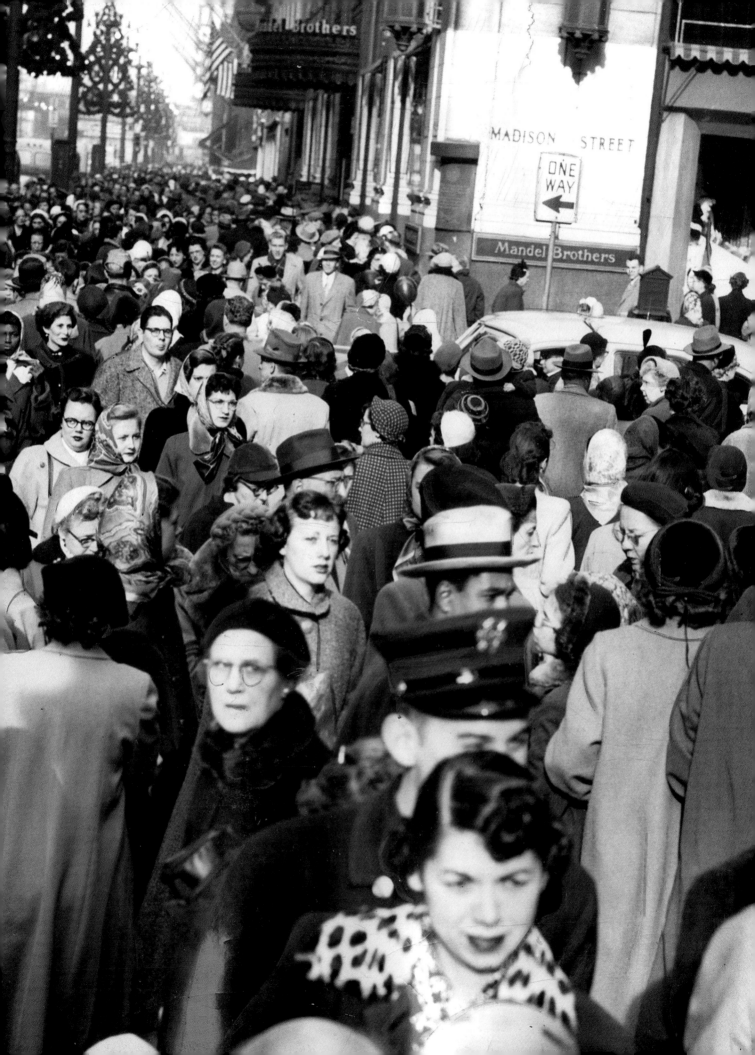

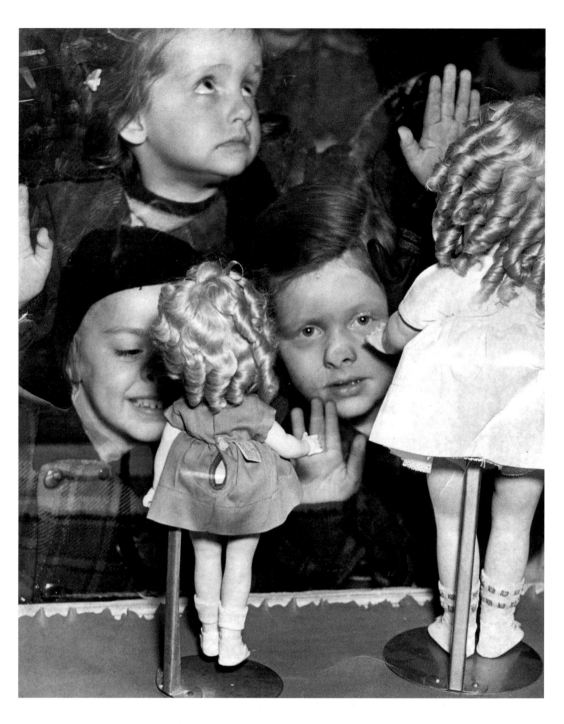

A toy-filled store window mesmerizes downtown fans, their noses against the pane, in 1936.

later Wieboldt's, after it merged with Mandel in 1960, all presented displays ranging from the traditional Nativity to outer space-themed holiday tales.

Before long, the cold would drive shoppers inside, which was the point all along, to buy gifts and, of course, to visit that jolly fat man with a white beard and red suit.

As early as December 1888, the Tribune reported, "Santa Claus is in town. . . . He trudges through fields of cotton wool in the shop windows. Sometimes he has reindeer; more often he walks in solitary majesty, with a Christmas tree across his shoulder."

A Tribune writer once imagined that the first live department store Santa was a newsstand vendor who had stood at Dearborn and Van Buren streets through too many 19th century winters. "When the toy department manager of the house approached him that November

afternoon and spurred his histrionic ambitions into life, there were snows and northwest winds in the old man's chest protectors."

Still, if that's how Santa got indoor work, other Kriss Kringles stood on Loop street corners, ringing bells for charity. Outdoors and indoors, the Santas of State Street were a fixture through good times and lean years. They heard girls wishing for dolls. "Or rather it is often 'Ein grosse Dollie,'" as the Tribune noted in 1901, when Chicago echoed with German and other Old World languages brought here by great waves of immigrants.

The bloodshed in World War I altered the tenor of boys' wish lists. "Christmas toys are not military this year," the Tribune reported in 1921. "Firemen, policemen, and motormen have supplanted the soldiers on the toy counters of loop department stores." Some Santas heard wishes for practical gifts. A Tribune writer who worked as a street-corner Kriss Kringle in 1914 asked a 7-year-old girl her wish. "Please, Santa Claus," she said, "will you bring us something to eat? My papa has been sick a long time."

The 1948 State Street parade included "11 giant balloon floats, including figures of Mortimer Snerd, Superman, Humpty Dumpty, a dachshund, a piggy bank, and a 60-foot Noah's Ark, with animals' heads bobbing from its windows."

Still, it wasn't just tinsel and glitter; human nature doesn't take a midwinter vacation. In 1900, a woman arrested for stealing a pipe in The Fair said it was a present for her husband that she had meant to pay for. "She was fined $1," the Tribune reported.

That same year, the paper told the tale of Robert Simpson, a "booster" or shoplifter, and not a good one, it would seem. Caught season

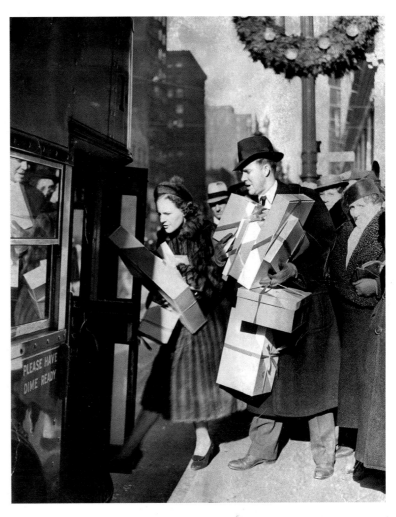

after season, the 24-year-old asked to be let go after being arrested at Siegel, Cooper & Co. on State Street. "It would be the only Christmas present I ever got," he told an unimpressed judge. "For the seventh time in seven years Robert Simpson will eat his Christmas dinner in jail," the Tribune noted.

Though most of Santa's haunts—the Boston store, The Fair, Mandel Bros. and Goldblatt Bros.—failed to survive the suburban mall exodus of the 1970s, the Christmas spirit still sparkles on State Street. Macy's continues Field's window traditions and Target moved into the Louis Sullivan-designed former home of Carson Pirie Scott.

So as shoppers stroll down that great street, they might still hear bells jingling, see fellow Chicagoans loaded down with packages—and watch the next generation of tykes being transfixed by the lights and sights of State Street.

—RON GROSSMAN

In 1937, a bus gives a lift to gift-laden shoppers at State and Madison streets.

For orphans, a yearly joy ride

Why shouldn't a needy kid get to enjoy a car ride and a picnic?

A T a time when automobiles were rare but orphans were plentiful, a tradition began in Chicago to bring them together. The idea was simple: Why shouldn't a needy kid get to enjoy an automobile ride and fun picnic in the park?

In 1904, five children from a local orphanage piled into a car and frolicked for a few hours in Jackson Park. The next year there were 12 youngsters. Within 10 years—and for the next 60 years—hundreds of cars (and occasionally some buses, trucks and taxis) were bringing upward of 5,000 children to a neighborhood park for an annual daylong festival of fun. The outings also included physically and mentally disabled children, and elderly people from rest homes.

The Orphans Automobile Day Association tackled the complicated logistical task of arranging for hundreds of volunteer drivers to pick up three or four kids each from homes like the Angel Guardian Orphanage at 2001 W. Devon Ave., Chicago Nursery and Half-Orphan Asylum on Foster Avenue, the Illinois Children's Home and Aid Society in Evanston and dozens of other facilities.

The children, from toddlers to teens, got as much food as they could eat: Hot dogs, ice cream and cotton candy galore. Year after year, the Tribune reported on the gallons of orangeade and pounds of Cracker Jack consumed. The kids were entertained by clowns and other performers, a traveling animal show from the Lincoln Park Zoo, a Punch and Judy show and their own imaginations. Through the years, it was held in Grant Park, Lincoln Park and the picnic grove near Riverview amusement park.

Interestingly, the tradition continued during World War II, when gasoline rationing and other shortages forced a number of beloved activities to cease for a few years.

Ron Hayes, 76, of Rogers Park, fondly remembered those picnics in the late 1940s. He moved to Angel Guardian in 1946 before fifth grade after his mother fell ill and was unable to

Left: In 1964, youngsters gather in Lincoln Park for food and fun sponsored by the Orphans Automobile Day Association. The tradition started 60 years earlier, when a car took five children from an orphanage to an outing in Jackson Park. Years later, hundreds of cars carried thousands of children, including those with physical and mental disabilities, to the daylong festival.

Below: Four-year-old twins enjoy a lunch in Lincoln Park during a 1937 Chicago Orphans Automobile Day outing.

care for him and his three siblings. He recalled the excitement he felt as the picnic neared and on the big day itself.

To keep order, the nuns brought smaller groups of children to wait for pickup at the front of the building. "The cars were lined up all the way down on Devon Avenue," he said. "The kids would jockey for position when they saw someone they thought they were going to like."

The orphanage "was a good place, good education, very strict," he said. "With that many kids, I guess you had to be strict."

But that made the annual outing particularly sweet. "It was free time at Lincoln Park for most of the day," he said. "It was really something."

—STEPHAN BENZKOFER

CHAPTER TWELVE:
Colorful Characters

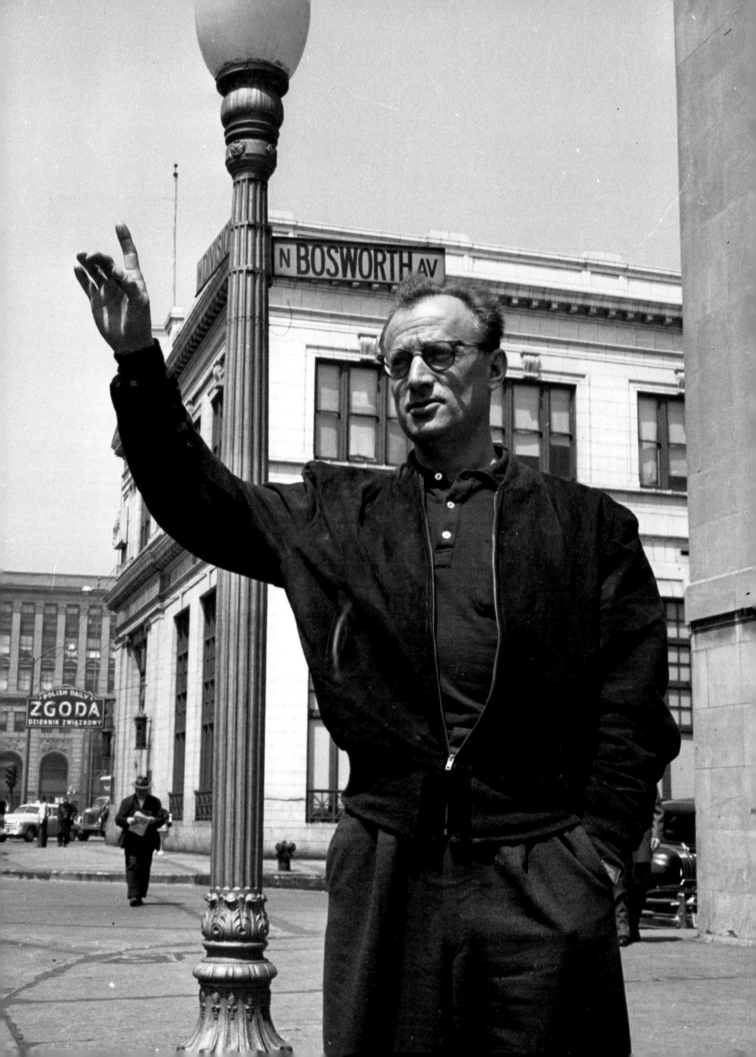

Nelson Algren

Chicagoans and famous author had complicated relationship

Nelson Algren works a typewriter on May 24, 1956, for a Chicago American story after the 1956 release of "A Walk on the Wild Side."

I N life, Nelson Algren and Chicago were star-crossed lovers. He wooed the city with a lyrical intensity that made comfortable Chicagoans uncomfortable. In death, however, Algren has been embraced by his hometown.

There is a memorial fountain in Polonia Triangle, the blue-collar neighborhood of Algren's stories and novels. Next to the Division Street stop of the CTA's Blue Line, the fountain is inscribed with a quintessentially Algren sentiment: "For the masses who do the city's labor also keep the city's heart."

His fans gather for scholarly and offbeat celebrations every year for his March 28 birthday, just as they have since his death in 1981. This newspaper sponsors the Nelson Algren Literary Awards, a short-story contest. An Algren museum honors the writer in the Miller Beach area of Gary, where he lived with his sometime lover, Simone de Beauvoir, the French existentialist writer.

Algren wrote gritty, urban tales such as, "How the Devil Came Down Division Street," a barroom debate over who is the neighborhood's biggest drunk.

In 1957, the Tribune wasn't so supportive of Algren. An editorial called one of Algren's novels his "latest dubiously edifying work." Noting that his books were populated by big-city lowlife, the editorial concluded: "Algren is inclined to assume that people who earn salaries and live in the suburbs are stuffed with kapok."

Polish groups pressured Chicago Mayor Edward Kelly to keep Algren's 1942 novel, "Never Come Morning," out of the Chicago Public Library.

> ## "Like loving a woman with a broken nose, you may well find lovelier lovelies. But never a lovely so real."
>
> **—ALGREN ON CHICAGO**

To give the movers and shakers their due, Algren's imagery wasn't the stuff of which tourist brochures are made. Paris is called the "City of Light." Rome is the "Eternal City." Algren's Chicago could be known as the "City In Need of Plastic Surgery."

He explained his love of Chicago with an analogy: "Like loving a woman with a broken nose, you may well find lovelier lovelies. But never a lovely so real," he wrote in "Chicago: City on the Make." Though now considered a masterly hymn to the city, it was greeted suspiciously in 1951. The Chicago Daily News, the most literary of Chicago's newspapers, said the book made the "Case for Ra(n)t Control"

Considering how Algren came to writing, it's not surprising he didn't craft well-tempered

Opposite: Nelson Algren at the corner of Bosworth Avenue and Division Street in 1956. The Chicago American wrote that he was back home to write a new novel with a Chicago locale.

novels like those of Henry James and Jane Austen. Tramping around the Southwest during the Great Depression, he stole a typewriter to finish his first novel, "Somebody in Boots." The theft landed Algren in a Texas jail.

At trial, his lawyer invoked "Les Miserables," the story of a hungry man who steals a loaf of bread and is ever after haunted by the transgression. Perhaps moved by the tale, the judge suspended his sentence and gave Algren 24 hours to get out of town.

Other jail inmates weren't so lucky. Algren's cellmates were no angels. But neither were the guards who beat them and the administrators who half-starved them, pocketing money earmarked for feeding them. From the experience, Algren distilled a repeated theme of his fiction: Fancy titles don't always differentiate the good guys from the bad guys.

In "Chicago: City on the Make," he stated it explicitly: "The hard necessity of bringing the judge on the bench down into the dock has been the peculiar responsibility of the writer in all ages of man."

It wasn't his muse but necessity that inspired Algren to hop freight cars. Algren had a University of Illinois degree in journalism, but in those lean years Chicago's newspapers weren't hiring. So he took his job search on the road, one of the legions of Americans looking for work.

He didn't find an editor who'd take him on, but in hobo encampments he was exposed to a slice of life light years distant from his family's middle-class world. His parents were Jewish but not observant. His father, by Algren's account, was "a fixer of machinery in basements and garages." His mechanical skills were offset by an explosive temper that regularly got him fired.

The family lived in middle-class neighborhoods, first in Park Manor on the South Side, then in Albany Park on the Northwest Side. The move was Algren's chief childhood trauma: being a self-proclaimed White Sox fan in schoolyards ruled by Cubs fans.

The young Algren was more athletic than bookish. In 1951, the Tribune's "Tower Ticker" columnist noted that Algren's teammates hoped he'd join them for a Hibbard (now Roosevelt) High School reunion at the Edgewater Beach Hotel. The school's basketball team, on which Algren played, won the city championship in 1927.

The column hinted that Algren might be a no-show. He had recently published "The Man With The Golden Arm," his breakout novel about a gifted card dealer and aspiring musician done in by his addiction to morphine.

Time magazine and The New York Times praised it. Algren was compared to Fyodor Dostoyevsky, the Russian novelistic explorer of society's lower depths. Director Otto Preminger made it into a movie staring Frank Sinatra.

The novel's financial success enabled Algren to buy a cottage in the dunes of Miller Beach in Indiana, where Simone de Beauvoir joined him. She was writing "The Second Sex," which made her a feminist icon. He was working on "Chicago: City on the Make," a love letter to the city.

It's just over 100 pages and hard to pigeonhole. In "Algren: A Life," Mary Wisniewski thinks of it as a guidebook. "Looking at Chicago after reading 'Chicago: City On The Make' is like looking at sunflowers after seeing the Van Gogh painting—the subject has changed because of the artist's vision." Algren noted that it's easy to love Chicago for its boulevards, beaches and museums. The hard part is loving it "For all our white-walled asylums and our dark-walled courtrooms, overheated district stations and disinfected charity wards, where the sunlight is always soiled and there are no holiday hours."

The Tribune, in 1951, predicted the book would appeal only to masochists. In the years that followed, Algren increasingly felt that Chicago wasn't returning the love he felt for it. In 1975 he left the city—exiting in Algren style with a rummage sale of the contents of his walk-up apartment at 1958 W. Evergreen Ave.

When he died six years later, a proposal to rename Evergreen Avenue in Algren's name was nixed because neighbors said it would confuse the mailman.

Yet perhaps that slight has been balanced by the renewed attention his books have enjoyed. Algren didn't care about having his name on a monument: "I'll be all right so long as it has been written on some corner of a human heart," he said. "On the heart, it doesn't matter how you spell it."

—RON GROSSMAN

Bill Veeck

Baseball's Barnum, legendary executive was major influence on White Sox and Cubs

White Sox owner Bill Veeck passes out free tickets to the next White Sox home game to cabdrivers on May 20, 1959.

MARY Frances Veeck had to think about the question for a few seconds: How would her late husband of 35 years, the legendary baseball executive Bill Veeck, handle being 100 years old?

"Bill at 100?" she finally responded during a 2014 phone interview from a South Side retirement complex. "Well, we're all trying to imagine him at 100, because he was always so active. But I'm sure he would have been fine being that age if he were still alive."

Veeck, born Feb. 9, 1914, was one of the most influential sports executives of the 20th century—the man who helped break the color barrier in the American League by signing Larry Doby to play for the Cleveland Indians in 1947 and four years later famously had a 3-foot-7-inch Chicago actor named Eddie Gaedel pinch-hit for the St. Louis Browns.

But while Veeck is recognized internationally, it is Chicago that claims the man who owned the White Sox twice and was a longtime resident of the Hyde Park neighborhood, where he died in 1986.

"He was real—a genuine person, and his personality helped identify Chicago to the world," said veteran television producer Tom Weinberg, a friend who co-produced the documentary "A Man for Any Season" about Veeck in 1985.

"He really loved living in Maryland (where his family resided from 1961 to 1975)," added Veeck biographer Paul Dickson. "But he had to go back to Chicago because it was where he belonged. All his friends were there—he was just a fixture in the city."

Veeck's centennial didn't garner the level of hype and attention received by Wrigley Field, which opened as Weeghman Park just a few months after William Louis Veeck Jr. was born.

But to some longtime baseball fans, Veeck's 100th birthday deserved the same hype as the Friendly Confines. That's because attending a baseball game on both the North and South sides would be unimaginable without Veeck's influence.

It was Veeck who, as a 23-year-old front-office executive for the Cubs, devised and oversaw the radical reconstruction of the Wrigley bleachers in 1937, which included the ivy-covered walls and hand-operated scoreboard.

It was Veeck who helped revive the White Sox, during his initial ownership of the team from late 1958 to 1961. In 1959, the Sox reached the World Series for the first time in 40 years. And during Veeck's initial stint with the team, he also introduced the first explod-

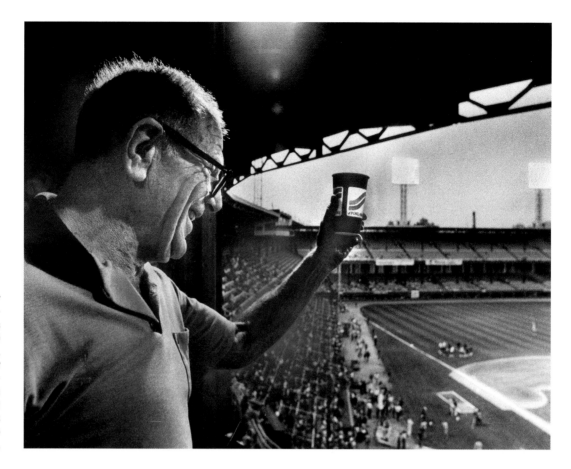

White Sox owner Bill Veeck acknowledges the cheers of nearly 19,000 fans on Sept. 30, 1980, in Comiskey Park during ceremonies honoring the 66-year-old baseball maverick's contributions to the game.

ing scoreboard and made his team the first to display the names of the players on the backs of their uniforms.

And it was Veeck who saved those same White Sox from moving to Seattle when he gathered investors to reacquire the team in December 1975 and keep it at Old Comiskey Park. During that second ownership stint, until 1981, he introduced even more timeless innovations—including then-Sox announcer Harry Caray's singing of "Take Me Out to the Ballgame" during the 7th-inning stretch, which is still a staple on the South Side and has been more famously adopted by the Cubs, first with Caray, then with a steady stream of singing celebrities.

"Baseball in Chicago was special to Bill," said Roland Hemond, who was Veeck's general manager during his second ownership stint with the Sox.

"That's why he came back the second time," Hemond added. "It would have broken his heart if the Sox left town, so he made every effort to keep the team there."

While Veeck's spirit will hover over Chicago baseball for years to come, some observers say his memory is somewhat slighted in the city today. True, a portion of Shields Avenue near the South Side ballpark has been renamed Bill Veeck Drive. And the press box there is also named for Veeck.

But after that…

"He's invisible," wrote David Fletcher, founder of the Chicago Baseball Museum, in an email to the Tribune. "The Sox press box is named after Bill with a plaque near its entrance honoring him, but the Sox fans don't see this. The Cubs have done nothing to commemorate their former Hall of Fame employee (Veeck was inducted posthumously in 1991), who is responsible for their most iconic features at Wrigley Field: the landmark-status scoreboard and ivy on the walls."

"It is very sad that such a historical figure is virtually ignored in the city where he was born and died," Fletcher wrote.

For their part, the Cubs honored Veeck as part of the Wrigley Field centennial in 2014,

but some observers say more could be done to permanently honor him at Wrigley, where the owner was a frequent bleacher spectator in the 1980s, holding court and handing out homemade lamb chops to unsuspecting fans.

"I know it's not an intentional slight, it's more of an out-of-sight, out-of-mind thing, but some sort of plaque should be in Wrigley Field recognizing Bill," said veteran broadcaster Tom Shaer, who covered Veeck's last years in Chicago. "His involvement with the ivy and the bleachers is a big deal."

It was at Wrigley Field where Veeck learned the business of baseball under his equally innovative father, William Veeck, the Cubs' president from 1919-33, who was responsible for adding the second deck to the stadium and who pioneered Cubs radio broadcasts; and club secretary Margaret Donahue, the first female executive in major league baseball and the first person in pro sports to sell season tickets to patrons.

Bill Veeck developed a lifelong fascination for concessions while working at Wrigley, first as a vendor, and eventually as head of concessions in the late '30s, when he employed a young scorecard vendor named Jack Ruby, who would later kill JFK assassin Lee Harvey Oswald, and bought paper cups from a salesman named Ray Kroc, who later created the McDonald's chain.

"Concessions was his thing," said Roger Wallenstein, a beer vendor for Veeck during his second ownership stint with the Sox. "So when we would talk after games, he was always interested in how I did and when the sales were the most brisk. Which made me feel like a big shot."

In addition to the ballparks, the memory of Veeck lives on in other parts of the Chicago area.

The five-bedroom colonial-style home where he grew up in Hinsdale—and where Veeck and his first wife, a circus performer named Eleanor Raymond, lived in an adjoining coach house—sold in 2017 for $1.35 million. Not too far away in Willowbrook, Eric Soderholm, who was one of Veeck's first free agent signings in 1976 with the White Sox, has a framed letter that Veeck wrote to the player's parents, praising Soderholm as "a fine ballplayer and just as important, a gracious gentleman."

"That was typical Bill," said Soderholm, who recalled being shocked when he met Veeck, who had his right leg amputated because of injuries suffered while serving with the Marines in the Pacific during World War II.

"This was in the winter of '76, when he was in the hospital (at Illinois Masonic) being treated for emphysema," Soderholm said. "I opened up the hospital door and he was sitting in his bed smoking, using the ashtray in his wooden leg for the ashes.

"He was larger than life, like a cartoon pirate."

Veeck is an icon for the longtime fans who attend Sox Fest every year. These fans remember Veeck's accomplishments—and his faults, including trading away talented future All-Stars like Johnny Callison, Norm Cash and Earl Battey for washed-up veterans during his first ownership stint, and Veeck's troubles maintaining competitive teams during his second stint.

"The dynamics of escalating salaries due to the advent of free agency (in 1975) made it difficult for him to stay in business," said White Sox historian Richard Lindberg.

Longtime Sox fans treasure those last Veeck years for the fun he brought to the ballpark, from the competitive 1977 South Side Hit Men to the promotions, including the controversial 1979 Disco Demolition event planned by Veeck's son Mike, in which disco records brought in by fans were blown up by radio personality Steve Dahl. That event ended with an on-the-field riot and a forfeited game.

Weinberg, the veteran TV producer, was one of the many investors the owner lined up when he bought the Sox in 1975.

"When the deal went through, there was a celebration in the Bards Room (the room in old Comiskey Park where Veeck entertained the press)," Weinberg recalled. "I remember Richard J. Daley showing up—he was a huge Sox fan and he loved Veeck."

"The first thing he did (after buying the team) was take off the hinges on his office door," Weinberg said. "Anyone who wanted to could walk into his office."

—RON GROSSMAN

Jane Addams

Hull House founder battled ward boss in bid to clean up streets

Nobody pushed Jane Addams around. Chicagoans know Addams as a leader of the social settlement movement and co-founder of Chicago's famed Hull House. But she was so much more. She was a tireless and strident peace activist, an invaluable voice demanding the right of women to vote and the winner of the Nobel Peace Prize. She became one of the most famous women in America and one of the most famous and highly respected Americans of her time.

She strongly felt that social services meant more than just feeding mouths and clothing bodies. Addams created a community, living with and getting to know the people she helped. She respected immigrant cultures, and provided education, training, citizenship classes and child care for working parents. She fought to improve their employment and living conditions.

Hull House, 800 S. Halsted St., where the museum stands, made an immediate splash. It was the local entry in the national social set-

The exterior of Hull House at Polk and Halsted streets on Jan. 8, 1956.

tlement movement that was such a hot topic in drawing rooms and lecture halls. An 1891 Tribune story described it as "the house of two young women who brighten and refine the lives of their neighbors and enlarge the surroundings of their horizon. They have made Hull House a pleasant and instructive home for all the neighborhood, where humanity and culture and hearty, gentle companionship are hourly felt, and where charity is but a pleasing and unnoticed incident."

But the gentle Jane Addams, whose father had been a banker and state senator, also turned out to be a politically savvy, down-in-the-wards street fighter, who wasn't so gentle when it came to public corruption.

Addams recognized that many problems in the squalid 19th Ward could be cleaned up if the city would help. So she sought the city contract for scavenger, that is, trash hauler and street cleaner. At that time, the city let yearly contracts to the lowest bidder—or the most-connected bidder—who would then hire men to clean the streets and alleys and remove the trash, animal carcasses and piles of manure. The contractor's goal was to make money, so generally he paid poorly, didn't hire nearly enough men and pocketed the difference. Those who were hired weren't supervised. In the 19th Ward, that led to dreadful, dangerously unhealthful conditions. But Addams' bid failed after the administration managed to quash it by ruling that her paperwork lacked a key affidavit claiming that she could actually do the work. She then managed to get appointed as a garbage inspector in the Public Works Department, overseeing the scavengers.

Addams' efforts to improve not just the lives of the "Hull House people," but also the whole ward, threatened the powers-that-were, namely Ald. John Powers, the as-yet unchallenged and undisputed boss of the ward. Powers had the garbage inspector post eliminated by ordinance and replaced by a job where only men were eligible.

"Gentle" Addams went after Powers, calling the ward king the "most corrupt alderman in this city, the owner of three saloons and a gambling room." Hull House put up candidates election after election but was unable to unseat

him. Powers, in turn, attacked Hull House and Addams, saying she was hurting the neighborhood's reputation and promising that he would run them out of his ward. In the end, Powers was too strong. As alderman, he employed or helped employ thousands of voters.

But Addams wasn't beaten either. The much-imitated Hull House grew, adding buildings, staff and programs every year. Addams wrote 11 books, spoke to hundreds of civic groups and traveled the globe fighting for the better world she so clearly envisioned.

The world took notice. A Tribune story quoted an Englishman who said, "Your American presidents come and go, and we in England often do not remember their names, but we all know Jane Addams and can never forget her."

—STEPHAN BENZKOFER AND RON GROSSMAN

Above: Jane Addams, circa 1933.

Left: Evangeline Wallace, left, teaches pottery to Domminick Randazzo, right, at Hull House in 1927.

King of the con men

'Yellow Kid' bilked country bumpkins, city slickers alike

WHEN talking about colorful Chicagoans, don't forget Joseph "Yellow Kid" Weil.

A regular entry on Chicago police blotters in the first half of the 20th century, Weil was dubbed the "king of the con men" by reporters who eagerly chronicled his nefarious schemes. He brought out the poet in headline writers. A 1924 Tribune story was titled: "Weil Loses His Sangfroid As Accuser Glares."

The lead paragraph wasn't too bad either. He was described as a "debonair fast talker who plants in the provinces and reaps in the cities"—a reference to Weil being an equal-opportunity swindler who fleeced country bumpkins and city slickers alike. In his later years, he worked the local, off-beat lecture circuit, claiming to have taken suckers for a total of more than $8 million. Yet when he died in 1976 at the age of 100, the Kid was virtually a pauper, leaving an estate of $195 in the form of a credit at the Sheridan Road nursing home that was his final address.

When the Lake Front Convalescent Center threw a party for Weil's 99th party, he told a Tribune reporter he had no regrets about what he had done with his life. "I'd do it the same way again," he said. Sometimes he claimed to be not a victimizer but a victim of reporters giving free rein to their imaginations in order to sell papers.

According to the Tribune, he told one judge: "The dastardly fabrications of the metropolitan newspapers, the reprehensible conduct of journalists to surround me with a nimbus—er—a numbus of guilt, is astonishing." Yet in his "Autobiography of a Master Swindler," he acknowledged his chosen profession, even as he bemoaned its decline. "There are no good confidence men anymore," he wrote, "because they do not have the necessary knowledge of foreign affairs, domestic problems, and human nature."

He certainly demonstrated more than a smattering of knowledge of those fields. He characterized the psychology underlying his working methods much as a judo expert explains how he turns his opponent's strength against him. He said: "A chap who wants something for nothing usually winds up with nothing for something." On other occasions, he defended his swindles with a Robin Hood twist. "He said he 'never took a dollar from a man who didn't deserve to lose it' because of greed," the Tribune recalled in Weil's obituary.

During World War I, Weil and his long-time confederate Frederick Buckminster swindled a Kokomo, Ind., banker out of more than $100,000, duping him "into purchasing fake stock in an Indiana steel mill by posing as representatives of German interests at a time when German ownership of American securities was embarrassing," the Trib noted.

Opposite: Starting in 1906 and for decades afterward, master swindler Joseph "Yellow Kid" Weil, shown here in 1952, was a regular on the pages of the Tribune. He died in 1976 at age 100.

Below: Weil, front left, in court on Dec. 9, 1949, when he was released on a charge of swindling $3 from the Little Sisters of the Poor. At right is Sister Ludwina of the religious order, and attorney John Phillips stands next to Weil.

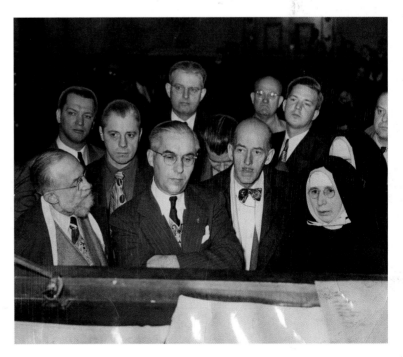

Bankers were a favorite target of Weil, who took a Fort Wayne, Ind., banker for $15,000 in a 1917 scheme in which a confederate posed as an Englishman. A year later, Weil had no less than six phony brokerage offices up and running, their supposed bona fides supported by fake letters on counterfeit stationery of J.P. Morgan & Co. "We have learned of several letters bearing the supposed signature of Mr. Morgan," an assistant state's attorney told a Tribune reporter.

But Weil was not above fleecing at the other end of the economic ladder. Under a 1949 headline: "The Yellow Kid Beats $3 Case By Technicality," the Tribune reported he pocketed a $3 check solicited on behalf of the Little Sisters of the Poor. Weil told the judge he'd be happy to give the nuns the money. "And I would have been happy to give you a year in the Bridewell (a nickname for jail) if the case had been submitted to me on the proper charge," the judge told Weil.

Like many other areas of his life, the story of Weil's nickname had several versions. It was attributed to his fancy-dan attire, a supposed taste for yellow gloves, spats and vests, an etymology Weil denied in his autobiography. Others credit it to "Bathhouse John" Coughlin, a turn-of-the-20th century alderman and protector of vice in Chicago's red-light district. Apparently "The Bath" hung the moniker on Weil in 1901, borrowing it from a comic strip character named "The Yellow Kid."

Weil was, in his own way, civic-minded. In 1928, doing time in the Leavenworth, Kan., federal prison, he sent letters to Chicagoans appealing for money so fellow inmates might properly celebrate Passover. He signed the letter: "Joseph Weil, president Jewish congregation."

He also felt strongly that there was a pecking order among gentlemen thieves, and Weil had nothing but contempt for one peer. In 1949, one Sigmund Engel, called "Chicago's marrying swindler" for defrauding women over a five-decade career, finally was being charged. As Weil commented, his "neatly trimmed mustache and parted beard fairly bristled," the Tribune noted. "There isn't a day that someone doesn't abscond with a woman's money," Weil

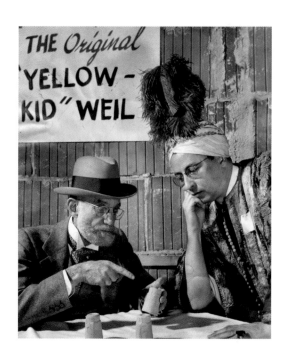

said. "Preying on the love of women for money is one of the most despicable ways of making a livelihood I ever heard of."

Though he could be proud, he wasn't above taking a blow to the ego—if it might save him from a stint in the clink. When Weil was charged in 1925 with writing a bum check, a court-appointed doctor from the "psychopathic laboratory" found the Kid had the intelligence of a 16-year-old. "He is foppish to the last degree, a moral imbecile, possessed of a busy brain that is eternally plotting against somebody but unaware that injury is being done to others," the psychiatrist told the judge.

Weill seconded the motion. "I can't defend myself," he told the judge. "Why the very learned Dr. Hickson says I have the mentality of a child of sixteen." He was sentenced to 30 days in jail.

And he could wax philosophically on the vagaries of human existence, as in 1925, when he lost a Sheridan Road hotel he owned for failing to make his loan payments.

"Life is a funny proposition, after all," he told a Trib reporter. "We are born, we live a while, and then some one forecloses the mortgage."

—RON GROSSMAN

"Yellow Kid" Weil, left, gives mystery novelist Milton K. Ozaki a lesson in the shell game at a Chicago party in 1947. "A chap who wants something for nothing usually winds up with nothing for something," Weil once said.

Polish Robin Hoods

Burglar brothers spent years in the headlines—and behind bars

NEWSPAPER editors long indulged Chicagoans' fascination with bad-guy antiheroes like Al Capone and John Dillinger. Yet few got as much ink as the Panczko brothers, the self-styled Polish Robin Hoods.

Joseph "Pops," Edward "Butch" and Paul "Peanuts" were a trio of burglars, adept at picking locks, popping car trunks, and getting charges dropped and trials postponed.

From the 1940s through the 1980s, they generated headlines like: "Panczko Tries to Buy His Way Out of Jam," (1958), "Once Again Pops Panczko Beats the Rap" (1959) and "Butch Panczko Arrests Hit 78" (1960). The Chicago Crime Commission calculated that Pops got 119 continuances on felony charges in a 2½-year period.

In fact, all of the brothers spent time behind bars: Peanuts served 26 years, and Pops was sent to prison 12 times. When they were scheduled to be released virtually simultaneously, the Tribune headlined the story: "Lock all doors, here come the Panczko boys."

Butch was in the clinker for only 10 days, suggesting that he had the most adroit lawyers.

The mountain of pilfered goods they piled up was all the more remarkable considering those court-ordered timeouts. Summing up his career in 1986, Pops told a hushed courtroom: "All my life, I stole. That's what I do."

The brothers' heists were legion. They stole 12,000 electric razors from an Oak Park warehouse. Peanuts robbed a Florida jewelry shop, attempting to flee in a motorboat with $1.75 million worth of diamonds, rubies and emeralds. Butch got caught trying to redeem 6,254 stolen trading stamps in a department store. Ever the Teflon brother, he was fined $1 for the caper. Arrested for a tavern brawl, Butch and the patron he was wrestling with told the judge they weren't fighting, they were dancing a waltz.

The son of Polish immigrants living on the Northwest Side, Pops, the eldest brother, came to his trade helping his parents make ends meet

Edward "Butch" Panczko, from left, and his brothers, Paul "Peanuts" and Joseph "Pops," fed Chicagoans' fascination with antiheroes.

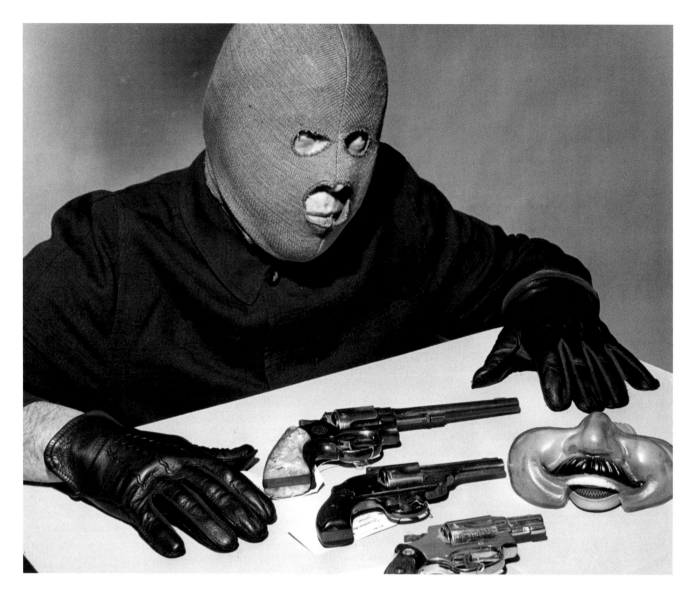

A detective wears a hood and gloves seized in the home of Paul "Peanuts" Panczko in 1964. The revolvers also were found there.

during the Great Depression. As an 11-year-old, he stole chickens at the Fulton Street market and peddled them to hard-pressed neighbors, three for a buck. Over the years, those childhood adventures ripened into the Chicago legend of Polish Robin Hoods.

U.S. District Judge Brian Duff didn't buy into it. He scoffed at the notion that Pops was "some sort of Robin Hood character" when sentencing him in 1986 to four years for stealing $250,000 worth of gems from a jewelry salesman's car.

Still, if the judge disdained Pops, the brothers were neighborhood celebrities.

In 1957, a detective spotted Pops at Ricky's, a delicatessen at Division and California. When the cop tried arresting him, Pops re-sponded with a shove to the chest. Butch happened upon the scene and joined in the fray. Customers and a waitress rooted for the bad guys and jeered the detective. Years later, Peanuts married a waitress who worked at Ricky's, explaining that she sent him salamis while he was doing time in Tennessee. After her, he took a fourth wife, telling the Tribune: "She doesn't want anything from me. She just wants me out of crime."

Puzzled by Pops—"He bemoans his arrests but seems eager to boast about them"—a judge ordered a psychiatric examination. The shrink pronounced Pops a "sociopathic personality . . . not amenable to treatment." Pops did exhibit wild, emotional swings.

Escorted into one courtroom, he lightheart-

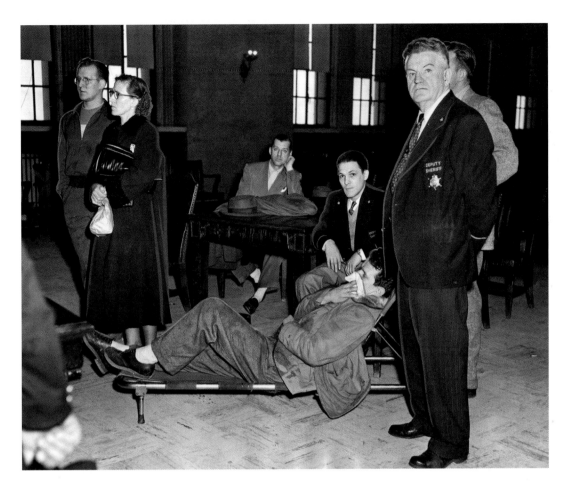

Edward "Butch" Panczko, shot by police who broke up a currency exchange burglary, is carried into Judge Thomas E. Kluczynski"s courtroom Feb. 24, 1951. At left are Panczko's sister, Louise, and brother John.

edly told a bailiff: "If you see a coat in here that you like, let me know and I'll steal it for you."

Convicted of burglary, he left court morbidly thinking he'd die in prison. "You see me again at my wake," he called out to a relative.

The years were increasingly unkind to Pops. He was constantly tailed by the police and booked on the slimmest of evidence. It was said that the one name every Chicago cop could spell was P-A-N-C-Z-K-O.

Once Pops was picked up because his car was parked in front of a jewelers convention. Another cop found a ring of auto ignition keys in Pops' pocket. At the time, he didn't have a car or a driver's license.

"The cops are driving me goofy, tailing me so I can't make a living," Pops complained to John O'Brien and Edward Baumann, Tribune crime reporters who chronicled the Panczko brothers.

Pops' family life went south. Butch died in 1978. Peanuts "flipped," testifying in 1986 against Michael Karalis, an accomplice of his

and Pops' in a jewelry robbery in South Bend, Ind. Pops also became a prosecution witness, explaining Karalis had denied him a fair share of the loot.

"If he had given me the right cut, I wouldn't be here today," Pops said on the witness stand.

Peanuts disappeared into the federal government's witness protection program. Pops was sentenced to four years; Karalis got a suspended sentence, despite two previous convictions.

Pops emerged from prison in 1989, not so much determined as compelled to be an honest man. "I'm over with crime," he told O'Brien and Baumann. "I'm getting too old. My feet hurt."

Pops, who died in 2002, suffered a final indignity. He was living with a sister in 2000 when robbers posing as gas company workers conned their way into the home. A nephew chased them out, and the police theorized that Pops was targeted for being old and infirm.

"What goes around comes around," said Sgt. Richard Rybicki. "There is a God."

—RON GROSSMAN

Daniel Burnham

Famous architect's name conspicuously absent when 1909 plan unveiled

MANY men and women helped raise Chicago out of the ashes of the Great Fire of 1871 and transform it into the major city it would become in the 20th century, people such as Marshall Field, Charles Wacker, Aaron Montgomery Ward, Potter Palmer, Jane Addams and the Mayors Carter Harrison (father and son). And it is only fitting, in a city renowned for its skyline, that an architect would rival those giants of their day for his lasting fame and enduring legacy.

When Daniel Burnham's Plan of Chicago was presented in 1909, he already was widely acclaimed for his globe-trotting urban planning, with projects in San Francisco, Washington, D.C., and Manila, Philippines. He was hailed for wrestling the vision of the 1893 Columbian Exposition into wildly successful reality.

Firms bearing his name erected numerous famous structures, including the Rookery and Masonic Temple (since torn down) in Chicago, the Flatiron Building in New York City and Union Station in Washington.

Yet when the plan that has become synonymous with his name was actually unveiled to the public on July 4, 1909, he barely received a mention.

Burnham first appeared in the Tribune in 1883, at age 37, in a Q&A about the "prevailing styles in residences and public buildings." He reappeared in November 1884 being elected chairman of the newly founded Western Association of Architects convention.

Burnham's burgeoning reputation was truly burnished, though, after not only over-

The portrait of Burnham that ran with his obituary in the June 2, 1912, edition of the Tribune.

seeing the construction of the world's fair in 1893, but also designing and implementing many aspects of the dignified City Beautiful Movement showcased in that wondrous White City.

So when the Chicago Merchants Club commissioned the plan from Burnham in 1906, it was done with much fanfare. The Page 1 lead story in the Tribune on Oct. 27 proclaimed: "SEE NEW CHICAGO GEM OF AMERICA."

"The future Chicago is to be made one of the most artistic cities in this country—one of the world's show places," the Tribune intoned in the story. And a good deal of the excitement— and the energy behind the expectations—lay with the name attached to the plan. "Burnham in charge," one secondary headline declared.

The story set a high bar for success: "Daniel H. Burnham, the veteran architect . . . will

"The future Chicago is to be made one of the most artistic cities in this country—one of the world's show places."

—TRIBUNE ON BURNHAM'S COMMISSION, 1906

have general supervision of the work. He has donated his services and intends to make the Chicago plan in its entirety the masterpiece of his life."

The city was abuzz with possibility. The Progressive Era was in full swing, civic leaders envisioned shining cities that had sloughed off their 19th-century social problems, where children were being educated instead of working or running wild in the streets, where the horrible "smoke nuisance" that blotted out the sun in Chicago was finally blown away, where streets clogged by wagons and horses, pedestrians and streetcars were untangled and transformed into wide boulevards, where the lakefront wasn't a rail yard but a park.

What they wanted was Burnham's White City from 1893 writ large.

Burnham recognized that and had been encouraging it for years. In 1902, while working on plans to beautify the National Mall in Washington, he explained how the fair had energized the population. "It was Chicago with its World's Fair which vivified the national desire for civic beauty," he said.

When the project was launched in 1906, it had a skeleton and a bit of muscle. The Oct. 27 story talked of an outer parkway built into the lake on landfill and extending the length of the lakefront, a system of public squares and boulevards, and better traffic regulation. Here also, Edward Bennett, who would eventually get his due as co-author of the plan, was mentioned as Burnham's chief assistant.

"Chicago has a great civic asset in Mr. Burnham," said Charles Norton, president of the Merchants Club, in describing his hope that the city could "cut out all petty jealousies" to create and implement the plan.

The Plan of Chicago was anticipated with some flourish on July 4, 1909. The Tribune ran advertisements urging readers to make sure they reserved a copy of the Sunday edition so they wouldn't miss the special, color section showcasing Jules Guerin's beautiful paintings, which illustrated "the plans of Architects Burnham and Bennett" and were sure to inspire all citizens.

The Burnham-centered hype from 1906, subsequent stories and headlines over the 30 months, and advertisements just the day before, made the tone of the actual announcement even more striking: Burnham was barely mentioned. Instead, "Commercial Club workers" issued the report, according to a headline. (The Merchants Club merged with the Commercial Club in 1907.) The story emphasized how the plan represented "the composite production of many minds." It praised Guerin and other artists for "pictorializing the ideas of the architects," who remain anonymous until the end of the 80-inch story, and even then received short shrift. Bennett wasn't mentioned at all. Burnham was referenced in passing only as a member of the committee.

While the Tribune went the furthest in burying Burnham, other newspapers of the day took a similar tack. The Inter Ocean gave

"A great man was Daniel Hudson Burnham, [...] a man of power whose power was founded on faith— faith both in the big thing to be done and in the desire and capacity of the people to do it in the best way."

—HARRIET MONROE, 1912

Burnham and Bennett one-sentence credit for preparing the plan. The Chicago Daily Journal went so far as to say the book was the result of 30 months' work by the two, though both papers failed to give credit on the front page. (Interestingly, while no paper appeared to actually talk to Burnham, the Chicago Daily News quoted Edward Bennett—and that on its front page.)

The Tribune story instead praised Charles Norton for conceiving of the need for the plan and making it happen.

And unlike the launch story and later articles that stressed the "City Beautiful" and progressive ideals of a more livable metropolis, the July 4 Tribune report emphasized the importance of the plan in raising property values and bringing great wealth to the city's businessmen.

Did the petty jealousies breach the relationship between the Commercial Club and Burnham? Maybe the Commercial Club's leadership—including Burnham—felt that the plan was bigger than any one or two people, and they wanted to present the plan on its own merits. Also possible was that the severe economic downturn in the Panic of 1907 had sobered Chicago's business community and focused its attention on the ways the plan would help the recovery. Whatever the reason, the jettisoning of the star architect was a remarkable about-face.

What made the Plan of Chicago such an important document, though, was the implementation. If, after the unveiling, the 1,650 copies that were distributed to the mayor, aldermen, governor, legislators and libraries had just gathered dust, we wouldn't be writing about it.

Less than 18 months later, in a major breakthrough, the Illinois Central Railroad agreed to trade prime lakefront land on the south side of Grant Park, roughly from Roosevelt Road all the way to 51st Street, for land elsewhere. That erased a major stumbling block to the idea of creating a continuous park running the length of the city, and it provided a much-needed location for a big new attraction: the Field Museum. Burnham wasn't part of these negotiations, or at least received no credit or mention, but the Tribune did highlight in a separate short story how his plan informed the project. Another notable plan success would come a few years later when work would begin on the Municipal Pier, today called Navy Pier.

Burnham wouldn't live to see much of his plan implemented. He died while touring Europe with his family on June 1, 1912. His obituary ran on Page 2 of the Tribune. It called him "designer" and "founder" of the Chicago Plan, praised him as an industrious visionary and as a giant in his field.

But an appreciation by Harriet Monroe that followed about a week later offered a more fitting eulogy: "a man of power whose power was founded on faith—faith both in the big thing to be done and in the desire and capacity of the people to do it in the best way."

—STEPHAN BENZKOFER

The Washington Porter clan

The rise and fall of Chicago's very own dysfunctional millionaire family

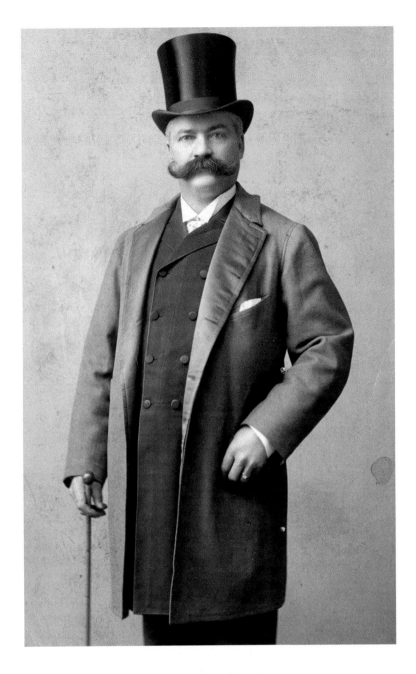

Chicago businessman Washington Porter was the president of Porter Brothers Co., a fruit trading company that was the first to ship fruit to Chicago via a rail car.

Washington Porter made his fortune putting California fruit on Chicago's tables.

In 1869, he and his brother, who lived on the West Coast, partnered to ship fresh produce by rail. Then the Civil War veteran took his money and wisely invested in real estate, buying up parcel after parcel in Chicago after the Great Fire of 1871. By the late 1880s, he was one of Chicago's elite, a major player and a civic leader.

Porter lived in what may have been the golden age for wealthy businessmen in Chicago, when the moneyed class was held in high esteem as it helped mold the city into the metropolis it would become, often against the wishes—or at least without the help of—the town's elected leaders. For the Porter family, it was the best of times.

It wouldn't last.

And all of it played out publicly in the newspapers (not unlike, say, the Kardashians).

The grand civic visions of Washington Porter devolved into the tone-deaf high jinks of son Washington Porter Jr. The family's real estate savvy was forgotten amid accusations of being absentee landlords and failure to pay property taxes. The settled decorum of Lake Park Avenue money was frittered away in unseemly intrafamilial spats, lawsuits and bizarre projects.

For Porter Sr., the peak may have been 1893, when his name was not only floated as mayoral contender, but he also served on the prestigious board of directors for the wildly successful 1893 World's Columbian Exposition. In a Tribune profile published the week before Thanksgiving, shortly after the World's Fair closed, Porter was described as "one of Chicago's opulent citizens, a typical Westerner, and withal a character."

It is easy to imagine the Porters coming together that holiday, friends clapping Washington on the back and commenting on the glowing article.

The good press wouldn't last. Signaling

early that the 20th century wasn't going to be their time (or possibly simply that they lived in a very large house), the Porters were robbed four days before Thanksgiving 1900.

The brazen burglary occurred at their impressive brick mansion at 4043 Lake Park Ave. The thief climbed a pillar on the front porch, ransacked "Mrs. Porter's bed chamber" and stole jewelry and money. The Porters were home eating dinner at the time.

In 1910 and in 1914, Porter Sr. was indicted on charges of "keeping an immoral place." The frustrated authorities acted after Porter ignored numerous requests to monitor his properties. Nothing came of either case.

Eight months after her father was accused of being an absentee landlord, daughter Pauline was given a $72,000 building as a wedding gift. She confirmed her upbringing by commenting, "I don't worry about the address. The building is under a ninety-nine year lease, and as long as the rent money comes in, the address doesn't make so much difference." The Tribune played the eight-paragraph story on the front page under the headline: "Miss Pauline Porter Does Not Know Where It Is, but She Should Worry."

Thanksgiving in 1919 was no doubt an exciting affair as the family got to meet Washington Porter Jr.'s new bride. Junior had been attached to the U.S. legation in Copenhagen, Denmark, during World War I. In late summer 1919, he returned to Copenhagen, ostensibly for vacation,

but he sent a cable in early September with the surprise news that he was married.

Just six weeks later, Signe Dorothea Berg-Hansen Porter was on a train heading back east to catch a steamship to Europe, the marriage in shambles. The public wouldn't learn of it, though, until she filed for divorce in September 1920.

At that time, Porter Sr. told the Tribune that the troubles came as a complete surprise. "I had no intimations of a divorce suit," he said, but then described what was surely an odd arrangement for newlyweds: "My son left Chicago two weeks ago for a tour of foreign countries. I imagine he is in South America by now. His wife left Chicago for Denmark some months ago. I knew of no trouble between them."

But the "Danish girl bride" told a different story when the Tribune's Foreign News Service caught up with her in Paris. She said her father-in-law had pushed her out, buying her that railroad ticket–for Christmas Day, no less–"because my husband's cruelty was such that he feared that I might make charges resulting in his son's arrest." She said she had to pawn her Christmas gifts to pay for the steamship ticket.

Bad news comes in bunches, and Thanksgiving 1920 was likely a smaller, somber affair. Less than a week later, on Dec. 2, the Tribune reported that Pauline had divorced her husband, John Clay Muirhead, and won custody of their three children.

The story laid out the salacious details: Muirhead's infidelity, his promise to reform and then the private detective catching him in New York in the company of an actress from Ziegfeld Follies.

Porter Sr. died in 1922, just months after seeing Pauline marry Dr. Mark White. Senior had been in poor health ever since a stomach operation the year before, and he reportedly died of complications from the procedure.

The entrepreneur who had parlayed a fruit business into a real estate empire worth $4 million ($95 million in today's dollars), and whose grandiose plans were once front-page news, received a four-paragraph obituary on Page 19.

After the patriarch's death, the family's reputation took a nose dive, and Junior seemed to be at the center of it.

Washington Porter Jr., shown admiring artwork in 1941 in his Lake Park Avenue mansion, seemed to be at the center of his clan's reputational nose dive after his father's death.

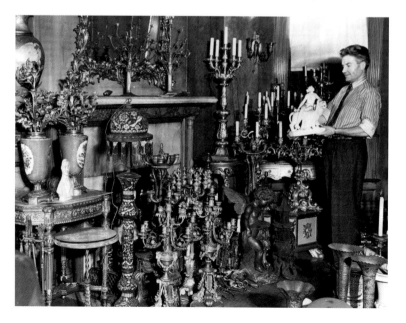

In 1931, Frances Lee Porter, his own mother, sued Junior for a million dollars, claiming he had abused her trust and was stealing from her. He responded by threatening to throw her out of the house they shared, and then accusing his mother's maid of stealing $10,000 in silverware.

The courts frowned on his behavior, ordering him to return his mom's money and pay the maid $500 for the false arrest.

It was also in the early 1930s, as the nation was in the depths of the Great Depression, that Junior announced plans for "a little World's Fair," maybe trying to grab some of his father's civic magic.

He said the elaborate structure being built in the backyard of the Lake Park Avenue mansion, planned to house his extensive art collection, would include a 150-foot-tall tower topped with a large, illuminated winged sphinx made of glass.

The Tribune reported, "The cost of the entire project, including sunken gardens, an arcade or double walk, terraces, and roof gardens, has been variously estimated at between $300,000 and $500,000."

The tone-deaf millionaire laughed off the cost of the Depression-era project, which he called "my Kiosk Sphinx": "O, it wouldn't be modest for me to tell," he told the Tribune. "I've really lost track anyway. I know I've found that one can write a lot of checks in five years."

Maybe not coincidentally, at this same time, Junior's name was included in a list of property owners who owed thousands of dollars in back taxes, and a law firm sued him for unpaid bills.

Frances Porter's death in May 1935 sparked a new round of lawsuits after she left the bulk of her estate to Pauline.

As if this weren't bad enough, Junior was sued in July by Dorothy Farwell Kolb, who accused him of scamming her out of thousands of dollars and a diamond ring while courting her and pretending he would marry her if she got a divorce.

Junior's financial woes and tax problems came to a head in September 1939 when the Cook County sheriff was ordered to seize personal property from the mansion to pay more than $50,000 in back taxes. Shortly after, Por-

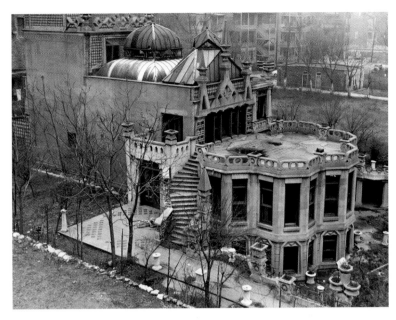

"I've found that one can write a lot of checks in five years."

—PORTER ON THE COST OF HIS "KIOSK SPHINX," 1933

ter was forced to leave the family mansion and the Kiosk Sphinx Museum.

The once-handsome home met the same fate as the family. In 1942, "an army of 200 kids" ransacked the place, carrying away souvenirs. The Tribune reported seeing a young boy "lugging away a miniature head of Medusa, done in marble, snaky locks and all."

In 1946, the "imposing red-brick mansion" was the poster child for abandoned buildings, the home for "hordes of rats." It was razed in 1957.

Porter's final days appeared to be spent at the periphery, staying at hotels with his long-time secretary Robert McDonald, but skipping out before paying.

Washington Porter Jr.'s last appearance in the Tribune was Dec. 5, 1943. In a one-paragraph brief on Page 27, the newspaper reported that the 49-year-old and his last friend were being held after skipping out on yet another hotel bill.

—STEPHAN BENZKOFER

Washington Porter Jr.'s Kiosk Sphinx, built in the 1930s in the backyard of his South Side mansion, included a large sphinx made of glass. The architecturally bizarre building was torn down in 1957 to make way for a Chicago Housing Authority project.

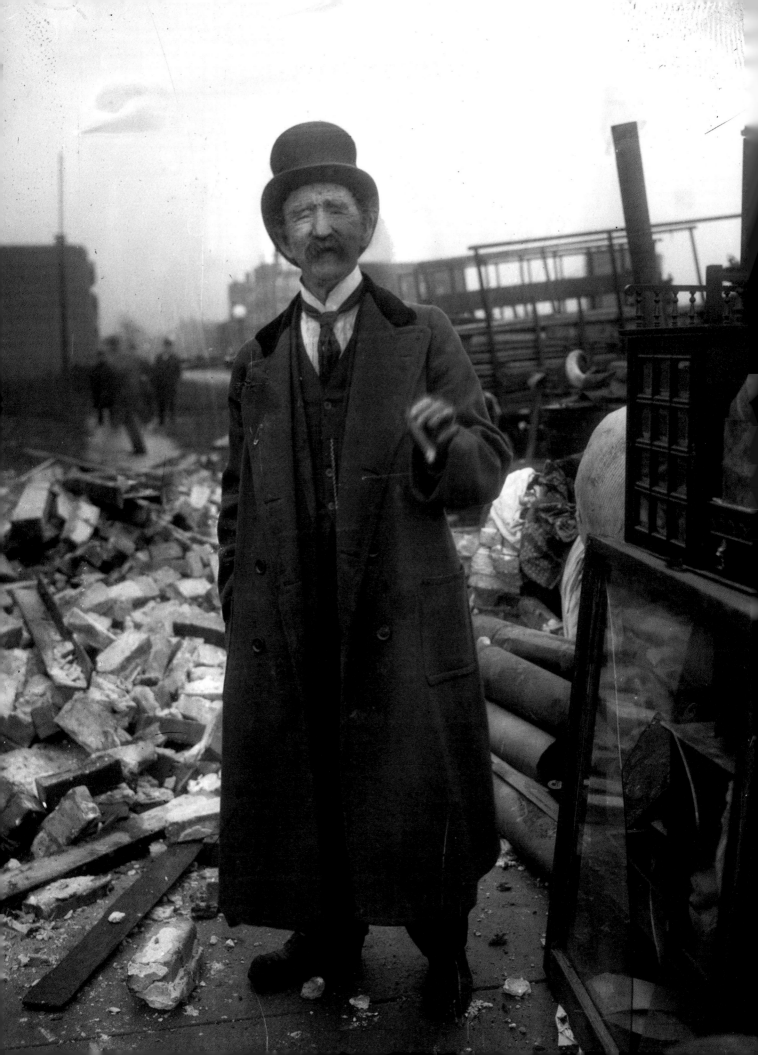

Captain George Streeter

How a sandbar in Lake Michigan turned into prime Chicago real estate—and a separate country?

O F all the luminaries for whom Chicago neighborhoods are named, none could match Captain George Wellington Streeter for unbridled chutzpah. Claiming a big piece of Chicago by squatter's rights, he dared the authorities to do something about it. From the 1880s until his death in 1921, Streeter asserted not just ownership but sovereignty over 186 acres of prime lakeshore, between the mouth of the Chicago River and Oak Street. Northwestern University's medical campus, its law school and the skyscrapers that line Lake Shore Drive sit on what Streeter called his "Deestrick of Lake Michigan." The Tribune went along with his shaky pronunciation, referring to the area as his "deestrict" or "deestrick." Now it's simply called Streeterville.

"The deestrick is mine," he told a Tribune reporter in 1901. "I discovered the deestrick. Who was the first man to know there was any land up there? Capting Streeter. Who was th' furst man to live thar? Capting Streeter."

Actually, the "discovery" predated the land. In 1886, Streeter said a storm tossed the Reutan, his excursion boat, onto a sandbar 400 feet offshore at about Superior Street. A nearby property owner, N. Kellogg Fairbank, gave Streeter permission to remain until the boat was repaired—an act of generosity Fairbank would forever regret. The vessel and Streeter remained in place. Sand piled up

around the Reutan, and garbagemen and street sweepers dumped trash there. Mainland property owners joined in, filling in the distance from the shore to the boat and claiming the resulting land was theirs according to the law of riparian rights. So, too, did the city, anticipating the projected route of Lake Shore Drive, and by their combined efforts, a neighborhood was created where there had been only water.

By the time he spoke to the Tribune, Streeter had "an army bristling with rifles and bayonets" defending his assertion that the land didn't belong to his landlubber opponents, the city of Chicago or the state of Illinois. It was, he declared, an autonomous entity with its own—that is, his—laws and regulations. Obviously that didn't sit well with Fairbank and his well-heeled neighbors, and a long struggle began, fought with lawsuits and bullets.

To finance his side of the battle, Streeter sold lots to upward of 200 prospective homeowners, as well as refreshments, alcoholic beverages and snacks to real estate shoppers and the just plain curious. Among those wounded during a 1915 clash between the authorities and Streeter's employees and customers, as the Tribune reported, were: "Crist Mantis, proprietor of popcorn stand in Streeterville; jaw injured from blow delivered by Patrolman Sullivan." Mrs. Nonie Hollst, described as an occupant of "one of the wagon homes on Streeter's land," was shot in the hip by another cop. The captain's wife, Maria, or "Ma" as he called her, wounded a policeman who tried to arrest her for selling beer without a liquor license.

Streeter himself was wounded several times and spent time behind bars. His courtroom appearances were marked by sound and fury. When a judge ordered him not to badger a witness, the Trib reported: "'I want to know'—yelled Streeter, fairly dancing in his anger." One prison stay was for the murder of a private guard hired by the lakeshore property owners, though the authorities couldn't specify what Streeter's role was. For their part, Streeter and friends tried unsuccessfully to have Fairbank's friends tried for the crime.

Between jail terms, Streeter was a well-

Opposite: Captain George Wellington Streeter after city judges finally ordered him and his belongings removed from Streeterville in 1918. City workers destroyed his house and put all his belongings outside in an effort to get Streeter to leave his self-proclaimed "Deestrick of Lake Michigan."

known local character, much sought out by reporters on slow news days. He played the part well, even took to the stage with his signature battered top hat. In 1902, he appeared at the Metropolitan Theater, on Clark Street, in a vaudeville review that had his ship sinking on that stormy night. He claimed prior show biz experience, saying he'd run a circus and built a theater in South Chicago. But as with his other claims, it's hard to tell where fact faded and fantasy began.

Of his Metropolitan Theater gig, the Trib's reviewer wrote: "The 'Cap' came out of the lake with a telescope and a carpet bag, exclaiming 'Thank God, that is all I got from the wreck!' and after various spyings of the land he bought 100 acres from Chief Pokagon."

In real life, Streeter offered various theories about why the land belonged to him. Sometimes he claimed it by squatter's rights, other times he said he'd bought a deed from a mysterious John Scott, "some place in Michigan."

The longest-running explanation was a purported land grant from President Grover Cleveland that Streeter waved in front of judges for 25 years—until, that is, a handwriting expert took the witness stand in a 1918 trial and put a chemical test to the document's signatures, as the Tribune reported. "Lo and behold, the signature of Cleveland faded away and there arose in its place the quaint and sturdy signature of President Martin Van Buren!" Streeter's name vanished by a similar process, revealing the true grantee to have been Robert Kinzie, a pioneer Chicagoan. The judge ruled that the document "was and is now clumsy forgery," adding that weather bureau records showed no evidence of a storm the night Streeter claimed to have been shipwrecked.

By then, Streeter and Ma had been evicted from the district several times. Just as often, Streeter tried to retake it by force. In 1902, the police pulled down the shanty where the captain lived off the grid, where the John Hancock Center now stands. "His lettuce and beets had been ruthlessly torn up by the roots," the Tribune reported. In 1910, he anticipated tank warfare, driving onto Streeterville with an internal combustion vehicle "that resembles a

freight car of stunted growth" to a Trib reporter's eye. "It constitutes the only home, castle, fortress, and habitat of the captain and his wife at the present time."

After the fiasco of the forged presidential land grant, the brick shack that had replaced the destroyed wooden shanty was burned by

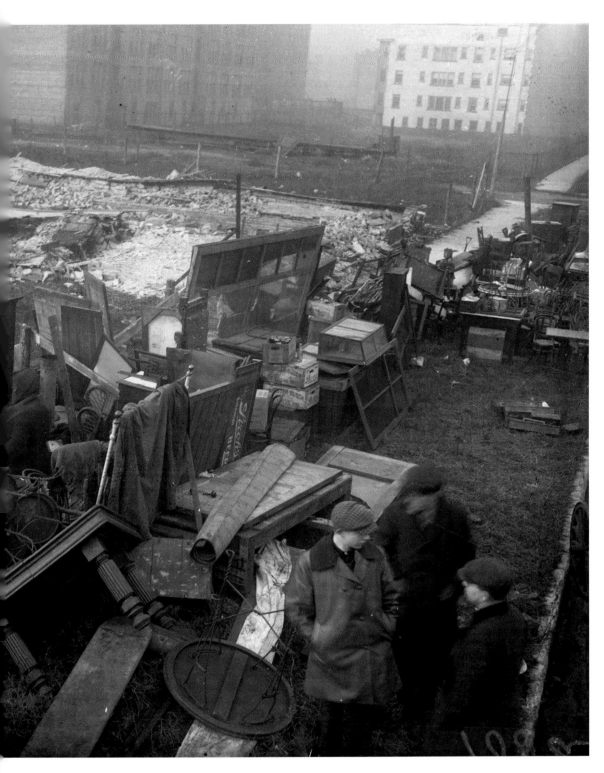

Curiosity-seekers inspect the damage after the Streeter riot, when city judges finally ordered Cap'n Streeter and his belongings removed from Streeterville in 1918. The Tribune reported in December 1918, "In the shadows across the sidewalk rose a pile of furniture, dishes, stoves, beds, and household paraphernalia lying cluttered in crazy confusion."

agents of Chicago Title and Trust, acting on behalf of a legitimate landowner. Shortly, a policeman found the captain and Ma living "in a wagon without horses, standing on Chestnut Street."

Three years later, in 1921, he was carried to his grave in a coffin with his battered old hat perched on top. The Tribune had already written his epitaph. On the night his brick shack fell, it observed:

"It was the ruin of an ambition of a quarter of a century—a piratical ambition, perhaps, but still an ambition."

—RON GROSSMAN

Mother Jones

Fiery union organizer stood fast with 'brave boys' of labor

TESTIFYING before a congressional committee in 1910, Mother Jones, a fiery union organizer, was asked to state her address.

"My address is like my shoes: It travels with me," she replied. "I abide where there is a fight against wrong."

For Mother Jones, then in her 70s, that was literally true. She was still racing around the country answering the call of hard-pressed workers, from the coal fields of Pennsylvania to the copper mines of Arizona. Long before, she'd had a permanent address in Chicago: 174 Jackson St. (as streets were then numbered), where she was a dressmaker with a wealthy clientele. And she left specific instructions where her final resting place should be: the Union Miners Cemetery in Mount Olive, Ill., northeast of St. Louis, alongside "her brave boys," as she called them.

In fact, she had no boys or girls to send her a Mother's Day card or bring flowers. Her four young children died in a yellow fever epidemic that also killed her husband. Yet neither friend nor foe called her by her name, Mary Harris Jones. To the sheriffs who arrested her and the vigilantes who ran her out of company towns at gunpoint, she was simply "Mother," just as she was to workers who hung her picture on their walls.

When she was buried in 1930, the priest called her "the Joan of Arc of labor" and said she was "armed with only the weapons of a burning mother's love," the Tribune reported.

There was a second opinion. A U.S. district attorney called her "the most dangerous woman in America" at her 1902 trial for urging West Virginia miners to go on strike. Not only were strikes then illegal, so, too, was talking about a walkout.

The route to those diverging images of Mother Jones began during her Chicago years. In her autobiography, she recalled: "Often while sewing for the lords and barons who lived in magnificent houses on Lake Shore Drive, I would look out of the plate glass windows and see the poor, shivering wretches, jobless and hungry, walking along the frozen lakefront." After the Great Chicago Fire of 1871 destroyed her business, she experienced the life of the poor firsthand.

She threw her lot in with the nascent labor and radical political movements of which Chicago was the epicenter. She was a Socialist Party activist and a luminary at the founding convention in Chicago of the Industrial Workers of the World, which aimed at creating one big union to oppose plutocrats like John D. Rockefeller Jr. It was the first age of the 1 percenters.

But she broke with both groups, distrustful of working-class bureaucrats no less than owning-class bureaucrats. Mother Jones' basic ideology was Americanism. When she said she had a permit to speak to striking steelworkers, a judge asked who issued it. She replied: "Patrick Henry; Thomas Jefferson; John Adams," Mother Jones wrote in her autobiography.

Unmoved, the judge fined her. Others put her in jail, which played into her hands. Like Gandhi and Martin Luther King Jr., she realized that a voice can be more powerful behind bars than on a soapbox. "Don't be afraid of jails. It's an honor to go to jail when your cause is just," the Tribune reported Mother Jones telling striking Chicago glove-makers in 1915. Some were arrested in a melee that began when a strike leader punched a factory owner and a cop, a teamsters official came to her aid, and he was beaten by the police.

A year earlier, the governor of Colorado ordered her held incommunicado in a hospital during a coal miners strike. According to the Tribune's account: "'Mother Jones' became extremely boisterous in the hospital today and so disturbed the patients that military officers threatened to put her in a padded cell."

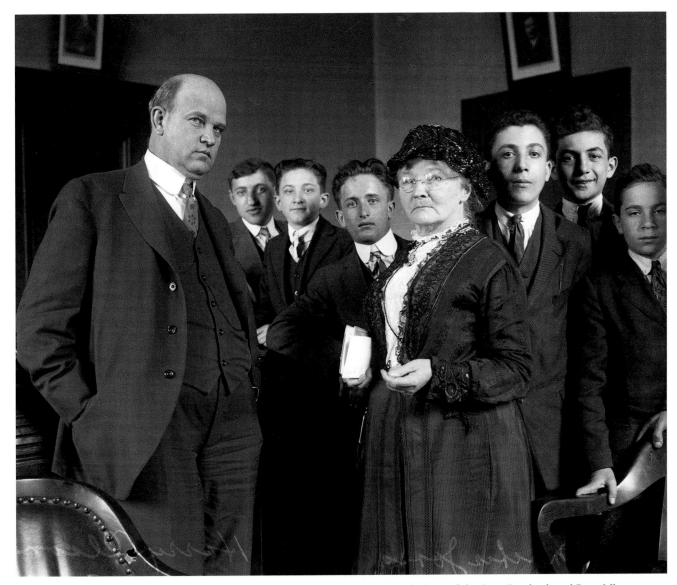

Labor union advocate Mother Jones is shown with Judge Harry Olson and members of the Boys Brotherhood Republic, a Chicago boys club, in 1915. Jones was lending moral support to the boys club, which was fighting a judge's plan to fingerprint "juvenile delinquents."

As in guerrilla warfare, Mother Jones had a knack for making a virtue of weakness. Mine and factory owners had the courts on their side. They had friends in halls of power who could send state militias to break a strike. They could evict strikers from homes in company-owned towns. But Mother Jones wasn't weaponless. First, she had a carefully crafted persona—a sweet, gentle old woman wearing old-fashioned ankle-length dresses—a target beyond the pale even to thugs looking to break heads.

She marshaled miners' wives in "broom and mop" brigades. A Tribune reporter saw one in action during a 1900 coal miners strike:

> "My address is like my shoes: It travels with me. I abide where there is a fight against wrong."
>
> —JONES, 1910

Mother Jones lost more battles than she won, but even in defeat she brought hope to the despairing.

"At the head of the column marched 'Mother' Jones with a woman carrying a strip of red, white and blue bunting nailed to a broom handle. Behind her, two by two, tramped the long line of miners' wives and daughters, armed with brooms and sticks." A parallel tactic was to make strike breakers run a gantlet of women banging on pots and pans.

In truth, she lost more battles than she won, but even in defeat she brought hope to the despairing. Her presence meant someone cared, and she persevered where others might turn back. Once she was told she couldn't take the road to an isolated hamlet because it, like everything there, belonged to the mine owner. So hiking up her petticoats, she stepped into a stream and followed its course to the company town.

Over her 50 years of organizing and agitating, Mother Jones campaigned for streetcar conductors and garment workers. She led a delegation from a Chicago boys club concerned about a judge's plan to fingerprint juvenile delinquents. But she was particularly drawn to the cause of miners. Men who "risk their life and health down in the blackness of the earth; who crawl through dark, choking crevices with only a bit of a lamp on their caps to light their silent way; whose backs are bent with toil, whose very bones ache; whose happiness is sleep, and whose peace is death," she wrote in her autobiography.

That emotional attachment led her to ask to be buried in Mount Olive, opposite a monument erected to the seven miners who were killed in the 1898 Virden mine strike, in which 12 people died and scores were wounded.

She also was deeply troubled by underage workers, children as young as 6 sent to textile mills because their fathers didn't earn enough in the mines. She led a march of child workers from Philadelphia to New York, where President Teddy Roosevelt had a home.

Halting at Princeton University, she introduced members of her Children's Crusade: "'Here's a textbook on economics,' I said pointing to a little chap, James Ashworth, who was 10 years old and who was stooped over like an old man from carrying bundles that weighed 75 pounds. 'He gets three dollars a week.'"

Still, her campaign for a better life for working folk was largely forgotten. Some feminists were leery of identifying their movement with Mother Jones because she thought a woman's place was at home, except those she called out for broom-and-bucket duty. Yet when later-day activists founded a muckraking journal in 1976, they named it Mother Jones.

And her memory survives in the mountains of Appalachia. During a 1989 strike, 40 female miners staged a sit-down in a coal company's Pennsylvania offices. The police who arrested them asked who they were, to which they replied: "Daughters of Mother Jones."

—RON GROSSMAN

Maurine Watkins

Pioneering journalist brought Roxie Hart to life in famous play 'Chicago'

On an April day in 1924, a Tribune editor sent Maurine Watkins to cover a coroner's inquest at a South Side funeral home. Newly hired to bring a feminine perspective to the crime beat, Watkins brought back an eyeful: "Thursday afternoon Mrs. Annan played 'Hula Lou' on the phonograph while the wooer she had shot during a drunken quarrel lay dying in her bedroom."

Who was this Mrs. Beulah May Annan? Watkins painted a picture for Trib readers: "They say she's the prettiest woman ever accused of murder in Chicago—young, slender, with bobbed auburn hair; wide set, appealing blue eyes; tip-tilted nose; translucent skin, faintly, very faintly, rouged, an ingenuous smile; refined features, intelligent expression—an 'awfully nice girl' and more than usually pretty."

Watkins' vigorous prose proved that a woman could hold her own with the jaundiced male reporters dripping cigarette ash into their typewriters. She fleshed out the story with details, legally irrelevant, but deliciously tempting to readers with a taste for the salacious and the macabre, whose numbers, Chicago papers then rightly assumed, were legion.

The Tribune's hiring of Watkins was no accident. The Trib had for years boosted circulation by targeting female readers with myriad features, especially in the Sunday editions. The newspaper doubled down on this strategy by actually hiring women to edit and report.

In 1915, the newspaper promoted Mary King as Sunday editor.

Fanny Butcher was hired in 1913 and became literary editor in 1922; she didn't retire until 1962. The legendary Genevieve Forbes Herrick joined the Trib in 1918 and wrote about nearly every subject imaginable, including politics. She was among the women who benefited in 1933 when first lady Eleanor Roosevelt banned male reporters from her news conferences. Sigrid Schultz covered Nazi Germany—from Berlin—from the mid-1920s until the outbreak of World War II.

When the editor read Watkins' copy back in April 1924, he put her byline on it, her first. That was then an editor's prerogative. Though he didn't know it, that editor had seen the first draft of an unforgettable character of American theater. Did Watkins herself have an inkling? Before and after her short stint at the Tribune, Watkins studied drama, the latter time at Yale University.

There she wrote a play, a ripped-from-her-own-headlines story called "Chicago." It was produced on Broadway in 1926, filmed the following year, made into a musical by Bob Fosse in 1975 and an Oscar-winning film in 2002. On the stage, Beulah Annan was transformed into "Roxie Hart" and given a show-stopping performance by Gwen Verdon.

Watkins was born in 1896 in Kentucky. She showed early talent as a playwright and founded a newspaper at her high school. At Radcliffe College, she took a playwriting course with George Baker, whose students included Eugene O'Neill. She dropped out before finishing her degree, relocated to Chicago and landed a $50-a-week job at the Tribune.

How she managed that is a mystery. One tradition has her turning on the feminine charms and batting her eyelashes. Yet she hardly seems

Beulah Annan, wanted on murder charges for the death of Harry Kalstedt in 1924.

From left, Fanny Butcher, Chicago Tribune literary editor, in 1941; Genevieve Forbes Herrick, Chicago Tribune reporter, circa 1946; Sigrid Schultz, Chicago Tribune reporter, in 1941.

to have been a Jazz Age flapper type. Her description of a visiting Italian nabob could have served as Watkins' self-portrait: "In a simple gray crepe dress, with broad heeled suede oxfords, her hair parted simply and coiled low, she looked like an old fashioned American girl—unbobbed, untinted."

Whatever the case, Watkins quickly demonstrated she could handle the job. She reported on conventions of anesthetists and men's clothiers. She brought a poetic eye to her subjects.

She reviewed movies with an acid tongue, saying of a silent film whose plot made no sense: "Maybe they lost the necessary subtitles, or perhaps the operator ran two or three reels backward."

But the perfect vehicle for her skills was crime stories. She could sum up a tale of senseless, brutal murder with a withering phrase. Of Loeb and Leopold, the infamous rich-boy thrill murderers, Watkins reported they dispassionately killed their young victim much "as they'd crush a beetle."

She wrote about an actor who doubled as a con man asking a judge for permission to speak. No, his honor replied. "You are too slick a talker, and there have been too many suckers already! I've a diamond ring and a watch, and I want to hold on to them!"

Somehow Watkins got access to "Murderers Row," a women's tier in Cook County Jail so dubbed for the seven accused killers it held.

There she met Belva Gaertner, like Beulah Annan accused of killing her lover. Watkins seems to have realized the literary possibilities in the parallelism of the two women's cases.

"A man, a woman, liquor and a gun—" she wrote in a Tribune article.

Shortly after each was acquitted, Watkins left the Tribune for Yale, where her mentor Baker had joined the faculty. She wrote "Chicago," and with Baker's imprimatur, it was brought to Broadway. It ran for 172 performances and toured for two years. But she repeatedly turned down Fosse's proposal to turn "Chicago" into a musical—some speculated she regretted her role in the women's acquittals—and it wasn't until after her death in 1969 that her estate granted the famous director and choreographer permission.

Watkins wrote other plays and Hollywood scripts but didn't have any other breakout successes.

A shrewd investor, she left an estate of over $2 million, much of it earmarked for endowing university programs in Greek and biblical studies. A recluse at the end of her life, she never went out without a black veil over her face. Of her personal life, very little is known, though some see a clue in a line from her play "Gesture": "The tragedy of every woman's life—that some man doesn't live up to her ideals."

—RON GROSSMAN

'The world's richest cop'

Capone-era police captain and union boss amassed a fortune

Capt. Dan "Tubbo" Gilbert was appointed chief supervising captain of the city force in 1935.

DAN Gilbert was a big shot, the kind of guy whose name rated boldface type in gossip columns throughout most of his 80 years. His 1970 funeral was a who's who of Chicago's establishment. Mayor Richard J. Daley and Col. Jake Arvey, the local Democratic Party chief, attended the services at Holy Name Cathedral. So, too, did a flock of business and union heavies.

It was a pretty good send-off for "the world's richest cop," as he was called by headline writers. The implication was that he didn't earn the title on a patrolman's salary or even a captain's salary, a rank he attained in a scant nine years on the job. Gilbert attributed his financial success to Lady Luck.

"You see in the press today that I'm a big bad gambler," Gilbert said, according to the Tribune's account of a 1950 political rally. "They say that I bet on football games and elections. Yes I do. And I'll bet on this election too—that I'll be the next state's attorney." Unfortunately, he was running for Cook County sheriff.

He had been even more forthcoming about his finances in an appearance a few weeks earlier before a U.S. Senate committee in Chicago to investigate organized crime.

As a courtesy to the Chicago Machine, committee Chairman Estes Kefauver, a Democratic senator with presidential ambitions, heard Gilbert's testimony behind closed doors. "Tubbo," as Gilbert was known to friends and foes, said he was worth $360,000. At the time, he was making $9,000 a year as chief investigator for the Cook County state's attorney. Gilbert attributed the difference between the two amounts to commodities trading and gambling.

Mathematicians and wiseguys say the odds are against a gambler ending up ahead of the game, but Gilbert did make big money in commodities.

In 1947, the Tribune reported that Gilbert's name was on a Department of Agriculture list of 100 elected officials "gambling in the wheat market . . . when inside knowledge of administration market moves would have enabled a speculator in wheat to reap enormous profits."

Whatever its source, his fortune enabled

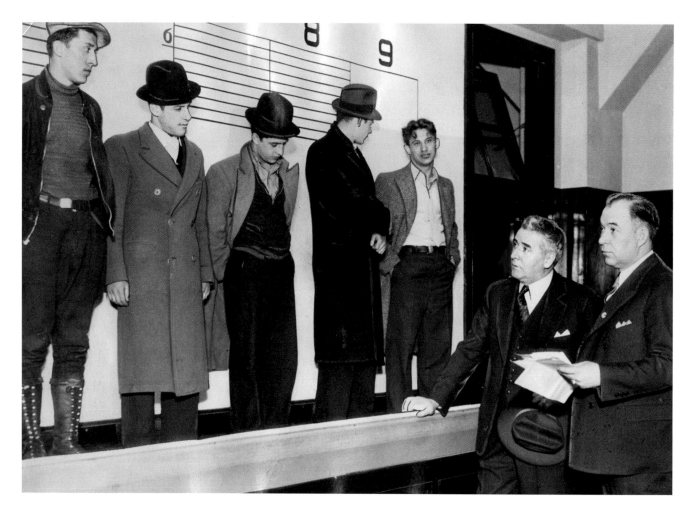

Supervising Capt. Dan Gilbert, second from right, attends a police showup in 1935 with Chief of Detectives John L. Sullivan, right.

The Valley was a place where police work, crime or union office seemed the best routes out of poverty. Gilbert chose all three.

Gilbert to live on Lake Shore Drive, a world apart from the Valley, the hardscrabble Near West Side neighborhood of his youth. The Valley was a place where police work, crime or union office seemed the best routes out of poverty. Gilbert chose all three.

At 23 he was elected secretary-treasurer of a Teamsters local, giving him a foothold in union politics that he wasn't about to surrender upon becoming a cop in 1918.

Looking back at his career, George Bliss, the Trib's ace investigative reporter, noted that by 1938, Gilbert controlled seven Teamsters locals. "Union leaders took their problems directly to Gilbert and he was said to have dic-

tated the men he wanted as officers of the locals," Bliss wrote in 1954.

Gilbert had no compunctions about mixing his police authority and union activities. When a 1934 strike of waiters and bartenders closed down the French Casino, which the Tribune observed "featured girls from the Folies Bergeres, in Paris," Gilbert ordered union officials to settle with the club, pronto.

"The state's attorney is opposed to unjustified strikes," Gilbert told them, "and as far as I can see, there is no justification for this one." The club's owner controlled the Music Corp. of America, a powerful booking agent of nightclub acts.

The following year, Gilbert forbade a breakaway Teamsters faction to meet, sending cops to block access to the Hod Carriers Hall, the Tribune reported. When the insurgents gathered instead at the Bricklayers Hall, Gilbert waited until the meeting was over, then arrested their leaders.

When John "Jake the Barber" Factor, mobster and half brother of Max Factor, disappeared in 1933, Gilbert had some minor hoodlums rounded up. Saying he suspected they knew something but couldn't prove it, he ordered them to leave town and pointed to an officer. "This man will bring you in feet first if you stay around," Gilbert said, according to the Tribune's account. "You may beat the law, but you can't beat bullets."

When Factor reappeared, just as mysteriously as he disappeared, he said he'd been kidnapped by Roger Touhy, another mobster; Touhy served 25 years before his conviction was overturned by a judge who denounced Gilbert's role in the affair. Finding that Touhy had been railroaded, Judge John Barnes ruled the jury had heard "perjured testimony, which Chief Investigator Gilbert procured and knew to be perjured."

Gilbert was already retired at that point. For decades, he'd been the Teflon cop. He was summoned before grand juries that declined to indict him.

Tantalizing clues surfaced but led nowhere.

In 1941, the Tribune reported the discovery of mafia financial records in the oven of an apartment formerly occupied by mob boss Jake Guzik. On a page that recorded payoffs for protection was the entry "Tub . . . $4,000." Gilbert denied it referred to him, because his friends called him "Tubbo," never "Tub."

In 1963, a loose-leaf notebook was found in a desk in the state's attorney's office. Inside were tidbits—names of girlfriends, mob associates, hangouts—of Capone-era hoodlums like "George 'Tony the Wop' Basso," "Thomas (Rubber Nose) Conley" and "'Two Gun' Ike Katsovitch."

"I never saw that book in my life," Gilbert told the Tribune.

By that time, Tubbo's luck was gone. When he ran for sheriff in 1950, he was tripped up by an enterprising reporter. Posing as a newly hired Senate staffer, Sun-Times reporter Ray Brennan conned the sealed transcripts of Gilbert's appearance before the Kefauver committee out of its transcription service.

Publication of Gilbert's testimony sank his first, and only, run for public office. After losing by a landslide, he retired as a cop and spent his remaining years shuttling between

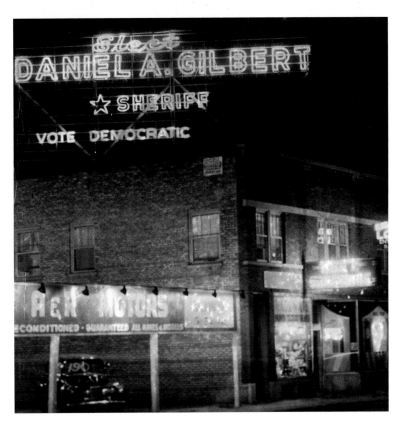

A sign promoting Gilbert's bid for Cook County sheriff is illuminated above 3808 N. Central Ave. on Nov. 1, 1950, in Chicago.

the West Coast and Chicago, minding his real estate investments and securities portfolio.

Perhaps the proper eulogy for Gilbert, indeed for the whole shabby era, was something Cook County State's Attorney Thomas Courtney reportedly observed in 1936, when Gilbert was accused of conspiring to fix milk prices. Editorial writers and civic-minded citizens were demanding Gilbert be fired, but Courtney declined to do so, saying:

"If many people feel that politics has entered into this, then I won't disagree with that conclusion."

—RON GROSSMAN

Ralph Metcalfe

Jesse Owens' teammate refused to run from biggest opponent— the Chicago Machine

Chicago Ald. Ralph Metcalfe in 1969.

Look closely and you'll see a Chicago legend flash across the screen in "Race," the movie about the 1936 Berlin Olympics. Ralph Metcalfe, an alum of Tilden Technical High School, finished second in the 100-meter dash, a 10th of a second behind Jesse Owens, the film's hero. Together, they delivered a one-two punch to Adolf Hitler's intention to make the Games a showcase for his racist ideology. Metcalfe and Owens were descendants of slaves, untermenschen—inferior beings, in the Nazis' vocabulary. But collectively, they won five gold medals. Other African-American athletes brought home still more medals, leading the Tribune to sum up their accomplishments with a headline: "Abraham Lincoln Won 1936 Olympic Games."

Still, Metcalfe couldn't have eaten at a Loop restaurant or lived in a white neighborhood in the 1930s. But he went into politics as a member of the Illinois State Athletic Commission and rose to be a U.S. congressman—by doing as he was told. That's the way the Chicago Machine operated. In 1972, however, he broke with Mayor Richard J. Daley, the all-powerful Democratic Party boss, over the same issue that inspires the Black Lives Matter movement: police brutality inflicted upon African-Americans.

His name is on the Ralph H. Metcalfe Federal Building on Jackson Boulevard. Yet how many passersby have the faintest idea why it's there? That is a pity. Metcalfe's is a tale of what determination can accomplish, even when the other fellows have been given a big head start.

Metcalfe was born in Atlanta in 1910 and, at 7 years old, came to Chicago with his parents who were hoping to escape the limitations of the Jim Crow South, as thousands of black families did during the Great Migration.

But by high school, it was clear that Ralph's story would be different. He had a gift for getting from here to there quicker than others, which, he was informed, wouldn't be enough: "I was told by my coach that as a black person I'd have to put daylight between me and my nearest competitor," Metcalfe told the Tribune shortly before his death in 1978. "So I forced myself to train harder so I could put that daylight behind me."

So much so that he went to Marquette University in Milwaukee on a scholarship. There he equaled the world record in both the 100- and 200-meter dashes, and was soon being talked about as "the fastest man on Earth." But approbation doesn't buy railroad tickets, and in the Depression years, neither his school nor family had the money to send him to the 1932 Olympic Games in Los Angeles.

Johnny Sisk, who knew him at Marquette and played for the Chicago Bears, explained to a Tribune reporter how Metcalfe got there: "Ralph Metcalfe solved his problem," explained Sisk, "by getting a dining car job on the Santa Fe railroad. That gave him transportation to Los Angeles, his meals and some room-and-board money before he settled in the Olympic Village."

Opposite: Ralph Metcalfe, who would later become a congressman, competes for Marquette University in 1932 at a U. of C. track meet.

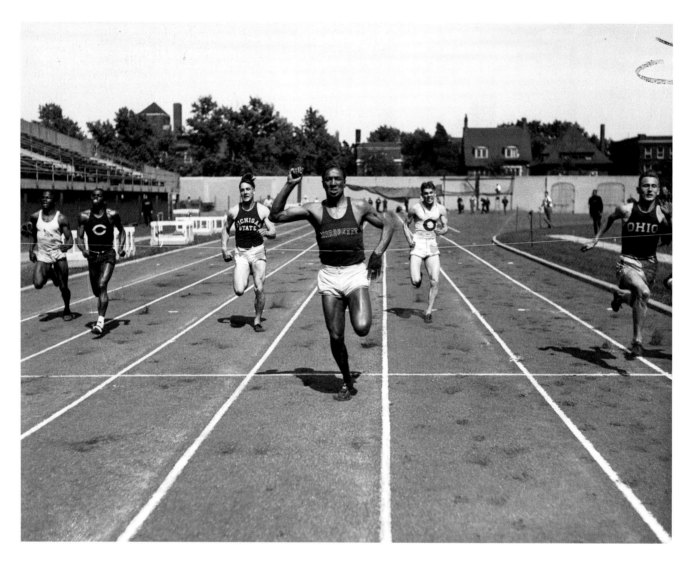

Metcalfe winning the 100-yard dash for Marquette at Stagg Field at the University of Chicago, 1932.

There he won a bronze medal in the 200-meter dash, and finished in a dead heat with another runner in the 100-meter race—the other runner got the gold medal only after the judges' protracted study of the photographs of the finish. Although he again failed to win the event at the Berlin Olympics, his high school coach would have been proud of him. Metcalfe and Owens were on the winning relay team, a victory Owens credited to Metcalfe. "It was the congressman who created a 7-yard gap between the U.S. team and the competing teams in the 400-meter relay, and not one could ever catch up with us," Owens told the Tribune years later.

After military service during World War II, Metcalfe went into politics under the tutelage of William Dawson, the city's most powerful black officeholder. Even after breaking with the Machine, Metcalfe credited his mentor. "I was taught by none other than the master himself, Rep. William L. Dawson," he told Tribune columnist Vernon Jarrett in 1975.

Dawson, whose base was the 2nd Ward, wanted to extend his empire to the 3rd Ward and pushed aside its committeeman to install Metcalfe in that post in 1952. Subsequently he became its alderman, then inherited Dawson's congressional seat.

Through all of these posts he was so firmly loyal to a Machine under attack by blacks and reformers that political mavens were caught flat-footed by Metcalfe's break with Daley. Jarrett noted it is usually the other way around: An independent gets elected, then makes his peace with the bosses. A long-serving creature of the Machine rarely turns independent.

For Metcalfe, the decisive issue was re-

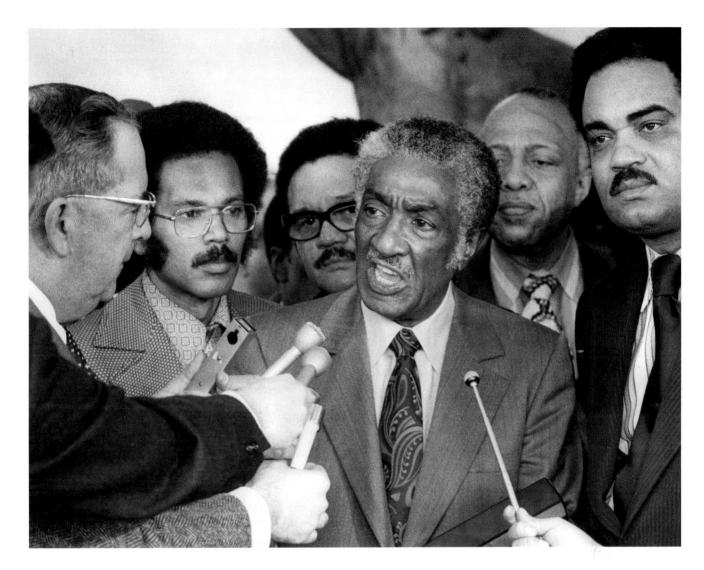

ports that cops were manhandling African-Americans—and that City Hall and the Chicago Police Department were ignoring their complaints. In 1972, Rep. Metcalfe held hearings at the Dirksen Federal Building, where a black dentist testified he was handcuffed because his license-plate light was out. Others said they had been beaten after being stopped for similarly minor infractions. In an 89-page report demanding reforms, Metcalfe called the Police Department "rotten to the core."

With Metcalfe having declared war on the Machine, Daley returned fire. Patronage jobs, the ultimate base of a Chicago politician's power, were taken out of Metcalfe's hands. Though he was still the 3rd Ward committeeman—narrowly surviving an attempt to beat him at the polling place—a Machine loyalist was given control of whom got which jobs on

a garbage truck or behind a clerk's desk in City Hall.

Yet the Machine pols couldn't dislodge him, even after Metcalfe committed the ultimate sin: backing Ald. William Singer, an independent who ran against Daley for mayor in 1975. At the time of his death three years later, Metcalfe was running for a fifth term, and was an odds-on favorite to win. Tributes poured in from friends and foes alike—those who thought he came late to the cause of civil rights, and others who thought him a trouble-maker.

But perhaps his most fitting epitaph is something he said during his battle with the Machine:

"I used to be called the world's fastest human—I have never run from a fight."

—RON GROSSMAN

U.S. Rep. Ralph Metcalfe holds a news conference about reports of police abuse of black residents in 1972.

Photo credits

All photos Chicago Tribune historical photos, unless otherwise noted below:

Page 4: Arnold Tolchin / Chicago American

Page 6: Armando Villa / Chicago Tribune

Page 10: Chicago Herald-American

Page 16-17: Hardy Wieting / Chicago Tribune

Page 52-53: Ernie Cox Jr. / Chicago Tribune

Page 55: Luigi Mendicino / Chicago Tribune

Page 59: Charles Cherney / Chicago Tribune

Page 62: Chicago Herald-American

Page 68: Chicago Herald and Examiner

Page 74: Luigi Mendicino / Chicago Tribune

Page 80-81: Walter Kale / Chicago Tribune

Page 82: Roy Hall / Chicago Tribune

Page 83: Gerald West / Chicago Tribune

Page 84: Duane Terry / Chicago Tribune

Page 85: Joe Migon / Chicago Tribune

Page 86-87: Phil Greer / Chicago Tribune

Page 88: Chicago Herald and Examiner

Page 94-95: Bill Allison / Chicago Herald-American

Page 97: Bill Allison / Chicago Herald-American

Page 100-101: Joe Mastruzzo / Chicago Tribune

Page 102: Bill Allison / Chicago Tribune

Page 103: Steve Marino / Chicago Tribune

Page 110: Dan Tortorell / Chicago Tribune

Page 111: Alton Kaste / Chicago Tribune

Page 112: Hardy Wieting / Chicago Tribune

Page 116: John Austad / Chicago Tribune

Page 117: Chicago Herald-American

Page 122-123: Dave Nystrom / Chicago Tribune

Page 124: Don Casper / Chicago Tribune

Page 126-127: James Mayo / Chicago Tribune

Page 129: Dante Mascione/ Chicago Tribune

Page 132-133: Nuccio DiNuzzo / Chicago Tribune

Page 134: Phil Velasquez / Chicago Tribune

Page 144: Chicago Herald and Examiner

Page 148: Leonard Bartholomew / Chicago Tribune

Page 151: Steve Lasker / Chicago's American

Page 152-153: Anne Cusack / Chicago Tribune

Page 156-157: Karen Engstrom / Chicago Tribune

Page 158: Anne Cusack / Chicago Tribune

Page 159: Chris Walker / Chicago Tribune

Page 161: Chris Walker / Chicago Tribune

Page 164-165: Chicago Herald and Examiner

Page 167: Leonard Bartholomew / Chicago Tribune

Page 184-185: Chicago American

Page 188: Chicago American

Page 190-191: Chicago Herald-American

Page 196: William Vendetta / Chicago Tribune

Page 197: Luigi Mendicino / Chicago Tribune

Page 201, top: Frank M. Moore / Chicago Tribune

Page 206: James Mayo / Chicago Tribune

Page 216: Phil Velasquez / Chicago Tribune

Page 218: Chicago Tribune historical photo / illustration

Page 228-229: Luigi Mendicino / Chicago Tribune

Page 230: John Austad / Chicago Tribune

Page 231: Don Casper / Chicago Tribune

Page 232, top: Ray Foster / Chicago Tribune

Page 232, bottom: William Kelly / Chicago Tribune

Page 234-235: William Kelly / Chicago Tribune

Page 236: Michael Budrys / Chicago Tribune

Page 237: Michael Budrys / Chicago Tribune

Page 238-239: Arthur Walker / Chicago Tribune

Page 241, top: James O'Leary / Chicago Tribune

Page 241, bottom: Jack Mulcahy / Chicago Tribune

Page 242-243: Walter Kale / Chicago Tribune

Page 244: Karen Engstrom / Chicago Tribune

Page 245: George Quinn / Chicago Tribune

Page 252-253: Harold Norman / Chicago Tribune

Page 256-257: Walter Kale / Chicago Tribune

Page 258: Bob Fila / Chicago Tribune

Page 259: Don Casper / Chicago Tribune

Page 270-271: William Yates / Chicago Tribune

Page 272: Tony Berardi Jr. / Chicago Tribune

Page 273, top: Luigi Mendicino / Chicago Tribune

Page 273, bottom: Val Mazzenga / Chicago Tribune

Page 278: Chicago American

Page 289: Chicago Herald and Examiner

Page 301: Brian Cassella / Chicago Tribune

Page 306-307: James O'Leary / Chicago Tribune

Page 308: William Yates / Chicago Tribune

Page 309: Luigi Mendicino / Chicago Tribune

Page 310-311: Phil Greer / Chicago Tribune

Page 312: Chicago Herald and Examiner

Page 313: Lee Olsen / Chicago Tribune

Page 316-317: Ron Pownall / Chicago Tribune

Page 318: Ovie Carter / Chicago Tribune

Page 319: Carl Wagner / Chicago Tribune

Page 320-321: Chicago Herald-American

Page 322: Jack Lembeck / Chicago Herald and Examiner

Page 327, bottom: Chicago Herald and Examiner

Page 328, top: Chicago American

Page 332-333: Carl Hugare / Chicago American

Page 334: Carl Hugare / Chicago Tribune

Page 335: Carl Hugare / Chicago Tribune

Page 346, top left: Max Arthur / Chicago Tribune

Page 346, top right: Don Casper / Chicago Tribune

Page 346, middle left: Max Arthur / Chicago Tribune

Page 346, middle right: Michael Budrys / Chicago Tribune

Page 346, bottom left: Don Casper / Chicago Tribune

Page 346, bottom right: Ovie Carter / Chicago Tribune

Page 352-353: Luigi Mendicino / Chicago Tribune

Page 354, top: Quentin C. Dodt / Chicago Tribune

Page 354, bottom: Jim Mescall / Chicago Tribune

Page 355, top: Al Phillips / Chicago Tribune

Page 355, bottom left: Eugene Powers / Chicago Tribune

Page 355, bottom right: Chicago American

Page 360-361: Cy Wolf / Chicago Tribune

Page 364: Arnold Tolchin / Chicago American

Page 365: Arnold Tolchin / Chicago American

Page 368: Bob Fila / Chicago Tribune

Page 370: Steve Marino / Chicago Tribune

Page 372: John Austad / Chicago Tribune

Page 374: Ray Gora / Chicago Tribune

Page 375, left: Eugene Powers / Chicago Tribune

Page 375, right: Luigi Mendicino / Chicago Tribune

Page 376: George Quinn / Chicago Tribune

Page 377: George Quinn / Chicago Tribune

Page 382: Frank Masters / Chicago Tribune

Page 383: Julius Gantter / Chicago Tribune

Page 395: Dante Mascione / Chicago Tribune

Page 401: Gerald West / Chicago Tribune

Front cover photo credits:

Top row, from left: Chicago Tribune historical photo, Chicago Tribune historical photo, Frank Hanes / Chicago Tribune

Second row: Chicago Herald and Examiner historical photo

Third row: Chicago Tribune historical photos

Bottom row, from left: Val Mazzenga / Chicago Tribune; Chicago Tribune historical photo; Chicago Tribune historical photo